The
Domain
of
Images

The Domain of Images

James Elkins

Cornell University Press

Ithaca & London

Copyright © 1999 by Cornell University

All rights reserved. Except for brief quotations in a review, this book, or parts thereof, must not be reproduced in any form without permission in writing from the publisher. For information, address Cornell University Press, Sage House, 512 East State Street, Ithaca, New York 14850.

First published 1999 by Cornell University Press.

Printed in the United States of America.

Library of Congress Cataloging-in-Publication Data
 Elkins, James, 1955–
 The domain of images / James Elkins.
 p. cm.
 Includes bibliographical references and index.
 ISBN 0-8014-3559-5 (cloth : alk. paper)
 1. Visual communication. I. Title.
 P93.5.E53 1999
 302.23 — dc21 98-26341

Cornell University Press strives to use environmentally responsible suppliers and materials to the fullest extent possible in the publishing of its books. Such materials include vegetable-based, low-VOC inks and acid-free papers that are recycled, totally chlorine-free, or partly composed of nonwood fibers.

Cloth printing 10 9 8 7 6 5 4 3 2 1

For my sister, F.V.E.

Contents

Preface

In the domain of visual artifacts, fine art is a tiny minority. Despite the current interest in mass media and multiculturalism, art historians interested in images still study mainly painting, drawing, photography, and printmaking. The history of visual images still begins with the cave paintings in Lascaux (instead of thousands of years before, with nondepictive marking), and it continues to favor European art and the succession of works that begins in Egypt or Greece. The new interests in non-Western material, gender and cultural studies, the politics of display, and the relations between fine art and popular culture have augmented art history, but they have not effectively displaced the discipline's interest in painting and drawing.

Taken as a whole, images are far more various. This book is about that richer field; art appears in it as a special case, a kind of image among many others. The objects I will be exploring are not unknown, and in our pictophagic age most of them already have their histories and their interpreters. But they are unknown in the sense that they remain disjoined from the principal histories of images and of art. They are sequestered for their apparent failure to achieve historical significance, their ostensive lack of expressive power, the technical demands they make on viewers, and the absence of visual theories and critical apparatus that might link them to fine art or argue for their importance. I aim to debate all of these suppositions: I will be arguing that nonart images can be just as compelling, eloquent, expressive, historically relevant, and theoretically engaging as the traditional subject matter of art history, and that there is no reason within art history to exclude them from equal treatment alongside the canonical and extracanonical examples of art.

That apologia is the burden of the first three chapters; the next several attend to other analytic problems that could be taken to prevent art history from looking more widely. Chapter 4 entertains the principal distinctions that have been made between art and everything else, and abandons them in favor of very broad terms including *image* and *visual artifact.* Once art is no longer immediately at issue, it becomes less easy to say what a picture is, and Chapters 4 and 5 also work toward a sharper sense of *picture* and several other crucial terms. A final obstacle to a more inclusive study of visual artifacts is the sheer bewildering variety of images, and the lack of a plausible account of their kinds, purposes, meanings, and genres. Chapter 6 rehearses the principal arguments in favor of lumping all images into one group, separating them in two (word and image), into three (word, image, and notation), into seven (the division I prefer), and into a practical infinity of individual examples.

With those preliminaries, I turn to the images themselves. The two parts of the book correspond to what are roughly called theory and practice: the first tries to build some bridges from art history, art criticism, and visual theory to the study of images in general, and the second is a provisional survey of some of the more interesting questions that can be put to specific images. If some agreed-on conceptual schema existed for distinguishing pictures from maps, or writing from calligraphy, then the second part of this book could have been a truly systematic survey in the manner of Janson's *History of Art.* It could then have included the fine arts and the standard sequence of European art history, as a small chapter in a much longer and more intricate history. It would be satisfying to write such a book; but because the sheer size and conceptual disarray of the field prevents it, I would invite readers to think of the possibility: the subjects treated in Part 2, if they could be suitably expanded, would encompass the historically rare *History of Art* within a vast *History of Visual Artifacts.*

Part 2 applies the sevenfold classification I find useful, but without keeping to it at every point. The exposition is what ancient orators called *epideictic:* a showcase of interesting examples, meant to at least gesture in the direction of the full richness of the domain of images. I had originally thought that Part 2 could be a systematic interrogation of the concepts introduced in Part 1, a deepening of the philosophic and disciplinary issues that surround

the privileging of fine art and alphabetic writing. But to do so would be to imply that a sharpened sense of words such as *picture* is the be-all and end-all of visual studies. On the contrary, I love the panorama of strange images, the landscape scattered with unpredictable artifacts. If I have partly given in to a classificatory impulse in Part 2, and dispersed the theoretical questions among an exotic collection of images, it is to show how rich the field is and how intrinsically interesting the actual images can be. I also hope the rough-and-ready classification suggests that the domain of images is not quite the trackless wilderness it has been taken to be. There are signposts everywhere, written in languages that were often invented and first spoken by art history.

In writing this book I have had the distinct sense of working to complete my education, of finally coming to terms with the objects that art historians might study. Is there any reason art history should not assume custodianship over the full reach of images, that we should not finally consider all images our responsibility? Just as classics embraces all Greek texts, from the earliest inscriptions in the eighth century B.C.E. to the smallest fragment of a lost drama, so art history might at last consider all images, no matter how hemmed-in they seem by the dry exigencies of epigraphy, typography, or paleography. I hope this book is a kind of invitation, saying — to put it as concisely as possible — that Manet is interesting, but so is a prehistoric potsherd with an indecipherable mark.

Acknowledgments

It is easy to get lost in the domain of images. The whole is a vast terra incognita, with entire histories waiting to be written. Originally, this book was almost twice the length it is now, because the second part — the survey of exemplary images — was bloated with every interesting species of image I could find. Like some overenthusiastic sixteenth-century explorer, I had collected so many samples that I nearly swamped the boat. I owe special thanks, therefore, to three people — two anonymous readers and Bernhard Kendler, Cornell University Press's exceptionally patient and diplomatic editor. They helped me realize that even though such a book can be written (and, as I still think, should be written) this is not that book. In this version, the survey in Part 2 is just a taste of what I think art historians and others might find of interest beyond the walls of art.

Another kind of acknowledgment is due to the thirty or more specialists who gave advice on various particulars. Without their help this book could not have found its way toward the kind of historical specificity that is so necessary if "image studies" are to be pushed beyond the level of philosophic generalization. I have thanked them, inter alios, throughout the book. Four, however, need to be thanked up front, because they read large portions of the manuscript and made extensive comments: Oleg Grabar read Chapter 7; Peter Daniels read Chapters 7 through 11 and the Glossary; Roald Hoffmann read Chapters 1 through 5, 13, and the Conclusion; and Daniel Russell read Chapter 12.

Chapters 1 and 3 are revised versions of "Art History and Images That Are Not Art," *Art Bulletin* 77, no. 4 (1995): 554–71. Chapter 2 was given as an invited lecture in the Princeton History of Science Worskshops, 1993. Parts of Chapter 4 are a revision of "Between Picture and Proposition: Torturing Paintings in Wittgenstein's *Tractatus*," *Visible Language* 30, no. 1 (1996): 72–95, and parts of Chapter 5 are based on "What Really Happens in Pictures? Misreading with Nelson Goodman," in *Word & Image* 9 no. 4 (1993): 349–62. A portion of Chapter 9 is revised from its original appearance as a "Reply" in *Current Anthropology* 37, no. 2 (1996): 222–23.

List of Plates

4. WHAT IS A PICTURE?

5. PICTURES AS RUINED NOTATIONS

5.1 Wittgenstein. *Portrait Bust.* Photo from Michael Nedo and Michele Ranchetti, *Ludwig Wittgenstein, Sein Leben in Bildern und Texten* (Frankfurt am Main: Suhrkamp, 1983), plate 306.

5.2 Hokusai. *Fuji from Hodogaya.* Detail. Late 1820s. Photo by author.

5.3 Portion of the Mandelbrot set. Printout and photo by author.

5.4 George Inness. *The Coming Storm.* 1878. Oil on canvas, 26 × 38½ in. Buffalo, Albright-Knox Art Gallery. Albert H. Tracy Fund, 1900.

5.5 Johann Jacob Froberger. *Lamento sopra la dolorosa perdita della Real Majestà di Ferdinando IV, Rè de Romani* (*Lament on the Death of Ferdinand IV, King of the Romans*), final manuscript page. From *Toccatas and Suites for the Keyboard,* book 4, suite 12, i. 1657. Vienna, Österreichische Nationalbibliothek, MS 18707.

5.6 Konrad Haebler. Page of M's. From Haebler, *Typenrepertorium der Wiegendrucke,* vol. 1, *Deutschland und seine Nachbarländer* (Halle: Rudolf Haput, 1905), xxxi.

5.7 Page from the signary of proto-Elamite. From R. de Mcquenem, "Épigraphie Proto-Élamite," *Mémoires de la Mission Archéologique en Iran* 31 (1949): plate 60. Reproduced by permission of Presses Universitaires de France.

6. PROBLEMS OF CLASSIFICATION

6.1 Paolo Giovio. *Impresa* for the Medici family. From Giovio, *Diologo dell'imprese militari et amorose* (1559), 40.

6.2 The dolmen known as "la Table-des-Marchands." Locmariaquer (Morbihan), Brittany. ca. 3500–3000 B.C.E. Drawing from Marija Gimbutas, *The Language of the Goddess,* 289.

7. ALLOGRAPHS

drop capital Geofroy Tory. Demonstration of the varying proportions of faces and letters. (Illustration modified to delete the top.) From Tory, *Champ fleury* (Paris: Geofroy Tory et Gilles de Gourmont, Wednesday, 28 April 1529).

7.1 Some classical Islamic cursive scripts. *From top: kufic,* "Eastern" *kufic, mahgribi, muhakkak, rayhan, sulus.* From *Brocade of the Pen: The Art of Islamic Writing,* ed. Carol Fisher (Michigan State University: Kresge Art Museum, 1991), figs. 1–6. Reproduced courtesy of the Kresge Art Museum.

7.2 Cebeci-Zâde. *Tughra* of Maḥmûd Khân, son of ʿAbd ul-Ḥâmid (Mahmud II, r. 1808–1839). 1233, Islamic calendar. Ankara, Collection of the Topkapi Palace Museum. From Suha Umur, *Osmanli Padişah Tuğralari* (Istanbul: Cem Yayinevi, 1980), 48, fig. 35.

7.3 A page from the Talmud, Mishnayoth *Zera'im,* Tractate *Kil'ayim,* chap. 3. From *Hebrew-English Edition of the Talmud* (London: Soncino, 1989), facing p. 18a.

7.4 Hrabanus Maurus and Hatto. Poem and self-portrait adoring the cross. ca. 810 C.E. (Graz: Österreichische Nationalbibliothek, 1973), MS NB 26.742. Photo by Leutner Fachlabor.

7.5 Mallarmé. *Un Coup de Dès Jamais d'Abolira le Hasard,* final double page. From the edition edited by Mistou Ronat (Paris: Change-Errant, 1980), n.p.

7.6 Lowercase *t,* as printed by a typography program. 1995. Photo by author.

7.7 Pages from a Qur'ān, showing *sūrat al-Fātiḥah*, I, 1–7. Gold Rayḥānī script. Sixteenth century. Afghanistan or India. London, British Library, Or. 11544, ff. 3v–4r. By permission of the British Library.

7.8 Page from Johann Georg van Schwandner, *Dissertatio epistolaris de calligraphiæ nomenclatione, cultu, præstantia, utilitate* (Vienna: Typographeo Kaliwodiano, 1756).

7.9 *Top:* Sample of Renaissance German *Kurrent* script. *Bottom:* Renaissance printed version of the same text. *Top,* from Hans Lencker, *Perspectiva*, fol. 4v. MS. Chicago, Newberry Library. *Bottom:* from Lencker, *Perspectiva, Hierinnen auffs kürtzte beschreiben* (Nuremberg: 1571), fol. 2r. Photographs courtesy the Newberry Library.

7.10 Monogram of the name "Hyacinthe." From Charles Demengeot, *Dictionnaire du chiffre-monogramme* (Paris, 1881).

7.11 Jost Ammann. Page from the genealogic record of the family Tucher. 1589. Nurnberg, Stadtarchiv, Leihgabe der Freiherrlich von Tucher'schen Familie, E 29/III Nr.

7.12 *Left:* Yanagida Taiun. *Cold Mountain,* detail of right-hand portion. *Right:* The initial portion of the text, in contemporary Chinese. ("By chance, I happened to visit an eminent priest.") *Left:* from *Traces of the Brush, Studies in Chinese Calligraphy,* ed. Shen Fu *et al.* (New Haven, Conn.: Yale University Press, 1977), 77.

7.13 Chu Ta. *Falling Flower.* 1692. Short Hills, New Jersey, collection of the estate of Mr. and Mrs. Fred Fang-yu Wang.

7.14 *Top:* Kamijō Shinzan, *Listening to Rain.* 1982. *Bottom:* "Rain" in modern Japanese. From *Words in Motion: Modern Japanese Calligraphy* (Washington, D.C.: Library of Congress, 1985), 106.

7.15 Mark Tobey. *Dragonade.* 1957. Milwaukee Art Museum, gift of Mrs. Edward R. Wehr. © 1998 Artists Rights Society (ARS), New York/Pro Litteris, Zurich.

7.16 Husain the Seventh. Amulet design naming the Seven Sleepers of the Qur'ān surrounding their dog Qiṭmīr. Istanbul, 1900. From Ibnülemin Mahmud Kemal Inal, *Son Hattatlar* [The Last Calligraphers] (Istanbul: Maarif Basimevi, 1955 [Devlet Mathaasī, 1954]), 801.

8. SEMASIOGRAPHS

drop capital Claude Paradin, The letter Y as an emblem of the way of virtue. From Paradin, *Les Dévises heroiques de M. Claude Paradin . . . et autres Aucteurs* (Anvers: Christophle Plantin, 1567).

8.1 Two transcriptions of the Luwian Hittite inscription on the Tarkondemos Seal. *Top:* after a drawing in Cyrus Gordon, *Forgotten Scripts* (New York: Dorset, 1987), 96. *Bottom:* compiled and redrawn from Emanuel Laroche, *Les Hiéroglyphes Hittites,* vol. 1, *L'écriture* (Paris: Editions du Centre National de la Recherche Scientifique, 1960), nos. 101, 320, 17, 391, 383, 228, respectively, except for the *a* sign, which is from Piero Meriggi, *Manuale di Eteo Geroglifico* (Rome: Edizioni Dell'Ateneo, 1967), table facing p. 142. Reproduced by permission of Editions CNRS and Edizioni Dell'Ateneo.

8.2 The Tarkondemos seal. Courtesy The Walters Art Gallery, Baltimore.

8.3 Stele from Boğazköy, Turkey. From David Hawkins, "Writing in Anatolia: Imported and Indigenous Systems," *World Archaeology* 17, no. 3 (1986): 363–76, illustration on p. 373. Photo courtesy David Hawkins, School of Oriental and African Studies, London.

8.4 *Top:* Martino Martini. Table of Chinese characters. 1659. *Bottom:* a modern Chinese character

corresponding to the lower-right of Martini's table. From Martini, *Martini Martinii . . . Sinicae historiae decas prima* (Amsterdam: J. Blaev, 1659).

8.5 Examples of the cuneiform sign for *king. Left, top to bottom:* ca. 2700 B.C.E., ca. 2500 B.C.E., ca. 2250 B.C.E., ca. 2035 B.C.E., ca. 1760 B.C.E. *Right:* Neo-Assyrian forms, ca. eighth century B.C.E. *Left and top right:* from Georges Jean, *Writing: The Story of Alphabets and Scripts,* trans. by Jenny Oates (New York: Abrams, 1992), 18, right. *Middle and bottom right:* from René Labat, *Manuel d'épigraphie akkadienne (signes, syllabaire, idéogrammes),* 4th ed. (Paris: Librairie Orientaliste Paul Geuthner, 1963), 102, no. 151. Drawing by author.

8.6 King Njoya. Characters in the Bamum Script. 1903. From Alfred Schmitt, *Die Bamum-Schrift* (Wiesbaden: Otto Harrassowitz, 1963), vol. 2, table 4, Zeichentafel A, p. 8.

8.7 Christian Kauder. Micmac prayer book, title page and credo. 1866. From Kauder, *Buch das Gut, Enthaltend den Katechismus, Betrachtung, Gesang* (Vienna: Kaiserliche Buchdruckerei, 1866).

8.8 The Latin alphabet compared with Old Canaanite and other early forms. Diagram by author.

8.9 Christian Doppler. Mathematical notation (*top*) and plate (*bottom*). From Doppler, "Versuch einer analytischen Behandlung beliebig begrenzter und zusammengesetzter Linien, Flächen, und Körper," *Ceska spolecnost nauk,* Prague, *Abhandlungen* 1 (1837–1840): 13 and fig. 8.

8.10 Inscription in Irish Ogham. Near Beaufort, Co. Kerry. Photo by author.

8.11 Logographic glyph and syllable sign gyphs for *pakal* (shield); in Mayan. From D. Stuart and S. D. Houston, "Maya Writing," *Scientific American,* August 1989, 86.

8.12 The verb *ts'apah* (was set upright), in Mayan. From Stuart and S. Houston, "Maya Writing," 85.

9. PSEUDOWRITING

drop capital Samson at En-hakkore. From Joannes Chrysostom, *Homilæ duæ* (London, 1593), the first Greek text printed in England.

9.1 Johann Scheible. Magic talisman. 1861. From *Das sechste und siebente Buch Mosis, das ist: Mosis magische Geisterkunst, das Geheimniß aller Geheimnisse,* 2d (?) ed. (Philadelphia: J. Weik, n. d. [c. 1870]).

9.2 Four-sided clay bar from the Palace of Mallia. Minoan. *Left:* drawings; *right:* photograph of face *a.* From Arthur Evans, *Scripta Minoa,* vol. 1, *The Hieroglyphic and Primitive Linear Classes* (Oxford: Oxford University Press, 1909), no. P 100. Diagrams: p. 170; photograph of face *a* from plate 8.

9.3 Archaic tablet, written in Sumerian (?). Uruk III. From Ignace Gelb et al., *Earliest Land Tenure Systems in the Near East: Ancient Kudurrus.* Oriental Institute Publications, vol. 104 (Chicago: Oriental Institute, 1989), vol. 2, plate 1, no. 1. Courtesy St. Mark's Library, General Theological Seminary, New York.

9.4 Adolph Gottlieb. *Letter to a Friend.* 1948. Oil, tempera, and gouache on canvas. © Adolph and Esther Gottlieb Foundation, New York. Licensed by VAGA, New York, NY.

9.5 Seal impression, and diagram. Ur, Iraq. From A. Nöldeke et al., *Uruk vorläufiger Bericht* (Berlin: Verlag der Akademie der Wissenschaften, 1932), vol. 4, plate 15g. Diagram: after Dominique Collon, *First Impressions, Cylinder Seals in the Ancient Near East* (Chicago: University of Chicago Press, 1987), [107]. Drawing by author. Photo © Bildarchiv Preußischer Kulturbesitz.

9.6 Zosimus of Panopolis. The formula of the crab. From Marcellin Berthelot, *Collection des anciens alchemistes grecs* (Paris: Georges Steinheil, 1888), vol. 1, 152, fig. 28. Drawing by author.

9.7 *Top:* Fragmentary predynastyic pot from Deir Tasa. *Bottom, left to right:* hieroglyphs for "tree," "libation," and "vomit." *Top:* from Guy Brunton, *Mostagedda and the Tasian Culture,* British Museum Expedition to Middle Egypt, First and Second Years 1928, 1929 (London: British Museum, 1937), plate 35, fig. 18. *Bottom:* from William Arnett, *The Predynastic Origin of Egyptian Hieroglyphs* (Washington, DC: University Press of America, 1982), plate 2 b, e, f. Reproduced courtesy of William Arnett.

9.8 Representations of scorpions. *From top:* P. Toscanne, "Sur la figuration et le symbole du scorpion," *Revue d'Assyriologie et d'Archéologie orientale* (Paris) 14 (1917): 191, figs. 56–58; 189, figs. 44–47; 192, figs. 59–60; William Arnett, *The Predynastic Origin of Egyptian Hieroglyphs* (Washington: University Press of America, 1982), plage 17, courtesy of William Arnett; Toscanne, 187, figs. 1–5; 188, figs. 14–26; and Godfrey Driver, *Semitic Writing: From Pictograph to Alphabet* (London: Oxford University Press, 1976), 48, fig. 23A, by permission of Oxford University Press, partly adapting Toscanne, 188, figs. 34–38.

9.9 Samples of predynastic Chinese pottery marks. Hsiao-t'un, An-yang, Honan. From Kwong-yue Cheung, "Recent Archaeological Evidence Relating to the Origin of Chinese Characters," trans. Noel Barnard, in *The Origins of Chinese Civilization,* ed. David Keightley (Berkeley: University of California Press, 1983), 327–29, fig. 12.22, detail. Illustration modified.

9.10 Painted sign on a flat-backed *hu* vase. Middle Ta-wen-k'ou period, ca. 3500–2500 B.C.E. Pao-t'ou-ts'un, Ning-yang, Shantung. Redrawn by author, after William Boltz, "Early Chinese Writing," *World Archaeology* 17, no. 3 (1986): 433, and Kwong-yue Cheung, "Recent Archaeological Evidence," 328, fig. 12.4. Reproduced courtesy of Routledge, London.

9.11 The characters "Father Ting." Rubbing from a bronze *ting* vessel. From Léon Long-Yien Chang and Peter Miller, *Four Thousand Years of Chinese Calligraphy* (Chicago: University of Chicago Press, 1990), 388.

9.12 The characters *kuan,* "to cleanse the fingers." Rubbing from a bronze vessel. From Chang and Miller, *Four Thousand Years of Chinese Calligraphy,* 390.

9.13 The runic and runeless golden horns. Early fifth century C.E. Discovered in 1639 and 1734 near Gallehus, Tønder amt, Sønderjylland, Denmark, and destroyed in 1802; formerly Copenhagen, Royal Art Museum. Drawings from Lis Jacobsen and Erik Moltke, *Danmarks Runeindskrifter,* 2 vols. (Copenhagen: Ejnar Munksgaard, 1942), vol. 2, figs. 36, 40.

10. SUBGRAPHEMICS

drop capital Andres Brun. The letter P in scroll form. From Brun, *Arte muy provechoso para aprender de escrivir perfectamente* (Saragossa: Juan de Larumbe, 1612), n.p.; reprinted in *Andres Brun, Calligrapher of Saragossa,* ed. Henry Thomas and Stanley Morison (Paris: Pegasus, 1929), n.p.

10.1 Naumoff (n.i.). Picture-writing of starving hunters. 1882. Southern Alaskan, example collected in California. After Mallery (1893), 353. Drawing by author.

10.2 Yukaghir picture-writing. Siberia, ca. 1930. From IA. P. Al'kora, *Iazyki i pis'mennost' narodov severa.* Leningrad, Institut Narodov Severa, Trudy po Lingvistike, Nauchno-issledovatel'skaia assotsiatsiia. (Moscow: Gos. Uchebno-pedagog., 1934), vol. 3, figs. 1 and 3.

10.3 The Narmer palette, obverse. ca. 3000 B.C.E. Carved schist. The Egyptian Museum in Cairo. Outline drawing from Sir Alan Gardiner, *Egyptian Grammar,* third edition (London: Oxford University Press, 1957 [1927]), 7. Reproduced by permission of Oxford University Press.

10.4 Hieroglyphic Egyptian for "lassoing the ibex by the hunter." *Bottom:* written as a single line. *Top:*

with the ideographs expanded into a picture. *Top:* from Henry Fischer, *The Orientation of Egyptian Hieroglyphs,* part 1. *Reversals* (New York: Metropolitan Museum of Art, 1977), fig. 1. *Top:* courtesy Henry Fischer. *Bottom:* courtesy Emily Teeter.

10.5 Variations on the name Narmer. From Gérard Godron, "A propos du nom royal [Narmer]," *Annales du Service des Antiquités de l'Egypte* 49 (1949): 217–20, plate 1. © Institut Française d'Archéologie Orientale du Caire.

10.6 Giotto. *Lamentation.* Fresco. Padua, Arena Chapel.

10.7 Impression on an envelope. Karum Kanish level II (ca. 2000–1500 B.C.E.). Kültepe, Turkey. From Nimet Özgüç, *Kültepe muhur Baskilarinda Anadolu Grubu: The Anatolian Group of Cylinder Seal Impressions from Kültepe.* Türk Tarih Kurumu yayinlarindan, 5th ser., vol. 22 (Ankara: Türk Tarih Kurumu Basimevi, 1965), plate 20, fig. 60.

10.8 Engravings after a drawing by Jacob Böhme, representing the Sixth Age. *Top:* 1730; *bottom:* 1682. From *Jacob Böhme, Sämtliche Schriften,* facsimile of the edition of 1730, ed. Will-Erich Peuckert (Stuttgart: Fr. Frommans Verlag, 1955–), vol. 7, *Mysterium magnum* (1958), § 44.

10.9 Julian Schnabel. *E o OEN.* 1988. Courtesy Pace Gallery, New York City.

11. HYPOGRAPHEMICS

drop capital Paul Franck. The letter G. From *Künstrichtige Schreibart Allerhand* (Nuremberg: Christoff Gerhard, 1655), n.p.

11.1 Petroglyph in Järrestad, near Gladsax, Sweden. From Oscar Montelius, "Sur les sculptures de rochers de la Suide," *Congrès International d'Anthropologie et d'Archéologie Préhistoriques,* 7th sess. (Stockholm, 1876), vol. 1, 453–87, fig. 1, p. 479.

11.2 Wilhelm Tomsohn. Plans and selected orthostats of the passage tomb Cairn T, at Loughcrew, Ireland. ca. 3500 B.C.E. From Eugene Conwell, *Discovery of the Tomb of Ollamh Fodhla* (Dublin: McGlashan & Gill, 1873).

11.3 Martin Brennan, diagram of sun's track across Stone 14 on the summer solstice. ca. 3500 B.C.E. Loughcrew, Ireland. From Brennan, *The Stars and the Stones: Ancient Art and Astronomy in Ireland* (New York: Thames & Hudson, 1983), 94.

11.4 Elizabeth Shee Twohig. Drawing of Stone 14, Loughcrew, Ireland. ca. 3500 B.C.E. Courtesy of Elizabeth Shee Twohig.

11.5 Photograph of part of Stone 14, Loughcrew, Ireland. ca. 3500 B.C.E. Photo by author.

11.6 Taoist Ling-pao talismans. *Left:* talisman for the Sovereign of the West. Late third century C.E. From *T'ai-shang ling-pao wu-fu hsü, Tao-tsang* 388, chap. 3, p. 10.

11.7 Jean Fautrier. *Tourbes.* 1957. Collection Galerie Di Meo, Paris.

12. EMBLEMATA

drop capital Jacobus Publicius. A snake as the letter S. From Publicius, *Artes orandi, epistolandi, memorandi* (Augsburg: Erhard Ratdolt, 1490 [1482]).

12.1 Emblem of God. Woodcut. From Horus Apollo, *Hieroglyphica* (Paris: Kerver, 1551), 222.

12.2 Leonard Thurneisser zum Thurn. Medal. ca. 1580. From J. C. W. Moehlen, *Beiträge zur Geschichte der Wissenschaften in der Mark Brandenburg . . . I. Leben Leonhard Thurneissers zum Thurn* (Berlin and Leipzig: George Jakob Decker, 1783); reprinted as *Leben Leonard Thurneissers zum Thurn* (Munich: Werner Fritsch, 1976), 226.

12.3 Two versions of Robert Estienne's printer's mark. *Left:* from *Biblia Sacra* (Paris: Robert Estienne, 1532). *Right:* from Estienne, *Fragmenta poetarum veterum Latinorum, quorum opera non extant: Enii, Pacuvii, Accii, Afranii, Lucilii, Naevii, Laberii, Caecilii, aliorúmque multorum* ([Paris]: Henricus Stephanus, 1564).

12.4 Johann Theodor de Bry. The four flames of alchemy. 1617. From Michael Maier, *Atalanta fugiens* (Oppenheim: Hieronymus Galler, 1618), emblem 17, "Orbita quadruplex hoc regit ignis opus."

12.5 Geofroy Tory. Printer's device. 1529. From Tory, *Champ fleury* (Paris: Geofroy Tory et Gilles de Gourmont, Wednesday, 28 April 1529).

12.6 Half of the heraldic shield for Richard Plantagenet, Marquis of Chandos, son of the first Duke of Buckingham and Chandos, of the family Temple-Nugent-Brydges-Chandos-Grenville. Nineteenth century. From Stephen Friar, *Heraldry: For the Local Historian and Genealogist* (London: Alan Sutton, 1992), color plate 21.

12.7 The arms of the West Dorset District Council. From Stephen Friar, *Heraldry: For the Local Historian and Genealogist* (London: Alan Sutton, 1992), 170.

12.8 Albrecht Dürer. *The Arms of Death.* 1503. Engraving. Photo by author.

12.9 The Pope as Antichrist. 1556. Munich, Hofbibliothek. From E. Diederichs, *Deutsches Leben der Vergangenheit in Bildern* (Jena, 1908), vol. 1, fig. 362.

12.10 Coaster, advertising Guinness beer. ca. 1995. Photo by author.

13. SCHEMATA

drop capital The letter C in a landscape. From Andres Brun, *Arte muy provechoso* (1612), n.p., reprinted in *Andres Brun* (1929), n.p.

13.1 William Law. Schema depicting Adam, hooked by Satan, with Sophia above and a heaven of evil stars. 1764. From Law, "An Illustration of the Deep Principles of Jacob Behmen, the Teutonic Philosopher, in Thirteen Figures," in Böhme, *The Works of Jacob Behmen, the Teutonic Philosopher* (London: M. Richardson, 1764), vol. 2, plate 9.

13.2 Georg Gichtel. Frontispiece to Jacob Böhme, *Aurora, oder Morgenröthe im Aufgang.* From *Jacob Böhme, Sämtliche Schriften,* ed. Will-Erich Peuckert (Stuttgart: Fr. Frommans Verlag, 1955–), vol. 1. By permission of Fromman-Holzboog.

13.3 Carl Jung. *Systema mundi totius.* 1914. Watercolor. Courtesy Erbengemeinschaft Jung. From *C. G. Jung, Bild und Wort,* ed. Aniela Jaffé (Freiburg im Breisgau: Walter-Verlag AG Olten, 1977), 76.

13.4 Francisco Torti, *Lignum febrium* (fever tree). From *Therapeutice specialis ad febres periodicas perniciosas* (Frankfurt and Leipzig: Bartholomeus Solanus, 1780 [1756]), facing p. 500.

13.5 Phylogenetic tree of mitochondrial DNA types. From Linda Vigilant, Mark Stoneking, Henry Harpending, Kristen Hawkes, and Allan Wilson, "African Populations and the Evolution of Human Mitochondrial DNA," *Science* (27 September 1991): 1503–1507, fig. 3.

13.6 *Left:* Nunik from Umivik, carved wooden maps of a portion of the coast of Greenland. ca. 1884. *Right:* contemporary map of the same coastline. *Left:* from *Kalaallit Nunaat Greenland Atlas,* ed. Christian Berthelsen et al. (Pilersuiffik, 1990), 1. Photo by Lennert Larsen. *Right:* adapted from *Greenland 1:250,000* (Washington: U.S. Army Map Service, 1957), quadrants NQ 23-24-12, NQ 25-26-5, NQ 23-24-8.

13.7 Klaus-Peter Hartmann and Horst Pohlmann. The religions of Lebanon, detail. *Inset:* a portion of an enlargement intended to clarify the region around Beirut. 1979. Adapted from *Tübinger Atlas des Vorderen Orients* (Wiesbaden: Dr. Ludwig Riechert Verlag, 1990), plate A VIII 7. © Dr. Ludwig Reichert Verlag, Wiesbaden, Germany.

13.8 D. P. Brachi. Annual sunshine record at Withernwick in the East Riding of Yorkshire. 1967. From Frances John Monkhouse and H. R. Wilkinson, *Maps and Diagrams: Their Compilation and Construction* (London: Methuen, 1971 [1952]), fig. 98.

13.9 A. R. Hinks. Retro-azimuthal projection of the world, centered at Malaccan, Malaysia. Continent outlines added by author. Adapted from Hinks, "A Retro-Azimuthal Projection of the Whole Globe," *Geographical Journal* (London) 73 (1929): 245–47, plate 3, facing p. 246.

13.10 Georg Scheffers. A hyperbolic shadow cast by the elliptical perspective representation of a circle, lit from a point source at *L*. From Scheffers, *Darstellende Geometrie* (Berlin: Julius Springer, 1920), vol. 2, fig. 587.

14. CONCLUSION

14.1 Envelope, franked with Modena #4, 25c buff. 1851. Photo by author.

14.2 Two pages from Abraham von Frankenburg's *Raphael, Oder Arzt-Engel* (Amsterdam: Jacob von Felsen, 1676), title page and p. 46.

14.3 The back of one of the *Tabulae Iliacæ,* and a restoration of the full pattern (the preserved portion is at the upper left). Augustan. *Left:* The *Tabula iliaca* 2.NY, reverse. New York, Metropolitan Museum of Art, Fletcher Fund, 1924, acc. 24.97.11, negative 57.979A. *Right:* from Maria Teresa Bua, "I guiochi alfabetici delle tavole iliache," *Accademia Nazionale dei Lincei, Memorie, Classe di Scienze morali, storiche, e filologiche* 16 (1971–72): fig. 2, p. 10.

14.4 Engraving of fossil infusoria in flint. 1837. From M. Turpin, "Analyse ou étude microscopique des différens corps organisés et autres corps de nature diverse qui peuvent, accidentellement, se trouver enveloppés dans la pâte translucide de silex," *Annales des Sciences Naturelles* ser. 2, vol. 7, *Zoology* (Paris: Crochard, 1837), 129–56, plate 7.

14.5 The Nymphalid groundplan. From Nijhout, *The Development and Evolution of Butterfly Wing Patterns* (Washington, D.C.: Smithsonian Institution, 1991), 24, fig. 2.1, modified from B. N. Schwanwitsch, "On the Groundplan of Wing-Pattern in Nymphalids and Certain Other Families of Rhopalocerous Lepidoptera," *Proceedings of the Zoological Society of London* 34, ser. B (1924): 509–28, and E. Süffert, "Zur vergleichende Analyse der Schmetterlingszeichnung," *Biologisches Zentralblatt* 47 (1027): 385–413.

14.6 Comparison of three butterflies in the family Amathusiidae, showing the gradual disappearance of elements of the nymphalid groundplan. *Left: Stichphthalma camadeva; middle: Faunis menado; right: Taenaris macrops.* From Nijhout, *The Development and Evolution of Butterfly Wing Patterns,* 27, fig. 2.2.

14.7 Patterns on selected moth wings, compared with a variant on the Nymphalid groundplan. Families include Sphingidæ (C, D), Arctidæ (E), Saturnidæ (G, H, I), Noctuidæ (J, K), and Geometridæ (L). From Schwanwtisch, "Color-Pattern in Lepidoptera," *Entomologicheskoe Obozrenie* 35 (1956): figs. 26–40, p. 535.

PART I

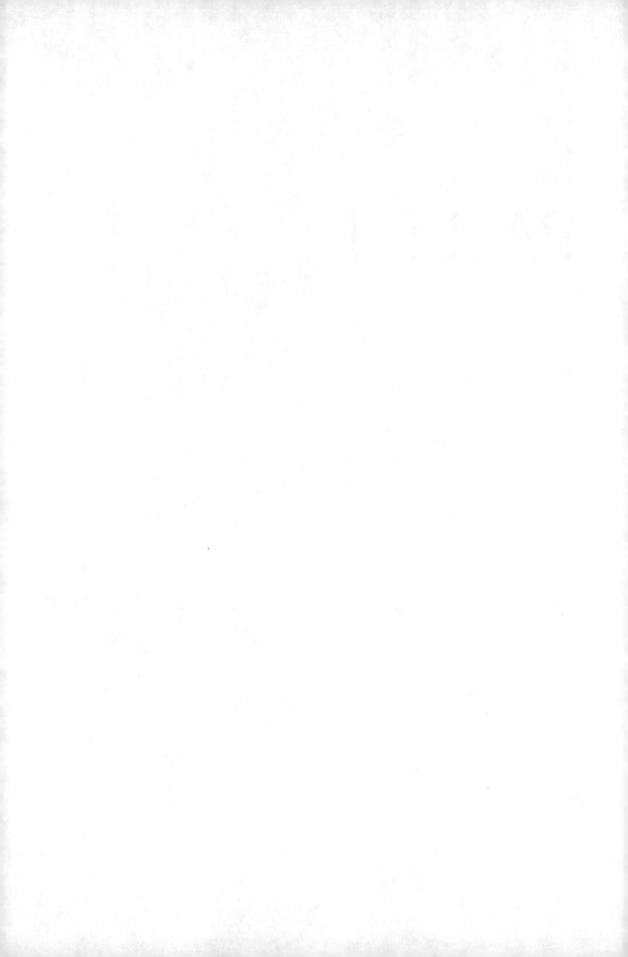

1 : Art History and Images That Are Not Art

Most images are not art. In addition to pictures made in accord with the Western concept of art, there are also those made outside the West or in defiance, ignorance, or indifference to the idea of art. In the welter of possibilities two stand out. Non-Western images are not well described in terms of art,[1] and neither are medieval paintings that were made in the absence of humanist ideas of artistic value.[2] Together the histories of medieval and non-Western images form the most visible alternates to the history of art, and they attract most attention in the expanding interests of art history. So far, it has proved useful to describe both medieval and non-Western images using the language of art history, so that they stand partly outside art and partly within it.[3]

In the past few decades, art historians have become interested in a wide variety of images that are not canonical instances of fine art, including anti-art, "low" art, outsider art, and postcolonial art, as well as images from popular culture (especially television and advertising). Though such images are often described as alternates to art history's usual subjects, they are closely dependent on fine-art conventions even when they are not

1. Although the study of non-Western art is taken to be a twentieth-century interest, it begins in the seventeenth century, at the same time as the kinds of scientific images on which I concentrate in this chapter. A convenient place to start the history of Western attempts to comprehend non-Western images is Vincenzo Cartari, *Imagini de gli dei delli antichi* (Padua: Pietro Paolo Tozzi, 1626). One of the best and most general meditations on the question of interpreting non-Western ideas is Martin Heidegger, "A Dialogue on Language," in *On the Way to Language*, ed. Peter D. Hertz (San Francisco: Harper & Row, 1971), 1–56. For a good summary of the problem in anthropology (which can be read as a guide to issues in art history), see Stanley Tambiah, *Magic, Science, Religion, and the Scope of Rationality* (Cambridge: Cambridge University Press, 1990).

2. As Hans Belting puts it (*Likeness and Presence: A History of the Image before the Era of Art*, trans. Edmund Jephcott [Chi-

cago: University of Chicago Press, 1994] 459), paraphrasing Hans Sedlmayr, in the "humanist definition of art . . . the new presence *of* the work succeeds the former presence of the sacred *in* the work." At that point the "history of the image before the era of art" — that is, from late antiquity to the earliest Renaissance — comes to an end, and the "development of art" commences. In relation to problems of definition I discuss later, the asymmetry in Belting's comparison is crucial: To be a logical parallel, it would have to read, "The new [sacred] presence *of* the work succeeds the former presence of the sacred *in* the work." Like the question of non-Western art, the shift or loss of presence has deep connections to the kinds of scientific and "informational" images I discuss. It is significant in this regard that the historian of science Bruno Latour has written a short essay on presence in Renaissance and Baroque paintings, "Opening One Eye While Closing the Other: A Note on Some Religious Paintings," in *Picturing Power*, 15–38. Latour claims in part that linear perspective is the signal that presence is transposable, so that scientific "mobility" begins to cancel religious "immutability" (*Picturing Power*, 26). I argue differently in Elkins (1994), suggesting that perspective has always had an ambiguous role in these questions and that now it is itself a fading presence. On the general subject of presence in art, the most important accounts are Michael Fried's ongoing interrogation of "presence" and "presentness" and George Steiner, *Real Presences* (Chicago: University of Chicago Press, 1989).

3

actively quoting or subverting them. To discuss even the most anarchic anti-art, it is necessary to attend closely to the corresponding practices in fine art. Duchamp's *Fountain* cannot be understood apart from the kinds of sculpture that it is not; when Alfred Stieglitz remarked that the *Fountain* looked like a Buddha, he was naming one way it might be recuperated into fine-art meanings.[4] Postcolonial and outsider art is similarly attached to the practices it works to avoid.[5]

In general, art history tests its boundaries by working with popular, medieval, and non-Western images. But the domain of images is substantially larger. In particular there is another group of images that seems to have neither religious nor artistic purpose, and that is images principally intended — in the dry language of communication theory — to convey information.[6] There is no good name for such images, which include graphs, charts, maps, geometric configurations, notations, plans, official documents, some money, bonds, patents, seals and stamps, astronomical and astrological charts, technical and engineering drawings, scientific images of all sorts, schemata, and pictographic or ideographic elements in writing: in other words, the sum total of visual images, both Western and non-Western, that are not obviously either artworks, popular images, or religious artifacts. In general, art history has not studied such images, and at first it might appear that they are intrinsically less interesting than paintings. They seem like half-pictures, or hobbled versions of full pictures, bound by the necessity of performing some utilitarian function and therefore unable to mean more freely. Their affinity with writing and numbers seems to indicate they are incapable of the expressive eloquence that is associated with painting and drawing, making them properly the subject of disciplines such as visual communication, typography, mathematics, archaeology, linguistics, printing, and graphic design.

Still, it is necessary to be careful in such assessments, because informational images are arguably the majority of all images. If pictures were to be defined by their commonest examples, those examples would be pictographs, not paintings. An image taken at random is more likely to be an ideographic script, a petroglyph, or a stock-market chart than a painting by Degas or Rembrandt, just as an animal is more likely to be a bacterium or a beetle than a lion or a person. The comparison is not entirely gratuitous, and I make it to underscore the final barriers that stand in the way of a wider understanding of images, just as the remnants of anthropomorphism keep the public more engaged with lions than with bacteria. Some images are closer to art, others farther away: In my analogy, fine art, non-Western art, medieval art, outsider art, and popular imagery might be the familiar mammals and other chordates, and informational imagery the many other phyla. It is the distant phyla that are least well known and most numerous of all.

The variety of informational images, and their universal dispersion as opposed to the limited range of art, should give us pause. At the least it might mean that visual expressiveness, eloquence, and complexity are not the proprietary traits of "high" or "low" art, and in the end it might mean that we have reason to consider the history of art as a branch of the history of images, whether those images are nominally in science, art, writing, archaeology, or other disciplines. In the first three chapters I survey the field of image studies, which is under way in disciplines such as the history of science, and to argue three points about the importance of informational images: that they engage the central issues of art history such as peri-

3. One of the more promising attempts to describe non-Western images using Western language is David Summers's work-in-progress; see, for example, Summers, "Real Metaphor: Towards a Redefinition of the 'Conceptual' Image," in *Visual Theory*, ed. Norman Bryson, Michael Ann Holly, and Keith Moxey (New York: HarperCollins, 1991), 231–59, and Summers, "The 'Visual Arts' and the Problem of Art Historical Description," *Art Journal* 42 (1982): 301–10.

4. See the analyses in Thierry de Duve, *Kant after Duchamp* (Cambridge, Mass.: MIT Press, 1996).

5. This is one of the points made by Homi Bhabha; see *The Location of Culture* (New York: Routledge, 1994).

6. For communication or information theory, as it applies to visual images, see, for example, Reiner Matzker, *Das Medium der Phänomenalität: Wahrnehmungs- und erkenntnistheoretische Aspekte der Medientheorie und Filmgeschichte* (Munich: Fink, 1993); Abraham A. Moles, *Information Theory and Esthetic Perception* (Urbana: University of Illinois Press, 1966); and Edward R. Tufte, *Envisioning Information* (Cheshire, Conn.: Graphics Press, 1990), reviewed by Ian Hacking, "Matters of Graphics," *Science* 252 (17 May 1991): 979–80. An interesting specialized study is William H. Kruskal, "Criteria for Judging Statistical Graphics," *Utilitas Mathematica* 21 B (1982): 283–309.

ods, styles, meanings, the history of ideas, concepts of criticism, and changes in society; that they can present more complex questions of representation, convention, medium, production, interpretation, and reception than much of fine art; and, finally, that far from being inexpressive, they are fully expressive and capable of as great and nuanced a range of meaning as any work of fine art.

Among the disciplines engaged with these images, the history of science is predominant, but interest in apparently nonreligious, nonart images is not limited to science. In many societies such images comprise the principal alternate to religious imagery, and for that reason alone, it is not prudent to assimilate whatever is taken to be informational with science or technology. The idea of counting, for example, has given rise to visual forms as well as written ones. In the West the visual history of numeration extends in time from the earliest Upper Paleolithic "tallies" on bone and slate to the inception of abstract symbols for numbers, and from there to visual elements in the most recent number theory — a significantly longer continuous range than is normally covered by the histories of art or science.[7] The history of visual elements in mathematics also extends beyond the boundaries of the history of science; diagrams occur in modern texts, but also in pseudonumerical marking systems such as the Peruvian string quipu.[8] In later chapters I also consider pictorial elements in writing, such as pictographs and ideographs, and their intersection with symbols, rebuses, ciphers, monograms, watermarks, and other images — including not only certain "word–image" questions but also accounts of the very different symbioses of picture and pictorial writing in Egyptian hieroglyphics and Mayan script. The places at which writing approaches images are especially intriguing and underexplored. "Picture-writing," for example, denotes images that look like pictures but can be read; there are examples ranging from Nearctic Native American and Siberian visual "stories" to semisystematic Australian paintings. Traditions of invented scripts and pseudowriting also draw on pictorial conventions. Pictorial pseudowriting begins with the prehistoric European Vinča culture and includes such diverse phenomena as the Baroque misinterpretation of hieroglyphics and Asian, African, and American invented scripts.[9] Even schemata, the principal

objects of study in visually oriented research in the history of science — and arguably the central type of nonart images — include not only modern scientific examples but also genealogical trees, graphs, and charts from the medieval period to the Baroque, representing everything from the macrocosmic-microcosmic universe to angelic scripts. For these reasons it is best to say that scientific images play a part in informational images but are not necessarily their exemplars. Instead of confining nonart images to the sciences, or opposing "fine art" to "scientific images," we should understand visual elements in science as efflorescences of informational images in general.

Nor is the category of informational images pure, so that it is possible to make too firm a distinction between religious, artistic, and informational images, as if they somehow divided the domain of images between them. I think it makes sense to use terms such as *informational images* as convenient labels rather than as definitions, because they say less about pictures than about the current shape of the disciplines that study them: "nonart" images, in the end, are whatever contemporary art history does not study. Decoration, for example, slides in and out of art history in accord with how much historical meaning can be assigned to it. Scientific images can appear informational when they are studied in fine-art contexts, but to historians of science they can seem charged with

7. See Elkins (1997) and my essay "On the Impossibility of Close Reading: The Case against Alexander Marshack," *Current Anthropology* 37, no. 2 (1996): 186–201, and reply to appended comments in that same issue (220–24). I emphasize *continuous,* as the examples of Lascaux and other prehistoric images that usually begin art-historical treatments are not continued in unbroken narrative into the ancient Near East, where the history of art proper gets under way. See Whitney Davis, "Beginning the History of Art," in Davis, *Replications: Archaeology, Art History, Psychoanalysis* (University Park: Penn State University Press, 1996).

8. For the quipu, see Marcia and Robert Ascher, *Code of the Quipu: A Study in Media, Mathematics, and Culture* (Ann Arbor: University of Michigan Press, 1981); and the same authors' "Ethnomathematics," *History of Science* 24 (1986): 125–44. An early notice is *Lettera apologetica dell'Esercitato Accademico della Crusca contenente la Difesa del libro* [published in 1747] *intitolato d'una Peruana per rispetto alla supposizione de'Quipu scritta alla Duchessa di S^xxx* [Madame de Grafigny] (Naples: s.n., 1750).

9. For the Vinča material, see Elkins (1998).

anything except mere information. Because I am beginning where I must begin, with the accepted categories of art history and visual theory, I use terms such as *informational images* or *nonart images* opportunistically, wherever they seem to fit. These opening chapters all proceed that way, using a variable terminology to name whatever has been taken, at one time or another, to be different from art. As the arguments accumulate they will undermine such distinctions, and Chapter 4 opens with a review of the terminology and a critique of art/nonart distinctions. From that point on, any apparent distinctions between art and other kinds of images are only local or heuristic.

NONART IMAGES IN ART HISTORY

Art history is centrally positioned in the emerging field of image studies because it possesses the most exact and developed language for the interpretation of pictures. Existing art-historical methods, which are normally trained on art objects, can embrace images of any kind, from graphs to ideographic writing; conversely, art-historical inquiries can be enriched by what is happening in other disciplines. I want to make that case in several stages, looking first at nonart images as they already appear within art history and then (in the next two chapters) considering what art history might glean from interpretations current in other disciplines. Ultimately, I hope that the interdisciplinary blurring will complement the terminological blurring, opening the way to the wider perspective I mean to promote.

As a general rule, art history has treated scientific and other informational images as ancillary sources for the interpretation of fine art rather than as interesting images in their own right. Yet it could be urged that the potentially disruptive nature of such images remains invisible as long as they are treated as evidence for other kinds of pictures. As a prelude to that possibility, it is helpful to review three of the major reasons that art history has taken an interest in nonart images.

Art That Uses Science

In the twentieth century especially, artists have looked to science for imagery, and art historians have worked to explain pictures by locating the relevant scientific sources. The artistic tendency to use science to inform art is an extension of a Romantic and late-Romantic attitude that can be traced back to writers such as Edgar Allan Poe (who made use of scientific and mathematical sources in his stories), and it normally operates by reinventing the "dry" scientific material in order to bring out its expressive meanings.[10] In a reciprocal fashion, art historians who refer the artworks back to their "objective" sources are performing an anti-Romantic or modernist gesture, explaining pictures by restoring their scientific origins.[11] Just as some Romantic art vivifies science, some contemporary art history reinvests expressive images with scientific or "objective" referents. Even though it is grounded in early Romanticism, this dual movement has not exhausted itself, and a number of artists lend themselves to such analyses. Postimpressionists such as Seurat and Signac were influenced in more or less unscientific ways by books containing color solids and patches.[12] Artists as different as Odilon Redon and Wassily Kandinsky were interested in microscopic images, and modernists from Picasso to Ernst and Duchamp were apparently swayed by misunderstood notions of exotic geometric and physical theories.[13] Although there

10. See *Romanticism and the Sciences*, ed. Andrea Cunningham and Nicholas Jardine (Cambridge: Cambridge University Press, 1990).

11. In this sense, art historians participate in the complementary directions of the history of ideas: Some studies are concerned with Romanticism in science, and others with science in (mostly literary) Romanticism. See *Romanticism in Science: Science in Europe, 1790–1840*, ed. Stefano Poggi and Maurizio Bossi (Dordrecht: Kluwer, 1994); and, in contrast, *Die Deutsche literarische Romantik und die Wissenschaften*, ed. Nicholas Saul, Publications of the Institute of Germanic Studies, vol. 47 (Munich: Iudicium Verlag, 1991).

12. See Floyd Ratliff, *Paul Signac and Color in Neo-Impressionism* (New York: Rockefeller University Press, 1992); and Robyn Roslak, "The Politics of Aesthetic Harmony: Neo-Impressionism, Science, and Anarchism," *Art Bulletin* 73 (1991): 381–90.

13. Kandinsky appears to have been influenced by microscopic images ca. 1937; see *Kandinsky: Catalogue Raisonné of the Oil-Paintings*, ed. Hans Roethel and Jean Benjamin (Ithaca, N.Y.: Cornell University Press, 1984), cat. 1088 and passim. Redon's interest in microscopical images was sparked by Armand Clavaud; see *Odilon Redon: Prince of Dreams, 1840–1916*, ed. Douglas Druick (Chicago: Art Institute of Chicago, 1994), 137, 148, 149. I thank Thomas Sloan for this refer-

are fewer art-historical studies of the influences of science on contemporary art, artists such as Robert Rauschenberg, Vito Acconci, Dorothea Rockburne, Rosamund Purcell, Frances Whitehead, and Joan Fontcuberta continue to find new ways of incorporating mathematical, physical, botanical, medical, and zoological images in their work.[14]

There is much more to be explored in this vein, but historical and methodological limitations prohibit the approach from doing wider justice to the relations between science and art. Because the search for scientific sources depends on specific iconographic parallels, it cannot explain the more indirect (but no less important) relations between early science and Baroque imagery, or between Enlightenment science and neoclassical imagery,[15] and it cannot come to terms with more abstract influences on twentieth-century art, such as popular notions of the uncertainty principle, nuclear fission, and fractal geometry.[16] Histories of the influence of optical or perspectival theories tend to explain only limited aspects of post-Renaissance art,[17] and even when it comes to explicitly optical art such as Seurat's, scientific explanations might have only a tenuous grip on what makes the paintings meaningful.[18] I mention fractal geometry among other possibilities because connections between chaotic dynamics and art continue to be

of interest to a wide range of computer-graphics specialists, artists, and mathematicians. Some scientists have made aesthetic claims about their mathematics that are inappropriate by historical standards (Benoit Mandelbrot, for example, says that his fractal geometry is like minimalist painting),[19] and some art critics have used scientific terms such as *chaos* or *turbulence* in ways that are not meaningful by scientific standards.[20] These are

14. Dorothea Rockburne's fresco described in Brooks Adams, "High Windows: Dorothea Rockburne's Skyscapes," *Artforum* 31, no. 9 (1993): 78–82, uses graphs of the Earth's electromagnetic field. Frances Whitehead experiments with botanical forms and liquids; see, for example, the review by Jim Yood, *Artforum* 28, no. 11 (1989): 146–47. Joan Fontcuberta has made artworks based on scientific descriptions of animals that do not exist; his "Fauna" series is described by Jean Fisher in *Artforum* 27, no. 2 (1988): 141–42.

15. For these topics, see Barbara Maria Stafford, *Artful Science: Enlightenment, Entertainment, and the Eclipse of Visual Education* (Cambridge, Mass.: MIT Press, 1994).

16. The journal *Leonardo* is a source of information on many of these parallels.

17. For connections between optical science and painting, see Martin Kemp, *The Science of Art: Optical Themes in Western Art from Brunelleschi to Seurat* (New Haven, Conn.: Yale University Press, 1990); the discussion of Chardin in Michael Baxandall, *Patterns of Intention: On the Historical Explanation of Pictures* (New Haven, Conn.: Yale University Press, 1985); and the discussion of Fra Angelico in Samuel Edgerton, *The Heritage of Giotto's Geometry: Art and Science on the Eve of the Scientific Revolution* (Ithaca, N.Y.: Cornell University Press, 1991). For nineteenth-century optical themes, see Jonathan Crary, *Techniques of the Observer: On Vision and Modernity in the Nineteenth Century* (Cambridge, Mass.: MIT Press, 1990).

18. The best work on Seurat's color theories, I think, is still William Innes Homer, *Seurat and the Science of Painting* (Cambridge, Mass.: MIT Press, 1964), because it records empirical observations that have yet to be tested. See also Alan Lee, "Seurat and Science," *Art History* 10, no. 2 (1987): 203–26; the skeptical account in Paul Smith, "Seurat, the Natural Scientist?" *Apollo* 132, no. 346 (1990): 381–85; and Smith, *Seurat and the Avant-Garde* (New Haven, Conn.: Yale University Press, 1997).

19. Benoit Mandelbrot, *Fractal Geometry of Nature* (San Francisco: W. H. Freeman, 1982), 23, citing Freeman Dyson, "Characterizing Irregularity," *Science* 200 (1978): 677–78.

20. I have argued these points in Elkins, "The Drunken Conversation of Chaos and Painting," *M/E/A/N/I/N/G* 12 (1992): 55–60; see also Larry Short, "The Aesthetic Value of Fractal Images," *British Journal of Aesthetics* 31 (1991): 342–55. The entire topic of spurious art–science parallels has been

ence. The most comprehensive source on the influence of physics and geometry is Linda Dalrymple Henderson, *The Fourth Dimension and Non-Euclidean Geometry in Modern Art* (Princeton, N.J.: Princeton University Press, 1983). See also Conrad H. Waddington, *Behind Appearance: A Study of the Relation between Painting and the Natural Sciences in This Century* (Cambridge, Mass.: MIT Press, 1970); and Lucy Adelman and Michael Compton, "Mathematics in Early Abstract Art," in *Towards a New Art: Essays on the Background to Abstract Art,* ed. Michael Compton (London: Tate Gallery, 1980), 64–89. (For an assessment of Waddington's book, which puts him in the context of the "two cultures" debate, see Roy Porter, "The Two Cultures Revisited," *Cambridge Review* 115, no. 2324 [1994]: 74–80.) Other studies are primarily psychological (e.g., Paul Vitz, *Modern Art and Modern Science: The Parallel Analysis of Vision* [New York: Praeger, 1984]) or formal (as in John Richardson, *Modern Art and Scientific Thought* [Urbana: University of Illinois Press, 1971]). Jean-François Lyotard, *Duchamp's TRANS/formers: A Book* (Venice, Calif.: Lapis, 1990) belongs in a different category, as Lyotard does not set out to explain Duchamp's thinking so much as to participate in it.

the kinds of oblique references that iconographic studies of scientific images in art have trouble accommodating. Ultimately, the approach lacks the flexibility to demonstrate the full relation between science and art — what twentieth-century art is *not* influenced by modern science?— and it does not yet possess a methodological strategy that would justify concentrating on more literal parallels.

Science That Uses Art

Other nonart images have attracted attention because they share fine-art conventions or show vestiges of expressive meaning. The two most important examples are probably medical imaging and computer graphics. Medical images have been of interest not only because they have directly influenced artistic practice from the fifteenth century onward but also because medical illustration inevitably evokes affective questions of gender, pleasure, and pain and commonly uses pictorial conventions very close to those of contemporaneous fine art.[21] Thus Andreas Vesalius's figures have affinities with Italian landscape and figural compositions, Charles Estienne's figures are allied with the School of Fontainebleau, Govard Bidloo's dissections use Dutch still-life conventions, and Bernard Albinus's figures have close parallels to neoclassical art theory.[22] In a way, medical illustration is the shadow of fine-art depictions of the body, participating in many of its meanings and conventions but remaining hidden within the ostensibly scientific. So many conventions of fine art have been brought over into anatomic illustration that the only major formal difference between the two is that medical illustrators were routinely granted license to portray aspects of death, sexuality, and the inside of the body that were proscribed for fine artists.[23] In the twentieth century those distinctions have collapsed, and artists from Joseph Beuys to Arnulf Rainer, Hermann Nitsch, and Karen Finlay make free use of medical images and scenes of the body's interior.[24]

The same can be said about computer graphics. Even though the academic separation of art history and computer graphics might seem to indicate they have little in common, it is possible to demonstrate an ongoing dependence of computer graphics on the older history of art. The rendering routines that have been developed in the last two decades model light effects that are found in Renaissance and Baroque paintings — that is, even where they set out to mimic nature directly, graphic designers tend to choose phenomena that are not only amenable to computation but are also in line with inherited pictorial versions of naturalism. In so doing, computer software developers recapitulate the history of art in various particulars: The

succinctly articulated by Leo Steinberg, "Art and Science: Do They Need to Be Yoked?" *Daedalus* 115, no. 1 (1986): 1–16.

21. For early anatomical interest, see Bernard Schultz, *Art and Anatomy in Renaissance Italy* (Ann Arbor: UMI Research Press, 1985). For the relation between anatomy and painting in Michelangelo, see my "Michelangelo and the Human Form: His Knowledge and Use of Anatomy," *Art History* 7 (1984): 176–86; and for parallels between anatomy and French Academy drawing, see my "Two Conceptions of the Human Form: Bernard Siegfried Albinus and Andreas Vesalius," *Artibus et historiæ* 14 (1986): 91–106, with reference to David G. Karel, "The Teaching of Drawing in the French Royal Academy," Ph.D. diss., University of Chicago, 1974.

22. For Vesalius's figures, see *The Illustrations from the Works of Andreas Vesalius of Brussels,* ed. J. B. Saunders and Charles O'Malley (Cleveland: World Publishing Company, 1950). Charles Estienne, *De dissectione partium corporis humani* (Paris: Apud S. Colinaeum, 1545), is the subject of a work-in-progress by Valerie Traub (Vanderbilt University), which brings out Estienne's connections to Renaissance eroticism and the pornographic booklet *I modi*. Bidloo's compositions are discussed in Mario Perniola, "Between Clothing and Nudity," trans. Roger Friedman, in *Fragments for a History of the Human Body,* ed. Michel Feher (Cambridge, Mass.: MIT Press, 1989), vol. 2, 236–65, esp. 258. Albinus's neoclassical affinities are discussed in my "Two Conceptions of the Human Form." See also Marie-Hélène Huet, *Monstrous Imagination* (Cambridge, Mass.: Harvard University Press, 1993), and the review by Lorraine Daston, *Isis* 84, no. 1 (1994): 132.

23. The best recent text on medical images is Barbara Stafford, *Body Criticism: Imaging the Unseen in Enlightenment Art and Medicine* (Cambridge, Mass.: MIT Press, 1991). See also the reviews by Dorinda Outram, "Body and Paradox," *Isis* 84 (1993): 347–52; Elkins, *Art Bulletin* 74, no. 3 (1992): 517–20; and Elkins, *Pictures of the Body: Pain and Metamorphosis* (Stanford, Calif.: Stanford University Press, forthcoming).

24. An interesting essay on Beuys and anatomy is Matthias Bunge, "Joseph Beuys und Leonardo da Vinci, Vom 'erweiterten Kunstbegriff' zu einem erweiterten Kunstwissenschaftsbegriff," *Das Münster* 44, no. 2 (1993): 93–106, and *Das Münster* 46, no. 3 (1993): 227–36. For Rainer and Nitsch, see, for example, Robert Morgan, "Gunther Brus, Hermann Nitsch, Arnulf Rainer," *Arts Magazine* 59 (May 1985): 196.

history of three-dimensional rendering rehearses the early history of linear perspective; the current interest in translucent "mylar" layering revives diaphanous rococo effects of fresco and oil paint; and the routines for lighting gradients (such as Phong and Blinn rendering) recall seventeenth- and eighteenth-century interests in specular and diffuse reflections.[25] In a wider sense, the conventions of computer-generated perspectival scenes in military and scientific simulations, architecture, and commercial games appear "natural" or mathematically driven to their designers, even though they can be shown to derive from Western landscape painting of the last two centuries. Many kinds of computer graphics inadvertently (and sometimes intentionally) draw near to fine-art traditions from the Renaissance onward, and those parallels are a major reason why computer graphics are presented and studied as independent works of art.[26] Both medical illustration and computer graphics are marginal to the mainstream interests of art history, but they are also firmly connected with that history by virtue of their formal and expressive borrowings.

Science as Part of the History of Visuality

Finally, art history has taken an interest in nonart images that can be used to illuminate the history of visuality, even if these images do not contribute directly to the production of artworks. Celestial and terrestrial maps, panoramas and dioramas, pictures made during scientific voyages, and botanical, paleontological, geological, and zoological illustrations are among the prominent examples. These subjects are never without their links to fine art, even though they might be limited or oblique. Parallels between maps and paintings have been widely discussed in art history — for example, in the "mapping impulse" that Svetlana Alpers has analyzed in seventeenth-century Dutch painting, the interest in "topographical" scenes in nineteenth-century American art, and the coincidence of navigation, astronomy, and the inception of linear perspective.[27] Dioramas and panoramas are even more directly implicated in fine-art production, as the history of panoramas is the story of ongoing searches for talented landscape artists and architectural draftsmen.[28] As Barbara Stafford has shown, travel illustrations made for geological,

archaeological, anthropological, and botanical purposes are testimony not only to the meanings the scientists wished to extract from what they saw but also to contemporaneous notions of the sublime, the picturesque, and the landscape genre.[29] Unlike images in the first two categories, these tend

25. Each of these is argued my "Art History and the Criticism of Computer-Generated Images," *Leonardo* 27, no. 4 (1994): 335–42, and color plate. A complementary case regarding virtual reality is made in my "There Are No Philosophic Problems Raised by Virtual Reality," *Computer Graphics* 28, no. 4 (1994): 250–54; and see further the examples of "paint programs," in "What Are We Seeing, Exactly?" *Art Bulletin* 79, no. 2 (1997): 191–98.

26. The parallel between scientific and "fine-art" computer-generated images can be demonstrated by comparing the "science" and "art" portions of the annual SIGGRAPH conference. For intentional copies of Old Master works and architectural monuments, see John R. Wallaca, "Trends in Radiosity for Image Synthesis," *Photorealism in Computer Graphics*, ed. Kadi Bouatouch and Christian Bouville (New York: Springer, 1992). For further bibliography, see my "What Are We Seeing, Exactly?" and Delle Maxwell and Annette Weintraub, "A User's Guide to the Electronic Cliché," *Papers, FISEA 93* (Fourth International Symposium on Electronic Art) (Minneapolis: Minneapolis College of Art and Design, 1993), 83–93. I thank Eduardo Kac for this reference.

27. For the first, see Svetlana Alpers, *The Art of Describing: Dutch Art of the Seventeenth Century* (Chicago: University of Chicago Press, 1983). For an assessment of "topographical" painters, see, for example, Angela Miller, *The Empire of the Eye: Landscape Representation and American Cultural Politics, 1825–1875* (Ithaca, N.Y.: Cornell University Press, 1994), 152. The conjunction of mapping and perspective is explored in Jane Aiken, "Renaissance Perspective: Its Mathematical Source and Sanction," Ph.D. diss., Harvard University, 1986; and Samuel Edgerton, *The Renaissance Rediscovery of Linear Perspective* (New York: Harper & Row, 1975).

28. See first Ralph Hyde, *Panoramania! The Art and Entertainment of the "All-Embracing" View* (London: Trefoil, 1988); and also Silvia Bordini, *Storia del Panorama: La visione totale nella pittura del XIX secolo* (Rome: Officina, 1984); Stephan Oetterman, *The Panorama: History of a Mass Medium*, trans. Deborah Lucas Schneider (New York: Zone Books, 1997 [1980]); and Heinz Buddemeier, *Panorama, Diorama, Photographie: Entstehung und Wirkung neuer Medium im 19. Jahrhundert*, Theorie und Geschichte der Schönen Künste, Texte und Abhandlungen, vol. 7 (Munich: W. Fink, 1970).

29. For examples of the construction of scientific meaning in these contexts, see, Bernard Smith, *Imagining the Pacific: In the Wake of the Cook Voyage* (New Haven, Conn.: Yale University Press, 1992); Brian Ford, *Images of Science: A History of Scientific Illustration* (New York: Oxford University Press,

to be used to make general points about the ideas that drove picture-making in the fine arts, and so they are less tightly bound to the forms of individual paintings and drawings. That freedom is a strength, as it avoids the search for direct influences, but it is also a weakness, because it elucidates tendencies in art and the history of associated concepts more than individual artworks.

I list these three examples to evoke the general outlines of the field. When art history encounters nonart images, it tends to use them to illustrate the history of fine art. In each case, what attracts art-historical interest and gives the images a relatively independent meaning is their closeness to fine art. Those images that have less to do with painting and drawing get less attention. The outlandish distortions of many map projections tend to be overlooked in favor of those projections that resemble the distances and angles of vision common in painting, just as the less naturalistic and intuitive aspects of computer graphics or the less spatially resolved strategies of medical illustration tend to appear less meaningful than their more pictorial instances.[30] There are many studies of gendered figures in the history of medical illustration, fewer of pictures of body parts, and virtually none of histological and sectional anatomies. In general, the supposition behind the art historical studies might be put like this: Some scientific and nonart images approach the expressive values and forms of fine art, but many more are encased in the technical conventions of their fields. Those images are a kind of desert in which interesting pictures are stunted and far between. They are inherently informational and without aesthetic value, and they are properly considered as kin to equations or spreadsheets: They are notations, not images in a deeper sense.

WIDER MEANINGS
IN "INEXPRESSIVE" IMAGES

It is important to resist this conclusion, both for the sake of the expanding discipline of art history — which would otherwise find itself against an unbreachable barrier at the "end" of expressiveness, interest, or aesthetic value — and also because it is demonstrably untrue. Especially significant in this regard is a text by the sociologist of science Michael Lynch and the art historian Samuel Edgerton on the ways in which astronomers handle images. Astronomers routinely make two kinds of images: "pretty pictures" for calendars, press releases, coffee-table books, and popular-science magazines such as *Scientific American;* and "scientific" images, normally in black-and-white, for publications such as the *Journal of Astrophysics.* "Pretty pictures" are often given strongly chromatic false colors, and initially Lynch and Edgerton hoped to find evidence that expressionist painting might lie behind that practice, making the astronomical images interesting examples of the diffusion of fine art. But according to their informants in the laboratory, fine art influences neither the "scientific" images nor the "pretty pictures."[31] Even though the astronomers might set aside time to make "pretty pictures," they do not consider them seriously in terms of the history and meanings of art, or even intend them to be anything more than eye-catching or decorative. On the other hand, they are intensely concerned with their "scientific" images, because they want to make them as clear, unambiguous, simple, graphically elegant, and useful as possible. To that end they use a range of image-processing tools to "clean up" the raw data provided by the telescopes. To make the "noisy" image in Plate 1.1 into the

1992); and Martin Rudwick, *Scenes from Deep Time: Early Pictorial Representations of the Prehistoric World* (Chicago: University of Chicago Press, 1992). For landscape, the sublime, and the picturesque, see Barbara Maria Stafford, *Voyage into Substance: Art, Science, Nature, and the Illustrated Travel Account, 1760–1840* (Cambridge, Mass.: MIT Press, 1984); and Timothy Mitchell, *Art and Science in German Landscape Painting, 1770–1840* (Oxford: Clarendon Press, 1993). For a discussion of pictorial values in dioramas, see J. Gage, "Loutherbourg: Mystagogue of the Sublime," *History Today,* 13 (1963): 332–39.

30. Technically, it would be better to say that out of the sum total of mappings, art history pays most attention to projections, and within that class to gnomonic and related projections. A good introduction to the full diversity of the field is Georg Scheffers, "Wie findet und zeichnet Man Gradnetze von Land- und Sternkarten?," in *Mathematisch-physikalische Bibliothek,* ed. K. Strubecker (Leipzig: Reihe, 1934), vols. 85–86.

31. Lynch and Edgerton, "Aesthetics and Digital Image Processing: Representational Craft in Contemporary Astronomy," in *Picturing Power,* 184–220, esp. 193. See also Lynch, "Laboratory Space and the Technological Complex: An Investigation of Topical Contextures," *Science in Context* 4, no. 1 (1991): 81–109.

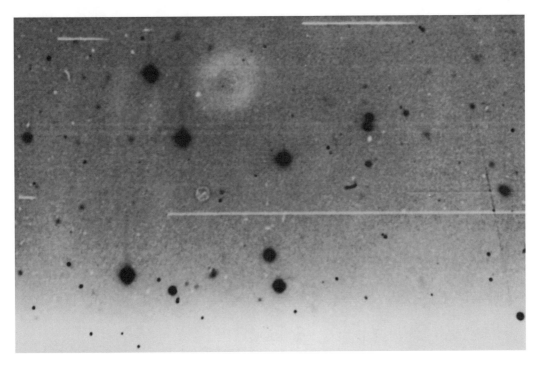

PLATE 1.1 *"Noisy" CCD image.*

"clean" image in Plate 1.2, the astronomers used image-processing software to remove "electronic bias" (which makes the top of the first plate darker than the bottom), a "donut" caused by out-of-focus dust in the telescope (top center), rows of "burnt-out pixels" (the bright and dark horizontal lines), a spot of epoxy glue (left of center), and cosmic ray traces (the smaller dark spots). At first it seems this has little to do with anything that might concern a history of art, but Lynch and Edgerton point out that this kind of care is not outside aesthetics. It precisely *is* aesthetics: It is the original, pre-Kantian sense of aesthetics as the "perfecting of reality"— the very doctrine that governed Renaissance painting.[32] Even when the astronomers use false colors for their scientific images, they do so in order to make natural forms clearer and more susceptible to quantitative assessment. Their images always aim to give what they consider to be the most rational version of phenomena. This, I think, is a fundamentally important result, and no work on nonart images should proceed without taking it into account.[33] What happens in nonart images can be just as full of artistic choices, just as deeply engaged with the visual, and just as resourceful and visually reflective as in painting, even though its purposes might be entirely different. Lynch and

Edgerton agree with Leo Steinberg, Thomas Kuhn, and others that not much is to be gained by comparing the scientists' criteria of elegance, clarity, and simplicity with artistic criteria, and that the two senses of images are worlds apart — but in terms of the attention scientists lavish on creating, manipulating, and presenting images, the "two cultures" are virtually indistinguishable.[34]

32. Lynch and Edgerton, *Picturing Power*, 214, 218n26, quote Hans-Georg Gadamer (*Truth and Method* [New York: Crossroad, 1989], 74–75) to the effect that science has usurped the original sense of aesthetics, making everything that is not scientific imaging merely what the astronomers call a "pretty picture."

33. Peter Galison has proposed a three-stage history of scientific atlases from the eighteenth to the twentieth centuries, from those that report the scientist's privileged understanding of nature, to those that mechanically report what the instruments record, to those that include scientists' interventions and improvements on mechanical description. The methods Lynch and Edgerton report are close to Galison's third category, and they have the advantage of tying his analytic criteria to the older history of the reception of images. Galison, "Judgment against Objectivity," paper delivered at the 1996 College Art Association, Boston, February 1996.

34. Steinberg, "Art and Science," 6. See also Subrahmanyan Chandrasekar, *Truth and Beauty: Aesthetics and Motivations in Science* (Chicago: University of Chicago Press, 1987); Lynch

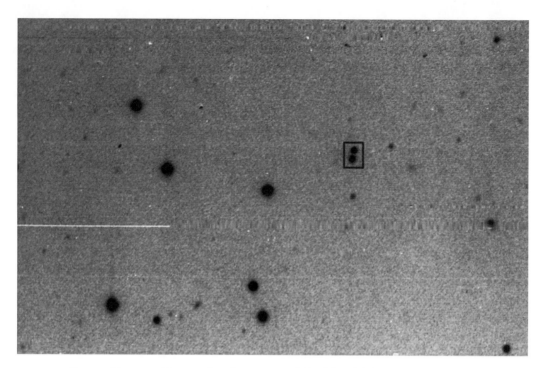

PLATE 1.2 *Processed image, with cursor box drawn around the object* QSO 0957+561.

Where images are the objects of such concerted attention, then affective, historical, and social meanings — in short, the panoply of meanings that concern art history — cannot be far behind. It is certainly true of the astronomical images that Lynch and Edgerton studied, and it might also be true of even more intractably "inexpressive" images. And with that, I want to pause to make a half-serious, half-conjectural attempt at writing art history for some apparently totally inexpressive images.

and Edgerton, *Picturing Power*, 185, citing Steinberg, "Art and Science"; and Thomas Kuhn, "Comment on the Relation between Science and Art," in *The Essential Tension: Selected Studies in Scientific Tradition and Change* (Chicago: University of Chicago Press, 1977), 340–51. For recent uses of *beauty, elegance,* and related terms, see Peter Galison, "Theory Bound and Unbound: Superstrings and Experiment," in *Laws of Nature: Essays on the Philosophic, Scientific, and Historical Dimensions,* ed. Friedel Weinert (Berlin: Walter de Gruyter, 1995), 369–408.

2 : Art History as the History of Crystallography

Whatever other purposes an art-historical account might have, it needs to locate meaning beyond the bare constraints of necessity. Pictures have to seem as if their makers had some choice, and could record meanings other than the ones their patrons demanded, or that the medium required. "Expressive meaning" in this sense is one of art history's principal criteria for art. As a rule, images that are closer to fine art seem the most expressive, and those farther away appear effectively devoid of meaning beyond their immediate purposes of conveying facts. They are affectless carriers of data, beyond the pale of expressive intention.[1]

I have mentioned medical illustrations as an example of images that can be palpably close to contemporary fine art; they are routinely described in expressive terms. Geometric and mechanical drawings are a little more distant and are more likely to be treated as enabling devices (tools for some more engaging purpose) or cited as parts of a general historical background. From this vantage point, it looks as if art history could expand outward and away from fine art, sifting less and less expressive images to get at nuggets of expressive meaning, until it finally encountered purely inexpressive images. That boundary would then be a kind of absolute limit to art history's interest.

Schemata, diagrams, graphs, and tables are among the images that are seen as overwhelmingly, obdurately inexpressive and geared toward the cold transmission of information. The assumption would be that they have no "degrees of freedom," to use the mathematician's term: They can only convey facts, and there is no room for personal, political, social, psychological, gendered, or other kinds of meaning that artists can more or less freely incorporate into their works. In comparison to the astronomical images, such pictures are a pure vacuum of artistic meaning: At least the astronomical images participate in the late-Romantic attraction to infinity, isolation, extreme distances, imperfect vision, and other traits of the modern and postmodern sublime.[2] Diagrams and tables look inert, hopelessly incapable of any such purpose.

For the most part, diagrams and related geometric images have not participated in the growth of art-historical interests and may not be classed as pictures or images at all; rather, they are apt to be seen as outgrowths of writing or mathematics. But I would like to argue that it is also possible that despite these apparent obstacles, images such as Labanotation (graphs of a dancer's movements), seismographs, sonar charts, weather tables, genealogical flow charts, and electroencephalographs can be read according to the conventions of fine art: They can be discussed using the language of Western fine-art images and assigned expressive as

1. Conversely, disciplines such as communication theory sometimes assume that any meaning aside from the "message" is undesirable. See Robin Kinross, "The Rhetoric of Neutrality," in *Design Discourse: History, Theory, Criticism,* ed. Victor Margolin (Chicago: University of Chicago Press, 1989), 131–43.

2. See, for example, Thomas Weiskel, *The Romantic Sublime: Studies in the Structure and Psychology of Transcendence* (Baltimore: Johns Hopkins University Press, 1976).

well as informational meaning. Even the most decidedly inartistic charts, mathematical notations, geometric "configurations," tables, and tabular printouts of numbers might exhibit determinate nonessential choices in formatting, font, and "composition." If that is the case, then the reasons art historians posit for excluding such images would need rethinking.

What I have in mind here is an experiment: an example of what might happen if art history were to turn its attention not to the more assimilable images of scientific and medical treatises but to the stark plates that seem on the verge of freezing into typography, abstract geometry, or numbers. The illustrations of crystals in chemistry and mineralogy texts are a convenient example, as they seem to be almost wholly informational, extrapictorial, inexpressive, and utilitarian, and for those reasons they are definitively beyond the pale of images that might contribute to a history of art. But it turns out — so I will claim — that even these images respond unexpectedly well to the interpretive protocols developed within art practice and art history. The readings that result raise a number of difficult questions about how we choose the subject matter of art history and what we want from art or pictures.

As I move through these images I'll also be touching on an ancillary theme — ancillary to scientists and historians of science, but potentially central to art history. It concerns the kind of technical interpolations that have to be made in order to say anything sensible about such images. To say that crystallographic images "respond" to art history's hermeneutic strategies is not to say that the readings are easy, and there are moments when unusual kinds of explanation are required. But the slow work of interpretation, and the interpolation of analytic or technical material into the historical narrative, are not effects unknown within art history as it is traditionally constituted. Any picture that has accumulated an extensive literature might require prefacing before it can be cogently discussed even to a specialist audience — one might think of Velázquez's Las Meninas, with its huge literature on mirrors, reflection, and epistemology, or the ceiling of the Sistine Chapel, with its labyrinth of proposed Catholic symbols.[3] The technical information that is required to describe crystal drawings is unusual in humanist narrative, but it raises the same issues as the specialized information that we routinely accept when it comes to images such as Las Meninas. It's acceptable to read, say, fifty pages of introductory material on the symbolism of the Sistine Chapel ceiling, but not fifty pages of chemistry introducing a picture of a crystal. What counts is the kind of explanation, not its density. Our choices in art history have to do with what we expect pictures to be, and how we assume that expression and history reside in some images and not in others. At the same time, to test the boundaries of art history, it is sometimes necessary to introduce specifically technical information — information that seems most distant from expressive redemption. I will be calling this the problem of appropriate explanation.

CRYSTAL DRAWING AND MIMESIS

It would be possible to begin this history before there were any pictures of crystals, as it appears that crystals themselves were among the earliest objects collected by hominids. Quartz and calcite crystals might have been modified by snapping them in certain places in order to accentuate their forms — in which case they would be among the earliest sculptures.[4] But if we begin with images, the earliest examples are records of specimens in curiosity cabinets, from the sixteenth century onward. They clearly take their representational strategies directly from contemporaneous Western painting, with its panoply of compositional and lighting arrangements. On occasion there is even resonance with late-medieval and Renaissance symbolism of mortality and the vanitas — for example, when crystals are presented as perfect products of nature, immune to mortal decay. Crystals have also served neo-Platonic ends when they were contrasted with regular and semiregular solids or mimicked in perspectivists' models. In these earlier sources, which have not yet been adequately

3. See my "On Monstrously Ambiguous Paintings," History and Theory 32, no. 3 (1993): 227–47, and "Why Are Our Pictures Puzzles? Some Thoughts on Writing Excessively," New Literary History 27, no. 2 (1996): 271–90, revised in Elkins (1999a).
4. See Robert G. Bednarik, "Paleoart and Archaeological Myths," Cambridge Archaeological Journal 2, no. 1 (1992): 27–57, esp. p. 34.

studied, crystals occur in isolation, on manufactured pedestals, or in accumulations of the "miracles of nature," in full light, half-light, and tenebrist shadow, but always within the current conventions of painting and printmaking. By contrast, the emerging discipline of crystallography demanded something more precise. To make informative pictures of crystals and to avoid mistaking similar crystals, an artist's drawing methods had to be tightly constrained.[5]

The history of crystallography can be divided into two large periods, before and after the Abbé Haüy's *Traité de minéralogie* (1799) that helped formalize the representation of crystals. Since Haüy, crystals have no longer been drawn using the range of illusionistic strategies common to Western drawing — the drawings show no gravity, color, *hachure, demi-teintes,* or texture.[6] Plate 2.1 is from a treatise written before Haüy, Moritz Anton Cappeller's *Prodromus crystallographiæ* (1723), and Plate 2.2 is a selection of drawing techniques from the second period, collated in 1923 by the historian Ludwig Burmester.[7] The three centuries before Haüy saw many conflicting theories; John Burke, the author of a recent history of crystallography, finds it lends "strong" support to Thomas Kuhn's conception of "revolutionary," paradigmless science.[8] However we choose to interpret that confusion of representational systems, crystallographic illustration in the second period coalesced into fewer, more consistently quantitative formulations.

Cappeller pays attention to chiaroscuro, giving conventional shadows to some salt crystals formed in *aceto vini* (the little "houseforms" in the center). His lighting is inconsistent — perhaps he is seeing and recording each specimen separately — and the idea of a standardized light source does not seem to have occurred to him. Still, there is enough attention paid to texture and shadows so that we get a general impression of the size of the crystals, and what they would have looked like arranged on a tabletop. In its episodic way his rendering is sensitive to the ordinary flaws that crystals always exhibit: Notice, for example, the imperfectly formed crystals in the right center, whose facets are curved and irregular. The drawing is limited by his eye as well as his patience, and both seem to give out when it comes to some shapeless fragments at the lower right.

Cappeller's style of direct and somewhat haphazard drawing never entirely vanished from crystallography, but after Haüy it became scarce.[9] Burmester, two hundred years later, has no interest in chiaroscuro, scale, or minor flaws. His forms are ideal geometric solids: octahedra, pyramidal dodecahedra (quartzoids, on the right), and rhombohedra (lower left). He is not recording "type specimens" or specimens of any kind but mathematical properties derived from many examples, and so his graphic method and his style are fundamentally at odds with Cappeller's. Where Cappeller samples many crystals, looking for the most perfect one of each type, Burmester abstracts idealized types from the average of many forms: it's the old debate between empirical surveys and idealizations that began with Praxiteles and Zeuxis.[10] Burmester's plate is less a reminder of how actual specimens might look — though it is essential that it still functions

5. General sources on the history of crystallography include Paul Groth, *Entwicklungsgeschichte der mineralogischen Wissenschaften* (Berlin: J. Springer, 1926; rptd., Wiesbaden: M. Sandig, 1970); Hélène Metzger, *La Genèse de la science des cristaux* (Paris: A. Blanchard, 1969 [1918]); John G. Burke, *Origins of the Science of Crystals* (Berkeley: University of California Press, 1966); and Hermann Tertsch, *Das Geheimnis der Kristallwelt; Roman einer Wissenschaft* (Vienna: Gerlach und Wieding, 1947). See also the *Historical Atlas of Crystallography,* ed. J. Lima-de-Faria (Dordrecht: Kluwer, 1990).

6. Given the abstract, excessively dry quality of the drawings Haüy championed — which bleed all visual incident from the objects they record — it is interesting that his younger brother, Valentin Haüy (1745–1822), printed the first sheets with relief lettering for the blind; see his *Essai sur l'éducation des aveugles* (Paris: Imprimé par les enfans-aveugles, et se vend à leur seul bénéfice, 1786).

7. Moritz Anton Cappeller, *Prodromus crystallographiæ de crystallis improprie sic dictis commentarium* (Lucerne: Typiis Henrici Rennwardi Wyssing, 1723; rptd., Munich: Kunst- und Verlagsanstalt Piloty und Loehle, 1922); Burmester, "Geschichtliche Entwicklung des kristallographischen Zeichnens und dessen Ausführung in schräger Projektion," *Zeitschrift für Kristallographie* 57 (1922–23): 1–47, plate following p. 706. For Cappeller, see Carl Michael Marr, *Geschichte der Crystallkunde* (Carlsruhe: D. R. Marx, 1825; rptd., Wiesbaden: M. Sandig, 1970), 73.

8. Burke, *Origins of the Science of Crystals.*

9. See Hermann Peter Joseph Vogelsang, *Die Kristalliten* (Bonn: M. Cohen und Sohn, 1875).

10. For examples in contemporaneous anatomic illustration, see my "Two Conceptions of the Human Form: Bernard Siegfried Albinus and Andreas Vesalius," *Artibus et historiæ* 14 (1986): 91–106.

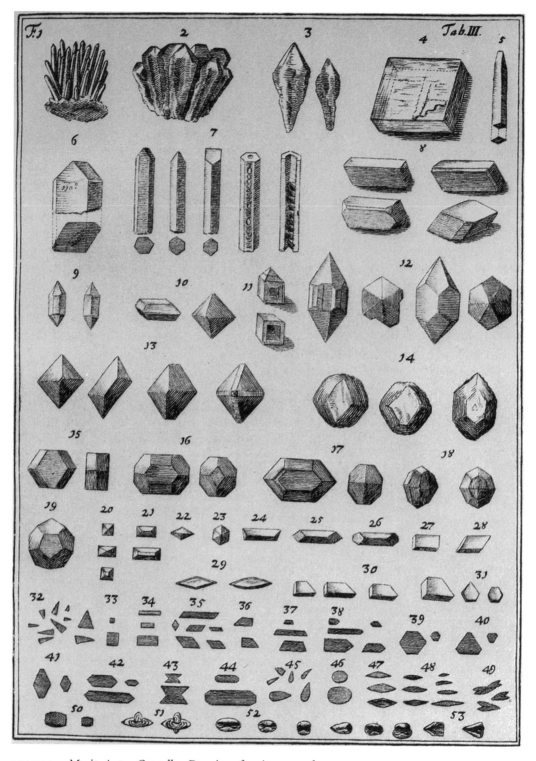

PLATE 2.1 *Moritz Anton Cappeller. Drawing of various crystals. 1723.*

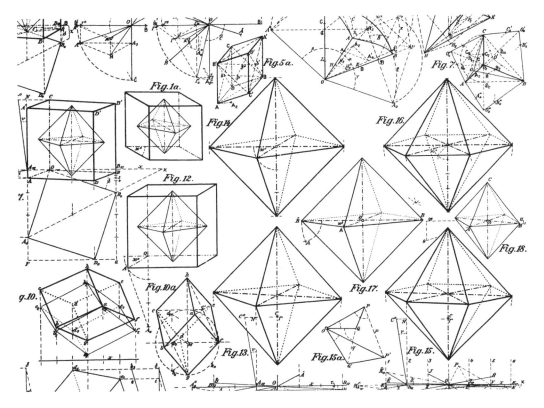

PLATE 2.2 *Ludwig Burmester. Varieties of parallel projection of crystals, detail. 1922–23.*

in that way — than a nonnaturalistic graphic notation in which lengths and angles can be measured directly from the picture. In principle, a crystallographer could take such a plate, put a ruler and protractor across it, and read off the properties of the crystals. (Normally that would not be necessary because the information would be given in the accompanying text.) His examples are in parallel projection, which means that they are fully quantifiable; it also means that they are not seen from any point of view. (They look as if they might be real objects, but they are oblique, axonometric projections that posit no center of projection and therefore no viewer.) At the same time it would be wrong to conclude that Burmester's drawing renounces naturalistic pictorial strategies or moves decisively toward nonrepresentational notation, as the fixed parameters of the various projections are all reminiscent of a single linear perspective view: It is as if each crystal is "seen" from above and a little to the right. Because most crystals are small, their parallel sides do not seem to converge, and the parallel projections end up looking like plausible real-world objects. Burmester's images

preserve an interesting tension between naturalism and notation, between the earlier sense that pictures themselves somehow carry meaning and the newer requirement that pictures convey exact quantitative information. The drawing conventions he surveys are outside Western traditions of naturalism but within mimesis, and in a sense they exist in order to embody two mutually contradictory ideals: quantitative rigor (which is available only with parallel projection) and perspectival illusion (as if these were crystals that could actually exist and be seen).

NEOCLASSICISM AND
THE BUILDING BLOCKS OF FORM

This is the main movement in the history of crystal illustration: away from haphazard naturalism and toward geometric notation. Much of the change seems to be motivated by mineralogists' concerns, but the shift is actually an adaptation and an anticipation of movements in contemporaneous fine art. The turn of the nineteenth cen-

tury, when crystals were first drawn in clear outlines against indeterminate grounds, was also the time of Benigne Gagnereaux, John Flaxman, and *les primitifs* — neoclassical artists and movements that stressed schemata over substance, flattened outlines over chiaroscuro and depth, and the tabula rasa of pure breathless abstraction over the lush Baroque undergrowth that seemed to be choking visual imagination.[11] Robert Rosenblum has described these developments in *The International Style around 1800*.[12] But the coetaneous development of spare engravings, linear architecture, and "flattened" pictorial space was more extensive than the examples Rosenblum presents, spreading far beyond the fine arts and embracing perspective, engineering, scientific illustration, geometry, architectural drawing, astronomy, academic nude studies, anatomy, and even crystallography.

In this context a few examples will have to suffice to evoke the spread of the International Style through those scientific and pedagogic disciplines. Four years before Haüy's *Traité de minéralogie*, Gaspard Monge published his codification of engineering drawing, *Leçons de géométrie déscriptive*, which also abstracts and circumvents linear perspective in favor of parallel and oblique projection. Architectural drawing, academic nudes, and anatomical drawing all adopted the new linear mode about the same time or a little earlier, and the conventions of abbreviated hatching, attenuated lines, light watercolor shades, and distant or infinite viewpoints were adopted in official pedagogy.

The affinity with crystallography is perhaps clearest in architectural drawing. The first years of the school also saw Jean-Nicolas-Louis Durand's experiments with the building blocks of architecture; his *Précis des léçons d'architecture* (1802–1805) shows how the indivisible "atoms" of architectural construction, called *parties,* can be laid out on graph paper and combined according to laws of economical construction.[13] The graphic effect is much like Haüy's theories of indivisible *molécules integrantes,* fundamental units that combine according to certain laws of *décroissement* to form crystals. In Plate 2.3, from Haüy's *Traité de cristallographie* (1822), little cubic *molécules intégrantes* (right center) are ingeniously assembled to form the top half of a quartzoid crystal (upper left). Anthony Vidler, writing on the contemporaneous "geometrization" of architecture, observes that

when a conventional architectural ornament is erased, "the geometrical form becomes prominent like the bony structure of an invalid."[14] Both the crystallographer and the architect were toying with ideas central to the eighteenth-century imagination: the limits of metamorphosis and the search for original forms. When Durand found regular *parties* in rectangular buildings, and Marc Antoine Laugier speculated on the cylindrical trees that lie at the origin of cylindrical columns, they were exploring principles of growth abstracted from organic analogies: The small tree resembles the large tree, as the small porch resembles the elaborate portico, or the *molécule intégrante* builds to the elaborate crystal.[15]

Laugier's ideal columns and Durand's *parties* resemble the larger objects they combine to form, and so do Haüy's *molécules intégrantes*. When Haüy began, he actually broke large specimens into pieces, so that he could show that cleavage yields only smaller versions of minerals' characteristic shapes. He imagined that if such fragments could be broken and rebroken carefully enough, under the microscope, even the tiniest pieces on the verge of invisibility would have the same form. Like Durand's *parties* and Laugier's rustic *cabanes,* these constituent "molecules" would resemble the ordinary macroscopic shapes of the original crystals. That is the common assumption of the dissective search for the tabula rasa, and it led neoclassical artists as well as crystallographers to stress the geometric building blocks of nature. At times the search also took a more radical turn, with the discovery of elementary forms that do not resemble the structures they combine to form. The architects Etienne Louis Boullée and Claude Nicolas Ledoux searched for "letters of the alphabet" or "building

11. See my "Clarification, Negation, and Destruction of Pictorial Space in the Age of Neoclassicism, 1750–1840," *Zeitschrift für Kunstgeschichte* 56, no. 4 (1990): 560–82.

12. Rosenblum, *The International Style around 1800: A Study in Linear Abstraction* (New York: Garland, 1976).

13. Durand, *Précies des leçons d'architecture données à l'École Polytechnique* (Paris: École Polytechnique, 1802–1805); and see the application of his rationalism in *Recueil et parallèle des edifices du tout genre* (Paris: École Polytechnique, 1800).

14. Vidler, "The Idea of Type," *Oppositions* 8 (1977): 94–115.

15. Laugier, *An Essay on Architecture,* trans. Wolfgang and Ann Herrmann (Los Angeles: Hennessey & Ingalls, 1977).

PLATE 2.3 *The Abbé Haüy. Molécules intégrantes in a quartzoid. 1822.*

blocks" — basic forms such as spheres, circles, and stepped pyramids — that would unexpectedly assemble into gatekeepers' houses, coopers' residences, or hunters' cabins.[16] Haüy also thought along counterintuitive lines. He adopted a more abstract, mathematical mode of analysis that led him to discover primitive *molécules soustractives:* building blocks that are quite unlike the crystals they form. He was fascinated, for example, that a tiny parallelepiped *molécule* of calcite (Plate 2.4, right) could be assembled in great quantities to form a very different hexagonal prism (left).

These two ways of conceiving elementary building blocks are a generative dichotomy for the period, as they embody the fundamental difference between the simple linear accumulation of form (in which the *molécules intégrantes* are simply piled up, one on another) and invisible or abstract construction (in which the *molécules soustractives* of physical substance are radically different from what they comprise). The model for the former is any number of commonplace activities, from building stone walls to laying the planks in a floor; the model for the latter is any unexpected metamorphosis. Both scenarios occur in fine art, but Haüy spelled them out most precisely, and with the most uncompromising rigor. The transition to neoclassicism can certainly illuminate the "revolution" in crystal drawing, but it is more accurate to say that crystallography rehearses late eighteenth-century preoccupations more clearly, and more radically, than painting or architecture.

FROM CRYSTALLOGRAPHIC REALISM TO CRYSTALLOGRAPHIC CUBISM

Crystal drawings, I want to suggest, are excellent markers of neoclassical preoccupations, and the same can be said of the conventions that developed in the following decades. After Haüy, crystal drawing shifted among the increasingly narrow choices arrayed in Plate 2.2 and eventually settled on a kind of parallel projection known as clinographic projection, which has remained the standard representational strategy.[17] Like all such projections, clinographic drawings have a faint but lingering affinity with perspective, and that property made them attractive as interest began to grow in the possibility of depicting the more complex crystal forms. Some of the most influential crystal draftsmen in the nineteenth century were contemporaries of the Munich realists and compatriots of artists such as Bromeis, Menzel, and Bumier. The last of them continued to work long after interest in pure description had faded; they were the spiritual allies of such late-Romantic and decadent artists as Holzel, von Stuck, and Sartorio, who worked on into the twentieth century.

The period saw some pinnacles of fastidious observation. The greatest of the crystallographic realists was Victor Goldschmidt; the bulk of his life's work is the enormous *Atlas der Krystallformen*, which records the precise external forms of actual specimens — that is, the fortuitous crystal "habits" that Haüy had pared away.[18] Appropriately, Goldschmidt's most accomplished work was done just before World War I, when conservative descriptive naturalism was still strong in German universities. His *Beiträge zur Kristallographie* (1914–18) is a marvel of myopic precision. Several plates of antimony from Felsöbanya in northwest Romania are unsurpassed models of delicate physical measurement: The angles of every plane are taken with an instrument and checked against the possible cleavages of antimony before being recorded (Plate 2.5).

16. These are Ledoux's transformations. For Ledoux's phrase "letters of the alphabet," see Anthony Vidler, "*Monuments parlants:* Grégoire, Lenoir, and the Signs of History," *Art and Text* 33 (1984): 12ff. For Boullée, see Helen Rosenau *Boullée and Visionary Architecture* (London: Academy Editions, 1976).

17. Clinographic projection was chosen by the editors of the influential *Zeitschrift für Krystallographie und Mineralogie* in 1877 and by François Ernest Mallard two years later. By 1880 it was universally accepted; see especially Mallard, *Cristallographie géométrique et physique,* 3 vols. (Paris: Dunod, 1879), vol. 1, chapter 5, "Systèmes de Représentations Graphiques." The earliest clinographic period therefore covers the years between the invention of the projection by Carl Friedrich Naumann (*Lehrbuch der reinen und angewandten Krystallographie* [Leipzig: F. A. Brockhaus, 1829–30], 3 vols.); its standardization, largely by Paul Groth (*Physikalische Krystallographie und Einleitung in die krystallographische Kenntnis der wichtigeren Substanzen* [Leipzig: W. Engelmann, 1876]); and its official adoption by the *Zeitschrift* the next year. An interesting alternate graph is shown in Hermann Yertsch, *Trachten der Kristalle,* Forschungen zur Kristallkunde, vol. 1 (Berlin: Gebrüder Borntraeger, 1926), 146.

18. Goldschmidt, *Atlas der Krystallformen* (Heidelberg: Carl Winters Üniversitätsbuchhandlung, 1918–).

PLATE 2.4 *The Abbé Haüy. A molécule intégrante and hexagonal crystal of calcite. 1822.*

In the realm of scientific illustration, this is the epitome of the descriptive empiricism that also flourished in late nineteenth-century academic realism, art criticism, biology, and natural history.[19]

In a sense, clinographic projection subverts the viewer's capacity to understand crystal drawings as representations of three-dimensional objects, because it flattens and distorts forms without seeming to do so.[20] Projections such as those in Plates 2.2 and 2.5 might seem like perspective views — that is, they might appear to be familiarly solid and scaled objects seen from our point of view — but in fact they are unexpectedly compressed and need to be mentally "expanded" to correspond with our anticipations of perspectival convention. This is one of the areas in which an art-historical exposition would be slowed by the need for a long technical explanation, as clinographic projections cannot be understood if they are seen in the way we habitually see Western pictures: They are constructed so that seeing has to be learned. There is a widespread assumption in the humanities that images made more or less in accord with perspective can be easily assimilated. A famous series of ethnographic experiments beginning in the 1920s seemed to confirm that at least some rudiments of perspective are widely understood among cultures that have no contact with Western picture-making — a result in harmony with the notion that the depictive rudiments of pictures do not stand in need of special introductions.[21] Clinographic crystal drawings are a counterexample. Crystallographic

19. See further the illustrations in Goldschmidt, Charles Palache, and Martin Peacock, "Ueber Calaverit," *Neues Jahrbuch für Mineralogie, Geologie und Paläontologie* 63, Abteilung A (1932): 1–58; Goldschmidt, *Beiträge zur Krystallographie und Mineralogie* (Heidelberg: Carl Winters Universitätsbuchhandlung, 1926–34); Goldschmidt, "Über Kristallzeichnen".

20. For tutorials in clinographic projection, see Edward Salisbury Dana, *A Text-Book of Mineralogy, with an Extended Treatise on Crystallography and Physical Mineralogy*, 3d ed. (New York: John Wiley & Sons, 1880 [1877]), appendix B, pp. 421–30; A. E. H. Tutton, *Crystallography and Practical Crystal Measurement* (London: Macmillan, 1911), 382–417; Victor Goldschmidt, "Über Kristallzeichnen," *Zeitschrift für Kristallographie* 19 (1891); Wherry, Palache, et al., "The Goldschmidt Two-Circle Method," Robert Luling Parker, *Kristallzeichnen* (Berlin: Gebrüder Borntraeger, 1929); and Margaret Reeks, *Hints for Crystal Drawing* (London: Longmans, Green, 1908).

21. The literature has been recently reviewed in Samuel Edgerton, *The Heritage of Giotto's Geometry: Art and Science on the Eve of the Scientific Revolution* (Ithaca, N.Y.: Cornell University Press, 1991).

PLATE 2.5 *Victor Goldschmidt. Antimony from Felsöbánya, Romania. 1915.*

manuals teach clinographic projection not only as a drawing technique but also as a kind of seeing, and crystallographers have to acclimatize themselves to its particular conventions (Plate 2.6).[22] How easy is it to guess that the crystal shape at the bottom left, which is in clinographic projection, corresponds to the top view that is shown just above it? The crystal at the lower center is even harder to understand: The top view and side view, given just above, show that it is very thin and has two triangular faces (labeled c), one above the other, oriented in opposite directions—a very confusing solid. Seeing clinographic drawings is an art: I think only a specialist could look at the crystal at the lower right and then draw the pattern at the upper right. A more formal art-historical exposition of this material would have to pause over this issue long enough to inculcate a certain measure of "visual literacy" in the reading of these images. It would be an unusual kind of technical preamble, and certainly an "inappropriate" intrusion of technical prose into a historical account.

The unexpected compression of clinographic projection is not unrelated to several alternate projections that were also developed during the nineteenth century. In particular, two such projections—gnomonic and stereographic—work to flatten and fragment fictive space in ways that are not seen in the fine arts until roughly forty years later. Gnomonic projections were introduced by Bravais in his "Études cristallographique" in the *Journal de l'École Polytechnique* in 1849, several decades before the erosions of continuous fictive space in painting, which might be dated to the 1880s. Bravais borrowed gnomonic projection from cartography because it allowed him to represent the orientations of crystal faces as straight lines. Gnomonic projection also, incidentally to Bravais's purpose, flattens an entire crystal into a network of lines (Plate 2.7). Here the myriad orientations of crystal faces become the intersections of an orderly grid, instead of the potentially confusing facets of a clinographic drawing. Certain crystals are more likely to cleave along certain combinations of faces, and this, too, is easily visualized by noting how diagonal lines converge on different intersections. This diagram is a generalization of a generalization, as it summarizes an entire class of crystals; a clinographic representation is typi-

cally an ideal form of a single kind of crystal, and this diagram sums all the ideal crystals in a given class. Hence its complexity, and the very faint diagonals denoting unusual cleavage planes. From a mineralogist's point of view, it is an easy matter to measure a crystal's properties on a gnomonic projection; from a perceptual standpoint, however, it is difficult to gain even a rough idea of what the original specimens would look like.[23] Hence gnomonic projections trade spatial coherence for quantified information.

Stereographic projection, second and more important of the new methods, was also taken from cartography; it first appeared in the *Zeitschrift* by 1878.[24] Such a projection does not flatten three-dimensional space as thoroughly as a gnomonic projection, and normally it is possible to gain some idea of the crystal's three-dimensional appearance (Plate 2.8, center).[25] Again, reading is a specialized ability that has to be learned: In Plate 2.8, the stereographic projection captures the properties of the four crystals around it, as well as some more outlandish shapes the author reproduces on another plate.[26] An informal explanation of stereo-

22. See Samuel Lewis Penfield, "On Crystal Drawing," *American Journal of Science* 9, no. 169, 4th ser. (1905): 39–75; and Penfield, "On the Drawing of Crystals from Stereographic and Gnomonic Projections," *American Journal of Science* 21, no. 171 (1906): 206–15.

23. Each intersection is labeled with its three-digit Miller index, so the picture can be "decoded" (restored to its three-dimensional shape) by checking the orientation against the schema at the upper left, which shows the relevant axes, and then reading the indices for individual planes. The most elaborate gnomonic projections are again Goldschmidt's; see his elephant folio *Krystallographische Projektionsbilder* (Berlin: J. Springer, 1887).

24. See Hermann Tertsch, *Das Kristallzeichnen, auf Gründlage der stereographischen Projektion* (Vienna: J. Springer, 1935); and Tertsch, "Zur Indizesbestimmung stereographisch projizierter Kristallflächen," *Zeitschrift für Kristallographie* 99 (1938): 61–66. Stereographic projections can also be "developed" or unrolled; see Berend George Escher, *Algemene Mineralogie en Kristallografie* (Gorinchem: J. Noorduyn an Zoon, 1950), 66–67, 108.

25. Carl Urba, "Mineralogische Notizen," *Zeitschrift für Krystallographie und Mineralogie* 5 (1880–81): 417–35, esp. pp. 418–25 and 435, "Stephanit von Přibram."

26. It is not accidental that crystallographers began to develop aids to visualization at about this time. See, for example, J. Martius-Matzdorff, *Die Elemente der Krystallographie mit*

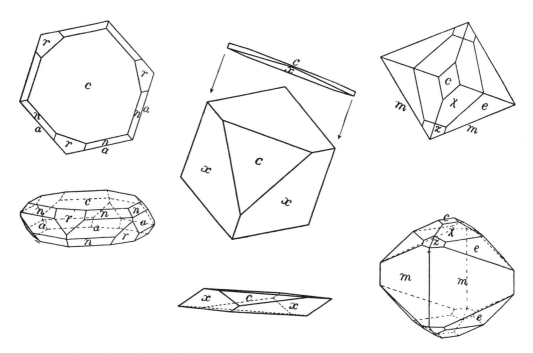

PLATE 2.6 *Samuel Lewis Penfield. Clinographic projections and plans of Corundum, Hematite, and Brookite. 1905.*

graphic projection might sound something like this: Imagine a light placed inside a crystal and a black dot painted in the middle of every face; then a stereographic projection is a picture of those dots projected onto a paper held above the crystal. It turns out that the dots are connected by arcs, instead of by lines, as in gnomonic projection. Thus the projection is like a map of the top half of a globe, and the approximate appearance of simple crystals can be deduced from it, just as we can imagine something of the shape of Greenland from its exaggerated shape on several standard map projections. As in the case of clinographic projection, the explanation itself becomes a kind of lesson in seeing — these are not "natural" images, and learning their kind of naturalism takes some patience.

The two projections have become standard in crystallography: Gnomonic projections are used to help analyze Laue photographs (X-ray diffraction plates), and stereographic projections are used in textbooks on morphology and symmetry. It is one of the many tempting coincidences of history that Laue's discovery came when it did: The year of Picasso's seminal cubist works *Ma Jolie* and the *Aficionado* was also the year of the ambiguous space of the Laue photographs. The two ways of making

pictures share a number of representational strategies, which can be roughly put in terms of the ways they are understood when they are first encountered. Initially both present the appearance of shattered or textured flatness, but with practice and familiarity the confusion gives way to a more or less coherent set of spatial references. The mode is still representational, but realism is compromised by strict formal disjunctions. The crystal in Plate 2.8 is flat and in relief at the same time; in cubist terms, its facets are pressed or fractured, and in the crystallographic lexicon, the facets are projected. (Technically, the spaces between the lines in a stereographic projection do not correspond to the facets of the crystal, so that the word *facets* is metaphoric in both stereographic projection and in cubism.) In both cases, the representation takes three-dimensional illusionism toward an abbreviated, compressed notation, without disappointing our most general expectations about naturalism.[27]

It would be misguided to pursue this parallel for

stereoskopischer Darstellung (Braunschweig: Friedrich Vieweg und Sohn, 1871).

27. Though abbreviation is paramount in crystallography, there are stereographic projections that rival paintings in the

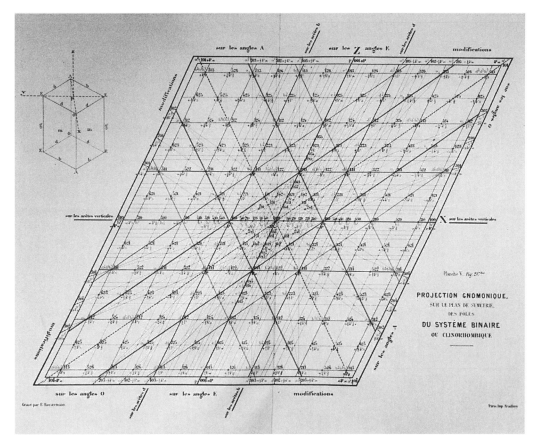

PLATE 2.7 *François Ernest Mallard. Gnomonic projection of the forms of the "système binaire ou clinorhombique." 1879.*

a number of reasons: the detailed reception of the images varies greatly, despite the initial similarity; there is no one-to-one connection between crystallographers and painters; and — preeminently — cubism could not be adequately explained, or even illuminated, by appealing to a contemporaneous practice that is itself just as much in need of explanation.[28] None of that means crystallography is not part of the wider cultural background of spatial experimentation that led to cubism, and a complete account of cubism might well take crystallography into account. Cubism and stereographic

projection even share a common prehistory in the late eighteenth century, when experiments in new perspective projections reached a pitch of nonnaturalistic complexity. From the 1750s onward, constructions involving such perspectival arcana as the neutral plane, multiple rabatments, and generalized vanishing lines produced destructions and negations of perspective "box space" that can probably be thought of as one of the crucibles from which the even more radical projections of crystallography emerged (see Plate 13.10). The

complexity of their articulation. That happens when the diagrams are intended to represent whole classes of crystals (as in Mallard's gnomonic projection [Plate 2.7]), and when the crystals are especially complex. For the latter, see Hugo Bücking, "Über die Krystallformen des Epidot," *Zeitschrift für Krystallographie und Mineralogie* 2 (1877–78): 321–45, esp. plate XIII.

28. The first of these points, the putative similarity between cubism and a certain operation on fictive space, is discussed in Elkins (1999b) in relation to the supposed parallel between cubism and Piero della Francesca. The third point, on the conceptual difficulty of explaining one cultural phenomenon in terms of another that might be no better understood, is the subject of my review of Hal Foster's *Compulsive Beauty* (*Art Bulletin* 76, no. 3 [1994]: 546–48, and the ensuing exchange, *Art Bulletin* 77, no. 2 [1995]: 342–43).

PLATE 2.8 *Carl Urba. Drawings of Stephanite: a stereographic projection (center) and four typical crystal habits. 1880.*

existence of such severe disruptions of naturalistic space might well be one of the licenses that eventually allowed painters to move forward with less radical innovations.[29]

A fuller analysis would no doubt uncover other correspondences. Once the doors to this kind of wider explanation are opened, they are very difficult to shut. I do not adduce crystallography when I teach cubism, and I don't call on crystallographic concepts to help me understand cubist pictures, but I also don't deny that my sense of tradition has been affected. Once I thought of cubism as part of a complex of ideas about art and its place in society; it did not include scientific illustration except as a vague accompaniment. Now the connection has become specific enough so that it resonates in my reading of cubism, and I sometimes turn to crystallography for more precise formulations of certain spatial operations — as if crystallography crystallizes the less focused thoughts of painting.

THE NOTION OF A CRYSTALLOGRAPHIC HISTORY OF ART

There are many dangers here, even aside from the ones I've mentioned. I am especially wary of implying that art history can take a cue from some ill-defined zeitgeist, or that more inclusive explanations are necessarily merely invigorating and not also reductive, corrosive, or misleading. I have risked this thought experiment in order to show how even "inexpressive" images can seem replete with expressive choices and art-historical meanings. Contemplating crystals and paintings together produces a strange sensation: a kind of slippage, as if there is a danger of sliding away from paintings and ending up — without even the slightest decrease in the density of analysis, or the texture of history — looking only at "dry" diagrams instead of "rich" paintings. It is odd, I want to say, that the shift from something we know and value — Picasso's cubism — to something that seems both alien and unrewarding — Laue's stereographic diagrams — is nearly seamless. It almost looks as if our chosen objects might be exchangeable.

29. See my "Clarification, Negation, and Destruction of Pictorial Space."

So the history of crystallography might do more than merely augment the history of nineteenth- and twentieth-century art: It is nuanced enough, and it has enough to do with expressive purpose, to form an alternate history of images in the last several centuries. The ideas and movements we know as events in the history of painting might also be expressed as moments in the history of crystal drawing, so that crystallography (for example, because there are other candidates) might serve to express large portions of the cultural and formal meanings we require of the fine art. The "deviations," "additions," and "lacunae" in such a history would only confirm its independence and the potentially plenary nature of its ideas and moments. Given space, it would be possible to write an entire textbook of post-Renaissance art based on crystals — or cartography, or microscopic images, or stamps, or pictures of hydraulic devices. Such a project would not be wholly capricious — not only because it could serve as an exemplary forum for debating the continuing affection we feel for the hierarchy of the genres and the preeminence of painting, but also because it could express, I think, the full range of pictorial ideas that we associate nearly exclusively with fine art. "Inexpressive" images are not only expressive, they are fully expressive in relation to comparable moments in art; and a history of such images, conceived as a history of art, could effectively question the way we think of the domain of the visual. Art history expands, looking outward from its center toward the odd images that are marginally pictorial; but we might also begin "outside" and tell our stories by looking back.

Once it begins, the substitution of crystals for paintings is effortless. In addition to its modernism, crystallography also has its postmodernism; it offers abbreviated historical quotations together with eclectic and whimsical experiments. The diagram titled "Pattern based on the space group p2mm(pmm)," from Peter Gay's *The Crystalline State* is a typical instance (Plate 2.9). Playful symbolic signs for symmetry classes are repeated elsewhere in modern crystallography and have their parallels in the "grids," geometric abstractions, symbolic schemata, and minimalisms of modern art. In general, recent crystallographic texts are more loosely eclectic than their modernist predecessors and more likely to indulge in a bricolage of

PLATE 2.9 *Peter Gay. Pattern based on the space group p2mm(pmm). 1972.*

methods and examples. In 1924 Ralph Wyckoff's *The Structure of Crystals* (Plate 2.10) presented visually sophisticated, almost surrealist illustrations. Nominally this is a collage of stereographic and gnomonic projections of dolomite, but spatially and compositionally it is similar to the "inner landscapes" of surrealists such as Tanguy and Matta, with their "lines of force" derived from cubist and futurist preoccupations, and also to postmodern collages that bring together different representational systems, from Rauschenberg onward. But do we need Rauschenberg, Tanguy, or Matta to read such a palimpsestic image? Is there anything to stop us from replacing our Rauschenbergs, Tanguys, and Mattas with these images — not only in our textbooks but also in our museums?

It is our inability to answer these questions without appealing to fragile notions of hierarchical value, to sentimental attachments to cherished images, or to the concerns of the art market that prompts me to take them seriously. They are mark-

ers of the state of our awareness of what we want art to be: On the one hand, we are not in possession of a concept of "art" or "picture" that would disallow this kind of apparently anarchic substitution; on the other, we continue to resist it.

Would it be possible to write (or to read) the history of art retold as the history of crystallography? Should there be a *Janson's History of Crystallography?* As outlandish or ridiculous as the idea might seem — even if it were possible to conceive it with any degree of seriousness — it is only the logical conclusion of speculations that have been going on for some time in other venues. Art history has long been familiar with the attraction of "low" art, and the field of cultural studies offers ample evidence that "low" art can be just as rich a field as the more traditional "high" arts. There have been attempts to mingle "hard" sciences and "soft" humanities at least since Wilhelm Dilthey's meditations on explanation and understanding. Literary theorists speak of the "mutual contamination" of

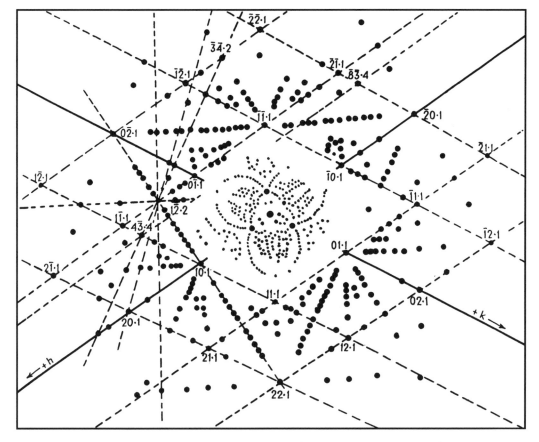

PLATE 2.10 *Ralph Wyckoff. Combination Laue photograph and gnomonic projection of Dolomite. 1924.*

discursive and expository narration, and philosophers such as Derrida have written examples of such hybrids. Similar movements in the history of science, such as Michel Serres's attempt to think of literature as a source for the hard sciences, work to break down analogous barriers.[30] In the philosophy of science, such critiques have been launched using a whole battery of arguments — logical,[31] social,[32] pluralistic,[33] and even mythic.[34] And on a more popular scale, debates about the canon must continuously return to the possibility that the canon itself might be replaced — not by some inferior or haphazard collection of international literature but by a selection that might function exactly as the traditional canon itself, and fulfill many of the ideological and disciplinary roles that the canon was thought to possess.

In part, these parallels evoke an art history that is more isolated, and more committed to its canon,

30. Serres, "Literature and the Exact Sciences," *SubStance* 59, no. 2 (1989): 3ff. Serres's defense of the unconscious protoscience in literature is bittersweet, as he is also critical of the way science engulfs all other disciplines. In that sense, his own work shows science yet another mine to exploit. See Serres and Bruno Latour, *Conversations on Science, Culture, and Time,* trans. Roxanne Lapidus (Ann Arbor: University of Michigan Press, 1995).

31. See the metacritique of Popper's "ultimate" critical principles by R. Nola, "The State of Popper's Theory of Scien-

tific Method," *British Journal of the Philosophy of Science* 38 (1987): 441ff.

32. See Steve Fuller, *Philosophy of Science and Its Discontents,* 2d ed. (New York: Guilford, 1993).

33. Methodological pluralism is advocated in the "instrumentalist" philosophy of Paul Feyerabend, *Against Method* (London: Verso, 1975), and his *Realism, Rationalism, and the Scientific Method* (Cambridge: Cambridge University Press, 1981).

34. This is advocated by Kurt Hübner, *Critique of Scientific Reason* (Chicago: University of Chicago Press, 1984).

than some other disciplines. It is true that commercially viable art-history textbooks (as opposed to experimental texts) continue to promote many of the same sequences of artworks.[35] One of the central concerns in current pedagogy is making room for artists and cultures who have not found places in the canon. But what if we stopped adjusting the canon, and discarded it instead? What if art in general, as a category, could be entirely omitted, and the substitition would be not only painless but *effectively invisible?* What if it would leave all our preferred interpretive methods, our theories, and our formalisms completely intact? What if it were as absorbing as anything we recognize as a history of art: What if it *became* the history of art?

35. For a bibliography, see my "Is It Still Possible to Write a Survey of Art History?" *Umění* 43 (1995): 309–16.

3 : Interpreting Nonart Images

ecause my principal purpose is to think of the domain of images in its entirety, without unreflectively privileging fine art, it is important to press on beyond the idea that nonart images are useful adjuncts to more important studies. The thought experiment on crystallography serves that purpose by imagining a version of art history that has entirely expunged fine art. I have no illusions about the possibility of such a history. If it were written, it would necessarily remain marginal — not because of entrenched conservatism, but because the discipline is constituted by narratives about art's social importance, its political functions, its patrons, its museums, and its economic value. Even if a book on crystallography could be written with the same eloquence and historical detail as a chronologically equivalent survey of art, it could only be an artificial prod against our ongoing, automatic, and often indefensible attachment to fine art. And it is for that reason rather than any other that I would not actually try to write such a book, or even to expand Chapter 2 beyond what is necessary to make my critical point.

But even as art history bypasses the expressive meanings of nonart images, they are being studied with interest in a number of other disciplines. Work is ongoing in archaeology,[1] cognitive psychology,[2] visual anthropology,[3] visual communication,[4] graphic design,[5] some aspects of word–image discussions,[6] the history of mathemat-

1. See, for example, John Halverson, "Art for Art's Sake in the Paleolithic," *Current Anthropology* 18, no. 1 (1987): 63–89, which presents an argument about the meaninglessness of cave art — a notion that has connections with the received idea that certain images, including Paleolithic "tallies," are inexpressive. For a study of archaeological representations, see Charles Goodwin, "Professional Vision," *American Anthropologist* 96, no. 3 (1994): 606–33.

2. In some of the most conceptually wide-ranging work, Phil Johnson-Laird has studied simple schemata — mental pictures — that are used to solve problems in lieu of full logical analysis. See Phil Johnson-Laird and Ruth M. Byrne, "Précis of *Deduction,*" *Behavioral and Brain Sciences* 16 (1993): 323–80, including criticism by various writers and "Author's Response: Mental Models or Formal Rules?" (368–80); Phil Johnson-Laird, Ruth M. Byrne, and Walter Schaeken, "Propositional Reasoning by Model," *Psychological Review* 99, no. 3 (1991): 418–39; Phil Johnson-Laird, "Mental Models and Probabilistic Thinking," *Cognition* 50, nos. 1–3 (1994): 189–

209; and Johnson-Laird, "How Diagrams Can Improve Reasoning," *Psychological Science* 4, no. 6 (1993): 372–78. There are also psychological studies of ordinary graphics, which tend to suffer from an art-historical standpoint because they concentrate on very simple graphics of a kind that has few parallels before the mid-twentieth century. See *Comprehension of Graphics,* ed. Wolfgang Schnotz and Raymond Kulhavy (Amsterdam: North-Holland, 1994).

3. Journals include *Visual Anthropology, Cambridge Archaeological Journal,* and *Current Anthropology.* A related work is Johannes Fabian, *Time and the Other: How Anthropology Makes Its Object* (New York: Columbia University Press, 1983).

4. Works relevant to art history include Fernando Dogana, *Le Parole dell'incanto: Esplorazioni dell'iconismo linguistico* (Milan: F. Angeli, 1990); and Elizabeth Chaplin, *Sociology and Visual Representation* (London: Routledge, 1994).

5. Graphic design remains more commercial, but there are exceptions; see Massimo Vignelli, *Grids: Their Meaning and Use for Federal Designers* (Washington, D.C.: U.S. Government Printing Office, 1978).

6. The journal *Visible Language,* for example, publishes essays on train timetables, charts, and maps; see the special

ics,[7] and the history, social study, and philosophy of science.[8] Most of the research is taking place in the various disciplines that study science, and a new interdisciplinary field of science studies is emerging from the blurred differences between the criticism, history, and practice of technology and the sciences.[9] The past ten years in particular have seen a dramatic increase in research that interprets science through its images.[10] Although some has to do with the role of specifically artistic images in science, more is concerned with images that appear

unallied with fine art.[11] The examples range from thumbnail sketches and notations of thought experiments to formal graphs and even "maps" of entire disciplines.[12] Recently historians and sociologists of science have introduced schemata to understand what the scientists do, and those graphs have themselves become objects of study.[13]

The field is still young, and the material has not

issues on "Diagrams as Tools for Worldmaking," *Visible Language* 26, nos. 3–4 (1992), and "Inscriptions in Paintings," *Visible Language* 23, nos. 2–3 (1989).

7. The principal journal is *Historia Mathematica;* see, for example, Marcia Ascher, "Graphs in Cultures: A Study in Ethnomathematics," *Historia Mathematica* 15 (1988): 201–27. The *Journal of Graph Theory* is sometimes also relevant to historical concerns.

8. These are four separate disciplines. Their respective associations in the United States are the History of Science Society, with its publication *Isis;* the Society for Social Studies of Science, with its publication *Science, Technology, and Human Values* (and the associated *Social Studies of Science*); the Philosophy of Science Association, with its publication *PSA,* which collects the proceedings of the annual conferences; and the Society for Literature and Science, with its journal *Configurations.* The four societies are abbreviated HSS, 4S, PSA, and SLS, respectively.

9. Several new journals mark this trend, especially *Perspectives on Science* and *Metascience.* Three of the societies named in note 8 had a joint annual meeting for the first time in 1994. (As of 1998, the SLS remains an outsider.) This is not to say that their objectives and methods are not still distant from one another; see Michael Ruse, "Do the History of Science and the Philosophy of Science Have Anything to Say to Each Other?" *PSA* 2 (1992): 467ff; and Steve Fuller, *Philosophy, Rhetoric, and the End of Knowledge: The Coming of Science and Technology Studies* (Madison: University of Wisconsin Press, 1993), reviewed by Michael Lynch in *Contemporary Sociology* 23, no. 2 (1994): 312–14.

10. French and Anglo-American researchers draw two different genealogies for this interest. In France, François Dagognet has written widely on the theory of images in science, and in the United States, Martin Rudwick has written on the importance of images in the history of geology and paleontology. The two are very different: Dagognet's work is the more abstract and is concerned with the nature of the image as such; Rudwick concentrates mostly on the detailed workings of scientific discovery. The difference has impelled Anglo-American scholars to emphasize the relevance of images to the history of science. See Rudwick, "The Emergence of a Visual Language for Geological Science, 1760–1840," *History of Science* 14 (1976): 149–95; Dagognet, *Tableau et langages de la chimie*

(Paris: Seuil, 1969); Dagognet, *Pour une théorie générale des formes* (Paris: J. Vrin, 1975); and Dagognet, *Philosophie de l'image* (Paris: J. Vrin, 1986). For the bifurcated genealogy (but not the conclusion I draw from it), see Alberto Cambrosio, Daniel Jacobi, and Peter Keating, "Ehrlich's 'Beautiful Pictures' and the Controversial Beginnings of Immunological Imagery," *Isis* 84 (1993): 662n1.

11. Among studies of scientific images that partake of fine-art conventions, see Martin Rudwick, *Scenes from Deep Time: Early Pictorial Representations of the Prehistoric World* (Chicago: University of Chicago Press, 1992), and also his review of A. Bowdoin Van Riper's *Men among the Mammoths: Victorian Science and the Discovery of Human Prehistory,* in *Nature* 366, no. 6453 (25 November 1993): 388. For related material, see Sylvia Massey Czerkas and Donald F. Glut, *Dinosaurs, Mammoths, and Cavemen: The Art of Charles R. Knight* (New York: Dutton, 1982); W. J. T. Mitchell, *The Last Dinosaur Book: On the Totem of Modern Culture* (Chicago: University of Chicago Press, 1998); and Susan Leigh Star and James Griesemer, "Institutional Ecology, 'Translations,' and Boundary Objects: Amateurs and Professionals in Berkeley's Museum of Vertebrate Zoology, 1907–39," *Social Studies of Science* 13 (1989): 205–28. The historian of science Gregg Mitman ("Hollywood Technology, Popular Culture, and the American Museum of Natural History," *Isis* 84 [1993]: 637–61) has studied the influence of Hollywood filmmaking on discovery in natural science; the images include footage of Komodo dragons and natural-science dioramas.

12. For a study of "maps" of disciplines, see Peter Taylor, "Mapping Ecologists' Ecologies of Knowledge," *PSA 1990,* 95–109.

13. Bruno Latour, Philippe Mauguin, and Geneviève Teil, "A Note on Socio-Technical Graphs," *Social Studies of Science* 22 (1992): 33–57. The graphs map distances between the world (or the "artefact," or the "evidence") and the scientific theory by arranging connections according to successive "abstractions," "modalizations," "translations," and syntagmatic and paradigmatic alterations. They can be interpreted by the *historical* study of schemata, which can elucidate the epistemological constraints that are imposed by their formal structures. The influential article on geological images by Rudwick ("Emergence of a Visual Language," 178) sums up its findings in a "highly diagrammatic representation" of the "visual language" of geology. For conceptual diagrams in social theory, see Michael Lynch, "Pictures of Nothing? Visual Construals in Social Theory," *Sociological Theory* 91, no. 1 (1991): 1–22.

yet been collected into a synthetic account, but it is already possible to discern two basic directions in the research: Some scholars are interested in scientists' images for what they have to say about the process of scientific discovery,[14] and others are intrigued by the way in which images can serve as "nonpropositional" substitutes for rational argument.[15] These orientations raise two complementary questions: The first asks how the history of images should be told, and the second is concerned with the philosophic and cognitive nature of the images themselves. In this context the historical research is more important, and so far it has shown remarkable variety.[16] A number of topics relate to the three kinds of art-historical research that I outlined in Chapter 1: Studies of scientific objectivity, for example, could be brought to bear on narratives about the rise of photography.[17] But I want to veer away from those possibilities, as they lead back toward the kind of art history in which nonart images are used to explain painting. Instead I want to cast some of the issues at stake in image studies as fundamental challenges to the methodological and theoretical customs of art history. Five subjects in particular show how the two disciplines might illuminate each other.

SKETCH, STUDY, AND FINISHED WORK, OUTSIDE OF ART

In the fine arts, if a drawing is associated with a painting, the two are likely to be similar. If we look at Charles de Tolnay's classic examples, Filippino Lippi's sketch for the *Resurrection of Drusiana* "is like a dream image, lacking consistency and structure," but it is also clearly a way of getting ready for the details of the final composition, whereas Ghirlandaio's drawing for the *Visitation* already adumbrates the fresco's structure: It is an "*a priori* rationalistic conception . . . the work of a rationalistic mind."[18] De Tolnay's analysis is heuristic, and he does not make it the basis for a wider theory of Italian drawing; but it goes to show the permissible differences between drawings and paintings. Some drawings can be rational scaffolds for paintings, and others might be nothing more than intuitive glimpses, but they must share objects, formal elements, or principles of organization with their associated paintings — the very idea of association depends on such affinities.

In scientific images the differences between sketches and completed illustrations can be much greater, and a single picture might be associated with many kinds of images. Plate 3.1 is an autoradiograph, recording the seepage of chemicals through a viscous jelly. It was made by spreading an "electrophoresis gel" between two glass plates and letting radioactive chemical samples diffuse along channels in the glass. The image is a print from an X-ray film placed on top of the glass. Autoradiographs are common images on television, as they are used in DNA identification in criminal trials. Their salient features are the positions and densities of the horizontal dark bands, together with the relation between bands in different columns (called "lanes").

This particular plate is the subject of a study by the historians of science Karin Knorr-Cetina and

14. An influential text in this vein is Bruno Latour and Steven Woolgar, *Laboratory Life: The Construction of Scientific Facts*, 2d ed. (Princeton, N.J.: Princeton University Press, 1986), although the authors' description (45ff) of measurements as "literary inscriptions" also privileges writing over images. As Karin D. Knorr-Cetina points out in *The Manufacture of Knowledge: An Essay in the Constructivist and Contextual Nature of Science* (New York: Pergamon, 1981), 14n49, there are also studies of architecture's influence on science; for instance, Randy Swanson, "Art and Science in Transition: Four Laboratory Designs of Louis I. Kahn Considered as Mediative Representation," Ph.D. diss., University of Pennsylvania, 1993.

15. See Johnson-Laird's work. The questions asked in this kind of inquiry depend on what is meant by the claim that pictures are "nonpropositional." According to Eugene Ferguson, "The Mind's Eye: Nonverbal Thought in Technology," *Science* 197 (26 August 1977): 827–36, esp. 835, pictures enhance "nonverbal reasoning ability," putting them somewhere between propositional and nonpropositional forms. These questions are distinct from studies that treat pictures as propositions — for example, Mark Roskill and David Carrier, *Truth and Falsehood in Visual Images* (Amherst: University of Massachusetts Press, 1983).

16. For an interesting study of the ways in which scientific illustrations can be conceived as "'model organisms' for the study of conceptual evolution," see James Griesemer and William Wimsatt, "Picturing Weismannism: A Case Study of Conceptual Evolution," in *What the Philosophy of Biology Is: Essays Dedicated to David Hull*, ed. Michael Ruse (Dordrecht: Kluwer, 1989), 75–137, esp. 129.

17. See Lorraine Daston and Peter Galison, "The Image of Objectivity," *Representations* 40 (1992): 81–128.

18. De Tolnay, *Handbook of Old Master Drawings* (Princeton, N.J.: Princeton University Press, 1943), 19, 20.

PLATE 3.1 *Autoradiograph.*

Klaus Amann, who are interested in how biologists discuss and interpret images, and in how images like this one, which is full of experimental flaws and irrelevant bands, are altered to produce plates fit for publication — plates that represent the truth.[19] In this case the scientists were unhappy with the results, and they discussed rephotographing the gel, editing the image by cutting and pasting portions of it to make a cleaner version, and repeating the experiment from scratch. There are potential parallels here with other strategies for image-making — for example, the astronomical images studied by Lynch and Edgerton — although the issues are more complex because the image cannot just be "cleaned" as if it were a print that had become stained. Instead, it needs to be compositionally adjusted to erase and alter marks that are integral to the objects under study — that is, the bands and lanes themselves. A comparative account of the strategies for producing acceptable images might reveal the ways that nonart images are partly the products of certain theories about images and about the world (astronomers, for example, run "image-sharpening" procedures, like those available on commercial software, to enhance their images). As in the fine arts, images are built to represent the world in certain ways.

I want to point out, however, a different characteristic of the autoradiograph, one that sets it apart from the ways in which images are connected to one another either in astronomy or in the history of art. Knorr-Cetina and Amann document no less than five different kinds of images that were either invoked or produced by the scientists in the course of attempting to correct the autoradiograph. The scientists recalled other autoradiographs as an artist might think of other paintings, but they also thought of the very different physical reality they were trying to represent. The object of the image is not to depict bands but to understand the transcription of RNA, and so the scientists were also thinking of molecular models and of laboratory apparatus that does not look anything like their autoradiograph. Knorr-Cetina and Amann reproduce several such drawings, done on the spur of the moment to help explain questions raised by the autoradiograph (Plate 3.2). The sketches depict a schematic "shorthand" version of RNA transcription within a gene labeled "CAT" (at the

PLATE 3.2 *Genetic "design" language on scraps of paper.*

top right), and they were intended to clarify hypotheses about the linking of genes that could account for anomalous bands on the autoradiograph. Nothing in the drawing resembles the autoradiograph in form or scale. Art history rarely has to deal with connections between images this different from one another, and it makes the act of interpretation — and the imbrication of *visual* meanings — especially difficult. Knorr-Cetina and Amann call the different acts of interpretation "image dissection" and "image arithmetic," and although their study is only a preliminary one, it is certainly true that new terms would have to be coined to explain how such images are connected.

REALISM AND CONVENTION,
OUTSIDE OF ART

Nonart images can also contain unexpected combinations of what Nelson Goodman calls the "routes of reference."[20] A typical image in the fine arts will have a predominant referential mode —

19. Knorr-Cetina and Amann, "Image Dissection in Natural Scientific Inquiry," *Science, Technology, and Human Values* 15, no. 3 (1990): 259–83; and compare Amann and Knorr-Cetina, "The Fixation of (Visual) Evidence," in *Representation in Scientific Practice*, ed. Michael Lynch and Steven Woolgar (Cambridge, Mass.: MIT Press, 1990), 85–122.

20. Nelson Goodman, "Routes of Reference," in *Of Mind and Other Matters* (Cambridge, Mass.: Harvard University Press, 1984), 55–70.

it will participate in the terms of realism, naturalism, expressionism, and so forth. Western images are rarely pure examples of any one mode, and it could be argued that the interest of a particular painting — by Caravaggio, for example, or Courbet — largely depends on the ways it negotiates several partly incompatible relations to whatever is construed as reality.[21] Informational imagery shares those impurities, but it can also blend more widely disparate modes. The sonar chart excerpted in Plate 3.3 shows water depths from 20 to 130 feet, and has inverted V-shaped marks indicating fish. Even though the marks are partly iconic — they record the relative sizes of the fish and their depths in the water — they are also partly symbolic, as they record the *motions* of the fish relative to the boat that is passing over them. A fish moving with the boat will make a more concentrated mark, and one that is diving, surfacing, or moving in some other direction will produce various tails on the V's. The image as a whole resembles a naturalistic landscape: It looks like a hill against a bright evening sky, and it is not difficult to reimagine it as an underwater vista. At the same time, it has no fictive space, because the sonar only records what is directly under the boat: The V marks and the contour of the bottom of the lake are produced by a series of vertical sections through the water, so that the shapes recorded in the image are more like silhouettes than glimpses of objects at different distances. Because the boat might move along an irregular route, the "scene" is not even a conventional cross-section but a serpentine path flattened onto the plane of the recording paper. The sonar chart is a composite of very different routes of reference: It is an x-y graph, a naturalistic scene, and a collection of symbols for the motion of fish. It needs to be read, seen, and deciphered, and a viewer must switch between modes of interpretation in order to comprehend it. In Goodman's terms, it makes use of notation, pictorial denotation, and verbal (or numerical) denotation. For Goodman, those are "routes of reference" because they are different kinds of denotation. (He opposes the phrase "routes of reference" to "roots of reference"; the latter pertains to the things signs signify.) Mixed routes of reference also occur on ancient artifacts, and on contemporary images such as computer screens (which are partly naturalistic pictures and partly notations). The fact that simultaneous routes of reference are so common among nonart images suggests that the normal state of affairs might be more referentially disordered than it appears in painting and drawing; or to put it another way, the very subtle distinctions between concepts of realism, naturalism, and kinds of antinaturalism that art history has elaborated might be the purified remnants of more heterogeneous origins. In this instance, art history could help elaborate the working concepts such as picture, decoration, landscape, and naturalism, and the history of science could elucidate how the routes of reference are combined.

RECEPTION HISTORY, OUTSIDE OF ART

Nonart images can be marked by unusually complex relations to one another (as in the autoradiograph and its associated drawings) or to their referents (as in the sonar chart). They can also have unexpectedly intricate histories of reception. Art-historical images change meaning continuously, in accord with shifting contingencies of critical reception and historical circumstance. Nonart images are even less stable, because they depend less on resemblance and more on specialized interpretive skills that are easily lost over time. As a result, one of the problems in the history of science is that images are reinterpreted and used to make very different points, often within a single generation. Although historians of science have tended to view this occurrence as a property of images in general, art historians might be more apt to say that new interpretations follow conventional responses to different kinds of pictures. The historian of science

21. In this regard, the early Baroque negotiations of varieties of naturalism and nonnaturalism are exemplary. See, for example, the discussion of *vero* and *verosimile* in Charles Dempsey, "Mythic Inventions in Counter-Reformation Painting," in *Rome in the Renaissance: The City and the Myth; Papers of the Thirteenth Annual Conference of the Center for Medieval and Early Renaissance Studies*, ed. P. A. Ramsey, Medieval and Renaissance Texts and Studies, vol. 18 (Binghamton, N.Y.: Medieval and Renaissance Texts and Studies, 1982), 55–77. Collages by Hannah Höch, Kurt Schwitters, or Robert Rauschenberg combine various perspectives (normally photographs) with flat-field painting, but in the terms I am exploring here they are more compendia of potentially compatible instances of realism (usually photographic realism) than combinations of inherently incommensurate kinds of representation.

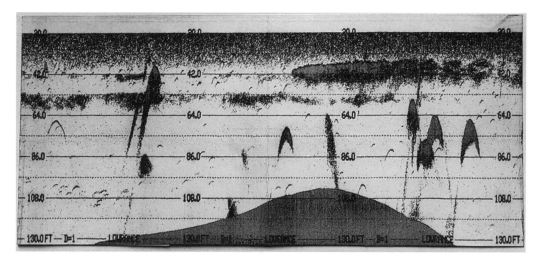

PLATE 3.3 *Portion of a sonar chart of Cayuga Lake, near King Ferry, N.Y.*

David Kaiser has studied interpretive change in relation to the Feynman diagrams used in particle physics (Plate 3.4).[22] When they were first introduced by Richard Feynman, the diagrams were graphs of the possible interactions of particles (for example, an electron and a positron decaying into two photons). Later they became more conventional graphs that were understood as if they plotted position in relation to time, and finally they were taken to be representational pictures, as if they showed actual objects in two-dimensional space. Kaiser calls such mutating meanings "dynamical appropriations." Several of them can be understood as attempts to use the diagrams of subatomic particles as naturalistic pictures, as if they were analogous to photographs. Even contemporary physics textbooks repeatedly warn that the angles of the lines, the lengths of the dashed "interaction lines," and the positions of the "vertices" are unimportant, and that virtually all the formal properties of the diagrams are "aesthetic."

Because the only thing that matters in a Feynman diagram is the number, direction, and kind of lines converging at a vertex, the diagram is not a naturalistic representation or a normative *x-y* graph: It is a new kind of image that is neither a picture of the world nor a conventional graph. For that reason the diagrams are strongly dependent on their surrounding text, and largely opaque without it. Nonart images are often weak in this sense, but their frailty as independent pictures is offset by their powerful rearrangements of viewers' pictorial expectations. Art history can contrib-

ute to these studies by explaining the specific expectations viewers bring with them (and therefore the reasons for the successive "dynamical appropriations"), and the history of science can demonstrate how those expectations can be held in check by sufficiently powerful new ways of lodging meaning in images.

In another case, the population geneticist Sewall Wright introduced landscapelike diagrams into the study of population growth, intending to help visualize the way in which a group of organisms might change (Plate 3.5). The viewer is supposed to think of topographic maps, but here the altitude lines are "fitness contours," leading to "fitness peaks," and the "landscape" is a "hypothetical multidimensional field of gene combinations . . . represented by two dimensions."[23] In other words, the genetic content of the populations — shown inside the heavy dotted lines — alters under the pressure of mutation, or environmental change, or random shifting (lower left and center), or adaptive change (lower right). The elegance

22. David Kaiser, "'Visual Languages,' Construction, and Science Studies: Dynamical Interpretations of Feynman Diagrams, 1948–1958," and "Dutifully Doodling: Pedagogy, Practice, and the Persistent Use of Feynman Diagrams," unpublished manuscripts, 1994 and 1997. Feynman diagrams have also been adapted for string theory; see *Superstring Theory*, ed. Michael Green, John Schwarz, and Edward Witten (Cambridge: Cambridge University Press, 1987).

23. Wright, *Evolution and the Genetics of Populations*, vol. 3, *Experimental Results and Evolutionary Deductions* (Chicago: University of Chicago Press, 1977), 446, 452.

PLATE 3.4 *Second-order Feynman diagrams in perturbation theory.*

and intuitive quality of these images comes directly from their analogic appeal to topographic maps, and even to the thought of walking through the genetic "landscape." The historian Michael Ruse has shown that Wright's images were used by other scientists in new ways: A paleontologist, for example, appropriated the landscape metaphor but used it to map morphological differences instead of genetic ones.[24] Again, it is the specific appeal to pictorial conventions that ensured both that the images would be influential and that their influence would be partly unpredictable. Nothing in Wright's mathematical modeling predicts the zigzag path in the "map" at the lower left, or the smoother meanderings in the next image. But they correspond to imaginary walks, and that is enough to set in motion the pictorial meanings that are familiar in the history of art. Feynman's diagrams and Wright's maps changed meaning because people were drawn, inevitably, to use them as if they were more than superficially related to the common kinds of pictures they both resemble.

FORM AND CONTENT,

OUTSIDE OF ART

So far I have been sketching properties of non-art images that have to do with their relation to one another, their ways of denoting the world, and their reception by successive interpretive communities. Nonart images are also interesting — and extreme — examples of the relation between pictorial and linguistic marking. Word–image relations that occur in fine art tend to take the form of incursions of language into the realm of the pictorial — for example, in cubist collages that include words. Images outside art reverse that relation because they are normally taken as propositions that might include nonessential pictorial elements. When scientific images begin to work as art does — that is, by giving up secure meaning in favor of a halo of pictorial possibilities — then their place in science becomes problematic. Even though their popularity as teaching tools, and even as guides for research, might increase (such is the power of a well-constructed image), their utility might become unpredictable. Wright's diagrams can mean anything that a topographic map might mean, and with different scientific concepts in play, the topographic allegories are potentially unlimited. A recently studied case concerns the German immunologist Paul Ehrlich, who in 1900 produced a series of eight drawings of the operation of antibodies (Plate 3.6). At the top left, black toxins approach a cell, uniting with "side chains" on the cell that are normally used to enable the cell to ingest nutrients. In response, the cell produces more side chains, which detach and float into the bloodstream (upper right). There the toxins bond to them, floating away harmlessly and letting the cell receive its fill of nutrients. Ehrlich's pictorial sequence accounted for the body's ability to cope with toxins, and successfully visualized the notion of an antitoxin. It was widely influential, giving rise to the Y-shaped diagrams that biology textbooks continue to use to help students imagine how antibodies operate. (The diagrams are still in use because Ehrlich guessed, by a stroke of luck, the approximate shape of the "side chains" and toxins.)[25] The remarkable thing about this sequence is that, at the time, Ehrlich had no knowledge at all of the forms of these objects, or even of the existence of side chains. The pictures *became*

24. Michael Ruse, "Are Pictures Really Necessary? The Case of Sewall Wright's 'Adaptive Landscapes,'" *PSA 1990*, 63–77, esp. 70.

25. I thank Roald Hoffmann for this information.

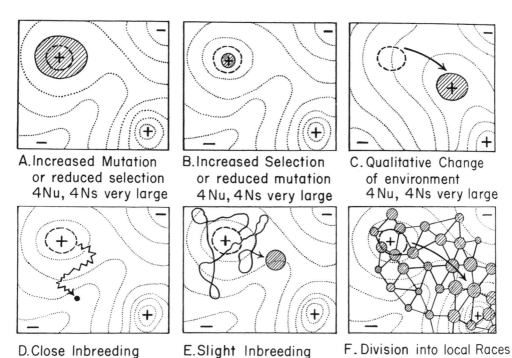

A. Increased Mutation
or reduced selection
4Nu, 4Ns very large

B. Increased Selection
or reduced mutation
4Nu, 4Ns very large

C. Qualitative Change
of environment
4Nu, 4Ns very large

D. Close Inbreeding
4Nu, 4Ns very small

E. Slight Inbreeding
4Nu, 4Ns medium

F. Division into local Races
4nm medium

PLATE 3.5 *Sewell Wright. Hypothetical multidimensional field of gene combinations.*

the theory and spurred the research that eventually grew into modern immunology. Initially, there was resistance not only to the specific theory but to the very idea of positing shaped entities instead of "forces" or abstract "experimental facts."[26] Even Ehrlich cautioned that his images "must be regarded quite apart from all morphological considerations"—that is, they should be seen as "a pictorial method," a "diagram" of abstract dynamic ideas.[27] But as the authors of the modern study point out, the diagrams initiated and partly guided the subsequent experimental practice, and they remain indispensable to the ways in which immunology is understood.

James Griesemer, Ruse, and others have argued that pictures in science can work both propositionally and nonpropositionally: Sometimes they illustrate or propose theories; other times they merely *exist,* taking a certain place in the chain of written discourse and modifying it in ways that are difficult to describe.[28] In the case of Wright's genetic "landscapes," Ruse has asked if the theory could have developed as it did without the pictures. Were they "really part of the thought"—that is, were they propositional elements of the theory—or

were they ancillary to Wright's argument? Ruse finds that even though they were initially mostly metaphorical, they *became* the theory for those geneticists who could not follow Wright's advanced mathematics.[29] In art history, I think both possibilities are better developed than in the history of science: "Propositional" influence takes the form of narrative or iconographic influence from one painting to the next, and "nonpropositional" influence is described in terms of styles or techniques. Because the two forms of influence occur together in paintings, they are not usually analytically separable—which lends a certain richness to art-historical accounts. In Ehrlich's diagrams, the shape of the front of the toxins (the portion that

26. See Cambrosio, Jacobi, and Keating, "Ehrlich's 'Beautiful Pictures,'" 666, 667.

27. Cambrosio, Jacobi, and Keating, quoting Ehrlich, "On Immunity with Special Reference to Cell Life," *Proceedings of the Royal Society of London* 66 (1900): 437.

28. James Griesemer, "Material Models in Biology," *PSA 1990,* 79–83, proposes three case studies of biological images that also function both propositionally and nonpropositionally.

29. Ruse, "Are Pictures Really Necessary?," 72.

PLATE 3.6 *Diagrams used by Paul Ehrlich in his 1900 Coonian lecture.*

fits onto the cell's side chains) is propositional, as it implies a specific kind of physical coupling, and the shape of the back of the toxins is nonpropositional, because it suggests motion or perhaps just toxicity. The toxins are therefore representationally hybrid — half propositional theories and half nonpropositional theories. That very conjunction might have ensured their influence: that is, it could have been the mixture of picture and proposition that gave later immunologists room to maneuver. Informational images that do not achieve that balance might not be fruitful for later workers, and, conversely, images that are more thoroughly nonpropositional might be too vague to have a hold on succeeding generations. The dichotomy rarely occurs in such a stark form in art history, and it might be that the study of informational images could benefit from art history's awareness of the multivalent relation between propositional and nonpropositional meanings,[30] just as art historians might see new possibilities in the strict sense of "proposition" at work in these examples.

THE LIMITS OF REPRESENTATION, OUTSIDE OF ART

Finally, images of all sorts grapple with the problem of what is representable. Historians and philosophers of science have studied how scientific visualization depends on simplifying, abstracting, labeling, marking, and schematizing the chaotic phenomena of nature into orderly graphic forms.[31] The idea that science operates by making successive abstractions from natural disorder has many points of contact with theories of representation in the arts.[32] Bruno Latour, Françoise Bastide, Michael Lynch, and others have written about the "cascade" of successive abstractions that propel scientific images away from the chaos of phenomena and into an interminable sequence of quantified "traces" — samples, field notes, sketches, graphs, archives. The same questions of abstrac-

30. Louis Marin's are among the most developed of many theories of linguistic structures in artworks. See, for example, Marin, "The Order of Words and the Order of Things in Painting," *Visible Language* 23 (1990): 188–203.

31. See Bruno Latour, "The Pedo-fil of the Boa Vista: Visualization, Reference, and Field-Work in the Amazon," paper given at the 1994 History of Science Society conference; and Michael Lynch, "Discipline and the Material Form of Images: An Analysis of Scientific Visibility," *Social Studies of Science* 15 (1985): 37–66.

32. Above all, parallels and contrasts could be drawn between Latour's work and E. H. Gombrich's theories of making and matching. See, for instance, Gombrich, *Art and Illusion: A Study in the Psychology of Pictorial Representation* (London: Phaidon, 1960); and his "The Heritage of Apelles," in *The Heritage of Apelles: Studies in the Art of the Renaissance* (Ithaca, N.Y.: Cornell University Press, 1976), 3–18.

tion arise in the arts, although it could be argued that the history of science tends to gloss over concrete differences in favor of an open-ended "cascade" of "traces" instead of attending to the exact moments of change that transform one level of detail, or one visible structure, to the next.[33] As interesting as these parallels are, however, they pertain to a domesticated sense of the unrepresentable, in which pictures need only to simplify an existing confusion or complexity. In more radical terms, what is unrepresentable can *never* be adequately put in an image because it is nonpictorial, unimaginable, forbidden, or transcendental.[34] This other sense of the unrepresentable is a crucial subject in modernism and abstraction, and it is especially bound up with questions of subjectivity and with the relation between medieval images and the sacred.[35] Scientific images share this sense, but the terms of their involvement are different because they are routinely called on to represent objects that have never had conventional visual equivalents. In the case of mathematical objects such as quantum wave packets or the Feigenbaum tree of population growth, the object is beyond full visualization not only because it is infinitely complex — most objects of fine art and science are complex beyond what the medium can render — but also for the irreducible reason that it is mathematical and not pictorial.[36] The question of the "reality" of mathematics (especially geometry), as well as its susceptibility to pictorial representation, has been a central issue from the seventeenth-century practice of finding graphical solutions to equations through contemporary debates about the inflationary universe.[37] The mathematical history of unrepresentability might well complement the art-historical account, as both entail signs and surrogates for absent forms and other visual metaphors.

The problem of the unrepresentable also surfaces when the objects to be depicted do not exist in three-dimensional space.[38] The philosopher and historian of biology William Wimsatt observes that it is common in scientific visualization to have to depend on more than one pictorial strategy, because the information is both figuratively and literally multidimensional.[39] In the lecture "What Do Viruses Look Like?" the biologist Stephen Harrison uses more than ten different ways of picturing viruses in order to help describe their struc-

ture.[40] Taken individually, each one explains only a few properties of a virus, but they cannot be fused into a single image. A sample shows how the images complement one another without combining in any simple fashion. Two early images

33. For the "cascade" and the "trace," see Bruno Latour, "Drawing Things Together," in *Representation in Scientific Practice*, 19–68, esp. 40. Michael Lynch ("The Externalized Retina: Selection and Mathematization in the Visual Documentation of Objects in the Life Sciences," in *Representation in Scientific Practice* 153–86, esp. 160–64) is a closer analysis.

34. This is the subject of the final chapter of Elkins (1998).

35. Rosalind Krauss, *The Optical Unconscious* (Cambridge, Mass.: MIT Press, 1993), is an analytic account of the relation between modernism and the failure of "opticality"; Whitney Davis, *Drawing the Dream of the Wolves: Homosexuality, Interpretation, and Freud's "Wolf Man"* (Bloomington: Indiana University Press, 1995), contains an analysis of the relation between unrepresentable scenes and actual pictures whose formations and interpretations depend on fine-art and scientific illustration. For medieval art, see Hans Belting, *Likeness and Presence: A History of the Image before the Era of Art*, trans. Edmund Jephcott (Chicago: University of Chicago Press, 1994); Georges Didi-Huberman, *Devant l'image: Question posée aux fins d'une histoire de l'art* (Paris: Éditions de Minuit, 1990); and Didi-Huberman, *Fra Angelico, Dissemblance and Figuration*, trans. Jane Marie Todd (Chicago: University of Chicago Press, 1995 [1990]).

36. The Feigenbaum tree is studied from this standpoint in Griesemer and Wimsatt, "Picturing Weismannism," 126–31.

37. In certain interpretations of cosmology, geometric relations are what are "real" and preexist the universe. For a sampling of discussions, see Michael Resnick, "Between Mathematics and Physics," *PSA 1990*, 369–78; William Lane Craig and Quentin Smith, *Theism, Atheism, and Big Bang Cosmology* (London: Oxford University Press, 1993); and Michael Friedman, *Foundations of Space-Time Theories* (Princeton, N.J.: Princeton University Press, 1983). Partly analogous questions are raised about chemical representations in Roald Hoffmann and Pierre Laslo, "La Représentation en chimie," *Diogène* 147 (1989): 24–54. The seventeenth-century custom of "constructing equations" is the subject of an excellent, and unique, essay by the historian Henk Bos: *Lectures on the History of Mathematics* (Providence: American Mathematical Society, 1993), chap. 2, "The Concept of Construction and the Representation of Curves in Seventeenth-Century Mathematics."

38. I mean this in the mathematical sense of objects that are described by more than three sets of parameters. Such objects might or might not correspond to actual three-dimensional objects.

39. William Wimsatt, "Taming the Dimensions — Visualizations in Science," *PSA 1990*, 111–35.

40. Stephen Harrison, "What Do Viruses Look Like?" *Harvey Lectures* 85 (1991): 127–52, esp. 128.

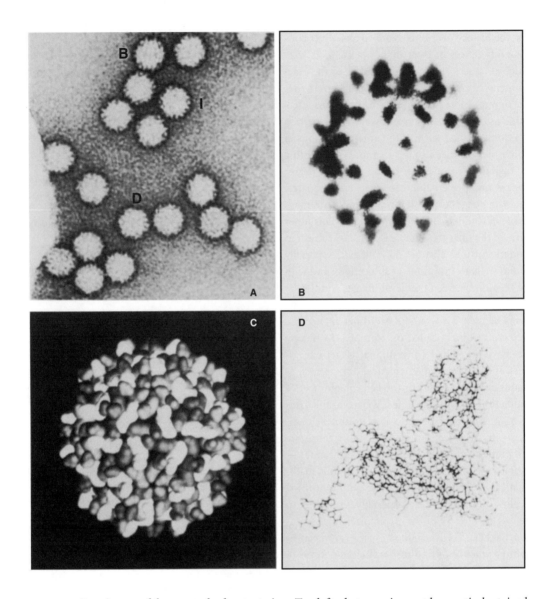

PLATE 3.7 *Four images of the tomato bushy stunt virus.* Top left: *electron micrograph, negatively stained with uranyl acetate.* Top right: *three-dimensional image reconstruction, based on the top-left image.* Bottom left: *surface view, based on crystallographic determination.* Bottom right: *complete atomic model of one subunit.*

(Plate 3.7, *top*) show what the "tomato bushy stunt virus (TBSV) 'looked like' twenty years ago," in a negatively stained electron micrograph (top left) and in a three-dimensional image reconstruction (top right). Since then X-ray crystallography has improved scientists' abilities to deduce molecular structure, and the TBSV virus now also "looks like" a surface view of clusters of molecules (Plate 3.7, *bottom left*). Each of the 180 bumps on the surface view is a "subunit" comprised of a chemi-

cal chain, folded into a certain shape (Plate 3.7, *bottom right*). The shape has the blurry outlines of two lumps or "domains," with an "arm" hanging down to the left — a structure that is sometimes schematized as three organic forms (Plate 3.8, *top*). Virologists also unravel the subunits into single polypeptide chains (Plate 3.8, *middle*), but to explain how the subunits build themselves into a spherical virus, it is better to redraw them as hard-edged geometric forms (Plate 3.8, *bottom*). "Rib-

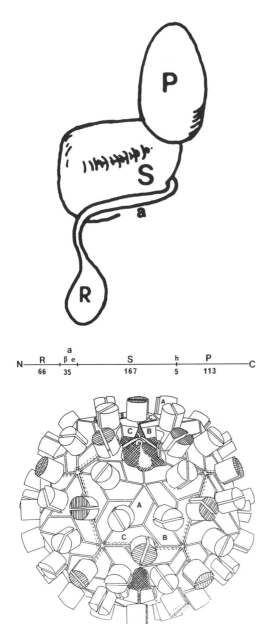

chain can be followed through the entire diagram, beginning at the lower left, and the image also shows how the next subunit, marked "A" at the lower right, twines inside this one.

Even in this brief sample there is an astonishing variety of pictorial means — from photographs to computer graphics to hand-drawn pictures, from geometric abstractions to organic approximations, from scales to perspectival views to projections, from shaded pictures to wire-frame schemata. Some recent work presents an even broader palette of images and a wider set of "routes of reference": electron density maps, ribbon "cartoons," stereo views, "worm diagrams," solid models of van der Waals surfaces, and electrostatic potential maps that look like mottled, half-deflated balloons. The images are routinely given false colors and animated, and the difference between watching a glowing high-resolution screen of tremendous complexity and looking at a reduced printout in a journal or a book is at least as large as the difference between looking at a painting and looking at a reproduction. Publication is an especially unfortunate occurrence for such work, as it flattens both the denotational and the formal differences between images. (I have watched specialists rotating three-dimensional, multicolored electron density maps on computer screens. To a person unfamiliar with the molecules, the effect is bewildering and kaleidoscopic. But scientists "get to know" individual molecules, and they can orient themselves in the most ferociously complex moving graphics. That skill belies art historians' sense that paintings are the most intricate and "dense" visual artifacts.)[42]

It is not surprising that certain chemists have

PLATE 3.8 *Three images of the tomato bushy stunt virus.* Top: *diagram showing the folded subunit.* Middle: *modular organization of the polypeptide chain, showing numbers of amino acid residues in each segment.* Bottom: *the packing of subunits in the virus particle.*

bon diagrams" are also widely used in contemporary microbiology (Plate 3.9); this one depicts the structure of one of the "domains" in a subunit. Ribbon diagrams might look like freehand scribbles, but they are tightly constrained by the shapes of the chemical chains.[41] Here the continuous molecular

41. There's an interesting play between constraint and freedom, as the diagrams are "analog" rather than "digital" in Goodman's sense: that is, their shapes are accurately determined, but the determinations are invisible, and smoothed into continuous curves. Ribbon diagrams are like the Bézier curves in computer graphics, in that their "handles" and data points can be located, with practice, even though they remain invisible on the screen or printout.

42. For examples, see Christopher Lima, James Wang, and Alfonso Mondragón, "Three-Dimensional Structure of the 67K N-Terminal Fragment of *E. coli* DNA Topoisomerase I," *Nature* 367 (13 January 1994): 138–46 and cover. I thank Alfonso Mondragón and Jonathan Widom for a tour of imaging facilities in the Biology Department at Northwestern Univer-

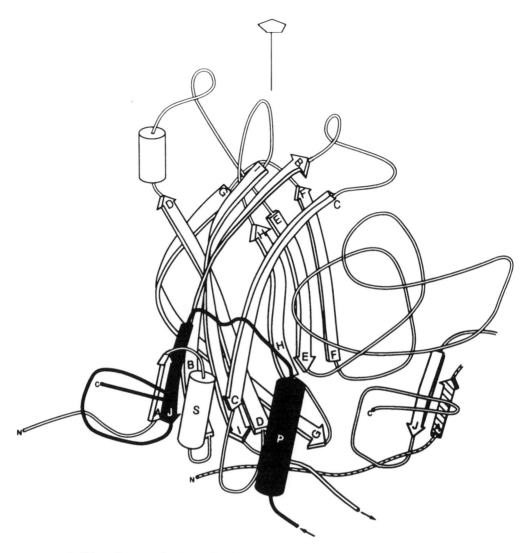

PLATE 3.9 *A ribbon diagram of a virus subunit.*

become interested in the aesthetic values of their visualizations.[43] But the deeper connections have to do with the ways in which pictures are used to try to see what can never be seen. As in the history of art, images of unrepresentable objects put a strain on the pictorial conventions they inherit, finally breaking them and becoming different kinds of pictures. Several of the images Harrison reproduces are already near the point of unintelligibility: The wire-frame picture is an incomprehensible tangle, and the final schema could not be much more detailed without becoming illegible. The question of the unrepresentable is not yet part of either the history of science or the history of art, and it offers an exemplary opportunity for collaboration.

POSSIBLE RELATIONS BETWEEN ART HISTORY AND "INEXPRESSIVE" IMAGES

These case studies point to interpretive issues that are shared by art history and the study of "inexpressive" images. In each, art history comes out the poor cousin of scientific image studies, in which the examples are at once more radical and more complex. At the same time, the interpretive strategies needed to elucidate what happens in the

sity, and Robert Beck, Jim Roemer, and Suma Jacob for information on medical imaging at the University of Chicago.

43. Roald Hoffmann, "Molecular Beauty," *Journal of Aesthetics and Art Criticism* 48, no. 3 (1990): 191–204.

scientific images are native to art history. Thinking of this reciprocal relation, I wonder if there might not be a way to rethink the hierarchical relations between the disciplines. The major possibilities can be put as a sequence of five progressively more difficult relations; I began this list in the first chapter with the three most common scenarios.

Using Nonart to Explain Art

Most often, when nonart images appear in art history they are used to account for fine-art practices. As important as that approach is for postimpressionism and some aspects of modernism, I have suggested that it is methodologically limited: It does not explain periods when influence was indirect, and it does not account for the more pervasive influences of science and technology on modern art in general. In terms of the confluence of disciplines, the approach also slights nonart images by restricting them to explanatory roles, and it rarely makes contact with real science (as opposed to the popularized accounts that normally reach artists).[44]

Using Art to Explain Nonart

It can also make sense to reverse the relation of art and nonart and use art to explain images that are not art. Some of the diagrams in the previous chapter can be understood in that way: Haüy's plates, for example, can be read more fully when they are seen against the background of neoclassicism. So far, most studies of this kind are confined to the nearest satellites of fine art: In Chapter 1, I named computer graphics and medical illustration as examples, and there are also the histories of bird and animal illustrations and botanical and mineralogical treatises.

Using Art and Nonart to Explain
the History of Seeing

Even where relatively few artistic conventions contribute to the making of nonart images (as in Lynch and Edgerton's study), it might still be possible to find deep affinities between modern "image processing" and older interests and to explain apparently inartistic practices in terms of a wider history of visuality, "scopic regimes," or ways of seeing.[45] This was the third possibility I mentioned in Chapter 1: writing on the history of visuality,

taking examples at will from various disciplines, and using art history as an interpretive anchor. Current interdisciplinary studies of visuality such as Barbara Stafford's and Jonathan Crary's are examples of this kind of synthetic approach.

Writing the History of Nonart as Art

A fourth and more radical possibility is to suspend the notion of dependence or relation altogether and resist asking whether a nonart practice might have influenced an art practice or vice versa. As I argued at the end of the previous chapter, even "inexpressive" images might be recounted as independent histories of art. Entire histories of fields such as astronomy, genetics, and microscopy have yet to be written from that standpoint.[46] Art history is in possession of such a large stock of concepts and examples bearing on artistic production that its explanations could easily complicate discourse on nonart images in general. Thought experiments such as the one on crystallography can also help to turn art-historical interest inward, prompting us to rethink assumptions such as the privileging of fine art, the tendency to use oil painting as a synecdoche for pictures in general, and, perhaps most fundamentally, the ultimately

44. In Elkins (1994) I suggest that in the twentieth century debates about perspective, vision, and art intersect real science in only one place — where they encounter Rudolf Luneburg's analyses of binocular vision. Unlike other theories of vision, Luneburg's are still partly untested, and therefore they do not belong to the history or popularization of science but to ongoing scientific inquiry. Such moments are exceedingly rare in fine art: even Duchamp's games and Seurat's theories were based on popular and out-of-date accounts, sometimes (deliberately or inadvertently) misconstrued.

45. Martin Jay, "Scopic Regimes of Modernity," in *Vision and Visuality,* ed. Hal Foster, Dia foundation Discussions in Contemporary Culture, no. 2 (Seattle: Bay, 1988), 3–28. The notion of the history of visuality lacks a reliable history, as it is always entangled in dubious notions such as Heinrich Wölfflin's history of "das Auge" (which he put in quotation marks). Wölfflin, *Kunstgeschichtliche Grundbegriffe: Das Problem der Stilentwicklung in der neueren Kunst* (Munich: F. Bruckmann, 1915), 18.

46. This is a point I made in a review of Martin Kemp, *The Science of Art,* in *Zeitschrift für Kunstgeschichte* 54, no. 4 (1991): 601. It has been developed most extensively by Michael Serres; see in particular Michel Serres, *Eclaircissements: Cinq entretiens avec Bruno Latour* (Paris: F. Bourin, 1992), trans. Roxanne Lapidos as *Conversations on Science, Culture, and Time* (Ann Arbor: University of Michigan Press, 1995).

indefensible allegiance to a core series of works in the face of the bewildering variety of images.

Writing about Images, without "Art" or "Nonart"

I can imagine one more possibility, and it is the one I want to pursue for the remainder of the book. Instead of preserving the differences between the histories of art, science, and mathematics and studying the "science of art" or the "art of science," we should perhaps acknowledge that in the end many divisions between kinds of images are untenable, and that it is possible to begin writing the history of images rather than that of art. Images are found in the history of art but also in the histories of writing, mathematics, biology, engineering, physics, chemistry, and art history itself — to name only the examples I have given so far. If there is a moral for art history, it is simply that there is a tremendous amount waiting to be seen. The purpose of the next chapter is to tear down the wavering distinctions between "art" and "nonart," "expressive" and "inexpressive," that have been obstructing the way to that wider panorama.

ON THE NOTION OF APPROPRIATE EXPLANATION

Before I turn to that, however, I want to add a few words about the notion of "appropriate explanation" that first surfaced in the descriptions of crystals. So far, although I have introduced images from several fields, I have not explained any of them, except perhaps the sonar chart. (I threatened, at one point, to explain clinographic projection.) Many of the images would require several paragraphs or pages of uninviting technical description. The genetic "maps" should ideally be prefaced by a discussion of population genetics and theories of genetic drift; a full account of Wyckoff's Laue photograph would involve an analysis of the projection and a correlation with the composition of the crystal, and an explanation of the perturbation diagrams would call for several hundred pages of explanation even for an audience familiar with freshman-level physics. People in the arts often view things differently — there the assumption is that images really should be immediately apprehensible, even if it makes sense to go on and enrich or correct our experience with the help of techni-

cal and historical knowledge. That is a root-level assumption, and it survives differing versions of interpretation, history, and art-historical writing. It defines itself partly against the background of nonart images, which appear to stand in need of extensive prefacing before their conventions can yield meaning.

But it is a tricky assumption, strongly dependent on differing groups of viewers. While it is true that scientists, on average, will expect to spend some time being introduced to the conventions of an image, it is not true that art historians always expect a measure of immediate access to images. Historians are content to wade through thirty or forty pages of prose in order to understand an image on the author's terms, and they are arguably more patient in that regard than are scientists, who might expect to spend no more than a minute or two puzzling out the conventions of a particular image. The difference lies in the nature of the prefatory information: In the humanities it is discursive prose, but in the sciences it is quantitative parameters, formulas, and densely coded sets of symbols. Entirely aside from the "difficulty" of such information (which is entirely in the eye of the beholder), it is rigid and prescriptive, and a viewer used to art will find it not only demanding but narrow.

One of the most intriguing examples of the problems attending appropriate explanation is the work of Felice Frankel, artist-in-residence at the Edgerton Center at the Massachusetts Institute of Technology. Frankel is a photographer who assists scientists in need of "visually effective" versions of their work for the cover of journals such as *Nature* and *Science*. In that capacity she rephotographs their material, adding color, creating stronger designs, and improving the visibility of key features (Plate 3.10). In a few cases the art–science boundary grows vanishingly small, and Frankel's interventions have also shown the scientists things they had not noticed in their initial work and sent them back to the laboratory for further research.

This plate is one of the images she chose for a book called *On the Surface of Things,* in which pictures of her work are accompanied by brief, nontechnical captions by the chemist George Whitesides. Reviewing the book, Roald Hoffmann described Whitesides's comments as explaining the pictures "without the impediment (to some)

PLATE 3.10 *Felice Frankel. Peeled polymer film on a silicon substrate.*

and the crutch (to others) of mathematics" — but often the features Whitesides explains do not correlate well with what the photographs show.[47] Speaking about this image (see Plate 3.10), Whitesides says it shows a piece of silicon that was "immersed in a chemical ice storm: a fog of reacting vapors that condensed as a tough glassy film on its surface." The description is evocative, especially because the image is mostly a brilliant cerulean blue. He uses all sorts of inventive metaphors to try to conjure the image's scientific significance. "The film was intended to keep the herds of electrons in the silicon from escaping," he says, "and to protect them from harm."[48] More often Whitesides's explanations diverge sharply from the images, because he focuses on small portions of images that have scientific meaning (a small oily puddle in a larger image of wet pavement) or on features that are not visible in the photographs (the microscopic diffraction gratings in a colorful piece of opal). An appropriate explanation, by these standards, would enable a scientist — a nonspecialist — to get a general sense of the subject matter that prompted each photograph, and perhaps to pursue the meanings further by way of the end notes. The artistic dimensions of the works — the pattern of the peel-

ing silicon, the roughness of the wet pavement, the rainbows in the opal — are left in a separate sphere of aesthetic appreciation. In the back of the book, Frankel gives some very brief notes about camera settings, and Whitesides provides references to the primary sources.

Often there is a kind of ladder of increasingly technical scientific information that might also count as appropriate, especially because these photographs were often the result of ongoing experiments. In an essay in *Technology Review*, Whitesides goes into a little more detail; he says the image is "a record of a failed procedure. The intent was to deposit a thin polymer film on a silicon-chip surface through reactions involving chemicals in surrounding vapor. The film cracked and peeled away as it formed. The image contains, in its shapes and hues, information about the thickness of the film when it broke off, the dimensions of the film when the accumulated internal tensions caused

47. Frankel and Whitesides, *On the Surface of Things: Images of the Extraordinary in Science* (San Francisco: Chronicle Books, 1997); Hoffmann, review of *On the Surface of Things*, *Nature* 389 (25 September 1997): 348.

48. Frankel and Whitesides, *On the Surface of Things*, 105.

failure, and the temporal sequence of the catastrophe."[49] Clearly, much is missing here. We aren't told what reactions were involved, or what chemicals. If the image contains "information," how exact is it? How thick was the film when it peeled? What was the "temporal sequence of the catastrophe"? *On the Surface of Things* and *Technology Review* provide glimpses into the scientific content, and both imply that aesthetic content needs no interpretation. For more detailed accounts we have to look elsewhere.

The chemist Daniel Ehrlich learned from this attempt and from Frankel's photograph and went on to publish an account of the successful deposition of the silicon film. His method involved setting down a "multilayer of adsorbed water" on a silicon dioxide base. After rapidly evacuating excess water, he introduced silicon tetrachloride to react with the water layer. The result was a thin layer of SiO_2, deposited on the substrate, and a byproduct of hydrochloric acid vapor. Peeled films like the one Frankel photographed happen, he says, because "a film that has too much water left in it will crack up when the water is pulled out."[50] If Ehrlich were to write a commentary on Frankel's photograph, it might well involve more quantitative precision: the exact amount of adsorbed water, the thickness of the film, and the means of regulating the water layer.

In terms of the issues at stake in this book, an appropriate explanation of Frankel's image would be different once again. I am interested in the fact that Frankel's photographs would not have been possible without abstract expressionism, and especially Jackson Pollock's paintings: They provide the indispensable historical background that impels Frankel to rephotograph the material as she does. Pollock and his contemporaries are behind Frankel's decisions about proportions, degree of internal differentiation, composition, shapes, and colors — but only in a general sense, because Frankel is not replicating earlier pictures. An art-historical explanation would involve some of the same concepts as a scientific explanation, including "failure," "internal tensions," and "catastrophe," but it would reinterpret them in terms of abstract painting. Frankel's work also fits well with contemporary artists' concerns: The publication of *On the Surface of Things* coincided almost exactly with the English translation of a major assessment of

nonfigural images, Yve-Alain Bois's and Rosalind Krauss's *Formless: A User's Guide*.[51] Their book explores the aesthetic of the surrealist *informe*, the "formless," as it appears in Pollock, Jean Dubuffet, Cy Twombly, Jean Fautrier, Gordon Matta-Clark, and dozens of other artists. If it weren't for the gulf between scientific imaging and surrealist-based art criticism, the two could be counted as aspects of the same phenomenon — and they are, in the larger scheme of twentieth-century image-making.[52] That way, the "aesthetic" aspect of Frankel's images would not be left dangling, as if all matters pertaining to her sense of pictures are beyond words. Instead, a formidably well-developed discourse within art history could be brought to bear on an equally eloquent (and formidable) discourse in surface chemistry.

Because the photograph is firmly wedged between a certain sense of art history and a certain practice of surface chemistry, fuller explanation for Frankel's book would have to weave elements from the texts in her book, in *Technology Review*, in Ehrlich's article, and in texts such as *Formless*. Blending such disparate sources would be a daunting task for any explanation, but it would be appropriate for an inquiry intent on elucidating the encounter between art history and surface chemistry — and it would place Frankel's images in a much richer and more detailed historical context.

Another example from a very different realm shows how widespread and difficult the question of appropriate explanation can be. The phrase "Aboriginal art" is used to refer to paintings made by Aborigines and sold on the Australian and international art markets. In general, the images are adapted from mythological stories, and they are normally geographically precise, referring to sa-

49. Whitesides, "Truth and Beauty in Scientific Photography," *Technology Review* (May–June 1996): 56–63, esp. 62, in regard to plate F.

50. Ehrlich and J. Melngailis, "Fast Room-Temperature Growth of SiO_2 Films by Molecular-Later Dosing," *Applied Physics Letters* 58 (10 June 1991): 2675–77. The first quotations are from Ehrlich and Melngailis, 2675; the second is a personal communication (September 1997).

51. *Formless: A User's Guide* (New York: Zone, 1997) is a translation of *L'Informe: Mode d'emploi* (Paris: Editions du Centre Pompidou, 1996).

52. Among the many stumbling blocks to the rapprochement between images like Frankel's and mainstream art criticism is Frankel's bright colors.

cred sites in a particular locality. When the middle-men and dealers come to pick them up from the artists, they ask for two kinds of information: the title (which is to say the subject), and a brief story line they can use to describe the painting to potential buyers. An artist might say a painting represents "wallaby dreaming," meaning an event in the Dreamtime of the wallaby ancestor, and he or she might also identify a few of the symbols in the picture. Normally the artist's explanation ends at that point. The dealers, curators, and historians add other information about style, period, tribal affiliations, and the relation of Aboriginal art to Western abstraction. In an introductory book called *Aboriginal Art,* Wally Caruana calls this the "appropriate level of interpretation."[53]

There are many reasons to wonder why this practice is called "appropriate." Most important, the relative paucity of explanation helps the paintings work as abstractions, so that viewers can enjoy the "pointillist" technique as if it were done by a modernist painter (Plate 3.11). The religious, tribal, geographic, and mythological meanings of the work — its nonart aspects — are avoided in favor of the appearance of Western modernist painting. Within the art world, most interest centers on the purity or lack of purity of Aboriginal painting, and art historians and critics ask what it means that the artists use acrylic paint, or that some visit the galleries and learn about Western marketing, or see books with illustrations of Western painting.[54] Historians such as Terry Smith argue that Walpiri traditions are effectively intact, while historians such as Donald Preziosi emphasize their postcolonial contamination.[55] But in the terms I am exploring here, appropriate explanation might be much more elusive. The artists might be intentionally misdirecting their dealers in order to protect private or sacred information; their explanations might be laconic or elliptic because they are disillusioned, rebellious, alienated, or uninterested in the art world; what they say might be fraudulent, intended to spark the dealer's interest; they might be offering popularized versions of full narratives; they might be drastically simplifying inenarrable details of the local topography; and they might be trying to modify what they say to fit the buyer's, the anthropologist's, the dealer's, or the art historian's idea of what is appropriate. For the anthropologist Fred Myers, such possibilities are part of a dialogue in which Westerners and Aboriginal artists misrepresent one another; in this context I am only interested in the fact that some Aboriginal paintings are radically simplified in nearly *all* interpretive situations — they are as far beyond what art historians would tolerate as the scientific monographs are beyond an average reader of Frankel's book.[56]

In regard to Plate 3.11, it would be possible to say nothing more than the artist's name (Welwi Warnambi, a Yolngu from Northeast Arnhem Land). A short caption or "story" might add that the painting "represents features of the landscape to the north of Blue Mud Bay," leaving it to viewers to see what they can.[57] In Chapter 10 we will look again at this image, and spend a page or two sorting out its principal meanings.[58] But even at the level of basic denotation, and without considering the endless problems of describing other cultures, evoking places the reader hasn't seen, and translating foreign languages, the painting calls for a much longer

53. Caruana, *Aboriginal Art* (London: Thames & Hudson, 1994), 99.

54. A thoughtful essay in this genre is Nigel Lendon, "Visual Evidence: Space, Place, and Innovation in Bark Paintings of Central Arnhem Land," *Australian Journal of Art* 12 (1994–95): 55–74. Lendon observes that the changes wrought by the art market have not increased "sophistication" but that "the most dense images in iconic terms existed before the era of communication with the outside world and perhaps these were made too literal and vulnerable through the systematic decoding by the first generation of anthropologists" (p. 72).

55. These points came out in discussion at the 1996 College Art Association conference in Boston.

56. Fred Myers, "Representing Culture: The Production of Discourse(s) for Aboriginal Acrylic Paintings," in *The Traffic in Culture: Refiguring Art and Anthropology,* ed. George Marcus and Fred Myers (Berkeley: University of California Press, 1995), 55–95. I thank Steven Feld for bringing this to my attention.

57. Howard Morphy, "From Dull to Brilliant: The Aesthetics of Spiritual Power among the Yolngu," *Man* 24 (1988): 21–40, caption to plate 2.

58. Most serious works on Aboriginal art strike the kind of compromise I aim at in Chapter 10. See *Australian Art,* ed. Ronald Berndt (Sydney: Ure Smith, 1964); Berndt, *The Australian Aboriginal Heritage* (Sydney: Ure Smith, 1974); Catherine and Ronald Berndt, *Australian Art: A Visual Perspective* (Sydney: Methuen Australia, 1982); H. M. Groger-Wurm, *Australian Aboriginal Bark Paintings and their Mythological Interpretation,* vol. 1, *Eastern Arnhem Land* (Canberra: Australian Institute of Aboriginal and Torres Straight Islander Studies, 1973).

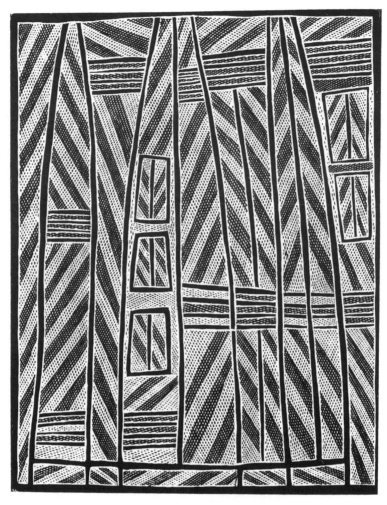

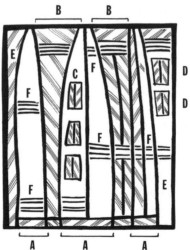

PLATE 3.11 Top: *Welwi Warnambi. Untitled painting, ca. 1975. Australian Aboriginal; Yolngu, Northeast Arnhem Land, Marrakulu-Dhurrurrunga clan.* Bottom: *diagram of the painting.*

explanation. Howard Morphy has written a book-length study on such paintings, adapted from his dissertation, which was aptly titled *Too Many Meanings*.[59] It has been argued that even extremely detailed iconographic explanations might be partly inappropriate. As Nancy Munn has pointed out, Aboriginal locales in the *jukurrpa* ("Dreaming") are not coterminous with landmarks but are "*centers* from which a space of uncertain or ambiguously defined limits stretches out."[60] Morphy himself has recently stressed the painting's optical "brilliance" (*bir'yun*), which helps it to be experienced as a "manifestation of spiritual power" even aside from its iconographic content.[61] Given these cross-cutting sources of meaning, each of them technical and each indispensable, what should count as an appropriate introduction?

I suspect that "inappropriate explanation" is one of the principal obstacles standing in the way of the art-historical appreciation of nonart images, and it is a theme I will return to at the end of the book. Is a picture no longer a picture if it demands that a viewer read a text before looking? Is a picture compromised by mathematics, by a long recitation of facts, or by an excess of symbols? What is a picture that it needs to be so pure? The more it is possible to shed assumptions about expressive meaning, nonart, and "informational" images, the more insistent such questions become.

59. Morphy, "Too Many Meanings: An Analysis of the Artistic System of the Yolngu of Northeast Arnhem Land," Ph.D. diss., Australian National University, 1977; see Morphy, *Ancestral Connections: Art and an Aboriginal System of Knowledge* (Chicago: University of Chicago Press, 1991).

60. Munn, "Excluded Spaces: The Figure in the Australian Aboriginal Landscape," *Critical Inquiry* 22 (1996): 446–65, esp. 453; and her *Walbiri Iconography, Graphic Representation, and Cultural Symbolism in a Central Australian Society* (Chicago: University of Chicago Press, 1986 [1973]), with a new afterword.

61. In the context of ritual, the *bir'yun* aids in the creation of "a feeling of Ancestral presence" because "intense sensations of light are felt as manifestations of that power." Morphy, "From Dull to Brilliant," 21 and 39. Morphy connects *bir'yun* with Nancy Munn's use of Charles Peirce's term, *qualisign*. See "From Dull to Brilliant," 39n12, citing Munn, *The Fame of Gawa* (Cambridge: Cambridge University Press, 1986). An interesting meditation on the understanding of Aboriginal art is Ulrich Krempel, "Wie liest man 'fremde' Bilder?" in *Aratjara, Kunst der ersten Australier*, ed. Benhard Lüthi (Cologne: DuMont, 1993), 37–40.

4 : What Is a Picture?

U p to this point I have been identifying images as "art" or "nonart," while also advancing arguments to undermine that distinction. The thought experiment in crystallographic history (Chapter 2) is meant in part to distribute a central property of art — expressive meaning — among all sorts of images and the five case studies in Chapter 3 are examples of problems potentially shared by art and nonart. At one time or another I have used at least eight terms to name images that are not taken to be art: I have called them scientific, nonreligious, inexpressive, non- or extra-aesthetic, utilitarian, informational, nonrepresentational (or aniconic), schematic, and notational. Each is a reflection of a certain way of construing what lies outside art, and each points to a limitation in the way that art itself is understood.

1. It is often tempting to call nonart images "scientific," but as I urged in Chapter 1, the majority are neither scientific nor mathematical. The commonest nonart images are pictorial elements in scripts (such as ideographic and pictographic signs). Because scientific images share many currents of post-Renaissance Western culture, they offer easily articulated methodological challenges for art history, and so they were optimal examples for the opening chapters. At the same time, their historical specificity makes them inadequate to the task of characterizing nonart images in general.

2. To get the argument under way, I opposed artistic images to religious ones (especially medieval paintings), suggesting that the two are such traditional antagonists that they are both effectively enfolded within art history. Even historians such as Hans Belting, who are extremely careful and reflective about the immiscibility of religious and secular uses, find ways of speaking about the divide, and also of crossing it. My opening move left "nonart" images sounding like "nonreligious" images, and I want to make it clear that I would not consider the latter an improvement over any of the other options. In the course of this book I will be considering a number of overtly religious images from a variety of faiths, as well as images produced in religious contexts (such as medieval maps, schemata, and figural poems). The question of religious function cuts across the categories I will be developing, and it can be elusive in any image.

3. Nor are nonart images "inexpressive": The burden of Chapter 2 is that even apparently wholly "inexpressive" images can be replete with historically specifiable meaning aside from their ostensive content. In art-world parlance, the word *expressive* can be used for any image that seems meaningful beyond its indispensable denotations: A graph might be "expressive" if it conveys something about its maker's intentions or identity, its place in history, or its affinity with related kinds of images. It can also be applied to an image that has an affective force, whether or not it can be readily put into words, or to an image that conjures a sense of its maker, or at least of the "author-function."[1] The ambiguity of the word strikes deep, and pre-

1. Dictionary definitions capture some of this bivalence. *The Concise Oxford Dictionary*, ed. J. B. Sykes (Oxford: Clarendon Press, 1976), gives for *express*, meaning number 2: "Reveal, betoken (of feelings, qualities); put (thought) into words."

vents it from being a good analytic tool. Instead of attempting to define it, I have been arguing that its opposite is incoherent: There is no "inexpressive" image in either sense, and the notion that whatever is not art is inexpressive is best understood as a sign of how imperfectly art historians have formulated what is to be preserved under the name "art." However "expressiveness" might be understood, it cannot function to sequester "art" from other kinds of images.

4. Nonart images are also called "non-" or "extra-aesthetic," implying they do not partake of the Western understanding of key concepts such as taste, judgment, and beauty. (The word *utilitarian* has the same valence, as it is an opposite to Kant's definition of objects of aesthetic judgment.) In some sense the claim is paradoxical because contemporary art history is engaged in a repudiation and critique of aesthetics and aestheticism; an anti-aesthetic stance is one of the touchstones of postmodernism.[2] On the face of it, an anti-aesthetic would unite nonart images (conceived as nonaesthetic) with postmodern fine art. But I do not think any such rapprochement could make sense within the study of postmodernism, except in the most abstract manner. The postmodern rejection of aesthetics is a peculiar kind of rejection, as it is a continuous, intimate struggle with what is taken to be modernist or Romantic about aesthetics. Such an ongoing, opportunistic skepticism is unrelated to the much simpler judgment that nonart images are nonaesthetic. (Or to the even simpler notion that artworks are "purely aesthetic.")[3] In addition there are at least two ways of arguing that several relevant properties of aesthetics pertain to nonart images: I have suggested that scientific images in particular make use of the original, pre-Kantian sense of aesthetic criticism, and it is also possible to stress the cognitive component of aesthetic response, as against Kant's exclusion of it. The second option is a recurring strain in current aesthetics, in which the contamination of Kantian judgment often entails an acknowledgment of propositional thought.[4] If nonart images are nonaesthetic, they are so in the original Kantian sense, rather than in any sense that is compatible with contemporary art history or visual theory.

5. Calling nonart images "informational" appears more straightforward, but it links them to twentieth-century communications theory and its ideals of the efficient transfer of capital and knowledge. The majority of images in Part 2 of this book are primarily intended to convey information, but the word itself is too narrow to give voice to the many kinds of meaning people have found in visual artifacts. *Information* sounds neutral, as if there were such a thing as knowledge without context, use, motive, or consequence; but images such as the pictorial characters in hieroglyphs are inseparable from contexts and uses. It also rings false for art history to decry "informational" images, as so much of what is written by art historians conveys information about artworks whose purposes are said to be richer than the simple conveyance of information. Calling nonart images "merely informational" only postpones the difficult task of separating information from other kinds of content in artworks. Underlying the idea that some images convey information (or merely do so) is the notion that art consists of information embellished with expression — a formula that would divide pictorial meaning in a particularly unnatural manner.

6. Nonart images are occasionally called "nonrepresentational" or "aniconic," even though many of them are strongly iconic. Many scientific images, including the majority of the ones we have considered, are more systematically faithful to empirica and to optical veracity than fine-art images. They can appear more naturalistic, or at least more reliable, than artworks in equivalent media, and they might also possess quantifiable relations to objects. (The objects represented in gnomonic projections of crystals, autoradiographs, and sonar charts can be measured directly on the page. Even rigorously perspectival paintings rarely yield to such measurements.) For analogous reasons I do not want to divide "perceptual" from "conceptual"

2. See for example *The Anti-Aesthetic: Essays on Post-Modern Culture*, ed. Hal Foster (Port Townsend, Wash.: Bay, 1983).

3. This judgment remains common in science. "The *Mona Lisa* is purely aesthetic; a typical electron micrograph is purely informational," even though "an aerial photograph can be quite beautiful [and] Ansel Adams's photographs do record geological detail," in the words of George Whitesides, "Truth and Beauty in Scientific Photography," *Technology Review* 98 (May–June 1996): 56–63; the quotation is from pp. 57–58.

4. Donald Crawford, *Kant's Aesthetic Theory* (Madison: University of Wisconsin Press, 1974).

images, although several historians have advocated versions of such a dichotomy.[5] Much of Western art is "perceptual" in the sense that it privileges forms of "opticality" or naturalism, but so do many other kinds of nonart, non-Western images. It might be that the identification of art with iconicity and nonart with nonnaturalistic depiction springs from unfamiliarity with the conventions of some scientific illustration.

7. For the same reason, nonart images are not well described as "schematic"; many are just as fully fleshed as paintings can be. (The term might crop up in visual theory simply because historians think of nonart images as line graphs rather than the more complex images we will be considering.) In the Kantian sense all images are schematic, since they are intermediaries between perfect one-to-one correspondence with objects and unrepresentable ideation. In historical terms schemata are a problematic category, and I have set aside a chapter to examine them in some detail. Either way, nonart images are ambiguously schematic and nonschematic: The historical senses of "schema" are inappropriate because they are too narrow to name all nonart images, and the Kantian usage is not useful, as it names *all* possible images, inside and outside of art.

8. Nonart images could be called *notations,* if it were not that the word has been co-opted by Nelson Goodman to describe especially systematic images such as printed music and Labanotation. Goodman's definition of notation is useful for a number of reasons, and later in this chapter I consider his account in some detail; but even relaxed versions of *notation* are not satisfactory substitutes for *nonart,* if only because *notation* itself has no clear opposite that could plausibly correspond to something essential about art.[6]

What does such a list suggest? Each of these concepts has its use, if only in revealing a specific construction of "art." They could be used as stepping stones toward an account of what a certain practice of art history understands as art. Ultimately, they could be used to show the fragility of the concepts that art historians would have to invoke in order to justify confining their study to paintings and other fine art. But for present purposes, the lesson here is that the line between art and nonart images is too labile to be helpful in thinking about images in general. From this point on I am going to

avoid judicative and normative uses of the words *art* and *nonart* and their various synonyms. No critique or judgment is intended by that omission, beyond the fact that I am interested in images other than those studied by art history. There is, after all, no coherent way to begin to displace the word *art,* despite the many attempts to do so; no history of images can be written without making use of notions of sequence, context, and interpretation that are informed by the experience of art. My purpose in not speaking further about art is not to shake off what I would consider to be the very conditions of historical meaning but to level the field for other ways of thinking about images. (Chapter 2, for instance, is not meant to expand "art" outward to the limits of the concept of the image but to quarrel with a particular understanding of the purview of disciplinary art history.)

Art is a very loud word, blustery and often effectively empty. It frequently seems to do more than it actually accomplishes, and it can overwhelm the kinds of affinities that I want to explore. And with that, I will set the word aside: not blithely or dogmatically or in the hope that omitting the word might also expunge the concept, but in order to attend to a variety of images without impaling them on a single insistent question.

THE DUAL SENSE OF PICTURES

As the word *art* recedes, the word *picture* comes forward, as if *picture* were both supported and protected by its near-identity with art. The less that art is available to help define it, the stranger *picture* begins to seem. The concept of a picture, it turns out, is central to our responses to visual artifacts in general — perhaps even more so than art, since its valence is more securely hidden. There is a deep-

5. Originally, E. H. Gombrich, *Art and Illusion* (Princeton, N.J.: Princeton University Press, 1972), and more recently, David Summers, "Conditions and Conventions: On the Disanalogy of Art and Language," *The Language of Art History,* ed. Salim Kemal and Ivan Gaskell (Cambridge: Cambridge University Press, 1991), 181–212.

6. The sense in which I mean *notation* is close to what Goodman means by *diagramming.* See Nelson Goodman, "Routes of Reference," in *Of Mind and Other Matters* (Cambridge, Mass.: Harvard University Press, 1984), 58. Compare, in the context of this argument, Jules Prown, "Styles as Evidence," *Winterthur Portfolio* 15 (1980): 197–210.

set affinity between some common uses of the word *picture* and the notion that there is such a thing as a purely visual artifact, independent of writing or other symbolic means of communication. In historical writing it is unusual to encounter a discussion of such a pure object, but the ideal of a perfectly visual image is ubiquitous. The word–image dichotomy that I will consider in the next chapter is an instance of this sense of *picture:* without a reasonably pure kind of visuality to set against writing, the dichotomy itself would be in trouble. Because I find *picture* indispensable, I want to take the remainder of this chapter and the next to make a more exact critique of the ostensible purity of pictures. The result will be a sharpened working definition of pictures that can serve in later chapters.

Essentially I will argue that art historians, philosophers, and others involved with visual images are conflicted about what they take pictures to be. Two incompatible meanings are often entwined in writing about pictures. One is the impossible ideal of the "pure picture" (the image unsullied by writing or any verbal equivalents, either in the object or in its interpretation): It gives meaning to concepts such as visuality, "visual meaning," and cognate terms, and it animates histories of naturalism and illusion. The other is the ideal — equally impossible in practice — of the picture as a substitute for writing, and hence a carrier of determinate meaning. An abundance of visual theories posit mechanisms that would allow pictures to be "read"; most depend on analogies between the structure of pictures and the structure of language. Pictures are also said to carry meaning in symbols (the central subject of iconography) and in narratives, and in general to possess an articulated internal structure of signs.

The second ideal is a fundamental theme in much twentieth-century writing about art, and its central figures include Ferdinand de Saussure, Charles Peirce, Roland Barthes, and the several incarnations of semiotic art history associated with names such as Hubert Damisch, Louis Marin, and even (in an earlier generation) Meyer Schapiro. The first ideal is much less theorized, and it tends to be associated with those historians who occasionally decline iconographic or narrative interpretations in favor of studies of naturalism, gesture, medium, or other technical or phenomenological sources of meaning. Writers who stress the un-

translatable, uninterpretable meaning of pictures also depend on some version of the notion of a pure picture. The writers who sometimes rely on the notion of pure pictures are as diverse as the various "purities" their texts imply: The group would include Walter Pater, Bernard Berenson, E. H. Gombrich, and Maurice Merleau-Ponty.

In this context I do not want to launch a history of either movement. Nor do I aim to propose a countertheory, because I have tried to do that elsewhere.[7] What I have in mind is a kind of symptomatology: I mean to suggest that the overwhelming majority of art historians entertain both ideals at once, so that they want both the possibility that an image might be purely visual and the potential that an image might prove legible or otherwise clearly structured. Louis Marin, for example, is driven by a fierce desire that pictures be somehow linguistic — and so his texts, such as *To Destroy Painting,* are both strong readings of pictures and extended evidence for the differences between pictures and a particular version of linguistic structures.[8] There is a curious and sometimes beautiful disjunction in Marin's books between the moments when he discovers some linguistic analogy and the moments (they often follow quickly behind) when some passage in the painting prevents a reading from actually taking place. Those passages are beautiful because they are at once exuberant discoveries and acts of mourning for the loss of meaning. (For Jacques Derrida, Marin's book *Des pouvoirs de l'image: Gloses* is principally about mourning, but there is also a complementary "icono-semiological theory" that works against mourning.)[9] Something of the same can be observed in Roland Barthes's searches for moments in pictures that are ultimately different from what is "coded" and therefore socially significant. Essays such as "The Photographic Image" replay Odysseus's encounter with the sirens: Barthes listens to the call of the purely visual object, he approaches, and then he veers back into the safer waters of coded images.

In the past few years I have come to think that this unavoidable duality of meaning is the funda-

7. Elkins (1998), chaps. 1–3.

8. Marin, *To Destroy Painting* (Chicago: University of Chicago Press, 1995).

9. Derrida, "By Force of Mourning," *Critical Inquiry* 22 (1996): 171–92; the quotation is on p. 177. See Marin, *Des pouvoirs de l'image: Gloses* (Paris: 1993).

mental theme for much of the interesting writing on pictures in the last century. It is a kind of touchstone, and the way authors treat it is a measure of many other things in their work: whether they approach it head-on, inciting a rhetorical collapse (as Barthes does), or weave it throughout their work, only occasionally allowing it to become explicit (as in Marin). And although it could be said that the most consistently absorbing writing never pushes too hard on one side or the other — never insists that pictures must be basically legible or illegible, never urges that pictures are structured in such-and-such a way — still there is something to be said for those few writers who have tried to work out, explicitly and in detail, how pictures can be both inside and outside of articulable meaning. At the least, forcing the issue holds up a mirror to the great majority of writers who decline to do so, and shows us what would happen if we pressed our unsteady intuitions on to their logical conclusions.

In this chapter and the next, I consider two such examples. The first is Wittgenstein, whose "picture theory" is, I think, the strongest and most consistent form of the desire to have pictures make determinate sense.[10] For Wittgenstein, that meant pictures are "propositions" in the logical sense — that is, they are equivalent to logical statements about the world. My reading is eccentric for several reasons, not least because it focuses on an aspect of Wittgenstein's work that is not usually associated with pictures in the usual sense of that word. But it seems to me that no other source shows as perspicaciously what the desire for linguistic (or logical) meaning entails, and what kind of object a picture might become if it were actually propositional. At the same time, Wittgenstein is utterly entranced by the mystery of pictures, their glassy silence. He once mused that the onion domes of St. Basil's in Moscow are sufficiently different from one another that they look very much like signs in some indecipherable language — as if they must mean something (Plate 4.1).[11] It might be better (and more in line with his vocabulary in *Tractatus*) to say that the feeling of propositional content is strong, but so is the conviction that such a thing cannot be a proposition. It is also said that Wittgenstein once dreamed about a rug that he thought had some hidden significance, as if it had a message it could not quite communicate: But as in his later critique of Freud's dream analyses, he declined to pursue the

dream by breaking its enigmatic code (Plate 4.2).[12] On the one hand there is the irresistible linguistic or symbolic "feel" of some images, and on the other the desire never to break into actual reading. The two possibilities play back and forth in Wittgenstein's writing exactly as they do — in much weaker and less self-consistent ways — in contemporary visual theory and art history.

The second reading (in the next chapter) aims at the same divided structure, but for a different effect. Nelson Goodman's theory of notations in *Languages of Art* remains a central text for the study of visual meaning, and even if he had nothing to contribute to this theme, it would be necessary to review his work here for what it contributes to image theory. Goodman asks a great deal of visual artifacts that are to be classed as "notations": he demands a rigor of signification and structure that is virtually unattainable even by such obvious candidates as electroencephalographs and computer printouts of graphs. His definition of notation will be very useful in the next chapter, but here I want to emphasize how it is also a version of the same double desire about pictures. What Goodman demands of notations, so I will claim, he wants to demand of pictures. His is another supremely rigor-

10. My account here has benefitted from a reading by Judith Genova. In her opinion, it is we who are interested in the potential fusion, or confusion, of *word* and *image* in Wittgenstein's use of *Bild*, and Wittgenstein did his best to keep them separate. But I would argue that the desire to create a single logical entity from propsitions and pictures is manifest in the picture theory. I also thank Alfred Nordman for noting this chapter's eccentric tendency to imply Wittgenstein meant to say "all pictures are propositions," rather than "all propositions are pictures." I think a qualified version of the former does capture his sense of *Bild*, though I am not proposing he argues as much in *Tractatus*.

11. Wittgenstein, *Lectures and Conversations on Aesthetics, Psychology, and Religous Belief*, ed. Cyril Barrett (Berkeley: University of California Press, 1967), 45.

12. This example is a Safavid Ardabil carpet, which is partly naturalistic in intention. As Rexford Stead points out, the chainlike arabesques in the central medallion are variants of *tchi*, "the Chinese cloud-band motif brought to Iran by the Mongols." In the center is a roundel that probably represents a pool, and Stead sees lotus blossoms floating on it, with "rhizomes that seem, magically, below the water's surface." But the elements do not add to a naturalistic scene, so the motif as a whole can be accurately called a "sunburst medallion." Stead, *The Ardabil Carpets* (Malibu, Calif.: J. Paul Getty Museum, 1974), 20.

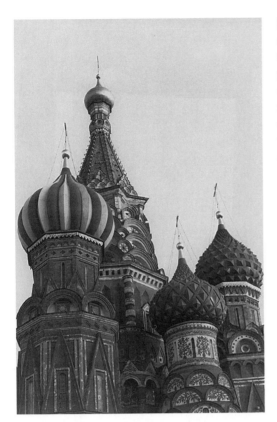

PLATE 4.1 *The Cathedral of the Intercession of the Moat (St. Basil's). Moscow, sixteenth century.*

ous working out of the wish that pictures have structured significance, except that the wish is displaced onto images that he cannot call pictures. In a weaker way, the majority of current theorists and historians want the same kind of reliable meaning (otherwise what could they research?), but they stop short of elaborating a theory as intricate as Goodman's definition of notation. And Goodman, too, is prey to the allure of pictures that are purely visual — or, in his terms, "dense" and unsystematic. Ultimately that aspect of pictures makes them more interesting than notations, but it is (in Goodman's view) far more difficult to construct a book on the ways in which ordinary pictures carry meaning than it is to invent a set theoretic apparatus to define notations.

I intend these two readings to make a point about what we think pictures are, and to provide concepts that will structure the rest of the book. Fundamentally, I think we wish pictures could sometimes be pure, devoid of codes, signs, letters, numbers, or any other structured sources of mean-

ing. At the same time, we hope that the pictures we are interested in will always have enough structure to yield meanings — to be, in the inevitable metaphor, legible. Wittgenstein's and Goodman's encounters with pictures entail two thematically similar but analytically quite different concepts that are set against "pure pictures": proposition and notation. The two will prove invaluable for understanding images in general.

(From this point on, I am developing a specialized vocabulary, building from such words as *picture, proposition,* and *notation.* All such words are collected and defined in the Glossary.)

TORTURING "PICTURE"
IN WITTGENSTEIN'S *TRACTATUS*

Of the various nineteenth- and twentieth-century theories of the meaning of images, the account Wittgenstein gives in the *Tractatus logico-philosophicus* stands out by implicitly denying it is necessary to distinguish between "pictures" and "propositions" or "sentences" in the logical sense. At first it might seem that this position has little to say to the humanities: After all, Wittgenstein was interested in the logical structure of the world, and not in paintings, and even if he did mean something like paintings when he said "picture," it still would not make much sense to equate pictures and propositions. In addition, resurrecting his *Tractatus* as a viable source instead of a historical document seems a dubious endeavor. Since the 1930s, the *Tractatus* has generally been left to historians of philosophy, and the living issues have tended to come from the later work. Whatever the picture theory became in Wittgenstein's later thought — and debate on this topic comprises the bulk of philosophic writing on the subject — it was an ancillary "view," showing "how things looked from one angle" rather than a model with foundational status.[13]

13. For the view that the picture theory continues beyond *Tractatus,* see Anthony Kenny, *Wittgenstein* (London: Penguin, 1973); for the contrary view, see Peter Hacker, "The Rise and Fall of the Picture Theory," in *Perspectives on the Philosophy of Wittgenstein,* ed. Irving Black (Cambridge, Mass.: MIT Press, 1981), 85–109. For the idea that Wittgenstein's later theory widens so that "pictures need not be images," see Ronald Burr, "Wittgenstein's Non-Representational [i.e., linguistic] Religious Pictures," in *Die Aufgaben der Philosophie in der*

But there might be good reason to reconsider the "picture theory" and Wittgenstein's *Tractatus logico-philosophicus* in light of contemporary visual theory. It is at least intriguing that Wittgenstein's use of "proposition" belongs in a direct line that runs from positivism through current semiotic theories of pictures. At root, the structure of meaning that semiotic art history posits — signs, lexemes, syntax — entails the logical elements about which Wittgenstein was concerned. In this respect Wittgenstein's position is much stronger, and more thorough, than contemporary semiotic models of pictures, as it demands not just essential fragments of linguistic forms but total identity between logical grammar and pictures — or so it seems. In art history, those propositional or linguistic aspects of pictures are balanced by awareness of elements that cannot be well described in language. Much of current art history is polarized by the difference, as there seems to be no intuitively acceptable way of creating a single picture of "picture" that includes both traits. The word–image distinction has grown into a generative opposition that tends to crowd out nuances and alternate formulations: Pictures are seen to be uncertain mixtures of linguistic forms and elements that are inenarrable or even unnamable. The picture theory, if it has anything to say outside the rarefied, sometimes artificial, and often ambiguous world of the *Tractatus*, might offer a unique way out of the polarized critical climate that now bears down on visual theory in the humanities. It might, in short, offer the most powerful possible critique of the word–image dichotomy, as it proposes a concept of *picture* that is undecidably both "visual" and "verbal" — or, in Wittgenstein's clearer and more honest language, "pictorial" and "propositional." In arguing this way, I am not advocating a revival of Wittgenstein's *Tractatus* (the work's structure contains too many problems in its support of the picture theory for this to be a sensible option), but for what it can tell us about what we want pictures to be. My essential claim is this: Wittgenstein's exposition tortures the concept of picture in just the ways contemporary visual theory tends to torture it, but he does it better, pushing the concept — as I think it must be, if it is to bear the weight we put on it — until it is nearly unintelligible.

The picture theory is exposited in two places in the *Tractatus*, in paragraphs 2.1–3.01, and again in 4.01ff, and Wittgenstein's commentators have mostly focused on those parts of the picture theory that are relevant for what Wittgenstein then goes on to develop — namely, his theory of propositions and logical forms. To my mind, the most careful commentary is still Max Black's *Companion to Wittgenstein's "Tractatus,"* and I will be commenting on Black's glosses as much as on the original. For my purposes, it is especially significant that Black takes the vernacular meaning of *picture* seriously, and one effect of that decision is that he keeps trying to pull the concept back toward its ordinary uses — a tendency of which I think he might have felt the later Wittgenstein would have approved. Still, he doesn't succeed in placing our *picture* in Wittgenstein's *picture,* and I pay special attention to the limits of his project of renormalizing *picture* as a sign of the potential problems in importing anything resembling the *Tractatus'* *picture* into contemporary discourse on art.

HOW DO LOGICAL PICTURES REPRESENT?

The first statement about the picture theory is paragraph 2.1, "We picture facts to ourselves." Black stresses that from the outset, Wittgenstein is taking *picture* as a nontechnical term, and that he is not using it "in some figurative sense." Instead "his remarks should be taken as intended to apply literally to all representational paintings, photographs, or diagrams such as maps, that can be 'read' as depicting how things stand in reality." [14] The "picture theory" is built on the premise that the concept "picture" can be used to describe what happens in "an electrical circuit, a map, a printed record of a game of chess," a sentence, a proposition, musical notation, logical sigla such as "aRb,"

Gegenwart / The Tasks of Contemporary Philosophy, ed. Werner Leinfellner and Franz M. Wuketits, Proceedings of the 10th International Wittgenstein Symposium, Kirchberg am Wechsel, Austria (Vienna: Hölder-Pichler-Tempsky, 1986), 352–54. The phrase in quotation marks is from Erik Stenius, "The Picture Theory and Wittgenstein's Later Attitude to It," 110–39, esp. 135.

14. Black, *A Companion to Wittgenstein's "Tractatus"* (Ithaca, N.Y.: Cornell University Press, 1982 [1964]), 74. Further references will be included in the text.

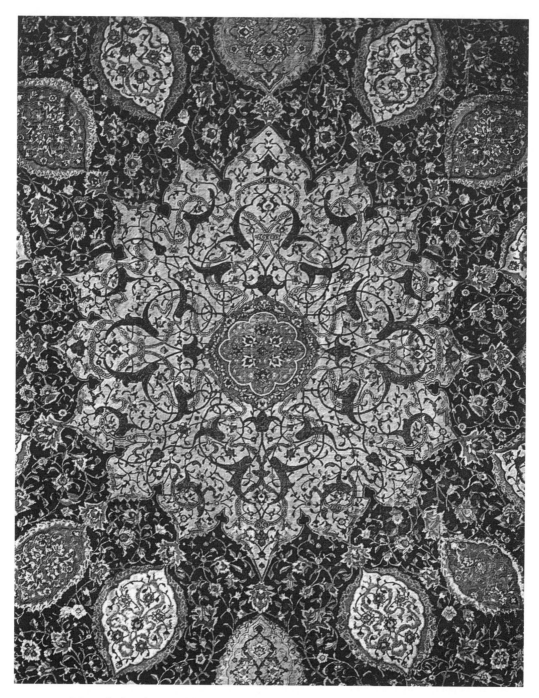

PLATE 4.2 *Maqsud of Kashan. Ardabil carpet, detail of central sunburst medallion. Persia, Safavid Dynasty, 1540 C.E.*

and — perhaps most fundamentally — everyday pictures (90).[15] As Guido Küng puts it, Wittgenstein "calls a sentence a picture (*Bild*) because he wants to compare it with a broad spectrum of other examples of pictures, ranging from a *tableau vivant* (*lebendes Bild:* a silent and motionless group of persons, etc., arranged to represent a scene) to a mathematical projection (*Abbildung*)."[16]

But there are immediately problems with this reasoning. While I agree with Black and Küng that there is no reason to assume, without having been told otherwise, that *picture* means anything other than representational images, making this explicit also sets up the dynamic that haunts the succeeding pages of both the *Companion* and the *Tractatus*.[17] It turns *picture* into a term that is about to be sorely tested, rather than a philosopheme that might merely need some adjustment (as Black adjusts *abbilden, darstellen, bedeuten,* and so forth to fit Wittgenstein's usage). Even if we allow that Wittgenstein is following mathematical protocol by letting *picture* function as an undefined term, it remains to be answered why he would choose such a nonphilosophic, ordinary word that has none of the benefits of definitional rigor and none of the advantages of well-worn but abstract vernacular usages. He could have tried *Darstellung* or *Vorstellung,* with their echoes of Hegel and Schopenhauer. But he chose the more ordinary, and much more slippery, *Bild.*

It is certainly the case that part of what Wittgenstein wants to conjure with his word is the idea of projection, especially in the mathematical sense but also in the word's perspectival and optical meanings. Yet he does not specify projection until 3.11, in part because he wants to leave the exact relation between *Bild* and world undefined for the moment. Later he mentions "feelers" or "antennae" between picture and world, and evokes the idea of "reaching right out to the world" and "actually" touching it — they are odd images, reminiscent of the visual rays and lines of projections, but also of insect communication and wordless tactile experience in general.[18] Throughout the *Tractatus* the mechanism of representation is left to vacillate between the most rigorous mathematical mappings and the most intuitive "feelings."[19] (And this is why graphic depictions of his "projection," and class-terminological symbolizations of the picture theory, seem to me misguided.)[20] But

projection is also omitted at the beginning because he wants to have *picture* function as *model* as well as two-dimensional painting or photograph (74–75): "A picture is a model of reality," he asserts (2.12). This also follows the German *Bild,* which means both "picture" and "model," and it is likely that Wittgenstein intended those uses from the first.[21]

Three numbered paragraphs after he has first mentioned pictures, Wittgenstein gives the first description of the properties that allow pictures to model states of affairs. "In a picture," he writes, "objects have the elements of the picture corresponding to them" (2.13). All Wittgenstein says here is that pictures have "elements," so they are not necessarily atomic, and that they have "corre-

15. For the sigla, see Wittgenstein, *Tractatus logico-philosophicus, The German Text of Logisch-philosophische Abhandlung,* ed. D. F. Pears and B. F. McGuinness (London: Routledge & Kegan Paul, 1961), 4.012.

16. Guido Küng, *Ontology and the Logistic Analysis of Language: An Enquiry into the Contempoary Views on Universals,* rev. ed. (Dordrecht: D. Reidel, 1967), 51. Compare *Tractatus* 4.0311.

17. It also provides the limits to accounts that stress logical relations over pictorial ones, such as Suzanne K. Langer, *Philosophy in a New Key* (Cambridge, Mass.: Harvard University Press, 1978).

18. 2.1515, 2.1511, 2.15121, respectively.

19. Garry L. Hagberg points this out in *Art as Language, Wittgenstein, Meaning, and Aesthetic Theory* (Ithaca, N.Y.: Cornell University Press, 1995), 11n7.

20. As in Guido Küng, *Ontology and the Linguistic Analysis,* 53.

21. This is stressed by Hacker, "Rise and Fall," 107n1. This idea, that a root of the concept "picture" is to be found in three-dimensional "proxies," "models," and "tokens," is one that has wide resonance in twentieth-century visual theory, from Freud's description of the origin of language in the *fort-da* game, to the art historian David Summers's theory of visual objects as "real metaphors," to the archaeologist Denise Schmandt-Besserat's theory of the origin of counting in Mesopotamian clay "tokens" that later became pictographs. I do not want to pursue any of these leads here; instead I would simply take note of a peculiar extension of the concept of "picture" into the realm of three-dimensional "proxies," which is also a point of sympathy between Wittgenstein and various strains of twentieth-century art. See Elkins (1998); Freud, *Beyond the Pleasure Principle,* in *The Standard Edition of the Works of Sigmund Freud,* ed. James Strachey, vol. 18 (London: Hogarth Press, 1955); Summers, "Real Metaphor," in *Visual Theory,* ed. Norman Bryson, Michael Holly, and Keith Moxey (New York: Harper Collins Icon Editions, 1991); and Schmandt-Besserat, *Before Writing: From Counting to Cuneiform* (Austin: University of Texas Press, 1992).

spondence" with objects. But it seems that something more is needed to make sense of this in light of what is about to transpire in the *Tractatus*. Black tries to elucidate Wittgenstein's intentions by expanding the word *element* into a theory of picturing (78–79). First, he says that the "elements" in a picture (he suggests the example of Frith's *Derby Day,* a distinctly odd choice, as it fits neither the taste of Wittgenstein's milieu nor that of mid-twentieth-century American academia) can be separated into "blobs of paint, black and white patches," and that we will cease differentiating such patches when we come to the smallest units that have denotational significance.[22] He proposes we call these units *graphemes,* on the model of linguists' use of *morphemes* to denote the smallest meaningful units of language.[23] Using this definition of *element,* he proposes three features of pictures that will have special resonance in the later development of Wittgenstein's thought. First, the elements must somehow resemble their denotata. He names Peirce and suggests that "graphemes stand for their objects iconically," no matter what exact "principal of element-thing coordination" is involved. Second, the arrangement of the graphemes in the painting — Black adds that they must be "suitably defined so as to exclude irrelevancies" — must be parallel to the arrangement of objects in the world: "The principle of representation of spatial structure is, broadly, speaking, *identity* of arrangement." And third, because pictures represent by virtue of conventions, "every representational picture belongs to an enveloping system of pictures governed by the same principles of representation." As H. O. Mounce puts it, "The structure which is common between the proposition and the world is revealed . . . only if we understand the rules for their use"; still, however, this third requirement might sound more like later Wittgenstein, with its emphasis on interpretation, than the more contextless analysis in the *Tractatus.*[24]

Each of these three criteria is strongly qualified. Spatial relations have to be adjusted "so as to exclude irrelevancies" before they can be correlated with the arrangements of objects in the world, and graphemes only resemble real-world objects by "sophisticated" routes. But given that the criteria are not intended to represent Black's sense of the structure of pictures, we might still wonder if they represent Wittgenstein's sense. Because Wittgen-

stein says he was led to question the *Tractatus* when Pietro Sraffa asked him to explain how a certain gesture — a rude flick of the hand under the chin — could have a "structural correspondence with the state of affairs that it represents," we know Wittgenstein must have assumed some more articulated, if fragile, account of representation. (The power of Sraffa's question comes from the fact that such a gesture "can easily communicate just as much as a fully articulate proposition," so it casts doubt on the idea that the meaning of a sign depends "on its own internal structure.")[25] From the present point of view, the question this episode raises is why it took a "certain Neapolitan gesture" to establish the shakiness of the picture theory. Determinate, symbolic gestures have been integral to Western painting and sculpture from Roman times, and so we might say that Wittgenstein had never clearly imagined a narrative picture as he wrote. But is this enough of an explanation? It could easily be argued that *all* the inchoate ordi-

22. Martin Donougho suggests *Derby Day* was Black's choice because it has so many discrete "elements" (that is, spectators and horses); but it's also interesting that the painting has relatively few nonsemiotic "blobs" — that is, I suspect Black was thinking of pictures in which elements coincide with denotational units.

23. Black's usage is a little eccentric here, as *morpheme* normally denotes the smallest meaningful unit of writing, such as *con-* in *construction,* and *grapheme* means the smallest disjoint unit of writing, such as the *c* in construction. *Lexeme,* a related term, denotes a "minimal unit of the mental lexicon" used in building words, such as the *-struc-* in *construction.* The closest to Black's meaning is *morpheme,* not *grapheme;* but all three terms could be used to widen the discussion at this point. For *grapheme,* see Manfred Kohrt, "The Term 'Grapheme' in the History and Theory of Linguistics," in *New Trends in Graphemics and Orthography,* ed. Gerhard Augst (Berlin: de Gruyter, 1986), 80–96; Robert Martin, "Sur la définition du graphème," in *Études de langue et le littérature français, offertes à André Lanly,* ed. Bernard Guidoux (Nancy: Université de Nancy, 1980), 485–90; Klaus Heller, "Zum Graphenbegriff," in *Theoretische Probleme der deutchen Orthographie,* ed. Dieter Nerius and Jürgen Scharnhorst (Berlin: Akademie-Verlag, 1980), 74–108; and Horst Singer, "Historische Graphetik und Graphemik," in *Sprachgeschichte,* ed. Werner Besch et al. (Berlin: Walter de Gruyter, 1984), 399–409.

24. Howard Owen Mounce, *Wittgenstein's "Tractatus:" An Introduction* (Chicago: University of Chicago Press, 1981), 29.

25. Karlheinz Lüdeking, "Pictures and Gestures," *British Journal of Aesthetics* 30, no. 3 (1990): 219–20. Lüdeking suggests that Sraffa's Marxist sympathies might account for his relative absence from the Wittgenstein literature (230n6).

nary senses of pictures involve "elements" that are "fully articulate" and yet do not "correlate" to the world. What understanding of *picture* could take so much for granted?

HOW ARE LOGICAL PICTURES STRUCTURED?

In Black's gloss, "picture" is a strongly logical concept. It has definable "elements" that resemble objects in describable ways and that combine into "structures" that also occur in the world.[26] The tripartite description of "elements," despite Black's qualified exposition — and his is by far the most nuanced of any commentary on this passage — is already beyond the pale of "pictures" as many people in the visual arts understand them. For a reader in art history or art criticism, all this might seem to belong to the realm of logic or linguistics, so that the only places Wittgenstein crosses the word–image gap and evokes the visual are when he talks later in the *Tractatus* about the nonverbal "mystical" that has to do with the fact "that" something exists instead of "how" it exists (6.44), and when he enjoins silence over whatever is nonsensical or senseless (7). It seems to me, however, that these earlier moments in the *Tractatus* capture a significant amount of the anti-rational, nonverbal glamour of the "purely" visual, and it is premature to say that Wittgenstein's "picture" has already left the fold of ordinary pictures and become a tool of rationality. And that is so because *picture* is not yet something that is firmly enough chained to its rational prison of *element, correspondence, grapheme, identity,* and *arrangement* to be sure that nothing remains free, unsaid, or unsayable.

Wittgenstein next asserts that the elements of a picture are "related to one another in a determinate way," otherwise the object is not a picture (2.14). Black sees this partly as an injunction against vagueness: "A smudged or blurred picture is not a picture at all; the sense of the picture must be precise, even if the picture depicts a non-atomic situation and thereby leaves much unspecified" (80). Black cites a Turner painting of a foggy sunset as an acceptably "precise representation of what it purports to depict"; what Wittgenstein wants to exclude are vague, indeterminate, or indefinite organizations in pictures. To those who work with visual images, this might seem like the last straw,

the stifling requirement that breaks the connection between Wittgenstein's "picture" and ordinary pictures. But Black also suggests a more lenient and (I think) more accurate alternate: "'Determinate' can also be opposed to 'indefinite,'" so that "the blobs of paint of which a picture is made must be organized in a single, definite way, out of the many that are possible . . . in order to constitute a determinate picture" (80). In this reading, when Wittgenstein says a picture's elements "are related to one another in a determinate way," he means "in a way that can be determined," or "in a way that is the case," rather than "in a distinct or precise way."

Two propositions later, Wittgenstein says more about determinateness: "The fact that the elements of a picture are related to one another in a determinate way represents that things are related to one another in the same way" (2.151). What is happening here is that the still largely undefined concept of "picture" is being stretched away from its vernacular and critical senses, so that it can accommodate the incipient theory of propositions. The stretching is nearing a breaking point with this kind of atomic correspondence theory, although it is again released just a little by the comment that Black appends.[27] Black comments on 2.151 by setting out a "picture" (he puts the word in quotation marks, as if in token of its increasing oddity):

$$\bigcirc \quad + \qquad\qquad (*)$$

The "picture" is identified by the asterisk in parentheses, instead of the marginal number that is usual in mathematics and logic. (It is interesting that Black chooses an affectless mathematical picture, in contrast to Wittgenstein's first picture of

26. Mounce, *Wittgenstein's "Tractatus,"* 30.

27. In response to 2.14, he had said that "a determinate picture" must possess a definite organization, leaving it open that there might be other kinds of pictures that Wittgenstein does not mention. I do not agree with that reading, because Wittgenstein says clearly, "What constitutes a picture is that its elements are related to one another in a determinate way," not "What constitutes a determinate picture is that its elements are related to one another in a definite way." Later Wittgenstein does say things that allow that not all pictures are determinate, although he never does so as fully, or explicitly, as Black implies by his commentary. See, for example, *Tractatus* 2.201; Black, *A Companion,* 90.

the two dueling stick figures in his *Notebooks, 1914–1916*, or the boxer invoked in his *Philosophical Investigations*. If this were a psychological inquiry into Wittgenstein's sense of "picture," I might want to claim that his philosophic sense of "picture" might be linked to belligerence. And if that is so, it is a meaning Black transforms into friendly admiration.)[28]

This "picture," Black says, has a meaning defined by several stipulations:

(i) the circle stands for Russell;
(ii) the cross stands for Frege;
(iii) that the circle is immediately to the left of the cross means that whatever the former sign stands for admires whatever the latter sign stands for. (The whole picture therefore means that Russell admires Frege.)

Black thinks that given just this picture, without the stipulations, we would be inclined to speak directly about "the fact (*)," as if "putting a circle and a cross side by side on paper uniquely generated a certain fact, which could then be identified without ambiguity or misunderstanding" (80). But the figure could "yield any number of facts" depending on how we read it. We might see it as a circle, a vertical line, and a horizontal line, and I would add that we also inevitably see it as a circle, a cross, two parentheses, and an asterisk. So understanding a picture as a fact, or as an object with a "definite sense," or as a fact that depicts something, or — in the terminology that is about to make its first appearance — as a proposition, entails "the selection of a definite articulation of the picture elements" and a definition of their relations.[29] Black does that for his indeterminate "picture" with his three stipulations. A little later Wittgenstein says, "The pictorial relationship consists of the correlations of the picture's elements with things" (2.1514), and Black asks, "What features of a picture are to be counted as elements?" (85).

In a literal reading of the text to this point, a picture is determinate, but in Black's reading, pictures are issued a reprieve and allowed to be sometimes indeterminate.[30] Now this accords very well with a prevalent model of painting, according to which it is inherently indeterminate and structurally vague but susceptible to "stipulative" reductive readings. But it does nothing significant to alter or erase the word–image dichotomy, and so I would like to stress the literal reading over the more familiar-sounding interpretation that Black offers. "Picture" as it emerges in 2.1–2.151 is a potentially powerful reworking of our usual "picture," because of the way it places these nascent logical forms in the heart of pictures rather than imagining them as a pole toward which pictures might incline, or from which they need to be rescued.

Two further issues move Wittgenstein's reading toward its breaking point: First, there is the difficult relation of showing and saying, and then the curious way that Wittgenstein stretches, blurs, and distorts *picture* without always being aware of doing so.

DO LOGICAL PICTURES SHOW, OR SPEAK?

The picture theory reveals its strength unexpectedly when it takes its most counterintuitive form, in the assertion that a statement is a picture. That leads Wittgenstein to several deeper connections between pictures and statements that follow from the distinction between showing and saying. Paragraph 2.15, which I began earlier, concludes: "Let us call this connexion of its elements the structure of the picture, and let us call the possibility of this structure the pictorial form of the picture" (2.1511). Black draws out the nascent distinction here between the "picture as a fact in its own right (an arrangement of blobs of paint on canvas, without any associated meaning) and the picture *as a picture* (a fact that *depicts* something, a possible state of affairs) (81). His paraphrase of 2.1511 ends this way: "Let the structure of the fact be called the structure of the picture, and the form of the fact be called the form or the form of representation of the picture"

28. See the *Notebooks, 1914–1916* entry for September 9, 1914, and *Philosophical Investigations* I.22n; I would also note that G. E. M. Anscombe, *An Introduction to Wittgenstein's "Tractatus"* (Philadelphia: University of Pennsylvania Press, 1971), makes the duelists actually touch swords.

29. Elsewhere the "referents of [the picture's] constituents" are said to be sufficient. See 4.01, and Black, *A Companion,* 164.

30. Black might be rescuing *picture* when it does not need to be, as Wittgenstein only says that arrangement in any picture *is* its determinateness, and every picture, no matter how "nonverbal" or "iconic" it seems, has an arrangement.

(82). *Picture* is bifurcated into something with internal structure and external form. He calls the "picture as a fact in its own right" the "picture-fact" and "the picture *as a picture*" the "picture in the full sense" (81).

Wittgenstein's own way of developing this thought is to place the truth function of a picture in its external relation, and its "sense" in its internal relation (92).[31] A picture's sense, which is contained in its internal structure, is not dependent on its truth value, which is expressed in its "form of depiction." Black reads 2.221 as "What a picture shows is its sense," rather than "What a picture represents is its sense," as Pears and McGuinness have it, and that allows him to see an anticipation of the central doctrine that will be made explicit only in 4.022: that a picture "*shows* its sense," but it "says" its truth content (92–93). Later, "Wittgenstein insists strongly that the logical form can only be displayed (*aufgeweisen*), mirrored or reflected (*gespiegelt*), shown (*gezeigt*), and that it cannot be depicted (*abgebildet*), represented (*dargestellt*), [or] said (*gesagt*)."[32]

This concept, and the entire impetus to use the word *picture,* probably came from Gottlob Frege. At one point Frege writes, "It would be desirable to have a special term for signs having only sense. If we name them, say pictures (*Bilder*), the words of an actor on the stage would be pictures; indeed the actor himself would be a picture."[33] It is important that this idea of silent pictures might be at the origin of Wittgenstein's "picture," but in the *Tractatus* it is not clear if a picture's internal structure cannot also be "asserted," "claimed," "said," or couched as any sort of proposition. By itself, a picture's sense agrees or disagrees with reality and can be true or false (2.222). The internal structure of the foggy sunset painting might be incoherent, and therefore false, without any reference to other foggy sunsets, painted or real. Because that is the case, it is not obvious what can both say and show, or what can only do one or the other.

There are some particularly elliptic passages here, with widely varying readings.[34] Because a picture's sense is already a truth statement, showing seems to be ubiquitous and prior to saying, and saying begins to look a little superfluous. As Black asks, "What function is left over for *saying?*" To G. E. M. Anscombe, the showing / saying distinc-tion names the difference between a picture and a proposition; the former shows, the latter says: "While a picture may be said to *show* how things are, *if* there is something it is a correct representation of, it certainly does not *say* that is how things are; the most that one could grant would be that we could *use* the picture *in* saying how things are: we could hold the picture up and ourselves say: 'This is how things are.'"[35] This line of reasoning seems to me too stark, and it gives away the complexity of the preceding analysis. Why would Wittgenstein have expended so much thought to bring *picture* closer to *proposition* if he had meant to make picturing so clearly not a matter of asserting?

It is better, I think, to try to put showing and saying together in the composite concept that is the "picture." Erik Stenius does this when he says pictures show both internal structure and external states of affairs. He develops the idea of "internal showing," which only happens when what is shown cannot also be said, and he concludes that "the internal structure of reality can only be shown or ex-

31. See further Bernard Harrison, "Frege and the Picture Theory: A Reply to Guy Stock," *Philosophical Investigations* 9, no. 2 (1986): 134–39.

32. Küng, *Ontology and the Logistic Analysis,* 54–55.

33. Frege, "Über Sinn und Bedeutung," *Zeitschrift für Philosophie und philosophische Kritik* 100 (1892): 25–50, esp. 33, cited in Küng, *Ontology and the Logistic Analysis,* 51n2. Frege's essay has been reprinted a number of times; see, for example, *Philosophical Writings of Gottlob Frege,* trans. Peter Geach and Max Black (New York: Oxford University Press, 1952).

34. Problems have arisen over the wording of 4.02211 ("A proposition *shows* how things stand *if* it is true. And it *says that* they are so"), where Wittgenstein seems to be saying that true propositions both say and show. It leaves open the question of what happens to negative propositions, and it has even seemed to be a "mistake." This is brought up in J. W. T. Wisdom, "Logical Constructions," *Mind* 40 (1931): 205, cited in Black, *Companion,* 165; and compare Erik Stenius's approach, in his *Wittgenstein's "Tractatus:" A Critical Exposition of Its Main Lines of Thought* (Oxford: Oxford University Press, 1960), 148. Rudolf Carnap's *Philosophy and Logical Syntax* (London: K. Paul, Trench, Trubner & Co., 1935) is an attack on the concept that a picture cannot depict its form of depiction. He argues, in Küng's words, that "although we cannot step *outside* any logical form . . . we can, nevertheless, make statements *about* the formal system of any language within the system of a metalanguage." Küng, *Ontology and the Logistic Analysis,* 55.

35. G. E. M. Anscombe, *An Introduction to Wittgenstein's "Tractatus,"* 65.

hibited by language, not described in sentences."[36] For *language,* we might substitute *pictures* in the ordinary sense. This is a more modulated interaction of showing and saying, although it still confines the "internal relations" of a picture to exhibiting sense.

Like Wittgenstein's "picture," showing and saying are partly propositional and partly not — or, to put it another way, propositions are always both shown and said. For Black, "saying" is "an aspect of" the sense, rather than a second function that is "superadded to it" (165). "Propositions show what they say," Wittgenstein claims, so that "tautologies and contradictions show that they say nothing" (4.4611). Showing, it seems, is something that is done by merely existing, and by possessing internal structure; and it can also be the only mode of meaning for statements that are void, contradictory, or tautological. Pictures are often that way.

TORTURING "PICTURE" IN
CONTEMPORARY VISUAL THEORY

Showing and saying are intriguing concepts for contemporary visual theory, especially if they are linked in the way I have suggested. They are the signs of a true fusion of the intuitive and fragile nonverbal, nonlinguistic sense of "picture" and the occasionally counterintuitive and often relentlessly determinate readings that insist on pictures' propositional logic. Still, no matter how powerful these ideas are, Wittgenstein's *Tractatus* can never become a foundation for contemporary visual theory: The picture theory is too much based on the logical atomism that Wittgenstein and the majority of writers after him have long since rejected. I have pressed the point in order to indicate how a more rigorous understanding of what we want to mean by *picture* is commensurate with Wittgenstein's formulations. He was, in this respect, one of the major art critics of the century: He took desires that are still felt in regard to pictures and made them more orderly and clear than most writers since his time have managed.

That is the doctrinal point I want to make; but in order to pursue the notion of "picture" that is characteristic of contemporary art history, it is necessary to leave off expositing the picture theory itself and consider instead a kind of side effect of the reading. What I have in mind is the violence that is done to *picture* throughout the text. It begins slowly, as picture enters the text as an undefined term, but it builds until the word has only the most improbable connections to its original meanings. As Black says, if I look at a picture of a red ball on a white kitchen tablecloth, I can pick out any number of formal resemblances between the picture and the actual state of affairs it depicts. The sentence "The red ball is on the white cloth" seems quite different, and in order to understand it as a picture I have to take special note of the fact that the ball, the cloth, and the relation between them are all "united in the sentence-fact" in the way that the physical denotata are united. Black seems fairly reconciled to this notion: "Since concatenation of elements in the sentence-fact means concatenation of the co-ordinated elements in the represented state of affairs, it is not far-fetched to detect a residual 'iconicity' even in a sentence" (89). Or is it? Do we really want a "residual" property to be the strongest link between our rather attenuated concept of "picture" and the sentences that we wish it to exemplify? And why isn't Wittgenstein more concerned about this — at least as concerned, we might ask, as Black is when he finds himself inventing this dubious example? Why doesn't he notice that he is left with "rather unexciting" correspondences when it comes to sentences?

Wittgenstein might have replied that the "determinate" picture, with its strict "elements" and "pictorial form," is very much like a sentence, and that Black's example takes "picture" too much as something that resembles and not enough as something that has structure. But what is at stake in the reading I am pursuing here is the concept of "picture" itself, which is sorely tried by this development. What is left of "picture," aside from its potentially "determined," well-articulated structure of pseudolinguistic "elements" and its various "forms of depiction"?

Wittgenstein knew he was being vague about pictures. G. E. Moore records some of his thoughts about that, in lectures given in the early 1930s:

In connection with the *Tractatus* statement that propositions . . . are "pictures," he said that he had not at that time noticed that "picture" was vague; but he still . . . thought it "useful to say 'A

36. Stenius, Wittgenstein's "Tractatus," 179, 181.

proposition is a picture *or something like one*'" although . . . he was willing to admit that to call a proposition a "picture" was misleading; that propositions are not pictures "in any ordinary sense"; and that so say they are, "merely stresses a certain aspect of the grammar of the word 'proposition'— merely stresses that our uses of the words 'proposition' and 'picture' follow similar rules."[37]

Stenius remarks that "one often has the impression that when [Wittgenstein] later speaks of themes related to the picture theory he, as it were, asks himself 'What did I really mean?' and does not find an answer to this question." In this regard the *Tractatus* is "vague," and so it stands to reason that Wittgenstein might have had a hard time recalling what *picture* had once meant.[38] Yet despite his memory that he had not noticed the vagueness when he was writing the *Tractatus,* there is some evidence that he did know some aspects of the theory were vague. In 4.011, he says that sign languages are pictures, "even in the ordinary sense, of what they represent," which Black calls an "important remark" that "can hardly be defended." "In this passage," Black thinks, "Wittgenstein seems to be aware that he has stretched the ordinary meaning of 'picture.'"[39]

The vagueness and the stretching go hand in hand throughout the *Tractatus.* At times the operations that would be required to revive the flagging "picture" are so extensive that they seem rather hopeless. Black makes a list of the "modifications" that are needed in Wittgenstein's doctrine to make the form and structure of pictures "fit the most general case of a representation" (90). First, we can no longer insist that elements in a picture resemble their denotata, so that iconicity needs to be replaced by some more general "abstract notion of one-to-one correspondence." And there can no longer be an identity between arrangements of elements in pictures and in real-world denotata; instead we have to speak about "*homology* of arrangements." The spatial arrangements in a musical score are homologous but not identical with the temporal relations in a performance. And third, "homomorphic structures may still be held to have something 'in common,' namely a *pattern* of relationships, indifferently exemplified by each member of a class of mutually homomorphic structures.

So, in a *very* abstract sense of 'same form,' we might still say that representation and what it represents have the same form (in my terminology, are homomorphic)" (91). This is "*very* abstract" indeed. Is there any reason not to abandon the word *picture* altogether, in favor of some neologism that would express its nonvisual meanings a little more accurately? Why not call "picture" something like *determinate depiction-vehicle?*

In my reading, the most compelling thing about the picture theory is this very abuse of the concept "picture." No matter how much it is distorted, its vernacular meaning remains indispensable. It is saved from disappearing into a nonvisual proposition by the vagueness that cloaks it, but it also repeatedly calls out for the kind of clarity that would ultimately destroy it. In terms of the philosophic claims of the *Tractatus,* this is a crucial elision on Wittgenstein's part, although we might also describe it as a calculated decision, as it allows the picture theory to remain afloat.

A harried sense of "picture" might be the inescapable sign, condition, and constitutive state of any such attempt. The fact that current visual theory harasses the notion of "picture" so consistently and resourcefully might be part of the desire to collapse the dual sense of pictures in order to both know and not know pictures, to have them both as analytic "propositions" and wordless objects. In terms of my own agenda, and the potential meaning of the *Tractatus* for visual art, the moral could be put something like this: Any attempt to escape from the word–image opposition by fusing *word* and *image* will involve doing some violence to the vernacular meanings of *picture,* and that violence might be expressed most powerfully in the *Tractatus.*

37. G. E. Moore, "Wittgenstein's Lectures in 1930–33," in *Philosophical Papers* (London: Allen and Unwin, 1959), 252–324, esp. 263, quoted in Black, *Companion,* 162–63.

38. Stenius, "Picture Theory," 134.

39. See further paragraph 4.013, which notes that the "essence" of "pictorial character" of propositions is "*not impaired by apparent irregularities* (such as the use of [sharp] and [flat] in musical notation)," and 4.0141, which observes that "there is a general rule by means of which the musician can obtain the symphony from the score"— a statement that I would imagine has entertained Nelson Goodman, as the bulk of *Languages of Art* is given over to specifying that what might mean.

In Wittgenstein's hands, *picture* nearly becomes — to use a word that plays a central role in sections 6 and 7 of the *Tractatus* — "nonsensical," *unsinnig* (376, 380). In literary terms, the picture theory can be read as the result of an intense desire to have exactness of concepts together with "mysticism," not only in the realm of "silence" but in the most immediate, familiar, unanalytic, unphilosophic interpretation. "Picture" is familiar and unfamiliar, "shown" and "said," defined and undefined, a term from the fine arts and from philosophy. Perhaps — to strike a somewhat extravagant note — it might even be that the true *object* of attempting to escape from the dual sense of pictures is to harass the concept.

5 : Pictures as Ruined Notations

Wittgenstein's newly minted sense of the word *picture* will be very helpful later in this book. The second text I want to assay is just as determined (or overdetermined), but with a crucial difference: Nelson Goodman feels the force of the desire that pictures should make sense — that they should "say" and not merely "show" — but he displaces his analytic ferocity onto an apparently less important class of images, and ends up inventing a term, *notation,* to describe what he finds. The displacement has a number of interesting consequences for contemporary senses of pictures.

Within the philosophic community, *Languages of Art* has generated a large secondary literature devoted to expanding and challenging its ideas.[1] In art history and criticism, it tends to appear forbidding, dry (and Goodman raises that theme toward the end of the book, when he makes a case for the breadth and depth of analytic cognition over inchoate emotion), and at the same time somewhat useless and irrelevant. For students of art history, *Languages of Art* is often a kind of trial by fire, and that experience later shows its effects in the way that Goodman tends to remain in footnotes. Goodman's claims work with great clarity when they have to do with what he calls "notational systems," and they work with more or less efficacy when it comes to marginal cases such as charts and pressure gauges. But the book seems to have little to say about pictures as they are usually understood.

Essentially I will be arguing that the dense, logical prose that does not seem to apply to pictures actually applies *best* to pictures. The ideal of a perfect "notational system" — an image that functions in a reasonable, systematic and rational way in its dealing with symbols and the world — is behind the informal approaches we all take to works of visual art. In effect, Goodman has provided an exemplary account of one pole of the dual sense of pictures, and then set it unhelpfully in a text that

centers on notations, graphs, charts, maps, and schemata. His criteria take the desire for meaning much farther toward analytic exactitude than Wittgenstein's concept of proposition. Wittgenstein remarked that he had only good manners, *gute Manieren,* when he made art (Plate 5.1). There is a tempting parallel to be made between the simplified forms that he borrowed from contemporary sculptors and the propositional, schematic nature of pictures in the picture theory. Everything is simple and orderly: *Gute Manieren* are also logical. It may be, on the other hand, that Goodman's analyses could not have been pushed so far if they had not been displaced onto notations.

THE FIVE CRITERIA OF NOTATION

Because analytic precision is at issue, it is necessary to review the relevant theory with some attention to detail. The most dense, and also the most important, part of *Languages of Art* is the opening of chapter 4, in which Goodman sets out a formal

1. Despite many local challanges, the principal rival account remains E. H. Gombrich's; see Gombrich, "The 'What' and the 'How': Perspective Representation and the Phenomenal World," in *Logic and Art: Essays in Honor of Nelson Goodman,* ed. Richard Rudner and Israel Scheffler (Indianapolis: Bobbs-Merrill, 1972), 129–49.

theory of notation based on five criteria. "Marks," he writes, are what we perceive in images as well as in utterances, gestures, and tones. Imagine a very sloppily drawn circle, dashed off so that the beginning of the arc does not connect with the end. In Zen, such a calligraphic circle is an *enso,* a sign denoting "simplicity with profundity, emptiness with fullness, the visible and the invisible," although in Zen fashion it can also represent the moon and a rice cake.[2] To Goodman, we understand the mark by assigning it to a character. Thus the circle might be read as the character called *enso,* or else as an O (that is, the letter after N), or as a o (the number zero). Judging the correspondences between marks and their characters is the province of syntax in Goodman's sense. (Later in the book I will be using it in two different ways.) After we decide which character the calligraphic mark denotes, we interpret it by assigning it to "denotata" such as simplicity, profundity, or rice cakes. Judging the relation between characters and their referents is the domain of semantics. Many different kinds of art obey namable rules of syntax and semantics, but only a few are sufficiently strict to qualify as notations. Of the five criteria of notation, two are syntactic and three semantic.

Consider then the set of natural numbers 0, 1, 2, 3, and so on. The marks involved are whatever shapes my computer screen shows, or my hand scrawls; the characters are the abstract numbers; and the denotata are real-world collections of objects such as three apples or four hens. The first criterion for the set of natural numbers to be a notation is that it be *syntactically disjoint.* That is, there should be no marks that can be assigned to more than one character. If the symbol § (which has no name, and is simply called "section") is to be read in this system, it must be assigned to 0 or 6, but not both. (There is more to this criterion, and we will encounter it again later in the book; for now, disjunction is the essential point.) The second criterion is that the system be *syntactically finitely differentiated* or *articulate,* so that it must always be possible to tell if a mark belongs to a character. The section mark § would never be mistaken for a natural number: 6 and 9 have closed loops with one tail, but no natural number has a closed loop and two tails. If a system is not articulate, it is *dense:* in this case, for instance, there might be an infinite number of characters partway between 6

and 9 that have ever so slightly different lengths of tail. These are the two syntactic requirements pertaining to the relations between mark and character; the remaining three are semantic, and have to do with characters and the things they denote.

A notational system must also be *semantically unambiguous,* meaning that there must be no character that means ambiguously six objects or ten objects. In the natural numbers, there is no such character, and so we would have to invent one — say, § refers ambiguously to 6 or 9. (In linguistics, the failure to meet semantic unambiguousness is called *polyphony,* the state in which a sign can denote more than one phonetic group or word.) Fourth, notations must be *semantically disjoint,* meaning that numbers 6 and 9 must not be possible ways of referring to a collection of 6 objects. To say it the other way around: It must be impossible to count a given number of objects correctly using more than one natural number. (In linguistics, the failure to meet semantic disjunction is *homophony,* the state in which one phonetic group or word can be signified by more than one sign. Some languages, such as Akkadian cuneiform, are strongly homophonic and polyphonic.)[3] And last, a notation should be *semantically finitely differentiated,* so that there should be no such thing as a number of objects (say, 6½) that cannot be definitely assigned to a character in the system, in this case 6 or 7. If that happens, then the system is said to be *semantically dense* — there will be intermediate objects that have no sure places in the system.[4] These are the five requirements for a notational system, and together they ensure a one-to-one correspondence between the notation (the musical score, the dance notation, the graph) and real-world denotata (a performance, a dance, a set of data). The performance might be verified as an instance of the score, and the score determines indispensable features of the performance. There is a strict correlation, in other words, between the notational schema and the artwork; all other systems of art are less tightly constrained.

2. John Stevens, *Sacred Calligraphy of the East* (Boulder, Colo., and London: Shambhala, 1981), 190.

3. Gene Cragg, "Other Languages," in Daniels and Bright (1996), 58–72, esp. 58.

4. Goodman, *Languages of Art,* 2nd ed. (Indianapolis: Hackett, 1976), 133, 135, 148, 151, 152, respectively, for the five requirements.

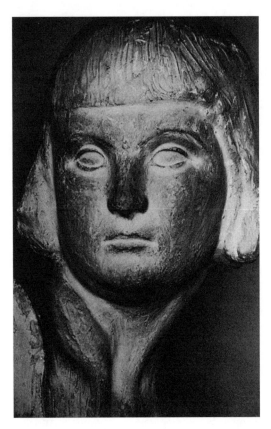

PLATE 5.1 *Wittgenstein.* Portrait Bust.

Associated with this is the concept of "replete" and "attenuated" dense symbol systems. Goodman's examples are a small segment of an electrocardiogram that looks like Mt. Fuji and a Hokusai drawing of Mt. Fuji.[5] It's a typically unlikely pictorial example, and Goodman does not illustrate it. Again I take that to be relevant, and here I reproduce a detail of a print (which was, of course, taken from an inkbrush drawing) with the kind of single line he has in mind (Plate 5.2).

The electrocardiogram, he claims, can be indifferently red, green, thick, or thin, and it will mean the same. All that counts is the relation of the line to x and y axes. Its wavy line is mostly comprised of "contingent" symbols, and not much of it is "constitutive" of meaning. The drawing of Mt. Fuji is different, as its colors, thickness, and background are all constitutive. It is "replete," because every namable property is constitutive, and the electrocardiogram is "attenuated," because many properties can be altered and its syntactic function will not change. Pictures, Goodman concludes, are more often more replete than diagrams.

In Goodman's argument, density is a characteristic feature of pictorial denotation, but it also leads to odd conclusions, as it compels him to say that things such as ungraduated thermometers "depict" temperature. Repleteness helps exclude such anomalies and move pictorial denotation a little closer to its ordinary usage, because an ungraduated thermometer is "of minimal repleteness": it doesn't matter what color the mercury is, or how thick it is, but only how high the column rises at any given moment.[6] Density and repleteness are a pair: Neither one alone is enough to describe pictorial denotation, but together they do a fairly good job, Goodman says, at bringing his notion of the concept in line with the ordinary notion — that is, a picture is something that resembles its object.

WHEN NOTATION BREAKS DOWN

These are the relevant fundamentals of Goodman's theory of notation. At this point I want to ease from the opening examples toward the question of pictures in the ordinary sense (and especially paintings) by looking briefly at a computer-generated printout of part of the mathematical object known as the Mandelbrot set (Plate 5.3). The black portion at the bottom, which dissolves into "fractal dust," is a portion of the Mandelbrot set, a mathematical object distantly akin to any graphed parabola or circle. The printout was done in a low-resolution monochrome window, 256 pixels on each side, so that individual pixels (black squares) remain visible. Each pixel denotes an area on the plane, and the computer takes a single point within each area and lets it stand for the entire area. At the top, the computer has measured a certain property in each area and has assigned a color value to each pixel. The "colors" are patterns formed by more than one pixel (some patterns require 16 pixels to form their repeating unit). Counting from the top, there are 18 "color" bands. In this image, the marks are the slightly irregular black squares; the characters are the computer's decisions to assign a square either black, white, or some intermediate patterned color. The object that

5. Goodman, *Languages,* 229.

6. Goodman, "Routes of Reference," in *Of Mind and Other Matters* (Cambridge, Mass.: Harvard University Press, 1984), 58.

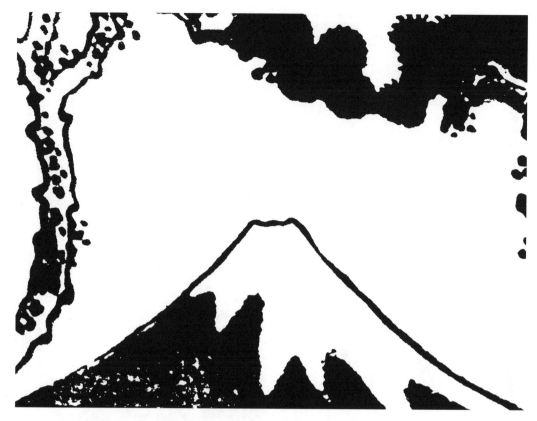

PLATE 5.2 *Hokusai.* Fuji from Hodogaya. *Detail. Late 1820s.*

the characters denote are the fundamental and related equations of the Mandelbrot set (that is, those that specify the form itself, and those that produce the criteria for the colors).

At the bottom of the printout, every black pixel can be invisibly interchanged with any other black pixel; all are syntactically equal. Problems arise because the lowest color bands are so diffuse that it is difficult to tell them from the individual pixels of the Mandelbrot set itself. Some squares at the left center of the image, where the Mandelbrot "filaments" seem to vanish, are undecidably part of the black Mandelbrot set and part of the color shading; and they are also undecidably single pixels and parts of indecipherable fragmented patterns.

The image of the Mandelbrot set is almost a fully fledged notation: It has a character set that is syntactically finitely differentiated (a black square cannot denote two colors at once), and it is semantically disjoint (a color refers to a single property of the set) and finitely differentiated (it is always possible to tell if a given color denotes a certain property). It has problems, however, with the second

criterion of a notation — syntactic finite differentiation — because some pixels might ambiguously denote black areas and others might mean light-patterned colors.[7] It seems to me that this condition, in which a mark might or might not denote a given character, is the typical condition of pictures; but it is also the only portion of this rather indifferent image that is even a little interesting. This is often the case with Goodman's theories: They become interesting exactly when they break down. That notion can be developed by taking a close look at two further examples, a diagram and a painting.

The sonar chart (see Plate 3.3) is a beautiful image, and for me it conjures thoughts of a sunset landscape, with overhanging clouds and birds, and at the same time it is a sinister image of missiles against a glowing sky. Those associations might not

7. Goodman might say that the image is a flawless instance of notation, as these ambiguities can be resolved by examining the software routines in the program, or by increasing the resolution. But I am concentrating here on the image as it is given.

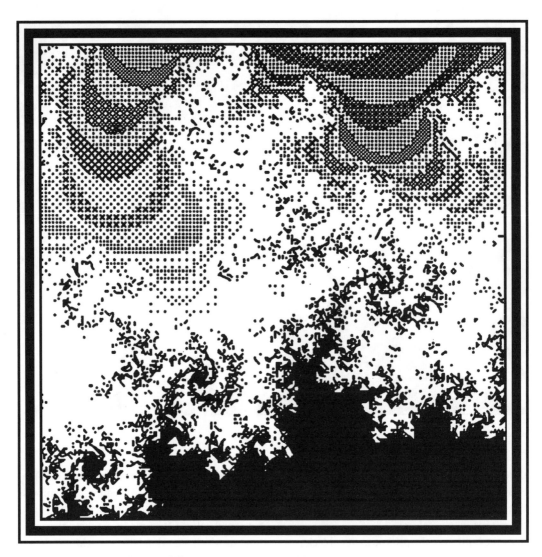

PLATE 5.3 *Portion of the Mandelbrot set.*

be irrelevant — and I will return to them — but the picture also has well-defined denotata. The "hills" are the lake bottom, and the cloudy shapes are either schools of small fish, algae, or echoes caused by temperature inversions. Inverted checkmarks are larger fish, or schools of smaller fish. The flocks of tiny checkmarks (most of them at the 42-foot depth, and some deeper, around 100 feet) are fish too small to snag. The boat moves while it makes the graph, so that a vertical strip of the graph shows what is happening under the boat at any moment. Hence this is not a moment in time, such as a snapshot might record, but a blurred narrative. As the boat comes up on a fish, it records first the end of the fish (front or back), then its middle, and then its end — yielding the inverted checkmark. If a

fish is rising while it is being scanned, the checkmark will rise, and if it is swimming with the boat, the checkmark will be elongated. A large fish crossing under the boat might appear short for the same reason.

Clearly there are some syntactically disjoint characters in this chart, and part of it — the horizontal graph with its numbers — would qualify as a notational system. What about the remainder? An initial problem in considering syntax is identifying marks and characters. To begin with, the marks are dense. Inverted checkmarks can be very small, so they disintegrate into the dust that is scattered across the entire image (this happens, for example, at the lower left), and they can also become indistinguishable from the haze of surface algae.

Characters, on the other hand, might or might not be dense, depending on how they are construed. According to the fisherman who piloted this boat, there are four classes of objects that cause marks: schools or algae, temperature inversions, small fish (denoted by checkmarks), and large fish (denoted by crescents). This is what the fisherman said, and it was his way of advising me what he was doing when he used the sonar to guide the boat. But there is another possibility that is more complex. Each of these character sets might be continuous and dense: "large fish" might come in an infinity of large sizes, and algae clouds might be as large as the image field or as small as a single dot. "Small fish" might overlap imperceptibly with "large fish." There are various configurations; let us call all such options strict sets, and call the simpler, disjoint sets lenient sets. I will return to this choice; for now, let us assume the strict set of character sets.

A given checkmark might belong to either the character for "small fish" or for "algae," but it must belong to one or the other. Hence the sonar chart is syntactically disjoint. But the chart lacks the second property of a notation — syntactic finite differentiation or articulation. Small inverted checkmarks might denote algae, small fish, or "background clutter" (the isolated points sprinkled across the image), and there is no way to decide which they might be. Because these decisions are impossible to make (even though the fisherman's experience led him to make many guesses along these lines), the chart is not syntactically finitely differentiated.

Let us pause a moment and consider the parallel with pictures. The sonar chart is not syntactically finitely differentiated, and therefore it is dense. Its marks cannot be assigned with confidence to single characters. It is also "replete," because an indeterminate number of qualities of any given mark might be significant (a mark's exact shape might have bearing on the fish's species, its speed and direction, as well as its size). The individual inverted checkmarks are not like the accents in a printed diacritical system (such as ∧ or ′) because they are not interchangeable within the syntactical schema. Goodman uses both *density* and *repleteness* to describe pictures. Speaking of the Hokusai fragment, he says that no "thickening or thinning of the line, its color, its contrast with the background, its size, even the qualities of the paper" can be ignored.[8]

The analysis does not differentiate between the density of marks in the sonar chart and in, say, a landscape by George Inness (Plate 5.4), except to suggest that they might possess different degrees of repleteness.

Although density and repleteness are apposite for both images, they are also barren because they do not lead anywhere except to the realization that every change in a pictorial mark might be meaningful. And is that ever true? Is it necessary to rescind interpretive control over such images? On the contrary: It is impossible, I think, to experience pure density or repleteness, and we do not assume them in either image. In fact, the very idea of understanding a picture comes from the undeliberated decision that only some changes would be meaningful or significant.

In the Inness painting, I think we assume fairly stable and straightforward character sets. For the sky, we might say "calm sky" and "stormy sky," or else "cumulus clouds," "stratus clouds," and "blue sky." For the land, we might say "elm trees" and "pine trees," or more generally, "forest," or more particularly, "trunks," "crowns," and "branches." A truly cursory reading might yield "land" and "sky," or even "picture," and a botanist might see more, but these are reasonable examples. As for marks, we might see "horizontal strokes," "zigzags," and "scumbling marks," and perhaps a few more. My point here is that we apprehend the picture by assuming a radically simple, largely disjoint, and extremely lenient set of characters and marks. Our seeing of the picture weaves those marks and characters together with a developing awareness that they are not so simply related, and that the painting is successfully dense. But no seeing is possible, I think, without the assumption of these kinds of workable sets.

So we assume lenient sets of marks and characters, even where they are demonstrably dense, and we assume specific degrees of repleteness even where there is no clear basis to do so. Not all clouds need to be stratus or cumulus, and, meteorologically speaking, there is a continuum of cloud types, beginning with cumulostratus. But there is a partly namable lenient set of nondense characters that Inness chooses from to make his forms, and we need to partly know and acknowledge that. There

8. Goodman, *Languages*, 229.

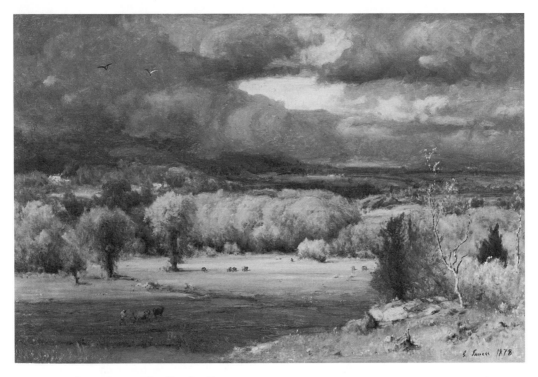

PLATE 5.4 *George Inness.* The Coming Storm. *1878.*

is near synonymy, "slant rhyme" as it is called in poetics, between these marks and characters, just as there is between the checkmarks and the crescents of the sonar chart. Painting, I am arguing, is just the place in which these inappropriate and obviously false ideas come into play. Without the weaving awareness of disjointness and fusion, there would be less pleasure in seeing; but without the initial and ongoing notion of disjoint and simple lenient sets, there would be no hope of perceiving the painting at all.

Semantic requirements might be less pressing in the sonar chart because they are logically posterior to the matter of syntax, but they do not offer much analytic solace. Let us assume that small fish come in all sizes, from macroscopic hatchling to three-inch fish, and let us also assume that the larger fish — the ones we were after the day I collected this chart — go on up to ten inches. Say that most large fish are around eight inches, and most small fish are around one inch. Those gradients, together with algae, temperature inversions, and a miscellany of tires and floating debris, would constitute the compliance classes for semantic analysis. Within most classes, real-world objects are assumed to be dense; this is what Goodman calls a

"dense-ordering specification," a requirement or assumption that real-world denotata are dense.[9] Our lenient character sets, on the other hand, are less dense, less likely to overlap, and more pragmatic. Lenient compliance classes tend to overlap less, if only because they take account of practical possibilities, probabilities, and habits of reading. Strictly speaking, however, compliance classes intersect, because a small checkmark might be a large or a small fish; but a fish cannot be both, and so the chart is semantically disjoint. Any given object might comply with several characters (a small fish might yield a small checkmark or part of an undifferentiated "algae cloud"), so that the chart is not semantically finitely differentiated. Both painting and chart fail to be notations, and in *Languages of Art,* Goodman's analysis would end with that observation.

MISREADING GOODMAN'S NOTATION

I'm heading toward an intentional misreading of Goodman's use of "notation," and I want to fortify my misprision by considering what happens

9. Goodman, *Languages,* 227.

when two crucial concepts — the polarity repleteness/attenuation, and the idea of a system — are read as if they were about the ordinary historical reception of pictures. Attenuation's ultimate form is the state of "character-indifference" that allows one instance of the letter O to be substituted for any other.[10] In Goodman's example, the electrocardiogram only displays one syntactically significant feature, and the letter O has only a few more — it is a closed loop, with no further marks, and that is all that is needed to differentiate it from other letters. Nothing further about its shape changes its syntactic functions. On the other hand, repleteness is hypersensitive to change. Anything in the Hokusai line might be significant, and nothing can be ignored.

Both of these situations seem questionable. In the case of the Hokusai, consider the possible variations on the line. It might change shape if more than one line block existed. One print might be overinked, so that the line might be soft and wider than normal. The press might have been overweighted, so that the impression made a strong relief. The paper might vary from one example to the next. The ink might become a little bluer, or a little warmer. The line might be overlapped by the adjacent colors from the other blocks.

I would say that we have a fairly good idea in advance about which of these are syntactically significant — that is, which will correspond to the meanings art history might propose. The shade of the ink will probably not seem significant, even if we notice it; by agreement, as it were, the shade is close enough. On the other hand, if the line blurs a little from overinking, the entire plate might look impressionistic, and that would certainly change its expressive value. Several conclusions might follow. First, marks are not consistently perceived to be dense but comprise a very specific set of disjoint elements. And second, repleteness is fictional, because we would be hard-pressed to name even a few more variations that might be syntactically meaningful. Even if we imagine that the shape of the line might somehow vary with every print, it is far from the case that we would read every alteration as syntactically significant. Many would be invisible, because they would not correspond to any known styles, periods, strategies or genres that we know how to read.

Problems also occur on the other end of the

spectrum, in the region of increasing attenuation. In a notation, Goodman writes, members of a character can be "freely exchanged . . . without any syntactical effect." He calls this "character-indifference."[11] Thus 10 and ten can be used interchangeably as far as numerical operations are concerned. Even here, though, we might wonder.[12] Is it really irrelevant that mathematicians do not write

$$\mathbf{10} + \mathit{10} = 20 \, ?$$

This might seem like an inappropriate question, because the mathematical syntax is unaltered by italics and font substitution. But to a mathematician, this equation would look as if it might have additional meaning — perhaps it will depend on a key explaining the significance of boldface and italics. The history of mathematical notation is full of typographic arrangements like the one just given.[13] Even if the mathematician knew that there was no key (for example, if she were reading the equation in this text), it would still not be equivalent to

$$10 + 10 = 20.$$

The same might be said of music notation, which is Goodman's chief example.[14] Some of the bars that link quarter- and eighth-notes tilt up and down, and others are level. Over the centuries

10. An instance of character indifference in linguistics is the distinction between *word types* and *word tokens,* in which the latter are instances of the former. *Word types* are character-indifferent. *Word tokens* might not be. I am not using that terminology here partly because characters are more general than words.

11. Goodman, *Languages,* 131–32.

12. An analogous argument is advanced under the name "integrational semiology" in Harris (1995), esp. 84–85 and 105.

13. Florian Cajori, *A History of Mathematical Notations* (Chicago: Open Court, [1928–29]), 2 vols.

14. In this connection, see W. Webster, "Music Is Not a Notational System," *Journal of Aesthetics and Art Criticism* 29 (1971): 489–97, and Benjamin Boretz, "Nelson Goodman's *Languages of Art* from a Musical Point of View," *Perspectives on Contemporary Music Theory* (New York: W. W. Norton, 1972), 31–44. I thank Jason Matheny for bringing these and the following sources to my attention.

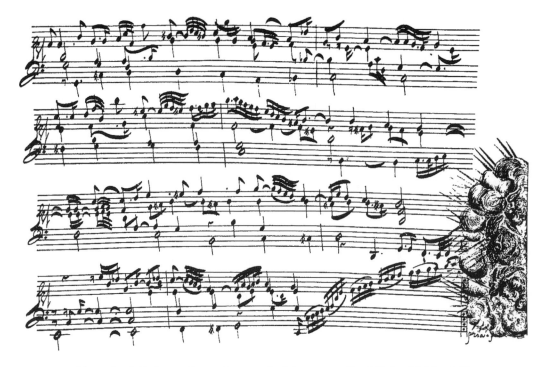

PLATE 5.5 *Johann Jacob Froberger.* Lamento sopra la dolorosa perdita della Real Majestà di Ferdinando IV, Rè de Romani (Lament on the Death of Ferdinand IV, King of the Romans), *final manuscript page.*

the rules governing their length and orientation have changed, and in handwritten manuscripts the marks denoting those bars can even have distinct curves. Bach liked to write his notes as Baroque flourishes, so that they seem to fly up and down following the melody. The same happens in many Baroque pieces; the tied notes in Johann Jacob Froberger's beautiful *Lament on the Death of Ferdinand IV* swing gently up and down, and then finally curve languorously up through three octaves, vanishing into a vision of heaven that shines with angels and barbs of light (Plate 5.5). Even in printed scores, typographic differences can make a single work look quite different. On the dedication page, all the bars are level, contributing to the even-tempered feel of the melody: It would be different if they slanted up in the first two measures. These variations, I think, have distinct effects on performance: The same piece might sound perceptibly different when it is played from different scores. Is there such a thing, therefore, as a freely exchangeable character?

In Goodman's account, there is a ready answer to this kind of objection: He would say that I am talking about marks and not characters. The char-

acters remain "indifferent," and what I am doing is reading other properties of the marks as if they pertain to different character sets. A bar tying a group of eighth-notes signifies a grouping independently of its orientation, but it also signifies a speed, and even an *accelerando,* by its orientation, its thickness, and possibly its curves. (Just as the word *accelerando* accelerates when it is set in italics.) I would therefore be claiming that the bars are more replete than they are usually taken to be, and not threatening the assumption that the character sets are "character indifferent."

But is that an adequate response? Is there a firm distinction between ordinary music notation and contemporary classical composers' wilder inventions, in which pages turn into elaborate schemata, maps, grids, tables, fragments, gestural abstractions, and even pure "pictures"?[15] How many

15. On modern music notation, see for example Gardiner Read, "Self-Indulgent Notational Aberrations," *World of Music* 15, no. 1 (1973): 36–49; Franzpeter Goebels, "Gestalt und Gestaltung musikalischer Grafik," *Melos* 39, no. 1 (1972): 23–34; and D. Charles, "La Musique et l'écriture," *Musique en jeu* 13 (1973): 3–13. Gardiner Read has pointed out that the most idiosyncratic notations are often the most rigidly prescriptive

properties of characters in music or in mathematics are truly without syntactic significance? (Even though contemporary graphic innovations in music notation are often looked on as irrelevant experiments, how can their "pictorial" forms *not* influence performance?) Is the number 10 really as "attenuated," as free of properties that are not "character-indifferent," as it is advertised to be? It seems to me that no character is freely exchangeable, and most characters are strongly replete. Non-Western societies sometimes use "concrete counting," in which ten of one object will use a different word than ten of another. Fiji Islanders, for example, call ten boats *bola* and ten coconuts *boro.*[16] Can we entirely ignore that part of our thinking, because we have adopted a uniform vocabulary? There are two ways to think of the collection of M's in Plate 5.6: either as instances of a single character, or as slightly but significantly different *choices*. Because the author who collected these was working in the first decades of this century, near the height of the nationalistic renascence of "Gothic" *Fraktur,* it is sensible to conclude that many — if not all — of these 258 fonts had specific ideological and cultural force. Some look back to the Renaissance; others are neo-Gothic inventions; and I suspect a few might have seemed tainted by the elitism of modern art.[17] In more distant cultures, the question only becomes more insistent. The translation of the cuneiform script known as proto-Elamite is stalled, partly because the archaeologists initially cataloged the marks as if each one was a character, so that they ended up with more than 5,000 characters (Plate 5.7). It has been argued that far fewer characters will do.[18] But how can we know what has syntactic significance?

We lack words and concepts, often, to say what the syntactic effects of formal alterations might be, but they are present nevertheless. As typographers and graphic designers know, every typeface has meaning: Typography is mechanized or computerized calligraphy. And it is not unreasonable to say the same of mathematical notation. I would not deny that we possess the idea of a freely exchangeable letter O, but I would question whether

syntactical meaning in painting or in mathematics can ever be discussed apart from the contributions of more or less replete marks. In effect, I would not so much wonder if character can be defined apart from mark, as whether their separation can ever make practical interpretive sense.

A second root problem concerns the concept of system, which is central to *Languages of Art*. It is presupposed in the beginning, when Goodman mentions "symbol systems" as a "strict" alternative to the word *languages* in his title. Throughout the text, *system* names the relationship between marks, characters, and compliance classes. (He reserves *schema* for syntactic relations, and *system* for full, semantic and syntactic relations.) Whether or not it is notational, a system is something comprised by rules. The five conditions for a notation are "negative and general," and so most systems will be known only by the absence of certain criteria.[19] But is that enough to justify calling them *systems*?

In mathematical terms, a system is different from a set, because the former contains the latter. Systems might be expressed in the form (A, 0, ∧), where *A* is the set in question (for instance, the natural numbers), *o* is a member of the set (such as the number 0), and ∧ is a unary operation on a member of the set *A* that can generate the members *o*, *o ′*, *o ″*, and so forth. For example, ∧ might be the operation of addition:[20]

$$\wedge(n) \rightarrow (n + 1).$$

16. See Denise Schmandt-Besserat, "Before Numerals," *Visible Language* 18 (1984): 48–60. As she points out, we still say "a couple of days" and "a pair of shoes," or "a herd of cows" and "a pride of lions," and so forth (51).

17. The book, Konrad Haebler's *Typenrepertorium der Wiegendrucke,* vol. 1, *Deutschland und seine Nachbarländer* (Halle: Rudolf Haput, 1905), is the first volume of a monumental study of European typefaces. The plate is only the reference to the *types* of M's that the text explores in more detail.

18. William C. Brice, "Studies in the Structure of Some Ancient Scripts," *John Rylands Library Bulletin* 45 (1962–63): 15–39, esp. fig. 1; and Robert Englund, "The Proto-Elamite Script," in Daniels and Bright (1996), 160–64.

19. Goodman, *Languages,* xii, 130, 160, 154.

20. See for example Stephen Cole Kleene, *Introduction to Metamathematics* (New York: Van Nostrand, 1952), 24ff. It was Joel Snyder's suggestion to concentrate on the meaning of "system" in considering Goodman, although the exposition is mine.

(that is, notational in Goodman's sense); but the more graphical and pictorial a notation is, the less likely it is to be understood as prescribing any limits to performance. Read, "The Dilemma of Notation," *Composer (USA)* 3, no. 1 (1971): 17–25.

Übersichtstafel der M-Formen.

1	2	3	4	5	6	7	8
9	10	11	12	13	14	15	16
17	18	19	20	21	22	23	24
25	26	27	28	29	30	31	32
33	34	35	36	37	38	39	40
41	42	43	44	45	46	47	48
49	50	51	52	53	54	55	56
57	57ᵇ	58	59	60	61	62	63
64	65	66	67	68	69	70	71
72	73	74	75	76	77	78	79
80	81	82	83	84	85	86	87
88	89	90	91	92	93	94	95
96	97	98	99	100	101		

PLATE 5.6 *Konrad Haebler. Page of M's.*

78 : THE DOMAIN OF IMAGES

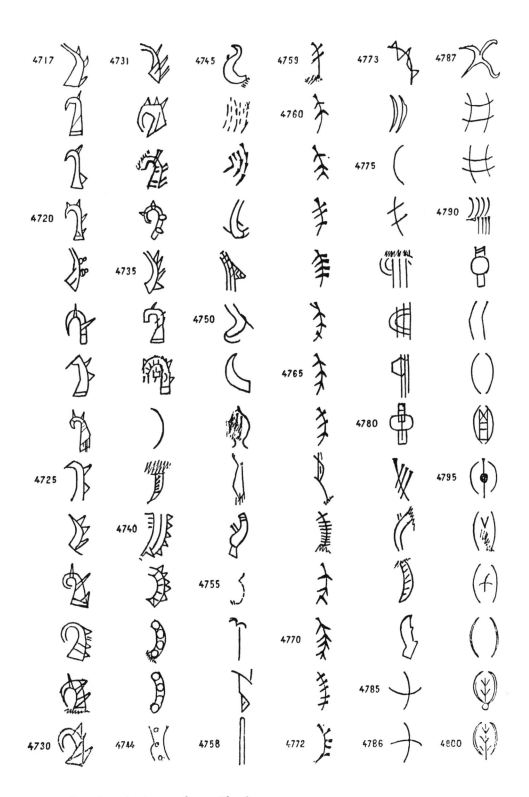

PLATE 5.7 *Page from the signary of proto-Elamite.*

If we step aside from the form (A, o, ∧), we lose the sense of the word *system*. Because a painting has neither a set of characters nor sample members in that set nor operations that would allow us to combine and transpose elements, it is not in any positive sense a system. The problem here is not that Goodman does not make positive distinctions among "systems" that are not notational (nothing compels him to do so, once he has set out his criteria for notation); it is that there is very little sense in calling nonnotational images "systems." *Languages of Art* leaves art out in the cold by failing to make much sense of how a "dense schemes" might operate.

One of the book's principal conclusions — the debunking of the connection between representation and resemblance — is marked by this same analytic absence. Considering relations within notational systems, Goodman makes the case that "descriptions are distinguished from depictions not through being more arbitrary but through belonging to articulate rather than dense schemes," so that "resemblance disappears as a criterion for representation." That puts him in a position to make a claim against Peirce's "iconic" and "symbolic" signs, as any sign might be understood as "iconic" — that is, representational — if it is related in certain ways to other signs, but no sign will be iconic in all symbol systems. Peirce's distinction, Goodman writes, becomes "transient and trivial."[21] This is a major analytic victory, but its power depends entirely on how well he can characterize nonnotational "systems," because without a sensible way to talk about what happens in such cases, Peirce's distinctions threaten to become the better-articulated alternative.

WHAT IS A PICTURE?

These problems are most visible when it comes to misapplying Goodman's categories far outside orderly notation, and I have been heading toward the general conclusion that his theories are at their best and most useful when they are misapplied. Any person looking at any average picture vaguely senses something articulate and "notational." The sonar marks are not reliably connected to fish. They change shape and syntactic function in each fraction of an inch. At the same time, however, they do not blur into an infinitely dense substrate:

They have the feeling of a system, just as we say informally that some pictures show evidence of a "visual language." It is not that pictures should not be discussed as notations because they lack system or possess density; it is that pictures might already be conceived in those terms even when we do not know how or what might be said about them. Sometimes it even seems that there is no other way of perceiving images except by thinking of the feeling of systems. The sonar chart is not syntactically disjunct, but it is close, and that closeness is what launches and supports interpretation. So Goodman's concepts, far from being unrewarding when they are applied to pictures, are rewarding when they are productively misused. They model our thought better than we usually care to know.

I do not think Goodman's findings on musical notation are as scandalous as the subsequent literature makes them seem (he claims, for example, that a performance wrong by a single note is not a performance of a work), nor do I think that his problems are always meaningful outside his definitional structures (it is not significant, for example, that his analysis allows us to tell "what performances are instances of a given work").[22] And it seems to me that his strictures are counterintuitive even where they fit best — that is, to notations such as printed music, digital watches, pressure gauges, and Labanotation. But his argument is an articulate model of the confused density of thought we bring to bear on images: It is a clear reflection of something that is originally unclear. Like Wittgenstein's marriage of picture and proposition, the notational theory in *Languages of Art* embodies both extreme points in our dual sense of pictures: the hope that pictures might absolutely make sense, and the contrary hope that they might never make sense. A picture is at one and the same time an object we treat as if it were notational in Goodman's sense, awash in half-realized disjunctions, syntactic and semantic systems, and finite character sets; it is also an object marked only by the absence of all of those properties.

Although I have used both Goodman and Wittgenstein to argue this point, the two lead in very different directions. Wittgenstein's insistence on

21. Goodman, *Languages*, 230–31.
22. The phrase is from Catherine Z. Elgin, *With Reference to Reference* (Indianapolis: Hackett, 1983), 109.

the propositional content of pictures pushes hard on the word *picture*. It makes actual pictures into fusile objects, impossibly reconciling irreconcilable properties. Psychologically, his is the most demanding solution to the hybrid nature of pictures, and the most repressed, because it must continuously deny that it's the *mixture* of showing and saying that makes pictures so compelling. That is why I suggested that Wittgenstein "harasses" or "tortures" the concept of a picture, as well as individual pictures, and I mean that many of us do the same, but more weakly and inconsistently. Goodman, on the other hand, is alert to failures. Ordinary pictures hardly even make it onto his radar screen because he is so intent on finding something pure — but he is also sensitive to the fact that he won't find purity in pictures. In his account (and I mean, as usual, by implication) pictures are ruins in which systematic meaning is wrecked on the shoals of repleteness and density. The theorists jointly map the two principal reactions to the mixed nature of pictures: Wittgenstein is the optimist, speaking for those who want pictures to be coherent objects of study; Goodman is the pessimist, mourning the irreparable damage pictures do to meaning.

In the next chapter I put the concepts of notation and proposition to work in considering how theorists and historians have divided some kinds of images from others. Throughout the text, *picture* remains in question. At times what matters is the idea, the hope, of pure visuality immune to any gloss. In other contexts the contrary hope impels writers to treat pictures as if they possessed legible systems of signs. This, then, is what I mean by "picture," as opposed to the covering terms *image* and *visual artifact*. Pictures are those images taken to be constituted by the in-built vacillation, contradiction, paradox, or uncertainty of "saying" and "showing." Something in them is linguistic, propositional, systematic, or otherwise semiotic. The rest, as Wittgenstein famously said, is "silence." Almost anything can be taken as a picture — a graph, a chart, a painting — and it might or might not resemble the world. But once it is so taken, it becomes the subject of conflicting interpretations, as viewers try to decide between seeing and interpreting.

6 : Problems of Classification

The vacillating sense of picture is an enabling concept for the study of images, and it will animate a number of the inquiries in Part 2. The other elements I have been trying to assemble are a skeptical disinterest in "art" and "nonart" (with "disinterest" taken in its proper sense, denoting neutrality rather than lack of interest), a willingness to see expressive meaning in a wide range of images, and an experimental attitude toward the application of art-historical methodology and historiography to unusual images.

That, at least, has been my argument to this point. One more introductory element remains, and that is the question of how images might be grouped or classified. Given the vastness of the field, it would be imprudent to choose any one criterion or system; instead it seems reasonable to install just enough order to enable the interesting questions to find voice, and to remain open to alternate ways of ordering the material whenever possible. Without a working classification, it would not be possible to recognize affinities between individual images and current problems in art-historical methodology or visual theory. It might be that the art-historical neglect of "nonart" has more to do with the tracklessness of the domain of images than with any other factor. Hence this chapter is a meditation on the notion of classification, as much as a proposal for any one principle of ordering: I argue for several kinds of order and propose that ordering itself is necessary for productive analysis.

THE CASE FOR ONE DOMAIN
OF IMAGES

First is the possibility that we might decline to subdivide images at all, and consider them instead as a single conceptual field, not heterogeneous in any essential way. If this is to be the strategy, then it becomes more important to ask about words such as *image* and *visual artifact* that I have been using as general signifiers throughout the opening chapters. In the Preface, I remarked that both terms function in this book simply as placeholders, denoting the total set of objects under consideration. I have not been making use of the optical valence of *image* or the archaeological connotation of *visual artifact*. Instead they have been denoting the whole set of meaningful patterns on surfaces. *Graphism* is another word that can be used for the same purpose: It is primarily a grammatical filler, a way to provide substance when a sentence requires a word for the largest set of objects covered by this book.

As a general all-purpose signifier, each of these terms has its drawbacks. *Image* is fraught with issues of the propagation and reception of light rays, and it normally belongs to the discourse of vision. *Visual artifact* sounds like a prehistorian's term, or an anthropologist's, and it stresses the "material culture" of an object over its meaning. *Graphism* is technical-sounding and draws attention to the marks and traces that comprise the object. (It also sounds like a habit or a neurotic symptom, rather than a universal behavior.) There are a few other possibilities: *text* has been widely used in recent literary and visual theory to denote any object prone to interpretation, whether it is a book or a painting. The domain of images would then be congru-

ent to the domain of texts, qualified as "written" or "depictive." But even though "text" has some currency in contemporary art history, it continues to sound a little awkward when it is said of a picture, and, most important, it seems to force the issue of pictures' relations to (written) texts. Although it is meant as a neutral term, it is not — as evidenced by the fact that (written) texts do not get called *pictures* or *images*. Later in the book I consider a reason to call all images *writing*, because they share certain properties that are attributed primarily to writing; but that also has its drawbacks — not least because there are many everyday cases in which it is strongly counterintuitive to think of writing while looking at a picture.

Given these rich and uncontrollable connotations, the best choice for a single term is a neologism. I will continue to use *image* and *visual artifact* as nondescriptive placeholders, but when I mean to focus attention on the "domain of images" as a whole I will use the Greek *gramma*, a word that means picture, written letter, and piece of writing. The verb *graphein* is even more open-ended: It means to write, draw, or scratch. Together, *gramma* and *graphein* preserve a memory of a time when the divisions we are so used to did not exist, and they help us remember, when we need to, that picturing and writing are both kinds of "scratching" — that is, marking on and in surfaces.

Gramma and *graphein* come in turn from the Indo-European root **gerebh-*, which provides our most general term for writing, drawing, and scratching.[1] (The asterisk indicates a hypothetical extrapolation from surviving linguistic evidence.) The opacity of *gramma, graphein,* and **gerebh-* to an audience other than historical linguists helps avoid the assumptions that creep in whenever words such as *image, text, graphism,* or *visual artifact* are used, and they also help snap us out of our word–image trance.

THE CASE FOR TWO

"Word and image" is certainly the most common division of *grammae,* and it has been so at least since Horace's *ut pictura poesis.*[2] It can readily be argued that the failure to decide on a distinction between words and images is a conventional part of the Western conversation on pictures and literacy.[3] My object in this book is not to critique

the polarity, but to try to stop it from preventing us from seeing other relations between images.[4] It is a measure of art history's ongoing reticence to engage the wider domain of images that historians still find the word–image opposition so charged with meaning (that is, whether they argue for or against it). There are few images in Part 2 that are not both "read" and "seen" in that they mix "words" (or letters, or writinglike marks) with "images" (or iconic signs, or representational marks). In a deeper sense, the protocols of reading and viewing are at issue in virtually all the images I will consider, and I am aware of my stake in this — that my own interest in images grows when a reader's or viewer's expectations are thwarted and an image becomes opaque to simple "reading" or "viewing."

Yet there are two important dangers in couching all such examples as word–image issues. First, it assumes the existence of a fairly well-constrained sense of *word* and *image.* I do not think that we are

1. "Indo-European Roots," ed. Calvert Watkins, v. *gerebh-,* in *The American Heritage Dictionary* (Boston: Houghton Mifflin, 1982), 1516. For Indo-European, see also T. V. Gamkrelidze and Viach. VS. Ivanov, "The Early History of Indo-European Languages," *Scientific American* 262, no. 3 (March 1990): 110ff.; the same authors' *Indoevropeiskii iazyk i indoevropeitsy, Indo-European and the Indo-Europeans: A Reconstruction and Historical Typological Analysis of a Protolanguage and Protoculture* (Tbilisi: Tbilisi State University, 1984); *When Worlds Collide: The Indo-Europeans and Pre-Indo-Europeans,* ed. John A. C. Greppin and T. L. Markey (Ann Arbor: Karoma, 1990); and J. P. Mallory, *In Search of the Indo-Europeans: Language, Archaeology, and Myth* (London: Thames & Hudson, 1989).

2. The distinction is analyzed but unquestioned as such in Rensselaer Wright Lee, *Ut pictura poesis: The Humanistic Theory of Painting* (New York: W. W. Norton, 1967), and Mario Praz, *Mnemosyne: The Parallel between Literature and the Visual Arts* (Princeton, N.J.: Princeton University Press, 1970).

3. A study might begin with the confusions over emblematic images and texts in the Renaissance; see Scipione Ammirato, *Il rota; overo, dell'imprese* (Naples: Appresso Giovanni Maria Scotto [Scoto], 1562); Pierre Langlois de Bélestat, *Discours des hieroglyphes ægyptiens, emblesmes, devises et armoiries* (Paris: Abel l'Angelier, 1583); and Nicolas Caussin, *De symbolica Aegyptiorum sapientia: in qua symbola, aenigmata, emblema, parabolae historicae apologi hierolyphica . . .* (Coloniae Agrippinae: Apud Ioannem Kinchium, 1654); and Jakob Masen, *Speculum imaginum veritatis occultae, exhibens symbola, emblemata, hieroglyphica, aenigmata . . .* (Coloniae Ubiorum: Sumptibus Ioannis Antonii Kinchii, 1650).

4. For a critique, see Elkins (1998).

in possession of a cogent and relevant concept of either term, and that lack can make word–image studies curiously ineffectual: It's as if the writer sets out to explore word–image relations but ends up finding examples that flawlessly conform to preconceived (and often enough ill-understood) senses of *word* or *image* that had been brought to the material in the first place. The absence of an adequate sense of *word* and *image* is attested not only by the profusion of scholarship on the subject (which does not seem to be united by a comprehensible interpretive platform) but also by the equally large range of words that are used to name the putative difference. My tendency is to be as fluid as the contexts allow, and in the previous chapter alone I named the "opposition" in at least a half-dozen ways. It is salutary to gather the synonyms together, if only to bring home how poorly the field is understood:

word	image
language	picture
language	art
verbal	visual
poesis	*pictura*
inscriptio	*figura*
denotative	connotative
code	uncoded image
semiotic	nonsemiotic
narrable	inennarable
written text	depictive text
writing	painting
discursive field	figural field
discours	*figure*
oppositional	continuous
discrete	continuous
digital	analog
structured	unstructured
systematic	non-systematic
Meaning	Being
saying	showing
truth content	sense
proposition	"silence"
propositional	nonpropositional
disjoint	nondisjoint
attenuated	replete[5]

What single subject of inquiry could possibly do justice to these different constructions? How could it possibly make sense to collapse them into a pair such as *word* and *image*?

A second reason for avoiding the word–image opposition is that it is demonstrably untrue.[6] Any sufficiently close look at a visual artifact discloses *mixtures* of reading and seeing. Everyday reading and everyday looking (say, reading this page, and watching images on television) are not pure acts, and so their "opposition" cannot comprise a binary pair. Any act of reading relies on a finite number of customs and strategies, and they are often at work in looking. The converse is also true: We look at images in various ways, in various orders, and at different speeds, and those ways of looking often come into play when we read. There are protocols of reading and looking, meaning signs by which we might recognize that we are reading or looking. Any visual artifact mingles the two, and so there is "reading" in every image and "looking" in every text.

Like *art* and *nonart, word* and *image* persist because they correspond to institutional habits and needs. They are too ingrained to be abandoned or easily critiqued, and so I will be using them occasionally when an object's history of reception makes it sensible to do so. But as in *art* and *nonart,* when I use *word* and *image* or their cognate terms I do not mean them as claims about the truth of an object, but as descriptions of the ways that an object has been understood. That descriptive orientation has the virtue of remaining open to historiographic differences such as the ones I have listed.

5. For the last six entries, see the previous chapter and the discussion of Wittgenstein and Goodman. Several just above them appear in Norman Bryson, *Word and Image: French Painting of the Ancien Régime* (Cambridge: Cambridge University Press, 1981), 1–28, esp. 255n31, which offers a list of concepts, works, and artists that goes from the pole of "discursivity" to the pole of "figurality": "Glyph, sigil / Hieroglyph, ideogram / Canterbury window [a work discussed in the text] / Masaccio / Piero / Still-life / Vermeer / (Cubism) / Abstract expressionism / Painterly trace." Inverted, the list is an interesting example of the kind of sequence in Table 8.1ff. "Depictive text" is favored by Whitney Davis, *Masking the Blow: The Scene of Representation in Late Prehistoric Egyptian Art* (Berkeley: University of California Press, 1992), 244ff. Jean-François Lyotard discusses several of these and opts for *discours, figure* in a book of that name (Paris: Klinksieck, 1971).

6. "Word–image opposition" is from Mieke Bal, *Reading "Rembrandt": Beyond the Word–Image Opposition* (Cambridge: Cambridge University Press, 1991).

Nelson Goodman's "notation" raises the possibility of dividing the domain of *grammae* into three parts. Provided his strictures are loosened, the division into pictures, writing, and notation has some critical advantages — which is to say it corresponds with many of our habits of seeing. "Notations" in this sense are images using organizational principles other than the formats associated with pictures or writing systems. (From this point on, the word *notation* shifts meaning a little, as I continue to call images such as electroencephalograms *notations* even as I move away from Goodman's strict criteria.) Adding notation to the diad of word and picture has the immediate advantage of freeing us from having to say that images such as those in Chapters 2 and 3 are "written" just because they have symbols. After all, a geometric diagram is "read" in a way entirely different from a written page — the eye scans back and forth, following rules entirely alien to writing systems.

Consider, then, some of the possibilities raised by dividing images into three parts. Presumably, we would want to say there is some intersection between the three fields: A map, for example, is usually a picture with some writing superimposed, and it also depends on some notations such as symbols for places, latitude and longitude lines, and so forth. The simplest mathematical depiction of the intersection of three sets is a Venn diagram of circles. We could inscribe pictures, notations, and writing in such a diagram, all inside a larger domain that could be called *images* or *grammae*. At first we might leave the question of their intersection undecided, and show them as opened circles:

(This diagram itself could be enlisted as evidence in favor of the tripartite division, as it seems to be something other than a picture or a piece of writ-

ing. At the same time, it could also be taken as evidence that the area of intersection is large, because it is not *purely* a notation, whatever we might take notation to be: it also contains writing, and it would not be entirely inappropriate to call it a picture.)

Here writing, notations, and pictures are also the vertices of an invisible equilateral triangle, present by implication. (It is the negative white space, the gap in the diagram.) The triangle is a ghostly remnant of two further kinds of notations: the "triangle graph" used in chemistry, genetics, geology, biology, and ethnology, which maps the positions of points in relation to three variables; and the illusory "negative triangle" known to experimental psychology, in which black forms outside a blank space create the illusion of a white triangle.[7] Those affinities suggest that the ill-defined blank space at the center might be specified more exactly. (In entertaining that thought, I am being led along by something that could be called notational thinking: I am impelled to explore possibilities suggested by the notation, just as a reader of a novel follows the possibilities suggested by the formats of writing, or a viewer follows the relations between forms in a picture. This line of argument could be used as a third critique of the word–image duality, as it demonstrates modes of deduction — trains of thought — that are not native to "words" or "images.")

If we are to make the diagram more specific, one possibility is that the Venn circles are perfect circles, in which case they would yield a programmatic division into seven subsets. It would then be tempting to say that each could be assigned to a distinct kind of image. Between picture and writing, for example, one might want to place pictographic scripts such as Egyptian hieroglyphs:

7. Such an illusion is illustrated in Elkins (1997), where it serves as an example of a rudimentary picture.

These two possibilities — the strict Venn diagram and the opened Venn diagram — have some truth to them, but a more flexible image might better correspond with our responses to images. It sometimes happens that the three realms do not seem to have significant overlap, and that could be drawn by connecting the broken lines so as to form four organic shapes:

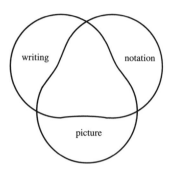

Here the fields are harmonious and contiguous with one another — their boundaries form a single closed loop — representing the common conviction that some images are unproblematic and pure.

I want to play a little more with this, in order to make a point about the limits of any such division. Jacques Lacan makes use of a slightly different form of this set-theoretic diagram in which the three circles are three-dimensional Borromean rings, interlocked as in the symbol of the Olympic games.[8] To him this helps indicate that there is no center to any of the fields, and that the existence of a field is a matter of its circumference — the torus that keeps it in place — rather than the empty space it encloses. For Lacan, Borromean rings are a suggestive image of the state of the psyche, formed of encircled emptinesses rather than bounded psychic "registers."

The same could be said of the triad of writing, picture, and notation. Interlocked rings do justice to the commonsense belief that all images are somehow related: A page of text might fall on the circumference of the "writing ring" at a point diametrically opposed to the unnamed center, but even there it will be intimately connected with the other rings. Because none of its terms have well-defined natures, and because pure examples are either rare or nonexistent, the rings are also a reasonable model of the hope that images are divisible into neat fields. In the previous chapter I suggested an image might elicit the "feeling" that it is a sys-

tem, or that it is a proposition. In an analogous fashion, images often feel like pictures, writing, or notation, even though we might not be inclined to say they are examples of pictures, writing, or notation. The phrase "feeling of a picture" (or writing, or notation) will often be useful in the following chapters. At times it makes sense to try to pin down the "feeling," and at other times precision would misrepresent the act of understanding. Either way, Lacan's rings model the conviction a viewer might feel that a given image is not an example of the very type it seems to exemplify. The center, as Yeats said, does not hold, but it is still the center.

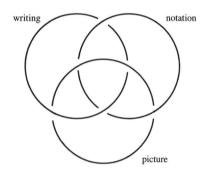

There are many other such possibilities. Perhaps they are all too schematic, or there is something inherently wrong with using a diagram to represent the tripartite division. (Though it is hard to say what tripartite division could not be modeled by a diagram.) Perhaps the entire diagram is artificially frozen from a moving continuum. Or it might be that things are just much more complicated. Paolo Giovio's Medici *impresa* is an interesting example in this regard (Plate 6.1). It also has knotted rings, but this time the three divisions are set as jewels in a large field, ringed round by an unlettered scroll, framed in an elliptical mirror, bordered by scrollwork that is itself inhabited by diamonds, sculpted crescent moons, bucrania, tragic and comic masks, swags, terms, and letters, all set against a ruled surface delimited by a thick black

8. The critical context is given, for example, by Joel Whitebook, "Ein Stückchen Selbständigkeit: Das Problem der Ich-Autonomie bei Freud," *Zeitschrift für Psychoanalyse und Ihre Anwendungen* 46, no. 1 (1992): 32–51, translated as "'A Scrap of Independence': On the Ego's Autonomy in Freud," *Psychoanalysis and Contemporary Thought* 16, no. 3 (1993): 359–82; and Hanna Gekle, "Spiegel-bilder des Ich: Zu Jacques Lacans Theorie des Imaginären," *Zeitschrift für Psychoanalyse und Ihre Anwendungen* 49, no. 8 (1995): 705–26.

tile,& erudito ingegno,anchor che paia che'l detto giogo fuſſe pri-
ma del gran Coſmo;il quale quando fù richiamato dall' eſilio alla
patria, figurò in vna medaglia Fiorenza aſſettata ſopr' vna
ſedia col giogo ſotto i piedi,per dinotare quaſi quel detto di Cice-
rone, Roma Patrem Patriæ Ciceronem libera dixit. E per la
bellezza fù continuato il portarlo nel ponteficato di Leone, e me-
ritò d'eſſere iſtampato nelle monete di Fiorenza.

D O M. *Piacemi molto queſta impreſa,e la giudico molto bel-*
la;ma di gratia Monſignore, non v'increſca raccontarmi an-
chor l'altre dell' Illuſtriſſ. Caſa de' Medici, e con eſſe toccar
diffuſamente il perche dell' impreſe; percioche l'hiſtoria porta
gran luce, e diletteuol notitia à queſto diſcorſo. G I O. *Io non poſſo*
andar più alto de' tre diamanti,che portò il gran Coſmo, i quali
 uoi

PLATE 6.1 *Paolo Giovio.* Impresa *for the Medici family.*

rectangle, beyond which are mixtures of Roman and Italic letters; and the whole is justified to four white margins.[9] Imagine this as a map of the domain of images, instead of the anemic Venn diagrams. If it captures something of our sense of the relations between images, then we would have to think primarily of how some images seem to include others, and so on without limit. No image would be pure, and by their nature images would consume and embody one another in an infinite sequence of enclosures and inclusions.

This is an extravagant notion, but it is not invented. Paolo Giovio's design is Renaissance proof that speculations like these have long been possible, and that the tripartite division might be more treacherous than it appears. I have entertained these diagrammatic fantasies to make a point about the implication of our own imagistic habits in such questions. Investigating the three fields induces a reciprocal motion in which the images lead us to think in certain ways. A diagrammatic

fantasy is also a rational inquiry, because we might learn as much by what the diagrams suggest as by applying pictorial and linguistic evidence. I take that as one of the deep currents in this book: Thinking about images means being led into certain thoughts *by* images.

All the same, I would not want to lose sight of the fact that the trichotomy often seems plausible even aside from the kinds of diagrams it elicits. Like the divisions into one and two, the triad of picture, writing, and notation often corresponds to working notions of images. Here is an example, as far-flung as any other (Plate 6.2). (These convictions, because they are our own, will necessarily appear in any number of historical contexts.) It is a drawing of a backstone from a passage-grave in Brittany, depicting a somewhat ill-defined central form, flanked by what appear to be four rows of hook-shaped marks.[10] The stone is a signal example of *graphein*, because it was literally made by scratching away at the surface (the forms are in relief), and on first look it could also be taken as an example of the duality of text and image, because it appears that the top portion is somehow like writing (or counting), and the lower portion — once hidden below the ground level — is somehow like a picture. But the shapes in that lower section, which include small hooks, cupules, and dots-in-circles, are not very well described as elements of a picture, and it begins to appear likely that more categories might be required beyond text and image.

At this place so far in the past (between 3500 and 3000 B.C.E.) and with so few relevant comparisons in the surrounding monuments, it's possible

9. Paolo Giovio, *Dialogo dell'imprese militari et amorose* (In Lione: Appresso G. Roviglio, 1559). See the facsimile edition (Delmar, N.Y.: Scholar's Facsimiles and Reprints, 1976), 40–41; and also Schenck (1973), 22.

10. For an introductory text on the Table-des-Marchands, see Gwenc'hlan Le Scouëzec, *Bretagne mégalithique* (Paris: Seuil, 1987), 200–203. For related material, see Philipp Gouezin, *Les Megalithes du Morbihan interieur* (Rennes: Intitut culturel de Bretagne, 1994). The hypotheses I mention here are all made problematic by the disparity between accounts of the stone's appearance. Joseph Déchelette, *Manuel d'archéologie préhistorique, celtique et gallo-romaine*, vol. 1, *Archéologie préhistorique* (Paris: Auguste Picard, 1924), 609, does not record a central form at all; others see it as elongated (a vulva) or round (a sun). The same could be said of the "rows," which could be construed as single signs.

PLATE 6.2 *The dolmen known as "la Table-des-Marchands." Locmariaquer (Morbihan), Brittany. ca. 3500–3000 B.C.E.*

to put almost any question to the image. Are the hook-shaped marks sexual symbols? To the archaeologist Marija Gimbutas the central form is a vulva, and the hooks "simulate the life force or represent emanation of its energy."[11] Other archaeologists have interpreted the "hooks" as simplified axes, on the model of more explicit axes engraved nearby (allegedly including one engraved in the capstone just above this image).[12] Hence the im-

age might be symbolic, and therefore like writing. But if it isn't symbolic, is it a picture? Does the upper portion present us with a scene that might

11. Gimbutas, *The Language of the Goddess* (New York: Harper & Row, 1989), 289.

12. For the hooks as axes, see Joseph Déchelette, *Manuel d'archéologie préhistorique,* and Pierre Giot, *Brittany: Ancient People and Places,* ed. Glyn Daniel, vol. 13. (London: Thames & Hudson, 1960), 50–52.

have taken place, that did take place, or that would someday take place? There is also a persistent tradition identifying the "hooks" as wheat or grass, and the central form as the sun; according to at least one author, the image is a naturalistic picture of a sun, setting in a field of wheat.[13] But perhaps its naturalism is not quite so refined, and the upper register represents a female goddess or priestess, surrounded by male worshippers — in that case it would still be pictorial, but also quasi-abstract. (Kandinsky, after all, went through a period of painting people as canes or hooks very much like these.) And what if it's not a picture at all? Could it be a quantifiable image — say, a set of directions for a ritual, a census of participants, or a chart of spiritual or lineal connections? Or perhaps just "ordinary" writing or counting? Early writers assumed as much: Armand-Louis-Bon, the comte Maudet de Penhouët, described the stone in 1805; he thought the "hooks" were specimens of Phoenician writing.[14] Forty years later the chevalier Joseph de La Poix de Fréminville thought the marks were secret druidical characters whose meaning had perished with their makers.[15]

If we sort through such thoughts, I think we find they divide into hypotheses about writing, pictures, and notation. The notion that the image is "a scene" or that "it represents" figures, wheat, or sexual symbols assumes a pictorial function. To say it might give "directions" is to think of it as writing, and to suppose that it is a "census" or a "chart" is to see it as numerical or tabular notation. If the hooks denote "life force," the image could be more specifically a diagram. In that case, we might prefer to decipher it rather than read it or simply look. (I will occasionally use the verbs *look, read,* and *decipher* to correspond to *pictures, writing,* and *notation.*)

The lower portion has the same critical effect. It could be understood as a picture (a collection of doodles or practice carvings), as writing (perhaps improvised, prelinguistic symbols, or accompaniments to a story), or as notation (a map or mnemonic chart of the community, or of the grave's arrangement). By collating the history of reception, and by attending to our own reactions, it is often possible to see the outlines of what we assume about a given image. In this case the division is tripartite; in others it might be undifferentiated, bipolar, or something more complex.

THE SEVEN AND SEVEN HUNDRED KINDS OF SCRATCHES

The next step, if we are to continue thinking of subdividing the domain of images, is to ask if there might be some reasonable number, greater than three but less than infinity, that might also correspond to some patterns in our reception of images. The organization of Part 2 reflects my own sense that seven distinct kinds of images is often an optimal division. I am not attached to the exact number, but in many contexts I would defend an account of images that depends on approximately this level of differentiation. It is sufficiently clear for the problems I want to consider: It is well enough articulated so that it can be exposited in a reasonable space, but not so ramified that it turns into an encyclopedia; and it fits the historical record well — its categories are often those used in the literature. It also grows naturally out of the two- and three-part divisions, so that the entirety of Part 2 can be seen as an expanded (and collapsible) version of either of those more basic schemes.

In outline, Part 2 triangulates writing, picture, and notation in order to frame the seven kinds of images. Chapters 7 through 11 move gradually from "pure writing," contaminated only by typography or calligraphy, through increasingly pictorial forms (for instance, pictographic scripts) toward the idea of a pure picture. The writing dissolves, leaving a purely visual residue. The remaining

13. Zacharie Le Rouzic and Charles Keller, *La Table-des-Marchands: Ses signes sculptés et ceux de la pierre gravée du dolmen de Mané-er-H'roëk* (Nancy: Albert Barbier, 1910). According to Ulrich Niedhorn, the Table-des-Marchands is the "Rosetta Stone" for all Neolithic art in Brittany, and he writes (the entire sentence is underlined): "Da sind in dem großen Tragstein vom Dolmen 'Table des Marchands' doch keine Ähren dargestellt! Das is eher die Sonne in einem Alignement, wenn man alle Mängel einer perspektivefreien Darstellung berücksichtigt!" See Niederhorn, *Die Kunst des Bretonischen Megalithikums, die Menhire und die Gestalt der Zeichen. Isernhägener Studien zur frühen Skulptur,* vol. 4. (Frankfurt: Haag & Herchen, 1991), 77.

14. Armand Louis Bon Maudet, comte de Penhouët, *Essai sur les monuments armoricains qui se voient sur la côte méridionale du département du Morbihan, proche Quiberon* (Nantes: s.n., 1805).

15. Fréminville, *Antiquités de la Bretagne, Côtes-du-Nord* (Brest: J.-B. Lefournier, 1837).

chapters, 12 and 13, begin again with partnerships of writing and pictures and move through increasingly complex aggregates of writing, pictures, and notation — leading eventually to the question of whether there might be something like pure notation. In that sequence, both writing and pictures burn away, leaving only notation. Because the chapters continuously approach some ideal of purity but find only contaminated examples, the "pure" forms of pictures, writing, and notation drive the sequences without ever appearing in them.

I begin with the examples that seem closest to pure writing — that is, ordinary printed pages, typography, and normative scripts of all kinds. Immediately there are pictorial elements that have to be taken into account: calligraphic forms, cursive scripts, and even the pictorial nature of the shapes of printed letters. *Allography* (Chapter 7) is the name for all variant shapes of a letter, including calligraphic forms and paleographic styles: Some examples are paleography, signatures and autographs, layout, typography, graffiti, and calligraphy. Allography is universal — there is no writing without it, and therefore no pure writing. The question for any account is how that rudimentary fact can find expression in a given analysis. "After" allography — if anything can be "after" a problem so ubiquitous and so universally unacknowledged as the pictorial nature of writing — are scripts whose characters are taken to be inherently pictorial. Chapter 8 takes up semasiography, the study of written characters that function in part by resembling what they denote: Hittite, Bamum, Assyrian, Phoenician, Egyptian, Chinese, and Mayan characters, and pictographic elements in mathematical and musical notations. Egyptian is the most famous instance, but there are also pictographic and other iconic signs in a wide variety of scripts, including the Roman alphabet. Mathematical and musical notations — with the word *notation* under interrogation in each instance — are also inherently pictorial, although they are not normally taken to be. Semasiographic scripts are more like pictures than the typographic and calligraphic embellishments of Roman script.

A little farther down the road from normative writing to pictures are scripts that are not "full" — that is, they cannot express the entirety of a language. When there is only a limited set of signs (a small "signary"), writing tends to become more

clearly pictorial. The symbols for the planets, for example, look like simple pictures. *Pseudowriting* (Chapter 9) is the name for all such limited signaries: It consists of defective scripts, as in Renaissance pseudohieroglyphs, rebuses, predynastic Egyptian and Chinese, Peruvian mnemonic scripts, Olmec, Aztec, Mixtec, Teotihuahacan, and Inuit; it also includes hobo signs, treasure signs, brands, and potter's marks.

At the pictorial limit of writing there are images that not only lack a full signary but also distribute what signs they have over a surface without comprehensible formatting. Once the order in which the signs should be read is no longer clear, the image begins to look more decisively like a picture. I call images that are taken to be comprised of disordered signs *subgraphemic* (Chapter 10): They include fine-art paintings and drawings, Egyptian cryptomorphic scarabs, and picture-writing. If it then becomes impossible to distinguish between signs, the image is *hypographemic*[16] (Chapter 11). Most images studied in art history are sub- or hypographemic: The latter includes fine-art paintings and drawings, Taoist "talismans," and some rock art. A typical painting has legible signs, but they are partly fused to one another and not arranged in any particular order for reading. Hypographemics are close to the ideal of a purely visual image, and they conclude the sequence from almost-pure writing to almost-pure picture. At that point the exposition shifts, moving in the direction of pure notation.

I start again, in Chapter 12, with common images that combine texts and pictures. One of the best general names for such images is emblems, since emblems are the most fully developed examples of the nearly universal practice of associating a short text and a few symbols with an image. The category includes advertisements, book illustrations (with their captions), and paintings in museums (with their labels). Paper money, coins, stocks, and tickets are also collages of words and pictures, but with notational elements added. Typical examples of paper money have pictures, captions, numbers, framing elements, emblematic

16. *Hypographemic* is not interchangeable with Saussure's *hypogram* or with Paul de Man's uses of the term. See Jonathan Culler, "Reading Lyric," *Yale French Studies* 69 (1985): 98–106. I thank Marc Redfield for this reference.

signs, seals, and other symbols. Heraldry is the most involved of these images, with its own specialized descriptive language and encyclopedia of formal rules, and it helps make sense of the other practices.

The most strongly notational images are those that have all the elements of emblems and are also based on geometric forms such as *reference lines* — curves, scales, grids, nets, or other geometric configurations that order the image. I call such images *schemata* (Chapter 13) partly to distinguish them from Goodman's use of the word *notation.* Part 2 ends with the most intricate and abstract examples, those furthest from writing or pictures and asymptotically close to pure notation: Examples include maps, engineering drawings, graphs, charts and tables, diagrams, flow charts, genealogical trees, Boolean circles, and geometric configurations.

Though this seven-part division determines the remainder of this book, it is far from a new archive for the classification of images. It is a recurring figure, a "natural" division into which images sometimes fall, and one that fits the length and purposes of this book more securely than the usual *word* and *image,* or the problematic *word, image,* and *notation.* Considered at greater length, with a more intense eye for individual cases, the seven would spontaneously fracture into seven hundred or seven thousand, and finally into a universe of unclassifiable unique images. Hence I am not be proposing the seven kinds as an optimal classification

but as an evanescent configuration that allows me to frame the questions I intend to ask.

The ideas that animate the following pages can be easily set out. Prime among them is the recurring fantasy that there might be such a thing as a purely visual picture, a page of writing uncontaminated by nonverbal meaning, or a chart or graph dedicated utterly to the propagation of data — that is, a pure picture, writing, or notation. That triple hope can account for many of our responses to images, and for the conviction that some images can be securely roped off from others. It also sets us thinking about grand distinctions and oppositions: word to image, picture and writing to notation. I find myself most intrigued by images that seem not to obey those simple mechanistic distinctions. Either they belong to one of seven (or more) categories, or they seem entangled in several modes of image-making. To some degree, that is an artifact of my own postmodern interest in failed categories, liminal instances, and unclassifiable objects. But it is also a property of many images, including some of the most ubiquitous, such as the pictorial elements in Chinese scripts. Especially given the hurtling development of new image technologies, mixed images can be said to be the norm rather than the marginal exception. The elusive ideals that we will stalk throughout Part 2 do not exist, but they turn our interests practically without our noticing, like compass needles swung around by the invisible pull of magnetic north.

PART II

7 : Allographs

ter contemplating these abstract problems, allography may seem to be a simple matter: Certainly, it appears, calligraphic and typographic shapes are ornaments to letters. (Throughout this chapter, I use *allography* to stand for calligraphy, typography, paleography, and layout: I mean it to denote the sum total of changes that can be made to letters without affecting their alphabetic identities.) It is as if the letters were a firm foundation, fixed in shape and denotation, and the allographs merely embellishment. That at least is the way calligraphy has traditionally been understood in the post-Renaissance West: It is an optional refinement, and takes whatever meaning it has from the history of ornament and from the insecure symbolism of gestures and patterns.

A first sign that the truth might be more complicated comes from the wide differences between calligraphies in the West and in China, Japan, and Islamic countries. In the West, the word *calligraphy* has come to mean "beautiful writing" — that is (as Simon Leys puts it), "writing that is made beautiful by the addition of various ornaments, or by the application of a decorative treatment."[1] In China, on the other hand, calligraphy is indissolubly part of the normative orthography of writing, and there is no writing — except deliberately "mechanized" Western-style fonts used in advertising, signage, and computer graphics — that is printed without gestural marks. "Chinese calligraphy" itself is an orientalizing misnomer, as the corresponding Chinese word is *shu,* which means only "handwriting" or "script" and not elaborated or aestheticized script.[2] The same observations can be made concerning the words for "script" and "beauty" in Islamic practice, in which the letter is additionally bound up with the sacred.[3] Books of Islamic pale-

ography are also studies in calligraphic styles: Until the twentieth century there was no possibility of writing entirely outside a named style.[4] In both the Chinese and Islamic traditions it would be misleading to interpret calligraphic marks as something potentially disengaged from writing itself: In this text I do not try to bend English usage, but the inevitable phrases "Chinese calligraphy" or "Islamic calligraphy" should be taken, at the least, as redundancies.

It is salutary for a Western reader unused to these traditions to contemplate the calligraphic styles in

1. Simon Leys, review of Jean Billeter, *The Chinese Art of Writing* (New York: Rizzoli, 1995), in the *New York Review of Books,* 18 April 1996, 28–31, esp. 28–29. For the history of uses of *calligraphy,* see Grabar (1992), 60.

2. A recent meditation on Chinese concepts of writing and painting is Hubert Damisch, *Traité du trait, Tractatus tractus* (Paris: Editions de la Réunion des Musées Nationaux, 1995), 21–38.

3. These are set out in Grabar (1992), 69 and 86–87. The scripts *ma'il* and *kufic* in Arabic, for example, are used almost exclusively for copying the Qur'ān, and they are resonant with sacred meaning.

4. See Louis Cheikho, *Spécimens d'écritures arabes pour la lecteur des manuscrits anciens et modernes,* 8th ed. (Beirut: Imprimerie Catholique, 1911), and Georges Vajda, *Album de paléographie arabe* (Paris: Librairie d'Amérique et d'Orient, 1958).

China, Japan, and Islamic countries: In each case the styles are universally known to the literate public — they are central to pedagogy and strengthened by long tradition. Chinese calligraphy in particular has given rise to such a proliferation of history and criticism that it is arguably as historiographically intricate as many aspects of Western painting and sculpture.[5] In China and Japan there are several standard scripts — *lishu* or *reisho,* the clerical or "official" script; *xingshu* or *gyosho,* the running or semicursive script; and *kaishu* or *kaisho,* the "standard" script. In recent decades artists have revived another five or six older scripts, such as *jiaguwen,* the oracle-bone script, and *jinwen,* bronze vessel script. In all there are about ten commonly studied scripts in both China and Islam — as compared with essentially two scripts in the West, which we call simply "printing" and "cursive."[6] Every calligrapher in the Islamic tradition knows the six classical cursive scripts — *thuluth, naskh, rīḥāni, muḥaqqaq, tauqīʿ,* and *riqāʿ* — together with about a dozen others; they are as fundamental for literacy in Arabic writing as the sequence classical, medieval, Renaissance, Baroque, and modern is for Western art (Plate 7.1).[7]

In the West, on the other hand, calligraphy has become a denigrated parasite, a hobby consigned to the ancillary role of adding nearly meaningless optical frills to the bedrock of working signs. In the last two centuries its meanings have shrunk still further, so that it signifies little more than affectation, social pretension, and effeminacy. That bias alone might account for our feeling that calligraphy can be assigned to the realm of pictorial ornament, because it appears so distinct from sturdy, noniconic orthography and even from mechanical and computerized typography. But a little reflection shows that it is not easy to distinguish calligraphy from pure writing even in Western scripts. For Oleg Grabar, "It is in fact difficult to assess the nature, in reality even the existence, of artistic writing in Western medieval art"; for other scholars, however, medieval paleography is entwined with aesthetic choices, so that every medieval "hand" is a calligraphic style.[8] Ancient Roman scripts, "regional hands" such as Luxeuil and Visigothic Minuscule, Insular scripts, and the various Carolingian and goth scripts are all styles; and the humanist scripts lead up to, and are continuous with, early

printed fonts.[9] Western calligraphy, typography, and other "ornamental" changes do not operate on some normative script that is free of any nonessential shapes. The Roman alphabet lacks a canonical form: Its letters have no forms that could count as entirely unornamented. **Even a sans serif font such as Helvetica has a recognizable shape and an expressive character,** and most other fonts only seem less normative by comparison. There is no foundation, no "zero-degree" script that is entirely unornamented, and therefore — it is important to state this directly — there is no hope of ever defining calligraphy, even in the West. Calligraphy is not a kind of change that happens to some previously pure letter. Writing is always also calligraphy, and it is never possible to fix the point where one leaves off and the other begins. It's a strange subject, which seems so obvious and yet proves so utterly elusive.

Luckily the impossibility of distinguishing between "foundational" letter and "ornamental" calligraph does not also obscure the difference between the *meaning* contributed by words and by calligraphy. There are times when calligraphy questions writing by making readers think of the tension between the shapes of words and their

5. In Islam and in the Chinese and Japanese traditions, calligraphy has long been a highly valued skill: Chinese artists experimented with distinct styles as early as the eighth century B.C.E., and the tradition was already highly refined in the third century C.E.; Islamic calligraphy was codified by the thirteenth century and practiced significantly earlier. See, for example, Yee Chang, *Chinese Calligraphy: An Introduction to Its Aesthetics and Technique* (Cambridge, Mass.: Harvard University Press, 1973); T. C. Lai, *Chinese Calligraphy: An Introduction* (Seattle: University of Washington Press, 1975).

6. For general information on Chinese calligraphy, an excellent introduction is Lothar Ledderose, "An Approach to Chinese Calligraphy," *National Palace Museum Bulletin* 7, no. 1 (March–April 1972), and see also his *Mi Fu and the Classical Tradition of Chinese Calligraphy* (Princeton, N.J.: Princeton University Press, 1979), esp. chap. 1, pp. 7–44.

7. The best introductory exposition is Mohammed Zakariya, "Observations on Islamic Calligraphy," *Fine Print* 4 (1978): 97–103; and see Zakariya, *The Calligraphy of Islam, Reflections on the State of the Art* (Washington, D.C.: Georgetown University, 1979).

8. Grabar (1992), 53, and compare Stan Knight, "The Roman Alphabet," in Daniels and Bright (1996), 312–32.

9. Knight, "The Roman Alphabet."

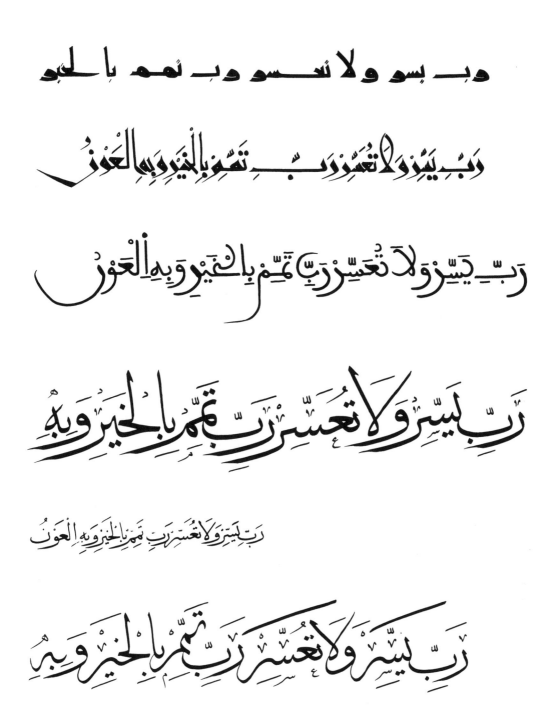

PLATE 7.1 *Some classical Islamic cursive scripts. From top: kufic, "Eastern" kufic, mahgribi, muhakkak, rayhan, sulus.*

senses. Such moments are the beginnings, the first glimpses, of pictures in writing — or to say it a little differently, they are the times when readers become aware that reading is always also looking.

Thinking of this, it's important to allow that pictures can be tremendously subtle: It can be almost impossible to realize that we're observing a picture when everything in sight looks like writing. The apparently random disjunction between a picture of a dog and the words *chien, Hund,*

canis, or *dog,* often taken as an example of the arbitrary nature of the phonetic sign, is also a token of the arbitrary nature of the lexical sign: The word *chien* does not sound like a dog, but it also does not look like a dog.[10] The word *dog* written in calligraphic letters raises that theme by being a little like a picture, and reminding a reader, no matter how faintly, of the arbitrariness of the lexical sign; and if the word *dog* were written with little dogs inside its letters (as in some medieval manuscripts), it would raise the question even more insistently by straining, as it were, to become a picture of a dog. Hence calligraphy puts the writing in question by threatening to turn it into something resembling a picture. It creates visual artifacts in which there are uneasy relationships between ostensive and graphical meaning. It brings ideas to mind that might be entirely unrelated to a text's meaning, impelling readers to think of conflicts between writing and ornament, picture and language, sign and signifier, meaning and meaninglessness, form and content. Reading the half-sentence in Helvetica font, I am temporarily unbalanced from my normal concentration, and for the next half-page or so — until the memory of the sentence fades — I find myself thinking more than I would like to about the ordinary font of the page, its "look." That "irrelevant" awareness is the first glimmer of the pictorial, and it produces a certain vertigo or discomfort in normal reading.

At times like those it can seem as if calligraphy is alien to writing, as if it comes from the realm of pictures and attaches itself more or less intimately to writing. Several of the Venn diagrams in the previous chapter are consonant with the notion that calligraphy belongs somewhere other than writing. Yet this simple topography of picture and writing is false in two ways. First, calligraphy is not a royal road from writing to picture, because there is no sequence by which calligraphic forms progressively turn text into pictures or even into independent decorative motifs: no instance of a continuous transformation from text to picture, from writing to ornament. And second, when calligraphy is allowed particularly free rein — in treatises on calligraphy, for example — it does not produce pictorial forms. Instead it displays traits that might be interpreted as eccentric, unusual, or extreme distortions of certain gestural elements that are also found in pictures. That phenomenon indicates

that calligraphy might not belong to pictures *tout court* but to parts of pictures, or to something else, as yet unnamed.

What, then, is calligraphy? Because it resists the set theoretic model, it might be prudent to let it define itself by its behavior: to watch and see what it does in any given case, as if it were a force that has specific and sometimes deleterious effects on whatever is taken to be pure writing. In the end I find it is biology that best accounts for calligraphy's actions: Concepts such as parasitism and symbiosis are closer to the mark than fields and domains. Allography is like a biote, with a variable and often unhealthy effect on the organisms it encounters. The conclusion I am aiming at, put roughly, is this: allographic changes are neither writing nor pictures, and the trinity of writing-picture-notation is insufficient to describe them. If pictures and writing are two organisms, then allography might not be a cross or a hybrid — it might be a parasite.

As
we consider
how calligraphy, typography, and
other allographies make language unexpectedly and inappropriately hard to read — as in
my balancing of lines in this "ornamental"
paragraph — we will do well to bear in mind the
part played by aggression against meaning.
Allography often works virulently, and
apparently pointlessly, against the
commonsense meaning
and intent of
writing.

*

CALLIGRAPHY AS STYLE, AUTOGRAPH, AND SIGNATURE

For some readers and some viewers, allography appears pictorial because it possesses the traits of an individual. Like a picture, which cannot be exactly reproduced, a calligraphic flourish belongs to a single hand, working on the collective anonymity of the system of writing. In the biotic model, allography would be the penetration of an

10. Rosalind Krauss, "Using Language to do Business as Usual," in *Visual Theory,* ed. Norman Bryson et al. (New York: Harper, 1991), 79–94, esp. 83.

individual into the collective body of writing.[11] Yet it is seldom clear how individual a "hand" or a calligraphic style can be.

The equation between allography and paleography weakens when it comes to specifying the kind of individuality that the marks imply. Calligraphy is a nervous art, and it can conjure an oppressive awareness of the tyrannical perfection of normative letterforms and of machinic typography. Its nervousness, I think, is one of its fundamental qualities, and it is related to skittish motions of the hand: the desire to doodle and scratch, the restless twitching of an unoccupied hand, the little bursts of freedom that follow on tightly constrained actions. Free-floating anxiety or purposive restraint are potentially autographic, but it's an open question how individual they are in the context of calligraphic styles.

Calligraphy tends to balance between an anonymous paleography, which cannot be assigned to any one person, and the idiosyncratic, autographic achievement of a single individual. In Western calligraphy, an anonymous style is available to anyone who is willing to learn it, but an autographic style is the author's alone, and can only be traced, forged, or emulated.[12] Islamic practice confounds that dichotomy. The six cursive styles in Plate 7.1 are each associated with a different pupil of the medieval calligrapher Yaqut al-Musta'simi (d. 1298), so that each style is both anonymous and autographic, continuously recalling its inventor.[13] In China the relation between anonymous style and autographic manner is even more elaborate, as calligraphers were expected to master not only the named styles but also the particular variants of those styles as practiced by well-known calligraphers; in addition, they were supposed to develop distinctive variants of their own.[14] The historical style, the historical variant, and the personal variant were three levels of individuality: The first was anonymous, the second eponymous, and the third autographic.

Ottoman *tughras* are the most intricate examples of these mixtures of uniform writing and individual allograph (Plate 7.2).[15] A tughra is an ornamental calligraphic composition arranged to fit the outline (or silhouette) of objects such as bows and arrows, prayer niches, flames, peacocks, lions, pigs, tigers, and owls.[16] When tughras are taken as representations of animals, they are one of the exceptions to the Islamic prohibition against imagery; at the same time they are ornamental monogrammic signatures, because there are names in the middle of the swirl of illegible letterlike shapes.[17] Often the name is effectively hidden in the theriomorphic (animal-shaped) calligraphy, so that even native Turkish speakers familiar with Arabic script cannot read the names without special instruction.[18]

Thus tughras are signatures (that is, reproducible scripts that might be generated by anyone) rather than autographs (original scripts, written by the bearer of the name), and in that respect they are more like the stamped signatures on form letters than "original" autographs. The sometimes undecidable difference between autographs and signatures is a theme in Western banking and phi-

11. For the kind of collection that implies such a thesis, see *Meister der Schreibkunst aus drei Jahrhunderten*, ed. Peter Jessen (Stuttgart, 1923) The reprint *Masterpieces of Calligraphy* (New York: Dover, 1981) has significantly poorer reproductions.

12. These questions are discussed in my "From Copy to Forgery and Back Again," *British Journal of Aesthetics* 33, no. 2 (1993): 113–20.

13. The calligraphers and their styles are *thuluth,* associated with Ahmad Tayyib Shah; *naskh* (the normal printing and writing script), associated with 'Abdallah as-Sayrafi; *rīḥānī,* associated with Mubarakshah Suyufi; *muḥaqqaq,* associated with 'Abdallah Arghun; *tauqī',* the normative chancellery script, associated with Mubarakshah Qutb; and *riqā',* combining *naskh* and *thuluth,* and associated with Ahmad as-Suhrawardi. Partly compiled from Annemarie Schimmel, *Calligraphy and Islamic Culture* (London: I. B. Taurus, 1990), 22, 23.

14. This is pointed out in Ledderose, "Chinese Calligraphy: Art of the Elite," in *World Art: Themes of Unity and Diversity, Acts of the Twenty-Sixth International Congress of the History of Art,* ed. Irving Lavin (University Park: Pennsylvania State University Press, 1989) 291–96, esp. 293.

15. For tughras, see Suha Umur, *Osmanli Padisah Tugralari* (Istanbul: Cem Yayinevi, 1980). Tughras on coins are well illustrated in *"Saltanatin Iki Yüzü": Yazi ve Tŭgra, "Heads and Tails": The Two Faces of Sovereignty,* exhibition catalog (Istanbul: Yapi Kredi, 1995).

16. Atiq R. Siddiqui, *The Story of Islamic Calligraphy* (Delhi: Sarita Book House, 1990), 19.

17. Oher representational images in Islamic calligraphy are discussed in Adolf Grohmann, "Anthropomorphic and Zoomorphic Letters in the History of Arabic Writing," *Bulletin de l'Institute d'Egypte* 38, no. 1 (1955–56): 117–22 and plates.

18. Tughras are also used as amulets, and so they function partly as signatures and partly as talismans or seals. There are books demonstrating how the letters can be disentangled and read, for example Umur, *Osmanli Padisah Tugalari.*

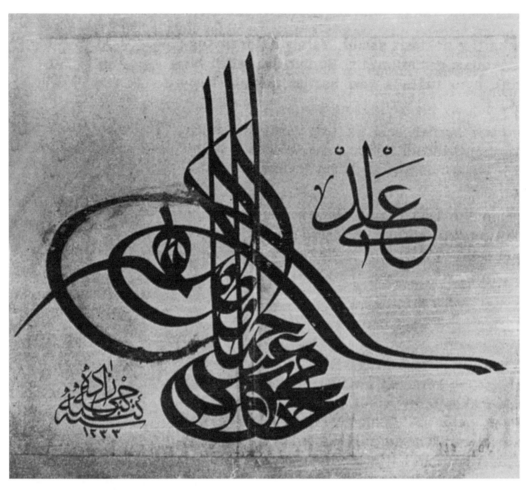

PLATE 7.2 *Cebeci-Zâde.* Tughra *of Maḥmûd Khân, son of ʿAbd ul-Hâmid (Mahmud II, r. 1808–1839). 1233, Islamic calendar.*

losophy, to which tughras add a unique complication: The scribes who were commissioned to write (or draw) tughras would sometimes add their own autograph signature at the lower left.[19] In this instance the caliph's name, Maḥmûd Khân, is signed and dated by the court calligrapher, Cebeci-Zâde.[20]

19. The slight, and sometimes pronounced, curvature of Islamic signatures is typical, and has legal and social meanings; see Brinkley Messick, *The Calligraphic State: Textual Domination and History in Muslim Society* (Berkeley: University of California Press, 1993), esp. chap. 12, "Spiral Texts."

20. The tughra itself reads "Mahmūd han bin ʿAbdülhamid el-muzaffer dāima" ("Maḥmûd Khân, son of ʿAbd ul-Ḥâmid, always victorious"). His by-name, "ʿAdLī" ("Just"), is to the right, and the calligrapher's autograph and date, "Ketebehu Cebeci-Zâde Sene 1233" ("Written by Cebeci-Zâde, in the year 1233"), is at the lower left. I thank Sujezana Buzov and Peter Kuniholm for for preparing translations.

The caliph's tughra becomes a "signed signature," or more accurately, an autographed signature: an elaborate cousin of the Western business letters that bear a signature together with a typed annotation "Signed in absentia by ———." The routes of reference from the named individual to the drawn and painted name can be quite devious. (Tughras are more complex in this regard than the signature-autograph combinations Jacques Derrida considers in the essay "Signature Event Context.")[21]

While it is true that allography often *seems* to be the work of an individual, it is more commonly in

21. Derrida, "Signature Event Context," in *Margins of Philosophy,* trans. by Alan Bass (Chicago: University of Chicago Press, 1982), 307–30; Béatrice Fraenkel, *La Signature, genèse d'un signe* (Paris: Gallimard, 1992); and see the discussion of signatures in Harris (1995), 80–83.

a twilight between individual and collective, or between unreproducible autograph, reproducible signature, eponymous style, and fully anonymous "styleless" writing.

THE PAGE AS A PICTURE

If we are to search for affinities between allographs and pictures, it's important not to neglect the fact that calligraphy can occur in relation not only to individual characters but to entire pages of normative script. The way that blank margins make an arbitrary frame around a rectangle of text is strictly analogous to the way a perspectival frame excises an arbitrary part of the visual world and makes it into a picture.[22] Perspective pictures and printed books with clear ruled margins began at roughly the same time and in the same part of the world.[23] Scrolls did not have this pictorial quality, because the *pagina* (column) of text was closely spaced, with continuous top and bottom margins on the order of one and a half to two inches.[24] A scroll could be opened to any convenient width as long as it revealed at least one column of text, and there was no incentive to make a rectangular "picture" out of a single column. There are examples of scrolls that imply pictorial frames: Chinese handscrolls with landscape paintings are an example, because viewers are free to open the scrolls to any width, framing their own evanescent pictures from the continuous landscape. The painted landscapes, in that sense, are like the continuously flowing text in a written scroll, and the momentarily framed scenes are like the pages, or *paginas,* of text that have rectilinear boundaries. But in purely written scrolls, especially in the West, the portion of text visible at any given moment is not especially pictorial. Printed books changed that, and the faint aroma of a picture is present on every printed page.

Out of an immense field, I will take three examples. When the page is subdivided, it can become both picture and frame in one, intensifying its pictorial nature.[25] One of the most extensive experiments in pictorial layout is the traditional format of the Talmud, the compilation of Jewish oral law. On a typical page the most striking pictorial feature is the central rectangle of larger text surrounded by smaller print (Plate 7.3). Within that central square there are actually two texts, the primary *mishnah* (the corpus of oral law) and the commentary on it, called the *gemara.* The *gemara* follows the *mishnah,* which is printed in the largest type, so that they form a single continuous column of text alternating *mishnah* and *gemara.* That format was invented in Alexandria, and it is contrasted in the printed Talmud by the other principal graphical form of commentary, invented in early Byzantine times: the form taken by the smaller text

22. Before the nineteenth century an extra word or two was printed in the margin at the lower right of each page, as if to say that special allowance should be made for the continuous nature of reading. Because the word or phrase was repeated at the inception of the next page, the flow of the text was interrupted in order to accentuate the unit, the *pagina,* bringing it closer to the closed rectangle of a picture. If we are thinking of pages as pictures, those extra few words in the lower-right margin are also like signatures, suggesting a correspondence with the contemporaneous fashion of signing paintings.

23. See, for example, Tom Conley, *The Graphic Unconscious in Early Modern Writing* (Cambridge: Cambridge University Press, 1992).

24. Leila Avrin, "The Book in Ancient Greece and the Hellenic World," *AB Bookman's Weekly* (13 May 1991): 1984; and see her *Scribes, Scripts, and Books: The Book from Antiquity to the Renaissance* (Chicago: American Library Association, 1991). The figure for the top and bottom margins is from a fourth century B.C.E. papyrus from Deveni.

25. Pierre Bayle's *Dictionnaire historique et critique* (1696) is an instance; it is composed in single blocks of text, set at the tops of the pages. Footnotes lead downward to a two-columned text. Both main text and footnotes have their own notes, which lead outward to the margins, where small, left-justified paragraphs fill the pages. The progression is down, and also away, from the main text, from unified blocks of text and toward fragmentation, and that movement perfectly mirrors and expresses the subterranean critiques that put Bayle's dictionary on the list of banned books. See Bayle, *Dictionaire* [*sic*] *historique et critique,* 3d ed. (Rotterdam: Michael Bohm, 1720), 4 vols. (The later editions have more voluminous notes.) The same motion and meaning, but in a typographically simpler fashion, occurs in an outwardly orthodox form in Spinoza's intricate *Ethics,* in which the scholia carry on an independent, and often subversive, dialogue with the main text. See Spinoza, *Renati des Cartes Principiorum philosophiae Pars I, et II, More geometrico demonstrata* (Amsterdam: Apud Johannem Rieuwerts, 1663); for the full text, Spinoza, *Ethica, more geometrico demonstrata,* in *Opera postuma* ([Amsterdam]: [J. Rieuwertsz.,] 1677). The texts themselves are discussed in Piet Steenbakker, *Spinoza's "Ethica" from Manuscript to Print: Studies on Text, Form, and Related Topics* (Assen: Van Gorcum, 1994). For the parallel between fragmented footnotes and fragmented, incomplete knowledge, see Stafford, *Body Criticism.* 164.

PLATE 7.3 *A page from the Talmud, Mishnayoth Zera'im, Tractate Kil'ayim, chap. 3.*

that flows around and enframes the *mishnah* and *gemara*.[26] That secondary text is in turn comprised of a hierarchy of commentaries by later rabbis. Some of them occupy places close to the *gemara*, and others are farther away, indicating their lateness or their slightly lesser importance. Some of the "Byzantine" commentaries have what may be called an Alexandrian relation to neighboring commentaries, and others have a Byzantine relation, flowing around their neighbors. All of this produces a strongly pictorial quality, conjuring not only our own picture frames — a partly anachronistic reference — but the robe, crown, vestments and ark of the Torah itself as it is traditionally kept in a synagogue, as if the central texts are surrounded and protected by increasingly secular accretions. (Most pages of the Talmud are unillustrated; I have chosen one with diagrams indicating how crops of different kinds might be arranged in fields, in order to suggest how intricate the typesetting could become.)

A second example, very different in the interpolation of pictorial and written forms, is Hrabanus Maurus's *De laudibus sanctae crucis,* written sometime before 814 C.E.[27] Hrabanus's showpieces are poems written on square grids, with larger shapes and figures superimposed (Plate 7.4). Unlike traditional figured poems, Hrabanus's figures are *in* his poems, which are themselves arranged in rectangular — that is, pictorial — formats.[28] The figures, in turn, enclose poems, words, or sayings. In this case the cross contains a palindrome that reads the same left to right as it does right to left, top to bottom, or bottom to top: "ORO TE RAMUS ARAM ARA SUMAR ET ORO." Like many palindromes, it is an awkward sentence, but it could be idiomatically translated "I pray, O cross and altar, to be saved through you." The praying figure beneath is the poet, and the letters in his figure spell another verse: "I beseech you, O merciful Christ, benevolently to protect me, Hrabanus, in thy Judgment."[29] On other pages, Hrabanus's superimposed shapes are themselves letters, and so, as Bruno Reudenbach and Elizabeth Sears have pointed out, there might be up to five "textual layers" (*Textebene*) in a single plate: the "background" poems that fill the rectangular page, the words formed by the large letters themselves, the verses inside the shapes (*versus intertexti*), the prose com-

mentaries that Hrabanus appended to each plate (*declarationes*), and further commentaries in a second book.[30] In this particular page, the picture is oddly disjunct from the writing, because the cross and self-portrait neatly elude every individual letter. At the same time, the letters work overtime to conjure pictures. The very act of reading the doubled palindrome suggests the sign of a cross, and the poem Hrabanus has inscribed over himself verifies the humility that his painted figure so clearly expresses. Picture and writing are very close, but worlds apart. Scholars who have undertaken iconographic analyses of Hrabanus's manuscript testify to that when they fail to account for the peculiarities of the pictures.[31] What difference does it make if the cross is above Hrabanus's head, or on a level ground? Does it matter that the first letters of the verse in Hrabanus's body are in his

26. For these two kinds of commentary see H. Cancik, "Der Text als Bild, Über optische Zeichen zur Konstitution von Satzgruppen in antiken Texten," *Wort und Bild,* ed. Hellmut Brunner, Richard Kannicht, and Klaus Schwager (Munich: W. Fink, 1979), 81–100. Cancik develops a theory of macrosyntax, following Peter Hartmann and others, and extending the sequence semanteme-syntagma-sentence (82).

27. Vienna, Österreichische Nationalbibliothek, cod. 652. There is a facsimile edition (Graz: Österreichische Nationalbibliothek, 1973).

28. Their affinities lie rather with ancient, medieval, and Renaissance "figured numbers" or *numeri figurati,* exposited by Iamblichus and others. See Iamblichus, *Theologumena arithmeticae,* ed. Vittorio de Falco (Leipzig: B. G. Teubner, 1922), translated by Robin Waterfield as *The Theology of Arithmetic: On the Mystical, Mathematical, and Cosmological Symbolism of the First Ten Numbers* (Grand Rapids, Mich.: Phanes Press, 1988); and, further, Ulrich Ernst, "Kontinuität und Transformation der mittelaltlerichen Zahlensymbolik in der Renaissance: Due *Numerorum mystica* des Petrus Burgus," *Euphorion* 77 (1983): 247–325, esp. 289–90.

29. This translation is from Elizabeth Sears, "Word and Image in Carolingian *Carmina Figurata,*" in *World Art: Themes of Unity in Diversity, Acts of the Twenty-Sixth International Congress of the History of Art,* ed. Irving Lavin (University Park: Pennsylvania State University Press, 1989), vol. 2, 341– 48, esp. 341.

30. Sears, 344n10, citing Bruno Reudenbach, "Das Verhältnis von Text und Bild in 'De laudibus sanctae crucis' des Hrabanus Maurus," in *Geistliche Denkformen in der Literatur des Mittelalters,* ed. K. Grubmüller et al. (Munich: W. Fink, 1984), 282–320, esp. 293–97.

31. A. Mott, "Die Kreuzessymbolik bei Hrabanus Maurus," *Beilage zur Fuldaer Zeitung* 4 (1905): 182.

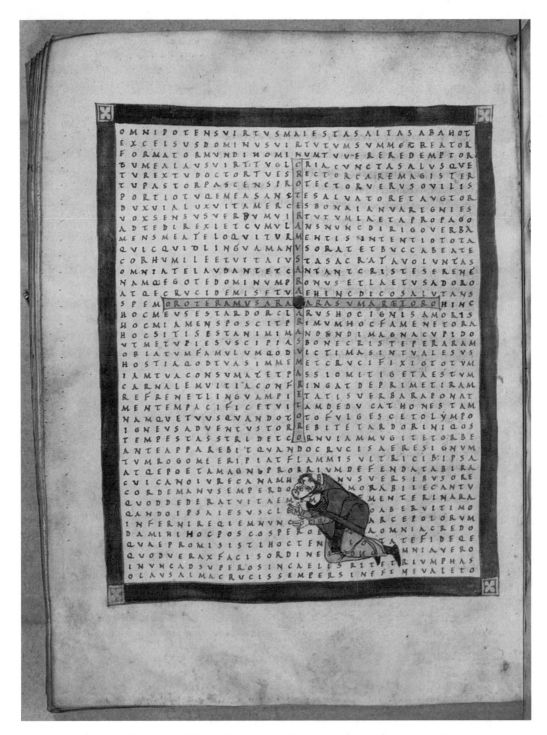

PLATE 7.4 *Hrabanus Maurus and Hatto. Poem and self-portrait adoring the cross. ca. 810 C.E.*

head, and the last in his feet? As often in shaped poetry, the figure ends up only loosely linked to the pictures, which are themselves simple — much simpler, in this case, than the exquisitely difficult wordplay.[32]

The unmanageable contrast between simple typographic meanings and extremely difficult verbal

32. In part the disparity could be assigned to the fact that another monk, known as Hatto, executed the figures but that would only displace the question of the image's meaning.

ones can be read as a sign of the difficulty — or the impossibility — of forcing a pageful of words into a picture. My third example is probably the most profound negotiation of the *agon* between pictures and picturelike pages: Mallarmé's poem *Un Coup de Dès Jamais d'Abolira le Hasard.* (The last double page is shown in Plate 7.5)[33] In that work some pages can be read as a viewer might interpret naturalistic pictures: The passage in which Mallarmé invokes a shipwreck is set in a falling motif, and isolated lines are vignettes of the scenes they describe. The line describing man as "bitter prince of the reef" is itself an atoll, and there are plumes, sails, and other shapes in Mallarmés images and in his typesetting.[34] Those are, in a way, introductory moments, informing the reader that the poem's typography is trying to express its grammatical structure. As the reading deepens, the few overtly visual correspondences fade into metaphorical visualizations of rhetorical and grammatical devices. *Jamais,* for example, is isolated on its page, where it resounds against the white paper like a single loud word echoing in a silent room. But in the end such "concrete" devices are only accents on the fundamentally anti-pictorial nature of the entire typographic and expressive project — and that is to represent *hasard,* the meaningless, chance, and momentary "place" or configuration. As the final page declares, the poem itself is a "constellation," something that seems to have meaning but does not, an act that is intensely deliberated but ends up meaning "nothing." *Un Coup de dès* is anti-pictorial in that it forms its picture of arbitrariness by flowing without interruption across frames and pages. It is a beautiful paradox: Print, behaving as print always does, forms the best representation, the best picture, of something unrepresentable. Mallarmé's poem is the most reflective conversation between typographic page and written meaning that has yet been produced, and it demonstrates with great persuasiveness just how close print and pictures are, and yet how difficult it is to ever fuse the two.

INFECTION FROM INSIDE AND OUTSIDE

Is it possible, beginning from examples like these, to configure a theory of allographic marks? The relation between pages and pictures is not at all straightforward, because allographic interventions do not make pages more picturelike. Nor is the relation between allograph and letter semiotic in nature, as allographic marks seldom *refer* to letters — their relation is much more active and invasive. Even concertedly pictorial works like Hrabanus's don't bring pictures to mind: They are more like texts that have been tortured and distorted by the application of something nonpictorial. Mallarmé's poem shows as much in its very careful renunciation of naturalistic purpose.

This is why I prefer the biotic metaphor, and especially the idea that allography *infects* both writing and pictures. An infection can seem to be caused by something outside the body, but it always strikes from within, and those two possibilities correspond to fundamental strategies in calligraphy, typography, and layout. An allographic mark can be made outside the text, as a frame or as supernumerary marks appended to letters, or else it can act from within, multiplying or distorting the essential strokes of the letters themselves and eventually disrupting them. A typical instance

33. The poem has been printed in a number of inaccurate formats and typefaces. All research that depends on the poem's appearance should begin with *Un Coup de Dès Jamais d'Abolira le Hasard,* ed. Mitsou Ronat (Paris: Change Errant/d'Atelier, 1980); and see Ronat, "Le 'Coup de Dès': Forme Fixe?" *CAIEF* 32 (1980): 141–47. Ronat's edition (illustrated here) is arguably the closest to Mallarmé's intentions, although the spacing of the gutter in this illustration is arbitrary and would presumably have been tightened. For interpretations see Virginia La Charité, *The Dynamics of Space: Mallarmé's "Un Coup de Dès Jamais d'Abolira le Hasard"* (Lexington, Ky.: French Forum, 1987); Jean-Claude Lebenstejn, "Note Relatif au *Coup de Dès,*" *Critique* 397–98 (1980): 633–59; Jacques Derrida, "The Double Session," in *Stephane Mallarmé,* ed. Harold Bloom (New York: Chelsea House, 1987), 79–96; David Scott, *Pictorialist Poetics: Poetry and the Visual Arts in 19th Century France* (Cambridge: Cambridge University Press, 1988), 138–70; Julia Kristeva, *La Révolution du Langage Poétique* (Paris: Seuil, 1970), esp. 265–314; Gerald Bruns, "Mallarmé: The Transcendence of Language and the Aesthetics of the Book," *Journal of Typographic Research* 19 (1979): 219–40; and Florence Penny, *Mallarmé, Manet, and Redon: Visual and Aural Signs and the Generation of Meaning* (Cambridge: Cambridge University Press, 1986). I thank Thomas Cobb for these and other references in regard to *Un Coup de Dès.*

34. Compare, however, Robert Cohn's literal-minded interpretations in *Mallarmé's Masterwork: New Findings* (The Hague: Mouton, 1966), and Cohn, *Mallarmé's "Un Coup de Dès:" An Exegesis* (The Hague: Mouton, 1949), esp. 118–22.

of the former is John Hancock's signature, with its optional swirls. The signature itself is largely intact, and it is calligraphic partly by virtue of its dramatic flourish. A famous example of design from the inside is the *chi-rho* page from the Book of Kells, in which the letters are bursting with internal forms, multiplying and mirroring their overall shapes. Typography also operates largely from the "inside," and computer-assisted design strengthens the metaphor by providing an outline, dividing the letter into interior, contour, and exterior (Plate 7.6).[35]

Calligraphic alterations that come from "outside" the text can be parasitic in the sense that they can easily overwhelm the printed or written meaning. Some Qur'ān pages have tremendous, elaborate borders framing scant verses, and it can seem as if the ornament is posing questions to the text: Which is more important? Which possesses the deeper religious meaning? Especially in Safavid and Mughal Qur'āns, arabesques can be so extensive that the text seems to lose its meaning — as if it were about to become mute, silenced by the richness of patterned prayer (Plate 7.7). In this sixteenth-century example, *sūrah* headings are written one word to a page.[36] In the West the near identity between frame and letter is sometimes exploited to very different effects. Johann Georg van Schwandner's *Dissertatio de Calligraphia* (1756) sports letters in decorative frames, and the frames themselves mimic the letterforms, creating an infinity of letters tangled in ornament (Plate 7.8).[37] A number of ordinary scripts have been pushed toward illegibility by excessive ornamentation attached to the "outside" of letterforms. A recent example is the German cursive script called *Kurrent,* which was the handwritten, cursive form of *Fraktur,* the characteristically German "Gothic" style in use through World War II.[38] In Renaissance practice, *Kurrent* involved fanciful ligatures and — even more of an obstruction to reading — repeated marks that could be taken for the spikes and curls of lowercase letters such as m, n, r, and i. The result must have been unintelligible to untrained eyes, as a word such as *und* (and) might be spelled *unndt,* and then those letters multiplied by supernumerary spikes, creating a nearly incomprehensible shape (Plate 7.9).[39]

The history of monograms is another instance of calligraphic force applied to letters from the "outside," in this case bending and knotting them into nearly illegible pictorial shapes. In Charles Demengeot's *Dictionnaire du chiffre-monogramme* (1881), the letters of the name *Hyacinthe* are bolted, pierced, sawn, and knotted around one another, in imitation of wood, paper, and metal (Plate 7.10). There are also monograms that are intentionally undecipherable: their allographic ligatures have fused into permanent bonds. *Siglum* is one word for such a fusion, and another is *logo;* the most accurate, however, is *hypogram,* a term I use in Chapter 11 to denote any sign that appears to be congealed from several others.

Calligraphy that works from the inside can be even more violent and less amenable to ordinary reading. The renaissance of such calligraphy took place in Nuremberg in 1601–1602, when three closely related books appeared in quick succession, each demonstrating letterforms more intricately fractured than any before or since.[40] Anton

35. See Douglas Hofstadter, "Meta-Font, Metamathematics, and Metaphysics: Comments on Donald Knuth's 'The Concept of a Meta-Font,'" *Visible Language* 16, no. 4 (1982): 309–38, with commentaries, 339–59.

36. Martin Lings and Yasin Hamid Safadi, *The Qur'ān* (London: World of Islam, 1976), 79.

37. Schwandner, *Dissertatio epistolaris de calligraphiæ nomenclatione, cultu, præstantia, utilitate* (Vienna: Typographeo Kaliwodiano, 1756), reprinted, in poorer quality (New York: Dover, 1958); and compare Guillaume Le Gangneur, *La Technographie; ou, Briefue methode pour parvenir à la parfaitte connoissance de l'écriture françoyse* (Paris: s.n., 1599); Leopardo Antonozzi, *Le Caratteri* (Rome: s.n., 1638), reprinted (Nieuwkoop: Miland, 1971); and Francesco Pisani, *Trattegiato de Penna* (Genoa: s.n., 1640 [?]).

38. See Gerhard August, "Germany: Script and Politics," in Daniels and Bright (1996), 765–68, esp. 765.

39. Greek ligatures invented in the fifteenth century and afterward are another example: Some work by transforming familiar letters into outlandish swirls, and others link letters with loops and lines. See, for example, William Savage, *A Dictionary of the Art of Printing* (London: Longman, Brown, Green, and Longmans, 1841), reprinted (New York: B. Franklin, 1961) and sampled in *English Bibliographical Sources,* ed. D. F. Foxon, ser. 3, no. 8 (London, 1966), *v.* "Greek," pp. 300–301.

40. Paul Franck, *Schatzkammer allerhand Versalien Lateinisch unnd Deutsch* (Nuremberg: K. Dieterichin, 1601); Anton Neudörfer, *Der Schreibkunst Das erste und andere Theil* (Nuremberg: Paul Kaufmann, 1601); and Christoph Fabius Brechtel, *Kurtze und Getrewe unterweissung der Fürnemsten Teutschen Hauptbuchstaben* (Nuremberg: A. Wagenman, 1602); all discussed in Werner Doede, *Schön schreiben, eine Kunst,*

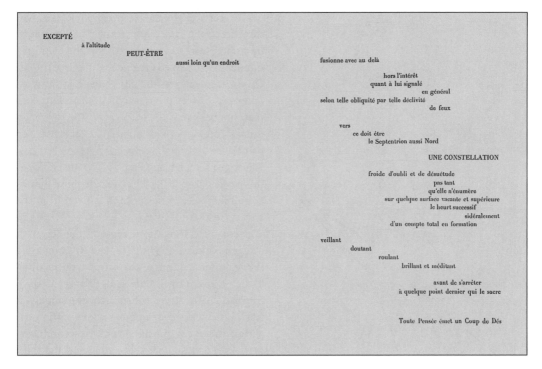

EXCEPTÉ

à l'altitude

PEUT-ÊTRE

aussi loin qu'un endroit fusionne avec au delà

hors l'intérêt
quant à lui signalé
en général
selon telle obliquité par telle déclivité
de feux

vers
ce doit être
le Septentrion aussi Nord

UNE CONSTELLATION

froide d'oubli et de désuétude
pas tant
qu'elle n'énumère
sur quelque surface vacante et supérieure
le heurt successif
sidéralement
d'un compte total en formation

veillant
doutant
roulant
brillant et méditant

avant de s'arrêter
à quelque point dernier qui le sacre

Toute Pensée émet un Coup de Dés

PLATE 7.5 *Mallarmé.* Un Coup de Dès Jamais d'Abolira le Hasard, *final double page.*

Neudörffer, the most important of the three authors, had to offer his readers step-by-step instructions for creating letterforms; without them his concoctions would resemble birds' nests more than letters. Another of the authors, Paul Franck, produced an outlandish book of capitals so ornate they could scarcely be recognized — or used. One of them serves as the ornamental capital that opens Chapter 11. It helps to think of a German "Gothic" letter M, such as one reproduced in Plate 5.6, but even then it looks more like a monstrous thorn bush than a letter.[41] A contemporaneous handwritten example, also from Nuremberg, shows the possibilities of this kind of calligraphy (Plate 7.11). The first letters of the words *Herrn Anthoni Tuchers* burst from their roots with an unprecedented energy, splaying into a thicket of stalks.[42] The letter A has its two verticals, but even before they have left the line they have divided into almost thirty parts, swirling off in three or four different directions. In the haze above, little can be distinguished; with Neudörffer's text as a guide, however, it is possible to pierce the thicket and find the essential structures. The T of *Tuchers* is given by the horizontal S that lies over the end of *Anthoni,* and by the upright S and the capping arc above it. The A of *An-*

thoni is visible in its upright and in the backwards-bending curve that meets it above *Herrn.* And the H of *Herrn* is the reversed C that is clamped to the line, together with an S-shape that floats in the upper left of the composition.

A fascinating multicultural example of infection from the inside is Yanagida Taiun's *Cold Mountain* (Plate 7.12, *left*).[43] Taiun's calligraphic style looks suspiciously like kakography (bad handwriting), but it is intended to express the whimsy

Johann Neudörffer und die Kalligraphie des Barock (Munich: Prestel, 1988), 64–75.

41. Franck, *Künstrichtige Schreibart Allerhand* (Nuremberg: Christoff Gerhard, 1655). Some of the letters, such as the I, outgrow the book itself and are printed on folding plates. There are several mid-century editions of Franck's book (for example, Nuremberg: P. Fürsten, 1650), all derived from his *Schatzkammer.*

42. The family Tucher is discussed in Doede, *Schön schreiben,* 151n41; the plate is reproduced as fig. 53, p. 59. See also Tucher, *Fundament unnd gründtliche Berichtung aller unnd jeder Alphabet wo die jren ordenlichen Uhrsprung unnd Herkome haben.* MS, sixteenth century. Chicago, Newberry Library.

43. For Yanagida, see *Words in Motion: Modern Japanese Calligraphy* (Washington, D.C.: Library of Congress, 1985), 76–77.

of poems written by the eccentric monk Han Shan sometime before the tenth century.[44] According to tradition, Han Shan and his companion lived on a mountain and carved their poems into tree trunks. On occasion they would come down to the local temple and sweep it out, laughing and joking, and then run back into the wilderness. The two "mad monks" are a popular subject of Japanese Zen painting, where they are shown with their brooms, wildly grinning or laughing, and so the choice of this particular style fits the general tenor of the poems. Taiun's eccentric script is derived from the ancient seal scripts by way of Dubuffet, Miró, and Western surrealism. Some sense of the degree of calligraphic distortion can be had by comparing the rightmost column of characters in the painting to their conventional equivalents (Plate 7.12, *right*). The first character is clear enough, even though it is a little waterlogged, and its bottom portion has sprouted an eye. Taiun has shrunk the second character into a little boat-shape one, and the third character is split in two: Half remains in its proper column, and half has migrated over to the left, where it sits under the second column of text. The fourth character is again fairly clear (top of the second column), but the fifth is decidedly wayward, more like scattered leaves than a single character. From that point on, at least to my eye, the words become plants and birds and stop making sense altogether. Even native readers feel this kind of accelerating difficulty. And yet even as the act of reading breaks down, the pictorial resurfaces, and the scroll reveals itself as a naturalistic scene of a forest — with vines, tangled trunks, staring eyes, and ghostlike figures.

CALLIGRAPHS AS SYMBIONTS, MIMICS, PARASITES, ANTIBIOTES, AND TOXINS

These are examples of the destructive violence of calligraphy, its ability to infect, degrade, and ultimately destroy written meaning. In the biological metaphor, I might say Yanagida Taiun's calligraphy

PLATE 7.6 *Lowercase* t, *as printed by a typography program. 1995.*

44. Yanagida says only that the script is an "ancient writing style," "unrelated to the content of the poems," in which characters are "arranged in decorative positions." I posit the Western connection on the strength of the disproportionate naturalistic excrescences, which are unparalleled in seal scripts and other early style. *Words in Motion,* 76.

PLATE 7.7 *Pages from a Qur'ān, showing* sūrat al-Fātiḥah, *I, 1–7. Gold Rayḥānī script. Sixteenth century, Afghanistan or India.*

has an antibiotic effect on writing. In biology "antibiosis" is a relationship of mutual harm between two organisms, and we approach that when the calligraphy makes the poem unreadable, and the poem refuses to bend to the calligraphic treatment.

The biotic metaphor also works for calligraphy that does not detract from written meaning. Allography brings its own meanings to bear, and sometimes it's more a matter of adding meaning to existing writing than tearing down or smothering meaning. Even Taiun's ferocious forest can be said to contribute to the theme of lunacy. Highly decorated Mughal Qur'āns communicate holiness apart from what the text says. In such cases calligraphy enriches texts in a peculiar way, as the written meanings and the calligraphic meanings are augmented by a tertiary sense contributed by the discord or harmony between the two. The relation can be symbiotic — mutually beneficial — because the meanings of both text and calligraphy nourish

each other. Very gentle allographs of letters, such as the difference between Helvetica g and Times g, are like biological mimics: They do not appear as additions or elaborations at all. They are camouflaged, contributing a nearly inaudible note of pictorial meaning.

More often, though, allographic marks are antibiotes, undermining the multiplicity and specificity of meaning in a text, working against the very idea of articulated meaning. To compose the ornamental paragraph at the beginning of this chapter, the words (and therefore the sense) had to be altered in order to make the pattern. It is nearly impossible to say what meaning was lost in doing so, and it is even harder to say what the resulting pattern *means:* It signifies my intention to emphasize the pictorial nature of some typographic layouts, even though the lozenge or mandorla has no clear relevance. In addition, the layout stands in the way of reading, because it is significantly harder to

PLATE 7.8 *Page from Johann Georg van Schwandner,* Dissertatio epistolaris de calligraphiæ nomenclatione, cultu, præstantia, utilitate.

ErſtIich muſtu haben ein Tafel von lindem holtz/2.ſchuhe lang/1.ſchuhe vnd 8.zol breit/vnd $\frac{2}{3}$.zol dick (welche du / wann dus brauchen wilt/ am aller bequembſten/als ein Schreibbültlein/ein wenig geleinet/ für dich legen ſolt) dazu muſtu haben ein leiſten der Tafel leng/$\frac{1}{4}$.zol dick / vnd $\frac{1}{7}$.zol breiter dann die Tafel dick iſt / vnnd diſe leiſten heffte oder leime vnten gegen dir/an die lange ſeiten/ſolcher Tafel/alſo das das $\frac{1}{7}$. vom zol/des die leiſten breiter dann die Tafel dick iſt/oben vberſteche/vnd diß wird zu zwerch/vnnd perpendicular linien / ein rechte vnd gewiſe regel ſein/vnd iſt diſe Tafel / ſampt der leiſten/inn der erſten Figur N° 1. mit A. ſignirt. Es ſoll dich aber gar nicht jrren/ob gleich mehr ding auff derſelben verzeichnet ſind / von welchen der bericht hernach volgen wird/wölte aber jemand/weniger koſtens halb/ nur ein gemein Linial / mit zweien nadelſpitzen / auff ein Tiſch oder anders ebens Bret hefften/das were auch genug hierzu.

PLATE 7.9 Top: *sample of Renaissance German Kurrent script.* Bottom: *Renaissance printed version of the same text.*

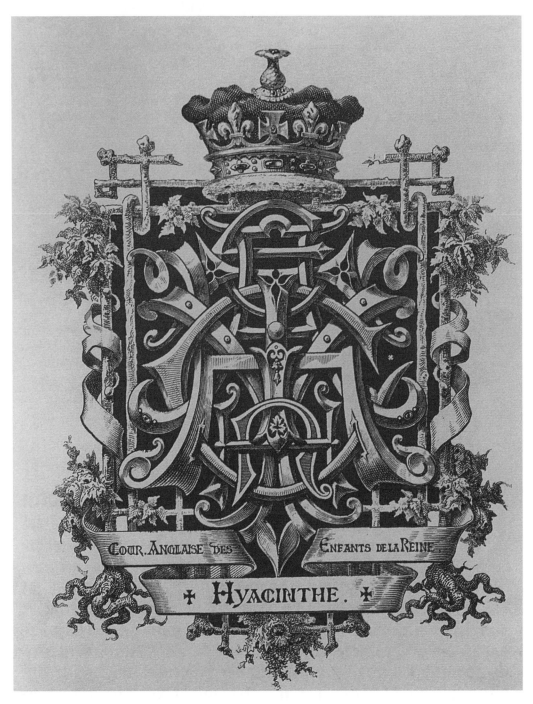

COUR. ANGLAISE DES ENFANTS DE LA REINE

✦ HYACINTHE. ✦

PLATE 7.10 *Monogram of the name "Hyacinthe."*

extract the meaning from a sentence when it is almond-shaped. The same applies whenever a text is in a uniform font or style (that is, it applies universally). A Qur'ānic *sūrah* (chapter) might say many things, but its calligraphy is bound to follow one of the acceptable styles, and so it only express a limited set of meanings. Throughout a hand-

written Qur'ān, the calligraphy calls to a devout reader, but the call does not vary as the text does. Because calligraphy is incapable of mirroring the mercurial movements of written meaning, it is also a force against eloquence, rhetoric, dialectic, and the motions of thought. Instead it has an unchanging meaning that continues like a drone bass

PLATE 7.11 *Jost Ammann. Page from the genealogic record of the family Tucher. 1589.*

throughout a text. (This is the reason it makes sense for Islamic scribes to list the number of *surahs*, words, letters, and even diacritical marks — there are 156,051 — in a single copy of the Qur'ān.)[45] Even if the style — say, *naskh*, a traditional Qur'ānic script — evokes profound and partly cognized thoughts of religious practice, devotion, the holiness of the text, and the style's historical precedents, it does so the same way in every verse and in every word.

In Oleg Grabar's view, calligraphy is one of the "intermediaries" between ornament and meaning, bringing up thoughts of the relation between written meaning and meaningless ornament.[46] I have not followed his formulation here, partly because I am not sure that allography is a middleman or an ambassador. When calligraphy actively corrodes meaning, it is difficult to imagine it as a "mediator," and even when it adds symbiotically to meaning, it does not appear as neutral ornament. Instead of linking the reader and the text, calligraphy is more like a demon tunneling into meaning than an ambassador mediating before meaning. ("Intermediary Demons" was Grabar's original title, which was dropped in the printed version.)[47]

Parasite, antibiotic, mimic, and symbiont are each names for allographic practices. There is one more possibility, which completes the list and underscores how different allography can be from an ornament, decoration, or picture. That possibility is that allography can entirely poison the act of reading, turning meaningful words into an inert,

incomprehensible residue. Chinese, Japanese, and Islamic calligraphers all developed styles that are virtually illegible — that shut down reading altogether. The Chinese grass script (*cau shu*) exists in a particularly wild form (*kuang*) that is opaque to most native speakers, even though — as Leys points out — it is also one of the most entrancing styles for viewers who have no knowledge of Chinese.[48] Islamic traditions are especially rich in such examples. A tray in the Victoria and Albert Museum, made for the Syrian ruler Badr al-Din Lulu (active ca. 1233–59), should read "Father of Virtue," but it says "Father of Oppressions." Apparently Badr did not bother to read the inscription, and perhaps he was content with the ornamental look of the calligraphy and the assumption that it must have a sycophantic meaning. There are complicated inscriptions in the Ince facade in Konya, the Qutb Minar in Delphi (eleventh century), and the Masjid-i Shah in Isfahan (seventeenth century), each in the words of one specialist "almost impossible to decipher even with an extensive knowledge of Arabic."[49] Some such inscriptions

45. Grabar (1992), 64, lists the figures.

46. Grabar (1992), chaps. 1 and 2.

47. Grabar (1992), xxv, 45–46. For suggestions about the potential use of *demons,* see Margaret Olin, review of Grabar (1992), in *The Art Bulletin* 75, no. 4 (1993): 728–31, esp. 730.

48. Leys, review of Billeter, *Chinese Art of Writing*, 28.

49. *From Concept to Context: Approaches to Asian and Islamic Calligraphy* (Washington, D.C.: Smithsonian, 1986), 108–09, on the impossibility of reading inscriptions. The in-

PLATE 7.12 Left: *Yanagida Taiun.* Cold Mountain, *detail of right-hand portion.* Right: *the initial portion of the text, in contemporary Chinese. ("By chance, I happened to visit an eminent priest.")*

were put in places where most of the population would not have been literate, and this is taken to indicate that the calligraphy itself has symbolic meaning — it denotes power, as in the tray, or holiness, as in the Mosques. In such instances allography has become what it has killed: It has turned into a kind of writing even when it has finally smothered the act of reading altogether. Allography can therefore be thought of as an extravagantly ineffecient way of saying simple things. Thousands of "meaningless" marks add up to single words — *holiness, power* — and in the process of proliferating they kill what they have been feeding on.

WHEN CALLIGRAPHY BECOMES STRONGLY PICTORIAL, AND VICE VERSA

If allography is toxic to writing — or, at the very least, if it skews readers' attentions, making them think of meanings other than written ones — then is it also inimical to pictures? In some traditions, calligraphy and picture-making are conceived as parallel actions. Again I'll give three examples, in parallel to the three examples of allography and writing.

The Chinese use the phrase *ch'i mo pu tuan,* "no break in the flow of spirit," to express the way that calligraphic poems can complement ink-brush paintings.[50] But the criteria are mostly unwritten, and so the nature of that judgment is partly inac-

cessible. When it is said that Chinese painting and calligraphy become inseparable, the topic is often the Ch'ing Dynasty painter Chu Ta (1626–1705). Some of his paintings, such as the *Falling Flower* album leaf from 1692, would seem to argue for a close correspondence between painting and text (Plate 7.13).[51] The two large characters are *she-shih,* which has been read "involved in social affairs," meaning that Chu Ta had painted the album leaf on demand, thus involving himself for the occasion in the entanglements of social life that his painting generally eschewed.[52] The smaller calligraphy in the lower center is the artist's signature, *Pa-ta-shan-jen,* and below it is the artist's seal, which is also probably to be read *Pa-ta-shan-jen.* The only other element in the picture, aside from the collector's seals on the right margin, is the falling flower itself.

Helmut Brinker speaks of this painting as a "total synthesis" of writing and painting, so that the

scriptions on the Dome of the Rock have been said to be illegible, but see Oleg Grabar, *The Shape of the Holy* (Princeton, N.J.: Princeton University Press, 1996). I thank Oleg Grabar for a generous reading of the argument, and for information on this list of "illegible" inscriptions.

50. Willetts, *Chinese Calligraphy,* 212.

51. The other leaves in the album are reproduced in Yang Yang, *Pa-ta-shan-jen shu-hua chi* (Tapei, 1974), plates 89–95. See Shen C. Y. Fu, "Format and the Integration of Painting and Poetry," in *Traces of the Brush, Studies in Chinese Calligraphy* (New Haven, Conn.: Yale University Art Gallery, 1977), 179–201.

52. Shen Fu, *Traces of the Brush,* 281.

characters are "painted" and the painted flower is "written."[53] But how closely does the one approach the other? Would we want to say that painting and text "are one"? This is an album leaf — that is, a painting — and the consonance between character and flower is congenial, witty, and entertaining rather than confusing. The marks that go into one do not go into the other, and there is no danger of committing a category error. Huang T'ing-chien's (1045–1105) version of the Western *ut pictura poesis* — "In the characters there has to be 'brush,' just as in the sentences there have to be 'eyes'" — speaks about an exchange or a mimicry, rather than an identity.[54] Something of the brush is "in" pictures, and something of the eye is "in" writing. We are teased, but not tricked, into thinking that the flower might mean something in the way the character does. If there is "no break in the flow of spirit," there is still a break in meanings, and in artistic practices. Instead of proposing a "unity" between calligraphic writing and linear painting, or even supposing that such a unity might have meaning, it might be better to say that the painting plays with a kind of affinity between writing and picturing. It is not serious play: If it were, there would be a serious chance of reading something in the flower, or reading across from *she-shih* into the flower. Instead Chu Ta gives us just a hint, just enough curl in the *shih* so that it makes a blossom, and just enough symmetry and balance in the flower so it is characterlike. That playfulness does not exist in the West. It is as if one of the Borromean rings I used in the previous chapter had almost perfectly overlapped another, as in a near-total eclipse: Conceptually, writing and painting are the same size, so that one might for a moment fit over the other and blot it out.

There are other arenas in which allographic marks and pictures come perilously close to each other. Some Chinese and Japanese calligraphy uses characters in a naturalistic fashion, so that the meaning of a verse matches the forms of its characters. Though there are famous examples of mimetic Japanese calligraphy — for example, Hon'ami Koetsu and Tawaraya Sotatsu's collaboration, in which Koetsu's calligraphy hangs "like tendrils" from Sotatsu's designs[55] — such works are in the minority outside of Zen practice. More widespread is the *sumi* painting that uses the pic-

tographic elements of characters that have so fascinated the West from Athanasius Kircher to Ernest Fenollosa and Ezra Pound.[56] Recently the Western interest in *sumi* painting, first popularized by John Graham's *System and Dialectics of Art*, has come full circle and influenced Japanese painters. Graham's book caught the interest of painters such as Mark Tobey, Franz Kline, Robert Rauschenberg, Cy Twombly, Ad Reinhardt, and Kenneth Noland, who painted gestural works that they interpreted in more or less Zen terms. In the West this is an often-told story, but it also has a curious sequel, as several generations of Japanese have been aware of Western versions of their own tradition.[57] The reciprocal movement can be dated to an essay by Hasegama Saburo, "The Beauty of Black and White" (1951), about Franz Kline. A recent Japanese artist who carries on the Eastern tradition with awareness of the West is Kamijō Shinzan. *Listening to Rain* (1982) is comprised of the characters for *rain* and *listen* (Plate 7.14, *top*). In the artist's words, *listening,* on the right, is "unbalanced," perhaps to convey the impression of a person listening. *Rain,* on the left, is "dry," to "give the impression of spray and raindrops."[58] The Japa-

53. Thus Brinker, "Bild und Schrift," in *Wort und Bild,* 72, and 73: "Schriftkunt und Malerei werden eins."

54. Günther Debon, *Grundbegriffe der chinesischen Schriftteorie und ihre Verbindung zu Dichtung und Malerei* (Wiesbaden: Steiner, 1978), 84. Translation modified.

55. See especially Hon'ami Koetsu (1558–1637), *Poems of the Kokin wakashu.* For the *Kokin wakashu,* an anthology of Japanese verse, compiled 905 C.E., see Helen Craig McCullough, *Brocade by Night: "Kokin wakashu" and the Court Style in Japanese Classical Poetry* (Stanford, Calif.: Stanford University Press, 1985). For Koetsu, see, for example, *Koetsu no sho: Keicho, Genwa, Kan'ei no meisho: tokubetsuten,* exhibition catalog (Osaka: Osaka Shiritsu Bijutsakan, Heisei 2, [1990]).

56. A delightful Western book on pictographic elements in Chinese writing is Edoardo Fazzioli, *Chinese Calligraphy: From Pictograph to Ideogram, The History of 214 Essential Chinese/Japanese Characters* (New York: Abbeville, 1987).

57. This is the impliction of Barbara Rose's "Japanese Calligraphy and American Abstract Expressionism," in *Words in Motion,* 38–43. In 1948 Morita Shirū called for Japanese calligraphy to be abstracted so it could be appreciated by people unable to read Japanese. See Bert Winther-Tamaki, "Mark Tobey, White Writing for a Janus-Faced America," *Word and Image* 13, no. 1 (1997): 77–91, esp. 88.

58. *Words in Motion,* 105–106, and Cecil Uyehara, "Kamijo Shinzan: Contemporary Master Calligrapher," *Calligraphy*

PLATE 7.13 *Chu Ta.* Falling Flower. *1692.*

nese character for *rain* has four small dots or dashes; when it is drawn by hand, the character can easily conjure rain (Plate 7.14, *bottom*). (In some texts, the character is glossed further: The top horizontal is said to represent the sky, the vertical axis the ascending warm air, the inverted U the falling cold air.)[59] In Shinzan's painting the four dashes are engorged into a synecdochic flood, and his brushstrokes, done in "flying white," mimic watery spray. To put it in formal terms — terms I critique in the next chapter — the character *rain* is a pictograph, and the character *listening* is an ideograph. One resembles; the other symbolizes.

The contrast between Tobey's nonsymbolic calligraphy and Shinzan's meaningful calligraphy has yet to be explored, and it has potential repercussions for the Western sense of abstraction. Shinzan's Japanese characters are well within the Japanese tradition, but they bear the marks of Western conventions of abstraction: In other words they obey the kinds of balance and composition that

pertain to Western abstract painting as well as Eastern calligraphy. Such paintings have not only the Western repertoire of abstraction but also the Eastern conventions of lettering and a determinate linguistic meaning. The unsteady East–West influences conjure a rather rude question. Why, I wonder, would we not want to say that such paintings are potentially more interesting than paintings by Klein or Tobey (Plate 7.15)? Claiming that the linguistic meaning of *Listening to Rain* delimits the meanings that are available to a "pure abstraction" such as Tobey's *Dragonade* certainly overlooks the fact that Tobey and other artists of his generation often gave descriptive titles to their paintings; but equally certainly, those titles do not intervene in individual painted marks. Conversely,

Review 9, no. 2 (1992): 6–13. I thank Tom Rimer and Cecil Uyehara for assistance in researching Shinzan.

59. D. M. Murray and T. W. Wong, *Noodle Words: An Introduction to Chinese and Japanese Characters* (Rutland, Vt.: Charles E. Tuttle, 1971), 86.

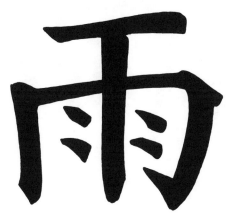

PLATE 7.14 Top: *Kamijo Shinzan*. Listening to Rain. *1982. Bottom: "Rain" in modern Japanese.*

Shinzan's phrases are rich in nonverbal associations to Japanese culture in general and to Tao in particular; such meanings, however, are anchored to the determinate texts from which they spring.[60]

In Japanese criticism of such paintings, it is said that it is possible to ignore the linguistic component by not reading the characters. But this is only a temporary and artificial interpretation, as *Listening to Rain* is made of linguistic signs. I take it that this is a problem that has serious consequences both for Western abstraction and the continuing Japanese tradition. Is Shinzan losing something by basing his abstractions on characters, or is he creating something richer and more interesting than a "pure," nonlinguistic abstraction?

My last example of "calligraphic pictures" is from a different tradition and shows a different kind of incompatibility between calligraphs and

pictures. In a Turkish illustration from 1900, the names of the Seven Sleepers of the Qur'ān surround their dog, Qiṭmĭr (Plate 7.16). The name of the dog is not made into the shape of a dog, but the sleepers surround it as they do in the Qur'ān. The verticals of the individual characters do not represent limbs or bodies — although I might imagine the sleepers stretched out, with their feet toward the dog — rather, the letters occupy the space that would be filled by limbs and bodies. (They even overlap a little, as if some sleepers had thrown a leg

60. Not all Asian reaction to Tobey's generation has resulted in calligraphic works. Min-Chih Yao, *The Influence of Chinese and Japanese Calligraphy on Mark Tobey (1890–1976)* (San Francisco: Chinese Materials Center, 1983), is an account of the author's gestural abstractions that were inspired by Tobey; they are not linguistic but centered on "structure and geometric form" (37).

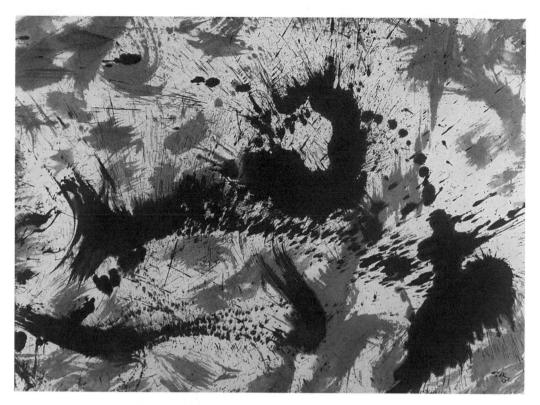

PLATE 7.15 *Mark Tobey. Dragonade, 1957.*

or an arm over their neighbors.) Hence the image is a little like a naturalistic picture but not fully recognizable as a representation of people and a dog. Because it is a protective charm, it is seen as well as read; in this case, that apparently means the calligraphy should go just far enough to conjure the scene without representing it.[61] What would we want to say differentiates this from a naturalistic picture? Relative position, after all, is the sine qua non of naturalism, and there are many Greek, medieval, and early Renaissance narrative paintings in which the figures' names are written on the image itself. (Without them, the pictures would be illegible, just as this one would be.) It might not be reasonable to say, as some writers have, that calligraphy "interrogates language"; but given examples like this, it seems to "interrogate" pictures just as much.[62]

I think of Chu Ta's and Shinzan's paintings and the Turkish amulet as the analogues to the page of the Talmud and the poems by Hrabanus and Mallarmé. The latter three are strange hybrids, and they show what "unnatural" things can take place

when writers try to mingle allographic and written forms. The former three are also hybrids, and they are just as strange, but they're the results of mingling allography and pictures. Neither relation is

61. Schimmel, *Islamic Calligraphy*, 12. The sleepers, starting at three o'clock and going clockwise, are Lafishṭaṭiyûsh, Yamlîḥâ (at six o'clock), Makṭalînâ (seven to nine o'clock), Makṭalînâ (nine to ten-thirty), Marnûsh, Dabarnûsh (twelve o'clock), and Shâdtûsh (one to three o'clock). There are two kinds of overlapping: when the tail of one character crosses part of another's name, and when some characters (especially Marnûsh) have serpentine boundaries that interlock with other sleepers jigsaw-puzzle fashion. The signature (or, more properly, autograph) at the lower right reads "Katabahu Husain Sâbiʿ ibn Muḥammad Nûwî Al-Ayyûbî" ("Written by Husain the Seventh, son of Muhammad Nûwî Al-Ayyûbî"). I thank Sujezana Buzov for preparing the translation.

62. This is adumbrated in Abdelkébir Khatibi and Mohammed Sijelmassi, *L'Art calligraphe arabe; ou, La Célébration de l'invisible* (Paris: Chêne, 1967), 20. There is additional material in the revised French edition, *L'Art calligraphique de l'Islam* (1994); and see the English version, *The Splendor of Islamic Calligraphy,* trans. James Hughes (London: Thames & Hudson, 1996).

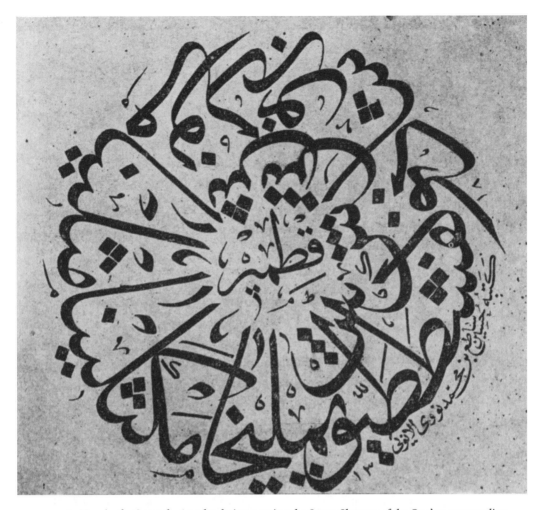

PLATE 7.16 *Husain the Seventh. Amulet design naming the Seven Sleepers of the Qur'an surrounding their dog Qiṭmīr. Istanbul, 1900.*

straightforward: Clear evidence that allography, whatever it might prove to be, is not a good fit for writing or pictures.

Allography is the first wedge I would insert into the dichotomy of word and image, or the trichotomy of word, image, and notation. The linguist's definition of allography—an allograph is a variant of a morpheme that does not affect its syntactic function—only postpones the moment when we have to ask what a "variant" is, and how it can, after all, have the most profound affect on syntactics and semantics.

8 : Semasiographs

ears before calligraphy or typography existed as practices or as words, they were unnamed possibilities for written marks. Even now it is not easy to decide how to characterize allographs, but they are a simple conceptual field in comparison with the scripts now known as "pictographic." Thinking only of allographs, it is almost always sufficient to imagine "pure" letterforms — fictional as they might be — as the underlying phenomena of writing, the base on which calligraphic, paleographic, and typographic elaborations are made. But in many scripts, pictures can appear to be entirely fundamental, as if letterforms were an "optional" reduction.

Hence it is necessary to abandon the very concept of allography as we turn to pictographic scripts — or, rather, to leave it in the background as an undefined term. For all its versatility, allography is too specific: It demands too narrow a sense of foundation and ornament, proper shape and parasitic companion, essential morphology and dispensable variant. In allography, pictorial elements are *on* or *in* writing; in "pictographic scripts" it appears they *are* writing. There is a sign in hieroglyphic Egyptian that looks like a falcon, and inevitably it occurs in many forms (see Plate 10.5). Which could count as the "pure," "inexpressive," normative falcon shape? And what, at least before the development of Hieratic and other Egyptian scripts, could distinguish a "calligraphic" elaboration from a pictorial one? The whole vocabulary of allographic change is inappropriate when pictures are obviously and permanently present as written signs. Yet at the same time — and this is the paradox that forms my starting point — the historical study of pictographic scripts is nearly always predicated on overlooking the pictorial nature of the signs and reading them as if they were non-iconic. Allographic meanings can be elusive, as I've suggested, but at least they are normally said to be available for interpretation; pictographic meanings are nearly always repressed.

Consider, as an opening example, the following alternate transcriptions of a text engraved on a royal seal, in hieroglyphic Hittite (Plate 8.1).[1] The two signs that comprise the king's name, *Tarkumuwa* (the second transcription does not assign a phonetic value to the "muwa" sign), certainly seem iconic in the sense that the signs resemble objects, and the pictograph for "land" is unequivocally a naturalistic representation of two mountains or hills. (The sign occurs also in Sumerian cuneiform and in Egyptian hieroglyphs, with the meaning "desert" or "foreign country.") The sign for "king" (*šar*) is like a crown, and might have been understood as such. Does it matter that *Tarkumuwa* is spelled with pictures? Is the "goat's head" hiero-

1. For the "Tarkondemos seal" (the name is based on a misreading), see the material analysis in Dorothy Hill, "The Rediscovered Seal of Tarqumuwa King of Mera," *Archiv Orientální* 9 (1937): 307–310 and pl.; for related material, see Cyrus Gordon, "Western Asiatic Seals in the Walters Art Gallery," *Iraq* 6 (1939): 3–34, esp. plate VIII, p. 24, no. 69; E. Laroche, *Les Hiéroglyphes Hittites,* vol. 1, *L'écriture* (Paris: Editions du Centre National de la Recherche Scientifique, 1960), L 391, 320.

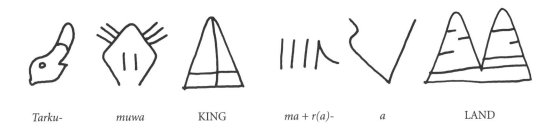

| Tarku- | muwa | KING | ma + r(a)- | a | LAND |

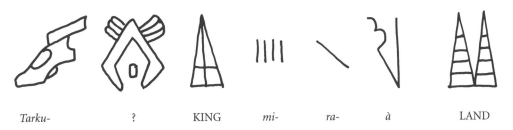

| Tarku- | ? | KING | mi- | ra- | à | LAND |

PLATE 8.1 *Two transcriptions of the Luwian Hittite inscription on the Tarkondemos seal.* Top: *after a drawing in Cyrus Gordon,* Forgotten Scripts. Bottom: *compiled and redrawn from Emanuel Laroche,* Les Hiéroglyphes Hittites, *vol. 1,* L'écriture.

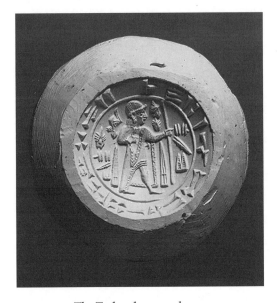

PLATE 8.2 *The Tarkondemos seal.*

As we embark on these questions it is important to bear in mind that the answers will not come from historical linguistics. To see how disengaged epigraphers and linguists are from such ideas, it is only necessary to compare the transcriptions with the actual object, called the Tarkondemos seal (Plate 8.2). On the seal, the phrase occurs twice, once on each side of the central figure, and again in cuneiform around the border. The two transcriptions "restore" an orderly left-right arrangement and "normalize" the signs in accord with the best available comparative material.[2] The epigraphers who made the transcriptions assumed character-indifference — that is, variants of a single character are insignificant. They took their normalized characters partly from the seal itself, simplifying its forms without explanation, and glyph — which looks more like an elephant's head in the first transcription — somehow expressive, in addition to its phonetic use? Is it smiling, and is that optional? Is the *muwa* face (or *muwa* helmet) stern, blank, or emotionally detached? Is its shape blocklike, elegant, or arbitrary?

2. The top drawing is based on one in Cyrus Gordon, *Forgotten Scripts: Their Ongoing Discovery and Decipherment* (New York: Dorset, 1987 [1968]), 96. The lower, except for the *a* sign, is from the standard source, Emanuel Laroche, *Les Hiéroglyphes Hittites*, vol. 1, *L'écriture* (Paris: Editions du Centre National de la Recherche Scientifique, 1960), nos. 101, 320, 17, 391, 383, 228 respectively. The *a* sign is from Piero Meriggi, *Manuale di Eteo Geroglifico* (Rome: Edizioni Dell'Ateneo,

partly from sign lists compiled from other inscriptions; the results are linguistically unexceptionable but visually odd.[3] The original object suggests further questions. Is it entirely without syntactical significance that the hieroglyph for *king* stands as tall as the whole of "Me-ra-à land"? Or that the signs naming the king are closest to his head, and those naming his territory are lower, as if they are the land he is walking through? That arrangement of signs was made by the person who engraved the Tarkondemos seal. Could the original readers have been entirely oblivious to them?

An earlier Hittite example shows how pictorial meanings could have been woven into the later script. The object is a damaged stele from Boğazköy, the Hittite capital (Plate 8.3). Its signs are intelligible in any language, as they have no ties to the languages of Hittite or Luwian that might have been spoken at the time. The inscription reads "(1) THIS (2) STELE (3) I (4) PLACED (4) IN FRONT." Certainly this is "primitive," as David Hawkins proposes, in the sense that it represents an early stage in the development of the script.[4] But is it primitive pictorially? On the contrary: It is more detailed, evocative, and multivalent than the Tarkondemos seal inscription and contains far more information than the simple reduced (and even phonetic) scripts that later came into use. The sign for "stele" in particular has a wonderful precision, and because it represents the stele itself, it is self-reflexive in a curious way. From a linguist's perspective, the sentence still means "I placed this stele in front," but considered as a visual artifact, it means much more — it resonates with observed detail and partly unrecoverable associations. The stele is *just this* stele, and the person, the "I," is characterized in much the same way as a portrait specifies its sitter. Their spatial relations say something: We might have lost the ability to read it, but as in a painting the dispositions of objects appear to have meaning beyond their nearest grammatical equivalents.

By and large, epigraphers ignore these questions because they are not part of normative reading. Yet if pictures are in the writing, then any reading also negotiates the script's iconic aspects. In linguistics, the pictorial properties of written characters matter only when they affect the signs' relations to the spoken language. Using the linguistic lexicon, one would say that some of the signs on the Tarkon-

demos seal function phonetically (they denote phonemes in the Hittite language), and others function ideographically (denoting concepts) or pictographically (by resembling objects such as mountainous "land"). This is one of the versions of a standard classification of written signs that is used throughout comparative linguistics. From the point of view I want to adopt here, however, such a classification presents immediate problems. It is apparent, for example, that *all* the signs in the Tarkondemos seal function iconically: *Tarku* and *muwa* almost comprise two figures between them, and there are strong similarities between the signs for *me, r,* and *a* on the one hand and the signs for *king* and *mountain* on the other. The sign *r* or *ra* is related to the sign for *king*, and the sign *a* looks like an inverted, distorted version of *r*, or of the sign for *king*. Phonetic signs resonate iconically with ideographic and pictographic signs.

The division into phonetic, ideographic, and pictographic is adequate for certain theories of writing, but is not helpful in describing the pictorial dynamics of a sentence written in a pictographic script. In Goodman's terms, signs in scripts like these are more replete and less "character-indifferent" than they might appear when the reader's only purpose is to get at syntax and denotation. Here I want to begin a longer exploration, continuing into the next chapter, of the iconic elements in writing before and apart from either syntax or allography. The fundamental problem could be described as arriving at an adequate sense of the

1967), table facing p. 142. I thank Harry A. Hoffner for help finding the relevant forms of the signs.

3. Another standard source is Meriggi, *Hieroglyphisch-Hethitisches Glossar* (Wiesbaden: Otto Harrasowitz, 1962), nos. 922, 266, 275, 372, 198 (omitting the *ra* and *a* signs). Some characters have been reassigned; see John David Hawkins, Anna Marpurgo-Davies, and Günter Neumann, *Hittite Hieroglyphs and Luwian: New Evidence for the Connection,* Nachrichten der Akademie der Wissenschaften in Göttingen, Philologisch-Historische Klasse, no. 6 (Göttingen: Vandenhoek & Ruprecht, 1974). See also Jan Best and Fred Woudhuizen, *Lost Languages from the Mediterranean* (Leiden: E. J. Brill, 1989), 109, who read "*Tar-qu-x-y šar Me/i-ra-à.*"

4. David Hawkins, "Writing in Anatolia: Imported and Indigenous Systems," *World Archaeology* 17, no. 3 (1986): 370–74, esp. 373. See further H. G. Güterbock, "Hieroglyphensiegel aus dem Tempelbezirk," *Boğazköy 5, Funde aus dem Tempelbezirk* (Berlin: Verlag der Akademie der Wissenschaften in Kommission bei W. de Gryter, 1975): 51–53

logically or grammatically "unnecessary" components in writing. I approach the question by examining the supposed progression from "primitive," purely pictographic scripts to "advanced" alphabetic ones — a story that has been elaborated from the eighteenth century onward. It is a vexed sequence, as it is at once ideologically saturated — it is the result of a certain kind of thinking about pictures and writing — and also demonstrably fundamentally correct, in that many scripts *did* develop away from pictographs and toward alphabets. Of special interest are a number of unruly writing systems that disrupt the sequence and suggest other ways of thinking about pictures in writing.

THE CONVENTIONAL HISTORY OF SCRIPTS

In the usual telling, the history of writing requires three steps to bridge the most "primitive" marks to the Roman alphabet. The sequence, from pictograph through ideograph to phonograph, was adumbrated in the Renaissance in reference to the imagined nature of Egyptian hieroglyphs and codified in the eighteenth century. Only a few contemporary scholars would assert that "all letters were originally pictures,"[5] if only because there is relatively little evidence of those posited beginnings, and it is now known that no writing system is a perfect instance of the sequence. But the story remains the principal scaffolding of our thought about the history of writing, both in historical linguistics and in philosophy, and so it is important to ask exactly how well it represents the history and actual states of writing.

Jacques Derrida occupies an ambiguous position in this debate. *Of Grammatology* takes its title from a word coined by the linguist Ignace Gelb to denote the academic study of writing.[6] Gelb's *Study of Writing* (1952) and Derrida's *Of Grammatology* (1967) have very different trajectories: Derrida's concern is writing in the context of Western metaphysics, and Gelb's is writing in the context of formal and historical linguistics (he intended *grammatology* to oppose phonology and morphology). Yet there is a sense in which their deep dissimilarities are vitiated by the word *grammatology* itself, which stands in both texts for a specific study of writing, and for writing's denigration in relation to

normative accounts of language and meaning (in linguistics or metaphysics). The two literatures that have grown from Gelb's and Derrida's books are like branches from a single trunk, and accounts in both fields tend to begin by acknowledging that fact.[7] Peter Daniels's introduction to *The World's Writing Systems* mentions Derrida but does not cite him further, just as Derrida cites Gelb but says only that "in spite of a concern for systematic or oversimplified classification, and in spite of the controversial hypotheses on the monogenesis or polygenesis of scripts, this book follows the classical model of histories of writing."[8] Derrida's project quickly moves away from actual writing and keeps to the eighteenth-century version of the genealogy of writing — both in *Of Grammatology* and in later texts that leave behind that book's title.[9] It would seem that Derrida's interest in writing, and the prominence he gave to the word *grammatology,* might have opened the doors to a more inclusive scholarship on the nature of writing, but at the same time the very broad definition of writ-

5. Nina M. Davies, *Picture Writing in Ancient Egypt* (London: Oxford University Press, 1958), 18, quoting Battiscombe Gunn on the subject of hieroglyphic Egyptian.

6. Gelb, in turn, took it from Friedrich Ballhorn's *Grammatography: A Manual of Reference to the Alphabets of Ancient and Modern Languages* (London: Trübner, 1861). Gelb notes that "the original German book does not use this term," which leaves its origin a bit obscure. Gelb (1974), 267n39. I thank Peter Daniels for drawing this to my attention. The original German is accessible in the later editions — for example, Ballhorn, *Alphabete orientalischer und occidentalischer Sprachen,* 11th ed. (Leipzig: F. A. Brockhaus, 1873 [1843]).

7. For example Harris (1995), 1–5, which rejects Gelb's position.

8. Daniels and Bright (1996), 3; and Derrida, *Of Grammatology,* trans. by Gayatry Spivak (Baltimore: Johns Hopkins University Press, 1974), 323n4. Oleg Grabar cites Derrida and Gelb together in Grabar (1992), 252n23, and then hardly uses either. He bemoans the fact that Gelb's "otherwise fascinating book ends up once again being a 'history' *of* rather than a discourse *on* writing."

9. In "Signature Event Context," for example, Derrida critiques Condillac's account of the development of language in part by noting it follows "a direct, simple, and continuous line," "from pictographic writing up to alphabetic writing, passing through the hieroglyphic writing of the Egyptians and the ideographic writing of the Chinese." Derrida, "Signature Event Context," *Writing and Difference* (Chicago: University of Chicago Press, 1978), 312, summarizing Etienne Bonnot de Condillac, *Essai sur l'origine des connoissances humaines* (Amsterdam: Pierre Mortier, 1746).

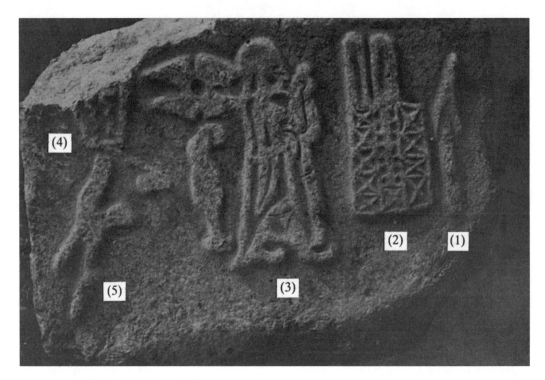

PLATE 8.3 *Stele from Boğazköy, Turkey.*

ing that he exposits has kept scholars away from the kinds of specific inquiries that typify Gelb's or Daniel's grammatologies. Only a few writers, such as Brian Rotman and Tom Conley, have realized how literary critics' and philosophers' continuing resistance to the graphic elements in writing is inconsistent with what Derrida and others have been exploring.[10]

There are a number of open questions here. It sometimes appears, for example, that the indifference to actual writing systems is complicit with the interest in the existence of those same systems, or that the iconic nature of such scripts is overlooked in the same manner, and for some of the same reasons, that French theorists have overlooked other aspects of visual culture.[11] Interesting as those questions are, I will not be pursuing them directly, as I am more interested in the scripts themselves and the problems they continue to raise. I want to begin, therefore, by going back to the founding moments in the eighteenth-century account, and noting how the meliorist progression works to exclude pictures.

The notion that pictographs are the most fundamental kind of written signs is related to the ideographic impulse in eighteenth-century thought,

and it developed independently in various centers including Paris, Rome, and London.[12] The brief chapter on hieroglyphs in William Warburton's sprawling multivolume work *The Divine Legation of Moses* was especially influential because it was excerpted in Diderot and d'Alembert's *Encyclopé-*

10. Brian Rotman, "Thinking Dia-Grams: Mathematics, Writing, and Virtual Reality," *South Atlantic Quarterly* 94, no. 2 (1995): 389–416, now in *Mathematics, Science, and Post-classical Theory*, ed. Barbara Herrnstein Smith and Arkady Plotnitsky (Durham, N.C.: Duke University Press, 1997), 17–39; and Tom Conley, *The Graphic Unconscious in Early Modern Writing* (Cambridge: Cambridge University Press, 1992).

11. A starting point could be Martin Jay, *Downcast Eyes: The Denigration of Vision in Twentieth-Century French Thought* (Berkeley: University of California Press, 1993), with the review by W. J. T. Mitchell, *Artforum* 32, no. 5 (1994): 9.

12. See, for example, Henri Sottas and Etienne Drioton, *Introduction à l'étude des hiéroglyphes* (Paris: P. Geunthner, 1922), and Pierre Marestaing, *Les Écritures égyptiennes et l'antiquité classique* (Paris: P. Günther, 1913). For the ideographic impulse, see Barbara Stafford, *Symbol and Myth: Humbert de Superville's Essay on Absolute Signs in Art* (Cranbury, N.J.: University of Delaware Press, 1979); an interesting example is *The First Six Books of the Elements of Euclid, in Which Coloured Diagrams and Symbols Are Used Instead of Letters, for the Greater Ease of Learners* (London: William Pickering, 1847).

die.[13] Warburton's position is sometimes misrepresented as the conviction that writing began with pictures, because they are the most natural way to notate ideas, and then moved smoothly toward the more efficient alphabet. Actually Warburton argues that "the easiest, and most natural conception of the abstract conceptions of the mind, was by arbitrary marks," and that the Egyptians eventually gravitated to hieroglyphs because "their love of mystery disposed them" to secret signs.[14] The idea was not new; Warburton got it from Athanasius Kircher's mystical interpretation of hieroglyphic obelisks. Warburton quotes Kircher's opinion that "Hieroglyphica Ægyptorum doctrina nihil aliud est, quam Arcana de Deo, divinisque Ideis, Angelis, Dæmonibus," although he leaves the details of Kircher's "visionary interpretations" to one side.[15]

Other elements of Warburton's theory coincide more closely with the received idea of a sequence from picture to alphabet. He describes the passage from pictures to letters as "a gradual and easy descent," and he speaks of letters as an efficient "abridgment" of hieroglyphic signs. Pictures were first in this account, and writing came after. "The first essay toward writing," he observes at one point, "was a mere picture."[16] Still, there is very little evidence in *The Divine Legation* for the existence of "mere pictures." Like the ideal of a "pure picture," the "mere picture" might only exist as an ideal; it does not seem to occur to Warburton to ask what such a picture might look like. Although he spends some time on hieroglyphic signs, Warburton scarcely mentions the prehieroglyphic pictures, and he does not discuss "mere pictures" at all.

Often enough the "gradual and easy descent" from pictographs to "arbitrary signs" is merely taken for granted, as in an engraving by Martino Martini (1614–1661) that Warburton later reproduced in *The Divine Legation* (Plate 8.4, *top*).[17] It shows how a mountain, the sun, a dragon, the sign for *king* (with a scepter and orb), a chicken, and a cock are represented in Chinese. The words Martini uses are meant to conjure a continuous development from naturalism to writing: The mountain, he says, is "pictured" (*pingebatur*); the sun is "represented" (*effingunt*); the dragon is "fashioned" (*formatur*); and the hen and cock are "drawn" (*ductibus*), as one might draw a Chinese character. It's a quite informal sequence, and Martini's lack of interest in semiotic rigor shows in the repetition of *pingunt*, ostensibly the first and most naturalistic principle, for the word *king*, which is midway down the list.

But to make it work, Martini has to hallucinate pictures in nonnaturalistic characters, and inappropriately extrapolate from Western-style drawings. Like Kircher and Warburton, Martini was entirely convinced about the pictographic nature of Chinese characters, and the force of his conviction impels him to see pictures even when his own theory prohibits it. The final character on Martini's list, which Warburton translates as "turkey," is currently written as in Plate 8.4 (*bottom*), but in Martini's table the forms at the lower left become letters, as if the Chinese for "turkey" were made of abstracted remnants of pictures, wedded to the Western letters A and Z.[18]

Derrida's writings in *Dissemination, Of Grammatology*, and elsewhere follow the same sequence of emphases and omissions. Even though a reader who encounters the history of scripts through Derrida might not think so, the "logocentric sequence of writing," as I will call it, has remained in favor (Table 8.1).[19] It has been challenged several

13. Abbé Etienne Mallet, "Écriture," in Denis Diderot and Jean de Rond d'Alembert, *Encyclopédie* (Paris: Briasson, David, Le Breton, Durand, 1755), vol. 5, pp. 358–59.

14. Warburton (1811), 127–28. For assessments of Warburton's *Divine Legation*, see A. W. Evans, *Warburton and the Warburtonians: A Study in Some Eighteenth-Century Controversies* (London: Oxford University Press, 1932), 52–66, and Robert M. Ryley, *William Warburton* (Boston: Twayne, 1984), 23–31, esp. 30n31 concerning Warburton's accuracy on hieroglyphs.

15. Warburton (1811), 116, 373, quoting Athanasius Kircher, *Œdipus Ægyptiacus, hoc est universalis hieroglyphicae veterum doctrinae temporum iniuria abolitae instauratio* (Rome: Ex typographia Vitalis Mascardi, 1652), vol. 3, p. 4.

16. Warburton (1811), 131–32 and 117, respectively.

17. Martini, *Sinicae historiae decas prima, res gentis origine ad Christum natum in extrema Asia, sive magno Sinarum imperio gesta complexa* (Amsterdam: J. Blaev, 1659); Warburton (1811), plate 6, facing p. 126.

18. The modern character is slightly different from the one Martini saw, but the left half is unchanged. I thank Noriko Horie and Elinor Pearlstein for the computer-generated characters here and in Plate 7.12.

19. For discussions of similar tables, see Diringer (1948), Gelb (1974), and recently E. Pulgram, "The Typologies of Writing-Systems," in *Writing without Letters*, ed. William Haas (Manchester: Manchester University Press, 1976), 1–28;

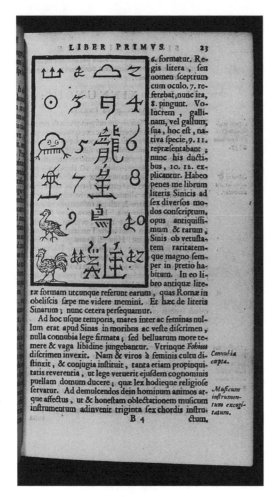

PLATE 8.4 Top: *Martino Martini. Table of Chinese characters. 1659.* Bottom: *a modern Chinese character corresponding to the lower-right of Martini's table.*

Semasiographic and glottographic are near synonyms for a number of other pairs, the commonest of which is *logographic* and *phonetic*. The same kind of distinction has been described by Florian Coulmas as the difference between *sense-determinative* and *sense-discriminative* elements, and by William Haas, following Hjelmslev, as *pleremic* and *cenemic*.[21] Peter Daniels and William Bright use *logosyllabic* and *phonetic,* but the former encompasses signs that denote words as well as some of those that denote morphemes.[22] Another useful, if slightly general, pair is *phonograms* and *semograms* for signs that denote sounds and those that denote meaning.[23] Roy Harris critiques the assumptions

times: Warburton mentions debates about whether Egyptian hieroglyphic signs stood for words or things, and modern scholars have found many counterexamples.[20] Still, Gelb's influential *Study of Writing* (1974) makes the same claims about the primacy of the pictographic sign, and current textbooks normally include some version of the pictographic theory because it proves generally true across many cultures.

Pulgram divides writing systems into pictorial, logographic, syllabic, alphabetic, phonemic, phonetic, and spectrographic systems, and wonders if his first class, "pictures," counts as a writing system. For a discussion, see Harris (1995), 58.

20. For the debate about words and things, see Warburton (1811), 376–82, rebutting Richard Pococke, Bishop of Meath, *A Description of the East,* 228–29. This is presumably Pococke, *The Travels of Richard Pococke through Egypt* ([London?], c.n. [1770]); and see Warburton, *Remarks on Several Occasional Reflections; in Answer to the Rev. Dr. Middleton, Dr. Pococke . . .* (London: Printed for John and Paul Knapton, 1774).

21. Haas, "Determining the Level of a Script," in *Writing in Focus,* ed. Florian Coulmas and K. Ehrlich (Berlin, Amsterdam, and New York: Mouton, 1983), 15–29, cited in Coulmas, *The Writing Systems of the World* (Oxford: Basil Blackwell, 1989), 49; and see the longer exposition in Haas, "Writing: The Basic Options," in *Writing without Letters,* 132–208, esp. 179.

22. They define "logosyllabary" as "a type of writing system whose characters denote morphemes, and a subset of whose characters can be used for their phonetic syllabic values without regard to their semantic values," but they define "morpheme" as "a minimal stretch of speech that has a meaning, either grammatical (*-s*) or independent (*friend*)" (Daniels and Bright [1996], xlii). In terms of the argument I want to pursue here, this conflates pictographs, ideographs, and syllabaries in an odd way, as it basically names the common state of semasiographic scripts (that is, steps 2–4 in Table 8.1). It is also inappropriate, I think, to give the word *syllabary* such prominent display in a term whose use would go far afield of syllabaries, even though *logosyllabic* is a condensation of *logographic* and *syllabic.*

23. Robert Ritner, "Egyptian Writing," in Daniels and Bright (1996), 73–84, esp. 74. Jochem Kahl uses the same terms but derives phonograms from rebuses and semograms in an intricate and historically specific manner from iconic signs (including pictures), symbols, and rebuses. Kahl (1994), 52–53.

TABLE 8.1. *A Version of the Logocentric Sequence of Writing*

Stage	Name	Traits
1	"Mere" pictures	The constituent marks are fused in the picture and are undifferentiable into signs
2	Semasiographic writing: pictographic or iconographic	The introduction of disjunct signs, signifying things
3	Semasiographic writing: ideographic	The introduction of signs signifying ideas
4	Glottographic writing: syllabic or alphabetic	The introduction of phonograms, signs signifying sounds in the language
5	Glottographic writing: "proper" or "full"	The gradual disappearance of pictographs and ideographs

behind several of the choices, and uses *glottic* and *non-glottic*.[24] I choose *semasiographic* and *glottographic* for several reasons, some of which will emerge later, but not the least of them is the elegant formula coined by Geoffrey Sampson, who says the two name the difference between signs that denote meaningful elements (such as words and objects) and those that denote elements of meaning (such as syllables).[25]

It is remarkable how consistently versions of this view have been held over the last several centuries. David Diringer, one of the authorities on writing systems, calls phonetic writing "true writing" and everything else "embryo-writing."[26] Alphabetic writing mimics the voice, and is therefore optimal; other kinds of writing are more primitive and also — the two concepts are linked — more purely to do with writing as opposed to speaking. Derrida and others are right to say that a project like Warburton's can only make sense as an attempt to exclude what Warburton would call "primitive,"

heathenish, inefficient forms of writing in favor of writing with a more intimate relation to the spoken voice. But the sequence, I think, does more than privilege the voice at the expense of writing: Structurally, and taken as a whole, it privileges the voice over *pictures*. Warburton's anxiety — and concomitant attraction — to non-Roman alphabets is set in motion not only by their nature as writing but as *pictographic* writing, and the purest, most dangerous property of such writing, the one that needs to be excluded at all costs, is its reliance on "mere pictures." It is pictures, and not speech, that pre-exist writing, and that must be contained before language can get under way.

BREAKING DOWN
THE LOGOCENTRIC SEQUENCE

In philosophy, the logocentric sequence is the first stage in a three- or four-part model of the transmission of meaning, what Chad Hansen calls the "classical Indo-European picture of how language operates in the world."[27] He writes it as follows:

written word → spoken word →
mental likeness → things

Hansen mounts a Wittgensteinian argument against the notion that speech (and ultimately writing) represents mental likenesses, by showing that it's incoherent to say that mental likenesses comprise a language apart from speech and writing. Instead, Hansen advocates a schema in which words (either written, thought, or spoken) represent things directly:

words: written, thought, or spoken → things

24. Harris (1995), 95–101, especially 97.

25. Sampson, *Writing Systems: A Linguistic Introduction* (London: Hutchinson, 1985), 31.

26. Diringer (1948), 31.

27. See Chad Hansen, "Chinese Ideographs and Western Ideas," *Journal of Asian Studies* 52, no. 2 (1993): 373–99, esp. 374 and 392; the exchange with J. Marshall Unger, *Journal of Asian Studies,* 52, no. 4 (1993): 949–57; and Hansen, *Language and Logic in Ancient China* (Ann Arbor: University of Michigan Press, 1983). I thank an anonymous reader for drawing my attention to "Chinese Ideographs and Western Ideas."

Hansen's work is among the most promising historically specific critiques of logocentrist views of language; any such critique will involve rethinking the major theories of meaning.[28] The logocentric sequence of writing (as in Table 8.1) corresponds to just the first term of the "classical Indo-European picture"—that is "written words." My own interest centers on that first step, and on its initial moments: I doubt that the logocentric sequence can launch a schema such as the one Hansen critiques, because writing cannot approach spoken language by detaching itself from pictures. The crucial problem, as I see it, is not that we privilege writing that is closer to speech, or that we continue to depend on models of mental languages; it is that in rushing to critique logocentrism we posit relatively pure scripts and neglect the conceptually challenging domain of written pictures. It could be that the entire "classical Indo-European picture" balances on the Achilles heel of its fear of pictures; one way to find out is to look as closely as possible at the infiltration of pictures in writing.

At this point I should perhaps reiterate that I am not denying that a number of writing systems have moved from mixed pictographic and ideographic to mixed semasiographic and phonetic, or from syllabic to alphabetic. Nor do I deny the direction of the chart is broadly correct, not least in the fact that scripts do not change from alphabetic "back" into semasiographic.[29] It is made plausible by many factors, but it is made adequate chiefly by the ongoing concentration on "proper" or "full" glottographic writing—that is, the Roman alphabet. The chart looks quite different if we choose to stress "impure" examples (those that do not fit the five levels of the chart), or if we decide to examine the elusive starting point—the "pure" pictures that supposedly started it all. Even the "pure" writing that caps the sequence begins to lose its purity if we ask about its *pictorial* content rather than its relation to speech.

Three introductory critiques can serve to open the questions I have in mind. First, I suggest that the progression from figurative to alphabetic is nowhere continuous, either by substitution, by gradual erasure, or by increasing abstraction. Instead a dialectic assures that the pictorial continues to affect the ostensibly nonpictorial. Second, the analytic distinction between pictographic and ideographic is insupportable, both in the histori-

cal sequence of a script's development and in the analysis of any one sign. And third, the last and most important stage might not exist at all—that is, there might be no such thing as a pure alphabet, and therefore no such thing as pure writing.

1. THE DISCONTINUOUS REPRESSION OF PICTURES

Several examples of the "gradual and easy descent" from picture to glottographic script are commonly adduced to justify the logocentric sequence. A principal case is cuneiform, whose slide from pictograph into syllabary (in various languages, and with admixtures of other forms) has often been put in the form of charts showing the gradual disappearance of obvious pictures and the rise of uniform characters.[30] A closer analysis, however, shows a discontinuous repression of the iconic: a movement with distinctly different stages rather than a smooth descent into the alphabet.[31]

28. I have written on the last steps of Hansen's "classical Indo-European picture" in another book (Elkins [1997], chap. 5); there, following Donald Preziosi, I call the progression from intention to object to meaning the "logocentric paradigm." The "paradigm" and the "sequence" are not equivalent, although they both participate in the same critique.

29. There are interesting counterexamples, such as the tendency in Akkadian cuneiform, in the first millennium B.C.E., to adopt increasing numbers of Sumerian logographic signs. Jerrold Cooper suggests the practice was a "scholarly affectation" intended to support the demand for scribes. See Cooper, "Sumerian and Akkadian," in Daniels and Bright (1996), 37–57, esp. 53–55.

30. For cuneiform, in addition to the sources listed in this section, see Adam Falkenstein, *Archaische Texte aus Uruk* (Berlin: Deutsche Forschungsgemeinschaft, 1936), updated by M. W. Green and Hans J. Nissen, *Archaische Texte aus Uruk*, vol. 2, *Zeichenliste der archaischen Texte aus Uruk* (Berlin: Gebrüder Mann, 1987).

31. Initially it is important to note that cuneiform signs are not forests of identical wedge-shaped marks but arrangements of a small number of sizes and directions of marks. Typically characters are built out of long and short marks, often with a range of intermediate lengths. That repertoire of strokes, together with the permissible directions (usually left-facing horizontal, upward-facing perpendicular, two left-facing diagonals, and a V-shaped mark; see Falkenstein, *Archaische Texte*, 9), gives the characters a certain pictorial organization. At the same time it limits the kinds of pictorial arrangements that are possible and gives rise to the characteristic fashion in which cuneiform characters occupy their allotted space. As the writing consolidated into columns,

In the Early Dynastic III period (ca. 2500 B.C.E.), the sign for *king* is clearly representational, combining what appears to be a crown with a head and body (Plate 8.5, *left*).[32] (In Sumerian this is *lu,* "great," and *gal,* "man.") The fusion of the two signs might be related to the earliest practice of denoting names or places by combining pictures, such as a person smelling or eating a plant, or a bird on an altar or other structure.[33] By the Akkadian period the body has become a little more schematic — a bit like a mummy — but still clearly recognizable (*left side, third from top*). The succeeding development is not an uninterrupted progression but has at least two stages. In the first, the crown merges with the figure, forming a complex whole (*left side, fourth and fifth image*). Here the character's iconic elements are fused in such a way that they no longer represent "man" plus "crown." Beginning in the mid-eighth century B.C.E., the character *king* undergoes a second decisive change: it Loses the outline marks that had given it naturalistic meaning. In the Akkadian examples collected by René Labat (*the sequence at right*), the figure is still somewhat "recumbent" — that is, in this orientation it preserves the general proportions and the three sections (crown, head, and body) of the original.[34] One of the earliest of these, from the neo-Assyrian period (ca. 720 B.C.E.), is no longer a figure but a set of unbounded marks open to the surrounding surface (*upper right*). The later canonical Monumental Assyrian form (ca. seventh century B.C.E.) is the standard cuneiform character against which the others are indexed (*right side, second from top*). Its two rows of marks are the traces of the upper and lower outlines of the king's figure. But it is non-naturalistic and bodiless.

What we have here are two breaks with the pictorial. First is the break with the *object,* whereby the character becomes single when its original was multiple or (in other cases) unrecognizable, and then comes the break with the *body,* so that the character loses its boundaries and becomes an open lattice. At the same time, these two metamorphoses are not independent, and each step has traces of the one before. The fascinating thing about this interrupted sequence is the pictorial logic in each stage. Many of the shapes of cuneiform are prompted by requirements of writing, because characters must be easy to make, discrete,

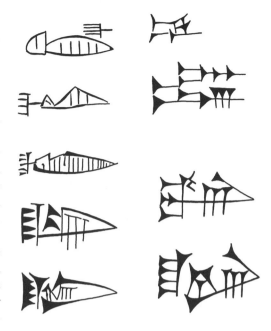

PLATE 8.5 *Examples of the cuneiform sign for* king. Left, top to bottom: *ca. 2700 B.C.E., ca. 2500 B.C.E., ca. 2250 B.C.E., ca. 2035 B.C.E., ca. 1760 B.C.E.* Right: *Neo-Assyrian forms, ca. eighth century B.C.E.*

rows, and "cases" (rectangular enclosures for text and numbers), the characters seemed to occupy roughly square or rectangular areas, and that appearance was underscored by the "framing" elements contributed by vertical and horizontal marks within individual characters. But the rectangularity is probably an illusion. Instead the characters occupy discrete areas and leave part of the surrounding space unused. Roman letters, in contrast, have little or no interior space: The letters in this sentence make only minimal use of the areas they enclose. Like Roman letters, cuneiform characters do not fully occupy a framed space (frames are used in many other scripts — for instance, in Chinese seals, Egyptian cartouches, and Mayan glyph blocks); unlike Roman letters, however, they do not rescind the communicative possibilities of the areas they enclose.

32. For other conjectures about its identity, see Béatrice André-Leicknam, in *Naissance de l'écriture, cunéiforme et hiéroglyphique,* exhibition catalog, Galeries nationales du Grand Palais (Paris: Éditions de la Réunion des Musées Nationaux, 1982), 4th ed., 72.

33. Falkenstein, *Archaische Texte,* 24.

34. René Labat, *Manuel d'épigraphie akkadienne (signes, syllabaire, idéogrammes)* (Paris: Librairie Orientaliste Paul Geuthner, 1963), 4th ed., p. 102, no. 151.

and oppositional in order to function. The codified Monumental Assyrian form owes part of its structure to the need to make a character for *king* distinct from similar characters. The later stage might possibly be associated with the standardization of the directions of individual marks, as it would have forced certain design changes. Other decisions were probably based on changing ideas about the appearance of actual objects. The conventions of dress, for example, might account for some of the early variations in the man's figure. But there is also a customary or conventional sense of the pictorial operating throughout. What prompts the scribe to create a form organized in a particular way, with a particular distribution of space and mark? Why do the wedges have the lengths they do and no others? What constitutes crowding? What is too diffuse? Is there a sense of vertical balance, as there is in Chinese calligraphy? Or should we look for horizontal compositional principles instead? In each stage, and with different signs, the answers to these questions change. Even the earlier and sloppier examples have their own rhyme and reason. Although much remains to be discovered, it seems best to avoid speaking of the forms of *king* only as the results of increased efficiency of communication and writing.[35]

A particularly fertile ground for investigation is the composition of multiple characters. The character for *mouth* is made by adding short marks to the area of the character *head* where the mouth would be. In Assyrian *water* placed in *mouth* yields the verb *to drink,* and the same process gives *to eat.*[36] That strategy was abandoned when further additions became necessary: The character *tongue* is made by adding a phonetic sign, with the value *me,* to the region of the neck; the character *lip* is made the same way, with the addition of the phonetic sign *nun.* Even here there is evidence of pictorial thinking. The phonetic additions are not placed where they are just because modifiers customarily occupy that position, but because they are close to the mouth. In addition, they lend the character an overall density that serves both indexical requirements (because reed pens cannot produce overly detailed shapes) and pictorial ones (because they balance the character, in accord with laws that have yet to be elucidated). Cuneiform characters are pictures, but pictures of an unusual kind, manifesting a visual sensibility quite different from what a modern Western writer might expect.[37]

2. THE DIFFERENCE BETWEEN PICTOGRAPHS AND IDEOGRAPHS

A second reason to doubt the logocentric sequence is the difficulty of distinguishing between pictographs and ideographs. Recent critiques of the sequence have pointed out that the earliest examples of some scripts — notably cuneiform at Uruk — are preeminently ideographic and "abstract," and that pictographic signs might play a greater role later in a script's development. There are parallels to be made with the history of pictures, in which figurative traditions have become abstract and vice versa.[38] The polarity itself might be a limiting factor in these debates, so that Western historians have a hard time seeing something other than a choice between ideograph and pictograph — yet another version, perhaps, of the word–image dichotomy. In this respect it is especially helpful to consider scripts that have been invented relatively recently, because they can be observed more closely than the older scripts.

The African Bamum writing is such a system; it was invented by Njoya, king of the Bamum in what was then German Cameroons, around 1903, and it went through five or six revisions before it was codified in 1918.[39] After several transformations the

35. As Peter Daniels has shown, later scribes experimented with deliberately "archaic" Sumerian forms, and ended up inventing signs entirely different from the actual Sumerian script; but even their attempts can be interpreted as evidence of a particular sense of the pictorial nature of their script. Peter Daniels, "What Do the 'Paleographic' Tablets Tell Us of Mesopotamian Scribes' Knowledge of the History of Their Script?" *Mar Sipri* 5, no. 1 (1992): 1–4.

36. L. W. King, *First Steps in Assyrian* (London: Kegan Paul, Trench, Tübner & Co., 1898), xxiii.

37. I thank John A. Brinkman for his thoughts on these questions, which are still insufficiently studied.

38. For the debate in Mesoamerican art, see Esther Pasztory, "Still Invisible: The Problem of the Aesthetics of Abstraction for Pre-Columbian Art and Its Implications for Other Cultures," *Res* 19–20 (1990–1991): 122; for the same issues in Chinese art, see Elkins, "Remarks on the Western Art Historical Study of Chinese Bronzes, 1935–1980," *Oriental Art* 33 (Autumn 1987): 250–60, revised in Elkins (1997).

39. Alfred Schmitt, *Die Bamum-Schrift,* 3 vols. (Wiesbaden: Otto Harrassowitz, 1963); Diringer (1948), 152–53; Jensen (1969), 210–13.

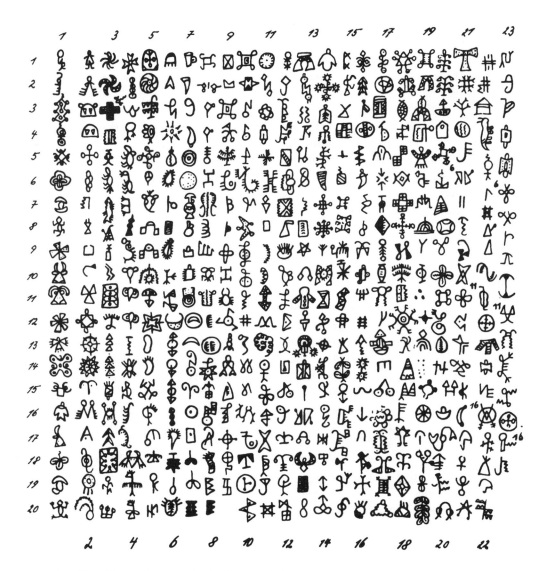

PLATE 8.6 *King Njoya. Characters in the Bamum Script. 1903.*

Bamum script became phonetic, but at the moment of its invention it was a welter of "pictographic" and "ideographic" signs (Plate 8.6). (The individual signs are identified by their positions on a grid, with the *x* or horizontal direction given first.) In the earliest version there are obvious pictures: *moon* (coordinates 7,13), *man* (2,2), and *house* (22,3). Some of the signs would be a little harder to guess, but they have a beautiful felicity that can only be described as iconic — for example, *horse* (4,16), *arm* (5,17), *belly* (17,7 — the sign has a round, bellylike shape, with a smaller circle at its center).

Is there a line to be drawn between these pictographs and the less easily deciphered ideographs?

We might guess that sign (8,3) is *to hear,* in which case (8,4) is naturally *to not hear.* But then are we far away from *to see* (7,19) and *to be blind* (7,18)? The sign (6,13) is read *fa, to give.* The object is apparently in the middle, and the triangles at top and bottom might be the arms of the two people.[40] (Compare the forms in *to ask* [6,14] and *no* [15,19].) And if they are arms, then the line crossing (6,15), *to not give,* might be the arm of one of the people reaching across the object. The line also looks like the diagonal that crosses international signs and means "no." That would be an ideograph by our standards, but these Bamum characters raise the pos-

40. A. Schmitt, *Die Bamum-Schrift,* vol. 1, p. 21.

sibility that our own "arbitrary" street sign is a little iconic after all: perhaps it is reminiscent of a person raising an arm to bar the way.

And how ideographic is it when *full moon* is shown by putting the crescent together with the round disk (7,12)? The reason for the sign is apparent enough: Otherwise *full moon* might look too much like *sun* (5,2) or *star* (16,20 — the smudge at the bottom is accidental). The two pictures combine in an illogical fashion, and they are not naturalistic in any strong sense — but neither are they arbitrary ideographic signs. *Full moon* is a kind of picture, different from *sun* with its whirling rays or *star* with its twinkling eyelashes. *Full moon* is a more ideographic sign, but not a purely ideographic one. Salt was precious in King Njoya's territory, and the sign for *salt* shows hands reaching inward to a circle (6,4).[41] Is *salt* represented naturalistically here? Or is this an arbitrary sign, an ideograph, surrounded by a pictograph of arms?

Thinking this way, one might wonder if there are any pure ideographs in the Bamum script. Does *deep water* (18, 7) conjure a pool or submerged cliffs? And even if it were not intended to, how could it avoid signifying in that way? Is there some iconic sense to *forget* (16, 10), with its closed-in box and stuffed-up ears or eyes on each side? Is *butterfly* (15, 17) entirely free of the feeling of a feathery insect? Isn't *fog* (15, 4) a picture of shifting layers of cloud and sky?[42] These instances could be multiplied and extended to include other "artificial" writing systems, and the same case could be made with the older, "natural" scripts such as Chinese. In the end, the distinction between pictographic and ideographic depends for its plausibility on the customary distinction between nonmimetic words and mimetic pictures — the word–image dichotomy, in another form — but no such distinction is carried through in writing systems such as King Njoya's.

3. ON THE NONEXISTENCE OF THE ALPHABET

So far I have reviewed evidence that questions the evenness of the steps between stages, and the distinction between one stage and the next. One might also argue that there is little evidence of scripts that correspond to any of the individual stages — with the important, and partial, exception of the Roman alphabet. There are a few fairly pure scripts — some syllabaries in particular — but it is not irrelevant that most examples are to be found among invented scripts. The most graphically elaborate invented script is the 5,700-symbol writing system devised for the Micmac by a succession of priests beginning in the seventeenth and eighteenth centuries, culminating in the Micmac prayer book printed by Father Christian Kauder in 1866.[43] It does not purport to represent the Micmac's Algonquin language; rather, it is strictly ideographic, with a small admixture of pictographs. On the title page the script is used to gloss the book's name and publication data, but the remainder of the book is purely Micmac script with no phonetic equivalents (Plate 8.7). Using the title page as a key, it is possible to begin to read the Credo: The third symbol is the word *the* (*das*), and the word *as* (*wie*) is in the middle of the second line, and *also* (*auch*) is at the beginning of the third line. A few signs are strongly pictorial (*book* is written large at the top of the title page, and it recurs as part of *publishing house* about halfway down), and other signs draw on common European symbols (the place of publication, *Vienna in Austria,* is denoted by two herladic shields). With the help of such clues, it is possible to begin reading the Credo: *I believe in* is the first sign, and so *God* is second; *the* is third, and so *father* is probably fourth — but then there are 5,696 more signs to master.

Given this complexity, it's not surprising that few people mastered the script, even in the "rude wildernesses and solitary deserts" of America, where they had no choice.[44] (Kauder's lack of success has been attributed to an inherent Native American disinclination to literacy, but given the syntactic awkwardness and formidable signary of the script, it could just as easily be common sense:

41. Ibid., 25.

42. Ibid., 238–39.

43. The sequence includes Chrestien Le Clercq; see his *Nouvelle relation de la Gaspésie, qui contient les moeurs et la religion des savages gaspésiens Porte-Croix, adorateurs du soleil* . . . (Paris: Amable Auroy, 1691), reprinted (Montreal: Bibliophile du Canadiana/Osiris, 1973); and *Premier etablissement de la foy dans la Nouvelle France* (Paris: Amable Auroy, 1691).

44. Kauder, *Buch das Gut,* n.p.: "in den rauhen Wildnissen und Einöden."

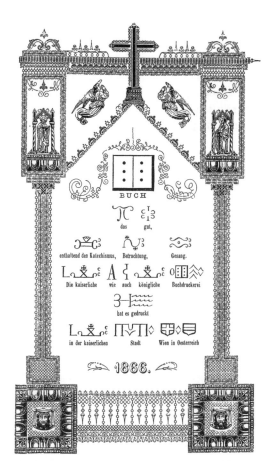

Credo.

(Symbolum Apost.)

PLATE 8.7 *Christian Kauder. Micmac prayer book, title page and credo. 1866.*

It's easier to memorize the Credo than read it off Kauder's pages.) Fragments of Kauder's book were still in use on Cape Breton Island in the 1920s, and there is evidence that they were treated reverentially as European sacred texts rather than read sign for sign.[45]

Fairly pure scripts like Micmac are the exceptions that prove the general rule: The chart does not list types of scripts that form a historical succession; instead the majority of scripts share different levels of the chart. Together with the first two critiques, this is a serious challenge to the veracity of the chart. But the deepest doubts I entertain about the logocentric sequence have to do not with its internal structure but with its endpoints. The notion of a pure picture is a focus of the next three chapters, but I want to say a few things here about the notion of pure alphabetic script.

According to one theory, intermittently debated in the literature, the alphabet is acrophonic in origin, meaning it was first written as signs denoting objects whose first letters began with the sound the alphabetic letter should represent. To denote an apple pictographically, I would draw an apple. I could also draw an apple to write the sound "a" acrophonically. The spoken names of the letters of the alphabet in Phoenician, Old Canaanite, and Hebrew are probably largely acrophonic. Phoenician *bêt* meant "house," and the letter "b" was first written as a little house. The apparently nonpictographic Roman alphabet is derived from pictographs and ideographs, and there is some evidence that one of its origins, the Old Canaanite script, borrowed from Egyptian hieroglyphs — a belated discovery, as it would have made Enlightenment Egyptologists happy and perplexed those

45. See John Lenhart, *History of the Micmac Ideographic Manual* (Sydney, Nova Scotia: Cameron, 1932); Walker, "Literacy, Wampums, the gúd3buk," 48–49; Diringer (1948), 155.

who thought Hebrew letters were original and sacred.[46] The earliest forms of the alphabet, known in Old Canaanite (ca. 1500 B.C.E.) and Early Linear Phoenician (ca. 1000 B.C.E.) have a distinctly iconic character, and some of those traits are still faintly echoing in our Roman alphabet. This is not widely known, in part because the evidence is fragmentary and contested, and in part because the alphabet has gone through so many changes that it is sheerest speculation to suggest in any one case that traits have carried through from the earliest forms. Nevertheless a few examples might be cited to show the kinds of metamorphoses and continuity that are at stake in such determinations.[47]

The letter A was originally an ox, from Phoenician *'alp*, which became Hebrew *'aleph* (Plate 8.8). The ox sign was a rounded head with two horns and occasionally an eye or an ear. As the form simplified, the head became a closed loop, and the horns turned into extensions, like an inverted **A**.[48] Hebrew *he*, which gives us our lowercase letter h, might have begun in Proto-Canaanite as a man calling out, and then gradually simplified into an h-like form. The letter *kap* began as a hand with four fingers, and its splayed form could still be evident in our letter K. Hebrew *lamed* derives from the Phoenician *lamed*, meaning "ox-goad," and the coiled shape is fossilized in our rectilinear letter L. The letter M probably comes from the hieroglyphic Egyptian sign for water (which has phonetic value *n*), and retains some of its ripple from the more literal transcription in Old Canaanite. The source of the letter R is the Egyptian sign of a man's head in profile, and it is clearly visible, once we have it pointed out, in our Roman letter.

These speculations might be deeply influenced by our own desires, and the evidence is far from clear. A few reconstructions are patently wishful thinking; one book provides a comparison plate of the lowercase letter k next to a specific hand gesture in the manner of modern sign languages. Still, it seems unlikely that the trend of such parallels could all be mistaken. Some letters passed through apparently unrelated intermediary shapes, and others had moments that appear to be precocious anticipations of current orthography. The letter that was to become A, for example, appears to occur at least three times as a "perfect" letter A long

before the pictographic ox's head gave way to linear abstractions.[49] But even with these uncertainties, the evidence is enough to show that what we consider as a noniconic alphabet is bound up with naturalistic representation. The epitome of non-naturalistic abstract writing, in other words, reverberates with pictures.

REMARKS ON MATHEMATICAL
NOTATIONS

At this point it is tempting to begin looking for alternate sequences and conceptual categories that might replace Table 8.1. But I would be wary of reconstructing a schema that ultimately serves a dubious purpose. The deeper critique — the assessment of the possibility of "pure pictures," especially those that can be linked to the inception of writing — occupy the next three chapters. I think its best to let the intricacy of actual examples speak against the logocentric sequence, and in that spirit I bring this chapter toward its conclusion by looking at a kind of writing even further from traditional studies of writing.

One of the places in which the continuing privilege of glottographic signs is most evident is in the large admixture of such signs in Roman scripts: As Chad Hansen points out, the ordinary English-

46. Gordon J. Hamilton, "The Development of the Early Alphabet," Ph.D. diss., Harvard University, 1985 (Ann Arbor, Mich.: University Microfilms International, 1985), cited in F. M. Cross, "The Invention and Development of the Alphabet," 90n11.

47. See A. F. Albright, *The Proto-Sinaitic Inscriptions and Their Decipherment* (Cambridge, Mass.: Harvard University Press, 1955); Benjamin Sass, *The Genesis of the Alphabet and Its Development in the Second Millenium B.C.*, vol. 13 of *Ägypten und altes Testament*, ed. Manfred Görg (Wiesbaden: Otto Harrassowitz, 1988); W. V. Davies, "Egyptian Hieroglyphics," in *Reading the Past: The Writing from Cuneiform to the Alphabet*, ed. J. T. Hooker (Berkeley: University of California Press, 1990), 75–136, esp. Table 3, p. 132; John F. Healey, "The Early Alphabet," Ibid., 197–258, esp. 251–53; and Martin Bernal, *Cadmean Letters* (Winona Lake In.: Eisenbrauns, 1990).

48. This account follows Sass, *The Genesis of the Alphabet*, 108 ff. Plate 8.8 is based on David Diringer, *The Alphabet*, 3d ed. (New York: Funk & Wagnall's, 1968), vol. 2, figs. 21.1–12.5, 14.1, 14.2, 22.1, and Conclusion 25, p. 452.

49. Sass, *The Genesis of the Alphabet*, 109, thinks it might be a case of mistaken identity.

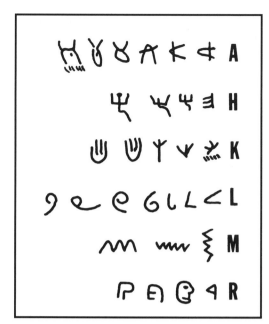

PLATE 8.8 *The Latin alphabet compared with Old Canaanite and other early forms.*

language keyboard has twenty-six letters with phonemic values and forty without.[50] (The font I used to type this manuscript has ninety-two non-phonemic characters.) The situation is even more unbalanced, as Hansen points out, if we include signs used in computer languages and — especially — numerical, logical, and mathematical formalizations. These last in particular are a largely untheorized part of writing. Brian Rotman has made a gesture in the direction of the problem by exploring how difficult it is for those who critique logocentrism and privilege writing to justify their ongoing exclusion of mathematical symbols. Traditionally, mathematical expressions, formulae, diagrams, and equations are excluded from publications in the humanities. They are virtually absent from texts that explore deconstruction, and it is even possible to write about philosophic logic without using formalisms. Jacques Derrida's seminal work, a critique of Husserl's *Origin of Geometry,* follows Husserl in omitting all diagrams (that is, despite the texts' ostensive subject, a discipline inseparable from actual drawn lines, arcs, points, and planes). It is to Rotman's credit that he draws attention to the problem, and to the contradiction in which deconstructive accounts of writing can so easily find themselves — even if he does not go

ahead and cross the line himself. Rotman's books and essays do use mathematical diagrams and formalisms, but very few by mathematical standards. As he knows, it is a very difficult problem: ultimately, one loses one's readers if there is a surplus of mathematical signs in a text. My own *Poetics of Perspective* was revised with the same issue in mind: I argue for the importance (and even the expressive meaning) of diagrams and other mathematical formalisms, but I found it necessary to virtually exclude all but the simpler examples in order to retain the readership I wanted.[51] Rotman also proposes that mathematicians and philosophers who habitually divide geometrical forms from mathematical symbols, and try to eliminate the former, are just rehearsing the old bias in favor of what I am calling "pure writing." They want letters to be sufficient and to comprise proper writing. Geometry, like semasiography, is too messy and too bodily to be admitted into the rarefied, Platonic realm of writing.[52]

Even though there is no good reason to exclude mathematical signs from a consideration of the iconic elements in writing, there is good reason to be cautious about assimilating iconic mathemati-

50. Hansen, review of Daniels (1996), *Journal of Asian Studies* 56, no. 1 (1997): 147– 48. Hansen makes this point as part of a critique of Daniels's emphasis on phonograms — an emphasis owing largely to Gelb's influence. I thank Stanley Murashige for bringing this to my attention.

51. Elkins (1994).

52. Rotman, "Thinking Dia-Grams." This despite the existence of literature on the place of mathematical notation in metaphysics. See Pavel Aleksandrovich Florenskij (1882– 1937), *U Vodorazdelov mysli* (Paris: YMCA-Press, 1985); and J. Fung, "Between Philosophy and Mathematics: The Parallel on 'Parallax,'" *Philosophia Mathematica* 4, no. 2 (1989): 165– 85. I thank Vladislav Shaposhnikov and G. B. Goutner for these references. There is also a long tradition of unreflective mathematical metaphysics, much of it — significantly — marginal to the mainstream traditions of Western thought. An interesting example is Kant's successor at Königsberg, Johann Friedrich Herbart, who wrote a treatise quantifying the quality of attention: *De Attentionis mensura causisque primariis* (Königsberg: Apud Fratres Bomtraeger, 1822). The essay caught the attention of the cranky, condescending Augustus de Morgan, who included it in his *Budget of Paradoxes,* 2d ed. (Chicago: Open Court, 1915), vol. 1, 253–54. Morgan also notes William Howson, *A Grammar of Infinite Forms: Or the Mathematical Elements of Ancient Philosophy and Mythology* (Edinburgh: Oliver & Boyd, 1823). (*Budget,* 256–58.)

cal signs to iconic written ones.[53] I agree with Goodman that numbers and their basic operators comprise a notation, and not a writing, for the simple reason that their syntax and semantics is absolutely, rigidly determined in any given case in all its possible permutations. And aside from those logical requirements, there is the fact that mathematical notation does not follow the orders of reading. A formula might demand many motions of the eye that a sentence does not, and it might even possess signs denoting the order of reading, such as fractions, that are not available as such to writing. In that sense mathematical notations, as the phrase is normally used, also correspond to the sense of notation operative in this book: a kind of image that is neither read as writing nor seen as a picture. A full history and analysis of mathematical notation remains to be written, but it is possible to show in a relatively short space that mathematical notation is in the same difficult relation with pictures as writing.

In mathematics, a number of symbols and symbol configurations have the feeling of pictures without either being pictures of anything or conforming to schematic or graphic rules. Mathematics is replete with typographical morphemes that have the feeling of pictures, such as Π, ϕ, \pm, \div, \geq, \leq, \neq, $\sqrt{}$, \int, ∂, Σ, and ∞. Extremely complicated iconic configurations can be constructed with the aid of such formalisms. Because they spell equations and not sentences, they tend to stand

Mathematical treatises share the same format as illustrated books, except that the "captions" to their "pictures" are to the right or left instead of above or below. There are indistinct boundaries between formulas (meaning, in this context, statements typographically homologous to the explanatory text), figures, and diagrams. In contemporary science, when a formula is wider than a line of type, it is continued onto the next line with the help of a snaking bar. In general the purpose of mathematical formalisms is to avoid such expressions and to keep the expressions short enough so that they can be surrounded by text.

The exceptions to this are principally complicated fractions and logical relations. Phi (ϕ), the golden ratio, can be expressed by a "continued fraction" such as:

$$\phi = 1 + \cfrac{1}{1 + \cfrac{1}{1 + \cfrac{1}{1 + \cfrac{1}{1 + \cfrac{1}{1 + \cfrac{1}{1 + \ldots}}}}}}$$

The fraction can be continued *ad infinitum,* but it is usually written just long enough to show its triangular shape. The same value can also be represented by iterated formulae such as:

alone as centered paragraphs or as paragraphs accompanied by reference numbers, as in Max Black's example of Wittgenstein's idea of a picture (see page 64). As Black's example suggests, there is a wide difference between an equation in a text, say "$(-1)^{-i} = (e^{i\pi})^{-i} = e^{\pi}$," and its appearance in a typical mathematical treatise, framed by text above and below, and labeled by an equation number in the right margin:

$$(-1)^{-i} = (e^{i\pi})^{-i} = e^{\pi} \qquad (1)$$

In these *expressions* — the word denotes something less than "figures," and certainly not pictures — the geometric form is not relevant. The continued fraction would usually be written

$$\phi = 1 + \cfrac{1}{1+} + \cfrac{1}{1+} \ldots$$

53. See also the remarks on the linguistic status of mathematical notations in Harris (1995), 134–44.

for typographic convenience.[54] Other mathematical formulae are conventionally expressed as patterns. There is, for example, Pascal's triangle, which can be written as an infinite triangle, although it need not be pictorial at all:

$$
\begin{array}{ccccccccccccc}
 & & & & & & 1 & & & & & & \\
 & & & & & 1 & & 1 & & & & & \\
 & & & & 1 & & 2 & & 1 & & & & \\
 & & & 1 & & 3 & & 3 & & 1 & & & \\
 & & 1 & & 4 & & 6 & & 4 & & 1 & & \\
 & 1 & & 5 & & 10 & & 10 & & 5 & & 1 & \\
1 & & 5 & & 15 & & 20 & & 15 & & 6 & & 1 \\
\end{array}
$$

In practice, Pascal's triangle is used to solve problems (binomial expansions) that are not themselves pictorial in nature, and it is seldom presented as a triangle. Normally the fourth line of this triangle, for instance, would be written

$$x^3 + 3xy^2 + 3x^2y + y^3,$$

a significant increase in typographic uniformity. This is a common relation of notation and writing in mathematics: Graphical notations are presented as heuristic forms, ready for "formalization"—conversion into more typographically normative, writinglike expressions. Such conversions are said to increase generality, but it is not always easy to see how they do so. In the case of Pascal's triangle, the triangle itself is an effective and general representation of the idea, and the individual equations gain only in typographic uniformity and in explicitness.

On occasion, mathematical notation reaches peaks of pictoriality without requiring anything beyond numbers and typographic characters. Christian Doppler, an early-nineteenth-century mathematician, invented a notation to be able to speak concisely about geometric problems arising from sets of planes and intersecting lines (Plate 8.9, *top*). His notations became far more intricate than the austere, shadowless, and fleshless diagrams he uses to make introductory points (Plate 8.9, *bottom*).[55] This is an extreme instance, but the possibility of becoming pictorial is inherent in any mathematical notation. Several signs such as the integral \int can stretch to any size to accommodate large expressions, but mathematicians routinely censor anything that becomes too pictorial, preferring to fold it back into the domain of the typographic.

Choices like these remain unstudied. In mathematics and science, formalisms are preferred to more pictorial alternates for reasons of generality, economy (because mathematical typesetting is expensive), and increased logical power. But those reasons are only part of the story: Twentieth-century mathematics also continues to turn away from pictorial possibilities, just as late-eighteenth-century engineering abandoned illusionistic drawing and as late-nineteenth-century geometry abandoned elaborate visualization.[56] Derrida and later writers are only following the wake of those antipictorial tendencies.

THE IRRUPTION OF THE PICTORIAL

Pictures are domesticated and repressed in all scripts. In the common reception, that repression is so successful that it scarcely needs mentioning; hence the paucity of texts on the pictorial affinities of writing. But in fact the repression is universally unsuccessful, and pictures find their way into all writing. I close with two diametrically opposed examples of pictorial interventions: one so abstract and attenuated that it is a cousin to the mathematical notations; the other so explicit and disruptive that the writing erupts into living figures.

The Ogham script, which is the earliest surviving record of the Irish language, seems at first glance to be austerely nonpictorial (Plate 8.10). But it has a formal feature that is unique among all scripts and that makes it insidiously pictorial: It is inscribed along an edge or corner of a stone, so that a person reading it does not face a flat surface. (In the photograph, the thin stela is shored with a concrete buttress.) Some characters are etched to the right, others to the left. The effect, to my eyes, is an uncanny disorientation mingled with a faint sense of menace: It's always the edge (often fairly sharp) that faces me as I read. (There is a sugges-

54. Harold Davenport, *The Higher Arithmetic* (New York: Cambridge University Press, 1983 [1952]), 79ff.

55. Doppler, "Versuch einer analytischen Behandlung beliebig begrenzter und zusammengesetzter Linien, Flächen, und Körper; nebst einer Anwendung davon auf verschiedene Probleme der Geometrie descriptive und Perspective," *Ceska spolecnost nauk*, Prague, *Abhandlungen* 1 (1837–1840): 13 and fig. 8.

56. See Elkins, "Clarification, Destruction, Negation of Space in the Age of Neoclassicism," *Zeitschrift für Kunstgeschichte* 56, no. 4 (1990): 560–82.

Werden mehrere z. B. q Systeme von parallelen Linien im Coordinatensysteme als zugleich vorhanden und dergestalt angenommen, dass das eine System aus m, das andere aus n, ein drittes´ aus p Linien u. s. w. besteht, so hat man unleugbar die Gleichung:

$$y = \underset{\underset{2\varrho-1}{\alpha^1}}{\overset{m}{\underset{1}{\mathcal{CW}}}}\left\{\underset{1}{U}x+\underset{1}{V}+\frac{(\varrho-1)\delta}{Cos\,\varepsilon}\underset{1}{}\right\}^{\overset{\alpha^1}{2\varrho}} \omega \; \underset{\underset{2-\varrho}{\alpha^2}}{\overset{n}{\underset{2}{\mathcal{CW}}}}\left\{\underset{2}{U}x+\underset{2}{V}+\frac{(\varrho-1)\delta}{Cos\,\varepsilon}\underset{2}{}\right\}^{\overset{\alpha^2}{\varrho}} \omega \; \underset{\underset{2\varrho}{\alpha^3}}{\overset{p}{\underset{3}{\mathcal{CW}}}}\left\{\underset{3}{U}x+\underset{3}{V}+\frac{(\varrho-1)\delta}{Cos\,\varepsilon}\underset{3}{}\right\}^{\overset{\alpha^3}{2\varrho}} \omega.....\overset{t}{\mathcal{CW}}$$

$$\underset{\underset{2\varrho-1}{\alpha q}}{\overset{t}{\underset{q}{\mathcal{CW}}}}\left\{\underset{q}{U}x+\underset{q}{V}+\frac{(\varrho-1)\delta}{Cos\,\varepsilon}\underset{q}{}\right\}^{\overset{\alpha q}{2\varrho}};$$

und diese Gleichung abermals combinatorisch dargestellt, liefert somit den Ausdruck:

$$\text{XI.)}\; y = \underset{1.\,\psi}{\overset{q.\,\psi}{\mathcal{CW}}} . \underset{1.\,\varrho}{\overset{(n,m,p....t)\varrho}{\mathcal{CW}}}\left\{\underset{\psi}{U}x+\underset{\psi}{V}+\frac{(\varrho-1)\delta}{Cos\,\varepsilon}\underset{\psi}{}\right\}^{\overset{\overset{(\psi)}{\alpha}}{2\varrho}}_{\underset{\underset{2\varrho-1}{\alpha}}{(\psi)}};$$

welches die Gleichung von q Systemen von Parallellinien ist, wovon n, sodann m, p, t, zu einander parallel laufen.

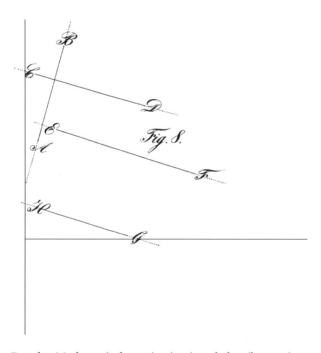

Fig. 8.

PLATE 8.9 *Christian Doppler. Mathematical notation* (top) *and plate* (bottom).

tive parallel in Japanese sword-making, in which the handles are occasionally signed by their makers using a set of very simple linear marks that form a standard code.)[57] Ogham stones are normally boundary markers, so who is to say that Ogham's linear character is not a figural property, an entirely appropriate, and pictorial, reminder of the danger of crossing boundary lines?[58]

57. Lydia Icke-Schwalbe, *Das Schwert des Samurai: Exponate aus den Sammlungen des Staatlichen Museums für Volkerkunde zu Dresden und des Museums für Volkerkunde zu Leipzig* (Berlin: Militarverlag der Deutschen Demokratischen Republik, 1979); Kotoken Kajihara, *Zusetsu Nihonto yogo jiten* (Fukuoka-shi: Kajihara Fukumatsu, Heisei 1, 1989).

58. See Damien McManus, *A Guide to Ogham,* Maynooth Monographs no. 4 (Maynooth, Ireland: An Sagart, 1991). Other scripts are cemented to register lines, even though they

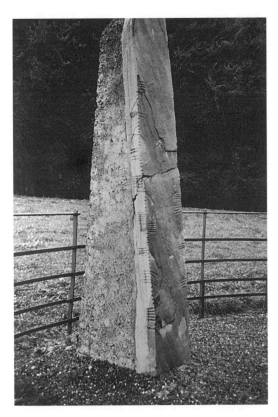

PLATE 8.10 *Inscription in Irish Ogham. Near Beaufort, Co. Kerry.*

My opposite and concluding case is Mayan script, a curious instance of how figural elements can terrorize scripts that have not developed canons for the formal repression of the pictorial. The Mayan script contains a syllabary and a signary of logoglyphs, single glyphs that represent words. In that way a word can be shown pictographically or as an assemblage of phonetic signs.[59] I say *assemblage* because the syllabic signs are arranged in the same squarish *glyph blocks* as the pictographic glyph for the whole word (Plate 8.11). The syllables make a pictorial composition, with a certain order of reading that circulates within the glyph block. In the example, *pakal* is written with the syllable signs *pa*, *ka*, and *la*, read top to bottom, left to right. In Mayan it is necessary to name not only prefixes, main signs, and suffixes (called postfixes) but also superfixes and subfixes.[60] In this way the main sign can be framed in all four cardinal directions by ancillary signs. There are formal similarities between logoglyphs and the syllable signs that can be used to spell them out. In the case of *pakal*, the sign *pa* is shield-shaped, and so are the others to a lesser

degree; the logoglyph for *shield* has four ornaments that resemble the four components of the syllable signs.

Mayan syllabic glyphs occur in figurative and abstract forms, and the former can either be personified (anthropomorphic), theriomorphic, or fragmentary (in "head form" or "full-figure form"). On the left of Plate 8.12, the verb *ts'apah* ("was set upright") is spelled in syllable signs as *pakal* was in the previous example. In the middle, the order of reading — the "composition," in pictorial terms — is disrupted when the *pa* syllable sign is inserted into the *ts'a* sign. The operation is called an "infix," on the analogy of suffix, prefix, superfix, and subfix. As far as I know, this in itself is unparalleled in other languages, as its equivalent in English would be inserting one syllable of a word into another — something like spelling *dissever*, which is syllabicated *dis • sev • er*, as *d | sev | iser* or *disse | er | v*. The right-hand illustration in Plate 8.12 shows the astonishing optional use of a "full-figure glyph" for the syllable sign *pa*.[61] The newly anthropomorphic *pa* holds the *ts'a* sign under its arm, so that the verb is read by looking at the full figure, and completing the sense by reading the syllable signs it carries. Again, there is no parallel in other writing systems. (In Egyptian hieroglyphs from the Ptolemaic period, figural signs sometimes "pick up" phonograms, creating an apparently analogous situation, but those configurations become new signs in their own right. Mayan full-figure glyphs remain syntactically disjoint from their accompanying phonograms.)[62]

are written on flat surfaces; see, among others, the "Saracen" alphabet in Athanasius Kircher, *Prodromus coptus sive Aegyptiacus* (Rome: S. Cong., 1636).

59. Mayan signs are normally called *glyphs*, and the difference between a glyph and a sign is best understood by thinking of the pictorial nature of the gylphs (they are arranged in framelike shapes). Otherwise, in matters of grammar, the distinction between *glyph* and *sign* is often not meaningful.

60. William F. Hanks, "Word and Image in a Semiotic Perspective," in *Word and Image in Maya Culture: Explorations in Language, Writing, and Representation*, ed. Hanks and Don S. Rice (Salt Lake City: University of Utah Press, 1989), 14.

61. For full-figure glyphs, see Ian Graham and Eric von Euw, *Maya Hieroglyphic Inscriptions* (Cambridge, Mass.: Peabody Museum of Archæology and Ethnology, 1977), vol. 2, part 2.

62. For examples, see François Daumas, *Valeurs phonetiques des signes hieroglyphiques d'epoque greco-romaine* (Montpel-

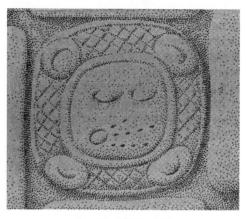
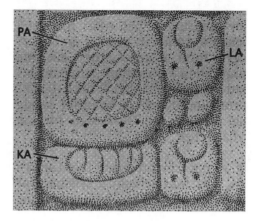

PAKAL ("SHIELD")

PLATE 8.11 *Logographic glyph and syllable sign glyphs for* pakal *(shield), in Mayan.*

It is difficult to imagine a more perverse relation of word and image. The syllable itself has come alive, and it has taken the remainder of the word and subdued it, just as a Mayan king vanquishes a rival king. The verb, *was set upright,* fits the figure's action, so that the entire glyph becomes a pictograph, and even a picture, of the action of setting something upright, as well as a group of syllabic signs. The very image of the "*pa*-man," with his burden of phonemes, expresses containment and engastration as well as "setting upright," and so the pictorial performs a kind of unnecessary metaphoric enactment of the linguistic.

And because the signs are variable — they have a wide range of permissible allographic variants — the glyph block is also weirdly self-referential. A reminder of the syllable's former state as an abstract syllable glyph is inscribed on the belly of the syllable *ts'a,* in the form of a pillow shape with lozenges. Details like that can conjure an infinite regression, words coming alive and swallowing or "subjugating" other words.

A Mayanist might not care that the *ts'a* sign is slightly different when it is carried by the "*pa*-man." But to an eye alert to corporeal changes, the transformation the *ts'a* sign undergoes when it is to be carried might be read as a response to its new pictorial setting — its shape is changed when it takes on some of the significance of a picture.[63] Likewise, a Mayan scholar might not notice that the *pa* sign's hook nose looks like the hook in the *ha* syllabic sign, but in pictorial terms that visual rhyme gives the "*pa*-man" a kind of linguistic

significance: The hook nose's slant rhyme makes the pictorial body more textual. To put it in the hybrid language it deserves, we might say that the hook nose is a kind of infix in its own right. More could be said along these lines, as the slightly varying contours, circles, and curves in each sign follow a complex *pictorial* logic that is not entirely assimilable to the linguistic requirements, though it cannot be understood apart from them. There is no study on these pictorial elements — the morphemes or "elements" in David Kelley's term[64] — of the Protean Mayan signary, because Mayanists are still engrossed in deciphering linguistic meanings. In this context let me propose that these questions constitute a huge unopened field: The "elements" of these signs carry pictorial meaning

lier: Institute d'Egyptologie Universelle Paul-Valery, 1988). I thank Emily Teeter for this parallel. The relation is the pictorial equivalent of *embedding,* a term used to describe the occurrence of clauses one within another; but *embedding* is significantly less pictorian than the Mayan practice.

63. In Peirce's "semeiotic" theory, the *ts'a* syllable glyph undergoes a slight graphic change when it shifts from a mostly symbolic sign to a combined symbolic and iconic sign. This is one of the shifting, mobile examples of signification that Peirce especially liked, and so it is a more appropriate example of his theories than more static, categorical instances of "icon," "symbol," and "index." See Charles Sanders Peirce, *Elements of Logic,* Book 2, *Speculative Grammar,* esp. chap. 3, in *Collected Papers of Charles Sanders Peirce,* ed. Charles Hartshorne and Paul Weiss (Cambridge, Mass.: Harvard University Press, 1965), 156–73.

64. David Kelley, *Deciphering the Maya Script* (Austin and London: University of Texas Press, 1976), 14.

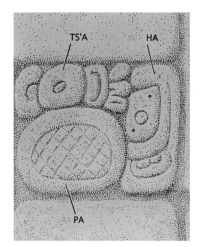
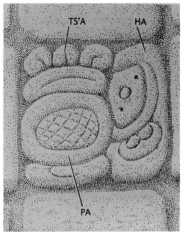

PLATE 8.12 *The verb* ts'apah *(was set upright), in Mayan.*

within, before, and despite their linguistic functions, and the most minute laws of their form and combination are linked to Mayan pictures and pictorial meanings.

Mayan and Ogham are extreme instances, and they suggest the tremendous variety of pictorial effects in writing. The crucial property that makes pictorial texts resistant to ordinary linguistic interpretation is their partial lack of Goodman's character-indifference. I think it matters that the sign for *land* in the Tarkondemos seal comes up to the level of the king's name, and no higher. A *land* sign slightly smaller would mean something slightly different. There's a lovely example of this slippage in the Bamum script, which has two signs for the word denoting "winged termite" (19,11 and 19,14 in Plate 8.6). As Njoya worked on his script, he sometimes inadvertently duplicated and reinvented signs, and so it is possible that these would eventually have been adjusted to one another. But as they are, they make a distinction that was not present in the spoken language, specifying the concept "termite" with greater precision than the language itself. This is an isolated example, but I would like to suggest that it is the general condition of all scripts that have naturalistic signs, and therefore ultimately of all scripts: Their iconic nature contributes to meaning in excess of what the cloned sign would nominally mean. Visual meaning is not consistently character-indifferent, because each instance of a character might differ slightly from the next. (Ultimately, of course, it *must* differ, but as in Chapter 5, I am concerned with the limits on

"repleteness." Not every difference carries meaning, and that is why the Tarkondemos seal can be read at all.)

English has a weak echo of this in the practice of variant spellings. In the sixteenth and early seventeenth centuries, writers in English, German, and other languages could spell almost at will, and in the hands of a writer such as Shakespeare the choices have expressive valence. It is unfortunate that Shakespeare's works tend to be read in modernized versions, because many outlandish spellings echo other words — an effect that any writer uses by choosing appropriate synonyms. William Empson's *Structure of Complex Words* and Joyce's *Finnegans Wake* are only the most sensitive responses to that universal possibility. In Njoya's script, the effect is stark and less easily explained in words, as it is the *picture* of swarming or clustering termites that contributes to the meaning. The termite signs are akin to any two similar forms in a painting: The difference between one tree and the next is often meaningful, even though it quickly escapes the reach of words like *tree*.

Most texts don't, or can't, contain the pictorial as efficiently as the Roman alphabet. Yet I would argue that there are meanings waiting to be discovered wherever writing involves pictorial decisions — which is to say, throughout the realm of writing. Although it might be hard at first to tie such meanings to the ones linguists find, that is not a sufficient argument for restricting meaning to verbal denotation. I might not know, in the end, what the asterism at the end of this chapter means, but the

fact that I put it there indicates something indispensable to my meaning. (Among other things, it is a reminder that I have omitted the entire field of *metagraphemics,* the study of diacritical marks and punctuation.)

The next step in unfurling the logographic sequence is to question its top level: What, exactly, distinguishes the most pictorial pictographs from the pictures that are ostensibly their nearest cousins? How much sense does it make to leap from *pictures* — a term that is, in this context, still undefined — to fully developed forms of writing? The next chapters are attempts to pry apart the line in Table 8.1 that divides the most writinglike pictures from the most picturelike writing.

* *

*

9 : Pseudowriting

Keeping in mind the slippery nature of pictures — so that it remains unclear exactly what a picture, in Warburton's or Derrida's sense, might be — a reasonable next step would be to try extending the concept of writing toward pictures, perhaps separating full writing systems from those that are only partly functional. Such scripts, which I will call pseudowriting, are not at all uncommon; there are many symbol systems that can only convey a limited range of ideas. Prehistoric and modern potters' and craftsmen's marks are pseudowriting in that they record the names of workers (or their towns or clans) and nothing more.[1] The Indus Valley seals might do the same.[2] Renaissance and Baroque humanists were interested in Egyptian, which they couldn't read, and the result was a spate of books with Egyptian pseudohieroglyphs.[3] There are also modern examples; on the Kamchatka Peninsula the Wotjäke have a system of pseudowriting called the *tamga:* simple zigzags and Y shapes that serve only to record the numbers and names of families.[4] Any specialized system of signs comprises a system of pseudowriting, including the symbols used in international signage. The difference between writing, pseudowriting, and other more pictorial uses of signs can be illustrated by a page from Johann Scheible's *Sixth and Seventh Books of Moses*, a nineteenth-century compendium of spells and incantations, allegedly recording the lost knowledge of "black and white magic" passed on by Solomon's high priest Sadock.[5] Most of the spells are not evil;

1. In addition to Chinese, Egyptian, and Old European examples cited in this chapter, see the "quasi-alphabetic" Phoenician or Aramaic marks in Max Edgar Lucien Mallowan, *Nimrud and Its Remains* (London: Collins, 1966), 223.

2. The case is still undecided, with several contending theories. Perhaps the most reliable work is by Asko Parpola; see his *Deciphering the Indus Script* (Cambridge: Cambridge University Press, 1994).

3. The pseudohieroglyphs in Francesco Colonna, *Hypnerotomachia poliphili*, are the most complex in terms of the number of glosses they receive: first an "ekprasis," then the pseudohieroglyphs themselves in a woodcut, then a Latin "translation," and then a commentary. The whole procedure deepens the mystery, because it raises so many questions about interpretation. See Dorothea Schmidt, *Untersuchungen zu den Architekturekphrasen in der Hypnerotomachia Polifili* (Frankfurt: R. G. Fischer, 1978); Ludwig Volkmann, *Bilderschriften der Renaissance: Hieroglyphik und Emblematik in ihren Beziehungen und Fortwirkungen* (Leipzig: K. W. Hiersemann, 1923), reprinted (Nieuwkoop: B. De Graaf, 1969);

Giovanni Pozzi, "Les Hiéroglyphes de l'*Hypnerotomachia Poliphili*," in *L'Emblème à la Renaissance*, ed. Yves Giraud (Paris: Société d'Édition d'Enseignement Supérieur, 1982), 15–27; and Erik Iversen, *The Myth of Egypt and Its Hieroglyphs in European Tradition* (Copenhagen: Gad, 1961), reprinted (Princeton, N.J.: Princeton University Press, 1994), 66–70.

4. Max Buch, "Die Wotjäken, Eine Ethnologische Studie," *Acta Societatis Scientiarum Fennicæ* 12 (1883): 465–652, esp. 569 and plate 3.

5. [Johann Scheible,] *Das sechste und siebente Buch Mosis, das ist: Mosis magische Geisterkunst, das Geheimniß aller Geheimnisse*, 2d (?) ed. (Philadelphia: J. Weik, n.d. [ca. 1870]). The book was also published in New York, "Im Commission bei Wm. Radde," in 1861, and there is an English translation, *The Sixth and Seventh Books of Moses* (New York: n.p., 1880).

the third seal, for example, is intended to make people well-disposed and grateful, and to shame enemies (Plate 9.1). Its accompanying incantation, written principally in German, invokes several dozen angels and names of God. The seal itself is written partly in Hebrew characters. Aside from the center of the image, which I will consider in a moment, it is mostly Hebrew pseudowriting, mingled with invented letters. The sign at the extreme lower right is not a Hebrew character, although it is reminiscent of an *ayin* or *tzadee;* the fifth character (reading toward the left) is an actual *tzadee.* (This is an instance of Goodman's problem of syntactic finite differentiation, played out in a text intentionally devised *not* to conform to the rules of writing.) As a whole, the seal suggests words and syllables, but it is never quite legible.[6]

Scripts in pseudowriting might be undeciphered or indecipherable, public or private, grammatically inflected or ungrammatical, sacred or secular, performative or descriptive. The origins of their pseudonymous natures are less important than the basic fact that they are all like writing, but unable to serve as records of a language. Pseudowriting places us one stage closer to "pure pictures" than semasiographic scripts, but there is still a shadowy area between pseudowriting and anything that we would want to call a picture. There are many kinds of relatively disorderly marked surfaces — on contemporary artists' canvases, as well as on cliffs, cave walls, and potsherds — that create the impression of a concerted effort to write as well as draw or paint. Again following Ignace Gelb, I will be calling that intriguing zone *subgraphemics.* The center of Plate 9.1 slips into subgraphemics where the characters become more fanciful. Other seals in the *Sixth and Seventh Books of Moses* mingle chemical and astrological signs with forms reminiscent of German *Fraktur;* this seal uses script forms, a modified Christian orb, and variations on Russian letters. To put it properly, these characters are *kalmosin,* angelic letters (see Plate 12.2), but they go beyond the ordinary forms of such scripts because the characters overlap and tear free of their register lines, making it difficult to know what constitutes a complete character.[7] One long, looping character hooks a character below it, making a kind of pound sign (£) and forming a ligature between two lines that effectively derails any attempt to read. At the lower right of the center section, the

characters seem even to have abandoned their normative allographic shapes: They look more like ink spills, or little pictures that have been adjusted to appear like characters. The whole middle portion of the seal looks like a picture, with text framing it. I assign such forms to subgraphemics and hypographemics; together they are the subject of the next two chapters.

What distinguishes the pseudowriting in the frame from the disheveled subgraphemics in the center? As a provisional definition it's helpful to say that pseudowriting includes every image that is not writing but still contains orderly disjoint signs. That simplification serves to make the essential point that there are dysfunctional scripts that look like they could plausibly be read. Our feeling that an image is (or should be, or might be, or once was) writing weakens when the signs begin to overlap or fuse; it strengthens when the signs are uniform, well-ordered, and rationally spaced. There are at least two recurring cases: Either the pseudowriting has a clear syntax (that is, an interesting sequence of characters), so that it looks as if it's ripe for deciphering; or it seems to lack syntactic ordering, so that it appears as a list, a sample, or a fragment rather than a potentially legible script. The possibilities can be set out as in Table 9.1. Examples of asyntactic pseudowriting vary widely, from chemical and alchemical signs to hobo signs, astrological and astronomical signs, angelic and demonic signs in Cornelius Agrippa and on ancient Middle Eastern artifacts, graffiti "handles," suits on playing cards, and ephemeral private sign systems such as Isidore of Seville's reading marks.[8] When they

I thank Dan Sharon Byron Sherwin of the Spertus Institute of Jewish Studies for bibliographic assistance; Sherwin suggests the work might be an example of Christian Kabbalah — magical practices allegedly taken from Jewish teachings but without real relation to them (personal communication, December 1997).

6. Sherwin reads the word *haham* (wise man) at the beginning of the penultimate line, but it might also be a fortuitous arrangement of letters.

7. For *kalmosin,* see Albertine Gaur, *A History of Writing* (London: British Library, 1984), 188–90.

8. Sir William Gurney Benham, *Playing Cards: History of the Pack and Explanations of Its Many Secrets* (London: Spring Books, 195–?); Samuel Weller Singer, *Researches into the History of Playing Cards; with Illustrations of the Origin of Printing and Engraving on Wood* (London: R. Triphook, 1816); Stan Richards et al., *Hobo Signs* (New York: Barlenmir House,

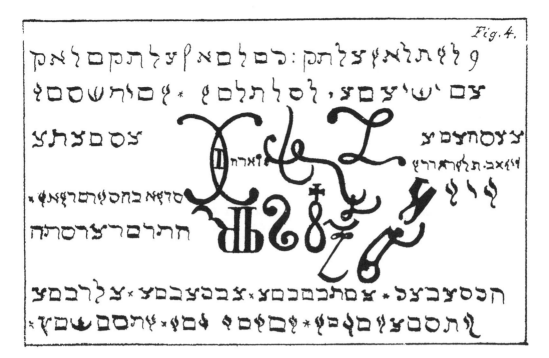

PLATE 9.1 *Johann Scheible. Magic talisman. 1861.*

occur by themselves, they tend to strike modern Western viewers as decorative and nonlinguistic, and that impression is strengthened if the characters themselves are pictorial, as in chemical, mathematical, or physical signaries such as ⊗ and ⊕ (mathematical symbols for vector operations), Egyptian pseudohieroglyphs, or utilitarian signaries like ♥, ♣, ♦, and ♠.

Pseudowriting can shift back and forth from apparently syntactic to apparently asyntactic. The middle of the bottom line of Plate 9.1 looks asyntactic where it repeats two characters with asterisks interposed, and then alternates two others. But the top line looks readable because it varies the sequence of signs. Even the simplest variations in the order of the characters can make pseudowriting appear syntactic. This sequence

♥ ♠ ♣ ♦ ♠ ♠ ♥ ♣ ♦ ♠ ♠ ♠ ♥ ♣ ♦ ♠

looks as if it is rule-bound, and it might provoke a mathematician or card player into deciphering it.[9] Pseudowriting becomes more pictorial — it ap-

1974); Frank Coffield, *Vandalism and Graffiti: The State of the Art* (London: Calouste Gulbenkian Foundation, 1991); *Das Endgultige Buch der Spruche und Graffiti,* ed. Angelika Franz (Munich: W. Heyne, 1989); Rennie Ellis, *Australian Graffiti* (Melbourne: Sun Books, 1975); John Bushnell, *Moscow Graffiti: Language and Subculture* (Boston: Unwin Hyman, 1990); Craig Castleman, *Getting Up: Subway Graffiti in New York* (Cambridge, Mass.: MIT Press, 1982); *Nezna revoluce v prazskych ulicich,* ed. Jan Halada and Mirko Ryvola (Prague: Lidove nakl., 1990); *An der Wand: Graffiti zwischen Anarchie und Galerie,* ed. Johannes Stahl (Cologne: DuMont, 1989). For older sign systems, see Thomas Astle, *The Origin and Progress of Writing, Hieroglyphic as Well as Elementary* (London: Chatto & Windus, 1876), 172, citing Isidore of Seville, *Etymologiae.* lib. 1, chap. 23, "De notis vulgaribus," and John Nicolai [= Nicholaus], *Tractatus de siglis veterum omnibus elegantoris literaturae amatoribus utilissimus: In quo continentur, quae ad interpretationem numismatum, inscriptionum, . . .* (Leiden: Apud Abrahamum de Swart, 1703); and Heinrich Cornelius Agrippa von Nettesheim, *De occulta philosophia,* in *Magische Werke sammt den geheimnissvollen Schriften des Petrus von Albano, [Giorgius] Pictorius von Villingen, Gerhard von Cremona, Abt Tritheim von Spanien dem Buche Arbatel der sogennanten Teil,* Geheime Wissenschaften, parts 10–14 (Berlin: H. Barsdorf, 1921), 5 vols. in 3, vol. 5, p. 111ff, esp. 230–31.

9. There is a game called Eleusis, in which one player sets out any number of cards and then the other tries to guess the rule that generated the sequence. Because the success of the game depends on keeping to a fairly uniform level of difficulty and mode of symbolization, it is a good model for the necessity of reasonably uniform interpretive communities for functioning systems of pseudowriting. Martin Gardner, *Penrose Tiles to Trapdoor Ciphers* (New York: W. H. Freeman, 1989).

TABLE 9.1. *Kinds of Pseudowriting*

Pseudowriting limited signaries	Asyntactic pseudowriting	Indefinite signaries: Zosimos's "formula of the crab"
		Numerable signaries; chemical notations
	Syntactic pseudowriting	The marginal lines of the third seal from the *Sixth and Seventh Books of Moses*

proaches subgraphemics — when the signary is in doubt. Can we see a linguistic code in this?

Or this?

When the signary is unclear, reading slows and finally stops, even though the feeling of writing might persist very strongly, guiding our responses even when we know reading is hopeless. There are parts of Plate 9.1 that look as if they should be legible, even though the characters are obviously mutating back and forth from Hebrew or Yiddish into capricious *kalmosin*. The challenge in understanding pseudowriting is to understand these various twilight zones of reading and half-reading.

THE TRAITS OF WRITING . . .

In Part 1, in relation to the word–image dichotomy, I proposed that the words *writing* and *picture* tend to be applied not to definable classes but to images that fulfill a sufficient number of uncognized expectations, so that if a given image has, say, only three of the traits of writing, it might still be perceived as writing. In this theory, no image is entirely writing or a picture. This is a kind of statistical approach to the problem, and it means that instead of an opposition between words and images we could speak of admixtures of writerly, pictorial, and (eventually) notational traits.

Thinking about the traits of writing entails a kind of artificial reflexivity. It takes a special act of attention to evaluate pictorial elements such as typographic style while also reading this page, just as it requires a kind of artificial concentration to think of how a given picture resembles writing.

But there are many cases in which it is not possible to naïvely read or look, and we need to weigh our suppositions about writing and picturing in order to reach an understanding of the image. How do we know that something like this Minoan clay bar is written, and not pictured (Plate 9.2)? (How do we know, in other words, apart from what could be concluded from its date and place?) [10] Scholars who study artifacts that are ambiguously written and pictured often encounter this problem, although I know only one attempt to list the signs of a written text: Jochem Kahl's four criteria of writing in early dynastic hieroglyphs. [11] For most writers, writing and pictures are simply self-evident.

Comprehension of a text comes after comprehension that the text exists at all. In effect, we gather clues in the first instants of viewing that tell us the artifact is writing, and therefore something to be read. Elsewhere I have argued that there are approximately ten *traits of writing* that combine to make an artifact look like it might be susceptible to reading. [12] In practice, only a few are necessary to prompt a viewer into reading, and even a printed page like this one does not have all ten traits. But in the most complete case an image that appears to be writing will possess (1) disjoint signs, because otherwise it might look fused, like the center of Plate 9.1, or like a painting. This first trait is a relaxed version of Goodman's first criterion for

10. For the context, see Arthur Evans, *Scripta Minoa*, vol. 1, *The Hieroglyphic and Primitive Linear Classes* (Oxford: Oxford University Press, 1909), number P 100.

11. Kahl's criteria are orientation, linearity, "das 'Kalibrieren' der Schriftzeichnun" (roughly, uniform character size), and context. See Kahl (1994), 30–31. Despite its title (*Signs of Writing*), Harris (1995) is a different project, concerned with signs in writing, and writing as signs.

12. I set these out in Elkins (1997), chap. 4, in which I call them the "signs of writing"; in this context, however, that name would be ambiguous, because denotation is not at issue. (The numbering in this book is also slightly different, for purposes of concision.)

notational disjointness, although I mean not so much that characters should be analytically differentiable as that they not be actually physically fused. The more confusing the artifact becomes, the more it is necessary to be precise about this first trait (in the next chapter I dissect it into several ancillary questions). In addition, if an image is understood as writing, it will often have (2) a rationally comprehensible spacing between signs (as in the white spaces in this text between words, and the narrower spaces between letters). Historically, writing is often framed or otherwise embellished, and so a text might also need to possess (3) signs that are distinct from whatever is understood as decoration, and (4) from whatever is taken as framing elements, borders, or register lines. Ordinarily, written signs must also be (5) more or less uniform in size, (6) fairly simple (otherwise they begin to look like pictures in their own right), and (7) fairly uniform in each of their appearances. There are also characteristic "looks" to written surfaces, and we tend to judge them by noting (8) how evenly the marks are "formatted" or aligned with their frames or register lines. This page is a very uniform object, with its horizontal lines and indented paragraphs; but even a slender column of hieroglyphs follows immediately apparent rational rules of alignment and orientation. Finally, there has to be (9) a minimally diverse signary, as one or two signs, repeated over and over, will not look like writing, and (10) a sense of syntax, so that the signs are arranged in a meaningful, and not just a mechanical fashion.

These traits of writing can be found in varying degrees wherever an image looks like it might be writing. The Minoan clay bar fulfills some of them and fails others. Its signs are disjoint, but there is no rational spacing between them (the first and second criteria). Instead they seem to have drifted apart from one another, as far as the edges of the bar would let them. The marks are uniform, simple, and sufficiently diverse (the fifth, sixth, seventh, and ninth criteria), but there does not seem to be any order to their arrangement, or any consistent syntax (the tenth criterion). I can't find syntax — that is, interesting sequences of signs — because I can't follow the order of the signs to begin with. In that respect, the bar is more like a map than a text. It fails the eighth criterion most conspicuously, because the marks are not aligned with one another

or with their rectangular fields. Only a few passages, such as the sequence of lozenges, have the kind of orderly alignment that writing systems normally possess. On a rough count, that makes five out of the ten traits of writing — a low enough score, I think, to account for my hesitation to identify this as writing. (The fact that it is writing is not immediately relevant; that kind of judgment depends heavily on context and the viewer's intent.)

The ten traits of writing raise interesting questions about pictures and notation. A "pure picture," in these terms, would be an object that fails each and every one of the criteria. It would be the pure absence of system, character, and sign — a void in which no meaning could survive. In accord with the dual nature of pictures, that impossible condition is balanced by the assumption (or conviction) among theorists of images that pictures are structured according to many of the traits of writing. Later in the book I will be developing some parallel "traits of notation," and they could apply almost as well; pictures would once again be images that fail to possess certain rudiments of systematic signification. Pictures are unstable: The clay bar is pictorial to the extent that it seems to vacillate between an image that is almost writing and one that is partly meaningless.

. . . AND THE HABITS OF READING

Part of identifying an image as writing is finding a sufficient number of the traits of writing; another part is deciding how close to actual reading it may be possible to come. A native speaker of English will read an English printed page without hesitation; a reader largely unfamiliar with a script might pause before deciding to read, or before trying to read. In paintings and in archaeological artifacts, the same kinds of decisions can be much more subtle, and they also help us decide what counts as an instance of writing, picturing, or notating. There are several distinct orientations in regard to artifacts that might be writing, or that we perceive as writinglike.[13] I will call these *habits of*

13. This list is modified from my "Reply," *Current Anthropology* 37, no. 2 (1996): 222–23, although I have rearranged it to suit this theme. The list in *Current Anthropology* is more concerned with levels of self-reflexivity in reading; it is an ex-

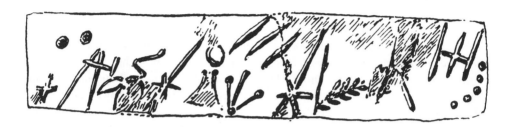

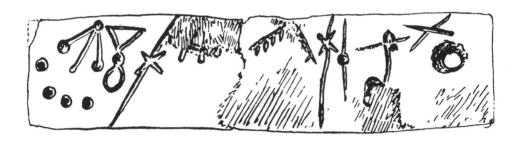

PLATE 9.2 *Four-sided clay bar from the Palace of Mallia. Minoan.* This page: *drawings;* next page: *photograph of face* a.

reading, to complement the traits of writing. Consider, as an example, two very different objects: an archaic Mesopotamian tablet and a painting by Adolph Gottlieb.

Some of the earliest writing is pictorial in the way it uses "cases" to divide sentences, and in the apparently careless disposition of signs within any one case (Plate 9.3). Each case, in effect, becomes a

panded version of several ideas proposed by Whitney Davis, [untitled reply,] *Current Anthropology,* 204–207, esp. 206. In particular, the notion of "taking the temperature" of a reading is Davis's.

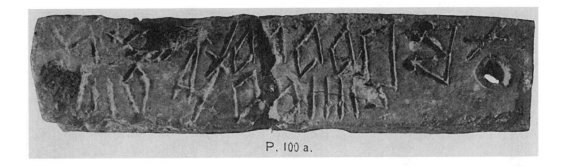

P. 100 a.

little picture: There is no fixed order of signs, and so a reader contemplates the entire case, summing and rearranging the signs, until a meaning becomes clear. Some of Adolph Gottlieb's "pictographic" paintings take a tentative attitude to writing and end up exploring the same possibilities (Plate 9.4). Certainly Gottlieb wished *not* to be read, and the scribe wanted his signs to be legible; but the images lack the same three traits of writing: uniform characters, a comprehensible order of reading, and a rational system of spacing. As a result, we perceive the images as sets of cases or frames containing writinglike signs, even though we are dissuaded from actually reading. Gottlieb's paintings are not, in effect, read by any historian or critic; rather, they evoke reading, and make reading one of their subjects. This painting of Gottlieb's is especially writinglike: It is titled *Letter to a Friend*, and it repeats and simplifies several of the pictographs he had developed from 1941 onward. Near the upper left is a "wriggley shape" of the kind that he once said "would be a snake." [14] There are also sculptural and masklike objects that he had used in other paintings, here reduced to linear outlines. Along the right margin is short column of pseudowriting — a relatively unusual occurrence in the pictographic paintings. Faced with such an image, a viewer might sample a given sign (say, an eye), making an informal inventory of its various occurrences. In effect, the same happens with the tablet, because even experienced viewers are likely to look first at the drilled holes that indicate numbers and only afterward try to decipher the other signs. (The upper-left-hand case, for instance, records 990 *iku* or 350 hectares of land, and the one underneath it contains the name of a temple administrator.) [15] Reading in any normal sense doesn't take place with either image, but the

feeling of writing compels a viewer to think again and again of reading; it continuously pulls the eye from its freer roaming and pushes it toward the strict motions that would enable it to read. (It is especially interesting in this respect that one of Gottlieb's principal models for his "compartments" are Tlingit artifacts whose divisions have a tight, repetitive symmetry. Gottlieb dissipates the symmetry in order to diffuse the sense that the image might be naturalistic or decorative. In doing so he intensifies a viewer's thoughts of reading.) [16]

There are a few Near Eastern tablets that are even closer to Gottlieb's canvases, and it is relevant that they might have been intentionally devised as illegible pseudowriting (Plate 9.5). The tablet and impression shown here might even have been forgeries of writing itself — something nearly unimag-

14. Adolph Gottlieb, interview with Dorothy Seckler, October 1967, in the archives of the Adolph and Esther Gottlieb Foundation; quoted in Charlotta Kotik, "The Legacy of Signs: Reflections on Adolph Gottlieb's Pictographs," in *The Pictographs of Adolph Gottlieb*, ed. Sanford Hirsch (New York: Hudson Hills Press, 1994), 59–67, esp. 65.

15. Ignace Gelb, *Earliest Land Tenure Systems in the Near East: Ancient Kudurrus*. Oriental Institute Publications, vol. 104 (Chicago: Oriental Institute, 1991), vol. 1, p. 33, suggests "either 'AN.ATU-912.KI (= PN), the temple-administrator,' or 'the temple-administrator of the household of the deity dATU-912.KI.'" The numerals in the top case are 5 bur'u. . . and 5 bùr. . .— that is, 990 iku = 349.24 hectares. Gelb includes a line drawing of the tablet, which shows (among other things) that the signs in the lower-right case continue around the sides; a slightly different drawing (superior in some details) is reproduced in Ellen Seton Ogden, "The Text of an Archaic Tablet in the E. A. Hoffman Collection," *Journal of the American Oriental Society* 23, no. 1 (1902): 19.

16. See the Chilkat blanket once owned by Gottlieb, illustrated in Evan Maurer, "Adolph Gottlieb: Pictographs and Primitivism," in *Pictographs of Adolph Gottlieb*, 31–40, esp. 37, plate II-12.

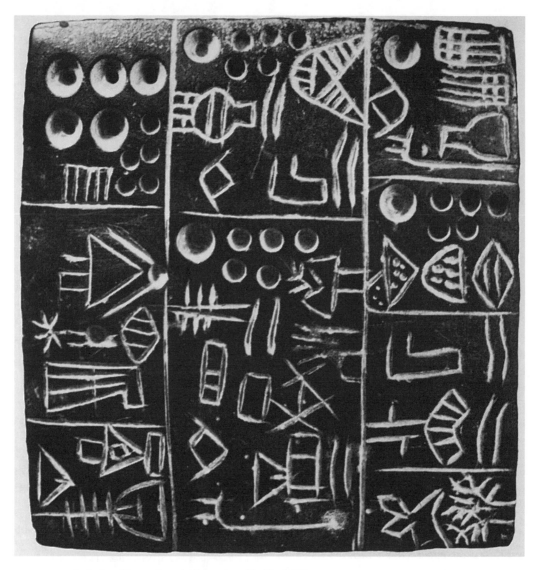

PLATE 9.3 *Archaic tablet, written in Sumerian (?). Uruk III.*

inable today, when the written vernacular would be universally recognizable.[17] The "forged" tablets are an especially good match with Gottlieb's painting, because the tablets and the painting insistently remind viewers of reading, while disrupting any possibility of reading.

(A word on far-flung comparisons: Several times in this book I entertain parallels between Western paintings and artifacts from very different cultures. Chapter 2 evoked, but did not illustrate, a connection between Picasso's analytic cubism and some strategies in crystallographic illustration. Several other examples are dispersed throughout the text. In each, what matters is not the formal similarities

but correspondences between modes of reading, looking, and decipherment. As both linguists and

17. Ignace Gelb, in *Seals and Sealing in the Ancient Near East,* ed. McGuire Gibson and Robert D. Biggs, Bibliotheca Mesopotamia, vol. 6 (Malibu: Undena, 1977), 109, says "The writing, language, and function of these seals are a mystery to me." (Quoted in Dominique Collon, *First Impressions: Cylinder Seals in the Ancient Near East* [Chicago: University of Chicago Press, 1987], 107.) See also Arnold Nöldeke, *Uruk vorläufiger Bericht,* vol. 4 (Berlin: Verlag der Akademie der Wissenschaften, 1932), vol. 4, plate 15g; Leon Legrain, *Archaic Seal-Impressions,* Ur Excavations, vol. 3 (London: Oxford University Press, 1936), no. 431; and Heinrich J. Lenzen, *Uruk Vorläufiger Bericht,* vol. 19 (Berlin: Verlag der Akademie der Wissenschaften, 1963), plates 16 d–f.

PLATE 9.4 *Adolph Gottlieb.* Letter to a Friend. *1948. Oil, tempera, and gouache on canvas.* © *Adolph and Esther Gottlieb Foundation, New York. Licensed by VAGA, New York, NY.*

PLATE 9.5 *Seal impression, and diagram. Ur, Iraq.*

art historians know, there are some very exact and unexpected formal parallels to be made between very different cultures, but not all of them entail parallels in reception and interpretation.[18] The danger in this adage — often repeated among linguists, and less commonly among art historians — is that formal links can sometimes be clues to deeper congruences of the concepts of writing or picturing.)

18. A particularly seductive example is the comparison of Mondrian's *Broadway Boogie-Woogie* and a fifteenth-century Islamic calligraphic painting, proposed in Grabar (1992), 18, 47–48, 249n3, and plates 3 and 4. The comparison is aptly critiqued in Margaret Olin, review of Grabar (1992), *Art Bul-*

Here, then, are the habits of reading that might be at work when we look at such objects.

1. *Noticing writing.* In this most distant stage, I scan a surface for the traits of writing, notation, or pictures. In each of the examples in this chapter, I would quickly (instantly, so it seems) find enough traits to make me feel comfortable saying the images are either writing or writinglike. The presence of special symbols, diacritics, register lines, pictures, or notations would not be a problem at this stage, because no actual reading will have taken place. The "forged" tablets fare the worst at this stage, as I have a hard time collecting enough traits of writing, or even finding enough repeated signs, to make me think too seriously that they are writing.

2. *Testing the waters.* Then it might occur to me to test the possibility of reading by trying out a reading on part of the artifact. The experiment would not be aimed at full understanding; it would merely be a sample reading, a tentative foray intended to discover whether some mode of reading might fit the object. Whitney Davis has compared this stage to sending up a weather balloon, testing as if to see if the conditions for reading are right. The test is not entirely under my control, and the balloon might or might not return with a sample reading — I might or might not come away with the sense that reading may be possible. For example, I might look at the archaic tablet (Plate 9.3), noting patterns of organization. In several places a large conical depression is accompanied by five smaller ones — an arrangement that reassures me that the tablet has to do with counting. Gottlieb's painting doesn't reassure me as much, although the small number of signs might mean that each one has significance. (A large collection would make me skeptical.)

3. *Taking the temperature of a reading.* Another mode, which mingles with the first two, is thinking about the relation between several such tests or moments of reading. If an artifact seems partly well-behaved as a notation or a script and partly wayward or incomprehensible, I might be drawn to think about what kind of reading could ever be extracted from it. Looking at the Gottlieb, I notice several passages that are similar to one another, and several eye signs that appear to be character-indifferent as Goodman says — that is, they look to be instances of the same character. Other passages seem capricious, decorative, uncontrolled,

or otherwise incompatible with my first ideas about reading. The pseudowriting along the right margin reminds me of a caption or a slogan. (I also notice he has signed his name, perfectly legibly but camouflaged inside a smear of paint.) Together, those observations give me at least a working sense of the level or kind of reading that might be possible.

4. *Actually reading.* In some cases this last stage is effortless and homogeneous (as with this page), but in others it might require hard work and be rewarded with a patchy sense of the object's meaning. Objects such as the archaic tablet will routinely stop experts in some places, so that no reading is complete — or rather, a "full" reading includes lacunae and conjectures. The same is true of Gottlieb's painting, because it is known that he mingled "universal" signs with private ones and with signs that had no special meaning. Art-historical readings of Gottlieb's "pictographic" paintings are partial and conjectural, and they don't try too hard to be complete because they know thoroughness is a chimera. The same cannot be said of the archaic tablet, but the slow accumulation of known meanings produces the same result.

When a text is available to be read, this sequence of the habits of reading might well collapse into one seamless step. In prehistoric artifacts, undeciphered scripts, ciphers, sigla, hermetic scripts, and some modern painting, however, the intermediate steps become paramount, and the objects cannot be assessed without thinking of them. A devout reader will know that the talisman from the *Sixth and Seventh Books of Moses* cannot be read, as the "temperature" of its reading varies too wildly. At the same time that very illegibility might prompt the reader to use the talisman, because it obviously *is* writing. (In the terms proposed by the *Sixth and Seventh Books of Moses,* its readers are not people but angels. An angelic reader, presumably, would be more accommodating than a human one.)

Seeing the archaic tablet, I know it can be read at a certain level of exactitude, and with an allow-

letin 75, no. 4 (1993): 729: "Grabar's central comparison . . . is ingenious. For it compares a work that a Western non-Islamicist is unlikely to recognize as writing to a painting by a Western 20th-century abstractionist least identified with calligraphy. It is also the moment, however, where the dialogue between East and West seems most arbitrary, supported as it is only by a formal similarity."

ance for uncertainties. Seeing the Gottlieb painting scattered with signs, I know it can be read at another level of exactitude. Despite the many differences in intention, culture, and context, the potential unevenness of the readings is similar. (And I take it that was part of Gottlieb's purpose.) What differs is the *propriety* of reading. Most modern painting is not read: Historians, artists, and critics do not normally go over the symbols in paintings one by one, with the intent of producing a definitive reading. But they do test the waters, contemplate reading, take the temperature of a reading, sample readings, and sometimes — for a few moments or a few inches — actually read. The difference between the objects, which is so great in so many ways, dwindles to nearly nothing when it comes to thinking about reading rather than reading.

MNEMONIC PSEUDOWRITING

With the traits of writing and the habits of reading as guides, we can plunge deeper into the murky area where scripts give way to pictures. The difference between syntactic and asyntactic pseudowriting is certainly crucial for our sense that an object might be a picture, and Table 9.1 also suggests that it matters whether or not it's possible to count the signary (the number of signs in the script). If the signs are countable, then the graphism is apt to look like something that could be read. If not, it might seem more like an artist's open-ended collection of symbols.

Writing can also be put in doubt when each sign appears to stand for an indeterminate number of referents. Mnemonic pseudowriting is an interesting example. *Mnemonic scripts* are pseudowriting in which each sign is used to jog the memory into recalling images, verses, and even whole texts. (They are the counterparts of *mnemonic pictures*, which are collagelike images used to help readers memorize long poems or orations.)[19] Each sign in a mnemonic script stands for much more than a single phoneme or word. (Technically, the signs are phraseographs, enuntiagraphs, or narrative signs — they denote phrases, sentences, or full narratives.) The Micmac script was used as a mnemonic pseudowriting when latter-day worshipers used a few symbols to remind them of the entire Credo (see Plate 8.7). Easter Island Rongorongo

script might have been a mnemonic pseudowriting, providing aids for priests' memories of rituals. There are many examples; a typical Native American Ojibwa text consists of a series of semasiographic signs that stand for verses (in the jargon they are phraseographs), and so it was probably not read outside a small coterie of shamans.[20]

The distinction between *proper* and *mnemonic* scripts is widely made, and it has been used to distinguish "defective" Native American scripts from proper European scripts, but it does not stand up to scrutiny. Presumably a mnemonic pseudoscript would serve to help the memory rather than as a permanent record; it would require an oral tradition of exegesis to keep its meanings alive. Each generation of Ojibwa shamans would have to tell the next what each sign meant. The distinction is interesting but shaky: What script does not depend on memory, and what word cannot be forgotten?[21] What system of writing does not serve a "group of people" as opposed to all people? Still, there are instances of mnemonic pseudowriting designed for very small groups of people and even single readers, and in those cases the distinction between mnemonic pseudowriting and full writing begins to seem more viable.[22]

19. Often mnemonic pictures take the form of monstrous figures, studded with letters, numbers, and ancillary symbols. Several are discussed in my *Pictures of the Body, Pain and Metamorphosis* (Stanford, Calif.: Stanford University Press, forthcoming). See, for example, *Rationarium evangelistarum* (Pforzheim: Thomas Anshelm, 1507); or the facsimile edition of the 1502 printing, titled *A Facsimile of the Text and Woodcuts Printed by Thomas Anshelm . . .* (Cambridge, Mass.: Houghton Library, 1981).

20. For the Ojibwa script, see Jensen (1969), 40–41, and James W. Van Stone, *The Simms Collection of Southwestern Chippewa Material Culture* (Chicago: Field Museum of Natural History, 1988). For other examples see Heinrich Buttke, *Die Entstehung der Schrift, die verschiedenen Schriftsysteme und das Schrifttum der nicht alfabetarisch schreibenden Völker* (Leipzig: T. D. Weigel, 1877).

21. G. Träger, "Writing and Writing Systems," in *Current Trends in Linguistics*, ed. Thomas Sebeok, vol. 12 (The Hague: Mouton, 1974), 373–496, proposes "writing system" be defined as a "conventional system of marks . . . which represents the utterances of a language" (380), thereby including any conventional agreement to read any artifact. Harris (1995), 19, criticizes Träger's position; but "agreements" can be severely restricted in time and space and still operate as reading.

22. Otherwise it appears that the distinction has to rest on the possibility of deciphering a script after all its speakers

PLATE 9.6 *Zosimus of Panopolis. The formula of the crab.*

The Western hermetic tradition is replete with mnemonic pseudowriting, because alchemists and others invented secret signs to remind them of complex ideas, ingredients, and processes. The alchemical signary is a historically fluid, asyntactic mnemonic pseudowriting — just the place to find signs that mean much more than a single concept. Zosimus of Panopolis provides several examples; he was a Greek alchemist, the first in the Western tradition to leave writings under his own name. One manuscript attributed to him contains a line of symbols that has come to be known as the "formula of the crab" or scorpion (Plate 9.6).[23] The thirteen symbols — here numbered by a nineteenth-century editor — are explained in a Greek gloss, as if the entire formula could be rewritten as a sentence. Using the gloss it is possible to partly explain the formula; it describes an alchemical transmutation involving copper, lead, tin, and silver. The first sign (1) is a common marginal annotation in Greek alchemical manuscripts of the period, and it means "attention" or more precisely "A formula begins here." It belongs, therefore, to a class of words, phrases, and symbols including "ecco," "nota bene," •, and §, that serve as pointers to speech. The second symbol denotes a mixture of lead, copper, and zinc identified by Zosimos's French editor as "molybdochalque." The third signifies copper, because according to a tradition that goes back to the Egyptians the planets each have associated metals. Copper is often associated with Venus, and this is a Greek version of Venus's mirror (which we still use to denote "female").[24] The fourth sign is two coppers fused, bound by the lead with which they are melted. Next comes the sign of the crab or scorpion — different manuscripts have slightly different versions, some with stingers and some without — which signified an operation involving a heated mixture of copper and silver. The sixth sign is uninterpreted in the gloss, and the seventh sign is given by the Greek word ἐμέριτος, a word whose meaning is uncertain. (It's a *hapax*, a word that is not known, does not recur in a given text, and is therefore indecipherable.) The eighth and ninth symbols together signify fourteen drachmas; the tenth is an abbreviation that is glossed as "copper-lime, all of the shell" (meaning the shell of the philosopher's egg, a common symbol in alchemy); and the eleventh repeats the last three words of the tenth, "all of the shell." The twelfth and thirteenth together mean "lime of copper" (note the symbol for copper repeated). The formula ends, after the thirteenth symbol, with several words in Greek (they continue on the next line), ὁ νοήσας μαχάριος, "whoever has understood this will be happy."

Marcellin Berthelot, the first modern editor of the formula, calls it "un momento hiéroglyphique" and says it would have required an additional explanation to be comprehensible.[25] That conclusion is reasonable given the amount of attention the formula has attracted and its peculiar appearance in the middle of a manuscript that is otherwise less secretive (if not more straightforward). The formula combines an extraordinary number of different kinds of signs: Ordinary writing (in the coda), recognized symbols (numbers 3, 8, and 13), partly decipherable symbols (4), abbreviations (2, 10, 11, 12), linguistic pointers (1), numbers (9), partly naturalistic pictures (5), signs for rare or unknown words (7), and signs whose meaning might have been entirely private (6). Nothing is

have disappeared. By that criterion, Ojibwa is pseudowriting (and so, possibly, is Easter Island script) and Sumerian is not. But it is strange to use an archaeological criterion to capture an essential property of writing. It seems more likely that European interests are at stake, as mnemonic scripts are exclusively non-European.

23. Marcellin Berthelot, *Collection des anciens alchemistes grecs* (Paris: Georges Steinheil, 1888), vol. 1, 152–55.

24. For the tradition of planetary symbolism in alchemy, see J. R. Partington, "Report of Discussion upon Chemical and Alchemical Symbolism," *Ambix* 1–2 (1937–46): 61–64.

25. Berthelot, *Collection*, 155.

straightforward: Even the "crab" is a strange creature whose naillike appendages suggest it means something beyond whatever process is denoted by *crab* or *scorpion*. Together the signs are a compendium of possibilities, and it might be that the variety itself is the key to its cryptic or mnemonic nature. Any consistent set of signs would be a cipher that could be read by anyone in possession of the key. This, on the other hand, is partly a code: that is, a cipher without a single key. It might have originally been a mnemonic, but could also have been a combination mnemonic and code. Berthelot thinks it is "the last remainder of an ancient symbolism," conserved by a long oral tradition that reaches back before the earliest surviving manuscripts. But it seems more in accord with the later history of alchemy that it is an invented script, intended to remain private — partly mnemonic, partly coded, and partly deliberately incomplete.

With the sign of the crab we enter into the realm of what Suzanne Langer, following Ernst Cassirer, calls "symbols": signs with holistic cultural or religious meanings as opposed to signs in the proper sense, which are taken to have specifiable meanings in appropriate contexts.[26] (Goodman prefers to take "symbol" as a neutral, colorless term for sign, but in common usage the two words are far apart.) Some symbols have cloudy meanings, entwined with their cultural settings; others are a little more susceptible to words. When it comes to prehistoric materials, the meaning of "symbols" in Langer's sense is usually unrecoverable, and the same might be said of any signs that appear to have meanings that are holistic, scattered, or very broad. Even the meanings of the simpler narrative signs in Native American mnemonic scripts are often lost. The difference between the clear denotation of a sign and the fuzzy denotation of a symbol is sometimes useful, but I have not adopted the distinction because it implies a mystical, partly Hegelian sense of the cultural ambiance that inheres in every symbol. It is rash to assume that some meanings are inherently vague, if only because unspecifiable meanings inhere in the driest, most commonplace "informational" signs. Even so, the sign–symbol distinction is widely assumed and therefore helpful when it comes to assessing our reactions to artifacts. Zosimos's "formula" is partly made of signs and partly of symbols, and the quotient of symbols increases rapidly as we move away from potentially legible scripts and toward more problematic examples.

In mnemonic pseudowriting signs are often strongly pictorial and can have an unevenness about them that tends to put off any concerted attempt at reading. Taking the temperature of Zosimos's formula, I conclude it cannot be read, at least not all in one go, at one level or "temperature." Yet the distinction between mnemonic and ordinary scripts is fragile, and depends more on how complex we want to allow a single sign to be. Would we still want to call a script "writing" if each character stood for a verse, a ritual, an entire narrative, or even — if it is a "symbol" in Langer's sense — an accumulation of inchoate and unspoken ideas? This is another road from writing to pictures. On the one hand, there is normal, full writing, in which each sign stands for one determinate thing (as linguists put it, each morpheme denotes a sememe). On the other, there is picturing, in which each sign might be entirely beyond semantic control.

The point I am aiming at here is the collusion between strongly pictorial, deliberately mystical, and definitively illegible asyntactic pseudowriting and our ordinary sense of pictures. The farther we travel from full writing, the more our responses coincide with common reactions to pictures. Some "written" images look as if they might become pictures; others behave like pictures, signifying in all sorts of unstable ways. It seems to me that fine art shares many properties with defective writing. As often as not, I would prefer to see Western paintings as examples of asyntactic pseudowriting, or as subgraphemics or hypographemics (the subjects of the next chapters). The comparisons are far-flung, but they bring out the deeper cultural affinities of some modern painting, and they reconnect images of very different kinds that elicit similar responses.

PROTOWRITING IN EGYPT AND CHINA

I have been deliberately choosing relatively isolated, "artificial" examples in order to be able to explore more or less well-defined levels of disorganization. From these examples it might seem as

26. Suzanne K. Langer, *Philosophy in a New Key* (Cambridge, Mass.: Harvard University Press, 1960), 31–43, cited in this context in Denise Schmandt-Besserat, *Before Writing*, 157n2.

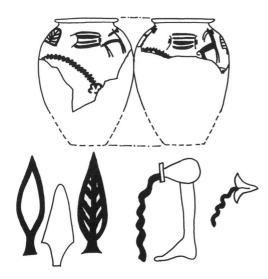

PLATE 9.7 Top: *Fragmentary predynastic pot from Deir Tasa.* Bottom, left to right: *hieroglyphs for "tree," "libation," and "vomit."*

if syntactic pseudowriting gives way to asyntactic pseudowriting, which eventually weakens and yields to "pure" pictures. What actually happened during the earliest, most "pictorial" stages of the major scripts is much less clear. Many writing systems suddenly entered the historical record more or less fully formed, and their only antecedents were loose traditions of scattered, nonuniform, and obviously unformatted symbols or marks that are normally taken to be decorative. Two examples of historical scripts can suggest the conceptual disarray of the field, and the difficulty of pressing "upward" from the most pictorial pseudowriting writing (see Table 9.1) to the "pure" or "mere" pictures at the top (see Table 8.1).

In Egypt, writing developed with great speed, so that isolated signs became recognizable hieroglyphic sentences within two or three generations, centering on 3020 B.C.E. The iconographic profusion in the century before the inception of writing might be regarded as picturing or pseudowriting, or some twilight combination such as prewriting (a practice antecedent to writing but not directly leading into it) or protowriting (a practice visibly congealing into writing). A potsherd from Deir Tasa is typical of the tantalizing similarities that occur between "decoration" and what appears to be pre- or protowriting: It depicts several forms, apparently distinct from one another (Plate 9.7, top).[27] The form at the upper left resembles later

hieroglyphs for *tree* (*lower left*), and a form just below it has been said to resemble hieroglyphs for both *libation* and *vomit* (*lower center, lower right*). (Notice the liplike shapes at the end of the stream on the potsherd.) A theory about the connection between these signs and hieroglyphic script has been skeptically received, because it fails to demonstrate direct connections. The usual linguistic stance is to disallow predynastic signs as protowriting and to treat them instead as a cultural milieu out of which writing developed (that is, as an iconographic practice or a kind of prewriting).[28] But the line between pre- and protowriting can shift very easily.

Plate 9.8 samples scorpion images on predynastic Egyptian and Near Eastern objects, comparing them with early dynastic hieroglyphs and cuneiform. Godfrey Driver offers the image at top left as "courting scorpions from nature" in order to help show that the other examples are reduced for use as iconic signs.[29] But the "naturalistic" pair is already schematized, and short steps lead from it to the "courting scorpions" in cylinder seals (*top rows*). Some of these images are Egyptian hieroglyphs, associated with the Scorpion King, a predecessor of King Narmer. Others are isolated predynastic signs on pots.[30] At the bottom are cuneiform scorpions and their prewriting predecessors. In epigraphic terms, I have mingled writing, protowriting, and

27. See William S. Arnett, *The Predynastic Origin of Egyptian Hieroglyphics: Evidence for the Development of Rudimentary Forms of Hieroglyphs in Upper Egypt in the Fourth Millenium B.C.* (Washington, D.C.: University Press of America, 1982), plate II. The original publication is Guy Brunton, *Mostagedda and the Tasian Culture,* British Museum Expedition to Middle Egypt, First and Second Years, 1928 and 1929 (London: British Museum, 1937).

28. For the theory that such signs are protowriting, see Arnett, *The Predynastic Origin.* Signs closer to writing are discussed in Bruce Williams, *Decorated Pottery and the Art of Naqada III: A Documentary Essay,* Münschner Ägyptologische Studien, vol. 45 (Munich: Deutscher Kunstverlag, 1988), and Günter Dreyer, "A Hundred Years at Abydos," *Egyptian Archaeology* 3 (1993): 10–12. I thank Emily Teeter for the last two references; and see also Pascal Vernus, "La Naissance de l'écriture dans l'Égypt ancienne," *Archéo-Nil* 3 (1993): 75–108.

29. Driver, *Semitic Writing: From Pictograph to Alphabet,* rev. ed., ed. S. A. Hopkins (London: Oxford University Press, 1976), 48, following P. Toscanne, "Sur la figuration et le symbole du scorpion," *Revue d'Assyriologie et d'Archéologie orientale* (Paris) 14 (1917): 191, fig. 56.

30. For these see Arnett, *Predynastic Origin,* 17.

prewriting from disparate contexts.[31] But I do so in order to stress the variably naturalistic and symbolic qualities of the building blocks of Egyptian. The analysis of written language properly begins where images aggregate and develop syntax; in pictorial terms, however, there is no difference between this collection and Konrad Haebler's page of M's (see Plate 5.6). No image is purely or perfectly naturalistic, especially in these historical contexts, and writing can begin anywhere.

In China the predynastic material is separated by up to 1,000 years from the first attested writing, and so it is historically unlikely to have been writing's direct precursor. Instead it raises the possibility that Chinese might have been built by stages from collections of signs into prewriting, protowriting, and writing proper. The earliest signs are neolithic pottery marks in simple shapes such as |, ||||, T, Y, X, ∧, and ∨, as well as swastikas, hexagons, Greek crosses, and "wheels," "fields," and "plants" (Plate 9.9). Most such pottery marks come from either the Yang shao culture (4800–4200 B.C.E.) or the much later Ma chia yao culture (ca. 2700–2000 B.C.E.).[32] Several scholars have tried to link such potters' marks with simple characters and numbers, but their suppositions have not been widely accepted: The forms, after all, are rudimentary and nearly universal.[33]

A second category of signs is the more elaborate shapes that stand alone on vessels (Plate 9.10).[34] Chronologically, if not culturally, they overlap the first category, with dates ranging from 4300 to 1900 B.C.E. Because they are much larger in proportion to the vessels than the simple neolithic marks, they do not seem to be simple signs — instead they look like decorations, emblems, insignia, or even symbolic pictures.

Third are dynastic Yin and Shang "emblems," although in a typical equivocation, they are also called "simple signs, designs, or pictures."[35] Before the fourteenth century B.C. they appear alone on the bottom of bronze vessels. In William Boltz's words, the theory would then be that "there must have come a moment when someone recognized a relation between the drawing of a clan emblem and the *name* of the clan, and fixed an association of graph with word."[36] That possibility, which strictly follows the Enlightenment sequence from ideograph to phonograph, is a plausible historical scenario, but it depends on the assumption that the

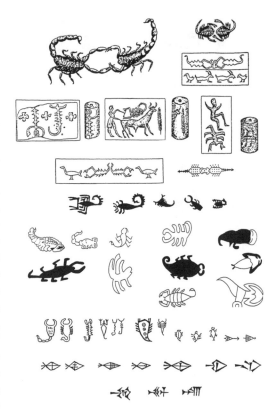

PLATE 9.8 *Representation of scorpions.*

isolated signs did not already have phonetic values. And *that* assumption derives from the idea that picturelike signs are semasiographic and not glottographic, simply because they are pictorial.

31. Although there is also a tradition of such heuristic collections; see Arnett, Toscanne, and Driver, and also E. Douglas Van Buren, "The Scorpion in Mesopotamian Art and Religion," *Archiv für Orientalforschung* 12 (1937–39): 1–28.

32. Hsi-kuei Ch'iu, "Han tzŭ hsing ch'eng wen t'i ch'u t'an so," *Chung kuo yü wen* 3 (1978): 162–71; Kwong-yue Cheung, "Recent Archaeological Evidence Relating to the Origin of Chinese Characters," translated by Noel Barnard, in *The Origins of Chinese Civilization,* ed. David Keightley (Berkeley: University of California Press, 1983), 327–29; and further Keightley, *Sources of Shang History* (Berkeley: University of California Press, 1983).

33. Ho Ping-ti, *The Cradle of the East* (Chicago: University of Chicago Press, 1975); for other citations see William Boltz, "Early Chinese Writing," *World Archaeology* 17, no. 3 (1986): 420–35, esp. 430.

34. Cheung, "Recent Archaeological Evidence," 327–29; Ch'iu, "Han tzŭ hsing ch'eng," 165; and Boltz, "Early Chinese Writing," 433.

35. Léon Long-Yien Chang and Peter Miller, *Four Thousand Years of Chinese Calligraphy* (Chicago: University of Chicago Press, 1990), 386.

36. Boltz, "Early Chinese Writing," 434.

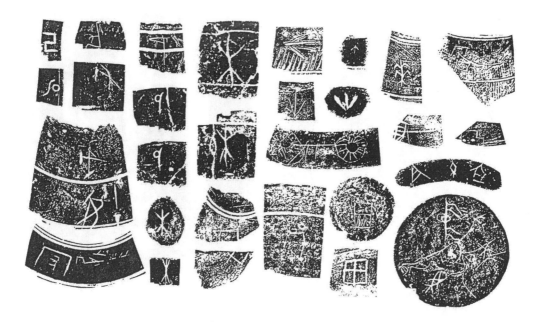

PLATE 9.9 *Samples of predynastic Chinese pottery marks.*

In the fourth stage, the "emblems"— considered to be semasiographic and largely pictorial — are accompanied by legible characters. In Plate 9.11, the "clan insignia" of two snakes is followed by a legible character for "Father Ting." Léon Long-Yien Chang and Peter Miller point out that "Father Ting" is actually a hand holding a scepter and a *ting* vessel (a kind of bronze vessel); hence the character is just as pictorial as the snakes.[37]

The fifth and last stage occurs when the "emblems" fall out of use and inscriptions are comprised wholly of legible characters.[38] Chang and Miller reproduce an early example that reads *kuan,* or "to cleanse the fingers" (Plate 9.12). They point out that it is possible to see a small vessel at the top of the inscription, which is pouring water over two hands (*top left* and *right*). The water pours down in three vertical lines and is collected in a larger vessel at the bottom. The authors urge readers to *read* the inscription, not merely *look* at it: "Although one is not required to read Chinese to appreciate it as an art form, in this case, a reading of the inscription is helpful, since it may otherwise appear as an illegible picture."[39] The assertion is a paradox: It appears as a *legible* picture without any knowledge of Chinese, and conversely, knowledge of the Chinese word *kuan* adds nothing to the appreciation of the image.[40] Early examples like this are very close to the picture-writing that

was also practiced in Siberia, America, and Australia, as we will see in the next chapter.

Which of these "stages," if we arrange them this way, should be called the inception of prewriting? And where does it begin to make sense to speak of protowriting, where developments lead more or less directly into the earliest written forms? The fourth stage appears to be clearly on its way to writing, but also quite different from writing — as if it included writing as one of two graphic possibilities along with clan insignia. The most entrancing question, the one that seems to cause the greatest conceptual difficulty, is the nature of the isolated signs. The second stage of Chinese characters,

37. Chang and Miller, *Four Thousand Years,* 389.

38. See *Mou Kun Ting, A Chinese Imperial Document of 3,000 Years Ago,* John Way's Calligraphy Series (Hong Kong: s.n., 1981).

39. Chang and Miller, *Four Thousand Years,* 390.

40. Many representations in the early script remain unexplained. What, for example, is the *ya,* the rectangular frame that surrounds some of the earliest clan names? It has been observed by William Boltz and others that the *ya* resembles Egyptian cartouches, and like cartouches, it has more than a passing similarity to the characters it encloses. But writing and pictures are so close here that a distinction might have no conceptual purchase. *Ya* is named after the modern character *ya* and has nothing to do with ancient meaning or usage. Nor does it resemble the modern character except that both enclose a central region. Boltz, "Early Chinese Writing," 421.

PLATE 9.10 *Painted sign on a flat-backed* hu *vase.*
Middle Ta-wen-k'ou period, ca. 3500–2500 B.C.E.
Pao-t'ou-ts'un, Ning-yang, Shantung.

PLATE 9.11 *The characters "Father Ting." Rubbing*
from a bronze ting *vessel.*

which I exemplified by the *hu* vase, presents severe problems for observers intent on classifying what they see into Western categories. William Boltz calls the sign on the *hu* vase "an emblem or ensign, one is tempted to say a 'hallmark'"; and on the same page he also refers to it as a "graph" and an "emblem-type character." Such signs, he thinks, are "not part of a 'text' of any sort" but are "insignia or emblem-type graphs" or "pictographs." They are similar to the later Shang "clan name" emblems, which in turn resemble "coat[s] of arms" and "heraldic emblem[s]."[41] Emblem, ensign, graph, insignia, pictograph, coat of arms, or heraldic emblem? The uncertain nomenclature is typical of the field; a reasonable approach might be to start by acknowledging the confusion of our accustomed categories. In these early Chinese examples, pictorial signs have not become characters, but the two interact and produce what physicists call a "jet" of other terms — emblems, pictographs, ensigns, hallmarks, hieroglyphs, symbols — a sure sign that we are near the realm of pictures.

FROM PSEUDOWRITING TO SUBGRAPHEMICS

Before the advent of photography, the two fifth century C.E. golden horns — one with runes, the other known as the "runeless golden horn" — had

been melted down (Plate 9.13).[42] Luckily, impressions had been taken of both, and so today we have the golden horns in the form of what engineering draftsmen call "generations" or "developments": The bands are unrolled so that they look more like lines of text. The originals curved, so that reading — if that is what was involved — was trickier than it appears from the flat transcriptions. (The half-flattened engraving is an attempt to have the best of both worlds.) Perhaps the horns were originally inspected by looking round and round, from top to bottom, or perhaps from the bottom up; either way the sequence could have yielded a set of visual episodes or a text.

The runic golden horn (*left*) had a flange of runes that has been translated as "I, Lægæst, son of Holt, made this horn."[43] (The inscription is in

41. Ibid., 433–34.

42. See Lis Jacobsen and Erik Moltke, *Danmarks Runeind-skrifter,* 2 vols. (Copenhagen: Ejnar Munksgaard, 1942), vol. 1, cols. 24–37, and George Stephens, *Handbook of the Old-Northern Runic Monuments of Scandinavia and England* (London: Williams & Norgate, 1884). For the influence of the golden horns on the movement away from Ossianic verse, see John Greenway, *The Golden Horns, Mythic Imagination, and the Nordic Past* (Atlanta: University of Georgia Press, 1977).

43. The transliteration is "ekhlewagastiR | holtijaR | horna | tawido." See Jacobsen and Moltke, *Danmarks Rune-indskrifter,* col. 31. I thank Thomas Sloan for translation from

PLATE 9.12 *The characters* kuan, *"to cleanse the fingers." Rubbing from a bronze vessel.*

early-fifth-century Old Norse; Holt is a woodland and harvest goddess, also known as Yngi, Holt-Ingi, Yngvi, Frea, and Fray.) No matter how we choose to describe Echlew's significance, such a horn could not have been a routine gift. But it is enough to tell us that the giver and the recipient are known, and to set up a narrative of ritual. We expect to see the "runeless" portion of the horn play out a drama of danger, propitiation, acceptance, or perhaps projected good. The runes, in short, put us in a narrative mood.

The majority of modern scholarship on the horn has concentrated on the runic inscription, and no one has convincingly read the images or what appear to be pictorial runes on the top register of the second golden horn. It has been suggested that the images show a primordial battle between two brothers, one good and the other evil, and there have been several outlandish interpretations connecting the runes to such things as Egyptian and Islamic astrology.[44] Among the obstacles that stand in the way of reading the runeless

horn is a lack of certainty about the order in which the signs are to be read. Some appear to conform to the right-left order of runic inscriptions, and others seem to congregate into little episodes of a visual narrative. That is the essential distinction between pseudowriting and subgraphemics: In the latter, the organization of the signs is in doubt. Each of the examples in this chapter, including the pseudowriting on the flange of the runeless horn, is fairly orderly and linear. The second register of the runic golden horn is substantially more confused: It might be several rows of signs, or a series of episodes, or one large scene. The ambiguity is enough to stop reading in its tracks.

Several kinds of visual artifacts hover on this boundary between well-formatted "writing" and apparently unformatted "pictures." Aztec and Mixtec codices are pseudowriting, as they are not full scripts; they are also subgraphemic in that they mix pictorial and written formatting. Mixtec codices have red register lines to guide "readers" through the manuscript. On either side of the reading path there are narrative pictures, but also glyphs denoting places and dates, and the two exist in various combinations.[45] Other Mesoamerican images are even less like pseudowriting. The frescoes at Teotihuacán are fundamentally pictures, although some have signs in "breath scrolls" or in streams of water; it is possible that they had mean-

the Danish. Klaus Düwel, *Runenkunde,* 2d ed. (Stuttgart: J. B. Metzler, 1983), 28, translates the text as "Ich Leugast [Gast des Ruhms] Sohn [besser: Nachkomme] des Holte machte das Horn." There have been many attempts at translating the inscription, largely because the horns have been culturally contested objects since they were discovered. See, for example, *Jacob Grimm, Kleinere Schriften* (Berlin: Ferd. Dümmler, 1884), vol. 4, 191–93.

44. H. Schneider, *Die Felszeichnungen von Bohuslän, das Grab von Kivic, die goldhörner von Gallehus und der Silberkessel von Gundestrup als Denkmäler der vorgeschichtlichen Sonnenreligion. Ein Deutungsversuch* (Halle: Gebauer-Schwetschke, 1918), 18–33. For Islamic and Egyptian sources, see Willy Hartner, *Die Goldhörner von Gallehus* (Wiesbaden: Franz Steiner Verlag, 1969), which is convincingly demolished by Ralph Elliott in *Medium Ævum* 40, no. 2(1971): 176–79. I thank Ralph Elliott for a reading of my interpretation, and for drawing my attention to Hartner's book.

45. For Mixtec codices, see Nancy Troike, "Pre-Hispanic Pictorial Communication: The Codex System of the Mixtec of Oaxaca, Mexico," *Visible Language* 24, no. 1 (1990): 75–87, with a bibliography of facsimiles of the six codices.

PLATE 9.13 *The runic and runeless golden horns. Early fifth century* C.E. *Discovered in 1639 and 1734 near Gallehus, Tønder amt, Sønderjylland, Denmark, and destroyed in 1802; formerly Copenhagen, Royal Art Museum.*

ing and were read, but they might also have simply denoted "speaking," "fertility," or other abstract senses already implied by the pictures.[46] The current split in Mesoamerican studies between scholars who decipher inscriptions and those who do not makes it especially hard to appreciate civilizations such as Teotihuacán, which had contact with literate cultures (specifically at Tikal) but chose not to adopt writing.[47] Are the frescoes at Teotihuacán pictures, or indistinguishably pictures-and-elements-of-writing, or pictures with "embedded text"?[48] Or are they — very much in the

46. For Teotihuacán, see Esther Pasztory, "Abstraction and Utopian Vision at Teotihuacán," in *The Art and Polity of Teotihuacán*, ed. Janet Berlo, (Washington, D.C.: Dumbarton Oaks, 1989); Pasztory, "A Reinterpretation of Teotihuacán and Its Mural Painting Tradition," in *Feathered Serpents and Flowering Trees: Reconstructing the Murals of Teotihuacán*, ed. Kathleen Berrin (San Francisco: Fine Arts Museum of San Francisco, 1988), 45–77; James Langley, "The Forms and Usage of Notation at Teotihuacán," *Ancient Mesoamerica* 2 (1991): 285–98, identifies 150 signs.

47. I thank Bruno Schultz for the reference to Tikal, and Tom Cummings for conversations on the possibility that the rulers at Teotihuacán might have intentionally avoided writing. For Pasztory's orientation, see "Still Invisible: The Problem of the Aesthetics of Abstraction for Pre-Columbian Art and Its Implications for Other Cultures," *Res* 19–20 (1990–91): 105–36, and my "The Question of the Body in Mesoamerican Art," *Res* 26 (1994): 113–24.

48. For the notion that "pictographic and ideographic image-signs" are "not distinguishable" from figures, see Marvin Chodas, "The Epiclassic Problem: A Review and Alternative Model," in *Mesoamerica after the Decline of Teotihuacán, A.D. 700–900*, ed. Richard Diehl and Janet Berlo

modern Western sense — pictures that retain a feeling of writing?

The upper registers of the runeless golden horn look like pictures, but the lower registers — where there is less space, and figures are squeezed into an orderly procession — look more writinglike. Certainly the three-headed ogre in the third register of the runic horn is part of a writinglike sequence that includes the archer, the suckling animal, and the suckling snake; but it is also swimming in a field of stars and plants, where animals float by, and a fish pecks at the head of a bird. When my eye begins to wander, when I start to feel the freedom of a picture, then I am no longer in the realm of pseudowriting.

We are very close here to the top level of Table 9.1. There are only two steps left in the deliquescence of writing: the subgraphemic deconstruction of syntax, and the hypographemic merging of every sign into a single jelled image.

(Washington, D.C.: Dumbarton Oaks Research Library, 1989), 219. For the notion of "embedded text," see Janet Berlo, "Early Writing in Central Mexico: *In Tlilli, In Tlapalli* before A.D. 1000," in *Mesoamerica after the Decline,* 19. See further Oriana Baddeley, "The Relationship of Ancient American Writing Systems in the Visual Arts," in *Text and Image in Precolumbian Art,* ed. Janet Berlo, B.A.R. International Series, no. 180 (Oxford: B.A.R., 1983), 55–77; Janet Berlo, "Conceptual Categories for the Study of Texts and Images in Mesoamerica," in *Text and Image,* 1–39; Karen Bessie-Sweet, *From the Mouth of the Dark Cave: Commemorative Sculpture of the Late Classic Maya* (Norman: University of Oklahoma Press, 1991), esp. chap. 2, "The Relationship Between Text and Image"; and William Hanks, "Word and Image in a Semiotic Perspective," in *Word and Image in Maya Culture,* ed. Hanks and Don Rice (Salt Lake City: University of Utah Press, 1989), 8–21.

10 : Subgraphemics

seudowriting ends at the border of a new realm, infinitesimally close to "pure" pictures yet decisively removed from them. Subgraphemic images have clear signs — well-distinguished one from the next — but the signs fail to show any clear order or arrangement, and so it is impossible to know how they might be read. So far I have been considering artifacts in which the signs do more than repeat or alternate (so that they have

a clear order but not a mechanical or "decorative" one) and in which they are aligned in rows, columns, or other comprehensible paths (so that one follows another). I have been using "syntax" as a ready synonym for those properties. (I take it that usage is rudimentary and self-evident, unlike the more elaborate "syntagmatic relations" that Ferdinand de Saussure studied, or Goodman's epistemological opposition of syntactics and semantics.) Things are less well-defined when it is no longer a matter of characters following one another along a line or curve, and "syntax" becomes more difficult, and more crucial.

Like *visual language, visual* or *pictorial syntax* tends to be used so loosely that it means almost nothing. In art history, *pictorial syntax* denotes a sense of order in a picture that is somehow reminiscent of the orders of written phrases or clauses. In that sense it is not unlike Vitruvius's use of "eurhythmy," meaning the subjective impression of proportional order in a building, regardless of whether the building might prove to be disproportionate.[1] Strictly speaking, and by definition, a picture cannot have a syntax, because a picture has no fixed order of reading as a sentence does.[2] The expression *pictorial syntax* is a way of naming the persistent impression that a writinglike order is present, and although there are any number of co-

gent schemes for deducing pictorial syntax in any given instance, they always depend on some agreement about the habits of reading and the traits of writing (as I defined those terms in Chapter 9). Pseudowriting preserves enough of the formatting of a writing system (that is, the eighth of the traits of writing) to guarantee that if it were to be read, the order of reading would be tightly constrained. In such a case, it makes good sense to call the order of signs "syntax," and it's also readily apparent when a list of characters is asyntactic. In subgraphemics, the formatting is severely compromised or else it cannot be recovered, and all that remains is a vague sense of written order. When there is no sign of written formatting, and the signs are all jumbled in a rectangular field, "syntax" is a phantom, a habit of reading transferred to a new domain. Luckily, actual interpretations of objects, as opposed to theorizing in linguistics and visual theory, do not demand rigor: What counts is the impression of written order. Throughout this chapter I investigate traces of syntax in images that

1. For an account of the meanings of eurhythmy, see Elkins (1998).

2. "Orders of reading" are discussed in my "On the Impossibility of Stories: The Anti-Narrative and Non-Narrative Impulse in Modern Painting," *Word and Image* 7, no. 4 (1991): 348–64, revised in Elkins (1999b).

TABLE 10.1. *Kinds of Subgraphemics*

"Pure pictures"		
Subgraphemics: pictures comprised of asyntactic signs	Pseudo–picture-writing: Pictures with some legible signs and some hypograms	The Narmer Palette; seventeenth-century mystical diagrams; some modern painting (e.g., Julian Schnabel)
	Picture-writing: Pictures whose signs can be read as sentences or narratives	Aboriginal paintings; Yukaghir messages; most Western narrative painting (e.g., Giotto)

no longer possess it. What counts is the lingering sense that syntax might be present, and that has been enough to drive many fruitful art-historical inquiries into paintings.

Not much of use can be said about the kinds of subgraphemics, although in Table 10.1 I distinguish between those that have a preponderance of disjoint signs and those that have disjoint signs afloat in a wash of nondisjoint signs.

The species of subgraphemics I propose here are certainly subject to adjustment. Picture-writing is not an especially evocative term, but it has the advantage of being recognized as a Library of Congress catalog heading. Other attempts to classify such images have depended too much on the distinction between pictographs and ideographs, or on the importance of legibility. Marcel Cohen, for example, proposes "la protoécriture" for pictographic scripts but then uses "picto-ideographic" to denote Native American picture-writing.[3] The best approach is to be circumspect, to favor neutral terms, and not to rush too quickly into reading, looking, or decipherment. Any category that includes both obscure "tribal" artifacts and central instances of Western fine art has to be handled carefully; but at the least, the reward for conceiving Yukaghir picture-writing together with modern painting is a sense of art history's ongoing preference for pictures that don't behave, that don't quite show themselves as logical structures, or show themselves as alogical fields of marks. Subgraphemics are a signal case of Goodman's hope for pictures — that they might be notational and make systematic sense — and the particular obstacles they present are endemic in the history and criticism of fine art.

At this point I can set out the general contours of our journey from writing to pictures: The sequence leads "upward" from noniconic characters (glottographs) through iconic ones (semasiographs), and on to incomplete writing systems (pseudowriting) and images that lack syntax (subgraphemics). The tables in this text expanding on each could be laid end to end, producing a single long graphic. In the next chapter I will insert a final wedge between "pure pictures" and images still slightly tainted with writing: hypographemics, the study of images that appear to be entirely made up of "fused," nondisjoint signs.

ALASKAN, YOLNGU, AND YUKAGHIR PICTURE-WRITING

There are a number of relatively recent, non-Western examples of picture-writing. They are seldom studied, and I want to begin by surveying a few in order to show how pictures have been used as writing in various cultures. An image from southern Alaska, collected in 1882, looks at first like a picture — two figures in a landscape, with a hut or a hill (Plate 10.1).[4] But it is also a sentence, or rather two sentences. It denotes something like "The occupants of this dwelling are not here. They had to leave to get something to eat." The figure on the left signifies that there is nothing to eat by spreading his arms wide, and the companion figure signifies eating and also points to the hut, where

3. Marcel Samuel Raphaël Cohen, *La Grande Invention de l'écriture et son évolution* (Paris: Imprimerie Nationale, 1958). Cohen also calls Chinese writing "ideophonographic" and Egyptian "ideographic": categories that are too simple to adequately describe the differences between those systems.

4. Mallery (1892), 353, and compare 333. The image is repeated in Jensen (1969), fig. 26; and see further Alfred Schmitt, *Die Alaska-Schrift und ihre Schriftgeschichtliche Bedeutung*, Münstersche Forschungen, vol. 4. (Marburg: Simons Verlag, 1951).

TABLE 10.2. *Summary of Tables 8.1 through 11.1*

"Pure pictures"	Table 11.1
hypographemics	
subgraphemics	Table 10.1
pseudowriting	Table 9.1
semasiography	
glottographics	Table 8.1
"pure (alphabetic) writing"	

there is no food. It is almost possible to read the image from right to left, as if it were a semasiographic script and the landscape were a register line. In English the result is awkward but not incomprehensible: "In hut [rightmost image] this [pointing arm of the right-hand figure], there is to eat [the other arm of the same figure] nothing [left-hand figure], so we have gone [since the pointed forms at the left are the helms and sterns of canoes]." Even if the grammar might sound more natural in an Alaskan language, the image itself ensures that such a reading cannot be the only one. It might be a sentence, but it is also a naturalistic picture, showing a stretch of land or ice and two figures, and so the picture itself functions as a pointing device. According to Garrick Mallery, who collected the image from an Alaskan named Naumoff, it would be carved or drawn on wood and placed either on the outside of a dwelling, on a trail, or close to the landing place where visiting canoeists would see it. In each case the picture would incline in the direction of the hut, so that visitors could at least get shelter there.

The image therefore combines three functions: It is a picture, naturalistic enough so that visitors could match the depicted hut with one they would presumably see in the distance; it is writing; and it is a sign signifying direction (as it inclines or points toward the actual hut). A full interpretation of such an image involves both reading and looking, the one adjusting and complementing the other. Although it is not easy to make a plausible reconstruction of the act of viewing, I imagine a visitor reading the sign and then comparing the picture it presents to the surroundings, and taking the sign's orientation as a clue. The picture would check the reading rather than adding ambiguity, as we might be inclined to say of a narrative painting.

The Alaskan image is a sentencelike scene — or, because everything is reversible here, a scenelike sentence. It looks deceptively familiar because it has the left-right or right-left order of reading typical of Western scripts. Other instances of picture-writing are less writinglike and more akin to Western paintings. Australian acrylic "paintings," for example, are often picture-writing in disguise. Plate 3.11, the Yolngu painting I introduced in Chapter 3, might appear abstract to a modern Western viewer, but to its intended public (or its original public, as many such images are made-to-order) it is a legible narrative scene. In Howard Morphy's explanation, the painting depicts a landscape, north of Blue Mud Bay in Arnhem Land, where an ancestral woman named Ganydjalala once searched for honey in "stringy bark" trees.[5] The trees she chopped down are the two vertical strips marked *b* in the diagram. By cutting them down she created ceremonial grounds (*molk*), which are the regions *a* between and around the trees. The cross-hatching represents "bees, larvae within the hive[s] and dust thrown up by the feet of the dancers" who celebrate and remember Ganydjalala's hunt. The cross bars (*f*) are ceremonial *djuwany* posts set up in the *molk,* and they are also manifestations of Ganydjalala herself, because she transformed herself into post figures in various places. A Western viewer might well be confused by the insouciant naturalism of the scene. The image is generally a view from above, showing two felled trees and their surrounding ground, but only one of the trees has a central line down its middle, and it shares that trait with the right-hand part of the *molk*. It is easier, almost, to see each vertical line as a tree.

Part of the denotational confusion comes from the painting's dual reference, as it also represents a stone spearhead quarry at Ngilipitji. From that perspective the rectangles at *c* represent stones that have been split down the middle, and the hatching inside them (which is a different color from that of

5. Morphy, "Too Many Meanings: An Analysis of the Artistic System of the Yolngu of Northeast Arnhem Land," Ph.D. diss., Australian National University, 1977, caption to plate 55, p. 64, and his *Ancestral Connections: Art and an Aboriginal System of Knowledge* (Chicago: University of Chicago Press, 1991).

PLATE 10.1 *Naumoff (n.i.). Picture-writing of starving hunters. 1882. Southern Alaskan, example collected in California.*

the surrounding design) represents piles of stone spearheads. After they were cut, the stones were moved to the edge of the quarry, where they are represented by the split-stone tables at *d* and also by red and white hatching at *e*. And there is a third level of representation as well: *c* and *d* also represent kangaroos that have been killed and laid out, fur side up; their backbones are the black midlines of the rectangles.

There is a large repertoire of Aboriginal paintings that has been described using numbered and lettered diagrams like the one I reproduce here.[6] In the majority of cases, the stories that result are very satisfying, because they name parts of the picture that immediately make spatial sense. In Central Australian painting, curved C shapes denote people, and concentric rings mean campfires. Yolngu painting can be different in its imbricated narrative and spatial references, and it can tell several stories in several ways. As Morphy points out, the image's overall "brilliance" (*bir'yun*) also works against any given reading, because the bees, larvae, dust, spearheads, and kangaroos are also just dazzling shapes. In his view, geometric painting can demonstrate connections between apparently unrelated events: "Figurative relations," he says, "are easily interpretable but obscure significant relations between things. Geometric representations, on the other hand, are initially difficult to interpret and obscure specific meanings but encode significant relationships."[7] Or, in terms of notation and picturing, the image is partly a map (or rather several translucent maps, laid over one another) and partly a naturalistic picture of the site after Ganydjalala left. In context, it would give rise to a fairly determinate narrative, and in that sense it is also writinglike.

Another example that blends writing, pictures, and notation is the remarkable wood engravings made earlier in this century by the Yukaghir in northeastern Siberia. Seeing them, we might think at first of trees in the Siberian forest, or of folded umbrellas (Plate 10.2). But they are love stories, made by women because they were prohibited from speaking their feelings. According to the Yukaghir pictorial conventions, women are the slightly wider "umbrellas," and men the thinner ones. Some female figures are also identified by their braids (as in Plate 10.2, *left,* at *tv*). Each figure has two legs, represented by close-cut parallel lines, and two arms, which come down at a steep angle from the pointed head. I. P. Al'kora, who published the only account of these drawings in 1934, says that the tiny transverse lines between the legs indicate feet, knees, and thigh bones, and that the higher lines stand for the belly, chest, neck, and head.[8] But the lines are not consistently drawn, and those few vestiges of naturalism do not seem to have mattered. The figures are almost purely nonnaturalistic and only weakly semasiographic.

The main point of most of the Yukaghir drawings is to depict a relationship. The inverted frames

6. For example, Peter Sutton, "Responding to Abstract Art," in *Dreamings: The Art of Aboriginal Australia,* ed. Peter Sutton (New York: George Braziller, 1988), 33–58; Ted Strehlow, "The Art of Circle, Line, and Square," in *Australian Aboriginal Art,* ed. Ronald Berndt (New York: Macmillan, 1964), 44–59.

7. Morphy, "Too Many Meanings," 329 and 345. See further Morphy, "Aboriginal Art in a Global Context," in *Worlds Apart: Modernity through the Prism of the Local,* ed. Daniel Miller (London: Routledge, 1995), 211–39. I thank Howard Morphy for a reading of my comments on Aboriginal art.

8. Al'kora, *Iazyki i pis'mennost' narodov severa,* Leningrad, Institut Narodov Severa, Trudy po Lingvistike, Nauchno-issledovatel'skaia assotsiatsiia (Moscow: Gos. Uchebno-pedagog., 1934), vol. 3, 149–80, esp. 155. In the series Institut Naredov Severa (Leningrad), Nauchno-issledovatel'skaia assotsiatsiia. I thank Marc Komdanayats for preparing a translation.

over the figures in Plate 10.2 are houses, and the network of lines connecting the figures in the left image denotes their "reciprocal love." Al'kora did not collect information about the interpretation of individual lines such as *t'v'*, *y*, *s*, or *r*, but he transcribes their collective meaning as "I love you with all the strength of my soul."[9] The curved lines that spring from the top of the male figure at *ji*, and the similar line that Al'kora traces from the female figure at *hg*, are feelings that "reach out" toward the other person, in this case to bring the two closer together.

The image on the left of Plate 10.2 represents perfect love, and the one on the right recounts a tragedy. The sign for unhappiness is the thick X that binds the top of a figure to its house, and here the female figure on the right, who also engraved the original design, expresses her unhappiness at what is about to happen to her. The image is addressed to the man labeled as *b*, who has gone to live with another woman, labeled *a*, and her two children, given by the smaller figures at the left. (The new woman is Russian, not Yukaghir, as shown by her Russian dress.) The connections between figures make the drama plain: Although the woman still loves the man (as indicated by the "reciprocal love" lines at *rs* and *tu*), he only loves his Russian wife (as shown by the lines at *vk*). There are also curved lines that "reach out" between the figures: The man still has some thoughts for the wronged woman, because curved lines at *kl* and *mn* reach through to her, but his Russian wife is blocking what is left of their relationship, as shown by the long curved line that begins at *vx* and cuts down between the two houses. A third kind of line is also present in this drawing, which Al'kora says "carries the idea of wandering, chasing thoughts": The woman's thoughts try to follow her beloved at *d'* but dissolve before they reach him. (The shape of "wandering, chasing thoughts" is very like a cloud of stream disappearing into the air, but Al'kora offers no pictorial interpretation.) At the far right, a man who lives nearby also has "chasing thoughts" for the woman who engraved this picture, but they do not reach her.

Al'kora offers the following transcription of the entire image: "You will find out (*b*) that you will fall in love with the Russian woman (*a*), who will block your path back to me (*c*); you will have children and enjoy family life. But I, forever sad, will think of you, even though I have a person nearby (*d*) who loves me."[10]

Very little in the Yukaghir images is nonsemiotic. Al'kora says that "neither a high degree of finish, nor the amount of ornament add anything to the meaning of the thoughts and feelings manifested in the design," and although his certainty on that point depends on the reliability of his informants, it tallies with the general absence of pictorial conventions.[11] Almost everything in the pictures can be read, except for a few naturalistic details such as the stepped construction of the houses or the shape of the Russian woman's skirt. A number of "reciprocating love" lines go uninterpreted, but it is entirely possible that their meanings were private or evanescent; they might have evolved as the women thought and drew at the same time. Even if each line and diagonal never had its own meaning, the entire cat's cradle is an efficient sign of emotional complexity.

Some elements seem arbitrary, as if they were allographic choices: Houses can be any thickness, and so can the sad X's; and the engravers often forgot to give figures knees, thighs, bellies, or hands. On the other hand, the scenes have a persistently naturalistic look. Once they are interpreted, they can appear as diagrammatic reductions of naturalistic scenes with the houses cut into cross-sections. The Russian woman's house is truncated, Al'kora says, because it is either "abandoned or about to be abandoned," but his interpretation goes against the grain of his informant's story, and a better reading would be the more naturalistic one — that the house is simply far away. Reading truncated houses as distant houses, the Yukaghir drawings have a fairly consistent, if strongly abbreviated, sense of space. Nor is it irrelevant that the natural form that most resembles the figures is a pine tree (ubiquitous where the Yukaghir live), so the figures are tacitly combined into landscapes.

The images are also notational, as they are diagrams of emotional attachments, and they are texts, because they tell stories that can be read in a circuitous format. This is as close as any example

9. Ibid., 155.

10. Ibid., 156. The translation in Jensen (1969) is inaccurate, as it adds the information that the speaker is alone, and that the new marriage is unhappy.

11. Ibid., 154.

PLATE 10.2 *Yukaghir picture-writing. Siberia, ca. 1930.*

I know to a fusion of notation and writing: Once the principles of interpretation are in hand, the images "read" quickly, often in a single direction (other drawings are long rows of figures), but it is also possible to see them as intricate graphics whose spatial relations have more affinities with graph theory than writing. If I look at these images for more than a minute or so, I find myself attending more to their topological relationships and trying to put meaning on the degrees of separation between figures and lines. Both reading and looking recede: I become uninterested in the pictorial nature of the images, and their texts become trite. What lingers is the feeling that the configuration itself holds even more attenuated or intimate meanings: In other words, writing and picturing slowly give way to notation.

INTRODUCTION TO PSEUDO−PICTURE-WRITING: THE NARMER PALETTE

There are at least a half-dozen other traditions of picture-writing waiting to be explored. In contemporary Jainism, the *devapuja* ritual involves drawing symbolic pictures of the soul's progress through the world, using swastikas and other forms to create a maze for the soul to follow.[12] It is unclear from the published accounts how much freedom worshipers have to design their own "map of salvation": some are fairly simple swastika-shaped designs, and others are more intricate labyrinths. The Ojibwa in Minnesota, the Cheyennes, the Sioux, and several other Native American tribes have traditions of birch bark and hide drawings that are combinations of maps, mnemonics, pseudo-writing, and enuntiagraphs.[13] The Micmac, Penobscot, Passamaquoddy, and other northeastern and

12. Collette Caillat and Ravi Kumar, *The Jain Cosmology* (Basel: Ravi Kumar, 1981), is a good introduction, and there are unique photographs in Jyotindra Jain and Eberhard Fischer, *Jaina Iconography* (Leiden: E. J. Brill, 1978). The *devapuja* is analyzed in a work-in-progress, *Things and Their Places: The Concept of Installation from Ancient Tombs to Contemporary Art.*

13. For the Ojibwa, see Walter James Hoffman, "Pictography and Shamanistic Rites of the Ojibwa," *American Anthropologist* 1 (1888): 209−29, and Mallery (1893), 338, 363, 566, 586−605, and passim. For Cheyenne picture-writing, see Mallery (1893), 363.

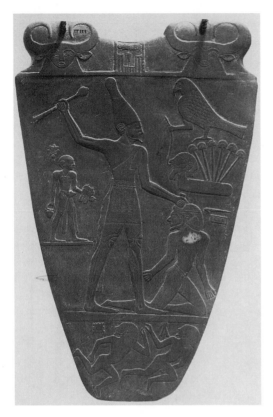

PLATE 10.3 *The Narmer palette, obverse. ca. 3000 B.C.E. Carved schist.*

Maritime tribes made mnemonic images and also symbolic maps.[14] There are also African examples: the Bambara in the Sudan made "pictures" with nonpictorial semasiographic elements.[15] It's an intriguing field, as the next step after picture-writing is a big one: It includes many if not most of the images that are normally called "pictures."

The central portion of the seal in the *Sixth and Seventh Books of Moses* and the writinglike scenes on the runeless golden horn were my first examples of subgraphemic images (see Plates 9.1 and 9.13). Looking at them is almost like watching writing melt into pictures. But not all such transitions are so easy, and writinglike passages can adhere like undissolved solids to otherwise pictorial scenes. A historically important example is the engraved Egyptian slate known as the Narmer Palette (Plate 10.3). The king's name is written in the small frame at the top center; it is traditionally given as Narmer (*N'rmr*), by reading the fish (*n'r*) and the small chisel (*mr*) below it.[16] Other small phonetic hieroglyphs scattered across the obverse name other figures. The hieroglyph behind the captive's head

is comprised of the sign for harpoon, with phonetic value *wa ʿ*, and the sign for lake or pool, *shi*. Together they spell *w ʿ-s*, so that the chieftain would be named *W ʿ-s* (or *Washi*). In Henry Fischer's alternate reading, the captive would come from the district *W ʿ-s*, meaning "Harpoon Lake" or "Harpoon Canal."[17] Either way the captive and his "label" comprise a unity of a sort that is entirely foreign to Roman scripts.

Hieroglyphic Egyptian has a pseudoalphabet (a signary of consonants with indeterminate vowels affixed), as well as signaries of biliteral and triliteral signs (signs denoting combinations of two and three consonants), and in addition it has signaries of logographic pictographs and ideographs with various functions.[18] An important class of ideographs are the determinatives, signs that help resolve potential confusions among syllabic and alphabetic spellings. A name that is female will have a special morpheme after it to signify gender, and determinatives are also used to tell the reader when a sign is to be read for its sound and when it denotes

14. Mallery (1893), 338–39, 341.

15. Marcel Griaule and Germaine Dieterlen, "Signs graphiques soudanais," *l'Homme,* Cahiers d'Ethnologie, de géographie et de linguistique, vol. 3 (Paris: Hermann et Cie, 1951), discussed in W. C. Brice, "The Principles of Non-Phonetic Writing," in *Writing without Letters,* ed. William Haas (Manchester: Manchester University Press, 1976), 29–44, esp. 41.

16. P. Kaplony, "Sechs Königsnamen der 1. Dynastie in neuer Deutung," *Orientalia Suecana* 7 (1958): 54–57.

17. The first interpretation is due to Alan Henderson Gardiner, "The Nature and Development of the Egyptian Hieroglyphic Writing," *Journal of Egyptian Archaeology* 2 (1915): 74, and Werner Kaiser, "Einige Bemerkungen zur ägyptischen Kunst," *Zeitschrift für Ägyptische sprache und Altertumskunde* 91, part 2 (1964): 89. For the second interpretation, see Henry George Fischer, "The Origin of Egpytian Hieroglyphs," in *The Origins of Writing,* ed. Wayne Senner (Lincoln: University of Nebraska Press, 1989), 60, and Peter Kaplony, "Zu den beiden Harpunenzeichen der Narmerpalette," *Zeitschrift für Ägyptische sprache und Altertumskunde* 83 (1958): 76–78. Norman Totten, "Iconography of the Narmer Palette: Origin of Egyptian Writing," *New England Social Studies Bulletin* 36, no. 1 (1978): 3–17, is a brief summary of the scholarship.

18. Besides the three phonetic signaries, other signs can function phonetically, as when a logograph is used as an acrophone (that is, taking its initial consonant only, for its phonetic value). For general theory see Kurt Sethe, *Vom Bilde zum Buchstaben: Die Entstehungsgeschichte der Schrift* (Leipzig: J. C. Hinrichs, 1939), reprinted (Hildesheim: G. Olms, 1964); and Sethe, *Das hieroglyphische Schriftsystem* (Glückstadt: J. J. Augustin, 1935).

what it resembles. Determinatives are pictures in several immediate senses. They are not *read* in the same way that adjacent signs are read; instead they are directives for reading, almost like signs in public places that begin *attention* or *caution*. As partly metalinguistic markers, they are more apt to appear *as* pictures and to be taken to represent objects in addition to what they say about the procedures of reading.

In some instances, the determinatives can spring free of the sentences and accompany them as pictures. Fischer gives the example of a hieroglyphic sentence signifying "lassoing the ibex by the hunter." In Plate 10.4, the glottographic signs that spell that phrase are at the top.[19] The three determinatives — *lasso, ibex,* and *hunter* — would normally be written as part of the hieroglyphic text itself, but in the example they leave the text and congeal as a picture below it. (Notice the signs for *lasso, ibex,* and *hunter* in Fischer's gloss at the bottom.) What remains in the hieroglyphic text at the top is phonetic information: It gives the pronunciation of the scene, and the scene supplies the meaning of the sounds. This is not the same as the Western configuration of picture and caption, although it is not easy to say what the differences are. A close equivalent is the woodcut illustrations of cities in certain early printed books, in which the same woodcut plate is used to illustrate various cities. The captions will say "Rome," "Jerusalem," or "Paris," and the buildings will remain the same. That is at least a partial parallel, because in the Egyptian example there is no way to *pronounce* the picture, and there is a mutual dependence between the two. In both examples, the configuration tilts in the direction of writing, as the pictures are more helpmates to the text than vice versa. But that is not a sufficient description of the Egyptian example, because the whole image is also a sentence. The hieroglyphic phrase at the top is a simple nominal predicate: It can only mean "[the action of] lassooing the /an ibex by the /a hunter."[20] The picture is more diffuse, and it could denote "The hunter lassoed the ibex," "Let the hunter lasso the ibex," and so forth. (It is, in other words, an enuntiagraph.) So are we to say that the "picture" is a sentence lacking mood and tense? This is also insufficient, for the specific reason that the "caption" also lacks mood and tense. In Egyptian, context normally decides those variables, because vowels are

PLATE 10.4 *Hieroglyphic Egyptian for "lassoing the ibex by the hunter."* Bottom: *written as a single line.* Top: *with the ideographs expanded into a picture.*

not written.[21] So it is accurate to say that without further contextual information, the "picture" lacks only sound, while the "caption" might be a homophone for any number of other entirely different sentences. The "picture" is more complete as writing than the writing is without its determinatives. In Alan Gardiner's phrase, "It may be more truly said that the phonograms determine the *sound* of the ideogram, than that the ideogram determines the *sense* of the phonograms."[22]

19. Fischer, *L'Écriture et l'art de l'Égypte ancienne* (Paris: Presses Universitaires de France, 1986), and Fischer, *The Orientation of Egyptian Hieroglyphs,* part 1, *Reversals* (New York: Metropolitan Museum of Art, 1977). For related questions, see Pascal Vernus, "Des relations entre textes et représentations dans l'Égypte pharaonique," in *Écritures, Systèmes idéographiques et pratiques expressives,* Actes du Colloque International de l'Université Paris VII (Paris, 1982), 45–69.

20. This reading is Fischer's; I thank him for suggestions on this and other subjects (personal communication, October 1997).

21. In some cases, mood, tense, and aspect can be communicated in the text itself. See Pascal Vernus, "Ritual sḏm.n.f and Some Values of the 'Accompli,'" in *Pharaonic Egypt: The Bible and Christianity,* ed. Sarah Israelit-Groll (Jerusalem: Magnes, 1985), 307–16, 378–82; and James Allen, "Tense in Classical Egyptian," in *Essays in Egyptian Grammar,* Yale Egyptological Studies, no. 2 (New Haven, Conn.: Yale University Press, 1986), 1–21. I thank Emily Teeter for these references.

22. Gardiner, *Egyptian Grammar,* 3d ed. (London: Oxford University Press, 1957), sec. 23, quoted in Fischer, *The Orientation of Egyptian Hieroglyphs,* 4. The preceding quotation is Fischer's.

The captive in the Narmer Palette is a similar case, embedded in an even more complex image. The *w's* hieroglyph behind the captive's head gives the phonetics, and the figure itself acts as determinative. There are three other examples on this side of the palette — two in the lowest register (just above each figure's head), and one behind the king. It has been suggested that Narmer himself (the large central figure) is also a determinative for the name engraved above his head, even though he is separated from his name by a register line.[23]

One element in particular appears to stand outside this relation between determinative and phonetic text, and that is the group at the upper right, just under one of the bovine faces of the goddess Bat.[24] It is much larger than the other hieroglyphs, but it does not seem to be a picture in the sense that the other figures are. According to Gardiner, the group is neither writing nor pictorial representation, and he speculates that at the early date of the Narmer Palette, ca. 3000 B.C.E., "complete sentences could apparently be conveyed only by symbolical groups of which the elements suggested separate words."[25] If so, the odd image might mean "The falcon-god Horus leads captives of the papyrus-land." That reading, proposed by Gardiner and William Arnett, depends on seeing two hieroglyphic signs in the group: the papyrus reeds and the captive's body, which is the hieroglyph for "land." Together they yield *t3-mhw*, "Papyrus Land." The group as a whole could denote the sentence "The falcon-god Horus leads captives of the papyrus-land," or it could signify that the Horus king is victorious over the Papyrus Land, or more simply the Delta.[26] In that case the signs *t3* and *mhw* would be analogous to the hieroglyphs behind the captive's head: They would be the phonetic accompaniments of the larger pictorial determinative nearby. Just as the large captive fixes the meaning of the phonemes *w'-s,* so the Horus falcon and the captive's head would determine the sense of the phonemes *t3-mhw.*

The group is a conceptually challenging object. If the elements were detached from one another (in accord with the criterion of disjointness) then they could be taken as formally equivalent to a set of hieroglyphs. If they were more naturalistic, they might seem to be a narrative picture. Grouped together as they are, they have the look of a single complex sign; if the "sign" is read as Gardiner does,

the group is an enuntiagraph. There are other possibilities as well: The group has also been read as a "symbolic picture" with a single interpolated hieroglyphic character, the reed, repeated six times. In that case it would be a version of the word *kho',* meaning one thousand, and because it is repeated six times, it would denote six thousand captives.[27] And because the falcon and its captive parallel the king and his captive, it can also be interpreted as a picture within the picture, each commenting on the other.

These interpretations are unstable because there is no convincing parallel for the object elsewhere on the palette — or even, in some readings, in other early dynastic objects. Distinctions between written sign and picture are complicated further by the variable nature of even the most obviously hieroglyphic elements in the palette. The name Narmer at the top is framed in a *serekh* (or more correctly *srh*), which represents a paneled brickwork facade. The *serekh* is a picture of a palace, and also a determinative, as it indicates that the person named by the signs inside it is a king. But the grouping was remarkably unstable. Plate 10.5 gives the major variants; the one on the obverse of the Narmer Palette is number 3.[28] Most have the Horus falcon on top, but in other examples the *serekh* is absent, as in number 4 which is from the reverse of the same palette. In some the chisel alternates with the catfish (number 15), or the chisel is missing (20 and 24), and a few have supernumerary characters of uncertain meaning (10 and 16). In one instance the catfish sprouts arms, swells to the proportions of a deity, and prepares to bludgeon a captive, just as Narmer himself does on the palette (number 11).

23. Fischer, "Origin of Egyptian Hieroglyphs," 67.

24. Fischer, "The Ancient Egyptian Attitude towards the Monstrous," in Anne E. Farkas, Prudence O. Harper, and Evelyn B. Harrison, eds., *Monsters and Demons in the Ancient and Medieval World: Papers Presented in Honor of Edith Porada* (Mainz: Philipp von Zabern, 1987), 15 and n. 20.

25. Gardiner, *Egyptian Grammar,* 7.

26. William S. Arnett, *The Predynastic Origin of Egyptian Hieroglyphics* (Washington, D.C.: University Press of America, 1982), 41.

27. Gardiner, "Nature and Development," 72.

28. Gérard Godron, "A propos du nom royal [Narmer]," *Annales du Service des Antiquités de l'Egypte* 49 (1949): 217–20, plate 1; the plate is analyzed in Pascal Vernus, "La Naissance de l'écriture dans l'Égypt ancienne," *Archéo-Nil* 3 (1993): 75–108.

PLATE 10.5 *Variations on the name Narmer.*

The variations have prompted alternate readings — Gérard Godron proposes inverting the sequence to *mr(i)-nˁr(i),* meaning "friend of *nˁr(i),*" and Gardiner suggests "the . . . *nar*-fish." [29] Clearly the conventions of naming were open to substantial variation.

Looking again at the enigmatic group in the central scene of the Narmer Palette, it is reasonable to infer that its meaning might not have been taken to be as closely dependent on its form as modern writers tend to assume. Despite our many freedoms, we make rather strong distinctions between writing and pictures. No such divisions appear in the Narmer Palette. A longer analysis could show that virtually every form on the palette is either legible or directly linked to written signs: As Jochem Kahl puts it, "pictures and writing (that is, representations and texts) can change into one another." [30] And given the palette's proliferation of writing, is there any portion that might be said to be pictorial? Gardiner's description of the central group seems almost like an apology: "There is no reason whatsoever for regarding this subject on the palette of Narmer otherwise than as a picture;

for though it was intended as a record and to convey information, and though its general sense may be defined in a very few words, yet there is nothing to suggest any particular verbal description and the scene is therefore not writing as we have agreed to understand the term." [31] But is it true that the central scene does not entail a "particular verbal description"? In Gardiner's own reading the mysterious group at the upper right is a "sentence," something like "The falcon-god Horus leads captives of the papyrus-land." The strong parallel between the group and the central scene of king and captive implies that it denotes the same sentence. Even if we choose not to interpret the group as an enuntiagraph, writing is so entangled with pictures that it cannot help disturbing any attempt to see the obverse as a picture. A purely narrative reading is certainly possible, and one has recently been proposed by Whitney Davis, but attention to the object's symbolic content will necessarily mar the orders of reading that a narrative sequence entails. [32] The palette is so firmly between pictures and what we have agreed to call writing that no single interpretive protocol will do.

FINE ART AS SEMASIOGRAPHY

This is the moment when it makes most sense to turn to ordinary paintings and to see how they work as subgraphemic images. In the previous chapter I mentioned Adolph Gottlieb, although his early "pictographic" paintings are an unusual and isolated case. Subgraphemics and hypographemics are different in kind, and the majority of all images studied by the history of art belong among the artifacts in this chapter and the next. Consider a characteristic Western narrative painting, Giotto's fresco of the Lamentation in the Arena Chapel, Padua (Plate 10.6). It conforms to the definition of

29. Gardiner, "Nature and Development," 74n3.

30. Kahl (1994), 29: "Die ägyptische Schrift und Kunst sind von komplementärem Charakter; Buld und Schrift (Darstellung und Text) können ineinander übergehen."

31. Gardiner, "Nature and Development," 72.

32. Davis, *Masking the Blow* (Berkeley: University of California Press, 1992), and see my review, "Before Theory," *Art History* 16 no. 4 (1993): 647–72. Recently Davis has extended his reading in the chapter "Narrativity and the Narmer Palette," in *Replications: Archaeology, Art History, Psychoanalysis* (University Park: Pennsylvania State University Press, 1997).

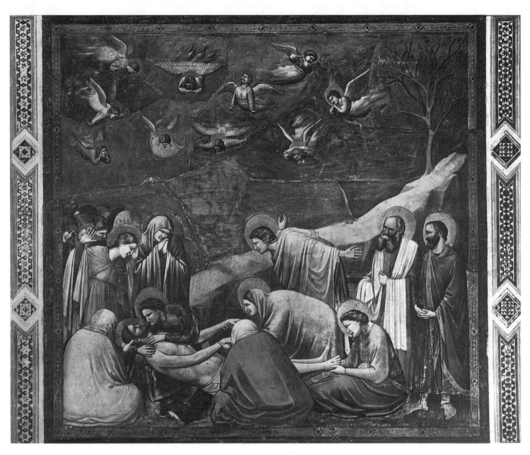

PLATE 10.6 *Giotto.* Lamentation. *Fresco. Padua, Arena Chapel.*

subgraphemics in that it is composed of asyntactic signs: The figures of Christ, the Virgin, Magdalen, St. John the Evangelist, Joseph of Arimathea (with the white winding-cloth), and Nicodemus (at the far right) are all distinct, which is to say they are disjoint signs; and they are asyntactic signs because they are not given in a determinate order. This rudimentary semiotic observation is typical in the way it distorts art history's usual way of putting things, but in its own terms it holds true of the great majority of paintings. In art history, "narrative" is a contested term, and at least some of its meaning is captured in the observation that Giotto's painting does have *some* syntax, and therefore some specifiable relations to "particular verbal descriptions." It is reasonable to assume, for example, that a viewer's attention will be either initially or intermittently focused on St. John, because his figure occupies the center of the painting. A viewer who follows St. John's gaze will glance down to the figure of Christ, which is a kind

of catchall for the gazes all around him. A subsequent glance up from Christ's head will be reflected back by the faces of his disciples. There are many other things to be said about the "structure of beholding" in the painting, and a monograph could be devoted to the ekphrases that have been offered by writers since the mid–sixteenth century.[33] Much of art history is animated by the tension between the knowledge that narrative paintings have no single syntax, and the compelling conviction that an optimal syntax can be revealed by a sufficiently vigilant reading.

In the immediate context of Gardiner's com-

33. See especially the careful analyses in Max Imdahl, *Giotto, Arenafresken: Ikonographie, Ikonologie, Ikonik* (Munich: W. Fink, 1980), and Cesare Brandi, *Giotto* (Milan:A. Mondadori, 1983). Both are cited in Giuseppe Basile, *Giotto: The Arena Chapel Frescoes* (London: Thames & Hudson: 1993), 23n45. The phrase "structure of beholding" is Michael Fried's; see *Courbet's Realism* (Chicago: University of Chicago Press, 1990).

PLATE 10.7 *Impression on an envelope. Karum Kanish level II (ca. 2000–1500 B.C.E.). Kültepe, Turkey.*

ment, it is worth noting that the picture's principal narrative meaning is stable and exact. The literature on Giotto is enormous, perhaps even more than the sum total of literature on all the other objects in this book combined, and so descriptions vary widely; but they tend to arise from, and return to, what medieval scholars called the *sensus litteralis*—the original Gospels, the painting's traditional title, and its most economic and natural-sounding paraphrases.[34] The fresco's traditional title, *Lamentation,* is an abbreviation of *The Lamentation over the Dead Christ.* Although it seems merely conventional, the title is almost inevitable, and the variations are largely without serious consequences—in Italian the painting has been called the *Deposizione* (which is technically a misnomer, as the Lamentation comes after the Deposition) and even the *Pietà* (which is a synecdoche for the whole, because it only names the Virgin's embrace of her son). But just in terms of the basic English title we might also say *The Lamentation over the Dead Christ with the Virgin and Saints* or *The Virgin and Saints Lamenting the Dead Christ.* The title and the principal players are less variable and more resilient than they might appear. In particular they are substantially more "particular" than Gardin-

er's comment would imply. Neither the Narmer Palette nor Giotto's painting are writing in the normal sense of that word, but that is not because they are unbound from "determinate" denotation or syntax.

The same dynamic between looking and reading applies to artifacts that are very far from the central instances of Western art. This seal impression from Kültepe, Turkey, also has disjoint signs (more obviously so than in the fresco), and it also presents the appearance of an intricate syntax that harbors a specific phrase or sentence (Plate 10.7). The seal impression records a tradition of especially finely worked Anatolian cylinder seals from the first half of the second millennium B.C.; to make it, the scribe rolled the seal across the middle of a clay "envelope" that enclosed another tablet

34. For the Giotto literature, see Roberto Salvini, *Giotto bibliografia* (Rome: Fratelli Palombi, 1938), and further Elkins (1999a). The total of formal analyses would have to include the presuppositions about the painting's composition implicit in parallels to earlier works such as a *Lamentation* attributed to the circle of Pietro Cavallini in Assisi, and various sarcophagi in Florence, Paris, and Ovieto. See the classic study by Erwin Rosenthal, *Giotto in der mittelalterlichen Geistesentwicklung* (Augsburg: Benno Filser, 1924).

and then wrote in a hasty cuneiform across the top and bottom. (Note that the scene begins to repeat on either end, where the cylinder finished one rotation and began the next.) The image follows a standard format in cylinder seals, in which a god or ruler accepts offerings, except that here there are many more offerings than normal. The god is the Sumerian Enki, who became the Akkadian Ea: He was the god of wisdom and of water, and he can be identified by the streams of water that seem to issue from his shoulders (the water comes from a vase that is not visible in this impression).[35] He stands at the left, just behind an incised line, which might be the gateposts of his temple, or a shorthand for the portal of the temple itself. The offerings come pouring in from the right. Starting from the bottom right, they begin with four monkeys holding vessels shaped like amphorae, four small birds just above them, four fish (one with a human head and one with a goose's neck and head), and five large birds (one seated). In the field between these creatures are eleven stars; toward the front and underneath them — partly obliterated by the deep cuneiform incisions — are ten or eleven goat's heads. (One of the goat's heads, the one just in front of the human-headed fish, is cleverly made by adding a neck and a horn to the body of a small bird.) And in front of all these creatures and objects, on the top margin, are a sun and crescent moon, another bird with a star, and an inscription that runs the height of the seal.[36]

The action is ambiguous from a modern point of view: At first it looks as if this is a rectangular scene framed by the two verticals, but in narrative terms Enki is at the extreme left, and the offerings come in from the right. The "border" of the scene, which was not actually incised into the seal, would be just to Enki's left. There is proof in the composition itself that the engraver did not care about borders: another small bird and a star float over Enki's head, and a second star lingers at his feet. It is as if they had already arrived in the temple, or else — reading the undrawn border differently — as if they were the last stragglers in the procession, paradoxically still in the very temple to which they were headed.

Considered as a whole, the narrative is perfectly clear, and it could be summarized in a single sentence: "These are the offerings that were given to Enki." But the narrative breaks down in the details.[37] Who arrives first? Who arrives last? Are the fish "above" the monkeys? Are they all floating among birds and stars, or are those elements decoration, added (as so many geometric forms in cylinder seals) to fill in the blank fields between significant forms? Does it matter that a goat's head can sprout from a bird? Are the two fish on the right less important because they do not have human heads? Enki is standing on a goat-fish: Could it as easily have been a fish or a bird? All that really exists for us is the fundamental motion of the narrative. Its details are lost but its central message is clear enough. In putting it this way, I am aiming at an equation of degrees of specificity: In terms of the latitude of possible verbal transcriptions, the cylinder seal and the fresco are parallel instances.

Recently it has come to look more probable that the images on seals like this one are partly writing, in which case some — but not all — of the flood of offerings and "motifs" would also be signs for phonemes, *spelling* offerings and possibly also the donor's name.[38] When more of such artifacts can be read, as I do not doubt they will be, the image might appear more orderly. But the result will never be a block of text enframed by a god, his temple, and symmetrical decorative motifs, if only because the tide of offerings would still continue in full force *through* the text: exactly, I mean to im-

35. See Dominique Collon, *First Impressions: Cylinder Seals in the Ancient Near East* (Chicago: University of Chicago Press, 1987), 43, fig. 152; 44; 164, figs. 760 and 761; and 165.

36. Nimet Özgüç reads the inscription "Ḫa-ra-áš-ta." According to John Brinkman, the "inscription" is best described as "cuneiform-style signs in a field," as only a few — signs for *king* and *overseer* — are clear (personal communication, spring 1996). See Özgüç, *Kültepe muhur Baskilarinda Anadolu Grubu: The Anatolian Group of Cylinder Seal Impressions from Kültepe,* Türk Tarih Kurumu yayinlarindan, 5th ser., vol. 22 (Ankara: Türk Tarih Kurumu Basimevi, 1965), 82.

37. For a different roster of creatures, see Nimet Özgüç, *Türk Tarih Kurumu Tarafindan Yapilan Kültepe Kazisi Raporu, 1949, Ausgrabungen in Kültepe, Bericht über die im Auftrage der Türkischen Historischen Gesellschaft, 1949 durchgeführten Ausgrabungen.* Türk Tarih Kurumu yayinlarindan, 5th ser., vol. 12 (Ankara: Türk Tarih Kurumu Basimevi, 1953), 238; Özgüç sees, among other things, "Fische mit Menschen-, Löwen-, und Hundeköpfen."

38. Jan Best and Fred Woudhuizen, *Lost Languages from the Mediterranean* (Leiden: E. J. Brill, 1989), 128–37, esp. 132.

ply, as in a narrative painting, in which namable figures are set "within"— and "as"— a naturalistic landscape.

Examples like the seal impression from Kültepe or the Narmer Palette could be used to argue that fine art, almost as a whole, finds its affinities among the images of this chapter. Attempts to read subgraphemic artifacts have to come to terms with the problem of indeterminate syntax, and the *species* of indeterminateness demonstrate affinities between images. Paintings that seem to have the most strictly determined syntax — for example, Greek vase paintings, in which the figures are labeled — can turn out to be the most syntactically ambiguous, and conversely paintings that seem wholly asyntactic can generate closely circumscribed descriptions. Even when figures are not labeled with words, their identities can be fixed by other pictures. The Narmer Palette is an example, with its semasiographic hieroglyphs, and the attributes that identify saints and other figures in Western painting can be understood as the same kind of pictorial label. (Attributes are little pictures that have to be placed near or on figures in order to identify them.) Even "cueing marks" that tell viewers about the direction of the narrative are indispensable accompaniments to narrative pictures.[39] No narrative scene is entirely unlabeled; otherwise it would not appear as a narrative: It would be an "iconic" image or one organized as an anatomy, epitome, or other nonlinear form.[40] In the broadest possible sense, the possibilities of narrative continue to be generative for Western art, even as it reacts against narrative: A syntactic order that has been smothered by nondisjoint signs or dismantled by ambiguous formatting still calls for reading over viewing.[41]

I do not mean these very general observations to somehow encompass the field of fine art any more than I intend Giotto's painting as an example of essential properties. Instead I want to suggest that art history's nuanced and persistent searches for verbal equivalents might be understood as responses to tantalizing fragments of the traits of writing (and occasionally of notation) that seem to be visible in painting. And to the extent that this is so, it might occasionally be helpful to reframe art-historical concerns in terms of subgraphemics. As we move even further from normative writing, into pseudo–picture-writing and then hypographemics, the comparisons become more historically specific and rewarding; but my purpose throughout is not to use one field to illuminate another, but to use both paintings and less usual images to sketch the shape of images as a whole.

FROM JACOB BÖHME
TO NEOEXPRESSIONISM

Close analogies with contemporary painting begin to appear in the seventeenth century, when the illustrations in mystical and other hermetic treatises started to use mixtures of pictures and unexplained symbols. Although most of Jacob Böhme's works were not illustrated until after his death, he sketched a figure for his *Mysterium magnum*, which was engraved in several versions: once for the 1682 edition, and again by Abraham von Sommerfeld for the 1730 edition (Plate 10.8). Böhme says the image represents the end of the "sixth age," when the "threefold cross" will appear alongside the "victorious sword" and the switch, thrown down by the "violent fire of God's rage."[42] Böhme's original drawing is lost; in the earlier printed edition, given at the bottom, the fire propels the instruments of destruction toward the Earth, as Böhme says. Von Sommerfeld says he consulted Böhme's own drawing to make the version at the top, where the fire is placidly burning a log off to one side of the other three symbols. The difference, as von Sommerfeld must have sensed, is decisive because it cannot be explained. Something happens to the syntax of the symbols when they are rearranged, and mysteriously they express Böhme's idea slightly differently.

39. For "cueing marks," see Davis, *Masking the Blow*.

40. The alternate forms are Hayden White's suggestions; the term *iconic* in this sense has been used by William Rubin to contrast against academic narrative painting before Picasso. See my "On the Impossibility of Stories: The Anti-Narrative and Non-Narrative Impulse in Modern Painting," *Word and Image* 7, no. 4 (1991): 348–64, revised in Elkins (1999b).

41. Some of the art-historical work most deeply affected by this is Louis Marin, *To Destroy Painting* (Chicago: University of Chicago Press, 1995).

42. *Jacob Böhme, Sämtliche Schriften*, facsimile of the edition of 1730, ed. Will-Erich Peuckert (Stuttgart: Fr. Frommans Verlag, 1955–), vol. 7, *Mysterium magnum* (1958), sec. 44, p. 273. The 1682 edition is *Mysterium magnum, Erklärung über das Erste Buch Mosis* (Amsterdam: s.n., 1682).

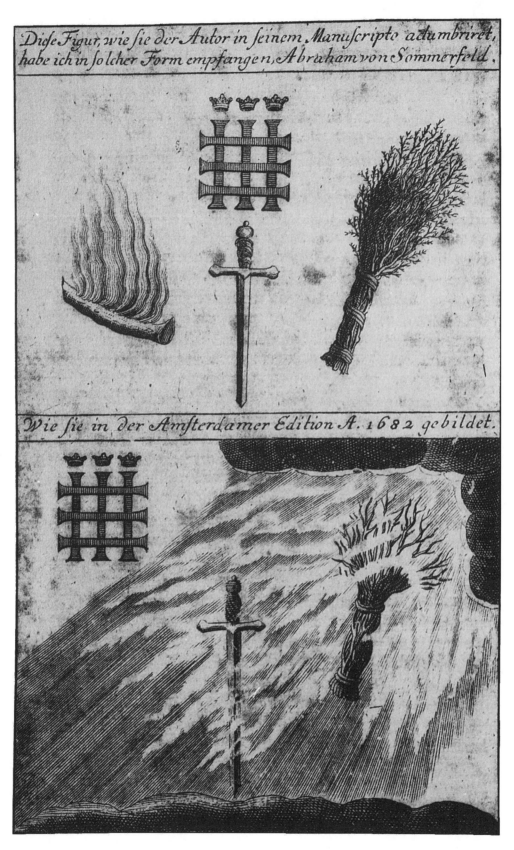

PLATE 10.8 *Engravings after a drawing by Jacob Böhme, representing the Sixth Age.* Top: *1730;* bottom: *1682.*

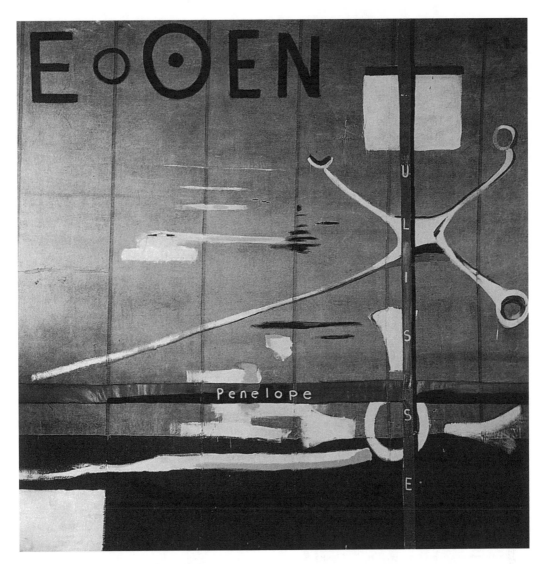

PLATE 10.9 *Julian Schnabel. E o OEN. 1988.*

Von Sommerfeld's version seems more enigmatic if only because it offers so little help to a viewer who wants to read, even as it presents itself as a picture. The feeling of reading is strong in both cases, but the earlier example is almost a picture with a lone symbol in one corner.

The blurring of half-understood symbols by a wash of textures or colors is a central strategy in neoexpressionism. The painting in Plate 10.9 is by Julian Schnabel, but many other artists (and movements) could stand in his place. The painting has legible words — "Ulisse" and "Penelope" — and also some pseudowriting at the top, where letters and near-misses for letters combine into a singularly unreadable sequence.[43] The background is a landscape with the kind of smeared symbols that were first used in seventeenth-century illustrations: a white window shade (or window) with a brown roller (or lintel); a kind of combination nerve cell and flow chart; three-quarters of a Maltese cross, and stacks of clouds that look suspiciously regular, as if they were obliterating some writing underneath. In the lower-left corner another white square is painted over the green sea, as if it is hiding a signature. The window shade, the

43. The painting's title is *E o OEN,* but one wonders if that is just typographic shorthand for what appears on the painting. See *Julian Schnabel, Oeuvres nouvelles,* ed. Jean-Louis Froment (Bordeaux: Musée d'art contemporain, 1989), 51.

nerve cell, and the Maltese cross are almost symbols, and they nearly form a vertical set of three, but as in the earlier of the two prints after Böhme's design, they are smudged and compromised until they are part of the fabric of the image. For some reason Schnabel's "carelessly" painted symbols are more interesting, more inviting, and apparently richer in meaning than more accurately drawn symbols might have been, and the reason has to do with their incorporation into a painting.

The genealogy of such images is intermittent, and after the renascence of mystical diagrams in the seventeenth century (continuing through the more geometric inventions of the Rosicrucians and Freemasons), it began again in modern art with Giorgio de Chirico and his brother Alberto Savinio, who brought together inexplicable objects, using paint to cement them into unified images. As elsewhere in this book, I am not attempting to build bridges across vast gaps in the historical record, or to claim that these examples might be taken as links in a historical sequence. My point is only that for a contemporary viewer, their meanings are unstable in a particular way. It is the "violent fire of God's rage" that ties the lower image in Plate 10.8 into a picture and slurs its symbols just enough to make it work as a picture — that is, to give it meaning beyond the accumulation of disordered signs. We perceive such images as unified objects, and we understand their unity as a source of some additional, unspecifiable meaning not available to symbols stamped in isolation against a blank page.

The examples of picture-writing in Alaska, Siberia, Australia, Turkey, and Egypt are clearer than the paintings and mystical diagrams because they aim to make perfect (written) sense. In their different ways, they are experiments in letting syntax go in the name of a less constrained storytelling. As Howard Morphy says of the Yolngu paintings, the desire to depict multiple stories forces a certain geometrization — it breaks the syntax of any one story. Giotto's painting also abandons the secure syntax of the biblical account in order to tell the story in a different, and presumably richer, way. The road to deeper and more elusive meanings forks when it becomes possible to merge one sign into another, or to ruin a sign so that it is no longer quite legible. That is why I divided subgraphemics into *picture-writing* and *pseudo–picture-writing* where some images are disjoint and others are fused (technically, they are hypograms). Schnabel's painting and Böhme's diagram (that is, the earlier one), which I take to be nearly twins in their sense of what makes pictures interesting, take the more difficult road. They blur their signs so that determinate syntax is not only effectively destroyed — as it would be in any image that abandoned the formats of writing — but also put into question. For how can reading even make sense when the signs refuse to remain regular and whole, and separate from one another?

A deeper question lurks here, and that is why we perceive such images to be more replete with meaning than "mere" texts or "pure" pictures. It does not make sense on the face of it, unless part of modernism (taking that term very broadly, as Western visual practice from the seventeenth century onward) is a project to reinvent pictures. In Chapter 4 I suggested that Wittgenstein's desire to escape from the dual nature of pictures might be aimed not at finding some viable synthesis but at harassing the concept of a picture — at wrecking the unattainable ideal of purity and clearing away the frustrating mixtures of writing and picturing that combine to make ordinary pictures. Such a project, if it is right to sense it in images like Schnabel's or Böhme's, is not an attempt to create a third term between pictures and writing, or to adjudicate the warring interpretive regimes of writing and picturing. It is an attempt to incapacitate pictures, to ensure that nothing works — and, paradoxically, by a logic I cannot explain, to make meaning happen in a new way.

11 : Hypographemics

enerally speaking, Warburton looked on hypographemics — images that seem like they might be read but lack a disjoint signary — as happy confusions, expressions of unlettered or undisciplined minds at play, indifferent to writing or picturing.[1] Petroglyphs and petrographs (rock paintings) were known to Enlightenment Europe, but they did not attract concerted attention before the later nineteenth century, when the age of decipherment had gotten under way. Images that appeared to be writing but were entirely unreadable tended to be assigned mystical and religious import. Hieroglyphs are the cardinal instance, and the entire history of the decipherment of runic inscriptions, down to and including present scholarship, is infused with superstitions regarding their evil nature.[2] Only in the last hundred years has it become possible to assay "readings" of such artifacts that do not immediately fall prey to assumptions about primitive mentality, religion, or language. In that respect it is especially interesting that prehistoric hypographemic images are so closely allied to modern Western painting: The mystical strain has never been far beneath the surface in abstraction, surrealism, and neoexpressionism.

Hypographemics exist in a netherworld. They fail to comply with most of our expectations and refuse to yield to even the most generous interpretive programs. Yet a subgraphemic image can be entrancing, because its surface can be lambent with the promise of meaning. Here, at the end of a long sequence from nearly pure writing to nearly pure pictures, there is almost nothing left that can help a reader find a foothold in an image. Hypographemics is the study of images that lack both a workable remnant of syntax and consistently nondisjoint signs. The most writinglike are those (at the bottom of Table 11.1) that still have *some* disjoint signs alongside others that are fused and confused. Next in line toward pure pictures are images that have internal structures but no isolable parts. Technically, they are hypograms: images taken to be comprised of a single composite sign, or of an indeterminate number of nondisjoint signs. Hypograms might seem exotic, but they are common in paintings, hermetic scripts, and prehistoric artifacts. Outside a community of Enlightenment chemists, symbols such as ♀, ♯, ⚗, and ♃ are hypograms — meaningless conglomerations of signs and sign fragments into indissoluble wholes. Likewise ⚭ is a hypogram made by fusing the lowercase letters q, p, b, and d.

That leaves one final division — images so close to pure pictures that they provide our examples of what pure pictures might be. In the table, I have called the category "holomorphs" (entirely illegible images) and listed abstractions, landscape paintings, and photographs as examples. Needless to say, the list is contentious. People have different

1. Warburton (1811), 119n.
2. See the polemical article by Elmer H. Antonsen, "The Runes: The Earliest Germanic Writing System," in Wayne M. Senner, ed., *The Origins of Writing* (Lincoln: University of Nebraska Press, 1989), 137–70.

TABLE 11.1. *Kinds of Hypographemics*

	"Pure pictures" or perfect holomorphs	Some abstractions; some landscape paintings; some photographs
Hypographemics: Images with nondisjoint signs	Isolated or fused signs (hypograms)	Potter's marks, Taoist "talismans," some modern painting
	Images partly comprised of disjoint signs, but lacking all formatting and cueing marks	Complex petroglyphs: for example Loughcrew, Ireland, and Järrestad, Sweden; some modern painting

reasons for proposing that images are pure, and at one time or another all of the words I listed in Chapter 6 — *uncoded, nonsemiotic, inennarable, continuous, analog,* and so forth — have been brought to bear. My interest here is not the history of attempts to promote images to the rank of pure pictures but the desire that drives such attempts; in that respect, hypographemics are especially interesting because they show the way we expect meaning to deliquesce, and what we take to be the lack of articulable meaning.

ON DISJOINTNESS

The cardinal trait of hypographemics is disjointness, and it is a slippery concept because a rigorously nondisjoint image would have no internal organization whatsoever — it could only be a structureless field. Normally a picture has an internal structure: Even monochromes by Yves Klein or "black" paintings by Ad Reinhardt have readily discernible passages. What is at stake, therefore, is the *degree* of nondisjointness. One of the more vexing obstacles to reading prehistoric hypographemic images is deciding when two signs are merely allographic variants of each other, and so should be read as instances of the same sign. There are several differing versions of this question, and they devolve from the traits of writing — which in turn come partly from Goodman's syntactic criteria for notations.

Carefully read, Goodman's two syntactic criteria divide into a number of related propositions. He first says that characters must be "finitely disjoint," so that no one mark can belong simultaneously to two characters. (A letter "b," for instance, cannot also stand for the number "6.") Without

the qualification "finite," the criterion is the same as the first of the traits of writing (that signs should be disjoint). Under the same heading, Goodman also discusses character-indifference, which entails that two marks, both of which are understood as examples of a single character, must not also belong to different characters. Strictly speaking, disjunction follows from character-indifference. He also distinguishes two ways that disjunction might fail: If a mark is equivalent to two characters, it "collapses" them into one character, and if two examples of a character might sometimes be given different syntactic meaning, then "instances of the same letter may not be true copies of one another." The other syntactic criterion is "finite syntactical differentiation" or "articulateness," and it requires that it is always possible to determine if a mark belongs to a character. For that to be the case, characters need to have "finite" differences: Informally, there have to be shapes that are definitively "between" characters. As Goodman points out, even small character sets can fail to be articulate and become dense; for example, a set comprised of two characters, one with "all marks not longer than one inch" and the other with "all longer marks."[3]

The branching possibilities of Goodman's theory can be contained, and made more practical, by correlating them with the traits of writing. The first trait, disjoint signs, combines Goodman's two principal criteria of finite disjunction and articulateness and uses them to mean something much simpler. If two signs are connected to one another, or if they overlap, it will not be clear whether they should be separated or read as a single sign. In alphabetic writing, that is rarely an issue, but in petroglyphs

3. Goodman (1976), 132–36.

and in modern paintings it is common. The linguist Manfred Kohrt calls this the "problem of segmentation," in which a viewer must decide how to divide a "string" of marks.[4] If a petroglyph has a row of circles, each touching the next, is it to be understood as a new sign, a set of circles, or a concatenation of figure eights? My fifth and eighth traits of writing (that all signs are more or less uniform in size, and that a given sign is fairly uniform in each of its appearances) are also related to Goodman's first criterion, and they are designed to help specify another common occurrence in petroglyphs and paintings. It is not likely that a typesetter could vary the sizes or shapes of characters enough to discourage the conviction that the text might be read, but in petroglyphs unexpected scale differences are the norm. A row of small circles might be accompanied by a huge circle, making it important to decide whether the large circle is equivalent to the smaller ones.

This theoretical armature helps articulate how archaeologists and art historians respond to hypographemic images. It is intricate, but without it interpretations can only skim the surface of an artifact, picking out a "sign" here and there, not following or even knowing the principles that allow that sign to emerge from its matrix of connections and appear plausibly separate and legible. Artists and critics commonly peruse paintings this way, and cursory surveys of rock art sites do the same. It can be important, though, to know why and how these partial readings are done — why it is so often satisfying to read so little, how we know when and where to read, and what kind of meaninglessness we expect in the remainder of the image.

THE PROBLEMS OF CONTEXTLESS INTERPRETATION

Interpretation is sorely tested by petroglyphs, especially where there is no writing, no sense of syntax, no consistent disjunction between signs, unreliable or missing cultural contexts, a lack of any continuous pictorial tradition, and no surviving language. Yet some are more amenable to reading than others. A series of Swedish petroglyphs in the provinces of Bohuslän, Östergötlande depict "naval battles" and other events (Plate 11.1).[5] In

this example from Järrestad, several forms are recognizable: From more elaborate markings on other rocks it is known that signs such as the two at the lower right are ships with rowers, and there are also animals and implements.[6] Paired ovals might denote prints left by sandals, and darker ovals might denote prints left by bare feet (at the middle left). Among these naturalistic signs are other marks that look more abstract, such as spirals. It might seem that the whole image — that is, this particular rock face — is an assemblage of disjunct signs, but there are hybrid and composite signs such as the one at the upper left, which elaborates a single "sandal" into a gridded oval, and one at the top right, which weds a "snake" to a foot. Near the lower right is a long slinking form that does not resemble any common object; it might represent an artifact, or it might be a pictographic sign or even a map.

To some early viewers, the Swedish rock carvings looked systematic enough to be examples of writing. In 1879, Oscar Montelius concluded they were an "écriture symbolique ou figurée," whose meaning was lost when the oral tradition ended.[7] Modern archaeologists are more circumspect, and the coexistence of clearly unitary signs such as the shoes, ships, and feet with compound and fused signs such as the "shoe-snake" and "shoe-grid" ef-

4. Manfred Kohrt, "The Term 'Grapheme' in the History and Theory of Linguistics," in *New Trends in Graphemics and Orthography*, ed. Gerhard Augst (Berlin: Walter de Gruyter, 1986), 80–96, esp. 89; and compare N. D. Munn, "Visual Categories: An Approach to the Study of Representational Systems," *American Anthropologist* 68 (1966): 936–50.

5. For early notices, see Axel Emanuel Holmberg, *Skandinaviens hällristningar* (Stockholm: P. J. Berg, 1848); B.-E. Hildebrand, "[Dessins anciens découverts sur les pans des rochers]," *Congrès International d'Anthropologie et d'Archéologie Préhistoriques*, 4th sess. (Copenhagen: De Thiele, 1875), 192; and Carl Georg Brunius, *Försök till förklaringar öfver hällristningar, med femton plancher* (Lund: Berlingska boktryckeriet, 1868).

6. The identification is based on contiguous rocks. For an attempt to find ship forms at Newgrange, in Brittany, and in Andalusia, see Arthur Evans, "The European Diffusion of Pictography and Its Bearings on the Origin of Script," in *Anthropology and the Classics*, ed. Robert Ranulph Marett (Oxford: Clarendon Press, 1908), 9–43, esp. 34–38.

7. Oscar Montelius, "Sur les sculptures de rochers de la Suide," *Congrès International d'Anthropologie et d'Archéologie Préhistoriques*, 7th sess. (Stockholm, 1876), vol. 1, 453–87, quotation on p. 471.

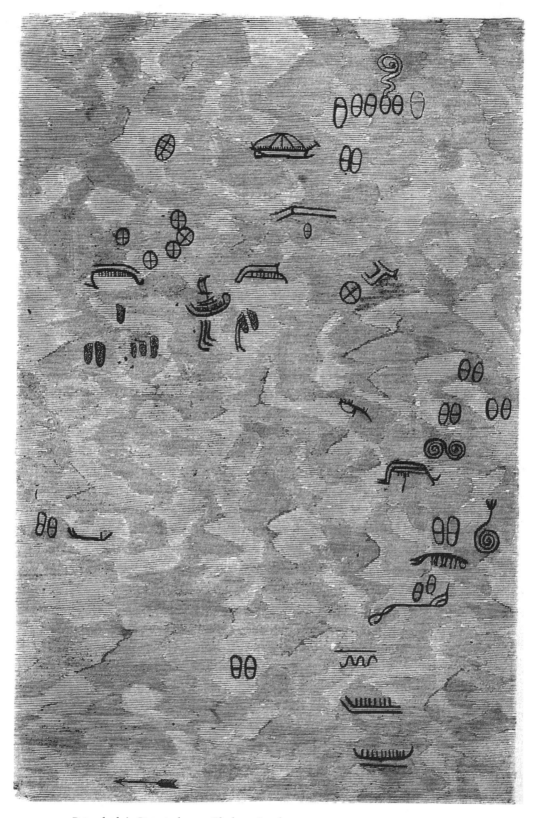

PLATE 11.1 *Petroglyph in Järrestad, near Gladsax, Sweden.*

fectively delimits what can plausibly be concluded.[8] The usual recourse is to go ahead and read the passages that have disjoint signs, and other Swedish petroglyphs have been interpreted as narratives of naval battles. But that position entails at least three assumptions that would be hard to defend: that the composite signs are effectively unities, that no segmentation is possible, and that disjoint signs are conceptually prior to nondisjoint signs, which become "ligatures," "decorations," or allographic variants. All such decisions are signs of a rote adherence to the customs of writing, and an unaccountable willingness to allow "pictorial" or "decorative" elements to find their own interpretations in each viewer's imagination.

The Swedish coastal petroglyphs are rendered partly interpretable by the naturalism of their signs, and by their uniformly depictive surfaces. But in rock art naturalistic signs can be in the minority, and some marks might not even be semiotic. Functional marks, for example, occur on the same surfaces with marks that are iconic or otherwise denotational.[9] "Cupules" are rounded pits that were sometimes used to grind herbs and even the rock itself, but in other cases they were apparently used for pictorial purposes, as a form of texturing or stippling. Some long notches in rock surfaces were demonstrably used to sharpen tools, while others were apparently made in the service of some naturalistic effect. Once these questions are asked, they tend to ramify: If a cupule can be naturalistic or functional, then it might also be naturalistic *and* functional in the same artifact. In the American Southwest and other regions, cupules were used to mark territory, and were engraved over existing petroglyphs. They then became part of the composite image, even as they were being used to grind ochre and other substances. In the same fashion, sharpening grooves sometimes remained functional even when they were also being used to represent things like deer tracks or spears.[10] The conundra of segmentation, nondisjointness, and nondenotational "noise" are partly generated by the lack of context. But relative lack of context and sequence is an endemic condition of a large percentage of prehistoric material — as it is, surprisingly, in modern art. Paintings that raise these same problems — those by Joan Miró, Yves Tanguy, Cy Twombly, Mark Tobey, Ferdinand Wols, and the early Barnett Newman, among others —

are not free of context, but they effectively deny context by presenting themselves as independent works. In that way they force viewers into one of two interpretive modes. Either they look, and enjoy, more or less at random, picking and choosing meaningful moments without interrogating the reasons for their choices, or else they try to read rigorously, and end up (as Nelson Goodman did) taking pleasure in the ruins of understanding, and the exact conditions that specify the downfall of meaning. In my experience, the normal art-world response to a painting by Twombly is an uncognized mixture of the two possibilities. We look, and find just enough to assure ourselves we aren't meant to see more, and then, in the moment when analysis gives way to reverie, without even knowing or thinking of the terms, we also take pleasure in sensing that the image has failed such criteria as syntactic finite differentiation or segmentation. We know these things intuitively because they are the common ground of reading. It is Goodman's virtue to have brought them out of their hiding places and revealed them in all their arcane, counterintuitive, inappropriately rigorous splendor.[11]

PETROGLYPHS IN LOUGHCREW, IRELAND

The principal passage tomb at Loughcrew, Ireland, brings these issues together in a single monument, and I want to consider it in some detail to underscore the difficulties of the inevitable search for linguistic structure (Plate 11.2). Like the passage graves in Brittany (see Plate 6.2) and the Irish tombs in the Boyne Valley, Loughcrew is a group

8. For this see H. Schneider, *Die Felszeichnungen von Bohuslän, das Grab von Kivic, die Goldhörner von Gellehas und der Silberkessel von Gundestrup als Denkmäler der vorgeschichtlichen Sonnenreligion* (Halle, 1918), 2–17.

9. The best classification of such terms is in Whitney Davis, "The Origins of Image Making," in *Replications: Archaeology, Art History, Psychoanalysis* (University Park: Pennsylvania State University Press, 1997).

10. See Jo Anne Van Tilburg, Frank Bock, and A. J. Bock, *The Church Rock Petroglyph Site: Field Documentation and Preliminary Analysis,* Occasional Papers of the Redding Museum no. 4 (Redding, Calif.: Redding Museum and Art Center, 1987), 31.

11. This flight from logical appreciation, and the pleasure in *not* reading, are the subjects of a work-in-progress, *Logic and Its Loss.*

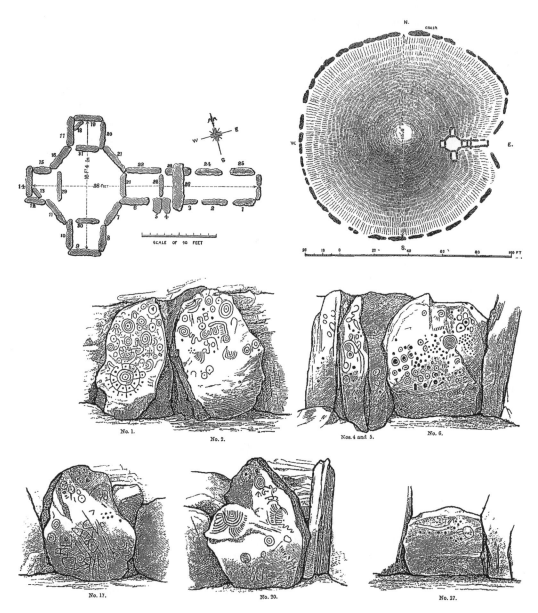

PLATE 11.2 *Wilhelm Tomsohn. Plans and selected orthostats of the passage tomb Cairn T, at Loughcrew, Ireland. ca. 3500 B.C.E.*

of rounded earth and stone tumuli with passages inside. The top left of Plate 11.2 is a cutaway view of Cairn T, the largest tumulus, and the top right is a close-up of the passage. The sides of the passage are set with large upright stones (orthostats), most of them incised with markings; the plate depicts seven of them. All that remains in the passage in Cairn T is the orthostats, the corbels of the four chambers at the end of the passage, and several large sills. There was activity at the site for two hundred years beginning about 3500 B.C.E., and then

again from about 2500 to 500 B.C.E. and intermittently thereafter; when the site was excavated beginning in 1863, the passage was partly choked with dirt. For the present purposes, then, the site is essentially a series of images.

There are very few hypotheses about the syntactics or semantics of the markings. There have been attempts to see symbols of water, regeneration, and natural cycles, most of them based on Marija Gimbutas's theories about continental sites. The nearby Boyne Valley tombs have also been interpreted in

that way, and in the absence of comparable literature on Loughcrew, Gimbutas's interpretive program would be the expected model. Aside from writing on related sites and on general meanings, there are only two attempts to give specific meaning to individual orthostats and markings. Eugene Conwell, who directed the original excavation, found stone and chalk balls in some cairns that fit into cupules in the orthostats.[12] Because the stones were between three-quarters of an inch and an inch in diameter, they would only have fit into the larger cupules. Several stones in Cairn T have two sizes of cupules (the dark holes in orthostats number 6 and 22), and so it is at least conceivable that there is a semantic difference between smaller and larger cupules. Unfortunately, the few stones Conwell found are now lost, and the cupules on many stones come in a number of sizes.

The second hypothesis was advanced by Martin Brennan in 1980; he observed the passage of sunlight across the backstone (number 14) on the morning of the summer solstice. Knowing that Boyne Valley passage tombs are sometimes aligned to the solstices, he mapped the progress of the sun's rays as they moved across the stone from left to right, falling as the sun rose and becoming less well defined until the passage returned to darkness (Plate 11.3).[13] Brennan's thesis is that the large sign at the top left represents the sun, and that it is repeated lower and to the right in order to mark the sun's path. Most of the interpretations he offers are not as specific: The large "wheel" on stone number 1, just at the entrance to the tomb, is identified as a "solar system" or "calendar," but he does not say how the calendar is divided, or how it models the solar system. His readings focus on the notion that the original builders of Loughcrew were interested in astronomy, and that their "suns," "calendars," "solar systems," and "cycles" were records of that fact.

It is not difficult to see the limitations of these two programs. Even if we still possessed all the original round stones, the placement and variations of the cupules is far too complex to draw any conclusions about meaning. Stone number 6 has a rough grid of large cupules at the left, but it also has some irregular rows in the middle and an arc and half-circle of cupules at the right. Stone 22 has four accurately placed, but incomplete, concentric arcs of cupules, but it also has an apparently random

configuration at the top. In Goodman's terms, the cupules lack syntax (they aren't ordered in a comprehensible or systematic fashion) and disjunction (they come in a continuum of sizes, so it's not clear if they are one sign or many). In terms of the traits of writing, the cupules lack the fifth and eighth traits of writing (if there are large and small cupules, they aren't uniform).

Brennan's theory fails for different reasons. The three principal "sun" signs on the backstone might follow the sun's path on the solstice, but there is a fourth sign at the lower left that is in perpetual shadow. (There is even a "sun" sign on the roofing stone over the back chamber, which would never be lit except by torches.) Nor does the theory account for the many other "sun" signs and variants elsewhere in the tomb, or for the generally even character of the marking throughout: If the backstone and the solstice were the center of attention, why mark so uniformly on every surface? And if the path of the sun's rays was so important, why mar the line with so many other symbols? And why mark so unevenly, with such manifestly uneven formatting, if a single arcuate *path* were the principal subject of the tomb?

Conwell's theory about the cupules and Brennan's theory about the solstices are typical for hypographemic objects in general: Both select elements that appear as repeated signs and "read" them by applying undefended notions of formatting, character-indifference, and orders of reading. When their criteria give out, the readings end. The residue — the majority of the markings, in the case of Loughcrew — remains uninterpreted. In archaeology as in fine art, the residue is said to be lost to history, and it becomes a source of private pleasure — as the many visitors to Loughcrew attest. The interesting thing here is that the pleasure is not taken in pure pictorial meaninglessness but (as in Wittgenstein) in the *promise* of meaning, the "feeling of meaning," or the "feeling of writing" or notation. I think that kind of pleasure is a mainstay of twentieth-century art, and for that reason alone it is important to try to understand the ex-

12. Conwell, *Discovery of the Tomb of Ollamh Fodhla* (Dublin: McGlashan & Gill, 1873), 52, 62.

13. Compare the evidence for the alignment of Newgrange; Michael O'Kelly, *Newgrange: Archaeology, Art, and Legend* (London: Thames & Hudson, 1982).

act configurations of failed writing and notation that make it most intense.

To get at the obscure source of pleasure and to construct a viable interpretation for such a site, it is necessary to begin again with the rudiments of syntax and the criteria for disjointness. The backstone is a fairly intricate object, but not beyond the reach of a formal analysis. The stones have been drawn several times, and each try reveals something of the artists' and writers' assumptions. As far as it is possible to judge given the tomb's current condition, Conwell's artist, Wilhelm Tomsohn, drew the stones as if everything unclear or fragmentary were part of a symmetrical form (see Plate 11.2, *bottom left*). Brennan simplifies and schematizes in accord with his predilection for astronomical diagrams (Plate 11.3), and the most recent illustrations, made by Jean McMann after tracings by Elizabeth Shee Twohig, assume so little that they end up marring some fairly clear configurations and making them look random (Plate 11.4).[14] Photographs offer no recourse against misprision, but I offer one here as contrast (Plate 11.5).

Because no reading has purchase without consensual decisions about the traits of writing, we can begin with those least likely to be disputed. The "sun" sign occurs four times on the backstone, and each is slightly different: The "petals" are disconnected and wilting in the sun at the top left, while the sun at the lower right has only six petals (although Shee Twohig and McMann see only a blob and two circles). That suggests the four are allomorphs of a single sign. The search for a signary can go a little further by noting that some forms are simplified versions of the sun sign: Just below Brennan's principal sun is a circle with a central dot, surrounded by four petals (although Tomsohn and Conwell see five, in an overzealous search for complete signs), and to its lower left is a collection of five petals without a center. Other variants are a little more distant from the "normative" sun: Between Brennan's first and second suns is a dotted circle with nine spokes, and just below it a central dot and eight spokes. There are also six dotted and undotted circles, five of them at the upper left. All such forms can either be considered distinct signs or allomorphs of the sun sign; if they are allomorphs, there are a total of sixteen sun signs on the stone. That assumption also makes it

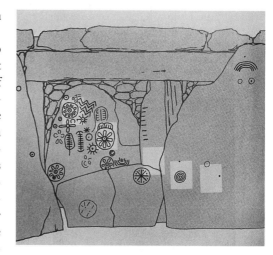

PLATE 11.3 *Martin Brennan. Diagram of sun's track across Stone 14 on the summer solstice. ca. 3500 B.C.E. Loughcrew, Ireland.*

plausible that the backstone has four distinct kinds of signs: In addition to the sun signs there are the zigzag lines at the upper right, two U-shaped sets of concentric half-circles at the bottom, and four herringbone signs (one just right of the zigzags). With the addition of whorls and cupules, the suns, half-circles, zigzag lines, and herringbones comprise an almost complete inventory of signs on the stone.

The problems begin when allomorphs stray so far from their normative instances that they start to look like new signs. The four herringbone signs, for instance, are each quite distinct. The one at the lower left is struck through by a vertically aligned pole shape, and ringed by a flattened oval. The one just to its right is missing most of its oval outline. The one at the top right is divided in two by its central pole, so that it looks like two combs. Just below it, the fourth herringbone is a single comb, turned so it is horizontal, with no outline. If we choose to see those as significant differences, we begin producing a large signary. The problem is analogous to the proliferation of characters in the proto-

14. McMann, *Loughcrew: The Cairns* (Oldcastle, Co. Meath: After Hours Books, 1993). Twohig has made a number of tracings and accompanying analysis; for example, her *Megalithic Art of Western Europe* (Oxford: Oxford University Press, 1981) and *Irish Megalithic Tombs* (Princes Risborough, Buckinghamshire: Shire Publications, 1990).

Elamite script (see Plate 5.7): It is insoluble, but it reveals the amount of variation we're willing to tolerate in a sign, and whether we're willing to allow one sign to vary significantly more than another.

The possibility of nondisjunction introduces another difficulty. The last herringbone sign might also be affixed to the sun sign below it, producing a new sign. Grammatically speaking, it would be a superfix (an affix that modifies a sign by attaching above it, as in some Mayan glyphs). Tomsohn, Shee Twohig, and McMann all interpret a faint curving line to the left of the last herringbone as a kind of connection between it and the third herringbone sign above it. To me the curve appears as a framing line, but if it is syntactically meaningful, then the two herringbones and possibly even the sun sign below them are all part of a single composite sign. This decision turns on another of the traits of writing, the fourth requirement that framing elements be distinct from signs. There are several possible ways to adjudicate the problem. A few other stones in the cairn have sinuous lines that seem to cling to the contours of other signs (one is visible, for example, on stone number 2). All such lines could be classified either as framing lines, as integral parts of larger signs, or as ligatures. It is also possible to consider this as a problem of segmentation. We might agree to segment any signs that have oval outlines, which would imply that this configuration is best read as three signs and a curvilinear framing mark.

Decisions like these are what allow reading to begin by lending stability to the basic assumptions about marks, signs, and characters. Although much of the scholarship on Loughcrew and similar sites focuses on semantic relations, it is important to note that no agreement on that score is possible without some prior attention to syntactics. This is just as true now as it ever has been. In a recent book the astronomer Tim O'Brien says the backstone has exactly four sun signs, and that the "most important" one (*second from left* in Plate 11.3) marks the equinox. He calls the "leaf" signs "grading symbols," as if they were primitive rulers. All this is done without justification, making his account impossible to correlate with others. (Some of his assumptions are clear enough: The "grading symbols" are reminiscent of *x-y* graphs.) [15] It's not that constructive dialogue is impossible; it's that it

depends on the explicit dissection of assumptions. Semantic differences can only be adjudicated by syntactic agreements, and syntactic agreements can only be reached when the principles of analysis are made explicit.

Once a signary is provisionally fixed, it becomes possible to think about larger units of syntax. The herringbone signs might be said to rise along a diagonal from the lower left to the upper right, and if I propose that pattern I must also allow diagonals as a principle of organization. The concentric half-circle signs also rise along a parallel diagonal (see Plate 11.4), and the suns fall along two diagonals: one, as Brennan says, from the upper left to the lower right, and another from the upper left to the lower left along the lefthand margin of the stone. Such judgments entail a certain tolerance, and it would be possible to describe that tolerance, or propose standards that are more exacting. Given the propensity of neolithic engravers in the Boyne Valley to fill the available space with whorls, meanders, cupules, and other iterated forms, it would also be possible to see the backstone as a set of five or six signs and a nonsemiotic "fill." [16] Brennan's is the most restrictive of this kind of assumption, as he effectively denies that any of the signs are semantically or syntactically meaningful except the first three sun signs. Any extended reading is a crippling assumption because it prevents any parallels with other stones.

Once a set of assumptions have been put in place, reading can begin. In this case, and within the limits of this description, I would propose the backstone is comprised of four signs, repeated along two opposing diagonals. Because that composition is otherwise unknown in related passage tombs, it would have to be tested by comparison

15. He also reads spirals as graphical indicators of the progress of light on successive days: Light that penetrates farther each day, as it does before the equinox, is recorded by clockwise spirals, and vice versa. The identification of the "leaf" signs with "grading symbols" also assumes that the sun was perceived to move up or down the central line, that the other symbols on the backstone were not used, and that each horizontal mark is two days. O'Brien, *Light Years Ago: A Study of the Cairns of Newgrange and Cairn T Loughcrew Co. Meath Ireland* (Dublin: Black Cat, 1992), 39, 42, 49.

16. See, for example, George Eogan, *Knowth and the Passage Tombs of Ireland* (London: Thames and Hudson, 1986).

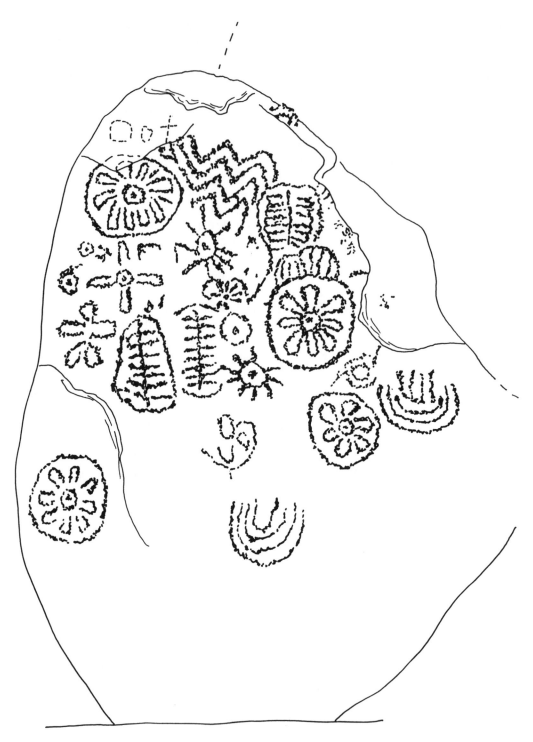

PLATE 11.4 *Elizabeth Shee Twohig. Drawing of Stone 14, Loughcrew, Ireland. ca. 3500 B.C.E.*

with other sites. Eventually any act of reading doubles back on itself, questioning the reader's assumptions; but at least this way the assumptions are presented as such, making the conditions of the possibility of reading the subject of discussion, rather than pinning dialogue on ritual, linguistic, astronomical, seasonal, and other semantic interpretations. An interpretation that set out to counter mine could address my assumptions about signaries and character-indifference rather than my

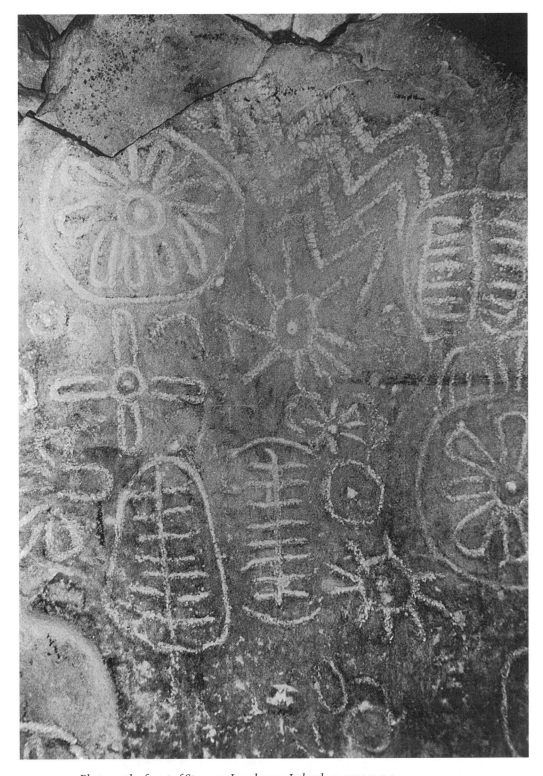

PLATE 11.5 *Photograph of part of Stone 14, Loughcrew, Ireland. ca. 3500 B.C.E.*

conclusion about diagonal lines.[17] The list of the traits of writing is very general, and also quite open-ended; the form I have given it in this book is suited to the examples I have chosen. But it turns out that "traits" are how we recognize legible meaning in difficult artifacts, so that lists like the one I have given can tell us a great deal about what we expect from any occurrence of apparently meaningful marks.

THE HYPOGRAPHEMICS
OF CONTEMPORARY PAINTING

It might appear that most hypographemic images are more orderly, and that the interpretive aporia that surrounds neolithic passage tombs is not a typical instance. Certainly contemporary painting benefits from a vast, if contested, range of comparable interpretations. But in a fundamental sense, any individual act of reading must begin from such assumptions, and the contemporary discourse is structurally analogous to the archaeological readings I have just sampled. Confronted with artifacts partly comprised of nondisjoint signs, viewers try to rectify the traits of writing until they can proceed with some favored habit of reading. In archaeoastronomy, the reading has to be precise (Brennan must assume that a sunlike sign denotes the sun); in contemporary painting, the reading can be less engaged (a critic might be content to "take the temperature" of a reading, or note that one might be possible).

The next, and penultimate, step on the way to "pure pictures" is hypograms, images lacking not only all syntax and formatting but also all disjunction. By definition, such an artifact would have to appear as a single fused sign, or a conglomerate object whose parts are inextricable. In a strong sense, that is a fair definition of painting: Paintings are understood to be images whose parts, no matter how clearly articulated they might be, are fundamentally fused into a single painted surface. In any event, most art historians and critics do not do more than acknowledge that source of unity, even though a painting would cease to be a painting if its figures and signs were actually disjoint. I take that as further evidence of our preference for reading, even when it seems only vaguely possible that an image might be related to writing. Still, there are some images that force the issue, compelling

viewers to understand them as wholes, and to contemplate their illegibility. Prehistoric potter's marks are examples, as they can seem to be conglomerated from several signs; and Taoist "talismans" are another (Plate 11.6). The talismans were part of Taoist initiation ceremonies; they were intended to be illegible, and their illegibility was ensured by running characters together into rivulets of meaningless strokes.[18] Some characters in the third seal of the *Sixth and Seventh Books of Moses* also approach this effect (see Plate 9.1).

All such practices bear on modern paintings that refuse to allow themselves to be "segmented." Examples could be brought to bear from early Kandinsky (where images are half-visible, embedded in matrices of abstract gestures) to Pollock's all-over paintings (in which figures are gradually obliterated by a violent overlay of marks and drips). In Mark Tobey's wilder ink-brush paintings the thought of legible calligraphy is continuously obliterated as the beholder looks (see Plate 7.15). Some of Jean Fautrier's canvases are especially close to

17. Brennan's solar trajectory and the crossed diagonals I have posited are both instances of notation, and not reading. (Brennan's is a graph, and mine is a grid of X's.) As such, they could be expanded or checked by correlating them with other hypotheses about notation in prehistoric images. The origins and development of notational practices from the Paleolithic onward are the subject of a large literature. Alexander Marshack's model of Paleolithic notation is one of the most accurately defined; he understands it as regular, iterated, "time-factored" practice that typically results in notches cut in sequence along register lines. In Elkins (1997) I argue that Marshack's methods depend on some of the same assumptions I have been proposing here: that decoration can be distinguished from notational marking, that marks do not coalesce into meaningful compound signs, that some notational marks are syntactically meaningful and others are not.

18. See Charles Benn, *The Cavern-Mystery Transmission: A Taoist Ordination Rite of A.D. 711* (Honolulu: University of Hawaii Press, 1991), and Anna Seidel, "Imperial Treasures and Taoist Sacraments — Taoist Roots in the Apocrypha," in *Tantric and Taoist Studies in Honour of R. A. Stein*, ed. Michel Strickmann (Brussels: Institut Belge des Hautes Études Chinoises, 1983), vol. 3, 305–52. At least one such talisman is anatomized into its components: see *Tao-tsang*, 216–19: 19b–20a, reproduced in Laszlo Legeza, *Tao Magic: The Secret Language of Diagrams and Calligraphy* (London: Thames & Hudson, 1975), 90 and fig. 66. The *Tao-tsang* numbers are as in Léon Wieger, *Taoisme*, 2 vols. ([Ho-chein-fu,] 1911–13). I thank William Alspaugh, Bibliographer of Chinese Studies, University of Chicago, for assistance with the *Tao-tsang*.

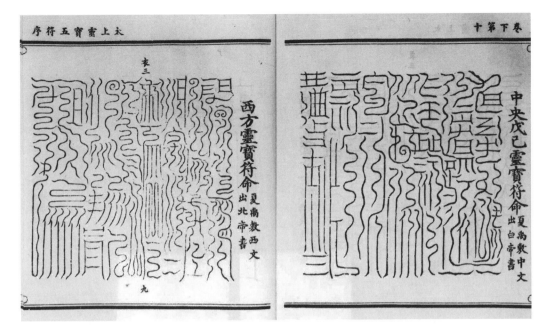

太上靈寶五符序

PLATE 11.6 *Taoist Ling-pao talismans. Left: talisman for the Sovereign of the West. Late third century* C.E.

the end of writing, in which written signs seem to be in the process of fusing into one another and into their material background (Plate 11.7).[19] Fautrier's *Tourbes* (1957) is painted griffonage (illegible handwriting). It is like a page of script gone out of focus — the writing has degenerated into a blur of undulating gestures, as if his hand is too exhausted to form the characters. At the same time the writing surface has thickened and congealed around what is left of the written marks. No single sign remains. Instead there is the sense of legibility, the memory of reading and writing.

Somewhere just beyond these melted images is the "pure picture": the indivisible object, the perfect holomorph, the structureless image. I can think of two senses in which such an impossible object can be said to exist: first, in imagination, as the siren that calls to any viewer who wants to see beyond writing; and again, as an illusion, whenever it seems that an image is significantly purer, more empty, or more uniform than anything that has come before it. Some landscape paintings have had that effect on viewers, when it seemed they had elided the rules of signification by depicting *nothing*, by being in no known genre, and by having no primary meaning.[20] For our century the central example is probably photography, as it presents itself as a seamless excerpt of the world. There

are also monochrome compositions by Kasimir Malevich, Yves Klein, Robert Rauschenberg, Ad Reinhardt, Mark Rothko, and Frank Stella that have appeared at times to be utterly indivisible. All such apprehensions are mistaken, and I take them as evidence that the desire for pure pictures persists even in the face of obdurate evidence to the contrary.

The elusiveness of pure pictures is one moral I would draw from this journey away from writing; another is its opposite and complement, the unquenchable desire for writing. I have tried to make the point that interpretation itself is strained when the images grow less and less like received ideas of either writing or picturing. The strain literally collapses interpretation. Either it is a matter of enjoying the images by bathing in a half-light of tentative conjectures, inconsistently applied, or it is an

19. See *Fautrier, 1898–1964,* ed. Suzanne Page (Paris: Musée d'art moderne de la Ville de Paris, 1989), cat. 150.

20. See, for example, Creighton Gilbert, "On Subject and Not-Subject in Italian Renaissance Pictures," *Art Bulletin* 34 (1952): 202–16, and Salvatore Settis, *Giorgione's Tempest, Interpreting the Hidden Subject,* trans. Ellen Bianchini (Chicago: University of Chicago Press, 1990); the subject is discussed at length in my *Why Are Our Pictures Puzzles? The Modern Origins of Pictorial Complexity* (New York: Routledge, forthcoming).

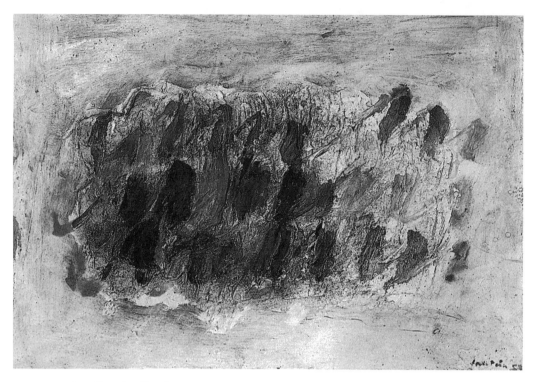

PLATE 11.7 *Jean Fautrier.* Tourbes. *1957.*

all-out struggle for analytic dominion over the most elusive and technical requirements of reading or notation. The difference is profound, and it is no wonder that the art world had opted for looser and less conclusive approaches. On the other hand, I have been trying to argue that both routes are responses to the same working notions of pictures, writing, and notation. Purity of meaning (in writing or notation) or meaninglessness (in pictures) is still the elusive ideal, and its persistent absence still makes our interpretations lazy or overzealous. We are still drawn to a certain specific kind of half-discovered meaning, infinitesimally close to "pure" pictures.

We take the greatest pleasure in pictures that toy with the traits of writing, and the habits of reading. We take the least pleasure in images that set out the rules too exactly. Our pleasure sours whenever any one trait of writing becomes too clear. I

was disappointed to find that the backstone at Loughcrew has a fairly clear signary, but glad to find a high variability among the individual signs. The traits of writing (and of notation, which come up in the next chapter) are bitter pills, and in my experience Goodman's *Languages of Art* is a dry and unpleasant experience for many readers. That is not just because the rules and theories are exacting, but because they are things we don't want to know — or, rather, we don't want to know that we already know them. Hypographemics is as far from the rules as it is possible to get. The rules are most thoroughly ruined in paintings by Fautrier or Pollock, and in the incomprehensible images of places like Loughcrew. It is as if writing had become decrepit but was lingering on, just strong enough to infect pictures with a faint but persistent sense of meaning. Perhaps it is the illness of writing and pictures that attracts us most.

12 : Emblemata

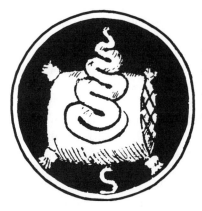

o we begin again, this time starting from mixtures of obvious pictures and real writing, and moving out and away from both and toward notation. The idea is to triangulate the domain of images and to complement the irregular journey from writing to pictures that has occupied the last five chapters.

Simply judging by quantity, and looking only at contemporary popular culture in the West, the images that form the subject of this chapter are the most numerous class of all. An emblem as I mean it is any image that includes an explanatory text: Without the text, the image would be slightly (or completely) baffling, and the two work together to make sense. (Or so it is in normative cases; there are many deviant examples.) Emblems therefore include most illustrations in books (in which captions are the explanatory texts) and virtually all advertising (in which the texts include slogans and "copy"), and I also mean emblems as that word is properly understood — that is, the text–image combinations popular in the late Renaissance and Baroque.[1]

So defined, the subject encompasses "word and image" studies in art history, including words that are sometimes written onto banners and scrolls in paintings of the Annunciation, graffiti in Dutch interiors by Pieter Saenredam, newspaper names and headlines in cubist painting and collage, and even paintings in museums together with their labels, either nailed to the frames or glued to the wall. It includes as well the letters in the ornamental or "drop" capitals that begin each chapter of this book, as their minimal texts account for (and often resonate with) the surrounding images.[2] Some ornamental capitals are just that — letters on decorative fields — but others are fully fledged emblems, with mottos, or capitals embedded in emblems.[3]

1. For emblems in general, see William S. Hekscher and Karl-August Wirth, "Emblem, Emblembuch," *Reallexikon zur deutschen Kunstgeschichte,* ed. Otto Schmidt, vol. 5 (Stuttgart: Alfred Druckenmüller, 1959), cols. 85–228; Arthur Henkel and Albrecht Schone, *Emblemata, Handbuch zur Sinnbildkunst des XVI. und XVII. Jahrhunderts* (Stuttgart: J. B. Metzlersche Verlagsbuchhandlung, 1967), with a *Supplement* (1976); and Mario Praz, *Studies in Seventeenth-Century Imagery,* 2d ed. (Rome: Edizioni di Storia e Letteratura, 1964–74), 2 vols. Hessel Miedema, "The Term 'Emblema' in Alciati," *Journal of the Warburg and Courtauld Institutes* 31 (1968): 234–50, is a convincing argument that aspects of modern emblem studies are anachronistic. Relevant specialized studies include *The European Emblem: Towards an Index Emblematicus,* ed. Peter Daly (Waterloo, Ontario: Wilfrid Laurier University Press, 1980); Daniel Russell, *The Emblem and Device in France*

(Lexington, Ky.: French Forum, 1985); and *The European Emblem,* ed. Bernard F. Scholz, Michael Bath, and David Weston (Leiden: E. J. Brill, 1990).

2. In addition to the sources named for each drop capital in the List of Plates, see the elaborate capitals in F. Hoffenroth, *Trachten-, Haus-, Feld-, und Kriegsgeräthschaften der Völker alter und neuer Zeit,* 2 vols. (Stuttgart, 1884–91); and the collection in *Early Venetian Printing Illustrated* (New York: Scribners, 1895).

3. One of the most elaborate Renaissance examples is Giacomo Paulini's unnamed alphabet: Paulini, [*Alfabeto antico*] (S.l.: s.n., c.1565), in which classical mythological scenes are set in landscapes, with ornamental figured frames.

ORI APOLLINIS

Quo modo Deum.

Oculo picto Deum intelligebant, quòd vt oculus quicquid fibi propofitum eft intuetur, fic omnia Deus cognofcit ac videt.

PLATE 12.1 *Emblem of God. 1551. Woodcut.*

Claude Paradin's "device," which opens Chapter 8, was actually the arms of a soldier.[4]

Only a few of these examples are descended from Renaissance emblems, but the term *emblemata* is a good one for the vicissitudes of linked texts and images, because many of the structural possibilities in advertising and book illustration were played out most fully in the Renaissance. Karl Josef Höltgen calls the realm I have in mind "applied emblematics": the study of "emblematic forms" in general, using the terms and possibilities of Renaissance emblems as a guide.[5]

Another virtue of linking so many disparate images to the word *emblem* is that the original Renaissance and Baroque emblems have a few well-understood and nearly invariant parts. The two most fundamental are present in this image from a 1551 edition of Horapollo's *Hieroglyphica* (Plate 12.1).[6] The image itself was generally called the *pictura*, or alternately the *icon, imago,* or *symbolon.*[7] Each word has its different resonance, and it is sometimes helpful to distinguish them. This emblem is fundamentally a landscape, and the best term for that is *pictura,* although it might also be called *imago* (a word associated more specifically with humanist practice). The floating eye is strongly nonnaturalistic, and it makes the everyday *pictura* into a *symbolon* — a symbolic image. If the eye had been accompanied by the rest of the figure, *icon* would have been better, as icons frequently depict single figures.

The accompanying text, which might be a caption, headline, legend, or "copy," was originally called the *inscriptio.* It normally consisted of a phrase, a verse, a sentence, or a single word (as in Cesare Ripa's *Iconologia,* in which allegorical figures are named simply "Prudentia" or "Fortuna").[8] In this example it is the phrase *quod est deum,* "how God is [represented]."[9] The *inscriptio* is normally above the *pictura,* but it can also be below or around it (as in circular emblems), and even within it (that is, somewhere in the space of the picture itself). Occasionally the *inscriptio* was called a *titulus,* conjuring the most famous "caption" in Western art, the little sign bearing the acronym I.N.R.I. (*Iesus nazarenus rex iudaeorum*) that is shown attached to the cross in scenes of the crucifixion. Other synonyms are *motto* (evoking the moral purpose of many emblems), *lemma* (with overtones of geometric proofs, in which lemmas are ancillary demonstrations), and *sentence.*

4. Paradin, *The Heroicall Devises of M. Claudius Paradin* (London: W. Kearney, 1591), reprinted (Delmar, N.Y.: Scholar's Facsimiles and Reprints, 1984), 296–97. The motto is *Hâc virtutis iter,* "This is the waie to vertue," because "labour doeth make the waie to attaine unto vertue."

5. Höltgen, *Aspects of the Emblem, Studies in the English Emblem Tradition and the European Context* (Kassel: Reichenberger, 1986), 91. I thank Bruce Baldwin for bringing this book to my attention.

6. For Horapollo, see *The Hierogyphics of Horapollo,* trans. George Boas (Princeton, N.J.: Princeton University Press, 1993 [1950]); Claude-Françoise Brunon, "Signe, figure, langage: Les *Hieroglyphica* d'Horapollon," *L'Emblème à la Renaissance,* ed. Yves Giraud (Paris: Société d'Édition d'Enseignement Supérieur, 1982), 29–48; R. Aulotte, "D'Égypte en France par l'Italie: Horapollon au XVI e siècle," *Mélanges à la mémoire de Franco Simone: France et Italie dans la culture européene* (Geneva: Slatkine, 1980).

7. The terms are listed in Céard and Margolin (1986), 63.

8. Cesare Ripa, *Iconologia* (Rome: Gli heredi di Giovanni Gigliotti, 1593), and for Ripa see also Erna Mandowsky, *Ricerche intorno all'Iconologia di Cesare Ripa* (Florence: L. S. Olschki, 1939); Émile Mâle, *L'Art religieux apres le Concile de Trente* (Paris: A. Colin, 1932); and Gerlind Werner, *Ripa's Iconologia: Quellen-Methode-Ziele* (Utrecht: Haentjens, Dekker & Gumbert, 1978).

9. Edgar Wind, "The Concealed God," in *Pagan Mysteries in the Renaissance* (New York: Barnes & Noble, 1968), 218–35, esp. 232 and fig. 84.

In some emblems the basic *pictura* and *inscriptio* are accompanied by a verse description, variously called the *subscriptio, declaratio,* or *epigramma.* In this example, the *subscriptio* is a sentence that might be translated: "An eye is understood as a picture of God, because just as the eye can see everything it is shown, so also God sees and understands everything." The modern analogue to the *subscriptio* would be a discursive caption, and like a caption, the *subscriptio* was normally formatted along with the emblem itself, either below it or on a facing page. In museums, paintings sometimes have minimal *inscriptiones* on the frames themselves, and longer *subscriptiones* on the adjacent wall. Advertisements often have slogans (*inscriptiones*) and copy (*subscriptiones*). If it weren't for the formatting, the *subscriptio* would blend into the more general concept of explanatory text (such as these paragraphs that gloss the emblem), ultimately including the entire book in which the emblem appears. Naturally that and other heresies were entertained almost from the beginning of Renaissance practice.

Pictura, inscriptio, and *subscriptio* are a durable triad, although they have been at odds with one another since they were first linked in the Renaissance.[10] Part of the fascination of Renaissance emblems and of modern advertisements is the tension between the puzzling image, the laconic *inscriptio,* and the mobile and apparently dissociated *subscriptio.* That tension affects reading and looking, as the viewer is often not entirely sure where to look first or where to look for an explanation. *Picturae* like the one in this example have to be interpreted, and some *subscriptiones* do not provide enough information to do so. Here the line "how God is represented" isn't enough, and the *subscriptio* is needed to clarify the point. Having read it we look back at the *pictura,* checking the image to recognize the eye that is at once an eye, God's eye, and God himself. Each successful emblem slightly subverts the viewer's or reader's expectations, diverting looking into reading and turning reading back into looking.

The Western fascination with emblematic meanings is well described in Plotinus's theory that emblems descend from Egyptian, a script whose pictures were thought to convey direct, unmediated experience of truths unhampered by the contingencies of the alphabet.[11] The problem, as Plotinus

knew, is that without a dictionary (which the ancient world did not possess in any case) actual hieroglyphs are illegible, so that even though an emblem is the very summit of direct expression, it needs a text to explain it. That dilemma captures the essential tension of emblems: Their pictures promise immediacy, but they end up requiring protracted decipherment. (Advertisers bank on their ability to keep people's attention while they decipher content and intention. Advertisements like Benetton's ethically dubious, surrealistically obscure third-world scenes can succeed in postponing any satisfactory understanding almost indefinitely.)

Emblems also present themselves as fundamentally disunified modes of expression. In the history of emblemata there have been attempts to make the *picturae* self-explanatory, so that texts would not be necessary, or to have the *picturae* engulf the texts, forging a tighter unity, or — in deliberate misapplication of the principle of emblems — to write texts that fail to explain the *picturae,* so that the *picturae* become even more enigmatic. In each variant it is possible to follow the workings of a desire to unify *subscriptiones, inscriptiones,* and *picturae* into a single, supremely evocative fusion of inadequate words and inexplicable images. In that respect it plays out, in a different guise, the desire for an image that doesn't quite make sense, that works like a trap to keep the viewer's attention. The history of emblems can be told as the history of negotiations between the desire for unified expression and the interesting possibilities afforded by dividing a viewer's attention, shuttling it between text and image, and suspending it in a state of deliberate partial mystification. An emblem, it has been said, is a rigorous but inexplicit allegory — that is, it doesn't reveal all its meanings (*tota allegoria*), but hides some (*permixta apertis allegoria*), which is a good formula for the mesmerizing mixture of the explicit and the implicit, the rigorous and the open-ended, the significant and the meaningless.[12]

10. See Schenck (1973), 59, and the excellent historical essay by Daniel Russell, "Emblems and Hieroglyphics: Some Observations on the Beginnings and Nature of Emblematic Forms," *Emblematica* 1 (1986): 227–39.

11. Plotinus, *Enneads* 5:8.

12. Daniel Russell, *Embematic Structures in Renaissance French Culture* (Toronto: University of Toronto Press, 1995), 39, citing Henri Morier, *Dictionnaire de poétique et de rhé-*

These properties of emblems can be found in an extremely wide range of images. Coins are a ubiquitous example. Numismatists make an inviolable distinction between the figure, called the device, and the ground, called the field; the two comprise the image, which is opposed to the inscriptions.[13] Coins normally don't have long texts (*subscriptiones*), because all inscriptions have to be short; but they often distinguish between laconic or "enigmatic" inscriptions — "E PLURIBUS UNUM" — and longer explanatory texts — "UNITED STATES OF AMERICA / QUARTER DOLLAR." (Those are the texts on the reverse of the Washington quarter.) To that extent, they preserve the triad of *inscriptio, subscriptio,* and *pictura.* Numismatics as it is usually understood is a subset of glyptics, comprising the study of coins and also antique gems, medals, signet rings, and wax stamps.[14] Yet even extremely complex coins, such as one minted by the Renaissance herbalist and Paracelsan Leonhard Thurneisser zum Thurn, possess the basic elements of emblems (Plate 12.2).[15] Thurn's medallion was made of silver (the moon's metal), and has an image of the moon on the obverse, surrounded by an annulus of texts and symbols taken from Cornelius Agrippa, referring to lunar spirits that might cure lunar ailments. The reverse has a magic square and four lunettes with other inscriptions and symbols. Despite its hermetic intent and dense symbolism, it creates the same sense of enigma and provokes the same search for meaning, as contemporaneous emblems.[16] The viewer looks from the picture to the text, hoping one will illuminate the other; the only difference between Thurneisser's medallion and the ubiquitous Washington quarter is that Thurneisser set out deliberately to foreclose any solution. That's not to say the American quarter is not enigmatic: To virtually every user, the eagle with its fascia and leaves, and the motto "E PLURIBUS UNUM," remain as opaque as Thurneisser's sigla for lunar deities. The essential common ground is the play between odd picture, odd short text, and (hopefully) lucid longer text.

13. For an early example, see Guillaume Du Choul, *Discours de la religion des anciens Romains* (Lyons: Guillaume Rouille, 1556).

14. For formally complex coins, see first the classic work by E. A. T. Wallis Budge, *Amulets and Superstitions* (New York: Dover, 1978 [1930]); George Frederick Kunz, *The Curious Lore of Precious Stones* (Philadelphia: J. B. Lippincott, 1913); Kunz, *Magic of Jewels and Charms* (Philadelphia: J. B. Lippincott, 1915); Reginald Campbell Thompson, *The Reports of the Magicians and Astrologers of Nineveh and Babylon in the British Museum* (London: Luzac, 1900), reprinted (New York: AMS Press, 1977); Thompson, *The Devils and Evil Spirits of Babylonia* (London: Luzac, 1903–1904); and Thompson, *Semitic Magic* (London: Luzac, 1908). The great majority of writing on coins is concerned with classification. The exceptions are rare; see, for example, Carol Humphrey and Vivian Sutherland, *Art in Coinage: The Aesthetics of Money from Greece to the Present Day* (London: B. T. Batsford, 1955). An unusually reflective book is George MacDonald, *Coin Types: Their Origin and Development* (Glasgow: James Maclehose & Sons, 1905), reprinted (Chicago: Argonaut, 1969). For the technique of glyptics, see Johann Lorenz Natter, *Traité de la méthode antique de graver en pierres fines* (London: J. Haberkorn, 1754), discussed in Barbara Stafford, *Body Criticism* (Cambridge, Mass.: MIT Press, 1993), 56. For signets, see Annemarie Meiner, *Das Deutsche Signet: Ein Beitrag zur Kulturgeschichte* (Leipzig: H. Schmidt, 1922).

15. J. C. W. Moehlen, *Beiträge zur Geschichte der Wissenschaften in der Mark Brandenburg . . . I. Leben Leonhard Thurneissers zum Thurn . . . II. Fragmente zur Geschichte der Chirurgie von 1417 bis 1598 . . . III. Verzeichnis der Dohm-und Kollegiatstifter . . .* (Berlin and Leipzig: George Jakob Decker, 1783), part 1, reprinted as *Leben Leonard Thurneissers zum Thurn* (Munich: Werner Fritsch, 1976), 226.

16. Like some emblems, some coins have no inscriptions. A textless version of Thurn's coin exists; if anything, it is more enigmatic. See Israel Hiebner, *Mysterium sigillorum, herbarum et lapidum, oder, Volkommene Cur und Heilung aller Kranckheiten, Schaden und Leibes* (Erfurt: In Verlegung Johann Birckners, 1651 *et seqq.*), 163.

torique, 3d ed. (Paris: Presses Universitaires de France, 1981), 71–72. The distinction is originally Quintilian's; he distinguishes pure allegory from the mixed forms typical of oratory by saying that the latter has "an admixture of plain meaning" (*plerumque partis permixta est*). *Institutio oratoria* VIII.vi.47, translation as in *The Institutio Oratoria of Quintilian,* trans. H. E. Butler (Cambridge, Mass.: Harvard University Press, 1986 [1921]), 329. The theory of allegory and emblemata that could be constructed from these beginnings is different from the current revival of the term in art theory, although the two could find common ground. See Stephen Melville, "Notes on the Reemergence of Allegory, the Forgetting of Modernism, the Necessity of Rhetoric, and the Conditions of Publicity in Art and Criticism," *October* 19 (1981): 55–92, reprinted in Gilbert Jeremy-Rolfe and Melville, *Seams: Art as a Philosophical Context,* Critical Voices in Art, Theory, and Culture, ed. Saul Ostrow, vol. 1 (Amsterdam: Gordon & Breach, 1996), 147–86.

PLATE 12.2 *Leonard Thurneisser zum Thurn. Medal. ca. 1580.*

The round format, in which an apparently symbolic figure is set against a flat field, is also common to bas-relief *tondi*, shields, stained-glass roses, Eucharistic wafers with stamped images, buttons, and some medals and medallions. There are also intricate combinations of symbolic images and texts in rectangular formats — for example, in postage stamps, bonds, certificates, tickets, stocks, some passports, miscellaneous legal documents, and paper money.[17] Each of these has its history, and the survey of all images I imagined in the Preface would have to include them. (Some are difficult to study because collections are not accessible; paper money, in particular, has yet to have a satisfactory general history.)[18] Like coins, many of them include notations along with writing: numbers, bar codes, and even magic squares.

So I would suggest that *picturae, inscriptiones,* and *subscriptiones* are common elements of meaning in all images that have attached texts. They entail several obligations, as the artist balances pictorial and textual expectations against each other.

First, it is necessary to ignore or openly disobey the conventions of naturalistic pictorial narrative. Because an emblematic figure exists in order to signify a concept, there is no need for the normal apparatus of naturalism or visual storytelling. Two versions of Robert Estienne's printer's mark demonstrate the point (Plate 12.3).[19] In the full version (*left*), a figure stands next to an olive tree and points upward at several grafting bandages. He says "NOLI ALTVM SAPERE, SED TIME," the second sentence of Romans 6:19, "Because of unbelief the

branches were broken. Be not high minded, but fear." As he speaks, the tree's natural branches fall to the ground, broken by God. The injunction, "be not high minded, but fear," is addressed to those who have been "grafted" onto the tree of life, and are only sustained by their faith and by God's

17. The early history of British stamp design was especially influential, and its types can be found in many other kinds of images. See, for example, Hastings Wright and A. B. Creeke Jr., *A History of the Adhesive Stamps of the British Isles* (London: Philatelic Society, 1899); Bertram Poole, *The Pioneer Stamps of the British Empire* (Princeton, N.J.: D. van Nostrand, n.d. [ca. 1970]); and David Scott's excellent *European Stamp Design: A Semiotic Approach to Designing Messages* (London: Academy Editions, 1995). Non-Western stamps are also instructive examples of the reinvention and adaptation of emblematic formats invented in the West; see, for instance, *Catalogue of Mongolian Stamps,* ed. Mongolian Post Office and Philatelia Hungarica (Budapest: Hungexpo Nyomda, 1978); Arnold C. Waterfall, *The Postal History of Tibet* (London: Pall Mall Stamp Co., 1981 [1965]); and the periodical *Postal Himal.*

18. *Standard Catalogue of World Paper Money, Based on the Original Work of Albert Pick,* ed. Colin Bruce II et al., 8th ed. (Iola, Wis.: Krause Publishing, 1996), 2 vols.; Albert Pick, *Papiergeld-lexikon* (Munich: Mosaik-Verlag, 1978); Arnold Keller, *Das Papiergeld der altdeutschen Staaten* (Berlin: Selbstverlag, 1952); Wayte Raymond, *The Standard Paper Money Catalogue* (New York: s.n., 1953); and Robert Friedberg, *Paper Money of the United States* (New York: Coin and Currency Institute, 1953). Richard Patterson and Richardson Dougall, *The Eagle and the Shield: A History of the Great Seal of the United States* (Washington, D.C.: U.S. Government Printing Office, 1976), includes speculations on the Masonic meanings of the pyramid and eye.

19. For variations, see L. C. Silvestre, *Marques typographiques; ou, Recueil des monogrammes, chiffres, enseignes, em-*

PLATE 12.3 *Two versions of Robert Estienne's printer's mark.*

love (or, in this passage, something more like his tolerance).

If this were a painting or drawing, the figure would be expected to behave a bit more rationally — for example, by not standing underneath the tree as its branches fall around him. And although there are instances of Renaissance paintings representing objects in midair (stones thrown at St. Stephen, for example, arrested halfway to their target, or frozen just on the saint's forehead), it would not be normal to see a branch actually falling.[20] Nor would the artist be so indifferent to the figure's gesture; in some versions he seems to point in random directions on and around the tree, or to measure it between his thumb and index finger. (It is also unnaturalistic to have Geofroy Tory's personal siglum, the Lorraine cross, stuck in the ground like a tiny cartoon tree.) The different versions of the emblem reflect the variable skill and patience of several cutters, but they are united in their indifference to narrative protocol. Some omit the figure altogether, and one, enlarged here (Plate 12.3, *right*), shrinks the whole into a smudge the size of a large postage stamp. (It is appropriate that the small device ornaments the title page of a small octavo volume on the fragments of classical

poets, as it is itself not much more than a reminder of the full image.)[21] *Picturae* seem careless or insouciant about the fine points of pictorial story-telling, as if the artists were somehow oblivious of the contemporaneous conventions of painting.[22] The large image is attractive, but a viewer searches in vain for meaningful details. The small image has its own fascination, mostly because a reader would know, without really seeing anything, about the richness of meaning compressed into such a small

blemèmes, devises, rebus et fleurons, des libraires et imprimeurs qui ont exercé en France depuis . . . *1470, jusqu'à la fin du seizième siècle* (Paris: P. Jannet, 1853 – 67). The device of 1532 is also reproduced in Hugh William Davies, *Devices of the Early Printers, 1457–1560: Their History and Development* (London: Grafton & Co., 1935), 663.

20. There are interesting examples in emblems: fruit falls in an emblem in Joachim Camerarius, *Symbolorum et emblematum ex re herbaria* (Frankfurt: Impensis Iohannis Ammonij, 1661), no. 9, illustrated in Henkel and Schöne, *Emblemata*, col. 243, and in Sebastián de Covarrubias Orozco, *Emblemas morales* (Madrid: Por Luis Sanched, 1610), no. 77, in Henkel and Schöne, *Emblemata*, col. 224; an acorn, a leaf, and a small fragment (another leaf?) fall in Andreas Alciatus, *Emblemata* (Lugduni: Excudebat Mathias Bonhomme, 1550), 220, and in the German edition, Jeremias Held, *Liber emblematorum* (Frankfurt am Main: Georg Raben, 1567), no. 205 – 206, both in Henkel and Schöne, *Emblemata*, col. 219.

21. The book has the beautiful title *Fragmenta poetarum veterum Latinorum, quorum opera non extant: Enii, Pacuvii, Accii, Afranii, Lucilii, Naevii, Laberii, Caecilii, aliorúmque multorum* ([Paris]: Henricus Stephanus, 1564).

22. Robert's nephew Henri continued the family business but had less feel for images. His book *The Art of Making Devices: Treating of Hieroglyphicks, Symbols, Emblemes, Ænigmas, Sentences, Parables, Reverses of Medals, Armes, Blazons, Cimiers, Cyphers, and Repus,* trans. "T. B. of the Inner Temple" (London: Richard Royston, 1698), has little to say about the pictorial aspects of devices; like many other manuals, it is principally concerned with the Latin mottos.

space. Either way, a certain awkwardness can announce that a picture is an emblem, and set viewers out on a search for significant details. There are no rules for that search, and so viewers constantly light on forms that aren't significant. Each viewer has to find his own way.

Strictly speaking, *picturae* are not pictures but allographic variants on written signs. Drop capitals are ready examples. The drop capital at the beginning of Chapter 13 is the work of the early-seventeenth-century Spanish calligrapher Andres Brun. His C is wonderfully moonlike, but all the stranger because of it. The ornamental capital in Chapter 9 is ostensibly a picture of Samson at En-hakkore; at the lower left is the ox jaw spurting blood. It is a reasonable assumption that the artist chose the K (either as a Latin k or a Greek *kappa*) because of the name En-hakkore, but there can be no explanation within the image for the weird visual puns between Samson's pose, the obtrusive K, and the ox jaw with its arching stream of blood. The snake in the drop capital to this chapter is an instance of the letter S, just as the S beneath it is a bit like a thread or a worm. Much of the interest of emblems comes from the absolute impossibility of ignoring the allographic embellishments in favor of the root meaning, coupled with the sometimes insurmountable difficulty of assigning them meaning. Guy Demerson has noted that in emblems each of the "little world of objects and gestures is interesting in its own right, independently of its transposition into a symbol," but what makes the "little objects" so fascinating is the faint tug of the symbolic against the natural, the written against the pictured.[23] What could the little trees in the "puissance" emblem possibly mean? What kind of sense could it make to say the two k's in En-hakkore somehow lent their shape to the battle? What could it mean to put a scatological "snake" on a tufted pillow?

The second obligation is that the picture's landscape is normally ignored by the figures. To the extent that emblematic figures can be thought of as living, they can usually only know and express their purpose as signs. They normally don't acknowledge even the most spectacular settings, both because they are sealed into their symbolic roles and because everything aside from the essential signs must be meaningless. An alchemical emblem engraved by Johann Theodor de Bry for the seventeenth-century hermeticist Michael Maier shows four flaming spheres balanced on the surface of a tranquil Dutch canal (Plate 12.4). Two boats are making their way up the canal. The wind is still, and the nearer boat is being rowed. We might expect to see the passengers throwing up their hands in astonishment. But they can't acknowledge what's right in front of them, because they are not part of the symbolic import of the emblem.[24] All that matters is four spheres, resting on water (Maier's text is concerned with the four "grades of fire" in the alchemical work)—and therefore no figure can walk or row through the landscape and be amazed by what he sees. There is no word to describe what these people are: They aren't travelers or fishermen or any ordinary sorts of people, and they aren't even decoration (they contribute to the sense that the fires are qualities of the everyday world). They are gaps in the emblem, present absences.

Third, and as a consequence, the picture's landscape must also be ignored by the viewer. Maier's plate is full of wonderful incidents: a scruffy outhouse, a looming dark cloud, well-observed trees. But we are not allowed to see them, any more than the fishermen are allowed to, because the picture is part of an emblem. Needless to say we do see them, and book collectors, students of hermetic philosophy, and art historians would agree that the value of Maier's emblems is significantly increased on account of their skill — that is, the artist's ability to render just these "meaningless" objects. Emblems are fascinating in part because of the willful blindness that we are expected to indulge, and the nearly impossible task of finding a place for our "irrelevant" pleasure in the reading of the emblem. A strange kind of meaninglessness and nonexistence plagues the "decorative" elements of emblematic *icones,* and it becomes a source of pleasure detached from the protocols of reading but intimately connected to our interest in the emblems as wholes.

23. Demerson, "Reflexions de synthese," in *L'Emblème a la Renaissance,* 151.

24. It could be argued that they do not see because they have "profane eye" and are not ready for the mystery. Other plates in Maier's book could be used to argue against that interpretation, as there are oblivious "decorative" elements in many scenes. Maier, *Atalanta fugiens* (Oppenheim: Hieronymus Galler, 1618).

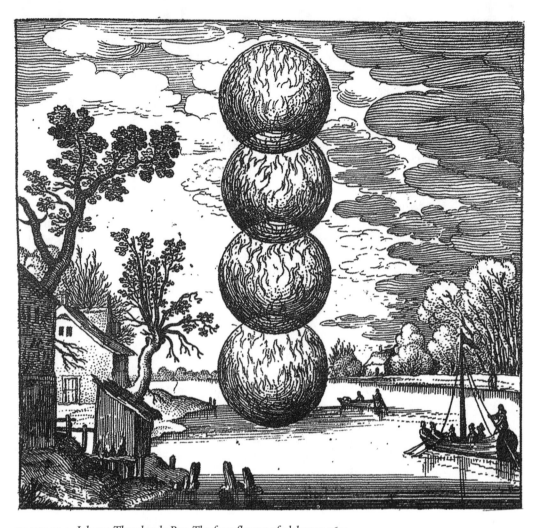

PLATE 12.4 *Johann Theodor de Bry. The four flames of alchemy. 1617.*

The fourth obligation is that, especially after the sixteenth century, the picture must not be entirely comprised of symbols; it needs to have its "meaningless" framing elements. Estienne's device and Maier's emblem are replete with "meaningless" forms, but even a crowded collection of symbols like Geofroy Tory's device-emblem will have some insignificant elements (Plate 12.5).[25] Tory says the broken vessel stands for the body, "qui est ung pot

de terre."[26] The book stands for human life, locked after death by three fates (the three chains) so that no one but God can read it. The plants signify virtues to which "the body" might aspire, and the sunbeams are heavenly inspiration. There is also a pun on Tory's name, as the vessel also supports a reel (an instrument for winding thread), which Tory calls a *toret*.[27] He says the reel represents *fa-*

25. P. J. Vinken, "Non plus ultra: Some Observations on Geofroy Tory's Printer's Mark," *Nederlands kunsthistorisch Jaarboek* 7 (1956): 39–52; Schenck (1973), 21–22; Roberts, *Printers' Marks*, 117. The phrase *device-emblem* is from Céard and Margolin (1986), 62; Tory himself calls his image a device but also a rebus ("Resbuz"). See Tory, *Champ fleury, auquel est contenue Art at Science de la deue et vraye Proportion des Lettres Attiques* (Paris: Geofroy Tory et Gilles de Gourmont, 1529), fol. 42v., also quoted in Schenck (1973), 106n50.

26. The theory that the pot commemorates the death of Tory's daughter Agnès is still repeated in the literature even though it was disproven in 1857. See Auguste Bernard, *Geofroy Tory* (Nieuwkoop: B. de Graaf, 1963).

27. There is a fair amount of terminological confusion about this object; it has also been called a *treuil,* a winch, a jeweller's drill, a wimble, a spindle, and a windlass. Most of the other options efface the parallel between a wound thread and the thread of life, woven and cut by the fates. Several are discussed and disproven in Vinken, "Non plus ultra."

MENTI BONAE
DEVS OCCVRRIT

NON PLVS

OMNIS TAN-
DEM MARCE-
SCIT FLOS.

PLATE 12.5 *Geofroy Tory. Printer's device. 1529.*

tum, "which pierces and influences" life, but he also uses the word *toret* without commenting on the pun. In that way he presents himself twice — once as a publisher, and again as a cipher. It might seem that this kind of emblematic image is more a symbolic image (a *symbolon*) than a picture — a *pictura* or *icon*. Yet even here, at the limits of symbolic density, the picture reasserts its "meaningless" nature. The reel is a beautiful piece of drawing, threaded through the vase's broken opening, gently canted against its rim, resting delicately on one point. The vase itself has much more detail than it needs, with its pendants, fluttering ribbons, and broken swag. They contribute an air of classical nostalgia, and a delicacy appropriate to the theme. Technically, they are not part of the symbolic structure, but any viewer will be alive to their potential meaning. They are what makes the *pictura* a picture and what rescues it from being merely legible. There are over fifteen variations of this device, all with slightly different details.[28] The problem for a viewer is knowing what to see, and what to read; this is a happy confusion, which softens the rigor-

ous but inexplicit allegory into an evocative game of implicit meanings.[29]

HERALDIC PETRIFACTION

A step further away from naturalism and "meaningless" forms, and toward symbolic content, brings us to heraldry. A coat of arms is still an emblem in my general sense, because it is a pictorial construction accompanied by an explanatory text. But heraldic compositions do not have pictures at their centers; instead they have heraldic shields, whose pictorial content is much more closely constrained. Books on the design of heraldry specify the permissible forms, names, positions, and linear styles of each heraldic device ("device" in this context means any heraldic symbol except a color), leaving very little open to improvisation.[30] There

28. Most are illustrated in Bernard, *Geofroy Tory.*

29. It has been suggested that the game, and the meaning, is open-ended and potentially infinite. Richard Cavell, drawing on Derrida's sense of "grafting" and "rupture," suggests that the mixed nature of the emblem opens the way to an interminable play of meaning. He adduces George Wither's *A Collection of Emblemes, Ancient and Moderne . . . Disposed into Lotteries, That Instruction and Good Counsell May Bee Furthered by an Honest and Pleasant Recreation* (London: Printed by A. M. for L. Grismond, 1635), reprinted (Columbia: University of South Carolina Press, 1975), in which emblems are playfully reinterpreted contrary to their original sense. But while it is true that emblems can provoke thoughts of infinite dissemination, in practice they seek and avoid meanings in historically determinate ways; that is especially true of hermetic emblems that are designed to avoid whatever sense seems to be emergent. See Cavell, "Representing Writing: The Emblem as (Hiero)glyph," in *The European Emblem: Selected Papers from the Glasgow Conference, 11–14 August, 1987,* ed. Bernard Scholz, Michael Bath, and David Weston (Leiden: E. J. Brill, 1990), 167–85.

30. Stephen Friar and John Ferguson, *Basic Heraldry* (New York: W. W. Norton, 1993), is a good introduction; then see Friar, *A New Dictionary of Heraldry* (Sherborne: Alpha Books, 1987). English material is emphasized in Arthur Charles Fox-Davies, *A Complete Guide to Heraldry* (New York: Dodge, 1909), reprinted, for example (London: Bracken, 1993), and based on Fox-Davies's *Art of Heraldry* (London: T. C. & E. C. Jack's, 1904); German material in Hugo Gerard Ströhl, *Heraldischer Atlas* (Stuttgart: Hoffmann, 1909). The connection between heraldry and emblems has been extensively explored by Michel Pastoureau; see, for example, "La Diffusion des armoires et les débuts de l'héraldique," in *France de Philippe Auguste: Le Temps des mutations,* Actes du Colloque International, ed. Robert-Henri Bautier (Paris: Éditions du Centre national de la recherche scientifique, 1982), 732–62.

are approximately fifty ways to "quarter" the shield — that is, to divide it into regions (by diagonals, in starbursts, and so forth) — and there are at least five thousand devices that can be placed in the quartered fields.[31] There are between three and five hundred kinds of crosses, and at least fifty "heraldic monsters" including such exotica as wyverns (dragons with two legs), yales (animals with the body of an antelope, tusks of a boar, legs of a lion, and two long movable horns), and alphyns (heraldic tigers with manes, long hair, and tails knotted in the middle). Each human figure, animal, or monster can be posed in at least fifteen *attitudes,* such as *sejant* (seated), *rampant* (on one leg), and *passant* (raising one paw). The nomenclature is wonderful and bewildering, and it provides names for most imaginable decorative schemes and symmetries, as well as for the paraphernalia specific to heraldica.

At their most complex, heraldic images have no parallel for systematic complexity. The shield can be quartered without limit, to make room for any genealogy or symbolic program — as we see in the righthand panel from a diptych shield made for Richard Plantagenet, Marquis of Chandos, son of the first Duke of Buckingham and Chandos (Plate 12.6). The Chandos family is the only one allowed to hold a five-part surname: Temple-Nugent-Brydges-Chandos-Grenville. The shield itself has 719 quarterings, each representing a branch of the family.[32] Every shape, number, color, decorative scheme, device, and "charge" (an object painted to appear in relief) has its name, and the 719 quarterings have their order that can be read as a genealogy.

The link between heraldry and emblems is best seen in the full coat of arms (Plate 12.7). (The terms *coat of arms* and *armorial bearings* are properly applied only to the shield, but in common usage they denote the shield and its surrounding objects.) There can be up to seven elements: a *compartment,* the ground on which the arms apparently rests; the *motto,* corresponding to the *inscriptio* in an emblem; the central *shield,* corresponding to the *pictura;* and four framing devices — the shield's two *supporters* on either side; the *helm* above, with its *crest;* the *wreath, torc,* or *torse* that covers the attachment of the crest and helm; and the *mantling* that flutters on either side of the helm.[33] Needless to say, each of the seven components of a coat of arms has its own nomenclature and rules.

Given this outlandish proliferation, it is not surprising that there is also a history of illegitimate elaborations, satires, fantasies, and rebellions against heraldic codes. Albrecht Dürer experimented with pictures made from the disassembled parts of coats of arms — for example, in this moralizing woodcut of 1503 (Plate 12.8). The compartment is still a bare stretch of ground, but it has expanded into a landscape. Tilted shields are found in heraldry, although this one looks fallen, and Dürer has made it slightly asymmetrical. A leather strap hooked on a forked stick precariously balances the remainder of the assembly: an elaborate helm, a crest in the form of a huge set of wings turned to the left, and a monstrously flourishing ribbon for mantling. The supporters have become a young woman and her "wild man" or wodehouse suitor. Supporters are often crowned, or have crowns around their necks (in which case they are said to be "gorged"), so the woman's crown is another heraldic device. There is no motto in sight (bar the artist's *cartellino* with his monogram), although the entire picture could be taken to imply a motto such as "The wages of sin are death." In the traditional reading, the man is Death, and he is impressing the woman with his noble coat of arms but concealing the fact that his one device is a death's head.[34] In the present context, it's interesting that Dürer could tell his story using nothing but the elements of heraldry. It is as if he could shake

31. Two of the most comprehensive surveys are John Woody Papworth, *An Alphabetical Dictionary of Coats of Arms* (better known by its running title, *Ordinary of British Armorials*) (London: T. Richards, 1858–74), reprinted as *Papworth's Ordinary of British Armorials* (London: Five Barrows, 1977); and Charles Norton Elvin, *Dictionary of Heraldry* (London: Kent, 1889), reprinted (London: Marlborough, 1977).

32. Stephen Friar, *Heraldry, For the Local Historian and Genealogist* (London: Alan Sutton, 1992), 21.

33. For crests and mottoes, see James Fairbairn, *Heraldic Crests: A Pictorial Archive of 4,424 Designs for Artists and Craftspeople* (New York: Dover, 1993), vol. 2 of *Fairbairn's Book of Crests of the Families of Great Britain and Ireland,* 4th ed. (London: T.C. & E.C. Jack, 1912). For mottoes, Charles Norton Elvin, *Hand-book of Mottoes* (London: ell and Daldy, 1860); and Sylvanus Morgan, *Armilogia, sive, Ars Chromocritica: The Language of Arms by the Colours & Metals* (London: T. Hewer, 1666).

34. For the idea that the woman doesn't see the death's head, see *Albrecht Dürer: Oeuvre gravé,* exhibition catalog, ed. Sophie Renouard de Bussierre (Paris: Petit Palais, 1996), cat. 157, p. 202.

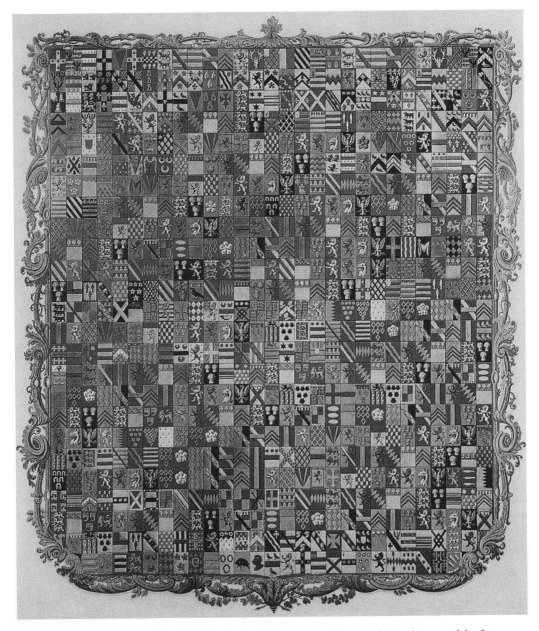

PLATE 12.6 *Half of the heraldic shield for Richard Plantagenet, Marquis of Chandos, son of the first Duke of Buckingham and Chandos, of the family Temple-Nugent-Brydges-Chandos-Grenville. Nineteenth century.*

a coat of arms, tumbling its components apart until they revealed themselves as a narrative picture.

Heraldry has affinities with other practices that divide images into compartments, such as signal flags, military ribbons, and perhaps even all-over Maori tattoos.[35] But there is no parallel for herald-

35. For signal flags, see George Henry Preble, *Origin and History of the American Flag and of the Naval and Yacht-Club Signals, Seals and Arms, and Principal National Songs of the United States, with a Chronicle of the Symbols, Standards, Banners, and Flags of Ancient and Modern Nations,* 2 vols. (Philadelphia: N. L. Brown, 1917); for the symbolism of military decorations, see Philip Robles, *United States Military Medals and Ribbons* (Rutland, Vt.: C. E. Tuttle, 1971). For speculation on Maori tattoos, see Heinrich Buttke, *Die Entstehung der Schrift, die verschiedenen Schriftsysteme und das Schrifttum der nicht alfabetarisch schreibenden Völker* (Leipzig: T. D. Weigel, 1877), plates 2 and 3.

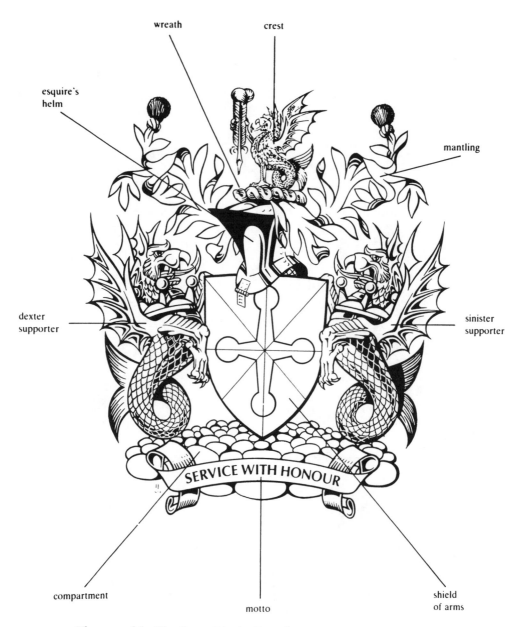

wreath crest

esquire's helm

mantling

dexter supporter

sinister supporter

SERVICE WITH HONOUR

compartment

motto

shield of arms

PLATE 12.7 *The arms of the West Dorset District Council.*

ry's exacting visual regimen, which I would interpret as the result of barring "meaningless" pictorial elements from an essentially pictorial practice. (Maori tattoos, for instance, mingle signs of status with optional framing marks, but heraldry keeps tight rein on "meaningless" decoration.) The pictorial rigidity of heraldry is precisely paralleled by the linguistic rigidity of blazonry, the art of describing heraldic devices. A blazon is the recitation of the contents of a coat of arms, and there can only be one correct blazon for any given coat of arms. Conversely, the blazon entirely specifies the

meaningful elements of the arms. As Stephen Friar puts it, "An accurate blazon is unambiguous and from it a coat of arms which is correct in every detail may be painted (emblazoned) or researched." [36] Taking the blazon as the referent and the coat of arms as the system of signs, heraldry entirely satisfies Nelson Goodman's two syntactic and three semantic criteria of notation. In the less restrictive sense in which I have been using the word

36. Friar, *Heraldry for the Local Historian and Genealogist* (Wolfeboro Falls, N.H.: Alan Sutton, 1992), 181.

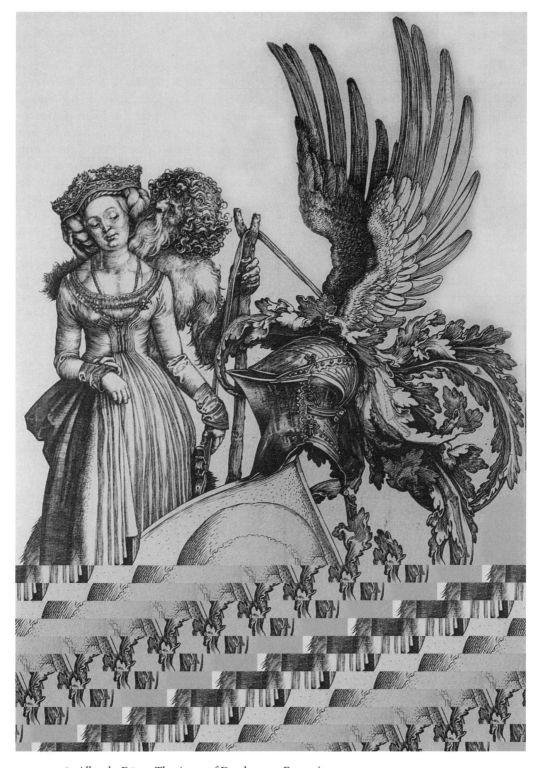

PLATE 12.8 *Albrecht Dürer.* The Arms of Death. *1503. Engraving.*

notation, heraldry is not pure notation because it retains traits of pictures and writing — but it is worth noting heraldry's compliance with Goodman's criteria because it shows just how exactly the language of heraldry matches the images.

Books of blazonry prescribe the vocabulary, sequence, and grammar of an acceptable description.[37] Just as there is only one way to construct a proper coat of arms with a given content, so there is only one way to put it into words. In blazonry, colors and charges are capitalized, and colors follow the description of objects that are colored. The order of objects described is fixed (it must begin with the shield, first naming the quartering and then the charges), and no punctuation is permitted except to separate components of the arms. The arms shown in Plate 12.7 would be blazoned as follows:

> Gyronny Vert and Gules a Saxon Cross per gyronny Argent and Or. On a helm with a Wreath Argent Vert and Gules a Sea Wyvern sejant Argent winged Or grasping in the dexter paw an Ostrich Feather palewise also Argent penned Gold. On either side a Sea Wyvern Argent winged and gorged with a Saxon Crown Or the Compartment composed of Graded Pebbles proper.[38]

The passage could be translated this way:

> The shield is divided into eight triangles by four crossed lines (gyronny). Alternate triangles are colored green and red (Vert and Gules). On it is a Greek cross with tapering arms ending in circles (a Saxon cross) colored white and gold (Argent and Or) following the pattern of eight triangles (per gyronny). On the helm is a torc with white, green, and red twists (Wreath Argent Vert and Gules), and on it a Sea Wyvern (Wyvern with a fish's tail), seated (sejant), colored white (Argent), with gold wings, holding in its right (dexter) paw a vertical (palewise) Ostrich Feather with a white shank and gold quills (penned Gold). On either side are winged Sea Wyverns wearing gold crowns ornamented with small balls (Saxon Crowns) around their necks (gorged). The compartment is comprised of pebbles, diminishing into the distance (Graded Pebbles), depicted in natural colors (proper).

It is interesting that in the midst of this very accurate ekphrasis there is considerable room for choice, and in fact a number of apparently different coats of arms could be properly made from the blazon. The description of the supporters and compartment is optional, and it is often omitted entirely, so that an artist could supply whatever devices seemed appropriate. In heraldry even more than in Renaissance emblems, the inscriptions are variable, and a single arms can have various mottoes. The shape of the banner has no heraldic significance, and neither does the shape of the mantling, although its colors are sometimes meaningful. The shapes, styles, and proportions of heraldic monsters and other charges are fixed by custom and not by description or measurement, and the relative size of each of the components, including charges on the shield, is at the armorer's discretion. All such changes would be allographic: They would not affect the semantics of the coat of arms, or even alter the syntax; but they would produce very different images. Because of these degrees of freedom, Dürer's plate is not only a moralizing picture but a functional coat of arms.

Heraldry is one of the few kinds of images that has a determinate pictorial syntax, as opposed to a written syntax. In past chapters I have been taking *pictorial syntax* as the subjective impression of the kinds of order familiar in written syntax. Here things are different, as the order is not subjective. Blazoning a coat of arms means following a determinate sequence that is not borrowed from reading: It is, in the terms I am developing here, notational. A coat of arms is only properly blazoned when it is read in a particular, highly determinate order that zigzags back and forth across the image and does not resemble any written syntax. The coat itself is therefore partly pictorial (wherever the armorer has freedom of choice), partly written (if the coat has a motto), and partly notational.

Heraldry pays a price for its notational rigor, and it is an unusual one, not common to other notational systems: The ekphrases (the blazons) lack semantics. They tell no story, and fail even to re-

37. For blazons, see Sir Bernard Burke, *A General Armory of England, Scotland, and Ireland* (London: E. Churton, 1842), reprinted as *The General Armory of England, Scoltand, Ireland, and Wales* (Baltimore: Genealogical Publishing Co., 1976).

38. Friar, *Heraldry,* 194.

cord the significance of the forms. (These arms belong to the West Dorset District Council, and each element has significance in that context.) An armorer has to identify each device with a family, a company, a place, or a historical event in order to produce the equivalent of an ancient ekphrasis that describes the content of a picture. But even with that limitation, heraldry is the most exact match I know between an image and its permissible description, and it is the closest any pictures come to possessing rigorous syntax.

Some of the most interesting heraldic images are even further from the conventions of heraldry than Dürer's woodcut. An example is this fifteenth-century broadsheet, representing two monarchs fighting Greco-Roman style on a Rube Goldbergish contraption hung with heraldic shields (Plate 12.9). The Pope (here pictured as the Antichrist) apparently has the upper hand — he seems calm, almost as if he is embracing or consoling Charles V, who for his part clamps his teeth down on his purse in a remarkably frank — if unintended — sexual allegory. Both have upset the ship of Europe by stepping off their places on its prow and stern. They have become "The winds that afflict the ship," as a legend puts it. The Pope steers with one foot, and Charles straddles the lion of France and the crow's nest. The entire scene is watched over by a comet that had appeared in 1460, prefiguring the event.[39] It was common practice to identify political allegories by scattering heraldic elements through an otherwise naturalistic scene; here the structure is more elaborate, and retains some of the symbolic rigidity of a more narrowly symbolic scene. The arms are identifiable, and viewers would have been intended to read them: For instance, the third one from the right on the bottom row is the shield of Pfalz — "a lion on quartered shield, second quarter, ordinary" in the language of blazonry.[40] (The shield at the lower left is Vienna, exactly as it appears at the bottom of the title page of the Micmac Bible [Plate 8.7], where it is used as a hieroglyph to denote the place at which the book was published.) The composition is well articulated but flexible, and it was used several times — originally the combatants were Pope Paul II and Frederick III, with a slightly altered machinery of staffs and wheels.[41]

What happens in this outlandish fantasy has its parallels (as far as heraldry goes) with a much more familiar image, the "graphical user interface" in contemporary computer design. Like most famous images in the history of art, the arrangement of the computer screen comes to most users by a chain of adaptations, imitations, and expropriations. It was originally developed in Xerox's Palo Alto Research Center (PARC) in the 1970s, and then by Apple Computer, and finally by Microsoft.[42] Although it is commonly called a "desktop," the screen looks very little like one, and Brenda Laurel has proposed that it might be more accurate to say the screen represents something similar to a desktop, or "someone doing something in an environment that's kind of like a desktop."[43] But certainly the desktop does not represent "someone doing something," as much as a group of objects. Some of the objects have real-world referents that are not appropriate to a desktop — for example, "windows" and pictorial backdrops. Others, such as Apple's Hypercard, are intentionally closer to the desktop metaphor.[44] It could be argued that much of the design's appeal lies in the confusion of its metaphors: The "windows" are opaque but "zoom" to different sizes ("opening"

39. Wilhelm Hess, *Himmels- und Naturerscheinungen in Einblattdrucken des XV. bis XVIII. Jahrhunderts* (Nieuwkoop: De Graaf, 1973), 107–108.

40. For the shields, see Ottfried Neubecker and Wilhelm Rentzmann, *10,000 Wappen und Embleme, von Staaten und Städten nach Bildmotiven angeordnet mit alphabetischem Register* (Munich: Battenberg, 1989), which is based on Rentzmann, *Numismatisches Wappen-Lexikon des Mitterlalters und der Neuzeit* (Berlin: H. Veit, 1876).

41. The earlier version (1470) is preserved in an etching in the Uffizi; it refers to the meeting between Paul II and Frederick III in the winter of 1468–69 and makes reference to a prophecy written by the Triburtine Sibyl in 19 B.C.E. See André Chastel, *The Age of Humanism: Europe, 1480–1530* (London: McGraw-Hill, 1963), 317, no. 8.

42. Benjamin Wooley, *Virtual Worlds* (Oxford: Blackwell, 1992). I thank Jesse Busch for bibliographic research.

43. *The Art of Human Computer Interface Design*, ed. Brenda Laurel (Menlo Park, Calif.: Addison-Wesley, 1990), 2. See also Ronald Baecker and William Buxton, *Readings in Human–Computer Interaction: A Multidisciplinary Approach* (Los Altos, Calif.: Morgan Kaufmann, 1987), and Ben Schneiderman, *Designing the User Interface* (Reading, Mass.: Addison-Wesley, 1987).

44. Apple Computer, Inc., *Hypercard Stack Design Guidelines* (New York: Addison-Wesley, 1989).

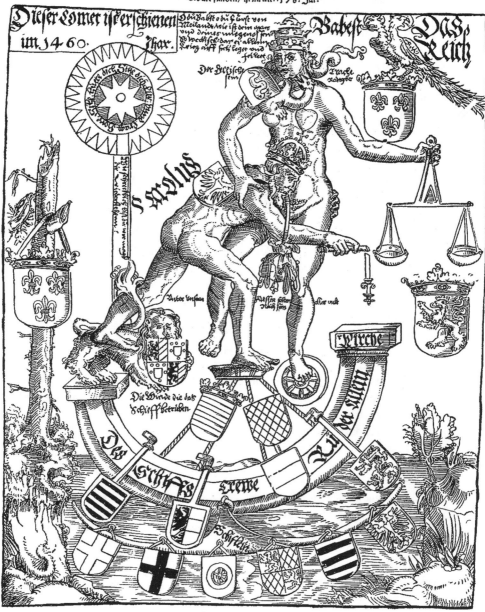

PLATE 12.9 *The Pope as Antichrist. 1556. Munich, Hofbibliothek.*

means expanding, not looking through). Some "menus" hang from the top border of the screen like windowshades, but others are "pop-up" or "hierarchical" and open in various directions; some elements of the desktop are decidedly flat, and others cast harsh shadows. Except when a single document fills the screen, most desktops are primarily pictorial: they give the illusion of depth, with objects hanging or floating in the foreground. In that they are related to any naturalistic picture, including the one we have just been examining. But the most striking similarity between computer screens and heraldic fantasies is the presence of emblems, because "icons" on computer

screens are nothing other than little pictures with attached explanatory text. The fact that some computer users can change the pictures at will, and that all users can change the texts, does not upset the parallel; emblems and heraldry were mutable from the beginning. Both the ubiquitous "desktop" and the unusual broadsheet are pictures, stocked with labels, banners, heraldic devices, "icons," and other legible paraphernalia — that is, they are pictures with engastrated emblems. In Goodman's terms, the "desktop metaphor" is a mixed one, combining various "routes of reference" into a single, amalgamated image. (In a strict sense, electronic "desktops" are examples of notations, as they restrict the user to certain sequences of operations — closing and opening, clicking, moving, duplicating and deleting — that cross the surface of the screen in a manner utterly unlike writing. But they are a curiously free form of notation, in comparison to the protocols of blazonry or the technical rules of mathematical notations like the ones we will consider in the next chapter.)

Most heraldry has not survived intact into the twentieth century, and the minimal emblems of the computer "desktop" are examples of the kind of diminution that has sometimes ensured their survival. Printer's devices were among the first to atrophy; by the eighteenth century they could be no more than hints of a book's contents.[45] The Sumerologist Friedrich Delitzsch used a stripped-down version of the cuneiform sign for *king* (similar to the one in Plate 8.5, *top left*) as a kind of combination *impresa,* monogram, family crest, and printer's device.[46]

Just as advertisements are among the free, unknowing descendants of emblems, so corporate logos preserve the last of the logic of heraldry.[47] Several anthologies demonstrate how legitimate heraldic designs were adapted for shop signs and businesses, and how they were altered during the industrial revolution for use as company "devices."[48] In the Victorian era, large companies sponsored sports teams and civic organizations, giving them official *imprese* in the form of elaborate heraldic banners and plaques. With the rise in modernism, companies began to streamline their devices, omitting one or another part of the full coat of arms. Today a few still survive in recognizable forms — the Canada Dry logo is a heraldic shield without any support or motto, and several

beer companies retain fairly elaborate but incomplete coats of arms. Most logos were stripped during the 1970s, under the general influence of minimalism and abstraction; today an average corporate logo is the shrunken, geometrized remnant of the central device that would once have occupied the principal field of the heraldic shield. The globe used by AT&T is a ubiquitous instance; it no longer has any compartment, helm, supporters, or even a framing shield, but it still has the minimal requirements of an emblem — a partly enigmatic image and an abbreviated, partly illegible text.

Images that consist of pictures and explanatory texts are so common that it takes a moment's reflection to realize they are largely specific to the post-Renaissance West. Coins are the important counterexamples, but even they can be assigned Western origins. In many other cultures images stood alone, without labels, and texts were sequestered in books and inscriptions, away from images. (I am reserving maps for the final chapter; they are also worldwide phenomena.) Like any very large generalization, this one has its weak points, but it is true enough so that I would suggest it could be used as part of a definition of modern Western culture. *Emblemata* occur in every advertisement, and every book and newspaper that uses captions. They occur on labels and signs and official documents, on flags and banners, and — as logos — on most every object we own, from our shirts to our televisions. That makes it even more intriguing that they are based on an unstable interaction between pictures and texts that are — at least for a

45. See the wonderful emblem of the body's viscera used by Charles Nicholas Jenty, reproduced in my *Pictures of the Body* (Stanford, Calif.: Stanford University Press, forthcoming), plate 8.

46. Delitzsch, *Die Entstehung des ältesten Schriftsystems, oder der Ursprung der Keilschriftzeichen* (Leipzig: J. C. Hinrichs'sche Bucchandlung, 1897).

47. Yasaburo Kuwayama, *Trademarks and Symbols* (New York: Van Nostrand Reinhold, 1973); *Seven Designers Look at Trademark Design,* ed. Egbert Jackobson (New York: Paul Theobald, 1952); David Carter, *The Book of American Trademarks,* vols. 1–7 (New York: Art Direction Book Company, 1972–79).

48. For example, E. R. Deerfield, *Stories of Inns and Their Signs* (London: David & Charles, 1974), and G. J. Monson-Fitzjohn, *Quaint Signs of Olde Inns* (London: Herbert Jenkins, 1926).

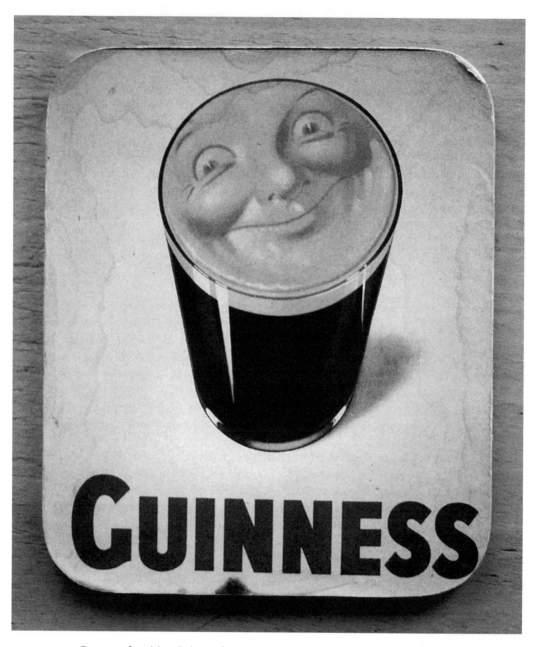

PLATE 12.10 *Coaster, advertising Guinness beer. ca. 1995.*

moment — unintelligible. Something about half-understood images attracts us so deeply that it impels our artistic practices, validates our currency, organizes our visual literacy (the phrase itself sounds emblematic), and directs our consumption. Otherwise — if we thought about things differently — we would be content with museums that had no labels, coins with no obscure mottoes, and "desktop icons" with no pictures. Emblemata are a nearly universal way of thinking about the strange meaninglessness of pictures. Plate 12.10 is a coaster advertising Guinness beer, which happened to be on my desk as I wrote these lines. It refers to an Irish custom of drawing a face in the beer foam to test its resilience. The little faces are odd, and everyone knows they don't mean anything — or do they?

13 : Schemata

oins and paper money already have complex organizational principles that border on notation, as well as examples of actual notation — denominations, bar codes, grilled cancellations, and patterns designed to foil counterfeiters. The intricate protocols of heraldry and blazonry are notational, and so are the computerized instructions that govern electronic "desktops." This final chapter concerns images that have fewer pictures and texts, and even higher quotients of notation, ending — in a pitch of complexity — with images that are nearly pure notation.

I call this chapter *schemata* and not *notations* for several reasons. I don't want to imply that there is such a thing as pure notation (for the same reason, no chapter is called *Pictures* or *Writing*), and I don't want to risk conflating Nelson Goodman's sense of the word *notation* with the wider meaning I have given the word in this book. Also, it is sometimes helpful to think of strongly geometric notations as schemata in the Kantian sense: as real or imagined visual structures, intermediary between states of lesser and greater definition.[1] That is the definition of an emphasis rather than a category, because any image truncates or otherwise simplifies what it denotes, but the search for a middle ground between unclassifiable detail and unhelpful reduction has repeatedly led to geometric principles of organization. The most important reason for enlisting the word *schema* is that it names a kind of image that is strongly notational but also infused with the full panoply of forms we have been looking at throughout the book: writing, pictures, framing elements, numbers, allographs, and so forth, with a high complement of geometric forms. There are nearly pure notations, but most notational images are strongly heterogeneous.

The "traits of notation" are much clearer than the traits of writing, or the negatively defined traits of pictures. We recognize an image as a notation most readily by the presence of geometry and mathematics. If an image has scales, rules, or axes, or makes use of geometric forms such as grids, con-

1. Kant, *Kritik der reinen Vernunft*, ed. Philosophische Bibliothek, vol. 37a (Hamburg: Felix Meiner, 1967 [1956]), B 179, p. 199; Robert E. Butts, "Kant's Schemata as Semantical Rules," in *Historical Pragmatics, Philosophical Essays* (Dordrecht: Kluwer, 1993), 69. *Schema* is an exceptionally complex word, with more than a dozen distinct uses in various disciplines. Compare, for example, Matti Kamppinen, "Cognitive Schemata," in *Consciousness, Cognitive Schemata, and Relativism: Multidisciplinary Explorations in Cognitive Science,* ed. Kamppinen (Dordrecht: Kluwer, 1993), 133–70, esp. 146–49; I. H. Paul, "The Concept of Schema in Memory Theory," in *Motives and Thought: Psychoanalytic Essays in Honor of David Rapaport,* ed. Robert R. Holt, special issue of *Psychological Issues,* monograph 18–19, also cataloged as vol. 5, nos. 2–3 (New York: International Universities Press, 1967), 218–58; David Rumelhart, "Schemata: The Building Blocks of Cognition," in *Theoretical Issues in Reading Comprehension,* ed. Rand J. Spiro, Bertram C. Bruce, and William F. Brewer (Hillsdale, N.J.: Erlbaum, 1980); Robert W. Howard, *Concepts and Schemata: An Introduction* (London: Cassell Educational, 1987), 31; and Jean Matter Mandler, *Stories, Scripts, and Scenes: Aspects of Schema Theory* (Hillsdale, N.J.: Erlbaum, 1984), 2.

centric circles, trees, tables, columns, bars, nets, latitudes and longitudes, *x*'s and *y*'s, or ascensions and declinations, then it looks immediately notational — it is clearly not writing or a picture. The three essential traits of notation are reference lines such as scales or grids, numbers or their equivalents, and more intricate geometric configurations. Yet it is essential, I think, not to exclude images whose geometric order is latent or unmeasured. A coat of arms is notational because it implies a strict order of reading (a blazon), and computer "desktops" and "windows" are notational because they require equally inflexible orders of reading. It is best to be ecumenical about images that aren't writing or pictures and to let the category of notation comprehend a range of images that are allied by their affinities to geometric order.

Like picturing and writing, notating is a matter of degree, and a given image might only be a notation on balance, even while it is also a picture and a text. It might seem that pictures would be left behind in the far reaches of geometric rigor, but I am arguing the opposite. Picturing is at stake even in the most torturous geometric labyrinth: It is pictures that are being "harassed," driven to their limits. Notation is another perdition for images: It is like writing in its inability to entirely tear down the concept of a picture and substitute some purer order.

EGGS: IN HEAVEN AND IN THE PSYCHE

Among the most pervasive prescientific schemata, where geometry is still unmeasured and half-hidden, is the "world egg," also called the macrocosmic–microcosmic diagram. In simplest terms it is a disk, surrounded by a radiating field of concentric circles labeled with effects, distances, times, quantities, or other attributes. In a typical example the central disk is the Earth, and the concentric circles are planets or spheres of heaven; or the center can be God, or Mankind, or even the philosopher's stone. The center operates by rules that are different from those of the encompassing rings: It is commonly pictorial, and sometimes emblematic, while the rings tend to be organized more in terms of writing — that is, they are lettered and often read around in rings.

Confusions and conflations of the "yolk" and "white" of the world egg account for much of the

schema's meaning. Thus the egg schemata in Robert Fludd's *Meteorologia* have concentric circles denoting both compass directions and heavenly spheres, and their meaning is doubled because the directions and spheres also turn out to denote directions and organs within the body.[2] Ramon Llul's *ars demonstrativa* and its seventeenth-century descendant *ars combinatoria* both make use of calculating wheels constructed on the model of macrocosmic–microcosmic schemata, with emblematic "yolks" and combinatorial "whites."[3] Horoscopes and related forms are also examples of diagrams in which compartments are arranged around a generative center.[4] In all such images, a viewer shifts back and forth between deciphering the notation, reading the texts, and looking at the picture.

The egg schema is remarkably flexible, and has been since its earliest examples in the thirteenth century. "Modern" deconstructions and obfuscations are present, at least in mystically inclined schemata, from the early seventeenth century. Plate 13.1 is one of thirteen figures invented by the eighteenth-century mystic William Law to illustrate the "deep principles" of Jacob Böhme's philosophy. It's an egg schema, but spun off its axis. Originally there were three spheres: the "Belly of Satan" underneath, Heaven above, and the mundane world in the center. But in this plate "poor Adam" has fallen from his state of grace, and he lies "as dead, on the outmost Border of the Spirit of this World." He has been snared by Satan (note the hook, which has toppled him), and he has renounced Sophia, represented by the second S that hovers at the top. Before the Fall, Adam was at the center of the macrocosm, and the planets orbited peacefully around him. Now the stars rain evil,

2. Fludd, *Philosophia sacra et vere Christiana; seu, meteorologia cosmica* (Frankfurt: Prostat in officina Bryana, 1626), title page and plate between pp. 140 and 141.

3. John Neubauer, *Symbolismus und symbolische Logik: Die Idee der* ars combinatoria *in der Entwicklung der modernen Dichtung* (Munich: W. Fink, 1978). For Llul, see first his *Ars demonstrativa,* in *Selected Works of Ramon Llull,* ed. Anthony Bonner (Princeton, N.J.: Princeton University Press, 1985), vol. 1, 305–568.

4. For comparative examples, see Giordano Bruno, *De imaginum, signorum, et idearum eompositione* [sic] (Frankfurt: Ioannes Wechel et Petrus Fischer, 1591), translated as *On the Composition of Images, Signs, and Ideas,* ed. Dick Higgins (New York: Willis, Locker & Owens, 1991).

PLATE 13.1 *William Law. Schema depicting Adam, hooked by Satan, with Sophia above and a heaven of evil stars.* 1764.

decentered influences, "of which the very best are but Death and Poison."[5]

The center cannot hold, and the more notational white, with its mixture of orderly geometry and symbols, is invaded by the glow of the pictorial yolk. Because of such infractions, the image is less than fully legible. The engravings made shortly after Böhme's death by his follower George Gichtel are even more heteromorphous, mingling egg schemata with many other kinds of images (Plate 13.2).[6] In this case, the frontispiece of Böhme's *Aurora,* an armillary sphere studded with eyes is juxtaposed with a view of the Earth and part of a zodiacal wheel. The three are intended to represent the rising sun of the Trinity, and the disheveled composition is itself a sign of illegibility: a mystical variant on the simpler concentric schemata used in other texts.

Maṇḍalas are a modern instance of macrocosmic–microcosmic schemata. Carl Jung's interest in maṇḍalas began under the influence of pre-Enlightenment schemata, before he was exposed to Eastern maṇḍalas, yantras, and mantras.[7] His

first "cryptogram," as he called it, was painted in 1916 (Plate 13.3). (The word *maṇḍala,* which Jung knowingly misused, has now become a synonym for involved symmetrical schemata of any sort.[8] *Cryptogram* is a more neutral term, and it avoids the unfocused allusion to Buddhist and Hindu practice conjured by the word *maṇḍala.*) Following Jung's own exegesis, the image is an elaborately layered world egg — he calls it "systema mundi totius" — meant to be read circumferentially (both clockwise and counterclockwise), diametrically (top to bottom, left to right), and radially (from the circumference toward the center, or vice versa).[9] Art and science, figured as a winged serpent and winged mouse, share the upper realm with an Orphic god whom Jung identifies as Erikapaois or Phanes. At the bottom is Abraxas, "his dark antithesis," along with a "devilish monster and a larva." At the left is a circle indicating "the body or the blood," a phallus representing the generative principle, and a serpent; and on the right the "light realm of rich fullness," with a bright circle, the Holy Ghost, and Sophia pouring from a "double beaker." For Jung, these are "antinomies of the microcosm within the macrocosmic world," and that is borne out by the image's mirrorlike repetitions, as the four outer elements are repeated

5. Law, "An Illustration of the Deep Principles of Jacob Behmen, the Teutonic Philosopher, in Thirteen Figures," in Böhme, *The Works of Jacob Behmen, the Teutonic Philosopher* (London: M. Richardson, 1764), vol. 2, p. 30. The illustrations are reprinted in The *"Key" of Jacob Boehme, with an Illustration of the Deep Principles of Jacob Behmen,* ed. Adam McLean, Magnum Opus Hermetic Sourceworks no. 9 (Grand Rapids, Mich.: Phanes, 1991), although the accompanying text omits the full citation of the source, and the commentaries deviate from Law's original.

6. Jacob Böhme, *Theosophia revelata. Das ist: Alle göttliche Schriften des . . . Jacob Böhmens,* ed. Johann Georg Gichtel ([Leipzig:] s.n., 1730), facsimile edition, *Jacob Böhme, Sämtliche Werke,* ed. Will-Erich Peuckert (Stuttgart: Fr. Frommans Verlag, 1955–), vol. 1, *Aurora, oder Morgenröthe im Aufgang.* For egg schemata, see also the frontispieces to the two parts of *De incarnatione verbi,* in *Sämtliche Werke,* vol. 4, and the frontispiece to *De signatura rerum,* in *Sämtliche Werke,* vol. 6.

7. For Eastern maṇḍalas, see Keiji Iwata and Kouhei Sugiura, *Cosmology and Manalas of Asia* (in Japanese) (Tokyo: Kodan-sha, 1990); Schuyler Cammann, "The Suggested Origin of the Tibetan Mandala Paintings," *Art Quarterly* 13 (1950): 106–19; Antionette K. Gordon, *The Iconography of Tibetan Buddhism* (New York: Paragon, 1966); Gordon, *Tibetan Religious Art* (New York: Paragon, 1963); Giuseppe Tucci, *Theory and Practice of the Mandala,* trans. Alan Houghton Brodrick (London: Rider, 1961). Mantras and yantras are related forms; see *Mantras et diagrammes rituels dans l'hindouisme, table ronde* (Paris: Éditions du Centre national de la

recherche scientifique, 1986); Swami Pranavananda, *A Treatise on Sricakra* (Yenugula Mahal, East Godovari Dt., A.P.: Sri Swami Pranavananda Trust, 1992); Saligrama Kirshna Ramachandra Rao, *The Yantras* (Dehli: Sri Satguru, 1988); Ramachandra Rao, *Yantras and Mandalas in Temple Worship* (Bangalore: Kalpatharu Research Academy, 1988); and *Bsrun ba'i 'khor lo brgya rtsa brgyad pa: A Collection of Mystical Bija for Use in Various Yantra and Related Esoteric Diagrams* (Dalhousie, H.P.: Damchoe Sangpo, 1979).

8. For an extended example of interest in maṇḍalas outside Jungian analysis, see Lawrence Slobodkin, *Simplicity and Complexity in Games of the Intellect* (Cambridge, Mass.: Harvard University Press, 1992), reviewed by David Goodstein in *Science* 256 (15 May 1992): 1034–36. For Jung's discovery of maṇḍalas, see *The Secret of the Golden Flower: A Chinese Book of Life,* trans. Richard Wilhelm, commentary by Carl Jung (New York: Causeway Books, 1975).

9. Jung, "A Study in the Process of Individuation," in *The Collected Works of C. G. Jung,* Bollingen Series 20 (New York: Pantheon, 1959), vol. 9, part 1, pp. 290–354. The essay was originally published as "Zur Empirie des Individuationsprozesses," in *Gestaltungen des Unbewussten* (Zurich: Rascher, 1950). There are more plates in the English edition, but Jung only printed a fraction of the original collection.

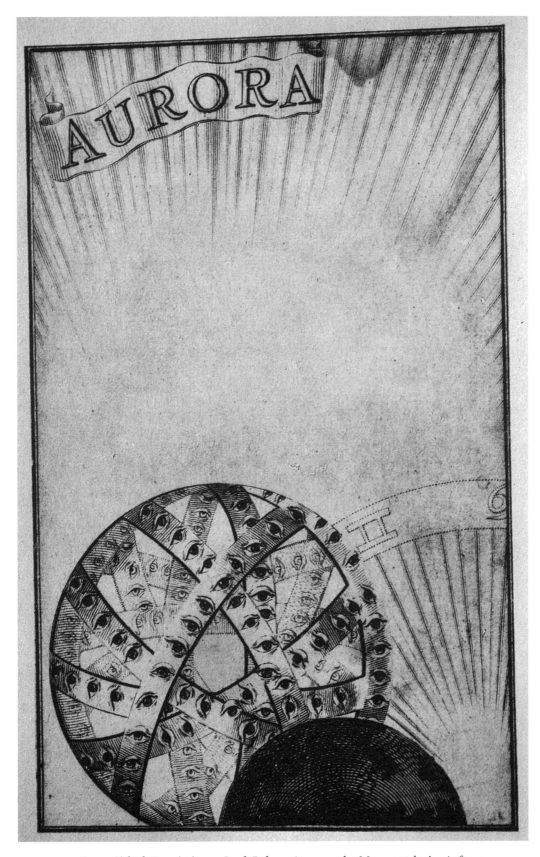

PLATE 13.2 *Georg Gichtel. Frontispiece to Jacob Böhme,* Aurora, oder Morgenröthe im Aufgang.

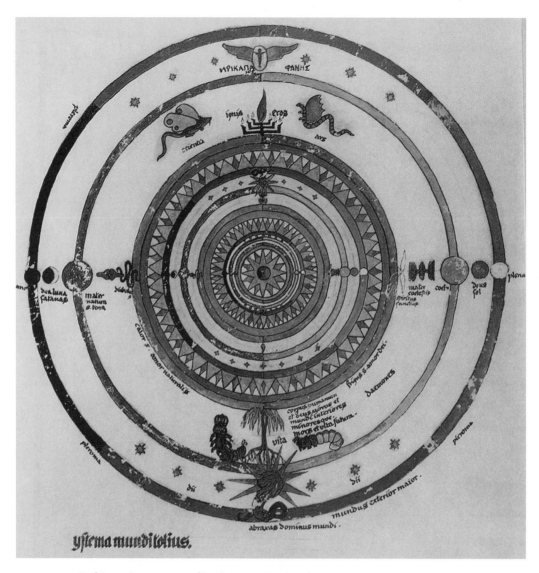

PLATE 13.3 *Carl Jung.* Systema mundi totius. *1914. Watercolor.*

and reversed in successive concentric rings until they disappear in "the innermost core, the actual microcosm." [10] The *cryptogram* is an infinitely layered macrocosmic–microcosmic schema, leading inward to what Jung called the "self" or the "*bindu*" at the center (*bindu* is the metaphoric center of the universe, and the tip of Shiva's penis). Jung's painting has no "yolk," no syntactically or semantically differentiated center: It is nothing but skins, with a dimensionless point in the middle.

Each of these schemata are partly pictures of something, but it is hard to know what might count as naturalistic. If I look only at the notational relations, and work at deciphering the images' meanings, I might overlook the pictorial aspects entirely.

But are the two separable? The historian of science Peter Galison makes such a distinction when he divides scientific images into "homomorphic technologies" (those that preserve the forms of what they denote) and "homologous technologies" (those that preserve logical relations of what they denote).[11] I am wary of those criteria, because it is often impossible to distinguish them even within a single passage. Law's and Gichtel's concentric

10. *C. G. Jung, Bild und Wort,* ed. Aniela Jaffé (Olten und Freiburg im Breisgau, 1977), trans. *Jung, Word and Image* (Princeton, N.J.: Princeton University Press, 1979), 75.

11. Galison, *Image and Logic: The Material Culture of Microphysics* (Chicago: University of Chicago Press, 1997), 19.

heavenly spheres are both logically and formally concentric, just as any narrative painting preserves spatial relations that are also logical affinities and hierarchies. Jung's *cryptogram* purports to illustrate logical relations in his psyche, but they are inseparable from the little naturalistic pictures that inhabit the different circles. Given such irreducible mixtures, it seems prudent to consider logical properties as an aspect of pictorial ones, even (and sometimes especially) those pictorial properties that are most naturalistic. The most interesting egg schemata convey logical relation through ostensibly iconic formats. The plates in Law's eschatological narrative are always also pictures of the heavens — the solar system as seen "from above," the Earth as seen "from heaven." In schemata the "homologous" or notational components loom especially large, but they are not absent even — or especially — in ordinary narrative paintings such as Giotto's. A schema, therefore, is not different from pictures by an absence of naturalism: Instead it differs by possessing other criteria of organization — such as world eggs.

TREES: FEVERISH AND MATHEMATICAL

The other major prescientific schema is the symbolic tree. Tree forms bent to the uses of symbolic exposition include genealogical trees (often upside down), the flow charts used throughout modern science and technology, exotica such as the Sephirotic tree or *arbor cabalistica* used in kabbalism, the generalized *arbor mystica,* the *arbor consanguinitatis,* the *arbor cognationum,* the "tree of Aristotle," alchemical Ripley scrolls, logical and theological trees, and various medical trees including "fever trees" and even "dermatology trees."[12] Often enough the tree's naturalism is minimal. The "fever tree" in Francisco Torti's *Therapeutice specialis ad febres periodicas perniciosas* (1756) is trained into a shape demanded by the taxonomy of fevers — fatal on the left, and recurrent on the right (Plate 13.4).[13] Half-dead, half-living trees are a common type, signifying themes as different as the Old and New Orders, the Choice of Hercules, and the Ages of Man. Two trees, one dead and the other alive, can also signify the synagogue and the church, or the Tree of Paradise (which withered after the Fall) and the Tree of Life (which promises salvation).[14] Torti's schema is not essentially differ-

ent, because the "evil" side signifies death and the "good" side life. As often happens, his tree has to be specially contorted to make medical points. Because tertian fevers were classified as either continuous or intermittent, he had to bend two branches together and fuse them (see the fifth label above "Febris"). A careful look discloses many branches that begin to grow horizontally in order to cross to another part of the tree and fuse with distant twigs. What appears at first to be either a fairly naturalistic tree reveals itself as a most unnatural creation, a painful rearrangement of natural forms. (In Galison's terms, the unnatural branches are homologous and the natural ones homomorphic, although again the division is not always clear.)

Some of the most strongly nonnaturalistic trees are the family trees used by geneticists, anthropologists, and genealogists.[15] Some are branching V's and others are mixtures of boxes, ovals, "nodes,"

12. In addition to references that follow, see Urszula Szulakowska, "The Tree of Aristotle: Images of the Philosopher's Stone and Their Transference in Alchemy from the Fifteenth to the Twentieth Century," *Ambix* 33, no. 2–3 (1986): 53–77. Ripley scrolls still have no good exegesis. Adam McLean is working on a corpus of scrolls; see Betty Jo Teeter Dobbs, *Alchemical Death and Resurrection* (Washington, D.C.: Smithsonian Institution Libraries, 1990), an intermittently unreliable and partly ahistorical account; and Stanton Linden, "Reading the Ripley Scrolls, Iconographic Patterns in Renaissance Alchemy," in *European Iconography East and West,* ed. György Szönyi (Leiden: E. J. Brill, 1996), 236–50, a preparatory account. For the *arbor cognationum,* see Isidore of Seville, *Etymologiae* (Paris: Les Belles Lettres, 1981–), cited in Ulrich Ernst, "The Figured Poem: Towards a Definition of Genre," *Visible Language* 20, no. 1 (1986): 24n18. For a "dermatology tree," see Jean-Louis Alibert, *Clinique de l'Hôpital Saint-Louis* (Paris, 1833), frontispiece, illustrated in Stafford, *Body Criticism,* 303, fig. 188. Flow charts and trees are explored in Whitney Davis, *Drawing the Dream of the Wolves: Homosexuality, Interpretation, and Freud's "Wolf Man"* (Bloomington: Indianapolis University Press, 1995), 71–104, 141–82.

13. For the fever tree, see also Thomas Henkelmann, *Zur Geschichte der pathophysiologischen Denkens, John Brown (1735–1788) und sein System der Medizin* (Berlin: Springer, 1981), 37.

14. H. Toubert, "Une fresque de San Pedro de Sorpe (Catalagne) et le thème iconographique de l'arbor bona — Ecclesia, arbor mala — Synagoga," *Cahiers archéologiques* 19 (1969): 165–89, discussed in Salvatore Settis, *Giorgione's "Tempest": Interpreting the Hidden Subject,* trans. Ellen Bianchini (Chicago: University of Chicago Press, 1990), 26.

15. Franklin C. Southworth, "Family-Tree Diagrams," *Language* 40, no. 4 (1964): 557–65.

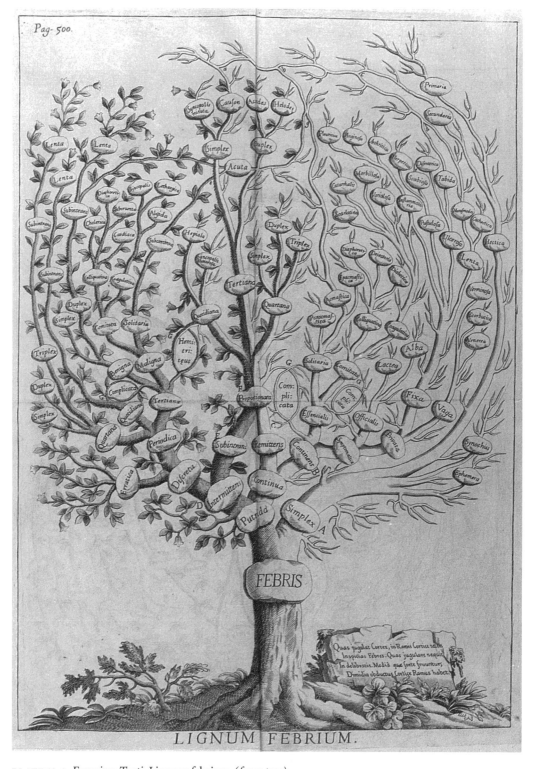

PLATE 13.4 *Francisco Torti.* Lignum febrium *(fever tree).*

and other elements from the branch of mathematics called graph theory. Perhaps the least naturalistic tree, however, is also the simplest: the schematic letter Y. Y-shaped trees were sacred to the Pythagoreans, who took them to embody the most rudimentary relation between three things: a mother, father, and child, or two numbers and their sum. The Y can be quite abstract; one of the most elaborate nonpictorial trees is the table of contents in Robert Burton's *Anatomy of Melancholy,* which would be over four feet long if the pages were taken from his book and assembled according to his directions.[16] On the other end of the scale are large genealogies, including tree diagrams of world history. A nineteenth-century example opens nine feet long and has enough detail to encompass the reign of each king and queen of England as a separate colored segment; its twining branches go back to Adam and Eve, whose fabulously long lifetimes dwarf the great empires of later history.[17]

Homology and homomorphism, naturalism and geometrization, mingle in schematic trees as they do in world eggs.[18] Another source of impurity, or confusion, is the mixture of genealogy and taxonomy. In Ferdinand de Saussure's terms, genealogy is diachronic and taxonomy is synchronic. In a genealogy, the smallest twigs are the newest, as in a real tree; in a taxonomy, the distance between any two twigs matters more than their age.[19] Logi-

cal and theological trees are the most geometric instances of the taxonomic type.[20] Their branchings are almost always dichotomies (favored by medieval Scholastics) and trichotomies, but there are also many more complex examples.[21] Theological trees (as opposed to logical trees) tend to branch, and then converge again, because the soul comes from God and returns to him — or to either heaven or hell. In that purely formal sense theological trees are the precursors of contemporary flow charts showing computer or neural net input and output: A single input might travel along an intricate pathway, but it might result in only a single output.[22]

Logic trees are ubiquitous in contemporary mathematics and science, and they are almost always strongly nonnaturalistic and taxonomic. In *Metamathematics,* Donald Kleene derives several trees from a linked series of mathematical statements. His choice of words shows how pictures are an untheorized presence even in such abstruse applications. He presents his tree initially as an "ex-

16. The "Synopses" or "Analyses" are distributed through the book. For the original layout, see *Robert Burton: The Anatomy of Melancholy, Oxford 1621* (Amsterdam: Ca Capo, 1971): "Synopsis" before the First Partition (eight unnumbered pages); "Synopsis" before the Second Partition (pp. 279–86); and "Analysis" before the Third Partition (pp. 489–93).

17. Edward Hull, *The Wall Chart of World History, with Maps of the World's Great Empires and a Complete Geological Diagram of the Earth* (London: Studio Editions, 1988).

18. There are also mixtures of the two, as when a tree represents ontological developments within an organism that recapitulate phylogenetic developments. For examples from Freud and Ernst Haeckel, see Davis, *Drawing the Dream of the Wolves,* 156–65.

19. Because distance is always measured according to criteria that derive from expectations about naturalism, taxonomy is not homologous; and, conversely, because any genealogy must obey the laws of biology, genealogy is not homomorphic. Intermediary examples make this especially clear; see, for instance, E. M. T. Campbell, "An English Philosophico-Chronological Chart," *Imago Mundi* 4 (1950): 60–104.

20. Porphyry might have invented such trees, but they are known in the works of the Ramists, and in the Renaissance they are common in Protestant theology. Walter J. Ong, *Ramus: Method and the Decay of Dialogue, from the Art of Discourse to the Art of Reason* (Cambridge, Mass.: Harvard University Press, 1958), 74–91.

21. Mary M. Slaughter, *Universal Languages and Scientific Taxonomy in the Seventeenth Century* (Cambridge: Cambridge University Press, 1982).

22. Early logic trees are horizontal; they were first righted — and made more treelike — by Théodore de Bèze, whose *Tractatus theologicæ* (1582) contains a chart of all Christendom, showing routes to salvation and perdition. After Bèze, theological trees were used by a number of seventeenth-century authors, including William Perkins, whose "table" of salvation and damnation appeared in 1616. Bèze's tree is a mannerist production, arranged (in imitation of Roman wall painting) as a precarious hanging mobile of ornately framed images held by swags. As Gordon Campbell has pointed out, Perkins's tree emphasizes the serious logic of Elizabethan Calvinism: He has "stripped away" all of Bèze's delicate ornaments, substituting "an ominous thick black line tracing the path of reprobation." See Théodore de Bèze, *Tractatus theologicæ,* 2d ed. (Geneva: E. Vignon, 1582), vol. 1, p. 170; Perkins, *The Workes of that Famous and Worthy Minister . . . W.P.,* 3 vols. (London: John Legatt, 1623–26), vol. 1, *A Golden Chaine,* facing p. 10; G. Campbell, "The Source of Bunyan's *Mapp of Salvation,*" *Journal of the Warburg and Courtauld Institutes* 44 (1981): 240–41; and I. Breward, *The Work of William Perkins* (Abingdon, Berks., 1970).

ample," in which the statements are numbered, and each is accompanied by a brief explanation justifying it or giving the numbers of the statements that justify it.[23] The entire "example" is denoted by a single reference number to its left:

(6)
1. A & B — second assumption formula.
2. A & B > A — Axiom Schema 4a.
3. A — Rule 2, 1, 2.
4. A > (B > C) — first assumption formula.
5. B > C — Rule 2, 3, 4.
6. A & B > B — Axiom Schema 4b.
7. B — Rule 2, 1, 6.
8. C — Rule 2, 7, 5.

Later this sequence, which is referred to as "deduction (6)," is rearranged into a "figure," in which the chain of deductions is presented graphically. Because the eighth formula, "C," was deduced from rules 7 and 5, it is written at the bottom, with 7 and 5 above it. And because formula 2 is involved in all the deductions, it is symbolized by the horizontal lines themselves:

```
                        1           2
                       ─────────
(a)   1           6        3            4
      ───────────────────────────────────
              7                   5
          ─────────────────────────
                        8
```

Again the "figure" is denoted by a marginal label, this time "(a)." And finally the formulas themselves are written in, with new numbers 1′ through 9′ and the original justifications. This yields "the deduction in tree form":

of branches — and a "height," defined as "the length of a longest branch (or in other words, the number of levels)." Logic trees typically involve a mixture of pictorial, notational, and written signs: Kleene's sequence combines a "deduction" (the first example, denoted by "(6)"), a "figure," (the second, denoted by "(a)"), and a "tree" (the third, denoted by "(b)"). Because the tree descends from the deduction, it expresses both simultaneous relations (a taxonomy) and chained deductions (a genealogy). Like the "graphical user interface," logic trees might owe their utility and their interest to the sheer number of apparently incompatible strategies they manage to compress into a single image.

In ways like this, the once-sturdy metaphors of trees and eggs continue to work in the more austere atmosphere of contemporary scientific and mathematical graphics. And there is a final possibility at the end this road: A tree might be constructed entirely to show logical relations, with virtually no thought of actual trees, and yet also be distorted in such a way that it hides the very relations implied by the arboreal form. A telling example is provided by the maps of human genomic affinities, presented in circular form (Plate 13.5). Here the phylogenetic relations implied by mitochondrial DNA types imply that Africans, and especially Pygmies, !Kung, and Yorubans, are closest to a hypothetical common ancestor. The authors distort the tree into a circle for efficiency's sake, although it is difficult to avoid suspecting that the format also helps them avoid making it look as if they had demonstrated the "primitive" nature of some Africans as opposed to Asians, New Guineans, and

(b)

```
                                            second
                                          assumption
                                            formula            Axiom
                                           4′. A & B         Schema 4a
            second                                          5′. A & B > A           first
          assumption            Axiom                      ──────────────2       assumption
            formula           Schema 4b                                            formula
          1′. A & B         2′. A & B > B             6′. A                     7′. A > (B > C)
          ────────────────────────────2             ──────────────────────────────────────2
                  3′. B                                   8′. B > C
          ───────────────────────────────────────────────────────2
                                    9′. C
```

Despite their austerity, the last two are trees, with "branches," an "above" and "below" — here denoted strictly by the logical or taxonomic relation

23. Donald Kleene, *Introduction to Metamathematics* (Toronto and New York: Van Nostrand, 1952), sections 21 and 24, pp. 93, 107.

Fig. 3. Phylogenetic tree relating the 135 mtDNA types found among the 189 individuals in this study. Markings on the branches indicate the 31 African clusters of mtDNA types; the remaining 24 non-African clusters are not labeled. This tree was constructed by first eliminating uninformative nucleotide positions (nonvariable positions and those variable positions that would have the same number of mutations regardless of the branching order of the tree). The 119 informative sites were then used to determine the branching order by the computer program PAUP (50). The program found 100 trees with a minimal length of 528 steps; there are many more (perhaps thousands) of trees of this length, and there could be shorter trees. The 100 trees we examined differed only in the arrangement of some of the terminal twigs, thereby making it possible to draw conclusions about features common to all, such as the presence of deep African branches on both sides of the root. One of the 100 trees of length 528 was chosen at random and is reproduced here; the consistency index for this tree was 0.34 for the 119 informative sites. The tree was rooted by using a chimpanzee mtDNA control region sequence (29) as an outgroup and the ancestral nodes (branch points) have been approximately placed with respect to the scale of accumulated percent sequence difference, as defined in Table 2. Three pairs of mtDNA types (4 and 5, 41 and 42, and 54 and 55) have 0.0% sequence difference because they do not differ at variable nucleotide positions, but they do differ by length mutations and hence are considered to represent distinct types. The population affinities of the mtDNA types are as follows: Western Pygmies (1, 2, 37–48); Eastern Pygmies (4–6, 30–32, 65–73); !Kung (7–22); African Americans (3, 27, 33, 35, 36, 59, 63, 100); Yorubans (24–26, 29, 51, 57, 60, 63, 77, 78, 103, 106, 107); Australian (49); Herero (34, 52–56, 105, 127); Asians (23, 28, 58, 74, 75, 84–88, 90–93, 95, 98, 112, 113, 121–124, 126, 128); Papua New Guineans (50, 79–82, 97, 108–110, 125, 129–135); Hadza (61, 62, 64, 83); Naron (76); Europeans (89, 94, 96, 99, 101, 102, 104, 111, 114–120).

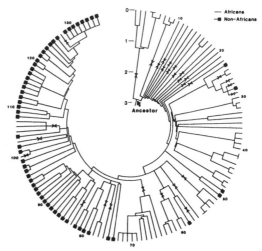

PLATE 13.5 *Phylogenetic tree of mitochondrial DNA types.*

Europeans.[24] (If the tree were unwound, it would be clear that Europeans are more distant from the "ancestor" than are Pygmies and African Americans.) In effect this is a naturalistic form, presented nonnaturalistically partly in order to hide certain properties that naturalism would make clear.

THE REPRESSION OF UNQUANTIFIED ELEMENTS IN MAPS

Eggs and trees are probably still the predominant examples of schemata, but since the Enlightenment they have been joined by a third kind that uses geometry more openly and rigorously. "Graph" will be my general term for images organized according to what I call *reference lines:* Just as writing is arranged along drawn or imagined register lines, so graphs are arrays set in order by drawn or imagined axes, scales, curves, nets, grids, rules, or lattices. The phrase *reference line* obviates the usual reliance on the other, more specific terms. The word *grid,* for example, has been given a particular valence by Rosalind Krauss and others, who have proposed it as the modernist icon above all others: the organizational principle that replaces earlier figure-centered compositions and expresses awareness of the decentered, dispersed self.[25] Such an analysis rings true for modernists such as Piet Mondrian and minimalists including Vito Acconci

but it is also true that grids have a far deeper history unrelated to the displaced subject. *Net* is a word favored by cartographers, but it is also too specific.[26] Many maps do not have ruled nets at all, and "net" is not apposite for images that depend on one-dimensional constructions such as number lines and scales, or for the constructions in sectors, slide rules, and proportional compasses.[27] *Net* is appropriate for modern cartography because it evokes a curvilinear lattice, but even though many graphs are curvilinear, it is not helpful to imply that nonlinearity is a normative condition. *Reference*

24. Linda Vigilant, Mark Stoneking, Henry Harpending, Kristen Hawkes, and Allan Wilson, "African Populations and the Evolution of Human Mitochondrial DNA," *Science* (27 September 1991): 1503–1507.

25. Krauss, "Grids," in *The Originality of the Avant-Garde and Other Modernist Myths* (Cambridge, Mass.: MIT Press, 1985), 8–22; and Yve-Alain Bois, *Piet Mondrian, 1872–1944,* exhibition catalog (Boston: Little, Brown & Co., 1995).

26. For examples, see Georg Scheffers, "Wie findet und zeichnet Man Gradnetze von Land- und Sternkarten?" in *Mathematisch-physikalische Bibliothek,* ed. K. Strubecker (Leipzig and Berlin: B. G. Teubner, 1934), Reihe 1, vol. 85–86.

27. For proportional compasses, see Galileo, *Operazioni del compasso geometrico, et militare,* trans. Stillman Drake as *The Geometric and Military Compass* (Washington, D.C.: Smithsonian Institution Press, 1978). The Istituto e museo di storia della scienza, Florence, sells a model of a proportional compass.

lines seems the best of the alternatives. It is a flexible term, and yet it is specific enough to capture what is essential about graphs: a linear, often scaled, often rectilinear geometric frame that imposes orientation and direction on an entire image.

Maps are the signal example of graphs in this general sense, as they are more common and widespread than the usual *x-y* graphs. Like egg and tree schemata, unquantified maps often depart from their geometric frames. The register lines — real or implied — are indispensable, but the real subjects of maps usually involve serve territorial, religious, or nationalist agendas; they aid navigation, but they also narrate journeys and the collection of pictures of faraway places, and even serve as legal documents.[28] (The same lack of interest in quantitative information, and the same ideological purposes, characterize contemporary artists' experiments with maps.)[29] The earliest historical maps — an Egyptian image of the afterlife and a Mesopotamian *mappa mundi* — convey a sense of right and left, up and down, north and south, but do not pretend to represent measurable distances or directions.[30] The Marshall Islanders' charts of ocean wells (made by tying palm-leaf ribs into arcuate patterns) also preserve cardinal directions, but they are principally intended to record angles between the ribs, and not distances. (They are also partly mnemonic notations, because each could only be used by its maker or someone trained by him.)[31] Non-Western and early Western maps are frequently hybrid forms, using both semiquantitative scales and other pictorial, written, and notational strategies that more or less contradict them.[32] In traditional Chinese culture, for example, there is no firm distinction between a map and a picture (both are given by the word *tu*), and some of the earliest landscape paintings are both plausible views and surveys of landholdings. Cordell Yee suggests that both maps and Tang dynasty "topographic" landscape paintings be thought of as mixed modes of representation, employing self-contradictory strategies and "variable perspective."[33]

28. For primitive maps, see B. F. Adler, *Maps of Primitive Peoples* (in Russian) (St. Petersburg, 1910), trans. and ed. H. de Hutorowicz, *Bulletin of the American Geographical Society* 43 (1911): 669–79; L. Bagrow, "Eskimo Maps," *Imago Mundi* 5 (1948): 92–94; and in general, Lloyd Arnold Brown, *The Story of Maps* (Boston: Little, Brown & Co., 1949).

29. Lucy Lippard, *Overlay* (New York: Pantheon, 1983), 112; also Roberta Smith, *Four Artists and the Map: Image/Process/Data/Place* (Lawrence, Kans.: Helen Foresman Spencer Museum of Art, 1981); David Woodward, *Art and Cartography* (Chicago: University of Chicago Press, 1987).

30. For the Egyptian "map," see Hellmut Brunner, "Illustrierte Bücher im alten Ägypten," in *Wort und Bild,* ed. Brunner et al. (Munich: Wilhelm Fink, 1979), 211, and *Ägyptische Unterweltsbücher,* ed. Erik Hornung (Zürich: Artemis-Verlag, 1972).

31. David Lewis, *We, the Navigators: The Ancient Art of Landfinding in the Pacific* (Wellington, New Zealand: A. H. and A. W. Reed, 1972), argues that the *rebbilib*-type stick charts might show Western influence because the "islands are given a relatively correct geographical position," although there is early evidence that Islanders could produce such maps. Generally, the indigenous and definitively non-Western *mattang*-type charts were "instructional and mnemonic," and lacked overall scale (pp. 201 and 204). The principal sources are Captain Winkler (no initial), "On Sea Charts Formerly Used in the Marshall Islands, with Notices on the Navigation of These Islanders in General," *Smithsonian Institution, Annual Report for 1899* 54 (1901): 487–508, which is a translation of his "Über die in früherer Zeit in den Marshall-Inseln ge-brauchten Seekarten, mit einigen Notizen über die Seefahrt der Mashall-Insulaner im Allgemein," *Marine-Rundschau* 10 (1898): 1418–39; August Erdland, "Die Sternkunde bei den Seefahrern der Marshall-Inseln," *Anthropos* 5 (1910): 16–26; Henry Lyons, "The Sailing Charts of the Marshall Islanders," *Journal of the Royal Geographical Society* 72 (1928): 325–88; and Nicholas J. Goetzfridt, *Indigenous Navigation and Voyaging in the Pacific: A Reference Guide,* Bibliographies and Indexes in Anthropology, no. 6 (New York: Greenwood, 1992).

32. Recently cartographers have devised a way to measure the distortions of unquantified maps relative to modern maps and charts. The method depends on a computer fit of selected points, and it generates a coefficient of distortion. See Matthew Stout and Helen MacMahon, "The Measurement of Planimetric Accuracy," in D. H. Andrews, *Shapes of Ireland: Maps and Their Makers, 1564–1839* (Dublin: Geography Publications, 1997), 327–29.

33. Maps and paintings are intermingled in the Tang dynasty, and one Tang source includes maps as a kind of painting. K. Yee, "A Cartography of Introspection: Chinese Maps as Other than European," *Asian Art* 5, no. 4 (1992): 29–47, esp. 41; and compare the "mapping impulse" in seventeenth-century Dutch art, as analyzed in Svetlana Alpers, *The Art of Describing* (Chicago: University of Chicago Press, 1983). See also Cordell D. K. Yee, "Chinese Cartography among the Arts: Objectivity, Subjectivity, Representation," in *The History of Cartography,* vol. 2, book 2, *Cartography in the Traditional East and Southeast Asian Societies,* ed. J. B. Harley and David Woodward (Chicago: University of Chicago Press, 1994), 128–69, esp. 147.

There is also the three-dimensional map. Sculptures made by nineteenth-century Greenlanders are an exceptionally beautiful example of unquantified maps: They mimic the inlets and headlands of the coast without any fixed scale, and with a floating sense of the requirements of naturalism (Plate 13.6).[34] The lefthand sculpture represents the coastline from A down to N, and then, when it is turned upside down, it represents the coastline from P up to X. It was used in conjunction with the righthand sculpture, which depicts the islands along the same stretch of coast. In the original usage, the island map would have been moved along the main map so that each island in turn was correctly placed in relation to its nearest headland. It is nearly impossible, I find, to imagine how these maps could have been used to navigate along the coast. Some features are radically diminished: The fjord at D, called Kangerdlugssuatsiaq, is said to be so long that a canoeist could not paddle to the end and back in a day, yet it is only a little notch on the map. Just south of it, the small fjord at F, called Arpertileq, is represented by a notch almost as large as Kangerdlugssuatsiaq's.[35] The island map is no better: The first island (e, Sardlermiut) is elongate and smooth on the wooden map but deeply bayed on the modern map, and the island just south of it (h, Nepinergit) is nearly half its size. Nepinerkit is supposedly pyramidal, but the modern map shows an irregular shape. The wooden island map also skips a number of islands unaccountably, and doubles back on itself to represent a cluster of islands.[36]

What criteria of naturalism are at work here? The main map is intended to represent the principal headlands, but it alters their shapes so drastically (and even omits fjords as large as those it represents) that it is difficult to see what counted as a sufficiently iconic presentation. The island map is even more distorted, although it might preserve some characteristic silhouettes that are difficult to appreciate without actually following the route by kayak. It's possible, looking at modern maps, that Sardlermiut Island (e) could look smooth from the landward side. Could the vagaries of actual kayaking — working against headwinds, watching as distant headlands come into view, keeping to the inland passage — make these maps look realistic? Or is this an ineluctable question of cultural difference?

Unscaled maps are often associated with non-Western and pre-Renaissance cartography, but all maps contain unquantified features. The literature contains an entire nomenclature to describe such unscaled or "exaggerated" features. Map theory is a young field, and the texts tend to use whatever terminology is at hand to describe degrees of abstraction and realism, alphabets and pictograms, calligraphy and typography, pictures and texts.[37] In the babble of terms a constant concern is to distinguish one unscaled sign from another — to keep large dots distinct from small ones, or wide roads separate from narrow ones. According to one manual, "solid and outline geometric figures" must be kept separate from the "physiographical symbols," "pictorial symbols," "divided symbols," "conventional point and route symbols," and "town symbols" — each of which has its particular graphic shape.[38] The contours of isobars, latitude, longitude, altitude, great circles, magnetic

34. The wooden maps were collected in 1884–85, in Ammassalik, and first published in Gustav Holm, "Ethnologisk Skizze af Angmagsalikerne," *Meddelelser om Grønland* 10 (1888): 101, 144, and plate 41, and see also Mallery (1893), 346; and W. Thalbitzer, "Ethnological Collections from East Greenland (Angmagsalik and Nualik)," *Meddelelser on Grønland* 39 (1914): 665–66. Photographs of the original objects have been published in Joachim Leithäuser, *Mappae Mundi, Die geistige Eroberung der Welt* (Berlin: Safari-Verlag Carl Boldt und Reiner Jaspert, 1958), 20, and *Kalaallit Nunaat Greenland Atlas*, ed. Christian Berthelsen et al. ([Copenhagen:] Pilersuiffik, 1990), 1.

35. All the labeled features on the modern map are named in the original source, and I have conflated several at the very end (around U, W, and X). In the sculpture, the isthmus G is represented by a curved notch denoting two tongues of a glacier that links the fjord F with the fjord I. In the hundred years since the maps were made, a number of the names have changed, and in addition the orthography has been altered, and most places also have Danish names as well; for instance, Arpertileq is also called Erserisek. I have not been able to identify two of the islands that are named in the original source.

36. Contrary to the literature, the island map seems to correspond only to the righthand side of the mainland map.

37. See first Arthur Howard Robinson, *The Look of Maps: An Examination of Cartographic Design* (Madison: University of Wisconsin Press, 1952).

38. Arthur Howard Robinson and Barbara Bartz Petchenik, *The Nature of Maps: Essays toward Understanding Maps and Mapping* (Chicago: University of Chicago Press, 1976), 29; and see George A. Schnell and Mark Monmonier, *Map Appreciation* (Englewood Cliffs, N.J.: Prentice-Hall, 1988).

PLATE 13.6 Left: *Nunik from Umivik, carved wooden maps of a portion of the coast of Greenland. ca. 1884.* Right: *contemporary map of the same coastline.*

coordinates, rhumb lines, and loxodromes must not be confused with the features of the terrain itself or its commercial and political divisions; they are distinguished by appropriate conventions of dotted, dashed, and "interrupted" lines such as —··—··—.[39] The *hachure* must be consistent, and if the landscape is lit, it must have either vertical, oblique, or combined light sources.[40] Any loosening of these strictures would mean that a map could become difficult to read, and worse than that, it would threaten the map's veracity by blurring the ostensible distinction between scaled and unscaled features.[41] A large road might cease to be a symbol, with arbitrary width, and begin to appear as a measured object, as wide as it should be given the scale of the map. The management of unscaled features is as important a feature of modern maps as the presence of measured reference lines.

In current practice the management of scaled and unscaled features, words and pictures, grids and ungridded forms, has reached a new pitch of complexity. The same half-century that saw the rise of the discipline of "visual communication," with its single-minded emphasis on the efficient transfer of information, is also the period in which maps have become capable of carrying more information per square inch than ever before.[42] Maps are now among our most complex visual objects. The *Tübinger Atlas des Vorderen Orients* (1990) is an example of this tendency to move away from easily read graphics and to capitalize on the density of information that only maps can achieve. The atlas is an unbound collection of plates, some of them so complex that their keys cannot be accommodated even in tiny print, and the sheets have to be supplemented by booklets.[43] It uses the full range of images: framed insets to pictographic symbols, stacked pictures, pie charts, grids, graphs, colors, and symbolic patterns. On one plate the religions of Lebanon are shown as pie charts, centered on each town and village and scaled in proportion to population (Plate 13.7). Around Beirut the circles crowd so densely and overlap so completely that scale, place, and direction are effectively lost. The thin segments representing Christians and Jews project well out into the Mediterranean, and the surrounding villages become a cacophony of intricately ordered symbols. Only a few carefully plotted landmarks and lines preserve the essential projection of latitude and longitude. (The mapmakers

offer a detail of the area bounded by the rectangle, which is reproduced here at the right; it nearly falls into the same illegible density.) In some maps the complexity is so far beyond useful visualization that the mapmakers forego grids altogether. The recent maps of the large-scale structure of the universe are such maps: They rely very little on coordinates and present their unimaginable findings against simple pie-chart slides of space.[44]

I make this comparison between the "simple" map of Greenland and the "complex" map of Lebanon to suggest that the difference between unquantified and quantified, Western and non-Western, is less than it might seem. The huge literature on modern mapmaking can be read as a valiant effort to quantify and contain unscaled features, and to render maps rigorously notational. But despite the best efforts, quantified notational elements battle against one another (as in the *Tübinger Atlas*), and against the maps' naturalism. Premodern, non-Western maps seem to have subdued their notational elements, but notations still distort them, occasionally producing indecipherable amalgams of measured and unmeasured parts (as in the map of the Greenland coast). Maps are among the most difficult and fascinating visual images because pictures resist scaling, reference lines, writing, symbols, keys, and the whole menagerie of interpolations that maps force upon them. Maps,

39. Georg Scheffers, *Lehrbuch der darstellenden Geometrie* (Berlin: Julius Springer, 1920), vol. 2, sections 415–28.

40. P. Yoëli, "Relief Shading," *Surveying and Mapping* 19 (1959): 229–32; R. Mean, "Shaded Relief," *U.S. Aeronautical Chart and Information Service* 91, no. 9 (1969): 515–20; and P. Richarme, "The Photographic Hill Shading of Maps," *Surveying and Mapping* 23 (1963): 47–59.

41. David J. Cliff and Mark T. Mattson, *Thematic Maps: Their Design and Production* (New York: Methuen, 1982).

42. *Representation in Scientific Practice,* ed. Michael Lynch and Steven Woolgar (Cambridge, Mass.: MIT Press, 1990); Edward R. Tufte, *Envisioning Information* (Cheshire, Conn.: Graphics Press, 1990), reviewed in *Science* 252 (17 May 1991): 979–80; Tufte, *The Visual Display of Quantitative Information* (Cheshire: Graphics Press, 1983); W. H. Kruskal, "Criteria for Judging Statistical Graphics," *Utilitas Mathematica* 21 B (1982): 283–309.

43. *Tübinger Atlas des Vorderen Orients* (Wiesbaden: Dr. Ludwig Riechert Verlag, 1990), 2 vols.

44. Margaret Geller and John Huchra, "Mapping the Universe," *Science* 246 (17 November 1989): 885, 897–904, and cover illustration; and Faye Flam, "In Search of a New Cosmic Blueprint," *Science* 254 (22 November 1991): 1106–1108.

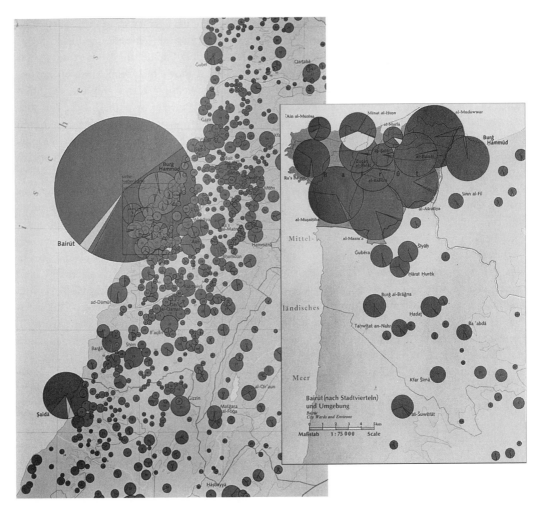

PLATE 13.7 *Klaus-Peter Hartmann and Horst Pohlmann. The religions of Lebanon, detail.* Inset: *a portion of an enlargement intended to clarify the region around Beirut. 1979.*

in that sense, are dramas of the repression of pictures.

THE REPRESSION OF THE ICONIC ASPECTS OF *x-y* GRAPHS

The representational properties of images do not fade as we move from unquantified, pictorial notations to more rigorous geometry. Instead, they are squeezed, forced to play marginal roles, or denied entirely. Graphs in the modern sense of that word — *x-y* graphs — are an interesting case, because they are normally said to have nothing to do with pictures.

Graphs were invented by the fourteenth-century Scholastic Nicole Oresme, but the familiar kind of isotropic, rectilinear, two-dimensional Cartesian coordinate grid, measured by two mutually orthogonal axes (introduced in high school geometry as the "*x* and *y* axes") did not come into use until five centuries later, at the beginning of the nineteenth century.[45] (The phrase *Cartesian coordinates* is a notorious misnomer, as Descartes did not use grids or square-ruled paper.) *Graphs,* as I will be using the word, includes the (supposedly) Cartesian sense but also unquantified images that depend on undrawn grid lines.

45. For the concept of graphs, see further Pierre Duhem, *Études sur Léonard de Vinci, ceux qu'il a lus et ceux qui l'ont lu* (Paris: A. Hermann, 1906–13), vol. 3; Eduard Jan Dijksterhuis, *The Mechanization of the World Picture,* trans. C. Dirkshoorn (Oxford: Clarendon Press, 1961); and Karl G. Karsten, *Charts and Graphs: An Introduction to Graphic Methods in the Control and Analysis of Statistics* (New York: Prentice-Hall, 1923).

In Oresme's original graphs, what we call the x axis is a line segment in the *subjectum* (the object that is being studied), and it is simply called the *longitudo*.[46] Measured quantities along the "longitude" are represented by vertical segments, each of which is called a *latitudo*. At first, the subject is represented by "the plane surface that is formed by the aggregate of the plotted *latitudines*," as if it were a fence made of adjacent posts. Only later does Oresme plot "difform" or variable intensities as vertical segments and join their tops in the curve that we tend to identify with all graphs. He calls that curve the *linea summitatis;* we would call it the function, or just the graph itself. It would not be correct to identify the longitude with the x variable, as it is simply "the whole of the line segment of the *subjectum* being considered; there is only one *longitudo* with an infinite number of *latitudines*."[47] Hence in Oresme's original graph, the horizontal direction is like a picture of the object, even though the vertical direction might be any number of quantities or "intensities" such as heat or velocity.

Oresme's graphs apparently had meaning for him by virtue of their form — that is, they meant something different as images from what they might have meant as numbers. He called the complete graph a *figuratio* or *configuratio,* and he attached a physical meaning to its shape.[48] His pictorial sense of graphs is especially clear in his consideration of the result of graphing distance in a body against heat. In modern terms, if the body is heated uniformly, the graph will be a horizontal line; if it gets hotter at one end, the graph will be a sloped line; and if it is irregularly heated, the graph will be a continuous curve. In Oresme's account, the *linea summitatis* is less important than the vertical segments that define it, the *latitudines,* and so it becomes significant that the three graphs are rectangular, triangular, and irregular. Oresme proposes that a "rectangular heat" will feel different from a "triangular heat" or a "difform heat." "Triangular heat" is sharp, like the triangle of the graph, and "rectangular heat" is smooth, as its rectangular shape suggests. Hence the graph is partly a naturalistic picture of the "subject," partly a nonnaturalistic notation, and partly a symbol for a quality of touch or of heat. The triangle's sharp apex is the sharpness of the end of the object, its maximum temperature, and the tactile sharpness of heat itself.

Not all graphs suggest a naturalistic parallel between their physical shape and the phenomenon under study, but I do not think it is extravagant to claim that shadows of Oresme's notion are still with us. An example is this graph of the hours of sunshine at a farm in Withernwick, Yorkshire (Plate 13.8). Hours in which the sun was shining appear as black bars, and despite that inverse logic, we can picture the sunny (blacked-in) days of early July and the blank, stormy days in November, December, and January. We can see when the sun rose (the dashed contour at the left), and how soon afterward the first sun hit the observing post. On some days in May, the sun must have come lower between hills or trees, as it struck only minutes after theoretical sunrise. Some days have many short intervals of sunshine, conjuring a skyfull of cumulus clouds. Others are sunless except for a few morning hours, suggesting a dark storm front advancing after clear weather. The graph also has its

46. For Nicole Oresme, *Tractatus de configurationibus intensionum* (also called *De uniformitate et difformitate intensionum*), see *Le Livre du ciel et du monde: Text and Commentary,* ed. A. D. Menut and A. J. Denomy, C. S. B. Mediæval Studies 3 (1941): 185–280, 4 (1942): 159–297, and 5 (1943): 167–333. There is a self-portrait by Oresme in the Bibliothèque Nationale, MS fr. 565, fol. 1r, illustrated in Kristina Herrmann-Fiore, "Giovanni Albertis Kunst und Wissenschaft der Quadratur," *Kunsthistorisches Institut, Florence, Mitteilungen* 22 (1978): 67.

47. Dijsterhuis, *Mechanization of the World Picture,* 194.

48. Maier, "La Doctrine de Nicolas d'Oresme sur les 'configurationes intensionum,'" *Revue des Sciences* 32 (1948): 52–67. His reasoning follows the Greek atomist doctrine that holds that the shape of atoms influences their function (fire atoms are sharp, and so forth). There are hard and soft versions of this doctrine. The hard version attributes the gross properties of the element to its microscopic form; such doctrines, though they were revived in the seventeenth century by Gassendi, were less pervasive than the softer versions, in which the conventional symbolic representations of atoms or elements were taken to be suggestive of the element's properties. See Pierre Gassendi, *P. G. Diviensis ecclesiae praepositi . . . opera omnia* (Lyons: Laurentius Anisson and Ioannes Bapt. Devenet, 1658), 6 vols., vol. 2; and Descartes, *Principia philosophiæ* (Amsterdam: L. Elzevirium, 1644), book 4, pp. 51, 58, and 62–63. Oresme's position in relation to modern science is well exposited in Anneliese Maier, *Zwei Grundprobleme der scholastischen Naturphilosophie* (Rome: Edizioni di Storia e Letteratura, 1951); Maier, *An der Grenze von Scholastik und Naturwissenschaft* (Rome: Edizioni di Storia e Letteratura, 1952); and P. Hoenen, S.J., "Die Geburt der neuen Wissenschaft im Mittelalter," *Gregorianum* 28 (1947): 164–72.

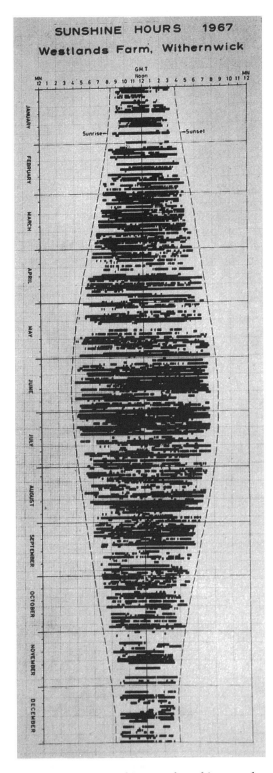

SUNSHINE HOURS 1967

Westlands Farm, Withernwick

PLATE 13.8 *D. P. Brachi. Annual sunshine record at Withernwick in the East Riding of Yorkshire. 1967.*

linea summitatis, or rather two of them, in the form of the sine curves of sunrise and sunset. They don't represent the course of the sun against the sky, but they leave a strong impression of it.

All those elements are pictorial, and there is also a strong impression of writing. The longer days of summer seem to stretch before our eyes, almost as if they were lines of script — as if it were possible to "read" the day and decipher the clouds as they pass. Would it be sensible to deny that the *form* of the graph also has meaning, even if it can't be assigned a quantitative formula? In Oresme's language, the gentle curve of the longer days of summer is expressive of that season, of its quality of light. If the *linea summitatis* had been differently shaped, we would be affected differently. A sine curve is simply the form of the light of summer.

Graphs are dependent on resemblance in a number of ways. The sonar chart that formed the first example of simultaneous "routes of reference" is a graph, and it is also unmistakably a naturalistic landscape and a conglomerate of several notational schemata (see Plate 3.3). The plot of sunshine at Withernwick is a panoramic picture, and a memory, of a summer. The coastal map of Greenland is a picture unaccountably distorted by irrecoverable navigational demands. The map of the religious groups in Lebanon is also a picture of the makeup of individual communities — their size, their insularity, their exchanges with one another. Given such variety, it is interesting that the iconic properties of graphs (especially x-y graphs) are so seldom discussed, and that they are taken to be irrelevant or illogical — a sign, perhaps, that the "logocentric" flight from pictures might bring us closer to notation as well as writing.

A NOTE ON GEOMETRIC
CONFIGURATIONS

Ascending this slope of notational complexity, we come at last to *configurations:* images organized according to geometries beyond simple scales and grids. Again maps provide some of the most accessible examples.

Possibly the most distorted world map ever created is A. R. Hinks's retro-azimuthal map of the world (Plate 13.9).[49] The concept comes from the

49. For Hinks's projection, see "A Retro-Azimuthal Projection of the Whole Globe," *Geographical Journal* 73 (1929):

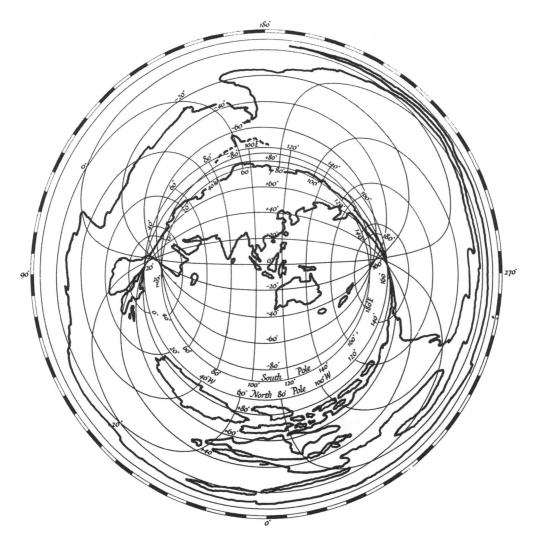

PLATE 13.9 *A. R. Hinks. Retro-azimuthal projection of the world, centered at Malacca, Malaysia. Continent outlines added by author.*

"azimuthal map," which shows the bearing (azimuth) of any place from the center of the map. The retro-azimuthal map shows the bearing of the center of the map from any place. The map reader finds his location on the map and then draws a line from the map's center through his location to intersect the compass on the map's circumference. That reading gives the azimuth of the center. The first of these maps was Meccacentric, to aid Muslims in finding the direction of Mecca for prayer.[50] It's hard to see, though, how such an outlandishly distorted, mathematically sophisticated map could ever be of practical use. The mapmaking process can be imagined in topological terms: take a globe, pierce the North and South poles, and open them into circular rings. Glue one pole down, and take

the other, flip it over, enlarge it slightly, and glue it down. In this example, the poles are concentric circles, Malacca is at the center, and the point on the globe diametrically opposed to Malacca is the entire circumference of the map. It can take some time to find the United States, which is reversed right to left, and to follow Central America as it twists up and to the right, expanding into South America, which then encircles the entire circumference of the map. Europe spins into the fold of

245–47, and the discussion on 249–50. See also Hinks, "The Projection of the Sphere on the Circumscribed Cube," *Geographical Journal* 57–58 (1921): 456; and John Synder, *Flattening the Earth* (Chicago: University of Chicago Press, 1993).

50. See James Ireland Craig, *The Theory of Map-Projections* (Cairo: National Printing Department, 1910).

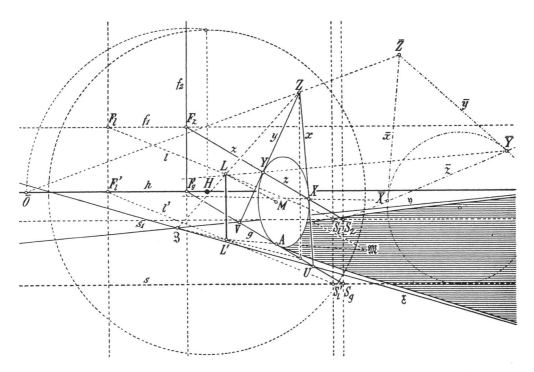

PLATE 13.10 *Georg Scheffers. A hyperbolic shadow cast by the elliptical perspective representation of a circle, lit from a point source at* L.

the map and emerges inverted and reversed just to the left of Arabia, with a tiny Africa clinging to it. (Parallels have been made between cartography and fine art — most notably, between Renaissance loxodromic maps and linear perspective, and between Dutch topographic views and seventeenth-century painting — and another such parallel suggests itself here. Hinks's map was presented in 1929, the year that Picasso was experimenting with the most extreme linear and "bone figure" distortions of the female form. As in the case of crystallography, a double history of cartography and painting would often find itself giving cartography priority for spatial innovations.)

Outside the constraints of actual geography, configurations can become even more complex. If I were to continue this sequence, the next images would come from projective or descriptive geometry or perspective — the fields that first applied the word *configuration* to geometric objects (Plate 13.10). I have examined such images elsewhere, so I won't go into detail here.[51] It is enough to say that what appears at first to be a naturalistic picture — a circle, standing upright, casting a long shadow — is actually a configuration of lines that serves to prove that under certain circumstances, a

circle's shadow will appear as a hyperbola (note the asymptotes on either side). Because the hyperbola is flat on the page, there is no question of it's being naturalistic, or in perspective. The cat's cradle of lines serves to make the transition from perspectival picture to geometric construction. Along the way, the interpretive protocols are very strict, and entirely unlike reading. The image is to be understood in a certain sequence, and each line and arc carries a specific semantic and syntactic charge — semantic in its relation to the illusionistic scene, and syntactic in its relation to other lines and ultimately to the "flat" construction of the hyperbola.

Such images raise the problem of appropriate explanation in an especially virulent form, as it can easy take several pages to adequately gloss the construction. The length of the explanation — the *subscriptio*, in emblematic terms — is evidence of the density of information that notational systems can bear. Writing seems meager by comparison, and the disparity raises an interesting possibility: Briefly put, notation might be to writing as writing is to pictures. For sheer density of information,

51. See especially my "Clarification, Destruction, Negation of Space in the Age of Neoclassicism," *Zeitschrift für Kunstgeschichte* 56, no. 4 (1990): 565–66, and Elkins (1994).

notations have no parallel, and in that respect the triangle of writing, pictures, and notation might be more like a straight line from pictures (the "meaningless" substrate) through writing (whose systems are constrained by characters) to notation (where the limits are only the density of the geometry).

"PURE NOTATION"

Of the three kinds of images that have been partly ordering this account, notation is certainly the most problematic. It occurs in prehistoric "tally marks" and therefore seems to predate writing.[52] It is present alongside writing from its earliest origins: There were illustrated mathematical treatises in Mesopotamia, Egypt, and ancient Greece, although little remains of the original illustrations.[53] But that-which-is-neither-picture-nor-writing did not become prominent in the West until the late Middle Ages, and it only flowered after the Enlightenment. There is a widely read literature in the humanities speculating on the extent and nature of images in twentieth-century culture.[54] Despite wide disagreements over the effects and nature of "visual culture," it is not often noted that what makes twentieth-century culture so different from that of past centuries is not only the quantity of images, or their ostensible effects on literacy, but the *kind* of images we create and consume. Nothing approaching the complexity and versatility of modern notations existed before the Enlightenment. In the Renaissance a few pictures would have been unintelligible without prior explanation, but the majority were iconic. Now it is common in science and technology to find images that are entirely opaque to untrained eyes, not only because they depend on specialized concepts but because they are organized according to specialized notational structures. Emblemata are the commonest twentieth-century images, and schemata are the most typical. Together they could be used to construct a fair definition of what images have become.

If notations were pure — even relatively pure — then their history would be a concern of specialists. But they aren't: They are sullied in conceptually challenging ways. Even the perspective diagram is inextricably attached to its pictorial purpose and origin. Nor are notations confined to the sciences, or to engineering, because everyone reads "graphics," charts, tables, graphs, and maps. Of all the

subjects of this "survey of exemplary images," schemata are most in need of further historical and analytic work.[55] Not only are they the fastest-growing kind of image, but they are arguably the most varied. Here I have confined myself to a single theme, which I take to be at once irreducible and often overlooked: The continuous presence of the concept of pure pictures. Pictorial elements interfere with notations, disrupting any straightforward reading. To understand a diagram like Jung's or Gichtel's, it is necessary to decide how to take the manifestly pictorial parts of the image. To comprehend Kleene's series of logical deductions, you have to think at least momentarily of a picture of a tree. In modern schemata, the choices are often made for us, by the unwarranted exclusion of all pictorial meaning. But what is the graph of sunlight in Withernwick if not a picture of each day? And what is a Feynman diagram, if not a diagram inspired by pictures of particles interacting?

At first it might seem that emblemata and schemata obey two different operative rules (the one: pictures and captions; the other: reference lines). But there is a deeper connection. As the ante is raised, and more and more elements are brought to bear on a single image — *inscriptiones, subscriptiones,* notational syntax, ruled lines, geometrical configurations — it becomes harder and harder for notational systems to break free of pictures. (Writing is easier to avoid: It can just be omitted,

52. See Elkins (1997, 1998).

53. For the illustrated Rhind Papyrus, Brit. Mus. 10057 and 10058, see *The Rhind Mathematical Papyrus,* ed. Arnold Buffum Chace (Reston, Va.: National Council of Teachers of Mathematics, 1979 [1927–29]), and Annemarie Eisenlohr, *Ein mathematisches Lehrbuch der alten Ägypter* (Leipzig: J. C. Heinrichs, 1877).

54. For a sample bibliography, see my "What Are We Seeing, Exactly?" *Art Bulletin* 79, no. 2 (1997): 191–98.

55. Contemporary music notations that mimic celestial charts, abstract paintings, and maps are among the most interesting examples. They challenge viewers to find significance in the face of flagrant mixtures of ordinary notation, pictures, or writing. There is little scholarship that addresses the central question of the *pictorial* valence of the scores: how specific visual devices (that is, not those specified in the notation) influence performance. See J. Evarts, "The New Musical Notation: A Graphic Art?" *Leonardo* 1, no. 4 (1968): 405–12; Erhard Karkoschka, *Notation in New Music: A Critical Guide to Interpretation and Realisation,* trans. Ruth Koenig (New York: Praeger, 1972).

or replaced by long prose descriptions.) The most interesting question that I think can be asked of a notation is the kind of picture it represses. What kind of a place is Withernwick when it is shown as it is in the chart? What kind of place is the world when it centers, azimuthally, on Malacca? Different notations depend on a different kinds of picture and put different pressures on them. Often enough the picture survives only in part, and only under the most severe restrictions and distortions. But it always survives.

14 : Conclusion: Ghosts and Natural Images

The ghosts that have animated this text — the ideals of pure pictures, writings, and notations — have never appeared in these pages. But they are spectral in every image, even the simplest (Plate 14.1). This envelope, mailed from Modena to Piacenza in 1889, is a picture simply because it is rectangular and has varied forms. It is also writing, because texts can be read in it, and it is a notation, because the stamps and cancellations make it possible for a postal historian to trace its route, deduce its carriers, and verify the postal rates. And the image is not just pictured, written, and notated: Many of the concepts and classifications I have been exploring are also in play. The words "Sig^ri / Cella e Moy / Piacenza" are in an exquisite calligraphic hand, with brilliant quick flourishes. Historically, they belong to the tradition in which allographic marks attach themselves parasitically to the letters, rather than bursting out from inside letterforms. The return-address stamp is a cartouche, and therefore akin to the postage stamp and the round cancellation. The stamp itself is an emblem in my general sense, although it works as heraldry with its eagle and crown. In addition, the envelope is palimpsestic, because the letter has bled through onto the front, reversed and at right angles.[1] (In nineteenth-century custom, the address is written directly onto the folded letter. This "envelope" could be unfolded, making a larger and stranger-looking image.) All together, it speaks for the common condition of visual artifacts: It is an echo chamber of many kinds of images we have touched on throughout the book, and a clear instance of none of them.

Images that combine traces of writing, pictures, and notation are ubiquitous and inescapable. I have suggested that emblemata (juxtapositions of writing and pictures) and schemata (combinations of writing, pictures, and notation) are the typical productions of post-Renaissance Western visual culture. Certainly most of our everyday images, from book covers to soup cans, are cobbled together from pieces of prose and pictures. It is odd, then, that we remain so inattentive to their complexity. Envelopes suffer the usual fate of allographic and "decorative" images: They are used as if they were straightforward informational objects.

1. Palimpsests were made by scraping or washing the ink off of papyrus or vellum and rewriting at a ninety-degree angle to the previous script (*palimpsest* is from the Greek *palimpsestos,* "rubbed over"). The ninety-degree turn was necessitated by the rectangular format of the scrolls and by the texture of papyrus (which is composed of ribbed strands pasted at right angles). Some palimpsests were written on several times; the maximum known is five, but the norm is two. Hence classical palimpsests have a strongly geometric quality, and they are structurally simple, even if they might be difficult to read. In the twentieth century the word *palimpsest* has come to denote much greater formal complexity and media beyond vellum and papyrus. The metaphors of effacement have changed from washing and rubbing to collaging, tearing, dissecting, and deconstructing; a palimpsest is any imbrication, overlaying, or bricolage of words, images, or notation. No matter how intricate they are, or how far removed from simple texts on papyrus, palimpsests have to do with legibility: Some writing must remain partly legible; otherwise the image is less a palimpsest than a griffonage — or, ultimately, less a script than a picture. The history of the word *palimpsest,* and its passage from the epigraphic sense to the figurative one, has not yet been clarified. Gérard Genette, *Palimpsestes: La littérature au second degré* (Paris: Seuil, 1982).

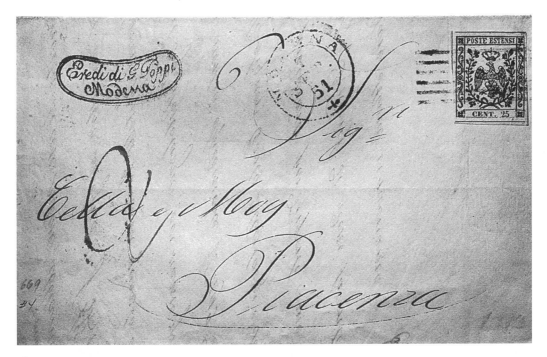

PLATE 14.1 *Envelope, franked with Modena #4, 25c buff. 1851.*

(A postal worker has carelessly scratched another cancellation over the name Cella, ruining the calligraphy simply by not noticing the envelope might have meaning that is not commercial. In his turn a philatelist has numbered and priced the envelope at the lower left: His only concern was the value of the stamp and cancellation.) People who take note of the vagaries of such images are "hobbyists" — in this case, paleographers, calligraphers, or postal historians.

The narrowness of the ordinary, utilitarian interpretation and the marginalization of more attentive interpretations are typical of the modern response to images. The utilitarian approach can be found — in different shapes, and with differing consequences — throughout the literature on the images in Part 2 of this book. Interpretations that assume the purity of what they interpret can be divided into three complementary practices, which I'll do as a way of starting to summarize the argument of the book.

1. In scientific and mathematical literature, complex schematic images are often taken as pure notations. The circular "tree schema" of mitochondrial DNA is an instance (Plate 13.5). If it were unrolled, leaving the African "ancestor" at the bottom, the mtDNA graph would form a lop-sided tree: The branches would veer off to the right, the way actual trees are when they are sculpted by ocean winds. In its more overtly pictorial form, the image would be irresistibly reminiscent of meliorist (and racist) schemata. Despite their notational pretensions, scientific illustrations are often picture-driven: Their meanings are directed and constrained by their dependence on pictorial formats. Sewall Wright's genetic "maps" and Feynman diagrams both borrow from overtly pictorial practices — from topographic maps and from bubble-chamber traces, respectively — and turn them to nonpictorial ends (Plates 3.4 and 3.5). The question, in both cases, is how much the pictorial origins continued to influence the way the notations were understood. As it turns out, their pictorial inspirations influenced later research, because people inevitably (and incorrectly) thought of pictorial meanings and possibilities, rather than following Wright's or Feynman's anti-naturalistic notational intentions.

2. Just as schematic images are taken as pure notations, so complex pictorial scripts are taken as pure writing. Semasiographic scripts such as hieroglyphic Hittite, Egyptian, and Mayan are normally interpreted without taking their pictorial elements into account. I have argued that such interpreta-

tion is underinterpretation, and that meanings go missing when *extragrammatical* pictorial elements are not included in the analysis. The same could be said of Linear B, archaic Chinese, Yi, and early cuneiform (Plate 8.5).[2] The Luwian inscription on the Tarkondemos seal — "Tarku, King of the Land of Mera" — changes meaning when the script is seen in place on the seal (Plate 8.2). Then it becomes clear that the sign *king,* the king's staff, and the mountains of his *land* are all identified with one another — they form the landscape through which the figure of the king walks. His name, on the other hand, is identified with his head, since the signs and the head are next to one another at the top. I took that as an especially clear example, although I would say that any highly pictorial script alters the act of reading, deviating attention toward the appearance of the image. The usual rules of reading in historical linguistics and epigraphy proscribe pictorial meanings and treat scripts as if their pictorial nature were a detachable impediment to their proper and primary linguistic meaning.

3. Complex schemata treated as notations and complex scripts treated as writing are two-thirds of a triad of reductive interpretations; it is rounded out by readings that take complex images and treat them as pure pictures. Whenever subgraphemic or hypographemic images are classified as pictures, they lose whatever waywardness they might have had by virtue of their incomplete traces of writing or notation. This is an issue in archaeology, because especially intricate images such as those at Loughcrew are apt to be understood as random or decorative assemblages, with a few meaningful signs thrown in (Plates 11.2–11.5). Art history and art criticism do the same with paintings by artists such as Julian Schnabel or Adolph Gottlieb (Plates 9.4, 10.9). Despite some linguistic content, such pictures are taken to be indecipherable and therefore best approached as holistic, nonlinguistic images — that is, as pure pictures. The challenge is to find a way of responding to such images, in both archaeology and art history, that takes their linguistic and notational remnants as seriously as possible. Otherwise, the images lapse into premature meaninglessness.

These three reductive interpretive regimens divide the chapters of Part 2 fairly evenly. (The ideal of pure writing governs the reception of the im-

ages in Chapters 7 through 9, the ideal of pure pictures is pervasive in the literature on the images in Chapters 10 and 11, and the ideal of pure notation is the preeminent interpretive method for images in Chapters 12 and 13.) Together the three comprise the first part of my argument: that the ghosts of pure meaning direct normative interpretations and disallow more vigilant responses to visual artifacts. A second part of the argument accompanies the first, as its shadow: that modern viewers are driven by a reciprocal interest in images that are *not* pure. We are haunted, as no other culture has been, by the specters of pure communication; at the same time, however, we are fascinated by images that ruin pure forms. At one and the same time we deny impurity and continue making and studying indecipherable, incomplete images, made of half-dissolved parts of other images. Most every illustration in this book is a hybrid of some sort, and I have even tried to enlist the Latin alphabet as a covertly pictorial practice by pointing to its pictorial origins (see Plate 8.8). The purest scripts (Roman), the purest pictures (for instance, the Inness landscape [Plate 5.4]), and the purest notations (such as the perspective diagram of the circle [Plate 13.10]) are all sullied. The shape of the modern affection for strange impurities can be judged by the fact that the images that seem most captivating — such as postmodern paintings, or non-Western picture-writing — are the most stubbornly impure.

I am going to try to summarize the theoretical drive of Part 2 in four arguments. These first two (that we assume and require images be pure, but that we are drawn to impurity) are the principal dynamic, the essential tension. They name part of the modern way of understanding images, as they were not present in all times and places. There is no evidence, for example, that Egyptian scribes thought about pure semasiography, or pure glottographics — although they did think of ways to write more efficiently, as Hieratic script testifies. The Chinese conceptualize the pictorial elements in their script very differently from the Western reception might suggest; the six traditional categories of writing (*liù shu*) blend semasiographic

2. For Yi see Dingxu Shi, "The Yi Script," in Daniels (1996): 239–43.

and glottographic examples instead of distinguishing them.[3] Clearly our divided state of mind is our own, and I want to pause for a moment, before continuing on to the third and fourth parts of the argument, to consider its history.

The basic genealogy of our bifurcated interests stems from pre-Enlightenment interest in scripts, and there is a specific connection to be made between modern and postmodern paintings and seventeenth- and eighteenth-century hermeticism. The two periods produced images that are remarkably close to each other, not least because they share a common interest, one that is not at all common in the West before the Renaissance, or in non-Western cultures: the artists of both periods prefer their meanings half-effaced, and they achieve their partial obscurity by mingling (and mangling) pictures, words, and notations. Painters like Julian Schnabel and mystics like Abraham von Sommerfeld are drawn to illegible scripts, incomprehensible pictures, and invented notations (see Plates 10.8 and 10.9). Although the seventeenth century is the renascence of this form of visual obscurity, experiments linking illegible writing to incomprehensible pictures began in the Renaissance. The classical starting point in histories of hermetic emblemata and mystical interest in hieroglyphs is Francesco Colonna's *Hypnerotomachia poliphili* (1499), with its elaborate invented Egyptian inscriptions. The practice of making pictures — often emblems — that fail to make clear sense comes to full flower in the late seventeenth and early eighteenth centuries in books on such subjects as Egyptian script, Rosicrucianism, Freemasonry, spagyric chemistry, astrology, and alchemy. The mystics' odd oil-and-water mixtures of sense and nonsense have a great deal to tell us about how we want images to work in fine art, from the torn texts in collages by Picasso and Braque to the burned-out writing in books by Ann Hamilton or Anselm Kiefer.

An archaeology of the practices of surrealism and neoexpressionism could begin with seventeenth- and eighteenth-century images. How are we to understand, for example, the differences between engraved calligraphy, German Gothic script, upper- and lowercase Latin, Hebrew, Greek, and the several italic fonts in Abraham von Frankenburg's *Raphael* (Plate 14.2)? Frankenburg is at the limit of a seventeenth-century tradition of revelatory typography, and his text makes bizarre use of pictorial, emblematic, schematic, and hypographemic images. Any given passage is likely to be illegible on account of its apostrophes, its elliptic grammar and its esoteric blend of kabbalah, prayer, and medicine; but even when the signs can be decoded, his wild mixtures of notational, written, and pictorial elements leave the reader with little sense of how to proceed. (Reading *Raphael* leaves the impression of an ecstasy whose source was obscure even to the author.) Frankenburg is an extreme case, or so it may seem, but many modern paintings aim at generating equal perplexities. The point is to remain just outside of normal reading, looking, or deciphering. A close study of pre-Enlightenment pictorial practices might well reveal strategies for evading clear meaning that we have come to see as high modernist, surrealist, or postmodern. By the same token, a study of the Enlightenment reaction against hermeticism might reveal the origins of our reductive interpretive agendas, and our insistence on plain information.

I take it that the importance of avoiding meaning in hermetic and modern images is evidence that our images are structured around pictures. The turn toward meaninglessness is a turn toward pictures, because pictures can interfere with meaning in any image. That brings me to the third component of the argument: Despite the divisions of *grammae* into two, three, and seven parts, pictures are the indispensable elements in this divided interpretive regime. In Chapter 8, I proposed that the recent Western interest in the gradual development of scripts from pictographs to alphabets is best understood as a flight from pictures. I want to underscore how this reading varies from the two major interpretations of the logocentric sequence: In linguistics, the move from semasiograph to syllabary (and ultimately to the linguists' favorite, the International Phonetic Alphabet) is accounted for by the "natural" desire to write more efficiently,

3. See Diringer (1948); Coulmas, *Writing Systems of the World* (Oxford: Basil Blackwell, 1989), 98–99; and William Boltz, "Early Chinese Writing," in Daniels and Bright (1996), 191–99l, esp. 197. For another perspective on the Chinese interpretation of Chinese scripts, see Chad Hansen, "Chinese Ideographs and Western Ideas," *Journal of Asian Studies* 52, no. 2 (1993): 373–99.

and in Derrida's work, it is accounted for in part by the deep-rooted privileging of speech over writing, which has been endemic in Western thought since Plato. There is truth to both accounts, and I only want to point out that pictures — real pictures, actual examples of pictures at work in scripts and images — are consistently absent from linguistic and philosophic accounts, and that prompts me to conclude that both approaches are predicated in some measure on the suppression of pictures. Pictures are the strongest agents for the corruption of meaning, and therefore the most virulent threat to *any* theory that seeks to understand systems of sense — like speech, writing, or notation.

Throughout the book I have been exploring alternate concepts of what pictures are, and watching as pictures are transformed, and occasionally nearly extinguished, in favor of writing or other kinds of images. The two most important, rigorous, and self-consistent models of pictures at work in twentieth-century writing — Wittgenstein's and Goodman's — have guided many of my comments. Wittgenstein's is the impossible dream of unity, in which pictures are miraculously the same as propositions. In the picture theory, pictures both say and show, both mean and represent; in the vocabulary of this book, writing and notation *are* pictorial. Our everyday use of the word *picture* often betrays a watered-down version of Wittgenstein's *Bild*, in that it reveals very little unease over the notion that the wordless, "uncoded" parts of an image can somehow coexist with the linguistic, "coded" parts. Wittgenstein fused the two by sheer force of thought, and the "picture theory" stands as an improbable monument of the effects that concerted theorizing can have on subjects normally left uninterrogated. Nelson Goodman's *Languages of Art* is also the result of tremendous analytic effort focused on objects that cannot normally sustain such attention. In my reading, Goodman is driven in part by a twinned fascination and disappointment about pictures. He wants them to make sense, because he loves the systems of sense; but he knows they don't, and so they become "dense" ruins in which meaning is continually failing. Together, Goodman's and Wittgenstein's theories model the self-contradictory nature of modern interpretations, preferring clear sense, and at the same time veering toward complexity. They help explain the dual nature of our response to pictures (the first and second parts of my argument) as well as the pervasiveness of pictures in all forms of image-making (the third part).

Both accounts put the concept of a picture under severe strain. Wittgenstein's *Bild* is an alien intrusion into the normal uses of the word, and Goodman's "picture" is an exile, always outside the light of systematic signification. Both of them — together, I think, with the plurality of twentieth-century theorists — are engaged in *pushing* the concept of a picture, as if they were trying to dislodge it from its natural place.[4] "Picture" is cathected, as Freud would say: It's like an itch, continuously distracting, continuously demanding attention. It's never there, or it's never there the way we want it to be; on the other hand, however, it is never absent, never just disappears to make way for other kinds of images.

Some of the most interesting questions that can be put to images, and image theories, concern the specific kinds of distortions that pictures suffer in different contexts, and this is the fourth and final point I would make in summary. It's an antitheoretical point in that I am aiming it at interpretations that enlist images as examples of global theories. It has been all too easy, in the history of Western writing, to inadvertently continue privileging alphabetic scripts by reducing pictures to quick-and-ready examples of conceptual issues. (And conversely, it has been too easy to construct books of examples — of watermarks, potter's marks, coats of arms, printers' devices, logos, handwriting samples — that have little theoretical support, and dip dangerously near rote collecting or

4. My own attempts to describe the nature of pictures could be adduced as an example. I have argued that the perplexing quality of pictures stems from the dual nature of the pictorial trace or mark. If every mark is partly semiotic (and therefore open to interpretation) and partly nonsemiotic (and therefore closed to meaning), then pictures would indeed frustrate both viewers intent on interpretation and those who want to shut it down in favor of mute appreciation. Although I would defend that account, I am aware that the proliferation of very different theories requiring newly adjusted senses of "picture" makes it unlikely that a purely semiotic approach will capture the strangeness of the concept. See Elkins (1998), and my "Marks, Traces, *Traits,* Contours, *Orli,* and *Splendores:* Nonsemiotic Elements in Pictures," *Critical Inquiry* 21 (1995): 822–60.

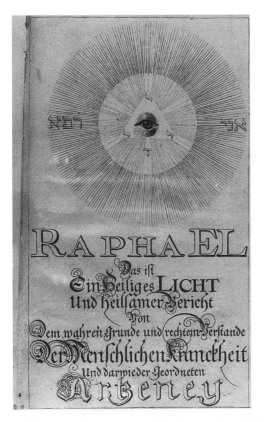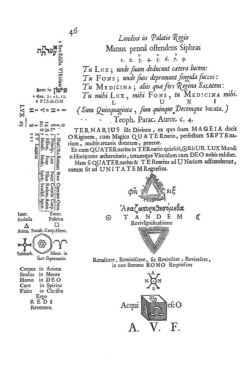

PLATE 14.2 *Two pages from Abraham von Frankenburg's* Raphael, Oder Arzt-Engel. *1676.*

antiquarianism.) If passages in Part 2 have seemed to slow reading inordinately, that is the nature of images: As Jean-François Lyotard says, pictures exist as impediments to sense. Each distortion of pictures is different, and each one creates — or tears down — meaning in its own way.

The seven-part classification of images has another purpose in addition to its overt agenda of opening and ordering the domain of images: It is a sample of particular things that can go wrong with any approach that depends on the notion of pure pictures. I offer Plate 14.3 as a talisman of the imminent interpretive failure of any such heuristic categories. It is a photograph of one of the twenty stone reliefs known as the *Tabulæ Iliacæ,* shown as it is preserved and in a reconstruction. The *Tabulæ* are of Augustan to Antonine origin, although as a type they probably descend from Egyptian and North African models.[5] Each depicts a narrative scene in bas-relief on the obverse, and a grid of Greek letters on the reverse. According to an inscription, the grids are to be decoded by

"grasping the central letter" and proceeding in any direction (the words ΓΡΑΜΜΑ ΜΕΣΟΝ, "central letter" can be read starting just above the corner of the grid).[6] In this case, the letter is the initial *iota* of the word Ἰλιας, and the phrase hidden in the grid is ἸΛΙΑΣ ὉΜΗΡΟΥ ΘΕΟΔΩΡΗΟΣ

5. See Anna Sadurska, *Les Tables Iliaques* (Warsaw: Panstowe Wydawnictwo Naukowe, 1964); Nicholas Horsfall, "Stesichorus at Bovillae?" *Journal of Hellenic Studies* 99 (1979): 26–48; Horsfall, "*Tabulæ Iliacæ* in the Collection Froehmer, Paris," *Journal of Hellenic Studies* 103 (1983): 144–47; also O. Guéraud, "La Stèle Gréco-Démotique de Moschion," *Bulletin de la Société Royale d'Archéologie* n.s., vol. 9, no. 2 (Alexandria: Société de Publications Égyptiennes, 1937), 161–89. An important early publication is Otto Jahn, *Griechische Bilderchroniken,* ed. Adolf Michaelis (Bonn: Adolph Marcus, 1873), with idealized neoclassical engravings.

6. The "key" was deciphered using the words preserved here, together with the end of the phrase preserved on another stone (outlined at the upper right of the diagram). See Maria Teresa Bua, "I guiochi alfabetici delle tavole iliache," *Atti della Accademia Nazionale dei Lincei* 16 (1971–72): 3–35, esp. 8.

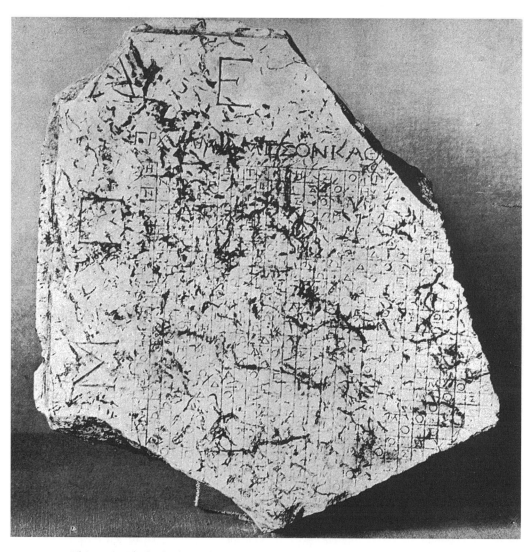

PLATE 14.3 This page: *The back of one of the* Tabulae Iliacæ. *Next page: A restoration of the full pattern (the preserved portion is at the upper left). Augustan.*

H{I} TEXNH, "Homer's *Iliad,* depicted by Theodoros" (referring to the bas-relief on the other side of the stone).[7] The different *Tabulæ* have differently shaped grids of letters — one is an altar, another an X shape — but they conform to the same rule of reading. In each instance a casual viewer would recognize some words at the upper-right and lower-right, where H{I} TEXNH appears clearly, but most of the rest would be a jumble. Given the rule of "grasping the central letter," the reader has many options: The full phrase can be read from the center to the right, and then down the right edge (perhaps the most natural choice), or from the center up, and then right. Those obvious choices are the ones usually mentioned, but a

viewer might also try reading diagonally up and to the right, or even down and to the left. The odd thing about the *Tabulæ Iliacæ* is that they can be read in a practical infinity of different orders: two squares right, then four up, two more right, six up . . . any zigzag that continuously increases its distance from the origin will do, and after a while the entire grid seems to be suffused with half-legible words and phrases. It passes from nearly perfect opacity to a kind of symphonic obviousness as the

7. The "segno verticale" in H{I} is added to make the scheme fit the square; the brackets as used in epigraphy are equivalent to the expression *sic.* See Bua, I giuochi alfabetici, 8n10. Sadurska, *Les Tables Iliaques,* 39, discusses the significance of the word τεχνη.

words ΘΕΟΔΩΡΗΟΣ, Η{Ι}, and ΤΕΧΝΗ continuously reappear. But the reading can never proceed, as one scholar suggests, "equally well in different directions" as it can with magic squares.[8] Some directions are manifest, and others are slow and difficult. The *Tabulæ Iliacæ* have been called "labyrinths," but that is not quite right either, as many paths are fairly easy, and strictly speaking there are thousands of possible routes.[9] Some choices are quick and linear, and others are serpentine, but all yield the phrase eventually. Perhaps it would be best to call the images pseudolabyrinths, because they offer optimal paths but do not constrain readers to them.

Which of my seven classifications best fits such an image? Can writing be formatted with this kind of freedom, where a phrase multiplies and overlaps itself with such combinatorial extravagance?[10]

Is this an allographic variant of the original phrase, and if so in what sense? Do the meandering paths of a reader's eye make it pictorial? Or are the paths linear enough so that they are still within the bounds of writing? The grid is a notational device, but can a notation be so ambiguous, so lacking in

8. Bua, 3 (in English in the original). For the most famous classical magic square, see Heinz Hoffman, "Sator-Quadrat," in the *Pauly-Wissowa Realencyclopädie* (Munich: Druckenmüller, 1978), suppl. vol. 15, pp. 478–565.

9. Piotr Rypson, "Homo Quadratus in Labyrintho: The Cubus or Labyrinth Poem," in *European Iconography East and West*, ed. György Szónyi (Leiden: E. J. Brill, 1996), 7–21.

10. For a positive answer, see *Pattern Poetry: A Symposium*, special issue of *Visible Language* 20 (1986), especially Piort Rypson, "The Labyrinth Poem," 65–95, and Ana Heatherly, "Reading Paths in Spanish and Portuguese Baroque Labyrinths," 52–64.

determinate syntax? Like many other images, the *Tabulæ Iliacæ* easily slip free of the terms and types on which I have been depending.

It strikes me that the concerted pursuit of an adequate concept of a picture is the single most pressing agenda in image studies. I feel about it somewhat the way Heidegger felt about the pursuit of Being: Without an adequate concept — by which I mean a fair sense of how we understand pictures to work, what we want them to look like and mean, how much sense we want them to make, and what effects we take them to have — the myriad individual inquiries in art history, art criticism, anthropology, archaeology, the history and sociology of science, computer graphics, and historical linguistics will continue to play out dramas largely scripted by unanalyzed parts of the concept. That imperative is essentially the burden of the first three parts of my argument. The fourth component, though, undercuts it. If the distortions of pictures are what finally matters, then the *act* of creating mixed and difficult meanings — both in creation and in interpretation — counts for more than an improved sense of what pictures are, or a better classification of their types and species, or claims about their status as art. I think the contradictory imperative of this fourth part of my argument also springs from the divided nature of pictures themselves, and is therefore not to be avoided or "solved" but negotiated and analyzed. Just as pictures are taken to be partly linguistic, so they attract — or better, demand — theories that might account for them in toto; but because they are also nonsemiotic and permanently beyond transcribable meaning, they require close-up, case-by-case attention, *in pars*. For some reason we have become especially sensitive to the dual nature of pictures, and especially vexed by it. Hence the panoply of tortured images, and torturous theories. I hope that Part 2 reveals enough order to make the domain of images look navigable, but I also hope, a bit more strongly, that it exhibits enough of the variousness of pictures to give pause to any theory.

MOTHS' WINGS AS ACHEIROPOIETAI

I want to end the book in the spirit it began, with a radical gesture in the direction of the full domain of images. Throughout the book, I have followed historical custom by considering only ob-

jects more or less intentionally manufactured by people. Yet nature is full of images that were not made by human hands: I mean such things as patterned rocks or the stripes on fish. Such images are so universal that it might be said they enclose the examples in this book as a small subset, just as this book encloses fine art as a special case. Art historians study natural images — including the history of botanical, geological, and medical illustration — but always with an eye to the representation, the artist's view of the object. *Aleamorphs* were natural "pictures" such as fossils, but historians who study them are less interested in the fossils themselves than in the representations of them. *Acheiropoietai* were divine images that were said not to have been made by human hands, although contemporary historians do not begin from that premise when they study representations of the Veronica or the mandorla.[11] True images "made by nature" have been left to scientists, for two not unrelated reasons: because it seems their meanings are not susceptible to historical interpretation, and because it appears that they are not made intentionally. Both objections can be answered using the existing conceptual apparatus of art history.

In the first chapters of this book I argued that scientific and other images need not be excluded from art history because they are part of the histories of representation that comprise the foundations of art-historical understanding. The same could be said of any image of what is taken to be the natural world. The fossil infusoria in Plate 14.4 were collected in Saxony and published in 1837; they show all the earmarks of the early nineteenth-century empirical interest in comparative anatomy. The author is concerned to show how the Radiolaria (which the authors call the "eggs of polyps") are constructed, in order to bring out analogies between infusoria and other animals.[12] This sample appears to have four species: a starry

11. These are discussed in Elkins (1999a) and (1998), respectively.

12. M. Turpin, "Analyse ou étude microscopique des différens corps organisés et autres corps de nature diverse qui peuvent, accidentellement, se trouver enveloppés dans la pâte translucide de silex," *Annales des Sciences Naturelles* ser. 2, vol. 7, *Zoology* (Paris: Crochard, 1837), 129–56 and plates; and Christian Gottfried Ehrenberg, "Observations préliminaires sur l'existence d'Infusoires fossiles et sur leur profusion dans la nature," *Annales des Sciences Naturelles*, 27.

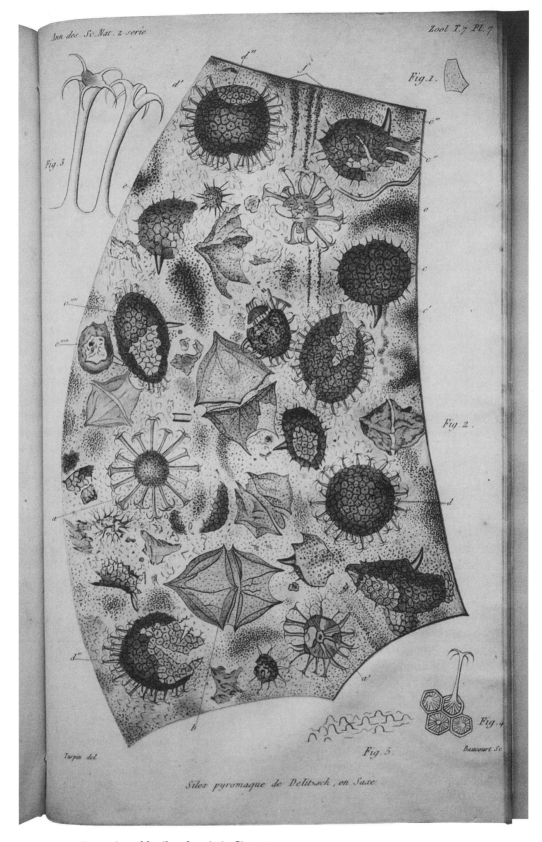

Fig.1.

Fig.3.

Fig.2.

Fig.4.

Fig.5.

Turpin del.

Baucourt Sc.

Silex pyromaque de Delitzsch, en Saxe.

PLATE 14.4 *Engraving of fossil unfusoria in flint. 1837.*

shape (labeled *a, at the left*), a light species that looks like a paper lantern (labeled *b, at the bottom*), a dark kind with spikes like a chestnut (labeled *c, at the upper right*), and another dark kind with branching spikes (labeled *d, at the lower right*).[13] The plate labels the varieties of each (*a, a', a''*, and so forth), and in the margins significant details are restudied at higher magnification. (The rock itself, a piece of flint, is shown natural size at the top right.) The result is a fairly lucid classification of confusing and fragmentary material.

One of the normative approaches to such an image would place it in the contemporaneous history of natural philosophy. When this plate was prepared, the fledgling discipline of comparative anatomy had recently got under way, using sharpened versions of comparative procedures that had been in use since the Enlightenment. Norton Wise has recently brought out how Napoleon's geologists, taking inventory of the minerals they found in Egypt, depicted them without words but with the intent that they should be legible for future generations who would discover the relevant laws of nature.[14] The prints of mineral specimens were presented as a kind of natural writing in which the signary was disjoint (because the artists distinguished between minerals), but still open-ended (because they had no idea how many minerals there were). The mineralogists could construct part of the "alphabet" but could not assign any semantic values to the characters. Ehrenberg's image belongs to a later moment in the ongoing "decipherment" because it focuses on the construction of each kind of object (here, each form of "egg") rather than the classification or numbering of different "eggs."

If I were to continue in this vein, I would be sketching a contribution to the history of science. (Such an account would try to follow linguistic models in later paleontology and mineralogy as well.) It would also be possible to treat this image as I have treated crystallographic images in Chapter 2 and maps in Chapter 13 — that is, I might try to describe the formal construction of the plate and link it with early nineteenth-century practices in fine art. In that way I might be able to find the expressive values in the image, by analogy with contemporaneous landscape painting and painterly realism. Eventually, as in Chapter 2, I might end up with an alternate history of art, reading expressive

values and social forces into pictures of fossils. What I intend here, though, is even more anarchic than the half-serious *Janson's History of Crystallography*. What could be said, I wonder, about this image as a reliable, essentially unmediated, record of a natural object? In what ways might it be possible to treat the actual fossil — the model for this plate — as if it were made by human hands?

Especially in archaeology, but also in anthropology and art history, it is important to distinguish intentional marks from unintentional marks (chance marks, "taphonomic" disfigurations caused by natural accidents, rock falls, decomposition, settling, and other natural factors), and even to distinguish intentional and unintentional marks from what Whitney Davis calls "paraintentional" marks such as those made by force of habit, through unconscious desire, by lack of interest, by distraction and mental discomposure.[15] In all of this huge field — still inadequately theorized in art history and archaeology — a common denominator is the search for reliable human agency. In the usual example, visual objects perceived to be free of intention are also perceived as meaningless: If a wave recedes and leaves a pattern in the sand, I either assume it was made intentionally and see a meaningful picture, or I refuse to do so and see only a meaningless pattern.[16] What this example obscures are the many instances in which we attribute some *nonhuman* agency and *intention* to a pattern. If a wave leaves a pattern, I might choose to say the picture had been *intentionally* drawn by God, Neptune, the Ocean, or even a group of sand fleas. If — to take a less mythological and hallucinatory example — I see a rock covered with strange fossils, I might well say that natural laws provide

13. Turpin recognizes four species but calls them all "eggs"; Ehrenberg names three of them: *a,* Xanthidium furcatum; *b,* Peridinium pyrophirum; *c,* P. delitiense. Turpin, 155–56.

14. Personal communication, 1996.

15. The term, although not the examples, is from Davis's session of that title at the 1996 College Art Association meeting in Boston.

16. This is not to imply I have a choice in the matter; such decisions are normally beyond analytic revision. See the essays in *Against Theory,* ed. W. J. T. Mitchell (Chicago: University of Chicago Press, 1985), and Steven Knapp and Walter Benn Michaels, *Against Theory 2: Sentence, Meaning, Hermeneutics, Protocol of the 52nd Colloquy, 8 December 1985* (Berkeley: Center for Hermeneutic Studies on Hellenistic and Modern Culture, 1986).

the agency and "intention" necessary to enable me to find meaning. Some of the laws would be Darwinian — they would explain the shapes of the fossil Radiolaria — and others would be chemical or specifically mineralogical. Any such collection of laws entails a minimal sense of agency, and it creates a historical sequence of forms and patterns. *History* in this sense is not measured in years or centuries but in geological epochs, and *agency* is not restricted to human intentionality but expanded to encompass any discoverable laws.

If I think of the meanings of the foraminiferous rock as residing in its mineralogy and biology rather than the history of science or art, I am making a decisive leap beyond the subject of this book. On the other hand, there is nothing odd about it from a scientific viewpoint, as it is the normal scientific response to visual objects taken from the natural world. A scientist searches for order and meaning in an object, and the meanings that emerge are necessarily human and historically mediated. That, at least, is how I would argue against the objection that natural images are somehow detached from the modes of understanding that have been developed in the historical disciplines.

This is the widest possible arena for the historical understanding of visual images, and it opens the field to an exhilarating variety of new images.[17] I close with one of my favorite kinds of image: the patterns on the wings of butterflies and moths. For a lay observer, it comes as a surprise that butterfly wings are systematic variations on a single pattern. The "Nymphalid groundplan," named after the group of butterflies that manifests the pattern most fully, can be quickly explained (Plate 14.5). The central feature is the *discal spot* (here labeled *D*). On either side of it are two mirror-image bands, called the *central symmetry system* (here labeled *Cp* and *Cd*, for proximal and distal). Closer to the butterfly's body is the *basal symmetry system* (labeled *H*) and just at the base of the wing there is a *root band* (*W*).

The operative principle in each element is mirror reflection. Just as the central symmetry system mirrors itself on either side of the discal spot, so the smaller basal system can separate into bands that reflect one another (as it almost does here). The root band can be imagined as half of a symmetry system, with the other part buried inside the butterfly's body. Farther out on the wing the same

principle is repeated, this time centering on the eyespots (*ocelli*). The bands on either side are sometimes called the *parafocal elements* (*Op* and *Od*). And last, the edges of the wing are trimmed with *marginal* and *submarginal bands* (labeled R_1 and R_2), constituting yet another mirrored pair.[18]

On this simple basis it is possible to understand even wings that seem to have nothing in common with the groundplan. Some have almost all the features of the groundplan: The butterfly illustrated on the left of Plate 14.6 can almost be compared point by point with the groundplan. It has a discal spot (*D*), which has become a backwards S, and the spot is flanked by a slightly fractured central symmetry system (*Cp*, *Cd*). Out at the margins of the wings are two blurred lines — the marginal and submarginal bands (R_1 and R_2). The butterfly lacks a few features of the groundplan: Its row of ocelli is not surrounded by parafocal elements (*Op*, *O*, and *Od*), and there is no root band (*W*) or basal symmetry system (*H*). On some butterflies, elements of the groundplan seem to just melt away. The middle butterfly still has a discal spot, although its is smeared into a hook-shaped mark and has lost most of its ocelli. The butterfly on the right retains only two ocelli on its hind wing, but even it has an unmistakable echo of the standard groundplan, as its front wing is a light area shading into dark on either side: the blurred remnant of the central symmetry system, the last foggy evidence of the fundamental mirror-image symmetry.

Other butterflies and moths display elaborate

17. Another is fingerprints, which have been exhaustively studied; their analysis yields a systematic classification as rigid as the protocols of heraldry. See *The Science of Fingerprints: Classification and Uses,* printed for the United States Department of Justice, Federal Bureau of Investigation (Washington, D.C.: U. S. Government Printing Office, 1984).

18. These identifications are from F. Süffert, "Zur vegleichende Analyse der Schmetterlingszeichnung," *Biologisches Zentralblatt* 47 (1927): 385–413, modified by B. N. Schwanwitsch, "On the Groundplan of Wing-Pattern in Nymphalids and Certain Other Families of Rhopalocerous Leipdoptera," *Proceedings of the Zoological Society of London* series B, vol. 34 (1924): 509–28; Schwanwitsch, "On Some General Principles Observed in the Evolution of the Wing-Pattern of Palearctic Satyridae," *Proceedings of the Sixth International Congress of Entomology,* Madrid, 1935 (Madrid: [Trabajos presentados,] 1940), 1–8; and H. Frederik Nijhout, *The Development and Evolution of Butterfly Wing Patterns* (Washington, D.C.: Smithsonian Institution, 1991), 24–25 and 43.

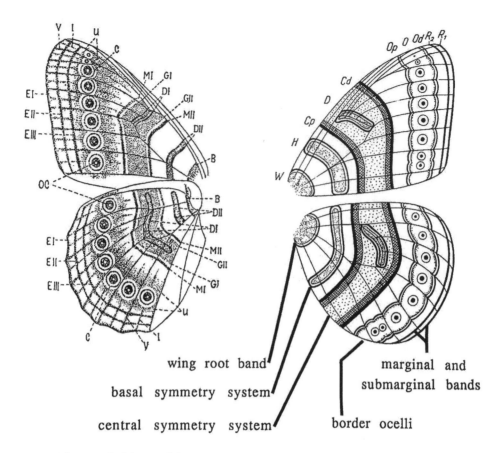

wing root band

basal symmetry system

central symmetry system

marginal and submarginal bands

border ocelli

PLATE 14.5 *The Nymphalid groundplan.*

distortions and multiplications of the original groundplan. Surprisingly, even the most intricate patterns can be traced back to the groundplan. Plate 14.7 shows a selection of moths. It begins, in the center, with a variant on the groundplan, in which the discal spot has split in two (labeled D^1 and D^2) and the ocelli have fused into a single band of color (eU). From that plan it is possible to understand some extremely "disordered" wings.[19] (In this plate each wing is also shown in schematic form, with the central and basal symmetry systems marked as toothed lines.) Some of the giant silk moths at the bottom left retain clear discal spots and central symmetry systems, and the discal spots take on elaborate eyelike shapes. Others are substantially more distorted: In the "tiger moths" (E) the central symmetry system divides itself into two regions, creating the characteristic serpentine stripes. The upper portion forms a "sort of trident," as one entomologist says, and the whole wing takes on a mottled or zebralike pattern.[20]

With a little practice, and not much more information than I have given here, it is possible to understand any butterfly or moth wing. The little brown moths that fly at windowscreens in the night have minutely dappled wings in imitation of flakes of bark or leaf litter, and at first they look like random smears or scuff marks (Plate 14.7, L). But with the groundplan in mind, they slowly resolve into bands and spots, teased apart and multiply reflected until they have almost blended to a uniform grey. There is suddenly sense in their tiny patterns: Instead of broken-off pieces of bark, they become elaborate dissimulations in which a complex order masquerades as simple chaos. With some understanding of the relevant genetics the interpretations can be pushed even farther, and it is possible

19. B. N. Schwanwitsch, "Color-Pattern in Lepidoptera," *Entomologicheskoe Obozrenie* 35 (1956): 530–46; the plate is also reproduced in Nijhout, *Butterfly Wing Patterns,* 28.

20. Schwanwitsch, "Color-Pattern in Lepidoptera," 536.

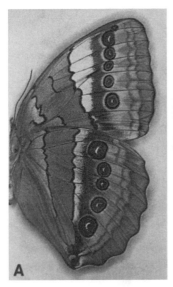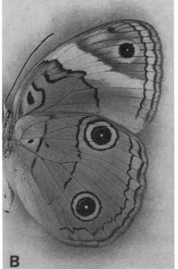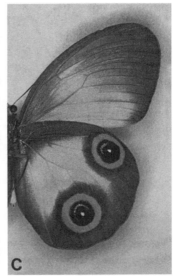

PLATE 14.6 *Comparison of three butterflies in the family Amathusiidae, showing the gradual disappearance of elements of the nymphalid groundplan.* Left: Stichphthalma camadeva; middle: Faunis menado; right: Taenaris macrops.

to use these observations to help fit butterflies and moths into evolutionary sequences. The patterns most thoroughly shattered are the most advanced: In terms of semantics, eyespots are the least advanced pattern, and bark is the most sophisticated representational feat.

Looking at butterfly and moth wings in this way is an unexpected pleasure, because it fulfills the perennial purpose of visual interpretation: applying a systematic method to an image that says nothing, and discovering articulate meaning. Meaningless colors are revealed to be a code, forms comprise a signary, patterns are resolved into a syntax: What was once nothing more than a colored surface becomes a picture, a notation, and a text. The patterns begin to make formal sense, because they are variants on an underlying model; they also make historical sense, because they are deviations and convergences in evolutionary sequences. There is no intentionality here, and therefore no expression in the usual sense, and there is also no secure semantics because entomologists are not agreed on what most patterns denote.[21] But the groundplan gives the wings a syntax, and places them in historical sequences: And what is the formal apparatus of art history if not a way of locating sequences, divergences, and similarities?[22] In this way the universe of meaningful images can be enlarged without limit, without losing its purchase in histori-

cal models of interpretation, or its dependence on concepts of picturing that unfold principally within the historical study of images.

ENVOI

There is no end to what can be seen once it no longer appears necessary to see only fine art. In writing this book I have been drawn to think about the obstacles that prevent disciplines such as art history, archaeology, the history of science, linguistics, and anthropology from speaking more often to one another. Art historians resist (and sometimes mistrust) scientific content, and they are especially wary of the long technical explanations that accompany scientific images. They might feel that archaeological, mathematical, and geometric

21. Some butterflies mimic other butterflies (in Batesian or Müllerian mimicry), others mimic forest undergrowth or other environments, and yet others make use of "flash coloration" to surprise potential predators. But much of the semantics is unknown or under debate, both in entomology and in Lacanian psychoanalysis, where surrealist ideas about insect semantics continue to be influential. The semantics of insect wings is discussed in my *The Object Stares Back: On the Nature of Seeing* (New York: Simon & Schuster, 1996).

22. Whitney Davis, *Replications: Archaeology, Art History, Psychoanalysis* (University Park: Pennsylvania State University Press, 1996). I thank Jason Matheny for helping me to clarify the claims in this last section.

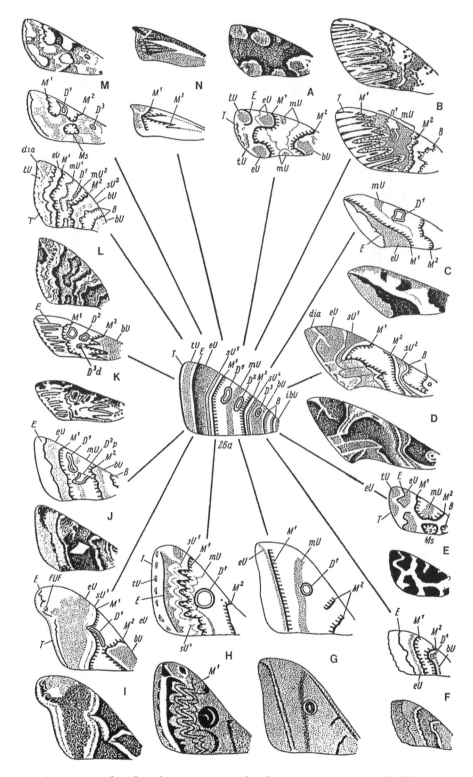

PLATE 14.7 *Patterns on selected moth wings, compared with a variant on the Nymphalid groundplan. Families include Sphingidæ (C, D), Arctidæ (E), Saturnidæ (G, H, I), Noctuidæ (J, K), and Geometridæ (L).*

images are inexpressive, suited only to impart information. Some find nonart images conceptually and formally impoverished, or so specialized they lose contact with wider social and political meanings. To others, images outside art are epistemologically narrow because they aim at the objective truth of things. In various ways I have tried to answer all of these claims, and to show that even the most unusual images call up the same questions of meaning, expression, form, and history that art historians have long associated with fine art.

In the course of this argument there is one assumption that I have not mentioned at all, except at the very beginning, and that is the notion that images outside art are intrinsically, ultimately less interesting than fine art. If it were articulated, the assumption might be put like this: Nonart images are less able to capture our imagination, to hold our attention, to absorb us, to affect us, to throw us into reverie or plunge us into critical thought. They are fundamentally, and as a whole, impoverished versions of the richer objects art historians choose to study. I have never thought that assumption is true, and as many readers will have guessed I spend much of my time wondering about images that are not fine art: they are the ones I return to, the ones I collect and put up on my walls, the ones that inhabit my imagination. They are the images that compel conviction, and the ones that can shine the strongest light on assumptions about fine art. After spending several years, on and off, looking at images that are mostly not in museums, I find that paintings make more sense as pictures and less, perhaps, as the privileged objects of art historians' attention. We love paintings, I think, for reasons other than their beauty, their expressive power, or the density of their meaning — the reasons that would ordinarily be given. Those properties don't distinguish paintings, because they are shared by many kinds of images. Rather, we love paintings for all kinds of contingent reasons: because of what they say about gender, the gaze, or class relations, or for what they tell us about people and places that we know. We love them, in other words, for what philosophers would call their accidental qualities. Things look very different when the familiar places and people of art history — the Medicis, Argenteuils, and Manets of our textbooks — lose their exclusive grip on the imagination. Then the interest that had been lavished on fine art partly disperses, and finds itself again in many other contexts.

At the outset I suggested the domain of images is not entirely unexplored, and that it is marked with signposts that are mostly legible in the languages of art history. Looking back, I am a little less sanguine about that metaphor, which belongs more to tourism than exploration. Instead it is as if I have been wandering around in a large dark landscape. The familiar images of fine art are like the lights of scattered villages, signaling to one another over large distances. In between, in the dark, are the uncounted numbers of images we are just learning to see.

Glossary

This glossary does not include etymologies, histories of usage, or citations beyond the uses in this text. For example, I define *hypogram* as it is used here; for Saussure's original meaning and Paul de Man's appropriation, see the references in the text.

Some of the terms defined here are less than optimal; phrases such as *notion of* or *taken to be* signal that the definition is given according to some accepted usage, and that it is also critiqued in the text.

For clarity's sake, cross-references appear in boldface only when it is not self-evident that they should be consulted.

abecedary
A list of the signary of an alphabet, in alphabetic or other conventional order.

abstract counting
Numeration in which the concepts of oneness, twoness, and so forth are distinct from the items that are counted. For example, the number 4 can serve to denote four of any object. Compare *concrete counting.*

acronym
An abbreviation comprised of the first letters of several words. Compare *siglum.*

acrophony
The production of a phonetic sign by writing a pictograph whose prounciation begins with the consonant that the phonetic sign then denotes. A picture of an apple might be taken as a phonetic sign for the sound *a.*

affix
A lexeme, glyph, or other unit of meaning added to another. Prefixes and suffixes are most common in Indo-European scripts; see *infix* for other possibilities.

allograph or allomorph
A variant of a morpheme that leaves its syntactic function intact. Calligraphy, typography, and layout produce allomorphic alterations of characters and entire scripts. See the *problem of individuation.*

alphabet
A set of characters that signify the consonants and vowels of a language. Daniels and Bright (1996) use *abjad* for a set lacking characters for vowels. Compare *syllabary, pseudoalphabet.*

alphabetomorphic
Said of a sign or image in the form of characters of an alphabet or similar signary.

armorial bearings
See *heraldry.*

artificial script
A script invented by a single person to serve an existing language. Morse code is an artificial script that substitutes for existing scripts, and Sequoya's Cherokee is an artificial script that provides a script where none had existed.

autograph
The concept of **signature** made by the signee and therefore not reproduceable.

blazonry
The art of producing correct verbal description, called a *blazon,* of **heraldry.** Among other properties, blazons enumerate **devices** (2).

carpet page
A page in a medieval manuscript set aside for decoration.

case
A rectangular area in a tablet enclosing text to be read as a unit.

character

(1) A grapheme or other sign in a script — for example, a letter in an alphabet or a sign in a syllabary or pseudoalphabet.

(2) A unit in Chinese writing, in which case it is normally not a grapheme.

character-indifference

In Nelson Goodman's account, a property of a system of signs (such as writing) in which instances of a sign can be freely exchanged without affecting syntax. **Word types** are examples of such signs.

character set

The full complement of characters in any given case.

chart

A map overlaid with lines useful in navigation (rhumb lines, loxodromes, and so on).

cherology

The study of sign or gestural languages.

cipher

A code in which the unusual denotations are explained or generated by a *key* (that is, a single formula or table of correspondences).

coat of arms

See *heraldry.*

code

A system of conventional signs (such as letters) given unusual denotations, or a system of invented signs. Codes can depend on more intricate rules than ciphers.

concrete counting

Numeration in which the concepts of oneness, twoness, and so forth are linked to the items that are counted. For example, a clay token in a symbolic shape combines the concept of the item that is counted with the concept of the number 1. Compare *abstract counting.*

configuration

Geometric elements more complex than parallel lines (as in the **register lines** of some writing), simple axes (as in the **reference lines** of *x-y* graphs), or **nets** (as in some cartography). See *notation.*

cryptograph

A text hidden in a picture.

cryptomorph

A picture hidden in a picture.

density, denseness

In Nelson Goodman's usage: the opposite of **syntactic finite differentiation,** in which every slightest change in a character entails a different syntactic significance.

determinative

A sign used to resolve potential ambiguities with syllabic and alphabetic scripts. A determinative can be phonetic, pictographic, or ideographic, and it can signify a part of speech, gender, word, or idea. See generic determinative.

device

(1) A loosely defined term for an emblematic or heraldic design, normally denoting a family name. Compare *emblem, logo.*

(2) Any **heraldic** symbol except a color.

(3) The figural design on a stamp or coin, as opposed to the **field** and **inscription** (2).

diagram

A synonym for *schema,* emphasizing its geometric aspects.

disjoint, disjunct

See *syntactic disjunction.*

drop capital, ornamental capital

A small **emblem,** usually consisting of a single letter and ornamental frame, set as the first letter of a paragraph.

egg, world egg

As used here, one of the principal forms of **schema,** using concentric circles as an organizing metaphor. (See also *tree.*)

embedding

The insertion of a dependent clause or sentence between two other clauses or sentences.

emblem

As used here, any picture accompanied by a text — for example, a book illustration together with its caption. In sixteenth- through eighteenth-century usage, an emblem is comprised of a *pictura,* an *inscriptio,* and a *subscriptio.* Compare *schema.*

enuntiagraph

A sign (including an entire image) that denotes a sentence. Related terms are *mythograph* and *phraseograph.*

field

The background of a stamp or coin, as opposed to the *device* (3) and *inscription* (2).

figuratio

An element of a graph, considered as a naturalistic shape; from Nicole d'Oresme's terminology.

full-figure glyph

A sign that is personified (represented as a figure). Used in Mayan writing. See *pars pro toto.*

*gerebh-

The most general term for patterns taken in by the eye. From the Indo-European root from which we derive *graph;* originally it denoted scratching. Compare *image* and *gramma.*

glottograph

(1) A sign that denotes a sound in spoken language.

(2) In Geoffrey Sampson's definition, a sign that denotes an element of meaning, as opposed to a meaningful element. See *semasiograph.*

glyph

Synonym for **sign** in Mayan, Rongorongo, Egyptian, and other scripts. In Mayan, glyphs might be arranged in **glyph blocks,** or a glyph block might contain a single glyph.

glyph block

A roughly rectangular area with rounded corners, within which Mayan glyphs are painted or sculpted.

gramma

A general term for **image,** stressing the affinity between writing, drawing, and notation.

grammatology, formal

The study of typology and form of writing.

grammatology, structural

The study of syntax and grammar.

graph

An image in which the organizing principle is provided by one or more **reference lines.** See *notation* and *table.*

grapheme

(1) A minimal unit of writing, defined in relation to the formal properties of a script rather than phonetic or sememic properties. In the word *construction,* each letter is a grapheme, but *con-* and *-ion* are **morphemes. Character** (1) is a synonym in many scripts. Compare also *lexeme.*

(2) In general, a minimal unit of an image. **Mark** and **trace** are allied terms and often synonyms. The word *grapheme* emphasizes meaning and interpretation, rather than production (*mark*) or transcendental conditions (*trace*). A grapheme, mark, or trace in this sense is necessarily both **semiotic** and **nonsemiotic.**

graphic (or graphism)

As used here, a synonym for **image** and **visual artifact:** a general nondescriptive term for patterns on surfaces, taken in by the eye. The word *graphism* accentuates the presence and character of the marks, which might be hypogrammatic or otherwise related to signs.

griffonage

Illegible (as opposed to indecipherable) script.

habits of reading

Ways that visual artifacts are approached when it seems possible that they might be read (1) noting that the artifact is writing (compare traits of writing); (2) testing out a reading on a sample portion of the artifact; (3) "taking the temperature" of a reading by comparing several test readings to see if they cohere; and (4) actually reading.

heraldry, coat of arms, armorial bearings

In this text, synonyms for images comprised of a shield, helm, and possibly also motto, banner, crest, torc, supporting animals, compartment, and other **devices** (2).

holomorph

An entirely illegible image.

homologous

Said of an image that preserves logical relations. Compare *homomorphic.*

homomorphic

Said of an image that preserves the form of the objects it denotes. Compare *homologous.*

homophony

In linguistics, the property of a phonetic value or word that can be denoted by more than one sign in a script. Compare *polyphony.*

hypographemics

The study of images comprised of nondisjoint signs: either apparently multiple signs (as in some petroglyphs), or apparently single (as in potters' marks).

hypogram or hypograph
 (1) An image taken to be comprised of nondisjoint signs, or alternately an image taken to be a single composite sign.
 (2) A defective or deficient sign.

iconic
 Said of a sign or image (picture, writing, or notation) that is a naturalistic representation of the object it denotes. In this text I do not distinguish between terms such as *iconic, naturalistic, realistic,* and **homomorphic.**

iconographic system
 Synonym for pictographic writing. I have avoided *iconographic* both because of its resonance with iconography and because the root *icon-* is used to denote a specific kind of image instead of images in general.

idea diffusion
 See *notion diffusion.*

ideogram
 A sign in ideographic script.

ideograph
 A **semasiographic** sign that denotes an idea, as when a picture of a lion signifies "bravery." Compare *pictograph.*

image
 In this text, a general nondescriptive term for patterns on surfaces, taken in by the eye, that is. See *gramma, graphism, visual artifact.*

infix
 A glyph inserted into another, as opposed to before it (*prefix*), after it (*postfix*), or above or below it (*superfix* or *subfix*). The general term is **affix.**

inscriptio, inscription
 (1) A partly enigmatic phrase, verse, sentence, or single word set above, around, below, or within the *pictura* of an emblem. The *inscriptio* is also called the *motto, titulus, sentence,* and *lemma.* See also *subscriptio.*
 (2) The text on a stamp or coin, as opposed to the *device* (3) and its field.

kinesics
 The study of gestures and other bodly motions accompanying speech.

latitudo
 Term used by Nicolas d'Orseme to denote the vertical (*y*) axis in a graph.

lexeme
 A minimal unit of written language, defined as a supplement to **morpheme.** For example, in the word *construction,* the con- and -ion are morphemes, but *-struct-,* a lexeme, is meaningless in contemporary English. *Lexeme* is sometimes defined as a minimal unit of the mental lexicon, but that is misleading, because morphemes are also minimal mental units. The salient difference is one of meaning. Compare also *grapheme.*

ligature
 (1) Allographic link between two or more characters that does not affect legibility (the characters remain **syntactically disjoint**).
 (2) New characters formed by slurring and combining frequently used **morphemes** and **lexemes** into new signs, as in Renaissance Greek typefaces.

linea summitatis
 Term used by Nicolas d'Orseme to denote the curve or straight line of an *x-y* graph (the functional values).

logo
 In popular usage, any image (map, picture, text, **monogram, emblem, acronym, siglum, device**) used as a sign for a company, brand, and so forth. Logos are often descended from **heraldry.**

logocentric sequence
 The ostensive progression from picture to pictograph, ideograph, and phonograph, culminating in the alphabet.

logoglyph
 A sign signifying a word; synonymous with **logograph** but generally used in Mayan writing, in which signs might be compound within a single **glyph block.**

logograph, logogram
 (1) A semasiographic sign signifying a word. In English, *&* is a logograph in this sense. See also *logoglyph.*
 (2) A glottographic sign signifying a word, in a lexicon that is monosyllabic. In English, *I* is a logograph in this sense; in Akkadian, a *Sumerogram* is a logogram adopted from the older Sumerian language.

logotype
 A set of letters, cast as a block, and used in printing a single word.

longitudo

Term used by Nicolas d'Oresme to denote the horizontal (*x*) axis in a graph.

maṇḍala

(1) An image used for meditation in Tibetan Buddhism.

(2) A symmetrical, often circular, often fourfold image generated by a patient in Jungian analysis and taken as an illustration of archetypes and a representation of the psyche; and by extension, any image so interpreted.

map

A composite **notation** comprised of (a) a metaphorical schema such as an **egg,** or a mathematically determined **net,** or a mixture of both, and (b) a palimpsest of superimposed writing, pictures, and other notations. See *chart.*

mark

The notion of a minimal unit of an image (**grapheme** [2]). The word *mark* emphasizes gesture and production, rather than meaning (*grapheme*) or transcendental conditions (*trace*).

metagraphemics

The study of punctuation and diacritical marks.

micrographic text

A kind of calligraphy in which the letterforms are small enough so that lines of text can be bent into the architectural, ornamental, or alphabetomorphic patterns.

mnemonic notation

Any notation that functions analogously to a mnemonic script.

mnemonic picture

(1) A late medieval or Renaissance picture made of miscellaneous symbols, intended to help readers memorize texts.

(2) By extension, any picture that functions analogously to a mnemonic script.

mnemonic script

Pseudowriting in which the signs function as clues to meaning, rather than fixed semasiographic or glottographic signifiers.

monogram

A **siglum** composed of a person's initials or an acronym.

morpheme

(1) A minimal meaningful unit of written language. Compare *lexeme* and *sememe.*

(2) Any unit considered effectively minimal, for example a word.

mythograph

A sign, or an entire image, that denotes a narrative. Coined from μυθος, story or legend, and *graphein.* Related terms are *enuntiagraph* and *phraseograph.*

naturalistic

See *iconic.*

net

The curvilinear or straight grid of projected or calculated latitudes and longitudes (or right ascensions and declinations, or almucantars and azimuths) in a map.

notation

(1) As used here, an image employing organizational principles other than the formats associated with pictures or writing systems, especially **reference lines** and other geometric **configurations.** Examples of notations are **heraldry, graphs, charts** and other **maps, tables,** and mathematical notations. See also *traits of notation* and *schema.*

(2) In Nelson Goodman's sense, a system of characters that fulfills five criteria: **syntactic disjunction, syntactic finite differentiation,** semantic unambiguousness, disjoint compliance classes, and semantic finite differentiation.

notion diffusion

A theory of the development of pseudo-languages and full languages that posits the idea that language is sufficient to inspire the invention of a script.

pars pro toto

(1) The synecdochic substitution of part of a pictograph or full-figure glyph for the whole.

(2) The same substitution, with altered signification. (For example, an arm might represent *valor* instead of a ruler's name.)

phoneme

A minimal unit of spoken language, usually defined by distinctiveness, systematic import, and unreducibility.

phonetic complement

(1) A determinative that repeats or complements a phonetic element in another sign, in order to indicate that the sign be understood phonetically rather than as a pictogram or ideogram.

(2) A phonogram appended to a logogram to provide a case-ending or other suffix for the word associated with the concept. In English, an example is the construction *X-ing* for *crossing.*

phonetic script

A writing system using syllabaries, pseudo-alphabets or alphabets: for example, signs with phonetic value.

phonogram, phonograph, phonetic sign

A sign with phonetic value.

phraseograph

A sign that denotes a phrase. Related terms are *enuntiagraph* and *mythograph.*

pictograph

A **semasiographic** sign that denotes what it resembles. Compare *ideograph.*

pictura

One of the three parts of an **emblem** (the other two are the *inscriptio* and *subscriptio*). The *pictura* is also called the *icon, symbolon,* or *imago.*

picture

Any image understood to be at least partly extra- or nonlinguistic, nonpropositional, unsystematic, nonsemiotic, or hypographemic. Unless it is qualified by the context, *picture* does not imply *naturalistic picture.* Compare *iconic.*

picture-writing

A Library of Congress subject matter heading, corresponding principally to certain subgraphemic images that deploy narratives in pictorial formats. See *subgraphemics* and *pseudowriting.*

polyphony

In linguistics, the property of a sign that has more than one phonetic value, or (in the case of logographs) that denotes more than one word. Compare *homophony.*

prehistory

An archaeological sequence in which marks have no plausible relation to writing. Compare *prewriting* and *protowriting.*

prewriting

A writinglike practice that predates writing in a given culture but seems distinct from it. Compare *protowriting* and *prehistory.*

problem of individuation

(1) In writing, the recognition and definition of **allomorphs.**

(2) In pictures, the recognition and definition of individual figures. Compare the problem of *segmentation.*

problem of segmentation

(1) In writing, the recognition and definition of **morphemes, lexemes,** and **graphemes.**

(2) In pictures, the recognition and definition of signs or other meaningful units. Compare the *problem of individuation.*

proposition

As in Wittgenstein, a sentence containing only logical elements; by extension, a unit of sense or meaning.

protohistory

An archaeological sequence with evidence of pseudowriting or marks with semasiographic or other possible relation to writing.

protowriting

A writinglike practice that appears to lead sequentially into full writing. Compare *prewriting* and *prehistory.*

pseudoalphabet

Signary in which each **character** denotes a consonant together with any vowel. Compare *syllabary.*

pseudopicture

An indecipherable scribbled imitation of a picture (coined to complement **pseudowriting** [2]).

pseudowriting

(1) Any set of disjunct signs that appears to be writing but cannot function as a record of a language or a transcription of a full system of writing.

(2) In paleography, an indecipherable scribbled imitation of cursive script.

rebus

(1) A text in which words, syllables, letters, numerical operators ($+$, $-$), and other signs (&, $) alternate with semasiographic signs drawn as if they were pictures (that is, oversize and out of format).

(2) A writing practice in which a character is reassigned in order to make use of part of its phonetic value.

reference lines

Geometric lines that impose orientation and sometimes direction on an image. The lines can be scaled or contionuous, drawn or

imagined, rectilinear or curvilinear. See also *register line, schema, notation.*

register lines

Geometric lines that impose orientation and sometimes direction on a text. The lines can be scaled or continuous, drawn or imagined, rectilinear or curvilinear. See also *reference line.*

roots of reference

Nelson Goodman's phrase for the relations between sign, signifier, and referent. Thus written, signs might refer to other signs, to sounds, to words, to phrases and larger sets of words, and to objects.

routes of reference

Nelson Goodman's phrase for the kinds of denotation: in his enumeration they include verbal denotation, notation, and pictorial denotation. In this text the term is used in a similarly open-ended fashion to refer to kinds such as writing, **notation** (2), and picturing. *Exemplification,* another of Goodman's *routes of reference,* denotes reference by a sample.

schema, schemata

(1) As used here, images with pictures, writing, and notation, usually based on **reference lines** and other geometric **configurations.** Compare *emblemata.*

(2) In philosophy, an image taken to be poised between perfect reproductive verisimilitude and perfect ideational abstraction.

script

The sum of signs used to write, independent of allographic variations. In this book, script and writing are not used synonymously: The former might be radically incomplete (for instance, pseudowriting, or even a single sign from a lost writing system).

semasiograph

(1) A sign that does not denote sounds in spoken language.

(2) In Geoffrey Sampson's definition, a sign that denotes a meaningful element, as opposed to an element of meaning. See *glottograph.*

sememe

The meaning of a **morpheme.**

semiotic, nonsemiotic

Possessing or lacking meaning, understood according to a variety of models but always entailing a primary distinction between sign, signified object (*referent*), and linguistic or

ideational correlate (*phoneme, signifier,* or *interpretant*).

siglum, sigla

(1) An **acronym** in the form of a single symbol—for example a **monogram.**

(2) Loosely, an invented sign that contrasts with the normative allography of a script—for example, ¶.

sign

(1) In writing, a formal unit of meaning—that is a **lexeme** or **morpheme.**

(2) In images in general, the notion of a minimal unit of meaning. See *semiotic* and *nonsemiotic.*

signary

The set of signs in a script, or their number. The signary of English is a, b, c . . . or the number 26.

signature

Either a signed name, made either by the signee or a surrogate, or a reproduction, made by a surrogate or a mechanical process. Compare *autograph.*

stimulus diffusion

See *notion diffusion.*

subgraphemics

The study of images whose signs are disjoint but lack formatting or syntactic order. See also *picture-writing.*

sublinguistic

Lacking the structural properties of language: agrammatical or possessing intermittent, inconsistent, or rudimentary grammar.

subscriptio

An explanation, often in verse, set above or below the *pictura* of an emblem. The *subscriptio* is also called the *declaratio* and *epigramma.* See also *inscriptio.*

syllabary

A signary in which each character is a syllabogram. See *alphabet* and *pseudoalphabet.*

syllabogram

Character denoting a consonant-vowel combination, normally consonant-vowel, vowel-consonant, or vowel-consonant-vowel.

symbol

(1) As used here, following Suzanne Langer (after Ernst Cassirer), a **sign** whose meaning is taken to be vague, holistic, cultural, private, affective, nonverbal, religious, or otherwise

unspecific or unspecifiable.

(2) Following Charles Peirce, a sign that denotes "by virtue of a law" as opposed to iconicity.

syntactic disjunction or disjointness

(1) In Nelson Goodman's usage, the first syntactic criterion of **notation,** requiring that no mark can be assigned to more than one character.

(2) In the wider sense adopted in this book, the criterion that signs or marks be physically separate from one another and not tied by **ligatures** or other overlaps.

syntactic finite differentiation or articulation

In Nelson Goodman's usage, the second syntactic criterion of **notation,** requiring that it must always be possible to tell if a mark belongs to a character. The opposite of articulation is denseness.

syntax

(1) In Nelson Goodman's usage, the study of relations between characters in a notational system, as opposed to semantics, the study of the relations between characters and what they denote.

(2) In writing or notation, the way characters or words are ordered, and specifically the orderings that affect meaning.

(3) In pictures, the impression that visual signs or marks are ordered as they would be in writing.

table

A partly unquantified **graph** whose **reference lines** are not fully divided into mathematical units.

tagmeme

(1) A place and the sign that fills it.

(2) A basic unit of grammar, as the *phoneme* is a unit of phonology and the *morpheme* a unit of writing.

trace

A near synonym for **grapheme** and **mark,** sometimes used interchangeably. The word *trace* emphasizes ontological conditions, rather than production (*mark*) or meaning (*grapheme*).

traits of notation

Properties that suggest a visual artifact may be a notation. They include (1) **reference lines** such as scales or axes, as opposed to **register lines;** (2) a prevalence of numbers over written signs; and (3) geometric **configurations** such as grids, **tables, charts,** and **nets.**

traits of pictures

Properties that suggest a visual artifact might be a picture. In this text they are defined negatively, as the absence of some or all of the **traits of notation** and **traits of writing.**

traits of writing

Properties that suggest a visual artifact might be writing. A visual artifact might be judged to be an instance of writing if it has one or more of the traits. Ideally, writing has (1) disjoint signs (compare *syntactic disjunction*); (2) rationally comprehensible spacing between signs; signs that are distinct from (3) decoration and (4) framing elements; (5) signs that are more or less uniform in size; (6) signs that are fairly simple and (7) fairly uniform in each of their appearances; (8) signs that are "formatted" or aligned with framing elements and **register lines;** (9) signs that comprise a minimally diverse signary; and (10) signs that evince a sense of **syntax.**

tree

A form of schema, using the image of a tree as organizing metaphor.

tughra

In Islamic calligraphy, a shaped calligraphic composition containing a signature.

visual alphabet

An alphabet in which each letter is elaborated allographically into a figure, object, or other picture.

visual artifact

In this book, a general nondescriptive term for patterns on surfaces, taken in by the eye. See *image.*

word-token

An instance of a word, character, or other sign. See *word-type* and *character-indifference.*

word-type

A word, character, or other sign. See *word-token* and *character-indifference.*

writing system

The sum of signs used to represent a language (including diacritical marks, abbreviations, and numbers), independent of allographic

variants. In this text, semasiographic signs that have no determinate relation to words or sounds in a language are also considered potential elements of writing systems (for example, Hittite inscriptions that can be "read" in any language). A **script** might be a subset of a writing system.

Frequently Cited Sources

Céard, Jean, and Jean-Claude Margolin. 1986. *Rebus de la Renaissance: Des images qui parlent.* Paris: Maisonneuve et Larose.

Daniels, Peter, and William Bright, eds. 1996. *The World's Writing Systems.* New York: Oxford University Press.

Diringer, David. 1948. *The Alphabet: A Key to the History of Mankind.* London: Hutchinson's Scientific and Technical Publications.

Elkins, James. 1994. *The Poetics of Perspective.* Ithaca, N.Y.: Cornell University Press.

———. 1997. *Our Beautiful Dry and Distant Texts: Art History as Writing.* University Park: Pennsylvania State University Press.

———. 1998. *On Pictures and the Words That Fail Them.* Cambridge: Cambridge University Press.

———. 1999a. *Why Are Our Pictures Puzzles? On the Modern Origins of Pictorial Complexity.* New York: Routledge.

———. 1999b. *Streams into Sand: Links between Renaissance and Modern Painting.* In the series *Critical Voices in Art, Theory, and Culture.* New York: Gordon & Breach.

Gelb, Ignace. 1974. *A Study of Writing: The Foundations of Grammatology.* Chicago: University of Chicago Press.

Goodman, Nelson. 1976. *Languages of Art.* 2d ed. Indianapolis: Hackett.

Grabar, Oleg. 1992. *The Mediation of Ornament.* The A. W. Mellon Lectures in the Fine Arts, 1989; Bollingen Series, vol. 38. Princeton, N.J.: Princeton University Press.

Harris, Roy. 1995. *Signs of Writing.* London: Routledge.

Jensen, Hans. 1969. *Die Schrift in Vergangenheit und Gegenwart.* 3d ed. Berlin: Deutscher Verlag der Wissenschaften.

Kahl, Jochem. 1994. *Das System der ägyptischen Hieroglyphenschrift in der 0.–3. Dynastie.* Göttinger Orientforschungen, Reihe IV, Ägypten, vol. 29. Wiesbaden: Harrassowitz.

Mallery, Garrick. 1893. "Picture-Writing of the American Indians." *United States Bureau of Ethnology, Annual Report, 1888–1889,* vol. 10, 1–822. Washington, D.C.: U.S. Government Printing Office. (The actual publication date is 1893; the volume number corresponds to the title.)

Picturing Power: Visual Depiction and Social Relations. 1988. Edited by Gordon Fyfe and John Law. Sociological Review Monograph, no. 35. New York: Routledge.

PSA 1990. 1991. Edited by Arthur Fine, Micky Forbes, and Linda Wessels. Vol. 2. East Lansing, Mich.: Philosophy of Science Association.

Schenck, Eva-Marie. 1973. *Das Bilderrätsel.* Hildesheim: Georg Olms.

Warburton, William. 1811. *The Divine Legation of Moses Demonstrated,* book 4. vol. 4 of *The Works of . . . William Warburton,* edited by Richard Hurd. 12 vols. London: Luke Hansard & Sons.

Picture Credits

Plate 1.1 "Noisy" CCD image. From Michael Lynch and Samuel Edgerton, *Picturing Power: Visual Depiction and Social Relations.* 1988. Edited by Gordon Fyfe and John Law. Sociological Review Monograph, no. 35. (New York: Routledge). Reprinted by permission of Samuel Edgerton.

Plate 1.2 Processed image, with cursor box drawn around the object QSO 0957+562. From Michael Lynch and Samuel Edgerton, *Picturing Power: Visual Depiction and Social Relations.* 1988. Edited by Gordon Fyfe and John Law. Sociological Review Monograph, no. 35. (New York: Routledge). Reprinted by permission of Samuel Edgerton.

Plate 3.1 Autoradiograph. From Karin Knorr-Cetina and Klaus Amann, "Image Dissection in Natural Scientific Inquiry," *Science, Technology, and Human Values 4,* no 3 (1990): fig. 1. Reprinted by permission of Sage Publications, Inc.

Plate 3.2 Genetic "design" language on scraps of paper. From Karin Knorr-Cetina and Klaus Amann, "Image Dissection in Natural Scientific Inquiry," *Science, Technology, and Human Values 4,* no 3 (1990): fig. 5. Reprinted by permission of Sage Publications, Inc.

Plate 3.4 Second-order Feynman diagrams in perturbation theory. From Norman Marsh, W. H. Young, and S. Sampanthar, *The Many-Body Problem in Quantum Mechanics* (Cambridge: Cambridge University Press, 1967), fig. 4.15. Reprinted by permission of Cambridge University Press.

Plate 3.5 Sewell Wright, "Hypothetical multidimensional field of gene combinations." *Evolution and the Genetics of Populations: III. Experimental Results and Evolutionary Deductions* (Chicago: University of Chicago Press, 1977), fig. 13. 1. Reprinted by permission of The University of Chicago Press.

Plate 3.7 Four images of the tomato bushy stunt virus. From Stephen Harrison, "What Do Viruses Look Like?" *Harvey Lectures* 85 (1991): fig. 2. Reprinted by permission of Wiley-Liss, Inc. a subsidiary of John Wiley and Sons, Inc.

Plate 3.8 Three images of the tomato bushy stunt virus. From Stephen Harrison, "What Do Viruses Look Like?" *Harvey Lectures* 85 (1991): fig. 2. Reprinted by permission of Wiley-Liss, Inc. a subsidiary of John Wiley and Sons, Inc.

Plate 3.9 A ribbon diagram of a virus subunit. From Stephen Harrison, "What Do Viruses Look Like?" *Harvey Lectures* 85 (1991): fig. 2. Reprinted by permission of Wiley-Liss, Inc. a subsidiary of John Wiley and Sons, Inc.

Plate 3.10 Peeled polymer film on a silicon substrate. Preparation by Daniel Ehrlich, Whitehead Institute. © Felice Frankel, Edgerton Center, Massachusetts Institute of Technology.

Plate 3.11 (bottom) From Howard Morphy, "From Dull to Brilliant: The Aesthetics of Spiritual Power among the Yolngu," *Man* 24 (1988): 21–40, plate 2, following p. 30. Diagram modified by the author. Reprinted by permission of Howard Morphy.

Plate 4.1 The Cathedral of the Intercession of the Moat (St. Basil's). Moscow, sixteenth century. Reprinted by permission of The Conway Library, Courtauld Institute of Art.

Plate 4.2 Maqsud of Kashan, Ardabil carpet, detail of central sunburst medallion. Persia, Safavid Dynasty, 1540 C.E. Los Angeles County Museum of Art, gift of J. Paul Getty.

Plate 5.1 Wittgenstein. *Portrait Bust.* Photo from Michael Nedo and Michele Ranchetti, *Ludwig Wittgenstein, Sein Leben in Bildern und Texten* (Frankfurt am Main: Suhrkamp, 1983), plate 306. Reprinted by permission of Wittgenstein Archive.

Plate 5.2 Hokusai. *Fuji from Hodogaya.* Detail. Late 1820s. Photo by author. Reprinted by permission of Tokyo National Museum.

Plate 5.4 George Inness, *The Coming Storm.* 1878. Oil on canvas, 26 × 38½ in. Buffalo, Albright-Knox Art Gallery. Albert H. Tracy Fund, 1900.

Plate 5.5 Johann Jacob Froberger. *Lamento sopra la dolorosa perdita della Real Majestà di Ferdinando IV, Rè de Romani (Lament on the Death of Ferdinand IV, King of the Romans),* final manuscript page. From *Toccatas and Suites for the Keyboard,* book 4, suite 12, i. 1657. Vienna, Österreichische Nationalbibliothek, MS 18707.

Plate 5.7 Page from the signary of proto-Elamite. From R. de Mcquenem, "Épigraphie Proto-Élamite," *Mémoires de la Mission Archéologique en Iran* 31 (1949): Plate 60. Reproduced by permission of Presses Universitaires de France.

Plate 6.1 Paolo Giovio. *Impresa* for the Medici family, From Giovio, *Diologo dell'imprese militari et amorose* (1559), 40. Reprinted by permission of Scholars Facsimiles and Reprints.

Plate 6.2 Drawing of "La Table des Marchands" from *The Language of the Goddess* by Marija Gimbutas. Copyright © 1989 by Marija Gimbutas. Reprinted by permission of HarperCollins Publishers, Inc.

Plate 7.1 Some classical Islamic cursive scripts. From *Brocade of the Pen: The Art of Islamic Writing,* ed. Carol Fisher (Michigan State University: Kresge Art Museum, 1991), figs. 1–6. Reprinted courtesy of the Kresge Art Musuem.

Plate 7.2 Cebeci-Zâde. *Tughra* of Maḥmûd Khân, son of 'Abd ul-Ḥâmid (Mahmud II, r. 1808–1830). 1233, Islamic calendar. Ankara, Collection of the Topkapi Palace Museum. From Suha Umur, *Osmanli Paḍisah Tuğralari* (Istanbul: Cem Yayinevi, 1980), 48, fig. 35.

Plate 7.3 The Babylonian Talmud, Rabbi Dr. I. Epstein ed., *Mishnayoth Zera'im* (London: Soncino Press, 1989).

Plate 7.4 Hrabanus Maurus and Hatto. Poem and self-portrait adoring the cross. ca. 810 C.E. Graz, Österreichische Nationalbibliothek, MS NB 26.742. Photo by Leutner Fachlabor.

Plate 7.7 Pages from a Qur'ān, showing *sūrat al-Fātiḥah,* I, 1–7. Gold Rayḥānī script. Sixteenth century. Afghanistan or India. London, British Library, Or. 11544, ff. 3v–4r. Reprinted by permission of the British Library

Plate 7.9 (top) Sample of Renaissance German *Kurrent* script. From Hans Lencker, *Perspectiva,* fol. 4v. MS Chicago, Newberry Library. Photograph courtesy of John M. Wing Collection, the Newberry Library, Chicago.

Plate 7.12 *Left:* Yanagida Taiun. Cold Mountain, detail of right-hand portion. From *Traces of the Brush, Studies in Chinese Calligraphy,* ed. Shen Fu et al. (New Haven, Conn.: Yale University Press, 1977), 77. Reprinted by permission of Cecil Uyehara.

Plate 7.13 Chu Ta. *Falling Flower*. 1692. Short Hills, New Jersey, collection of the estate of Mr. and Mrs. Fred Fang-yu Wang.

Plate 7.14 (top) Kamijo Shinzan, *Listening to Rain*. 1982. From *Words in Motion: Modern Japanese Calligraphy* (Washington, D.C.: Library of Congress, 1985), 106. Reprinted by permission of Cecil Uyehara.

Plate 7.15 Mark Tobey, *Dragonade,* 1957. Sumi ink: grey and black splatter and brush; white rice paper. 24⅜ × 34⅛ in. Milwaukee Art Museum, gift of Mrs. Edward R. Wehr. © 1998 Artists Rights Society (ARS), New York/Pro Litteris, Zurich.

Plate 8.1 Two transcriptions of the Luwian Hittite inscription on the Tarkondemos Seal. *Top:* after a drawing in Cyrus Gordon, *Forgotten Scripts* (New York: Dorset, 1987), 96. *Bottom:* compiled and redrawn from Emanuel Laroche, *Les Hiéroglyphes Hittites,* vol. 1, *L'écriture* (Paris: Editions du Centre National de la Recherche Scientifique, 1960), nos. 101, 320, 17, 391, 383, 228, respectively, except for the *a* sign, which is from Piero Meriggi, *Manuale di Eteo Geroglifico* (Rome: Edizioni Dell'Ateneo, 1967), p. 143. Reproduced by kindly permission of the publisher.

Plate 8.2 The Tarkondemos seal. Courtesy The Walters Art Gallery, Baltimore.

Plate 8.3 Stele from Boğazköy, Turkey. From David Hawkins, "Writing in Anatolia: Imported and Indigenous Systems," *World Archaeology* 17, no. 3 (1986): 363–76, illustration on p. 373. Photo courtesy David Hawkins, School of Oriental and African Studies, London.

Plate 8.5 Examples of the cuneiform sign for *king. Left, top to bottom:* ca. 2700 B.C.E., ca. 2500 B.C.E., ca. 2250 B.C.E, ca. 2035 B.C.E., ca. 1760 B.C.E. *Right:* Neo-Assyrian forms, ca. eighth century B.C.E. *Left and top right:* from Georges Jean, *Writing: The Story of Alphabets and Scripts,* trans. by Jenny Oates (New York: Abrams, 1992), 18, right. Reprinted by permission of Harry N. Abrams, Inc. and Thames and Hudson Ltd. *Middle and bottom right:* from René Labat, *Manuel d'épigraphie akkadienne (signes, syllabaire, idéogrammes),* 4th ed. (Paris: Librarie Orientaliste Paul Geuthner, 1963), 102, no. 151. Drawing by author.

Plate 8.6 King Njoya. Characters in the Barnum Script. 1903. From Alfred Schmitt, *Die Bamum-Schrift* (Wiesbaden: Otto Harrassowitz, 1963), vol. 2, table 4, Zeichentafel A, p. 8. Reprinted by permission of Harrossowitz Verlag.

Plate 8.11 Logographic glyph and syllable sign gyphs for *pakal* (shield); in Mayan. From D. Stuart and S. D. Houston, "Maya Writing," *Scientific American,* August 1989, 86.

Plate 8.12 The verb *ts'apah* (was set upright), in Mayan. From Stuart and Houston, "Maya Writing," *Scientific American*, August 1989, 86.

Plate 9.3 Archaic tablet, written in Sumerian (?). Uruk III. From Ignace Gelb et al., *Earliest Land Tenure Systems in the Near East: Ancient Kudurrus.* Oriental Institute Publications, vol. 104 (Chicago: Oriental Institute, 1989), vol. 2, plate 1, no. 1. Courtesy St. Mark's Library, General Theological Seminary, New York.

Plate 9.4 Adolph Gottlieb. *Letter to a Friend.* 1948. Oil, tempera, and gouache on canvas. © Adolph and Esther Gottlieb Foundation, New York Licensed by VAGA, New York, NY.

Plate 9.5 Seal impression, and diagram. Ur, Iraq. From A. Nöldeke et al., *Uruk vorläufiger Bericht* (Berlin: Verlag der Akademie der Wissenschaften, 1932), vol. 4, plate 15g. Diagram: after Dominique Collon, *First Impressions, Cylinder Seals in the Ancient Near East* (Chicago: University of Chicago Press, 1987), [107]. © The British Museum Press. Drawing by author. Photo © Bildarchiv Preußischer Kulturbesitz.

Plate 9.7 *Top:* Fragmentary predynastyic pot from Deir Tasa. *Bottom, left to right:* hieroglyphs for "tree," "libation," and "vomit." *Top:* from Guy Brunton, *Mostagedda and the Tasian Culture,* British Museum Expedition to Middle Egypt, First and Second Years 1928, 1929 (London: British Museum, 1937), plate 35, fig. 18. *Bottom:* from William Arnett, *The Predynastic Origin of Egyptian Hieroglyphs* (Washington, DC: University Press of America, 1982), plate 2 b, e, f. Reproduced courtesy of William Arnett, Associate Professor of History, West Virginia University.

Plate 9.8 Representations of scorpions. *From top:* P. Toscanne, "Sur la figuration et le symbole du scorpion," *Revue d'Assyriologie et d'Archéologie orientale* (Paris) 14 (1917): 191, figs. 56–58; 189, figs. 44–47; 192, figs. 59–60; William Arnett, *The Predynastic Origin Egyptian Hieroglyphs* (Washington: University Press of America, 1982), plate 17. Reproduced courtesy of William Arnett, Associate Professor of History, West Virginia University. Toscanne, 187, figs. 1–5; 188, figs. 14–26; and Godfrey Driver, *Semitic Writing: From Pictograph to Alphabet* (London: Oxford University Press, 1976), 48, fig. 23A, by permission of Oxford University Press, partly adapting Toscanne, 188, figs. 34–38.

Plate 9.9 Samples of predynastic Chinese pottery marks. Hsiao-t'un, An-yang, Honan. From Kwong-yue Cheung, "Recent Archaeological Evidence Relating to the Origin of Chinese Characters," trans. Noel Barnard, in *The Origins of Chinese Civilization,* ed. David Keightley (Berkeley: University of California Press, 1983), 327–29, fig. 12.22, detail. Illustration modified.

Plate 9.10 Painted sign on a flat-backed *hu* vase. Middle Ta-wen-k'ou period, ca. 3500–2500 B.C.E. Pao-t'ou-ts'un, Ning-yang, Shantung. Redrawn by author, after William Boltz, "Early Chinese Writing," *World Archaeology* 17, no. 3 (1986): 433, and Kwong-yue Cheung, "Recent Archaeological Evidence," 328, fig. 12.4. Reproduced courtesy of Routledge, London.

Plate 9.11 The characters "Father Ting." Rubbing from a bronze *ting* vessel. From Léon Long-Yien Chang and Peter Miller, *Four Thousand Years of Chinese Calligraphy* (Chicago: University of Chicago Press, 1990),388. Reprinted by permission of the University of Chicago Press.

Plate 9.12 The characters *kuan,* "to cleanse the fingers." Rubbing from a bronze vessel. From Chang and Miller, *Four Thousand Years of Chinese Calligraphy,* 390. Reprinted by permission of the University of Chicago Press.

Plate 9.13 The runic and runeless golden horns. Early fifth century C.E. Discovered in 1639 and 1734 near Gallehus, Tønder amt, Sønderjylland, Denmark, and destroyed in 1802; formerly Copenhagen, Royal Art Museum. Drawings from Lis Jacobsen and Erik Moldke, *Danmarks Runeindskrifter,* 2 vols. (Copenhagen: Ejnar Munksgaard, 1942), vol. 2, figs. 36, 40. Reprinted by permission of Munksgaard International Publishers.

Plate 10.2 Yukaghir picture-writing. Siberia, ca. 1930. From IA. P. Al'kora, *Iazyki i pis'mennost' narodov severa.* Leningrad, Institut Narodov Severa, Trudy po Lingvistike, Nauchno-issledovatel'skaia assotsiatsiia. (Moscow: Gos. Uchebno-pedagog., 1934), vol. 3, figs 1 and 3. Reprinted by permission of Institut Lingvisticheskikh Issledovanii Rossiiskaia Akademaii Nauko.

Plate 10.3 The Narmer palette, obverse. ca. 3000 B.C.E. Carved schist. The Egyptian Museum in Cairo. Outline drawing from Sir Alan Gardiner, *Egyptian Grammar,* third edition (London: Oxford University Press, 1957 [1927]), 7. Reproduced by permission of Oxford University Press.

Plate 10.4 Hieroglyphic Egyptian for "lassoing the ibex by the hunter." *Bottom:* written as a single line. *Top:* with the ideographs expanded into a picture. *Top:* from Henry Fischer, *The Orientation of Egyptian Hieroglyphs,* part 1. *Reversals* (New York: Metropolitan Museum of Art, 1977), fig. 1. *Top:* courtesy Henry Fischer. *Bottom:* courtesy Emily Teeter.

Plate 10.5 Variations on the name Narmer. From Gérard Godron, "A propos du nom royal [Narmer]," Annales du Service des Antiquités de l'Egypte 49 (1949): 217–20, plate 1. © Institut Française d'Archéologie Orientale du Caire.

Plate 10.6 Giotto. *Lamentation.* Fresco. Padua, Arena Chapel. Alinari/Art Resource, NY.

Plate 10.7 Impression on an envelope. Karum Kanish level II (ca. 2000–1500 B.C.E..) Kültepe, Turkey. From Nimet Özgüç, *Kültepe muhur Baskilarinda Anadolu Grubu: The Anatolian Group of Cylinder Seal Impressions from Kültepe.* Türk Tarih Kurumu yayinlarindan, 5th ser., vol. 22 (Ankara: Türk Tarih Kurumu Basimevi, 1965), plate 20, fig. 60. Courtesy of Prof. Dr. Nimet Özgüç.

Plate 10.8 Engravings after a drawing by Jacob Böhme, representing the Sixth Age. *Top:* 1730; *bottom:* 1682. From *Jacob Böhme, Sämtliche Schriften,* facsimile of the edition of 1730, ed. Will-Erich Peuckert (Stuttgart: Fr. Frommans Verlag, 1955–), vol. 7, *Mysterium magnum* (1958), § 44. Reprinted by permission of Fromman-Holzboog.

Plate 10.9 Julian Schnabel. *E o OEN.* 1988. Courtesy Pace Gallery, New York City.

Plate 11.3 Martin Brennan, diagram of sun's track across Stone 14 on the summer solstice. ca. 3500 B.C.E. Loughcrew, Ireland. From Brennan, *The Stars and the Stones: Ancient Art and Astronomy in Ireland* (New York: Thames & Hudson, 1983), 94. Reprinted by permission of Thames and Hudson Ltd., London.

Plate 11.4 Elizabeth Shee Twohig, Drawing of Stone 14, Loughcrew, Ireland. ca. 3500 B.C.E. Courtesy of Elizabeth Shee Twohig.

Plate 11.6 Taoist Ling-pao talismans. *Left:* talisman for the Sovereign of the West. Late third century C.E. From *T'ai-shang ling-pao wu-fu hsü, Tao-tsang* 388, chap. 3, p. 10. Reprinted by permission of Harvard-Yenching Institute.

Plate 11.7 Jean Fautrier. *Tourbes.* 1957. Collection Galerie Di Meo, Paris. © 1998 Artists Rights Society (ARS), New York/ADAGP, Paris.

Plate 12.6 Half of the heraldic shield for Richard Plantagenet, Marquis of Chandos, son of the first Duke of Buckingham and Chandos, of the family Temple-Nugent-Brydges-Chandos-Grenville. Nineteenth century. From Stephen Friar, *Heraldry: For the Local Historian and Genealogist* (London: Alan Sutton, 1992), color plate 21.

Plate 12.7 The arms of the West Dorset District Council. From Stephen Friar, *Heraldry: For the Local Historian and Genealogist* (London: Alan Sutton, 1992), 170.

Plate 12.10 Coaster, advertising Guinness beer. ca. 1995. Photo by author. Reprinted by permission of Guinness Ireland Group Ltd.

Plate 13.2 Georg Gichtel. Frontispiece to Jacob Böhme, *Aurora, oder Morgenröthe in Aufgang.* From *Jacob Böhme, Sämtliche Schriften,* ed. Will-Erich Peuckert (Stuttgart: Fr. Frommans Verlag, 1955–), vol. 1. Reprinted by permission of frommann-holzboog.

Plate 13.5 Phylogenetic tree of mitochondrial DNA types. From Linda Vigilant, Mark Stoneking, Henry Harpending, Kristen Hawkes, and Allan Wilson, "African Populations and the Evolution of Human Mitochondrial DNA," *Science* (27 September 1991): 1503–1507, fig. 3.

Plate 13.6 *Left:* Nunik from Umivik, carved wooden maps of a portion of the coast of Greenland. ca. 1884. *Right:* contemporary map of the same coastline. *Left:* from *Kalaallit Nunaat Greenland Atlas,* ed. Christian Berthelsen et al. (Pilersuiffik, 1990), 1. Photo by Lennert Larsen. *Right:* adapted from *Greenland 1:250,000* (Washington: U.S. Army Map Service, 1957), quadrants NQ 23-24-12, NQ 25-26-5, NQ 23-24-8.

Plate 13.7 Klaus-Peter Hartmann and Horst Pohlmann, The religions of Lebanon, detail. *Inset:* a portion of an enlargement intended to clarify the region around Beirut. 1979. Adapted from *Tübinger Atlas des Vorderen Orients* (Wiesbaden: Dr. Ludwig Riechert Verlag, 1990), plate A VIII 7. © Dr. Ludwig Reichert Verlag, Wiesbaden, Germany.

Plate 13.8 D. P. Brachi. Annual sunshine record at Withernwick in the East Riding of Yorkshire. 1967. From Frances John Monkhouse and H. R. Wilkinson, *Maps and Diagrams: Their Compilation and Construction* (London: Methuen & Co., 1971 [1952]), fig. 98.

Plate 14.3 The back of one of the *Tabulae Iliacæ,* and a restoration of the full pattern (the preserved portion is at the upper left). Augustan. *Left:* The *Tabula iliaca* 2.NY, reverse. New York, Metropolitan Museum of Art, Fletcher Fund, 1924, acc. 24.97.11, negative 57.979A. *Right:* from Maria Teresa Bua, "I guiochi alfabetici delle tavole iliache," *Academia Nazionale dei Lincei, Memorie, Classe di Scienze morali, storiche, e filologiche* 16 (1971–72): fig. 2, p. 10.

Plate 14.5 The Nymphalid groundplan. From Nijhout, *The Development and Evolution of Butterfly Wing Patterns* (Washington, D.C.: Smithsonian Institution, 1991), 24, fig. 2.1, modified from B. N. Schwanwitsch, "On the Groundplan of Wing-Pattern in Nymphalids and Certain Other Families of Rhopalocerous Lepidoptera," *Proceedings of the Zoological Society of London* 34, ser. B (1924): 509–28, and E. Süffert, "Zur vergleichende Analyse der Schmetterlingszeichnung," *Biologisches Zentralblatt* 47 (1027): 385–413. Courtesy of Prof. Fred Nijhout.

Plate 14.6 Comparison of three butterflies in the family Amathusiidae, showing the gradual disappearance of elements of the nymphalid groundplan. *Left: Stichphthalma camadeva; middle: Faunis menado; right: Taenaris macrops.* From Nijhout, *The Development and Evolution of Butterfly Wing Patterns,* 27, fig. 2.2. Courtesy of Prof. Fred Nijhout.

Plate 14.7 Patterns on selected moth wings, compared with a variant on the Nymphalid groundplan. Families include Sphingidæ (C, D), Arctidæ (E), Saturnidæ (G, H, I), Noctuidæ (J, K), and Geometridæ (L). From Schwanwitsch, "Color-Pattern in Lepidoptera," *Entomologicheskoe Obozrenie* 35 (1956): figs. 26–40, p. 535. Courtesy of Prof. Fred Nijhout.

Index

Note that the Glossary is not indexed; if you are looking for a definition, use the index as a supplement to the Glossary.

orthostats, 186–92
Ottoman writing, 99–101

page, 101–105
pagina, 101
painterly trace, *see* traces
paintings, 60, 90, 118, 192
 Aboriginal, 48–51, 165 table 10.1,
 166–67
 Chinese, 114–115
 contemporary, 192–94
 Dutch seventeenth-century, 233
 Japanese, 115–16
 medieval, 3–4, 52
 as rich, 27
 rock, 181
 sumi, 115
 as a synecdoche for pictures, 45
 Western narrative, 165 table 10.1,
 173–77
 see also abstraction; naturalism; neo-
 expressionism; surrealism; vase
 paintings
paleography, x, 90, 95, 99
 Islamic, 95
Paleolithic images, 5, 31 n. 1
paleontology, 38, 244, 246
palimpsest, 236
palindrome, 103
paper money, 90, 199
papyri, 101 n. 24, 234 n. 53, 235 n. 1
Paradin, Claude, 196
Parpola, Asko, 143 n. 2
particle physics, 37
Pascal's triangle, 137
passage-graves
 in Brittany, 87–89
 in Ireland, 185–92
Passamaquoddy picture-writing, 169
passant, 204
passports, 199
Pastoureau, Michel, 203 n. 30
Pasztory, Esther, 130 n. 38, 162 n. 46, 162
 n. 47
Pater, Walter, 55
Paulini, Giacomo, 195 n. 3
Peirce, Charles, 55, 61, 80, 140 n. 63
Penfield, Samuel Lewis, 23 n. 22
Penobscot picture-writing, 169
Perniola, Mario, 8 n. 22
Perkins, William, 221 n. 22
perspective, 17, 21, 36 n. 21, 233
 loxodromic maps and, 232
 printing and, 101
Peru, 5
petroglyphs, 181, 182 table 11.1, 182–92
 in Andalusia, 183 n. 6
 in Brittany, 87–89, 183 n. 6, 185
 in Ireland, 185–92
 in Sweden, 183–85
 in the United States, 185
petrographs, 181

Phanes, 216
philately, 237
 see also stamps
philosophy of science, 32
Phoenician, 89, 133
 Early Linear, 134
 "quasi-alphabetic" marks in, 143 n. 1
phonemes, 122
phonetic script, 126
phonetics, in Hittite or Luwian script,
 120–22
Phong rendering, 9
phonograms, 126, 135 n. 50, 139
 in Gardiner's account of Egyptian, 171
phonographs, 123
phonology, 123
photography, 43, 60, 193
 digital, 11–12
 Laue, 24, 46
 X-ray crystallography, 42
phraseographs, 154
Picasso, 6, 24, 27, 233, 239
Pick, Albert, 199 n. 18
pictographic writing, 127 table 8.1
pictographs, 122, 130–32
 as "pure" pictures, 182 table 11.1
 in Gottlieb, 149
 logographic, 170
pictorial syntax, see syntax
pictura, 196–97, 201
 corresponds to the heraldic shield, 204
picture-fact (in Wittgenstein), 64
picture-writing, 90, 159, 165 table 10.1,
 165–69, 180
 see also pseudo-picture-writing
pictures, ix–x, 28, 52–81
 and asyntactic pseudowriting, 156
 defined, 81
 dual sense of, 54–57, 67, 240
 dubious example of, 244
 elements in, 61–62
 as facts and pictures, 64
 fear of, 128
 "feeling of," 86, 187
 as impediment to sense, 241
 living, see *tableau vivant*
 mere, 125, 127 table 8.1
 as models, 60
 mnemonic, 154
 origins of, 60 n. 21
 pages as, 101–105
 pictorial form of (in Wittgenstein), 63
 "pretty," 10–12
 propositional content of, 33 n. 15, 39–
 40, 56–81, 84
 repressed in scripts, 137
 sense of, 64
 smudged or blurred, 62
 text "embedded" in, 162, 163 n. 48
 theory and, relation of, 38–40
 see also Bild; images; marks; natural-
 ism; paintings; "pure" pictures

picturesque, the, 9, 10 n. 29
picture theory (Wittgenstein's), 56–68
Piero della Francesca, 25 n. 28
pixels, 70–71, 234 n. 54
planets, symbols for, 90, 155 n. 24, 198
Plantagenet, Richard, Marquis of
 Chandos, 204
plaques, 211
Plato, 240
pleremic elements in a script, 126
Plotinus, 197
Poe, Edgar Allan, 6
Poix, Joseph de La, de Fréminville, 89
Pollock, Jackson, 48, 192, 194
polypeptide chains, 42–43
polyphony (linguistics), 69
Porphyry, 221 n. 20
portraits
 in pictographic scripts, 121–22
postage stamps, see stamps
postfix, 139
potter's marks, 90, 143, 182 table 11.1, 192
Pound, Erza, 115
pound sign, 144
Praxiteles, 15
Pre-Columbian art, 130 n. 38
"pretty pictures," 10–12
prewriting, 157, 159
Preziosi, Donald, 49, 128 n. 28
primitifs, les, 18
printer's mark, 199, 200 n. 19, 211
projection, 60
 axonometric, 17
 clinographic, 20–21, 23
 gnomonic, 23–24, 28
 oblique, 17
 stereographic, 23–25, 28
 see also perspective; geometry,
 descriptive
proposition (logical), see pictures,
 propositional content of
protocols of reading and looking, 84
proto-Elamite, 77, 188–89
protowriting, 156–60
pseudoalphabet, 170
pseudohieroglyphs, 90, 143, 145, 239
pseudo-picture-writing, 165 table 10.1,
 180
 see also picture-writing
pseudoscripts, 154
pseudowriting, 90, 143–64, 166 table
 10.2, 175
 mnemonic, 153–54
Pulgram, E., 125–26 n. 19
punctuation, 142
 see also diacritical marks
Purcell, Rosamund, 7
pure notation, *see* notations, pure
"pure" pictures, 5, 57, 89, 125, 128, 144,
 147, 234, 238
 as asyntactic pseudowriting, 157
 as reductive, 238

semasiography, 90, 120–142, 166
 table 10.2
 as an anachronistic concept, 238
 semasiographic signs, 154
semeiotics, 140 n. 63
sememe, 156
semicursive script, 96
semiology, integrational, 75 n. 12
semiotics, 84, 239 n. 4
 not applicable to allography, 105
semograms, 126
sense, 84
sense-determinative elements in a
 script, 126
sense-discriminative elements in a
 script, 126
sensus litteralis, 174
sentence (in emblems), 196
sentencelike scene, 166
Sephirotic tree, 219
serekh, 172
Serres, Michel, 29, 45 n. 46
sets
 in mathematics, 77–80
 strict and lenient, 73
Settis, Salvatore, 193, 219 n. 14
Seurat, Georges, 6, 45 n. 44
shamans, Ojibwa, 154, 169 n. 13
Shang, 158
Shee Twohig, Elizabeth, 188–89
Shen Fu, 114 n. 51, 114 n. 52
shields, see heraldic shields
Shinzan, Kamij, 115–18
Shiva, 218
Short, Larry, 7 n. 20
showing and saying (in Wittgenstein),
 63–65, 68, 81, 84
shu, 95
Shultz, Bernard, 8 n. 21
Siddiqui, Atiq, 99 n. 16
sigil, in Bryson's theory, 84 n. 5
siglum, 106, 153, 198, 200
 see also logical sigla; logo; sigil
Signac, Paul, 6
signary, 79, 90
 alchemical, 155, 181
 in butterfly wings, 249
 as inventory, 188
 limited, 146 table 9.1
 in Mayan script, 139
 minimally diverse, for writing, 147
 nondisjoint, 181–82
 numerable, 146 table 9.1
 in a sample of minerals, 245
signatures, 98–100, 101 n. 22
 John Hancock's, 106
signets, 198 n. 14
signs
 Alaskan Eskimo, 165–66
 alchemical, 144, 155 n. 24
 angelic and demonic, 144
 astrological, 144, 161, 238

asyntactic, 165 table 10.1, 174
basic assumptions about, 189
biliteral and triliteral, 170
commercial, 91, 211 n. 48
disjoint, 144, 146, 188–92, 246
disordered, 149
narrative, 154
nondisjoint, 181, 182 table 11.1
secret, 125
semasiographic, 154
 as synonym for glyphs, 139 n. 59
 "universal," 153
 in writing, 127, 146–47
 see also astrological signs; chemical
 signs; iconic signs; indexical
 signs; symbolic signs
Sijelmassi, Mohammed, 118 n. 62
silence (in Wittgenstein's theory), 81, 84
silicon film, 47–48
Sioux picture-writing, 169
Sistine Chapel, 14
Sixth and Seventh Books of Moses, 143–
 44, 146 table 9.1, 153, 170, 192
sketches, 33–35, 40
Slaughter, Mary, 221 n. 21
Slobodkin, Lawrence, 216 n. 8
slogans, 197
Smith, Bernard, 9 n. 29
Smith, Paul, 7 n. 18
Smith, Quentin, 41 n. 37
Smith, Terry, 49
sociology, 31 n. 4
 of science, 32
Solomon, 143
Sommerfeld, Abraham von, 177, 179, 239
sonar charts, 36, 71–74, 80, 231
Sophia, 214, 216
Sotatsu, Tawaraya, 115
space
 destruction and negation of, 25
 in fifteenth-century drawing, 33
 in a map of the universe, 228
 in a map of the world, 231–32
 multidimensional (more than three
 dimensions), 37, 41
 in a sonar chart, 36
spacing between signs, 147
spectrographic writing systems, 126 n. 19
speech, see voice
spelling, variants of
 in Bamum, 130–32
 in German, 106,
 in English, 141
 in Mayan, 139–40
Spinoza, Baruch, 101 n. 25
Stafford, Barbara, 7 n. 15, 8 n. 23, 9, 10
 n. 29, 45, 198 n. 14, 219 n. 12
 on footnotes, 101 n. 25
 on the ideographic impulse, 124 n. 12
stamps, 27, 199, 236–37
standard script (China and Japan), 96
Stead, Rexford, 56 n. 12

Steinberg, Leo, 8 n. 20
Steiner, George, 3 n. 2
stele, 122, 137–38
Stella, Frank, 193
Stenius, Erik, 64, 66
stereographic projection, 23–25, 28
Stevens, John, 69 n. 2
Stieglitz, Alfred, 4
stock certificates, 90, 199
styles
 in calligraphy, 98–101
 see also abstraction; cubism; decadent
 art; neoclassicism; realism;
 surrealism
subfix, 139
subgraphemics, 90, 144, 160–80
sublime, the, 9, 10 n. 29, 13
subscriptio, 197, 233–34
Sudan, 170
suits (on playing cards), 144–46
Sumerian, 120, 130 n. 35, 155 n. 22, 175, 211
Summers, David, 4 n. 3, 54 n. 5, 60 n. 21
superfix, 139, 189
supporters (in heraldry), 204
sūrahs, 106, 112–13
surrealism, 28, 108, 181, 239
Sutton, Peter, 167 n. 6
Swanson, Randy, 33 n. 14
swords, 138
syllabary, 126 n. 22, 128
 in Mayan script, 139
syllabication, 139
syllabic scripts, 126 n. 22
syllables, 127
 suggested in pseudowriting, 144
"symbolic picture" (on the Narmer
 Palette), 172
symbolic signs (Peirce's), 80, 140 n. 63
symbolon, 196, 203
symbols
 carelessly painted, 180
 Cassirer's definition of, 156
 contingent and constitutive, 70
 Goodman's definition of, 156
 on maps, 225, 228
 prelinguistic, 89
synchronic, 221
syntactic disjunction, 69, 71–72, 182, 187
 nondisjunction, 189
 see also disjunction
syntactic finite differentiation, 69, 71, 73,
 144, 182
syntactic pseudowriting, 144, 146
 table 9.1
syntagmatic relations, 164
syntax, 119
 blurred, 180
 in butterfly wings, 247–49
 in Goodman's theory, 69, 74, 77, 164,
 187
 loose definition of, 164–65
 pictorial, 164, 174